**Institute for
Research on
Public Policy**

*Institut de
recherche
en politiques
publiques*

F OUNDED IN 1972, THE INSTITUTE FOR RESEARCH ON Public
Policy is an independent, national, nonprofit organiza-
tion.

IRPP seeks to improve public policy in Canada by
generating research, providing insight and sparking debate
that will contribute to the public policy decision-making
process and strengthen the quality of the public policy deci-
sions made by Canadian governments, citizens, institutions
and organizations.

IRPP's independence is assured by an endowment
fund, to which federal and provincial governments and the
private sector have contributed.

F ONDÉ EN 1972, L'INSTITUT DE RECHERCHE EN politiques
publiques (IRPP) est un organisme canadien, indépen-
dant et sans but lucratif.

L'IRPP cherche à améliorer les politiques publiques
canadiennes en encourageant la recherche, en mettant de l'a-
vant de nouvelles perspectives et en suscitant des débats qui
contribueront au processus décisionnel en matière de poli-
tiques publiques et qui rehausseront la qualité des décisions
que prennent les gouvernements, les citoyens, les institutions
et les organismes canadiens.

L'indépendance de l'IRPP est assurée par un fonds de
dotation, auquel ont souscrit le gouvernement fédéral, les gou-
vernements provinciaux et le secteur privé.

The Art of the State III

Belonging?
Diversity,
Recognition and
Shared Citizenship
in Canada

Keith Banting,

Thomas J. Courchene and

F. Leslie Seidle, editors

Printed in Canada
Dépôt légal 2007

National Library of Canada
Bibliothèque nationale du Québec

LIBRARY AND ARCHIVES CANADA CATALOGUING
IN PUBLICATION

Belonging? : diversity, recognition and shared
citizenship in Canada / edited by Keith Banting,
Thomas J. Courchene and F. Leslie Seidle.

(The art of the state ; 3)
Collection of papers originally presented at a conference
held Oct. 13-15, 2005, Montebello, Quebec.

Includes bibliographical references.
ISBN-13: 978-0-88645-201-8
ISBN-10: 0-88645-201-5

1. Multiculturalism—Canada—Congresses.
2. Pluralism (Social sciences)—Canada—Congresses.
3. Multiculturalism—Congresses. 4. Pluralism (Social
sciences)—Congresses. I. Banting, Keith G., 1947- II.
Courchene, Thomas J., 1940- III. Seidle, F. Leslie IV.
Institute for Research on Public Policy V. Series: Art of
the state (Montréal, Québec) ; 3.

FC104.B44 2007 305.800971 C2006-906226-9

PROJECT DIRECTOR
F. Leslie Seidle

COPY EDITOR
Mary Williams

PROOFREADERS
Anne Holloway and Barbara Czarnecki

EDITORIAL COORDINATOR
Francesca Worrall

COVER DESIGN AND INTERIOR DESIGN
Schumacher Design

COVER ILLUSTRATION
Normand Cousineau

PRODUCTION AND LAYOUT
Anne Tremblay

PUBLISHED BY
The Institute for Research on Public Policy (IRPP)
l'Institut de recherche en politiques publiques
1470 Peel Street, Suite 200
Montreal, Quebec H3A 1T1

ix
Acknowledgements

1
INTRODUCTION
Keith Banting, Thomas J. Courchene
and F. Leslie Seidle

CANADIAN APPROACHES
TO RECOGNIZING AND
ACCOMMODATING DIVERSITY
39
Will Kymlicka
Ethnocultural Diversity in a Liberal
State: Making Sense of the
Canadian Model(s)

87
Roy McMurtry
Accommodating Canada's
Diversity

95
Yasmeen Abu-Laban
History, Power and
Contradictions in a
Liberal State

105
Daniel Salée
The Quebec State and the
Management of Ethnocultural
Diversity: Perspectives on an
Ambiguous Record

143
Marie Mc Andrew
Quebec's Interculturalism
Policy: An Alternative Vision

155
Katherine A.H. Graham and
Susan D. Phillips
Another Fine Balance: Managing
Diversity in Canadian Cities

195
David Ley
Spatial and Scalar Issues in
Managing Diversity in
Canada's Cities

INDIGENOUS PEOPLES
207
Evelyn Peters
First Nations and Métis People and
Diversity in Canadian Cities

247
John Richards
Culture Matters, but...
Explaining Trends among Urban
Aboriginal People

263
Joyce Green and Ian Peach
Beyond "Us" and "Them":
Prescribing Postcolonial Politics and
Policy in Saskatchewan

285
Roger Maaka
Maori and the State:
Diversity Models and Debates in
New Zealand

INTERNATIONAL EXPERIENCES
321
Christian Joppke
Immigrants and Civic Integration in
Western Europe

Contents

351
Randall Hansen
Diversity, Integration and the Turn
from Multiculturalism in the United
Kingdom

387
Marc Hooghe, Tim Reeskens and
Dietlind Stolle
Diversity, Multiculturalism and
Social Cohesion: Trust and
Ethnocentrism in European Societies

411
Mary C. Waters and Zoua M. Vang
The Challenges of Immigration to
Race-Based Diversity Policies in the
United States

FAITH-BASED COMMUNITIES
AND DIVERSITY

451
Tariq Ramadan
Religious Allegiance and Shared
Citizenship

465
Marion Boyd
Religion-Based Alternative Dispute
Resolution: A Challenge to
Multiculturalism

475
Sheema Khan
The Ontario Sharia Debate:
Transformational
Accommodation,
Multiculturalism and
Muslim Identity

ETHNOCULTURAL COMMUNITIES:
PARTICIPATION AND SOCIAL
COHESION

489
Jeffrey G. Reitz and Rupa Banerjee
Racial Inequality, Social Cohesion
and Policy Issues
in Canada

547
Pearl Eliadis
Diversity and Equality:
The Vital Connection

561
Stuart Soroka, Richard Johnston
and Keith Banting
Ties That Bind? Social Cohesion
and Diversity
in Canada

601
Bonnie Erickson
Ties That Bind and Ties That
Divide

611
Paul Howe
The Political Engagement of New
Canadians: A Comparative
Perspective

647
CONCLUSION: DIVERSITY,
BELONGING AND SHARED
CITIZENSHIP
Keith Banting, Thomas J. Courchene
and F. Leslie Seidle

689
Notes on contributors

Belonging? Diversity, Recognition and

T HIS IS THE THIRD VOLUME IN THE ART OF THE STATE SERIES OF THE INSTITUTE FOR Research on Public Policy (IRPP). The papers and commentaries presented here originated in a conference on the theme "Diversity and Canada's Future," held in Montebello (Quebec) in October 2005. The topic, which emerged from a discussion at a meeting of the IRPP board of directors, was pursued with characteristic vigour by Hugh Segal, then the president of IRPP. We are most grateful to him for his leadership and for the contribution he made during a number of stimulating discussions. His successor, Mel Cappe, demonstrated strong commitment to this project as it was brought to a successful conclusion.

The Art of the State III conference program was developed in collaboration with an advisory committee that included the editors, and Will Kymlicka (Queen's University) and Daniel Salée (Concordia University). The editors wish to thank their colleagues for their valuable advice. We also wish to acknowledge the financial support for the conference from the Canadian Institute for Research on Public Policy and Public Administration in Moncton.

At the IRPP, where teamwork is a reality, not a slogan, several people played an important role leading to the publication. Suzanne Lambert coordinated the conference arrangements with her customary skill; she was assisted by Virginie Leduc and Chantal Létourneau. Suzanne Ostiguy McIntyre managed the production process for the book. Francesca Worrall coordinated the editorial process with a rigorous eye and adroit management. Anne Tremblay provided layout assistance, Mary Williams and Anne Holloway copy-edited the volume, and Barbara Czarnecki and Anne Holloway proofread the manuscript. Jenny Schumacher was responsible for the cover design. Ara Karaboghossian, Grant Holly, Hugh Meighen and Laura O'Laughlin provided excellent research assistance at various stages of the process. We wish to express our sincere thanks to all these collaborators.

The strength of an edited volume is directly tied to the quality of the authors' contributions. All those who wrote papers and commentaries provided rich and timely insights on various dimensions of this broad and complex subject. They also demonstrated considerable openness to the editorial committee's comments and timeliness in revising their texts. We are deeply indebted to every one of them.

Finally, we wish to acknowledge the important contribution of France St-Hilaire, IRPP vice-president of research. France played a leading role throughout the process and was a member of the editorial committee that reviewed the texts that appear here. Through her insights and dedication, this is a much improved book.

Introduction

I T IS OFTEN SAID THAT DIVERSITY AND ITS BROAD ACCEPTANCE ARE DEFINING CHARACTER-istics of Canada. In light of the country's history, Constitution and demographic composition, this observation can hardly be contested. This does not mean that everyone agrees how Canadians' respect for diversity should translate into practice. In fact, diversity has given rise to two policy agendas that intersect and are sometimes in tension. One agenda focuses on the recognition of diversity. It seeks to respect cultural differences, expand the room for minorities to express their distinctive cultures and foster inclusion. The second agenda focuses on social integration and social cohesion. Its goal is to bring members of minority groups into the economic and social mainstream, and to sustain a sense of belonging on their part.

This volume explores both dimensions of the Canadian approach to diversity. Canada has long prided itself on being supportive of its official language minorities and of multicultural diversity. Within these two domains it has adopted policies and constitutional provisions designed to extend public recognition and support for official language and ethnocultural minorities, so that they are able to maintain and express their distinct identities and practices. Although protection of language rights was meant in part to secure Quebec's place within Canada, many Québécois nevertheless remain loosely — or not at all — committed to Canada. A third domain concerns Canada's First Peoples. Despite some progress on formal recognition of Aboriginal rights, the kind of self-government arrangement that a number of First Nations communities are seeking has not been achieved. Although the Quebec-Canada question remains fundamental and has been explored in countless research studies and reports, this volume concentrates mainly on diversity issues as they concern ethnocultural minorities (with a focus on recent immigrants) and Aboriginal

people. Recent debate on some of these issues has raised a number of questions, some quite fundamental. For example, do these minorities have a sense they are fully part of the country, that they really belong? Are Canadians really as tolerant of difference as we like to think, or is discrimination still a reality in this country?

A main concern of the second agenda referred to above is social integration. For decades, there have been tensions among the historic or founding peoples of the country, as evidenced, for example, by the very close results, against Quebec, in the 1995 sovereignty referendum and by certain clashes between Aboriginal communities and the wider society. In contrast, the integration of new Canadians has generally seemed to be a success story, and debate continues to focus mainly on fostering respect for minority differences rather than the erosion of the ties that bind. However, some cracks seem to be appearing. Recent cohorts of immigrants have fared less well in the labour market, despite having higher levels of education and training than their predecessors. There is evidence of greater residential segregation in some of our cities. The emergence of gang-related violence sometimes involving racial or Aboriginal minorities is disquieting. And the sharp debate about the potential role of Islamic Sharia law in Ontario in 2003-04 demonstrates how quickly flashpoints can emerge (and be resolved). These warning signals, together with the images of sectarian tension in other countries flashing across our television screens, have raised questions about social integration in Canada.

In western Europe, government policies have increasingly converged on a model of civic integration that emphasizes the desirability of immigrants adopting the language and culture of the receiving country. Until recently, these developments have had limited resonance in Canada, and Canadians have often been puzzled by the intensity of debates elsewhere. Canada's core policies on immigration and multiculturalism have enjoyed substantial political consensus, and occasional challengers have found little traction in political debate. Do Canadians really have reason to worry about social integration? If some recent immigrants are faring less well than earlier cohorts, what is to be done? Are new fault lines linked to race and religion straining social cohesion in Canada? And how can we narrow the enduring — and potentially explosive — gaps in life chances between many Aboriginal people and other Canadians?

In attempting to answer these questions, this book takes stock of Canadian diversity policies, examining their effectiveness in both supporting difference and enhancing integration. It brings together an impressive group of researchers from Canada and other countries to explore diversity and belonging in the contemporary

era. This chapter introduces the general issues that frame the book and summarizes the contributions to the volume. The first section of this chapter provides a brief overview of some of the approaches to the recognition and accommodation of diversity in Canada that have developed since the 1960s. The second section reviews a number of developments and emerging challenges to the effectiveness of these approaches. We ask whether some of the trends, including socioeconomic ones, are creating barriers to social integration and placing strains on social cohesion. The final section provides an overview of the ensuing chapters and commentaries.

Recognition of and Support for Diversity in Canada

DIVERSITY ISSUES IN CANADA REVOLVE AROUND MUCH MORE THAN POPULATION statistics and trends. It is nevertheless useful, before turning to questions of recognition, to highlight some of the main current demographic patterns.

- In the 2001 Census, 59.1 percent of the Canadian population had English as their mother tongue; 22.9 percent had French as their mother tongue. Between 1961 and 2001, the proportion of census respondents claiming neither English nor French as their mother tongue rose from 13.5 to 17.6 percent.[1]

- People who identify themselves as Aboriginal (First Nations, Métis or Inuit) account for a small but growing share of the country's population: 3.3 percent in the 2001 Census, compared with 2.8 percent five years earlier. There are more than 630 First Nations, and Aboriginal people in Canada speak more than 50 languages. In 2001, Cree was the Aboriginal language reported as a mother tongue by the highest number of people — 80,000. Inuktitut, the principal language spoken by the Inuit, was claimed as the mother tongue by 29,700.

- Canada has the highest per capita immigration in the world — three times higher than the United States, for example. During 2004-05, net international migration accounted for two-thirds of Canada's population growth, compared with 38 percent in the United States (Statistics Canada 2006). In October 2006, the federal government announced

that Canada planned to accept between 240,000 and 265,000 new-comers as permanent residents in 2007 — an increase from the range of 225,000 to 255,000 set for 2006, and the highest level in 25 years (Citizenship and Immigration Canada 2006).

- The composition of immigration to Canada has changed dramatically since the 1960s. The vast majority of immigrants now come from four countries: India, Pakistan, China and the Philippines. Some two-thirds of new arrivals settle in the country's three largest cities: in 2001, 48 percent of immigrants and refugees settled in Toronto, followed by 15 percent in Vancouver and 12 percent in Montreal (Statistics Canada 2003).

- According to the 2001 Census, 18.4 percent of the country's population were born outside Canada; 43.7 percent of the population in the Toronto Census Metropolitan Area (CMA) were born outside the country, and in the Vancouver CMA the proportion was 37.5 percent. The proportion of foreign born in Canada is considerably higher than in the United States, where 11.7 percent of the population were foreign born in 2003, but lower than in Australia (22 percent in 2001) and New Zealand (19.5 percent in 2001).[2]

The steps Canada has taken to recognize and protect diversity started some 250 years ago. The Royal Proclamation of 1763 recognized certain Aboriginal territorial rights in the colonies ceded by the French. The *Quebec Act, 1774* provided for the continuation of the French civil code and allowed Roman Catholics to practise their religion. At Confederation in 1867, the right to use French and English in the federal Parliament and the Quebec legislature, and in the courts of the two jurisdictions, was guaranteed. In 1964, the Royal Commission on Bilingualism and Biculturalism was appointed, partly in response to French-speaking Quebecers' discontent about their place within Canada. Language rights within federal jurisdiction were significantly expanded by the *Official Languages Act, 1969,* important elements of which were entrenched in the Canadian Charter of Rights and Freedoms in 1982.[3] However, successive Quebec governments have looked beyond language rights. They have sought greater powers and called for limits on the role of the federal government with regard to what they see as provincial matters — for example, through rules to constrain the use of the federal spending power. Failed attempts to recognize Quebec's distinctiveness within the Constitution have left many Quebecers frustrated about the degree to which other Canadians accept Quebec's particular history and culture.[4]

The roots of the federal government's multiculturalism policy are linked to the way it has addressed linguistic duality. The leaders of certain ethnocultural groups criticized the mandate of the Royal Commission on Bilingualism and Biculturalism because it excluded their own communities' heritage. The federal government responded by developing the 1971 multiculturalism policy, which had the following goals:

- ◆ to assist all Canadian cultural groups that have demonstrated a desire and effort to continue to develop a capacity to grow and contribute to Canada;
- ◆ to assist members of all cultural groups to overcome cultural barriers to full participation in Canadian society;
- ◆ to promote creative encounters and interchange among all Canadian cultural groups in the interest of national unity;
- ◆ to assist immigrants to acquire at least one of Canada's official languages in order to become full participants in Canadian society (Trudeau 1971, 8546).

As part of the constitutional reform of 1982, the Canadian Charter of Rights and Freedoms included a requirement (section 27) that the Charter be interpreted "in a manner consistent with the preservation and enhancement of the multicultural heritage of Canadians." In 1988, a statutory foundation for the policy was provided through adoption of the *Canadian Multiculturalism Act*. The legislation assigned to federal government institutions a shared responsibility to further the objectives of the policy, and the preamble included a commitment to achieving "the equality of all Canadians in the economic, social, cultural and political life of Canada." Following a major review, the policy was renewed in 1997.

The *Constitution Act, 1982* also recognized the historic place and rights of Canada's Aboriginal peoples (who are defined as the "Indian, Inuit and Métis peoples of Canada").[5] Notably, existing Aboriginal rights and freedoms, and ones that may be acquired through land claims agreements, are protected under section 35 of that Act.[6] In 1985 the rights of Aboriginal women were extended through Bill C-31, which amended the *Indian Act* to restore First Nations status to those women, and their descendants, who had lost it through marriage. There have been a number of important land claims agreements since the mid-1970s, including with the Cree in northern Quebec and the Nisga'a in British Columbia (Chartrand 2003, 109-11). In Yukon, self-government agreements apply to 11 First Nations. In 1999, the territory of Nunavut was created following the signing of a modern treaty. Its public institutions provide the Inuit, who make up about 85 percent of

the territory's population, with significant instruments to govern their community.

These achievements may be explained in part by Canadians' relatively strong support for key elements of diversity. For example, in the survey conducted in 2003 for the "New Canada" series published by the *Globe and Mail,* 70 percent of respondents said they were very proud of "the fact that people from different cultural groups in Canada get along and live in peace" (Parkin and Mendelsohn 2003, 11). In another major 2003 survey, three of every four respondents said they believed it beneficial to all Canadians that the distinctive cultures of Aboriginal peoples remain strong (CRIC 2003). Canadians also support their country's openness to and reliance on immigration. Based on the results of two international surveys conducted in 2002 and 2004, Daniel Hiebert (2006, 40) reported that "Canadians evince more support for immigration than the residents of any other country surveyed." In a 2005 survey some three-quarters of respondents agreed that Canada is enriched by the "know-how" and culture that immigrants contribute, and that immigration improves the international competitiveness of Canada's economy (further details are reported in box 1; see also RBC Financial Group 2005).

In addition, Canada's multiculturalism and immigration policies are often seen as models for other countries. For example, the United Kingdom's recently adopted citizenship ceremonies and language tests for citizenship were influenced by Canadian policies in this area (see Randall Hansen's chapter in this volume). International recognition of Canada's achievements was also reflected in the October 2006 announcement that the Aga Khan had chosen Ottawa as the home of the new Global Centre for Pluralism.[7] International recognition of Canada's approach to diversity can help Canadians appreciate further the significance of the constitutional recognitions and policies that are so central to the way the country is governed and how its people live together.

Emerging Issues and Implications for Social Cohesion

MUCH HAS BEEN ACHIEVED, PARTICULARLY SINCE THE 1960s, IN RECOGNIZING THE principal elements of Canada's diversity. However, diversity policies in Canada have also sought to bring minority communities into the economic and

social mainstream, and to foster their political and civic engagement. Yet, in recent years, some warning signs have begun flashing.

Many Canadians have long assumed that a reasonable level of economic integration — that is, secure employment and a decent income — would facilitate social integration. However, some recent arrivals are not doing as well as previous generations of immigrants. While immigrants have higher average levels of education than their Canadian-born counterparts, many work in jobs below their level of education, earn less than those born in Canada and experience higher unemployment rates (Reitz 2005, 7). In addition, the proportion of immigrants with family incomes below the low-income cutoff (LICO) has grown: the proportion of immigrants in this category rose from 24.6 percent in 1980 to 35.8 percent in 2000 (Picot and Sweetman 2005). There is also evidence that some children of immigrants (the second generation) are not doing as well as expected. According to one recent study, the positive impact of years of education on weekly earnings in 2001 was lower for second-generation men ages 25 to 37 from the Caribbean, Central and South America, and Oceania than for men of the same ages whose parents had come from other parts of the world.[8]

There is also the issue of lack of acceptance and, in some cases, discrimination against certain groups of immigrants. For example, in Statistics Canada's 2002 *Ethnic Diversity Survey*, about 20 percent of members of visible minorities reported perceived discrimination or unfair treatment sometimes or often, compared with 5 percent of the population aged 15 and over who did not identify as members of a visible minority; for Blacks, the corresponding result was 32 percent and for Muslims 30 percent (Statistics Canada 2003). In a major 2005 survey of Muslim women in Canada, some 44 percent of respondents said they had experienced discrimination or unfair treatment in the previous five years (Hamdani 2006, 23).

As for Aboriginal people, based on various socioeconomic indicators, the vast majority fare poorly compared with non-Aboriginal Canadians. Economic and other conditions are particularly unsettling in some inner-city neighbourhoods of certain western Canadian cities where there are growing concentrations of Aboriginal people. For example, in Regina and Saskatoon in 2000, the median total income of Aboriginal residents was just slightly more than half that of non-Aboriginal residents (Siggner and Costa 2005; 21). Aboriginal self-government remains an unfinished agenda. For example, in British Columbia,

47 land claims negotiations ("tables") have been launched through the British Columbia Treaty Process.[9] However, by late 2006 only three final agreements had been initialled. The auditor general (2006, chap. 7) reported that, in 2005, 12 of the tables were inactive, 17 were "challenging" and 18 were productive. British Columbia's premier, Gordon Campbell, who has launched a "new relationship" with First Nations, has said he is committed to making greater progress on land claims negotiations.

Questions are also being raised about how the members of various groups are relating — or not relating — to each other. In day-to-day interactions among Canadians, intolerance sometimes manifests itself — for example, through the defacing of religious monuments and buildings and through hate crimes and incidents of police brutality. Fortunately, most relations between people from different backgrounds do not lead to such tensions. In this regard, recent research has explored the relationship between diversity and social capital — feelings of trust in one's neighbours and participation in social networks that link people in common projects. In the United States, Robert Putnam's findings based on his *Social Capital Benchmark Study* suggest that individuals in ethnically diverse regions and neighbourhoods are less engaged in social networks, not only with people in other ethnocultural groups but also with members of their own ethnocultural groups. As a result, social capital is weaker than in areas where such interactions are richer (Putnam 2004). Canada is not completely immune from such a dynamic. Recent research by Aizlewood and Pendakur (2007) concludes that the larger the city the less likely residents are to participate and socialize with others. Soroka, Helliwell and Johnston (2007) find that interpersonal trust[10] declines as the visible-minority share of the neighbourhood population rises. However, they do not find a similar decline in participation in social networks as ethnic diversity in the neighbourhood rises, which suggests that findings from other countries cannot automatically be transferred to Canada.

Another emerging issue is the desire of certain communities to apply rules based on their religious distinctiveness. In late 2003, debate arose around a proposal from the Islamic Institute of Civil Justice to create a Sharia court in Ontario that would adjudicate family and inheritance disagreements according to Islamic personal law. Advocates pointed out that Jews, Catholics and Aboriginal people have relied on Ontario's *Arbitration Act, 1991* to resolve civil family disputes. Critics, including the Canadian Muslim Congress, argued that Sharia does not

view women as equal and therefore cannot provide equal justice to all parties in a dispute. The Ontario government asked Marion Boyd, former attorney general of Ontario, to study the matter. The conclusions of her December 2004 report (Boyd 2004) and the legislation the Ontario government introduced are discussed in her chapter in this volume.

Janice Gross Stein has addressed the impact of the increased salience of religion as a major dimension of Canadian diversity: "The Canadian commitment to multiculturalism is ...being tested by a resurgence of orthodoxy in Christianity, Islam and Judaism where lines of division between 'them' and 'us' are being drawn more sharply. And it is being tested because Canadians are uncertain what limits, if any, there are to embedding diverse cultures and religious traditions in the Canadian context" (Stein 2006, 3). Many Canadians support the principle that certain communities merit having "space" to protect their religion, language and culture. However, that support may fall if such groups promote actions that run counter to principles, such as gender equality, that are strongly held by the majority of Canadians.[11] For example, in a major 2006 survey (Trudeau Foundation 2006), 81 percent of respondents agreed with the statement "Immigrants and ethnic minorities should adapt to mainstream Canadian beliefs about the rights and role of women"[12] (see box 1).

Finally, recent debate on Canada's rules for dual citizenship has revealed quite divergent views. In summer 2006, some 15,000 Lebanese Canadians, many of whom spent little or no time in Canada, were evacuated from war-torn Lebanon. Some argued that the considerable expense to the federal government was not justifiable, while others claimed this was consistent with Canada's legal acceptance of dual citizenship. In November 2006, the minister of citizenship and immigration announced his department was reviewing the rules.

The issues reviewed above are hardly limited to Canada. Historically, concerns tend to surface during periods of rapid social change, reflecting anxiety about the sources of social order and the avoidance of conflict. Many liberal democracies seem to be living through such a period now. In France the 2004 law that bans the wearing of the Islamic headscarf and other "conspicuous" religious symbols in public schools was defended (with support from across the political spectrum) on the basis of preserving the rigorously secular character of the French state. Critics suggested that the government was taking an overly hard line in response to concerns about certain aspects of fundamentalist Islam. The riots

Box 1 10

Canadian Public

Opinion on Selected

Diversity Issues

- **Benefits of immigration:** In 2005, in response to the affirmation that "immigration enriches Canada because immigrants contribute their know-how and culture to Canada," 79% of respondents saw this as a strong or moderate benefit; 73% agreed (i.e., saw as a strong or moderate benefit) that "immigration improves the international competitiveness of our economy" (CRIC 2005a, 5).

- **Pride in multiculturalism and official languages:** In the 2003 *New Canada* survey, multiculturalism was ranked 11th of 18 "things and events that some people say make them proud to be Canadian," and "having two official languages, English and French" came 15th (Parkin and Mendelsohn 2003, 6).

- **Integration of immigrants and ethnocultural minorities:** A Trudeau Foundation (2006) poll asked respondents which of the following views was closest to their own: (1) immigrants and minority ethnic groups should blend into Canadian society and not form a separate community; or (2) immigrants and minority ethnic minorities should be free to maintain their religious and cultural practices and traditions. Almost half, 49%, chose the first and 40% the second.

- **Women's role and rights:** A question in the 2006 Trudeau Foundation poll began as follows: "Some immigrant and minority ethnic communities have very traditional practices and beliefs when it comes to the role and rights of women." Respondents were then asked which of the following views was closest to their own: (1) Canada should accept and accommodate traditional beliefs about the rights and role of women; or (2) immigrants and ethnic minorities should adapt to mainstream Canadian beliefs about the rights and role of women. Only 13% chose the first statement and 81% the second.

- **Aboriginal land claims:** In 2003, 45% of respondents to the *Portraits of Canada* survey agreed that all or many land claims made by Aboriginal peoples are valid; 49% indicated that few or none are valid (CRIC 2003).

- **Racism:** In 2003, 74% of respondents to the *New Canada* survey agreed there is still a lot of racism left in Canada (Parkin and Mendelsohn 2003, 6).

in the Paris suburbs in the winter of 2005 further underlined the unsettled place of the North African minority within France.

In the Netherlands, multiculturalism policies began to face criticism in the 1990s because they had not helped migrant minorities overcome poverty and participate fully in society. A number of incidents, including the murder in 2004 of filmmaker Theo van Gogh by a Dutch-born man of Moroccan descent, fuelled tensions. The Dutch government subsequently introduced measures to encourage the integration of immigrants. In the United Kingdom, events such as the 2001 race riots in certain northern English cities and the July 2005 London bombings have led to a rise in public concern about how multiculturalism has evolved in Great Britain. In this regard, David Goodhart, the editor of *Prospect*, sparked a strong response (from both sides) when he asked whether the British people's "limited set of common values and assumptions" is being eroded as the country becomes more diverse (Goodhart 2004, 30). Nobel Prize winner Amartya Sen (2006, 156) has criticized what he refers to as "plural monoculturalism," which he defines as "having two styles or traditions coexisting side by side, without the twain meeting." In his view, Britain is "currently torn" between interaction and isolation. In the last few years, the British government has taken steps, including initiating language and citizenship tests, to encourage greater integration of immigrants.

The above references to recent events and debates elsewhere, while merely illustrative, underline the degree to which certain diversity policies and programs are being contested in a number of advanced democracies. In the past five years, some of these debates have become intertwined with concern about international and domestic terrorist movements. Religion — or at least some interpretations thereof — has become a more salient focus and, in certain cases, a source of division. While the implications of such developments vary from one country to another, some of them have had an impact in Canada and clearly need to be taken into account. Leaders from various communities, along with policymakers, face new challenges as they chart a course that will leave their approaches to diversity on a secure, if perhaps modified, footing.

As a way of possibly striking a balance between the recognition of diversity and social integration, we see considerable merit in a vision based on principles of "shared citizenship," including the protection of equality, shared values, civic participation and cooperation with others to further joint pursuits. Shared

citizenship implies a certain level of social integration and engagement with the broader community, but it is not synonymous with assimilation or a lack of respect for difference. The meaning and implications of shared citizenship are discussed further in the concluding chapter.

Overview of the Volume

THE CHAPTERS AND COMMENTARIES IN THIS VOLUME ARE GROUPED UNDER THE following themes:

- ◆ Canadian approaches to recognizing and accommodating diversity;
- ◆ international experiences;
- ◆ indigenous peoples;
- ◆ faith-based communities and diversity; and
- ◆ ethnocultural communities: participation and social cohesion.

In the book's final chapter, the editors draw overall conclusions about the recognition of diversity and social integration in Canada and discuss a range of policy instruments that could help lower some barriers to integration and strengthen shared citizenship.

Canadian Approaches to Recognizing and Accommodating Diversity

The chapters and commentaries in this section provide an in-depth analysis of various approaches to recognizing and accommodating diversity that have been developed in Canada since the 1960s, starting with a comprehensive chapter on the policies and programs of the federal government. In light of Quebec's distinctiveness, a chapter on its government's approach, and the changes over time, follows. The last chapter in the section provides a comparison of the approaches to managing diversity that have emerged in four of Canada's largest cities.

Will Kymlicka, known internationally for his influential theoretical work on multiculturalism, begins his chapter with an analysis of the origins and evolution of Canada's models of diversity as they relate to francophones/Québécois, immigrant/ethnic groups and Aboriginal peoples. According to Kymlicka, while these models exist as "three silos, with their own separate histories, discourses, legal frameworks and governance structures," they are nonetheless the result of a "tidal wave" of liberalization that swept over Canada between 1965 and 1975. The

respective silos "have been (re)formulated by liberal political elites, supported by an increasingly liberalized public opinion, institutionalized within liberal-democratic governance, and integrated within the framework of a liberal constitution." The result was a wholesale transformation:

> In 1960, Canada was a more conservative, patriarchal and deferential society than the United States. By 1975, Canadians had become more liberal, egalitarian and autonomous than Americans. And one product of this liberalization of society and policy was, of course, the 1982 Charter, widely viewed as one of the most liberal constitutions in the world, and enormously popular in Canada for that reason.

While this change may be cause for celebration, Kymlicka moves on to discuss how these various diversity models are working in practice. The results are mixed. Focusing for present purposes only on the Quebec-Canada dimension, an obvious weakness is that attempts to recognize Quebec's distinctiveness in the Constitution have not been successful. However, Kymlicka adds that "the Québécois are now more liberal than English Canadians on many issues such as gender equality and gay rights. They may seek greater autonomy in order to build and sustain a distinct society, but the distinct society they wish to build is, if anything, more liberal than that of the larger Canadian society."

Kymlicka then turns to the issue of "shared citizenship." In contrast to many Western democracies, Canada never enjoyed the option of a single basic strategy for encouraging shared citizenship (that is, "nation-building"). Because of the country's bilingual nature and federal structure, "we cannot have a single monolingual public sphere...[or] a unitary national education system, welfare state or legal system...We need a different way of approaching this issue." Kymlicka believes that a key component of this different strategy is to have well-functioning liberal-democratic institutions that, in turn, will exert a "gravitational pull":

> History suggests that this pull exerts force not only on the ethnic/national group that initially established those institutions, but also on their descendants, who are socialized into them, and to immigrants, who often emmigrate to a liberal democracy precisely because they want to live in a country with well-functioning public institutions.

Kymlicka concludes by focusing on a series of factors that can contribute to the ability of liberal-democratic institutions to generate feelings of "solidarity, trust, democratic responsibility and community of fate." His parting words bring him full circle to the beginning of his chapter:

The politics and policies of ethnocultural diversity in Canada today are simply part and parcel of liberal-democratic politics generally — no different in character from any other field of democratic politics. They are inspired by the same overarching principles and subject to the same systemic distortions. And that, in itself, is no small accomplishment, given the illiberal and undemocratic character of ethnic relations in our history, and in much of the world.

In his commentary on Kymlicka's chapter, Roy McMurtry draws on his political experience before being appointed to the bench, including as Ontario attorney general during the patriation of the Constitution. He recounts that during his lifetime he has witnessed "the dramatic and positive evolution of Canadian diversity, recognition, accommodation and shared citizenship." He agrees with Kymlicka that events during the 1965-75 period helped create the climate for the "progressive new Constitution" of 1982, adding that "it nearly did not happen, given the political divisions in Canada at that time." McMurtry singles out two major current challenges that he believes could undermine the concept of shared citizenship:

> First, racial profiling threatens to undermine the perceived and substantive equality of both the Aboriginal silo and the immigrant/ethnic silo. Second, access to the justice system remains a significant problem, particularly given the critical role that it has in creating a sense of shared citizenship. The civil justice system, in particular, is becoming increasingly cost prohibitive, and this poses a significant risk of further disenfranchising Aboriginal and immigrant groups from the legal process.

McMurtry expresses particular concern about the "widespread lack of trust in our justice system within Aboriginal communities." The remedy, in his view, is not a separate justice system. Rather, "we need to ensure that Aboriginal people caught up in the justice system see more faces like their own in the courtrooms, in the police service and among court workers. We also need to establish more legal aid clinics and more sentencing circles involving Aboriginal communities and, of course, we must alleviate Aboriginal poverty."

Yasmeen Abu-Laban contributes the second commentary on Kymlicka's chapter. She states that it "provides an excellent frame of reference for an informed discussion about Canada's prospects and challenges," but adds that there is a need to be attuned to the diversity of narratives about Canada, including those of the indigenous peoples. There is also a need "to attend to the ways that social relations of power linger." In this regard, she cites the 2005 *Report of the Commissioner of Official Languages*, which stated that much remained to be done before equal status

for Canada's two official languages was assured. Finally, Abu-Laban suggests it is necessary to understand how diversity relates to "contradictions" within minority ethnic communities and policy-making communities; otherwise, there is a risk of playing into "an older, colonial portrayal of cultural inferiority." Abu-Laban closes by observing that since September 11, 2001, security concerns have led to racial profiling by government officials. Referring to the Maher Arar case,[13] she asks: "What do human rights and Canadian multiculturalism mean in light of all this?"

In the next chapter, "The Quebec State and the Management of Ethnocultural Diversity: Perspectives on an Ambiguous Record," Daniel Salée underlines that the Quebec government's diversity policies need to be seen in the context of the francophone majority's "strong sense of self and will to be acknowledged as a distinct nation." The French language and Quebec's francophone culture have been essential tools in this pursuit. In the context of what has been characterized as "interculturalism," greater emphasis has been placed on the integration of newcomers and less on the principles of multiculturalism. Salée describes the recent evolution of Quebec's public policies and programs as follows:

> Since 1990, the state has sought to engage ethnocultural minorities in a "moral contract" whereby they are enjoined both to abide by the fundamental liberal-democratic values that define Quebec's general common public culture and to develop a primary — but not necessarily exclusive — civic and political allegiance to Quebec society. In return, the state commits to stress the central contribution of ethnocultural diversity to the character of contemporary Quebec and to ensure that its institutions adapt to the various cultural, religious and identity imperatives and claims that inevitably permeate a truly plural society.

For Salée, Quebec's record seems quite positive: "The state's discourse and institutions are marked by a commitment — unmatched in virtually all other liberal democracies — to the recognition, respect and accommodation of difference." On the ground, though, significant socioeconomic gaps remain between Quebecers of European descent and new immigrants, members of racialized groups and First Peoples. From his perspective, the implications are quite broad:

> Many are growing dissatisfied with the disadvantaged socioeconomic situation that seems to stem from their minority position; they are disenchanted with the state's inability to fulfill its promises of social justice, equality, fairness and self-determination, and they question in the end whether they truly belong to Quebec society. Such sentiments are regularly reinforced by public debates over the hijab, the kirpan, the land claims of First Peoples or, more generally, the impact of ethnocultural diversity in the public sphere, which reveal more

often than not the unease of significant segments of the Eurodescendant population with claims and expressions of difference and with the actuality of otherness in the Quebec context.

Salée concludes that the degree of social change that would be required to close the above-mentioned gaps could be achieved only through "a radical departure from Eurocentrism" — a break that he considers most improbable.

In her commentary on Salée's chapter, Marie McAndrew indicates she shares his concern about the "common lack of effectiveness [that] characterizes most multicultural/intercultural diversity management policies…in combatting ethnic and social inequalities." However, she suggests that he "glosses over" differences experienced by racial minorities. In this regard, she notes that research has shown major differences in the graduation rates of Black youths in Quebec, with mother tongue and place of birth being significant factors. McAndrew contends, moreover, that social class and gender continue to be the main factors influencing school success. In addition, she contends that Salée does not draw a sufficiently sharp comparison between Canadian multiculturalism and Quebec interculturalism. The latter "has always been more concerned with weighing diversity and fundamental values," she writes. Moreover, "in Quebec, the integration of immigrants has also been the object of much more controversy, most likely because it could not be taken for granted, as it can in English Canada; thus, pluralist transformation has been more painful, more intense, more rapid and more thoroughly debated." According to McAndrew, this debate has had positive effects on "the capacity of Quebecers to live together": public opinion is more positive and less polarized and the "level of debate is pretty sophisticated and, in many instances, largely deethnicized."

McAndrew concludes by stressing that the linguistic and cultural concerns at the centre of debates about diversity in Quebec have left "very little room for public discussion of inequalities." In this regard, she notes that the visible minorities experiencing the greatest difficulties with socioeconomic integration and participation are post-1977 immigrants, for whom the mother tongue or language of public use is French. McAndrew expresses some optimism regarding policy developments under the Charest Liberal government (elected in 2003), including a 2004 action plan on socioeconomic integration and a major consultation launched in 2006 to define an antiracist strategy.

In the final chapter in this part of the volume, "Another Fine Balance: Managing Diversity in Canadian Cities," Katherine Graham and Susan Phillips start

with the premise that Canada's claim to being a diverse, multicultural nation is defined by its big cities. The authors focus on urban governments' approaches to diversity in Canada's four largest cities — Toronto, Montreal, Vancouver and Winnipeg. The first three are Canada's leading destinations for immigrants, and Winnipeg has Canada's largest population of Aboriginal people. Graham and Phillips begin by sketching the patterns of diversity in the four cities and identify certain underlying tensions in the social construction of diversity as a policy problem.

The authors then provide an overview of some of the new policy instruments, programs and institutions these governments have developed to address diversity:

- Toronto has been "proactively multicultural" while "dealing in a very focused way" with "troubling issues" such as racism.
- Montreal's approach is one of "intercultural accommodation," and there have been particular efforts to encourage immigrants' participation in neighbourhood life.
- Vancouver has been relatively proactive but has had to react to certain "hot button" issues such as "the expression of cultural preferences in urban space."
- Winnipeg has long celebrated multicultural diversity but has more recently devoted considerable effort to engagement with the city's growing Aboriginal population.

Graham and Phillips view the cities' various policy responses as reflections of a Canadian model that embodies individualism and group identity, as well as equity and special treatment. Finally, the authors address some of the challenges associated with an important reality: that responsibility for many policy and program areas relevant to diversity is held by, or shared with, provincial and federal governments. They call for "a collaborative effort involving the federal and provincial governments as well as the voluntary and private sectors."

In his commentary on the Graham and Phillips paper, David Ley discusses the concentration of immigrants in a few major cities in Canada. He contends that there are several inefficiencies in this "hyperconcentration": labour market competition between new and recent immigrants for low-paying service jobs leads to a race to the bottom; immigration is the main driver of population growth, which has an impact on environmental quality; and the hyperdiversity of gateway cities increasingly contrasts with the relative cultural homogeneity of most other parts of Canada.

Ley goes on to discuss the question of spatial segregation. He reports that, following an increase in the 1990s, immigrants accounted for 77 percent of the population of low-income census tracts in Toronto in 2001, and 47 percent of those in Vancouver. Moreover, half or more of these immigrants had resided in Canada for at least 10 years. This, according to Ley, raises "the prospect of prolonged residence in poverty districts." He closes his commentary with a brief discussion of the role of nongovernment organizations (NGOs) in the settlement process. For Ley, the contribution of NGOs goes beyond providing services: "NGOs generate and distribute the social capital, as well as the social services, that are the basis for a healthy civil society."

Taken together, these chapters and commentaries clearly illustrate not only the significance of the constitutional, legislative and program initiatives that have been taken to recognize diversity in Canada, but also their considerable variety. There is no single, neatly integrated diversity model in Canada. There is variation across the three dimensions of diversity; there is variation between Quebec and the rest of the country; and there is variation across different cities in which minorities are present in significant numbers. As Kymlicka reminds us, the presence of two officially recognized language groups and Canada's federal structure are among the factors that explain this variation. In light of this, learning from the experience of other governments (including those of the country's largest cities), and collaborating with them, may be among the keys to addressing some of the enduring and emerging challenges the authors identify.

International Experiences

Debates over multiculturalism have also been raging in many other countries, and the next part of the book provides a comparative perspective on issues that have been rising on the public agenda elsewhere and some of the policy responses that have emerged. In the first chapter, developments in the Netherlands, France and Germany are reviewed. A chapter on the United Kingdom is next, followed by a study of the influence of ethnic diversity on social cohesion in a range of European countries. The section concludes with a chapter on diversity policies in the United States.

In "Immigrants and Civic Integration in Western Europe," Christian Joppke argues that policies designed by western European countries to promote the integration of immigrants are converging as a result of four trends:

- more inclusive citizenship laws resulting from liberalized naturalization and the introduction of conditional *jus soli* citizenship[14] for the descendants of immigrants;
- a move toward Anglo/North American-type antidiscrimination policies, which have become mandatory with the 2000 European Union Race Directive;
- reinforcement of state neutrality in questions of cultural difference, as reflected in legislation in France and Germany that prohibits the wearing of religious symbols in certain contexts; and
- new civic integration policies that oblige migrants to acquire the host country's dominant language and to familiarize themselves with the country's institutions and political values.

Examining recent developments in the Netherlands, France and Germany, Joppke demonstrates that there have been significant national variations in the implementation of civic integration policies:

- The Netherlands, long perceived as liberal and multicultural, has adopted "the most repressive variant of civic integration" of immigrants.
- France has recently moderated its traditional assimilationist stance and is placing less stress on the obligatory and coercive dimensions of civic integration.
- Germany, a country that faced criticism for its alleged "segregationist" approach to immigrants, has adopted "the mellowest, least control-minded" variant of civic integration.

Joppke notes that, taken together, European civic integration policies differ from the Canadian approach. Since the 1950s, Canada has used "settlement programs" to encourage, but not oblige, the civic integration of immigrants. This difference is related to the fact that Canada predominantly selects fairly highly skilled immigrants, which eases the integration of newcomers. In contrast, the majority of newcomers to Europe are generally low-skilled family migrants, and they are targeted by a civic integration policy that, according to Joppke, has turned into "a no-immigration policy."

In his chapter, "Diversity, Integration and the Turn from Multiculturalism in the United Kingdom," Randall Hansen provides an overview of the policies the United Kingdom has adopted to accommodate diversity and some of the outcomes. His focus is on how visible minorities have fared in education, employment, income and social integration. Hansen observes the following:

- Against most measures, the economic integration of visible minorities is "a comparatively successful failure." The UK does better than most European countries; however, with limited exceptions, visible minorities continue to suffer socioeconomic deprivation.
- This deprivation is not constant among visible minorities or over time. Some ethnic minorities do better than others; against some measures, second-generation migrants have done better than the first generation, and against others they have done worse.

As part of what Hansen describes as a "retreat" from the commitment to multiculturalism, the UK has adopted "modest coercive changes" intended to strengthen civic integration — for example, new and settled immigrants are now obliged to pass an integration test, which includes a language component. Hansen concludes that, despite the greater focus on "loyalty and commitment to Britain," there has been no dramatic change to the basic principles and policies underlying the UK's approach to diversity and integration.

In "Diversity, Multiculturalism and Social Cohesion: Trust and Ethnocentrism in European Societies," Marc Hooghe, Tim Reeskens and Dietlind Stolle investigate how rising ethnic and racial diversity influences social cohesion in Western democracies, and the potential impact of policies on immigration and on the integration of visible minorities. They begin with a critique of some recent research that suggests the more diverse a society or a community, the less inclined its members will be to develop close ties with their fellow community members. The authors suggest that this literature has a number of shortcomings: most of the research has been conducted in the United States, with its distinctive pattern of race relationships; the strong focus on measures of generalized trust may need to be supplemented by indicators of "outsider-group hostility"; and, with their focus on one country, the studies do not assess the influence of policies that differ considerably from one country to another.

Relying principally on data from the European Social Survey conducted in 2002-03 in 21 European countries, Hooghe, Reeskens and Stolle find that ethnocentrism scores tend to be much lower, and levels of trust higher, in Scandinavia and in other countries of northern Europe than in southern, central and Eastern Europe. Using various indices of ethnic diversity, they find no negative relation between any of the measures and the two social cohesion indicators, trust and ethnocentrism.

The authors next explore whether multicultural and immigration policies have an effect on the two social cohesion indicators. Here they relied on a range of sources: the index of multicultural policies developed by Keith Banting and Will Kymlicka; information on whether governments grant the right to vote to foreign nationals; and information on naturalization policies. They find no significant relationship between any of the policies and ethnocentrism, but the results for generalized trust are more conclusive. In particular, they find that such trust is particularly high in countries that early on adopted voting rights for foreigners. While the authors are cautious about this finding, they suggest that granting foreigners the right to vote could lead to an increase in their participation in the social and political life of their adopted countries and afford them a better association with majority populations.

This section closes with a chapter by Mary Waters and Zoua Vang, "The Challenges of Immigration to Race-Based Diversity Policies in the United States." The authors review developments in the following policy areas: English-language use, the relationship of different categories of immigrants to the welfare state, and policies on racial diversity and racial inequality. Debates over language use are largely irrelevant, they argue, because the United States continues to be "extremely effective at stamping out any language other than English within one or two generations." In contrast, recent changes to the welfare system that deny certain social services to immigrants (both legal and illegal) are significant because they have begun to create different categories among legal immigrants.

After reviewing the history of attempts to diminish the historic inequality faced by African Americans, Waters and Vang analyze the current impact of policies in this area. They contend that the "relative success" of first- and second-generation immigrants, a good number of whom qualify for race-based advantages in hiring and university admission, may be undermining affirmative action — the "most far-reaching diversity policy" in the United States. Nevertheless, as they conclude, issues such as rising income inequality and the rising number of undocumented workers present significant challenges to the integration of immigrants.

The chapters summarized above underline the basic point that diversity policies most often reflect the context — historic, linguistic, religious and so on — of a given country (or subnational unit), as well as the fundamental values of the general population. At the same time, the countries reviewed here and others share certain common challenges. These include the heightened salience of religion as a

potential fault line (discussed below) and the enduring, sometimes growing, inequalities between certain racial and immigrant minorities and the majority community.

Indigenous Peoples

Although this volume devotes considerable attention to immigrants and ethno-cultural communities, it also explores issues related to recognition of the status and rights of indigenous peoples. Two chapters address the situation of Aboriginal people in Canada — one within the larger cities of western Canada and the other in the province of Saskatchewan. The final chapter analyzes the evolution of the relationship between New Zealand's Maori people and that country's government.

In "First Nations and Métis People and Diversity in Canadian Cities," Evelyn Peters reviews recent research on the theme that First Nations and Métis people are spatially marginalized in urban areas and that this has created a social divide between them and other residents. She finds that in Edmonton, Regina, Saskatoon and Winnipeg the First Nations and Métis populations, though growing, are not highly segregated. Drawing comparisons with the United States, she concludes that the low income levels of many First Nations and Métis people in these cities, while a reason for concern, cannot be characterized as concentrated poverty on a large scale. Peters rejects the idea that city-dwelling Aboriginal people constitute an underclass that is isolated from the rest of urban society.

In the second part of her chapter, Peters examines assumptions about the alleged incompatibility of urban and Aboriginal cultures. She believes that strong First Nations and Métis cultures can facilitate success in urban life; so too can the sense of belonging to one's Native group, and the growth of urban First Nations and Métis organizations. Based on her research on developments in Edmonton and Winnipeg, she points to the significant role Aboriginal institutions have played in the increase in tertiary employment for First Nations and Métis people. Peters concludes that policy development needs to take account of the varied history and characteristics of these organizations.

In his commentary on Peters's chapter, John Richards stresses that "an important measure of the advances made by any Aboriginal community is employment at good wages, and the key to good wages is formal education." In this regard, he reports that the increase in the high school completion rate between 1981 and 2001 among young Aboriginal women (ages 20 to 24) exceeded the increase among

non-Aboriginal women in 9 of 11 cities with significant Aboriginal populations; the increase among young Aboriginal men exceeded the increase among non-Aboriginal men in 6 of the 11 cities. Nevertheless, Richards contends, "so long as the quality of reserve-based schooling remains poor, and so long as churning between reserve and urban communities remains high, a large gap between the education levels of Aboriginal people and non-Aboriginal people will probably persist."

On the issue of spatial concentration of Aboriginal people within western Canadian cities, Richards expresses some disagreement with Peters. Using data from her chapter, he shows that whereas in 1981 the great majority of Aboriginal people in the four cities Peters studied lived in census tracts in which Aboriginal people were less than 10 percent of the population, in 2001 the majority of Aboriginal people in Winnipeg, Regina and Saskatoon lived in census tracts where Aboriginal people were more than 10 percent of the population. For Richards, "there is a trend toward geographic segregation by race" in those three cities.

The second chapter in this section, "Between 'Us' and 'Them': Prescribing Postcolonial Politics and Policy in Saskatchewan," is by Joyce Green and Ian Peach. They begin by noting that, according to some analysts, by 2045 one-third of the province's population will be made up of Aboriginal people. At present, there are significant gaps between Aboriginal and non-Aboriginal Saskatchewan residents on a range of socioeconomic indicators. For Green and Peach, the marginalization of Aboriginal people is not simply a consequence of a lack of capacity. Rather, factors such as lower educational attainment "are the contemporary manifestations of colonial public policy." In their view, racism or "colonial assumptions" are embedded in the province's legislative and judicial structures and processes, and in "the dominant political culture"; racism and its consequences frame the context for the marginalization of Aboriginal people.

The authors draw on a 1996 initiative aimed at negotiating a self-government agreement for Saskatchewan's First Nations to demonstrate the impact of "colonial assumptions." Considerable progress was made on an agreement that would have provided scope for First Nations to have a meaningful exercise of jurisdiction in several areas. As the authors recount, the negotiators developed a number of innovative constitutional and governance provisions. However, despite seven years of sustained effort, no agreement was reached because the Government of Canada refused to provide First Nations with the necessary resources, in the form of a 20-year socioeconomic strategy. In addition, according to the authors, certain

senior federal public servants frustrated the process. Green and Peach contend that political leaders need to make a sustained effort to lead public opinion on the "requirements of a just society" and to educate the non-Aboriginal public on "how all of society would be better off if Aboriginal people were better off." In conclusion, they suggest exploring the potential merits of the "indigenization" of federalism, governance, constitutional arrangements and cultural symbols:

> Previously, it was assumed that while the governments of the Canadian state might accommodate indigenous nations, those nations had to change to fit the accommodation offered. Indigenization means that the settler state and its relatively privileged populations must also change to accommodate the reality of indigenous nations and the politicoeconomic and cultural expression of indigenous nations' rights.

In the final chapter in this section, "Maori and the State: Diversity Models and Debates in New Zealand," Roger Maaka examines policies and programs that recognize and protect the distinctiveness of that country's indigenous citizens. The Crown has a long-standing relationship with the Maori, who account for 15 percent of New Zealand's population. The 1840 Treaty of Waitangi was intended to protect the rights of the Maori, including the possession of property. However, not a lot was done to give meaning to the treaty until the 1970s. Maaka reviews notable developments, such as the 1975 *Treaty of Waitangi Act,* which led to the establishment of the Waitangi Tribunal, as well as to the evolution of Maori parliamentary representation (there have been seats reserved for Maori in the House of Representatives since 1867).

Maaka then describes some of the other changes that have taken place since 1975. In his view, New Zealand has made "significant progress" compared with most other countries that have indigenous peoples. However, "it still operates on a model established in colonial times. Consequently, the nation continues to support a one-size-fits-all notion of citizenship, one that accommodates diversity only up to a point; that is, absolute authority resides with the government, and there is no power-sharing when it comes to its policies and programs." Maaka concludes by noting that issues related to budgets and the level of consultation with Maori communities continue to raise questions about the legitimacy and effectiveness of Maori policy and programming.

These chapters and commentaries illustrate that, where significant indigenous populations are present, governments have often found it quite difficult to find ways to recognize the distinctiveness of these communities in ways that are acceptable to

them as well as to a broad segment of the majority population. They also demonstrate that, as with racial and certain immigrant minorities in a number of Western countries, the recognition of indigenous peoples cannot be separated from socioeconomic and other indices that affect their life chances and sense of belonging.

Faith-Based Communities and Diversity

The next section focuses on faith-based communities and their place within Western democracies. First, a theoretical chapter identifies some of the factors that underlie recent debates about the relationship between Islam and citizenship. Next, a chapter and a commentary review some of the value conflicts that emerged during the recent debate about possibly allowing the application of certain Sharia principles to family law disagreements within the province of Ontario.

Tariq Ramadan, an internationally renowned scholar of Islam, contributed the first chapter, "Religious Allegiance and Shared Citizenship." In it, he analyzes the facets of Muslim identity and how they relate to citizenship. He begins by suggesting that the expression of religious allegiance has become a "problem" in the West because

- the religious sphere is considered a private domain that should not impinge on the public domain;
- to avoid creating conflict, the outward expression of religion in the public sphere must have its boundaries; and
- it is not always clear, for some believers, whether religious allegiance or allegiance to the state takes precedence.

Ramadan identifies four elements of Muslim identity. For him, to be a Muslim is

- to bear a faith;
- to take into account both the scriptural texts and the context — the social, political and cultural environment;
- to educate and transmit — to "be a witness before people"; and
- to act and participate in a social way.

Ramadan underlines that the four elements "are unchangeable, wherever one lives."

Ramadan next turns to citizenship. In answer to the question "What does citizenship presuppose?" he replies:

- recognition of a constitution or legislation that refers to the place where one lives;

- ◆ "a relationship of loyalty in conscience and in ethics to this constitution" — although that loyalty should be critical, not blind; and
- ◆ participation: "to consider oneself an active member of a community linked by a constitution."

Ramadan then explores the importance of context: "For many, for years, our Islamic training has cut off the reality of our Muslim identity from the context in which we live because it has not taken account of the context, because it has not in effect insisted on participation, because it has not stated what transmission means." He calls on Muslims to learn about the country in which they live and suggests that civic education should form part of Islamic education and training. However, "civic education is not simply knowing how Canadian, British or French laws operate; it is knowing the history of the people with whom one lives, understanding their sensitivities, understanding how they function, understanding their language."

Ramadan closes his chapter with an appeal that is surely relevant well beyond Muslim communities:

> There is no minority citizenship in Western countries. Faithful to their values, bearing multiple identities, Muslims must be committed to their society as citizens and share this commitment with their fellow citizens. The future relies on our understanding that we have common universal values and citizenship. It is time to get out of our respective intellectual, religious, cultural, social and political ghettos and come together, it is time to create new dynamics in the name of our common hopes and ethics.

Next, Marion Boyd reviews the series of events that followed an October 2003 announcement from the Islamic Institute of Civil Justice that, relying on Ontario's *Arbitration Act, 1991*, it intended to initiate a process to adjudicate family and inheritance disagreements according to Islamic personal law. The leading proponent's claim that this was the beginning of a Sharia court in Canada led to considerable opposition within and outside the Muslim community. A number of women's organizations, including some Muslim ones, argued that arbitration on the basis of Muslim family law would erode women's equality rights. This led the Ontario government to ask Boyd to conduct a review of the use of arbitration in family law, with specific attention to the impact on vulnerable individuals of alternative dispute resolution using religious laws.

Boyd recounts that in her 2004 report she attempted to strike a balance by recommending that religiously based arbitration continue (which would mean Muslims would have access to such procedures) but only if the processes and

decisions were consistent with the Ontario *Family Law Act*. This did not end the controversy. Indeed, concerns about the implications of the application of certain Sharia principles were even expressed in Europe — sometimes based on misinformation, according to Boyd. In late 2005, the Ontario government introduced legislation to ensure that all family law arbitrations are conducted only under Canadian law, which includes all provincial statutes. Family law resolutions based on any other laws or principles, including religious ones, will have no legal status and will constitute advice only. While it is too early to assess the impact of the legislation, Boyd concludes by stating that the controversy "challenged all Canadians to pay more attention to how the concept of multiculturalism is actualized in their day-to-day lives."

Sheema Khan sheds additional light on the events that Marion Boyd reviews in her chapter. To do so, she uses the concept of "transformational accommodation," which she describes as "a complex process whereby the religious and cultural freedoms of a collective are balanced with the rights and freedoms of the individual." According to Khan, both sides in the Ontario Sharia debate voiced their positions in relation to the Charter, particularly its protections for gender equality. Khan adds that transformational accommodation (as defined by Will Kymlicka) can also entail demands for inclusion within particular groups. Khan notes that during the Sharia debate Muslim women's groups came forward "to express their concern for the well-being of the most vulnerable members of the Muslim community: women and children." As for the media, "ignorance and fear of Sharia were prevalent in much of the...coverage." In particular, "very little attention was paid to the nature and history of 'Sharia.'"

As for the potential impact of the *Family Law Statute Amendment Act* that was adopted after the Boyd review, Khan makes the following observations:

> Resolutions based on laws and principles that differ from Canadian law have no legal effect and are not enforceable by the courts. The new law allows both parties in a dispute to consult religious advisers — it therefore does not abolish recourse to broad religious principles — but it is unclear whether this will have any meaningful effect on Muslims (and, in fact, on adherents of other faiths) intent on abiding by faith-based rulings. Some have warned that the practice will go underground, become unregulated and unaccountable. While few statistics exist, we know that informal Sharia tribunals are already in place, and they will be largely unaffected by the new statute.

These three texts help illustrate that potential conflicts between certain religious practices and widely held values (such as gender equality) present pluralist countries with particularly difficult challenges. They also point to the issue that

will be a central part of diversity agendas in the years to come: striking a balance between accommodating distinctiveness based on religion and respecting principles that are fundamental to the broader community's sense of shared citizenship.

Ethnocultural Communities: Participation and Social Cohesion

In the final section of the volume, three chapters address issues related to the recognition, participation and integration of ethnocultural communities. The first chapter explores the degree to which discrimination and unfair treatment may affect integration into Canadian society. The second compares measures of social integration for ethnocultural groups, francophone Quebecers and Aboriginal people. Two commentaries — one for each chapter — provide additional insights on some of these issues. The section concludes with a comparative study of the political engagement of new arrivals in Canada and ethnic minorities in the United Kingdom.

In their chapter, "Racial Inequality, Social Cohesion and Policy Issues in Canada," Jeffrey Reitz and Rupa Banerjee address the following questions: Does significant racial inequality exist in Canada? If so, does such inequality have an effect on the cohesion of Canadian society? Are current policies adequate to address the issue?

The authors note that within Canada's ethnocultural diversity, visible minorities experience the greatest economic inequalities, and that Statistics Canada's 2002 *Ethnic Diversity Survey* showed that many visible minorities report experiencing discrimination and vulnerability. Since Whites tend to remain more skeptical about the significance of racial discrimination, there is an apparent racial divide over the issue. Unfortunately, while a variety of research approaches show that discrimination exists, none has resolved the question of its relationship to overall inequality.

Reitz and Banerjee report that partly as a result of a sense of exclusion (expressed in feelings of perceived discrimination and vulnerability), racial minorities are slower to become integrated into Canadian society than immigrants of European origins. Data from the *Ethnic Diversity Survey* include seven indicators related to social integration: sense of belonging to Canada, trust in others, self-identification as Canadian, acquisition of citizenship, life satisfaction, volunteering for work in organizations and voting. The authors' research shows that on several indicators visible minority immigrants do not become integrated as quickly as those of European origins, and that on all applicable indicators members of the visible minority second generation are less integrated than their

White counterparts. These trends vary among visible minority groups, but the differences between visible minorities and Whites are more notable than variations among visible minorities. Analysis of social integration by immigrant cohort, generation and age shows that racial gaps in integration are more significant for the second generation than for their immigrant parents.

In addition, the authors' research shows that lower levels of integration for visible minorities are not particularly related to income levels, which increase with time spent in Canada. But they are partly explained by experiences of discrimination and vulnerability, which are especially salient in the second generation.

According to the authors, existing policies on multiculturalism and diversity in Canada emphasize the laudable ideals of equality of opportunity and opposition to racism. However, because the policies lack clear objectives, they may not address the issues effectively from the standpoint of minorities. This may reflect the lack of an interracial consensus on the significance of discrimination and insufficient effort to create such a consensus. According to the authors, "Without a new recognition of the significance of racial equality issues within the majority population, the most important precondition for improved policy may be the creation of more effective means for minority group participation" in the political decision-making process.

Pearl Eliadis contributed the commentary on the chapter by Reitz and Banerjee. She commends the authors for bringing together "the strands of evidence on socioeconomic status, immigrant status and ethnoracial background and [linking] them to equality and discrimination." She adds that "the identified causal factor — discrimination — is also the object of constitutional guarantees of equality under the Canadian Charter of Rights and Freedoms." As she writes, section 15 of the Charter can be used to settle competing claims, protects essential human dignity and freedom, and can "trigger judicial intervention and force a legislature to do its job."

Eliadis examines a number of recent developments in policies and practices related to equality rights. She underlines the importance of "systemic discrimination" as a key concept in this regard. This concept is especially important in the employment area because the plaintiff does not have to prove discriminatory intent; rather, a finding of discrimination can result from the operation of established procedures for recruitment, hiring and promotion. On race relations and the police, Eliadis states that several reports and court cases "demonstrate that the perception of unjust treatment is borne out by actual experience and findings of fact." Finally, she criticizes developments in British Columbia and

Ontario intended to provide direct access to human rights tribunals rather than relying on initial hearings by a commission. In her view, human rights commissions should be an increasingly important form of redress against discrimination. She concludes that "getting at the discrimination that underpins inequality in Canada for many of our citizens is an urgent project, not just a theoretical one."

The following chapter, "Ties That Bind: Cohesion and Diversity in Canada," is by Stuart Soroka, Richard Johnston and Keith Banting. The authors begin by summarizing two different interpretations of the sources of social integration in diverse societies: one underlines the importance of a shared sense of national identity and common values; the second puts the emphasis on widespread participation in the processes through which we manage diverse identities and values. The paper then explores differences across ethnic groups (including the founding peoples of Canada and more recent newcomers) through several measures of social integration: sense of pride and belonging in Canada, levels of interpersonal trust, the balance between socially liberal and socially conservative values, the extent of engagement in social networks that bridge cultural divides, and voting. To conduct their analysis, the authors drew on two opinion surveys: the second wave of the *Equality, Security and Community Survey* and the 2004 *Canadian Election Study*.

The various measures demonstrate persistent differences in the levels of trust various groups of Canadians have in each other, with francophone Quebecers, Aboriginal people and some visible minority groups showing lower levels of trust. The authors demonstrate that, for immigrant Canadians, it is the length of time in Canada that explains what at first glance appear to be strong ethnic differences: the longer new immigrants are in Canada, the more their sense of pride and belonging comes to equal — and in some cases exceed — that of the largest ethnic group. As they put it, the integrative power of Canadian life for newcomers is in some ways quite impressive.

According to the authors, there are nevertheless limits to the integrative power of time. Although newcomers from southern and Eastern Europe eventually come to feel they belong almost as much as those with ancestry in the United Kingdom and northern Europe, racial minorities remain less confident they fully belong. In the authors' view, the greatest challenges to social cohesion in Canada may not be rooted in the attitudes, beliefs and attachments of relative newcomers. Rather, the historic tensions among the founding peoples remain central, as large proportions of francophone Quebecers and of Aboriginal people score lower on some of the social cohesion measures than most members of ethnocultural minorities.

Belonging? Diversity, Recognition and
Shared Citizenship in Canada

The authors conclude that the two theories of social integration point in different directions. If social cohesion is rooted mainly in a common sense of national identity, then Canada faces enduring challenges. The second theory of social integration generates a more optimistic view. As the authors put it, "If the true source of social cohesion in today's multicultural world is to be found in the engagement of ethnic groups in community life and in the democratic processes through which we manage our diverse identities and values, then Canada seems to be reasonably positioned for the future."

In her commentary on the chapter by Soroka, Johnston and Banting, Bonnie Erickson focuses on two of the authors' measures of social cohesion: sense of belonging and membership in associations. On the first, she shares their concern that many non-Whites feel a low sense of belonging to Canada, even after allowing for time in Canada and other relevant controls. On association membership, Erickson raises some questions about the authors' measure. In her view, the categories they used to select associations are "very broad," and some organizations (such as certain sports groups) may have an ethnically specific, rather than diverse, membership. She suggests that some of the resulting network formation may lead to bonding (in-group) networks rather than bridging networks.

Erickson goes on to analyze certain findings based on questions from the 2000 *Canadian Election Study* that were intended to measure various aspects of tolerance. She found that some associations promote tolerance, some reduce it and others have no impact in this regard. In light of this finding, she observes that "just because Soroka, Johnston and Banting find that as many non-Whites as others belong to associations, and that second-generation Canadians have rather high levels of membership, we should not be too optimistic." Erickson also challenges the assumption that middle-class people, in part because of their higher levels of education, are more tolerant than working-class people. She found that professionals are less tolerant if they live and work in the places where newcomers and non-Whites are most concentrated, and thus provide the most competition. She concludes that "strong policy intervention" is required because "current practices and policies do not give all immigrants and non-Whites fair access to Canadian labour markets and social networks, making it difficult for newcomers to belong as much as they would like."

In the final chapter in this section, "The Political Engagement of New Canadians: A Comparative Perspective," Paul Howe examines whether the degree of integration of newcomers might be one of the reasons behind the significant

disengagement from democratic politics in Canada. Relying on past and current survey data, the chapter focuses on a series of interrelated political-attentiveness factors that have been identified as key "deficit areas" for young Canadians: political knowledge, political interest and attention to political coverage in the media. Foreign-born Canadians are measured against the native-born, and recent arrivals and those who arrived earlier are compared, in order to identify emergent changes within Canada's immigrant population. The engagement levels of foreign-born respondents are also assessed against those of young Canadians. Howe concludes that the growing ethnic and cultural diversity of Canada's immigrant population has not, to this point, generated obvious problems of political integration (as judged by the measures he uses).

In the second part of his chapter, Howe analyzes British data in order to identify key dimensions of disengagement among ethnic minorities in the UK. Based on several measures, he finds that the political disengagement of newcomers is more pervasive in the UK than in Canada. In addition, "Unlike the Canadian case, the shortfalls in various areas cannot be explained away as the early and ephemeral phase of a normal transition period for newcomers." Howe's assessment is that democratic disengagement among ethnic minorities in the UK can be linked partly to barriers to integration presented by class, language and identity. He concludes that the socioeconomic integration of Canada's immigrants represents "an important priority area for policy-makers." Linguistic fluency in one of the two official languages and ensuring new Canadians develop "affective attachments to Canada" are other policy objectives he believes should continue to be pursued. Howe favours enhanced civics education in elementary and secondary schools, adding that adjustments should also be made to services and programs that provide background civics education to adult new arrivals.

The findings of these three different but related research projects suggest that, based on certain measures of civic participation, recent arrivals and their children are engaging reasonably well with Canadian society. However, on other measures, such as sense of belonging to Canada and trust in others, there is a gap between immigrants and the rest of the population, and this gap seems to remain for the second generation despite their progress over time on other measures (such as income). When considerable numbers of people from visible minorities, who constitute the largest share of immigrants, report discrimination and unfair treatment, there is good reason for concern — not least because their perception

calls into question the true meaning of one of the most important sections of the Canadian Charter of Rights and Freedoms.

In the book's final chapter, the editors draw on the various contributions and some additional recent research to present overall conclusions about the recognition of diversity and social integration in Canada. They conclude that, while there is no justification for a radical shift in Canadian diversity policies, the warning signs cannot be ignored. To that end, they discuss some policy directions that could help strengthen shared citizenship and minorities' sense of belonging, with a focus on improving access to and outcomes in the labour market, protecting equality and encouraging political and civic participation.

Notes

1 The census data reported in this and subsequent points can be accessed at: www12.statcan.ca/english/census01/Products/Standard/Index.cfm

2 Among OECD countries, Luxembourg and Switzerland also have higher proportions of foreign-born residents: 33.0 percent and 22.4 percent, respectively (1999 data).

3 Although the path to the Charter can be traced to earlier initiatives such as the adoption (in 1960) of a nonbinding Bill of Rights under the leadership of Prime Minister John Diefenbaker, the entrenchment of a spectrum of rights and recognitions in 1982 was a highly significant event. The scope of the Charter extends well beyond recognizing various facets of diversity (for example, section 15 guarantees nondiscrimination based on a number of grounds), and the protections it affords no doubt explain in part its high level of support among Canadians, regardless of background, region, age or other factors. For example, in the 2003 *New Canada* survey (Parkin and Mendelsohn 2003, 11), 62 percent of respondents said the Charter of Rights and Freedoms made them "very proud" to be Canadian (see also box 1). Even in Quebec, where it is sometimes argued that the Charter was imposed as a result of the 1981 Constitutional Accord, which Premier René Lévesque did not sign, the Charter enjoys strong support. For example, in a 2005 survey, 65 percent of Quebec respondents agreed that protection of rights under the Charter is an advantage for Quebec to be part of Canada (CRIC 2005b).

4 On November 27, 2006, the House of Commons passed a resolution recognizing that the Québécois "form a nation within a united Canada."

5 Since the 1982 Act was adopted, it has become more current to use the term "First Nations" instead of Indian(s).

6 In addition, section 25 of the Charter provides that "the guarantee in this Charter of certain rights and freedoms shall not be construed so as to abrogate or derogate from any aboriginal, treaty or other rights or freedoms that pertain to the aboriginal peoples of Canada."

7 The centre will be funded through an endowment to which Aga Khan Development Network has pledged $10 million; the Government of Canada will provide $30 million.

8 However, the researchers did not find a comparable difference for second-generation women of the same ages (Aydemir, Chen and Corak 2005, 12). Oceania includes Australia, New Zealand and the surrounding islands.

9 Between 1871 and 1921, the federal government signed 11 treaties with First Nations, mostly in the Prairie provinces and Ontario. Only one of them, Treaty 8, covers a portion of British Columbia. The 1999 Nisga'a treaty followed a 1973 ruling by the Supreme Court of Canada in the *Calder* case that the Nisga'a held Aboriginal title before the arrival of the British.

10 As measured by the respondent's assessment of the likelihood that his/her lost wallet would be returned.

11 This potential tension is addressed in a brief explanatory document, "Canadian Multiculturalism: An Inclusive Citizenship," found on the Web site of the Department of Canadian Heritage. It includes the following statement: "Canadians are free to choose for themselves, without penalty, whether they want to identify with their specific group or not. Their individual rights are fully protected and they need not fear group pressures." Accessed October 27, 2006. www.canadianheritage.gc.ca/progs/multi/inclusive_e.cfm

12 However, the reference in the preamble to the "very traditional practices and beliefs" regarding women's rights that exist in some communities may have coloured some of the responses.

13 In 2002, American officials in New York deported Syrian-born Canadian citizen

Maher Arar to Syria during a flight stopover from Tunisia to Canada, on the basis that he allegedly had links to al-Qaeda. Arar was incarcerated and tortured for a year. In 2006 Justice Dennis O'Connor's inquiry into the matter concluded Arar had been wrongly deported and imprisoned.

14 Under this rule, children born in the country acquire citizenship whether or not their parents are citizens. In some countries, *jus soli* citizenship is tied to certain residence requirements for parents.

References

Aizlewood, Amanda, and Ravi Pendakur. 2007. "Ethnicity and Social Capital in Canada." In *Social Capital, Diversity, and the Welfare State*, edited by Fiona M. Kay and Richard Johnston. Vancouver: UBC Press.

Auditor General of Canada. 2006. *2006 Report of the Auditor General of Canada.* www.oag-bvg.gc.ca/domino/reports.nsf/html/06menu_e.html

Aydemir, Abdurrahman, Wen-Hao Chen, and Miles Corak. 2005. "Intergenerational Earnings Mobility among the Children of Canadian Immigrants." Statistics Canada. Analytical Studies Branch Research Paper Series, catalogue no. 11F0019MiE — no. 267. October 25.

Boyd, Marion. 2004. "Dispute Resolution in Family Law: Protecting Choice, Promoting Inclusion." December 20. www.attorneygeneral.jus.on.ca/english/about/pubs/boyd

Centre for Research and Information on Canada [CRIC]. 2003. "Canadians Want Strong Aboriginal Cultures but Are Divided on Aboriginal Rights." www.cric.ca/pdf/cric_poll/portraits/portraits_2003/Nov24_Ab_issues_final_eng.pdf

——. 2005a. "Diversity in Canada: Regions and Communities." CRIC Paper 18, October. www.cric.ca/pdf/cahiers/cricpapers_oct2005.pdf

——. 2005b. "Backgrounder: Quebecers See Advantages in Key National Public Policies." www.cric.ca/pdf/cric_poll/portraits/portraits_2005/eng_quebec_2005.pdf

Chartrand, Paul A. A. H. 2003. "Canada and the Aboriginal Peoples: From Dominion to Condominium." In *Reforming Parliamentary Democracy*, edited by F. Leslie Seidle and David C. Docherty. Montreal and Kingston: McGill-Queen's University Press.

Citizenship and Immigration Canada. 2006. *Annual Report to Parliament on Immigration.* www.cic.gc.ca/english/pub/annual-report2006/index.html

Goodhart, David. 2004. "Too Diverse?" *Prospect*, February, 30-37.

Hamdani, Daood. 2006. *Engaging Muslim Women: Issues and Needs.* Ottawa: Canadian Council of Muslim Women, October.

Harty, Siobhan, and Michael Murphy. 2005. *In Defence of Multinational Citizenship.* Vancouver: UBC Press.

Hiebert, Daniel. 2006. "Winning, Losing, and Still Playing the Game: The Political Economy of Immigration in Canada." *Journal of Economic and Social Geography* 97(1): 38-48.

Parkin, Andrew, and Matthew Mendelsohn. 2003. "A New Canada: An Identity Shaped by Diversity." Centre for Research and Information on Canada, CRIC Paper 11, October. www.cric.ca/pdf/cahiers/cricpapers_october2003.pdf

Picot, Garnett, and Arthur Sweetman. 2005. "The Deteriorating Economic Welfare of Immigrants and Possible Causes: Update 2005." Analytical Studies Branch Research Paper Series, Statistics Canada.

Putnam, Robert. 2004. "Who Bonds? Who Bridges? Findings from the Social Capital Benchmark Survey." Presentation to the annual meeting of the American Political Science Association, Chicago, September.

RBC Financial Group. 2005. "The Diversity Advantage: A Case for Canada's 21st Century Economy." Presented at the 10th International Metropolis Conference, October 20.

Reitz, Jeffrey G. 2005. "Tapping Immigrants' Skills: New Directions for Canadian

Immigration Policy in the Knowledge
Economy." *IRPP Choices* 11, no. 1.

Sen, Amartya. 2006. *Identity and Violence: The
Illusion of Destiny.* New York: W.W. Norton
& Company.

Siggner, Andrew J., and Rosalinda Costa. 2005.
"Aboriginal Conditions in Census
Metropolitan Areas, 1981-2001."
www.statcan.ca/english/freepub/81-004-XIE/
2005003/aborig.htm

Soroka, Stuart N., John F. Helliwell and Richard
Johnston. 2007. "Measuring and Modelling
Interpersonal Trust." In *Social Capital,
Diversity, and the Welfare State,* edited by
Fiona Kay and Richard Johnston.
Vancouver: UBC Press.

Statistics Canada. 2003. *Ethnic Diversity Survey:
Portrait of a Multicultural Society.* September.

———. 2006. "Canada's Population." *The Daily,* 27
September.

Stein, Janice Gross. 2006. "Living Better
Multiculturally." *Literary Review of Canada,*
September, 3-5.

Trudeau, Pierre. 1971. "Statement to the House
of Commons on Multiculturalism." House
of Commons. *Official Report of Debates,* 3rd
sess., 28th Parliament, October 8, 1971,
8545-46.

Trudeau Foundation. 2006. "Backgrounder:
Environics Research Group Poll for the
Trudeau Foundation."
www.trudeaufoundation.ca

Canadian

Approaches to

Recognizing and

Accommodating

Diversity

Ethnocultural Diversity
in a Liberal State:
Making Sense of the
Canadian Model(s)

ANADA IS A "STATISTICAL OUTLIER" AMONG WESTERN DEMOCRACIES IN ITS LEVEL OF
ethnic, linguistic and religious diversity (Laczko 1994). The criteria used to
measure levels of ethnocultural diversity are contested, but no one, I think,
would deny that issues of accommodating diversity have been central to Canada's
history. In the seventeenth and eighteenth centuries, the earliest European settlers
had to reach a modus vivendi with Aboriginal peoples; in the eighteenth and
nineteenth centuries, the British colonial administrators had to learn to live with
the long-settled French population; and in the nineteenth and twentieth cen-
turies, Canada had to accommodate successive waves of immigration. At each
step along the way, Canada's stability and prosperity — and indeed its very sur-
vival — have depended on its ability to respond constructively to new forms of
diversity, and to develop new relationships of coexistence and cooperation, with-
out undermining the (often fragile) accommodations of older forms of diversity,
which are themselves continually being contested and renegotiated.

This long history of diversity has resulted in what we might call a
palimpsest of federal laws and policies, with new layers continually being added
on top of the old. Recent multiculturalism policies for ethnic groups formed by
immigration overlie earlier linguistic and territorial accommodations of French
Canadians, which overlie earlier historic agreements and settlements with
Aboriginal peoples.[1]

If we look carefully at these policies, however, a different image may come
to mind — not so much three horizontal layers as three vertical silos. One strik-
ing aspect of these accommodations is how disconnected they are from each
other legally and administratively. These policies not only have different historical

origins, but they are also embodied in different pieces of legislation, they are administered by different federal government departments, they are enshrined in different sections of the Constitution, and they are articulated and negotiated using different concepts and principles. As a result, each forms its own discrete silo, and there is very little interaction between them.

To oversimplify, we can say that in the case of Aboriginal peoples, the historic roots lie in the Royal Proclamation of 1763; the framework piece of legislation is the *Indian Act, 1985*; the key constitutional provisions are sections 25 and 35 of the *Constitution Act, 1982*; the main federal government department responsible for administering and coordinating Aboriginal issues is Indian and Northern Affairs; and the guiding concepts used in articulating claims include treaty rights, Aboriginal rights, common law title, *sui generis* property rights, fiduciary trust, indigeneity, self-government and self-determination.

In the case of French Canadians, the historic roots lie in the *Quebec Act, 1774* and the *BNA Act, 1867*; the framework piece of legislation is the *Official Languages Act, 1969*; the key constitutional provisions are sections 16 to 23 of the Charter; the coordinating federal government agencies are Intergovernmental Affairs (within the Privy Council Office) and the Commissioner for Official Languages; and the main concepts used in articulating claims include bilingualism, duality, (asymmetric) federalism, distinct society and nationhood.

In the case of immigrant/ethnic groups, the historic touchstone is the 1971 parliamentary statement of multiculturalism; the framework legislation is the *Canadian Multiculturalism Act, 1988*; the key constitutional provision is section 27 of the Charter; the coordinating federal government departments are Heritage and Citizenship and Immigration; and the key concepts include multiculturalism, citizenship, integration, tolerance, ethnicity, diversity and inclusion.

Whenever claims relating to the accommodation of ethnocultural diversity are made (or contested) at the federal level in Canada, the political engagement almost invariably takes place within one of these three silos. Each silo has its own well-established entry points and opportunity structures, and anyone who wishes to effectively participate in these political debates must use these access points and master the relevant laws, constitutional provisions and terminology. Political actors frame their claims in terms of the established discourse within each silo in order to influence the implementation of policies or the formulation of laws, guided and constrained by the relevant constitutional provisions.

Given this tripartite structure, it is misleading to talk of "the Canadian model of diversity," as if there were one overarching policy on diversity from which policies regarding Aboriginal peoples, francophones and immigrant/ethnic groups could be derived or deduced. It's not as if there were a canonical statement about how Canada accommodates diversity that could be used to formulate policies on more specific forms of diversity. There is no master clause on diversity in the Constitution that stands above the various clauses relating to these three types of groups. There is no superministry of diversity — no diversity czar who oversees the federal ministries that administer policies relating to these groups. There are just the three silos, with their own separate histories, discourses, legal frameworks and governance structures.

To be sure, some commentators have claimed to find a distinctive logic underlying the three sets of diversity-related clauses in the Constitution that distinguishes them from other constitutional provisions. For example, it is sometimes said that what distinguishes the diversity-related constitutional clauses as a category is that all are fundamentally about the status of communities, and hence they rest on a distinctly communitarian logic. Others have argued that their distinguishing feature is that they are all about protecting cultures, and hence they rest on a culturally conservative or preservationist logic. On these views, the diversity-related clauses of the Charter rest on a communitarian-conservative logic, while the rest of the Charter rests on an individualist-liberal logic. Commentators who interpret diversity policies in these ways almost invariably then raise the paradox of the coexistence of these two logics. Critics argue that this paradox can only be resolved by jettisoning the illiberal diversity clauses/policies, while defenders of these policies argue that it is Canada's distinctive genius to have found a way to balance liberal and communitarian logics in a single constitution.

I believe that this familiar debate is doubly misleading. First, it exaggerates the similarities among the three diversity silos. It's true that these policies all have something to do with community, and we could even say, with rhetorical flourish, that they embody an idea of Canada as a community of communities. But it would be a mistake to suppose that there is a single idea of community or communitarianism that underpins these three sets of policies. It's not as if the Canadian government says, "Because we view Canada as a community of communities, all ethnocultural communities shall have the right to X." There is no singular logic of communitarianism (or of cultural

preservationism) that generates these sets of policies. Ideas of community may arise in all three cases — as may ideas of partnership, say, or recognition, or participation — but, as we will see, these concepts mean different things in each context, and they serve as place-holders for more differentiated principles and norms.

Second, this familiar debate exaggerates the extent to which diversity policies differ in logic from other policy fields. Indeed, I will argue that insofar as there is a common logic underlying diversity policies, it is not the logic of communitarianism or conservatism, but rather the logic of liberal constitutionalism — the same logic that informs the entire Constitution. The values of liberal-democratic constitutionalism motivate, shape and constrain these three sets of diversity policies in much the same way as they inform all other areas of public policy.

This is why I have titled this chapter "Ethnocultural Diversity in a Liberal State." The first and foremost fact about Canada's current diversity policies, I believe, is that they are liberal in their goals, in their legal formulation and in their administrative implementation. These policies have been (re)formulated by liberal political elites, supported by an increasingly liberalized public opinion, institutionalized within liberal-democratic governance structures and integrated within the framework of a liberal constitution.

This may seem obvious. After all, Canada is a consolidated liberal democracy, and one would expect its approach to diversity to be determined by liberal-democratic values. I will try to show, however, that this has important implications not only for how we describe these policies, but also for how we evaluate them and how we assess their future prospects.

It is important to emphasize that I am focusing in this chapter on *federal* diversity policies. Many of the trends I discuss would also apply to developments at the provincial or municipal levels (these are covered in other chapters in this volume). But the federal government has a special role in managing diversity, given its constitutional responsibilities and countrywide jurisdiction, and my chapter will focus on understanding and evaluating its policies. I will begin by briefly exploring the main outlines of the three diversity silos, then I will explore how they are rooted in liberal-democratic values. I will conclude with some tentative suggestions about how we should evaluate their current functioning and future prospects.

Three Forms of Diverse
Citizenship in Canada

C ANADA'S CURRENT APPROACH TO ETHNOCULTURAL DIVERSITY IS LIBERAL, BUT IT HAS not always been so. On the contrary: for most of its history, Canada took an approach that was deeply illiberal and undemocratic. However, there have been dramatic changes in the last 30 to 40 years in relation to all three types of diversity. Let me start with the case of immigrant/ethnic groups.

Immigrant/Ethnic Groups

The first set of policies I will examine concerns the treatment of immigrant/ ethnic groups. Ethnic groups are sometimes called "immigrant groups" to emphasize that they are neither indigenous peoples nor colonizers but were admitted under Canada's immigration policy. However, the term "immigrant group" is potentially misleading, since many of the group's members may be second, third or fourth generation. This is obviously true of those ethnic groups — such as Ukrainians, Poles or Jews — who have been in Canada for over 100 years. By contrast, other ethnic groups — such as Vietnamese or Somalis — are more recent, having arrived only in the past 30 years, and many of their members are still foreign-born immigrants.

Ethnic groups are a major element in Canadian society. First-generation immigrants — that is, the foreign-born population — formed over 18 percent of the overall population, according to the 2001 Census. If we add the descendants of earlier waves of immigration, the proportion of Canadians who have origins other than British, French or indigenous rises to around 50 percent.[2] So the issue of the status and treatment of ethnic groups is an important and long-standing one in Canada.

In the past, Canada, like the other major British settler societies (the United States, Australia, New Zealand), had an assimilationist approach to immigration. Immigrants were encouraged and expected to assimilate to the preexisting British mainstream culture, in the hope that over time they would become indistinguishable from native-born British Canadians in their speech, dress, recreation and general way of life.[3] Indeed, any group that was seen as incapable of this sort of cultural assimilation (for example, Asians or Africans) was prohibited from immigrating to Canada.

This racially discriminatory and culturally assimilationist approach to ethnic groups was slowly discredited in the postwar period, but it was only officially repudiated in the late 1960s and early 1970s. There were two related changes. First was the adoption of race-neutral admissions criteria (the points system), so that immigrants to Canada are increasingly from non-European (and often non-Christian) societies. This change was completed by 1967. Second was the adoption of a more multicultural conception of integration — one that anticipates that many immigrants will visibly and proudly express their ethnic identities and that accepts an obligation on the part of public institutions (the police, schools, media, museums) to accommodate these ethnic identities. This change was formalized in 1971 with the adoption of the multiculturalism policy by the federal government.

The original goals of the policy were fourfold: to "assist all Canadian cultural groups that have demonstrated a desire and effort to continue to develop a capacity to grow and contribute to Canada"; to "assist members of all cultural groups to overcome cultural barriers to full participation in Canadian society"; to "promote creative encounters and interchange amongst all Canadian cultural groups in the interest of national unity"; and to "assist immigrants to acquire at least one of Canada's official languages in order to become full participants in Canadian society" (Trudeau 1971, 8546).[4]

There have been various changes to the policy since 1971, primarily in the relative emphasis given to these four goals. Over time, starting in the mid-1970s, the second and third goals have increasingly received the lion's share of funding under the program.[5] But the core ideas have remained fairly stable: recognition and accommodation of cultural diversity, removal of barriers to full participation, promotion of interchange between groups and promotion of official languages acquisition. The policy was reaffirmed and given a statutory basis in the *Canadian Multiculturalism Act, 1988*. It was renewed in 1997, after 25 years of operation, following a major policy review.[6]

The policy functions at two levels. First, there is a small multiculturalism directorate within the Department of Canadian Heritage. It has a very modest budget (averaging $10-15 million per year) to administer a number of funding programs related to ethnic diversity. These include: support for academic research and teaching on ethnicity; antiracism education programs; support for ethnocultural organizations to organize heritage-language education and multicultural festivals, or to assist in immigrant integration services; and support for public institutions to implement reforms

that will remove barriers to the participation of ethnic groups.[7] Second, multiculturalism is also a government-wide commitment that all departments are supposed to consider in designing and implementing their policies and programs. For example, policies regarding Canada's public radio and television networks are decided by a separate federal agency — the Canadian Radio-Television and Telecommunications Commission (CRTC) — but these decisions are supposed to be informed by the goals of the multiculturalism policy; and to some extent they have been (Zolf 1989). Similarly, citizenship policies and programs to teach official languages are administered by a separate federal department — Citizenship and Immigration — and decisions about these policies are also supposed to be informed by the goals of the multiculturalism policy; one could argue that this, too, has been the case.[8]

Indeed, one reason given for providing the multiculturalism directorate with such a meagre budget is that the task of promoting multiculturalism should not fall on one office, but on all government officials. According to this view, the directorate is mainly a coordinator or clearing house that assists other departments in fulfilling their obligation to promote the goals of the multiculturalism policy. In reality, the extent to which other government departments pay attention to issues of multiculturalism varies, and officials in the multiculturalism directorate have complained about a lack of support from other departments and agencies.[9] However, the idea of multiculturalism as a pan-government commitment is affirmed in the *Canadian Multiculturalism Act,* which requires the multiculturalism directorate to monitor and report annually on how other government departments are fulfilling this commitment.[10]

Multiculturalism is best known as a policy of the *federal* government, and the *Canadian Multiculturalism Act* only covers federal government departments and agencies. However, versions of the policy have also been adopted by provincial and municipal governments, and even by businesses and civil society organizations. As a result, talk about multiculturalism policy in Canada is potentially ambiguous. It may refer to the modest funding programs administered by the multiculturalism directorate, which can be seen as the core of the federal policy. Or it may refer to the general federal commitment to promoting the goals of multiculturalism across all of its departments and agencies. Or it may refer to similar programs and policies at the provincial and municipal levels and within civil society.

At the apex of this field of multiculturalism policy is the multiculturalism clause of the Constitution. Section 27 states that the Charter of Rights and

Freedoms will be "interpreted in a manner consistent with the preservation and enhancement of the multicultural heritage of Canadians." This clause does not guarantee that multiculturalism policies will exist in perpetuity in Canada, or that the funds available for multiculturalism programs will not be cut (Kobayashi 2000). In fact, the clause has limited legal significance.[11] But it does provide some symbolic affirmation of the public commitment to the goals of multiculturalism, and it places multiculturalism above the fray of partisan politics.

Most Canadians have no clear idea how this complex of multiculturalism policies operates. They are vaguely aware that the federal government has an official multiculturalism policy, but they have little idea how, or even whether, this federal policy is connected to the adoption of a new multiculturalism curriculum in their local public schools, or to the appearance of a new multilingual ethnic channel on cable TV. In this sense, multiculturalism policies have permeated Canadian public life, with ripple effects extending far beyond their original source in one branch of the federal government. The 1971 federal statement on multiculturalism has initiated a "long march through the institutions" at all levels of Canadian society.

This, then, is a brief account of the basic contours of Canada's policy toward immigrant/ethnic diversity and of the shift from racial exclusion and cultural assimilation to race-neutral admission and multicultural integration. This shift was remarkably quick, given the breadth of the changes involved. The initial demands by ethnic groups for a multiculturalism policy arose in the mid-1960s, it was declared official public policy in 1971, and the administrative framework for implementing it had been worked out by the mid-1970s. So the contours of this first diversity silo essentially took shape between 1965 and 1975. While the policy was (and remains) contested, for reasons I will discuss later, it quickly became so embedded in Canadian political life that it was seen as appropriate to enshrine a multiculturalism clause in the Constitution in 1982. In short, multiculturalism went from being the bold idea of a few ethnic organizations in 1965 to the supreme law of the land in 1982, and it has since been reaffirmed — in 1988 and 1997 — with only minor changes in emphasis.

Aboriginal Peoples

The second set of policies concerns the rights and status of the Aboriginal or indigenous peoples of Canada: the Indians, Inuit and Métis. In the past, Canada,

like all British settler states, had the goal and expectation that its indigenous peoples would eventually disappear as distinct communities as a result of dying out, intermarriage, migration to cities and cultural assimilation. Various policies were adopted to speed up this process: stripping indigenous peoples of their lands; encouraging residential schooling of their children away from their home communities; restricting the practice of their traditional culture, language and religion; making cultural assimilation a condition of acquiring citizenship; and undermining their institutions of self-government (Armitage 1995; Cairns 2000). Any laws that gave Aboriginal peoples a separate legal or political status, such as those defining the system of treaties and reserves, were seen as temporary, paternalistic protections for a vulnerable population unable to cope with the rigours of modern life. They would prevail only until such time as these people were ready to stand on their own as equal and undifferentiated Canadian citizens.[12]

However, there has been a dramatic reversal in these policies, a change that in Canada started in 1969 in response to the federal government's White Paper on Indian Policy. The White Paper declared (in effect) that the need for paternalistic protections had passed, and that it was time for Aboriginal peoples to trade in their special status for the common rights of citizenship as individual Canadians. It therefore proposed to abolish existing treaties with Indians on the grounds that it was inappropriate and anachronistic for the state to stand in a treaty relationship with a group of its own citizens. It also proposed eliminating any special legal status for Indians on the grounds that this was inconsistent with norms of equality. In response, Aboriginal peoples engaged in a massive political mobilization to protect their lands, treaties and rights. They argued that these provisions were not inherently or originally paternalistic. On the contrary — they arose from the exercise of Aboriginal autonomy (that is, they reflected solemn and consensual agreements between Aboriginal peoples and Europeans), and they formed the legal and material basis for ongoing Aboriginal autonomy into the future.

The federal government quickly backed down, and the Aboriginal position was subsequently strengthened by a string of developments in the early 1970s, including the Supreme Court's recognition of Aboriginal title in the 1973 Calder decision;[13] the 1974 Mackenzie Valley pipeline inquiry's conclusion that resource development must respect Aboriginal interests and have Aboriginal consent (Berger 1977); and the 1975 James Bay and Northern Quebec Agreement with the Quebec Inuit and Cree affirming both land rights and self-government powers.

It is difficult to exaggerate the extent of the shift in thinking about Aboriginal policy over those few years — it was almost a total reversal. In 1969, the federal government was proposing to abolish existing treaties and denying that Aboriginal peoples had any distinctive political status. By 1975, it was not only promising to uphold old treaties, but it was also starting the process of signing new treaties and agreements, since treaties appropriately reflect the distinctive status of Aboriginal communities as self-governing. Since then, we have seen a battery of legal and political processes (land claims commissions, self-government negotiations, constitutional conferences, parliamentary committees, Royal Commissions) attempt to work out the implications of this new approach. Important moments include the entrenchment of Aboriginal rights in sections 25 and 35 of the Constitution, which not only affirmed "existing treaty and Aboriginal rights" but also extended constitutional protection to any land claims settlements or treaty rights that would be acquired in the future; the House of Commons Penner Report in 1983, which formally endorsed the principle of an Aboriginal right to self-government; and the inclusion of the principle of an Aboriginal right to self-government in the 1992 Charlottetown Accord. While the referendum on the Accord failed, the federal government has since declared that it will operate on the assumption that a right to self-government is implicit in the existing Aboriginal rights affirmed in the Constitution. This position was affirmed by the massive, five-volume *Report of the Royal Commission on Aboriginal Peoples* in 1996, and it underpinned the creation of Nunavut in 1999.

This, then, is a brief sketch of the Canadian approach to Aboriginal peoples and the shift away from paternalism/assimilation toward self-government. The Canadian government today accepts, at least in principle, the idea that Aboriginal peoples will exist into the indefinite future as distinct societies within Canada, and that they must have the land claims, treaty rights, cultural rights and self-government rights they need to sustain themselves as such. As with multiculturalism, the changes involved were dramatic and quick. The new contours of this second diversity silo were provisionally drawn between 1969 and 1975. This shift was (and remains) contested in Canada, for reasons I will discuss later. But, as with multiculturalism, it quickly became so embedded in Canadian political life that it was deemed appropriate to codify and entrench it in the Constitution in 1982, and subsequent reports and constitutional proposals have reaffirmed it and elaborated on it.

Francophones/Québécois

The third set of policies concerns the "French fact" in Canada — that is, the status of the French-speaking communities that were initially established during the period of French colonialism, centred in Quebec and New Brunswick, but with long-standing settlements in many parts of Canada. When the British defeated the French to gain control over New France, they were faced with the question of what to do with a long-settled French Canadian population that was accustomed to operating within its own full set of legal, political and educational institutions and that was deeply attached to those institutions. The institutions were shaped by the distinct language, culture and religion of French Canadians, and they served to reproduce a distinct national identity. In short, the British were confronted with the challenge of a "nation within" — that is, a historically settled and regionally concentrated group whose members conceived of themselves as a nation within a larger state and who gave varying levels of support to nationalist movements to defend their autonomous institutions and to achieve recognition of their distinct national identity.

As was true of the rulers of most Western countries, British rulers were nervous about the existence of such a nation within. They saw it as a threat, since it put into question the legitimate authority of the state to speak for and govern all of its citizens and territory. Western countries have historically attempted to suppress these forms of substate nationalism by restricting minority language rights, abolishing traditional forms of local or regional self-government, and encouraging members of the dominant group to settle in the minority group's territory so that the minority is outnumbered even in its traditional homeland. The British tried this strategy on French Canadians, first under the Royal Proclamation of 1763 and then under the *Act of Union, 1841*, in the hope that the French would be swamped by, and/or assimilated into, a British settler society. But both attempts failed miserably,[14] and by the time of Confederation, in 1867, it was clear that the national aspirations of the French would have to be accommodated through a framework of federalism and bilingualism. Federalism involved (re)establishing the French-majority province of Quebec as a political space within Canada where the French would be masters of their own home and sustain their own institutions. Bilingualism guaranteed the use of the French language not only in Quebec, but also in the federal Parliament and courts, so as to ensure equal opportunities for the French at the federal level.

This basic framework of provincial autonomy and federal bilingualism remains in place today, and in that sense the third diversity silo can be seen as having longer historical roots than either Aboriginal or immigrant/ethnic diversity policies. However, this apparent continuity is potentially misleading, for here too we have witnessed dramatic changes in the past 40 years. By the early 1960s, it had become clear that the sort of provincial autonomy and federal bilingualism available under the *BNA Act* was inadequate. Bilingualism in the federal government, for example, had not led to equal opportunities for francophones. On the contrary: bilingualism was largely token; the federal government operated almost exclusively in English, and as a result French Canadians were dramatically underrepresented in the federal civil service. Similarly, provincial autonomy had not enabled the French to be masters in their own home. Instead, they were second-class citizens in their own province, economically subordinate to the English elite that had been privileged under British rule, and relegated to the lower rungs of the economy. The accommodations built into the *BNA Act* were sufficient to prevent assimilation and to avoid the "Louisianization" of Quebec, but they were not enough to ensure either linguistic equality or national autonomy.

Faced with this situation, modernizing elites in Quebec in the 1960s engaged in a twofold struggle: first, to acquire the powers of provincial autonomy needed to improve the educational and economic opportunities for the francophone majority within Quebec, and to make the French language a language of social opportunity and mobility; and second, to achieve real linguistic equality within the federal government. In both cases, there was the implicit (and sometimes explicit) threat that if these goals were not achieved, secession was the likely result. If equality and autonomy could not be achieved within Canada, they would be achieved outside Canada.

The basic legitimacy of these two goals was accepted by the federal government's Royal Commission on Bilingualism and Biculturalism, established in 1963, and a series of reforms were enacted to help achieve them. On the bilingualism front, the key reform was the *Official Languages Act, 1969*, which created one of the strongest systems of federal bilingualism in the world in terms of the duties it imposes on the federal government to accommodate the use of both languages in its administration and public services. This commitment to full linguistic equality was then enshrined in sections 16-20 and 23 of the 1982 Constitution, reaffirmed in the 1988 revision to the *Official Languages Act* and strengthened once again in the 2003 Action Plan for Official Languages.

On the provincial autonomy front, a series of intergovernmental agreements was signed to strengthen Quebec's autonomy, starting with the 1964 agreement to allow Quebec to run its own pension scheme (which was crucial in enabling the modernization of the economy), and the 1977 Cullen-Couture Agreement to allow Quebec to run its own immigration program (which was crucial in ensuring that immigration was a benefit, not a threat, to Quebec's francophone majority). This commitment to honouring Quebec's distinctive needs for provincial autonomy is also implicitly reflected in the 1982 Constitution, with its guarantees of compensation in case of transfer of jurisdiction over language and culture (section 40), and its reservation concerning education in Quebec (section 59) so as to protect Bill 101. Since then, further intergovernmental agreements have been reached with Quebec to protect and expand its autonomy, most recently the 2004 health care agreement.[15] The federal government has also made other efforts to affirm Quebec's distinctiveness and protect its autonomy, such as the 1995 parliamentary resolution recognizing Quebec as a distinct society and the *Constitutional Amendments Act, 1996*, granting Quebec a veto over future constitutional changes. As a result of these developments, Canada today has one of the most decentralized federal systems in the world, ensuring Quebec a high level of autonomy, which it has effectively used to improve the status and opportunities of its historically disadvantaged francophone majority.

There remains disagreement within the federal government about how best to satisfy Quebec's aspirations for autonomy. Some have endorsed asymmetric agreements that would grant powers to Quebec that are not available to the other provinces; others have argued that any powers offered to Quebec must be offered to the other provinces. Some have endorsed amending the Constitution to confirm Quebec's increased autonomy (as occurred with the 1964 pension agreement); others have argued that nonconstitutional intergovernmental agreements are sufficient to satisfy Quebec's legitimate interests. But despite these disagreements about strategy, there has been a broad consensus since 1964 that the federal government must not be seen to be trampling on Quebec's autonomy and must be willing to negotiate a more cooperative, flexible or renewed federalism in response to Quebec's aspirations.

This, then, is a brief outline of Canada's approach to the French fact and of the shift from second-class citizenship to full linguistic equality and strong provincial autonomy to accommodate the national(ist) aspirations of a distinct

society within the state. Here, again, the shift was fairly quick. The new contours of this third diversity silo were essentially drawn between 1964 and 1977.[16] The shift was (and remains) contested, as we will later see. But, as with multiculturalism and Aboriginal rights, it quickly became so embedded in Canadian political life that core elements of this package were included in the 1982 Constitution, and subsequent developments have largely affirmed it.

The extent to which this model has been constitutionalized is more contested and complicated than in the first two cases. Official bilingualism is explicitly enshrined in the Charter, and, as I mentioned earlier, some other sections are clearly (albeit implicitly) a response to Quebec's concerns about provincial autonomy. But attempts to include a reference in the Constitution to Quebec's distinctiveness, as proposed in the 1987 Meech Lake and 1992 Charlottetown accords, have been decisively rejected by Canadians. The idea of formally entrenching in the Constitution any principle of asymmetry, special status or distinct society (let alone nationhood) for Quebec remains wildly unpopular in most of Canada.

Despite these constitutional rebuffs, the federal government has declared that its approach to federal-provincial relations will be premised on the assumption that Quebec is a distinct society, thereby confirming what is clear to any observer. Whatever the constitutional niceties, the federal government has understood the need to negotiate Quebec's claims for autonomy, particularly where these are seen as essential to Quebec's national project, if only because refusing to do so would likely increase support for secession. Even more striking, the Supreme Court has recently said, in its 1998 *Reference re Secession of Quebec*, that Quebec's distinctness must be taken into account in interpreting the Constitution, that protecting its distinctness is one of the justifications for federalism in Canada, and that failure to honour this constitutional value could provide legitimate grounds for secession. This is as close as one could come to the de facto constitutionalization of the third diversity silo.

The Liberal Foundations of the Canadian Models

THESE OVERVIEWS OF THE THREE DIVERSITY SILOS ARE OBVIOUSLY HIGHLY SCHEMATIC. They ignore the many ebbs and flows of federal policies. A careful analysis of any of these policy domains would reveal a multitude of advances and retreats in

response to shifting political coalitions and public opinion, or to the determination and power of individual ministers. Funding for multiculturalism programs goes up and down; the federal government toughens and relaxes its bargaining position when negotiating Aboriginal land claims and self-government agreements (just as the Supreme Court expands and contracts its interpretations of Aboriginal rights)[17]; the commitment to implement or extend federal bilingualism waxes and wanes, as does the openness to negotiate new agreements with Quebec.

Such day-to-day fluctuations are important, and much of our political and intellectual energies are spent trying to decipher them and attempting to predict which way the wind is blowing. But an exclusive focus on these short-term variations may obscure the fact that there has been a dramatic shift — a veritable sea change — in the baseline from which these advances and retreats are made. The federal government may play hardball when negotiating Aboriginal land claims, for example, but the obligation to negotiate land claims is now constitutionally entrenched, as are the principles of multiculturalism and bilingualism. There is no route back to the 1969 Indian policy White Paper,[18] or to the Anglo-conformity model of immigrant incorporation, or to the days when francophone Quebecers were hewers of wood and drawers of water, barred from the corridors of power.

Once we stop and think about this sea change in each policy field and notice the similarity in the timing of the changes, a different image of Canada's diversity policies may come to mind — not so much a horizontal palimpsest, or a set of vertical silos, but rather a tidal wave. Canada's current policies are, in large part, the result of a wave of reform that was concentrated essentially in a single decade — from 1965 to 1975. With all three types of diversity, this wave overturned the presuppositions of earlier policies and defined the basic parameters of multiculturalism, Aboriginal self-government and bilingualism/provincial autonomy that remain with us today.[19] This coincidence in the timing of reforms suggests that there must, after all, be some important common sources for these different policies. The outcome of the tidal wave was three discrete silos, each with its own norms, laws, historical references and governance structures. But it seems likely that there were similar forces at work generating the modern reforms in all three cases.

What name can we give to this tidal wave that swept over Canada between 1965 and 1975 and that profoundly reconstructed the three diversity silos? I believe that there is only one plausible answer to this question: liberalization. The decade 1965-75 was the most concentrated period of social and political liberalization that

Canada has ever witnessed. Liberalizing reforms were instituted across virtually the entire range of social policy — reforms that, among other things, liberalized abortion laws, divorce laws and access to contraception; abolished the death penalty; prohibited gender and religious discrimination; and decriminalized homosexuality. This era is often characterized as reflecting a human rights revolution in Canada, and indeed it saw the establishment of human rights commissions in virtually every province and at the federal level in 1977. Others have characterized it as the triumph of a rights-based liberalism, or a civil rights liberalism, in Canada.

All of these legal reforms were the manifestation of a much wider process of liberalization in civil society and public opinion. In 1960, Canada was a more conservative, patriarchal and deferential society than the United States. By 1975, Canadians had become more liberal, egalitarian and autonomous than Americans. And one product of this liberalization of society and policy was, of course, the 1982 Charter, widely viewed as one of the most liberal constitutions in the world, and enormously popular in Canada for that reason.

The reform of diversity policies in 1965-75 is related in some way to this more general process of liberalizing reform. But we can imagine two different interpretations of the relationship. One interpretation — the one I will defend — is that the reform of diversity policies is simply one more example of this liberalization, inspired by the same liberal ideals and principles, and enacted by the same liberal reformist coalitions. But there is an alternative explanation — namely, that these new diversity policies arose precisely as a reaction against liberalization, and as an attempt to contain its corrosive effects on traditional authorities and practices. According to this view, the new diversity policies were demanded by communitarian or conservative elites who worried that newly emancipated individuals would use their human rights and civil rights to question and reject traditional authority structures and cultural practices. Diversity policies, in short, were intended to set communitarian brakes on liberalization. This is the view upheld by those who say that the diversity clauses in the Constitution reflect a communitarian or preservationist logic different from the liberal and individualist logic of the rest of the Charter.

This alternate explanation has played an important role in Canadian debates, in part because Pierre Trudeau himself apparently believed in some version of it. His initial vision of the Charter did not include multiculturalism, Aboriginal rights or any recognition of Quebec's distinctness. He had supported

the original 1969 White Paper abolishing Aboriginal rights, was deeply ambivalent about multiculturalism and was a lifelong opponent of Quebec nationalism.[20] He seemed to believe that these were all communitarian deviations from a pure liberalism, and that they reflected an inward-looking and backward-looking form of group-think that was at odds with the autonomous individuality underlying the liberal tradition.

The credibility of this alternate view is reinforced by its links to larger, worldwide debates in political philosophy and international law. Some political philosophers have argued that ideas of multiculturalism and minority rights represent a communitarian reaction against universal human rights and civil rights liberalism (for example, Barry 2001). Similarly, some commentators (for example, Finkielkraut 1988) have argued that while the UN's original 1948 Universal Declaration of Human Rights was predicated on the values of the Enlightenment, the UN's subsequent support for indigenous rights, minority rights and multiculturalism reflects the values of the Counter-Enlightenment. Despite the assertions of these venerable sources and authorities, I believe that this alternative view is demonstrably false, at least in terms of the motivations for Canada's current diversity policies. Virtually everyone involved in reforming the diversity silos — from the political activists and civil society organizations that initially mobilized for the reforms, to the segment of the public that supported them, to the legislators who adopted them, to the bureaucrats who drafted and implemented them, to the judges who interpreted them — was inspired by the ideals of human rights and civil rights liberalism and viewed the reforms as part of a larger process of social and political liberalization.

To be sure, once these policy structures were in place, conservative and patriarchal elites within various communities attempted to gain control over them — or at least influence their implementation and direction. This is a universal phenomenon: once new powers or resources are made available, competition will arise for control over them. For example, once multiculturalism funds were made available and multiculturalism advisory councils established, conservative elites within immigrant/ethnic groups sought access to them. Once certain institutions of Aboriginal self-government were established, and once Quebec's provincial autonomy was strengthened, conservatives sought to use these new powers to protect their traditional authority. This sort of political contestation is inevitable. Indeed, it would violate every known law of political science if it didn't happen.

It is even possible that these policies have sometimes, unintentionally, served to strengthen the hand of conservative elites against the forces of liberal reform within various communities. So one important question we need to ask is whether conservative/patriarchal elites have been successful in capturing these policies, and what safeguards are in place to ensure that the original emancipatory goals and ideals are not subverted. I will return to this question in the next section when discussing how we should evaluate the actual operation of these policies and their future prospects.

But my focus in this section is on the foundations of the policies — the normative principles and political coalitions that underpinned their adoption in Canada. And here, I think, it is undeniable that they are an expression of the human rights revolution, not a reaction against it. This can be shown in many ways, but let me focus on three key links — genealogical, attitudinal and legal — between the human rights revolution and diversity policies.

Genealogy

Diversity policies can only be understood, I believe, as a stage in the gradual working out of the logic of human rights, and in particular the logic of the idea of the inherent equality of human beings, both as individuals and as peoples. In 1948, through the adoption of the Universal Declaration of Human Rights (UDHR), the international order decisively repudiated older ideas of a racial or ethnic hierarchy, according to which some peoples were superior to others and thereby had the right to rule over them. It's important to remember how radical these ideas of human equality are. Assumptions about a hierarchy of peoples were widely accepted throughout the West up until the Second World War, when Hitler's fanatical and murderous policies discredited them. Indeed, the colonial system was premised on these assumptions, and they were the explicit basis of domestic policy and international law throughout the nineteenth century and the first half of the twentieth century (such as Canada's racially exclusionary immigration laws).

Since 1948, however, we have lived in a world where the idea of human equality is unquestioned, at least officially, and this has generated a series of political movements that contest the lingering presence or enduring effects of older ethnic and racial hierarchies. We can identify a sequence of such movements. The first was decolonization, lasting roughly from 1948 to 1966. Some Western countries that signed the UDHR (for example, France, Spain and

Portugal) did not believe that endorsing the principle of the equality of peoples would require them to give up their colonies. But this position was unsustainable, and the link between equality and decolonization was made explicit in the UN's 1960 General Assembly Resolution 1514 on decolonization.

The second stage was racial desegregation, which lasted from approximately 1955 to 1965, initiated by the African American civil rights struggles. When the United States signed the UDHR in 1948, it did not believe that this would necessitate abandoning its segregationist laws. But this position too became unsustainable, and the link between equality and racial discrimination was made explicit in the UN's 1965 Convention on the Elimination of All Forms of Racial Discrimination. The African American civil rights struggle subsequently inspired historically subordinated ethnocultural groups around the world to engage in their own forms of struggle against the lingering presence of ethnic and racial hierarchies. We can see this in the way indigenous peoples adopted the rhetoric of Red Power, or in the way national minorities (such as the Québécois or the Catholics of Northern Ireland) called themselves "White niggers" (Vallières 1971), or in the way Caribbean immigrants to the UK adopted the rhetoric and legal strategies of American Blacks (Modood 2003). All of these movements were profoundly influenced by American civil rights liberalism and the commitment of its proponents to defend the equality of disadvantaged and stigmatized minorities through the enforcement of countermajoritarian rights.

However, as civil rights liberalism spread, it had to adapt to the actual challenges facing different types of minorities around the world. For American theorists, the very ideas of civil rights and equality have been interpreted through the lens of antidiscrimination in general, and racial desegregation in particular. For most American theorists, the sorts of countermajoritarian rights that civil rights liberalism must defend are therefore rights to undifferentiated citizenship within a civic nation that transcends ethnic, racial and religious differences.

In most countries, however, the sorts of minorities needing protection are different, and so too are the sorts of civil and political rights they require. African Americans were involuntarily segregated solely on the basis of race, excluded from common institutions that they often wanted to join. Many minorities, however, are in the opposite position: they have been involuntarily assimilated, stripped of their language, culture and self-governing institutions. They too have faced oppression at the hands of their co-citizens and have had their civil rights denied to them,

often with the enthusiastic backing of large majorities, on the grounds of their inferiority or backwardness. They too need countermajoritarian protections. But the form these protections take is not solely antidiscrimination and undifferentiated citizenship, but also various group-specific accommodations.

In the Canadian context, as we've seen, these include bilingualism and provincial autonomy (for the Québécois), land claims and treaty rights (for Aboriginal peoples), and various sorts of multicultural accommodations (for immigrant/ethnic groups). The struggle for these differentiated minority rights in Canada must be understood as a local adaptation of civil rights liberalism, and hence as a third stage in the human rights revolution.[21] Just as decolonization inspired the struggle for racial desegregation, so racial desegregation inspired the struggle for minority rights and multiculturalism.

As I noted earlier, some commentators have tried to argue that this shift toward recognizing group-differentiated rights represents a reaction against human rights and liberalization. According to this view, the first two stages in the human rights revolution — decolonization and racial desegregation — were inspired by Enlightenment liberalism, but the third stage represents a conservative reaction against civil rights liberalism.[22] This, however, is a gross misreading of history, at least in Canada. The third stage was inspired by the civil rights liberalism of the second stage (as well as the decolonization struggles of the first stage), it shared the second stage's commitment to contesting ethnic and racial hierarchies, and it sought to apply that commitment more effectively to the actual range of exclusions, stigmatizations and inequalities that existed in Canada.

Attitudes

The link between liberalization and diversity policies is also reflected in the nature of the political coalitions and public opinion that supported these reforms in Canada. If the alternative communitarian view of diversity policies were correct, then we would expect to see two competing political camps: a liberal camp in favour of liberalizing reforms on issues of gender equality, abortion, divorce and gay rights, so as to emancipate individuals; and a conservative camp in favour of multiculturalism, Aboriginal rights and accommodating Quebec, so as to protect communities from liberalizing reforms. In reality, the situation is just the opposite. There are liberal and conservative camps in Canada, but they line up very differently on these issues.

On the one hand, we have patriarchal cultural conservatives who believe that society is changing too fast and that more weight should be given to traditional authorities and practices. This is the group Michael Adams has characterized as the "Father knows best" crowd (1997, 2000); he estimates that about 35 percent of the Canadian population belongs to it.[23] Predictably, these people strongly oppose liberalizing reforms related to women's equality and gay rights. But they equally oppose multiculturalism, Aboriginal rights and accommodating Quebec. Indeed, the emergence of these diversity policies is one of the changes that they find most distressing. There has been no significant level of public support for these diversity policies among cultural conservatives.

Of course, having lost the battle to block these policies, patriarchal conservatives have not simply disappeared. As I noted earlier, they are regrouping in order to see how they can exploit the opportunities created by the policies. For example, conservative Protestants, who initially fought tooth and nail to block multiculturalism in the public schools since it would strip Christianity of its privileged position, are now regrouping to see whether they can invoke multiculturalism to regain some lost privileges (Davies 1999). But this *ex post facto* strategic appeal to multiculturalism must be distinguished from support for the policy's adoption, which patriarchal conservatives strongly opposed.

On the other hand, we have the liberal component of the Canadian populace, which has become increasingly egalitarian, antiauthoritarian and individualistic. Predictably, these people strongly support gender equality and gay rights, but they equally endorse diversity policies and view both sets of reforms as expressions of a single logic of civil rights liberalism. So both camps have operated on the assumption that diversity policies are an integral part of a larger process of liberalization, although they differ on how to evaluate this larger process; and changes in support for diversity policies over time track changes in support for liberal egalitarian values more generally (Dasko 2005).

Legal Definition

The link between liberalization and diversity policies can be confirmed by examining the way these policies have been legally drafted and judicially enforced. One of the most striking things about the new diversity silos is how tightly and explicitly they are connected to broader norms of human rights and liberal constitutionalism, both conceptually and institutionally. Consider the preamble to

the *Canadian Multiculturalism Act*. It begins by saying that because the Government of Canada is committed to civil liberties, particularly the freedom of the individual "to make the life that the individual is able and wishes to have," and because it is committed to equality, particularly racial and gender equality, and because of its international human rights obligations, particularly the international convention against racial discrimination, it is therefore adopting a policy of multiculturalism. It goes on, in the main text, to reiterate human rights norms as part of the substance of the multiculturalism policy.[24]

You could hardly ask for a clearer statement that multiculturalism is to be understood as an integral part of the human rights revolution, and as an extension of — not a brake on — civil rights liberalism. There is not a whiff of cultural conservatism, patriarchalism or preservationism in this statement. It is the very milk of Enlightenment liberalism and universal human rights. In fact, this point had already been clearly made in the original 1971 parliamentary statement on multiculturalism, which declared that "a policy of multiculturalism within a bilingual framework is basically the conscious support of individual freedom of choice. We are free to be ourselves" (Trudeau 1971, 8546).

These formulations are obviously intended as an instruction to the relevant political actors — from minority activists to bureaucrats — that multiculturalism must be understood as a policy inspired by liberal norms. Nor was this left to chance or to the goodwill of political actors. The *Canadian Multiculturalism Act* is located squarely within the larger institutional framework of liberal-democratic constitutionalism, and hence it is legally subject to the same constitutional constraints as any other federal policy. Any federal action performed in the name of multiculturalism must respect the requirements of the Charter, as interpreted and enforced by judicial bodies such as the Canadian Human Rights Commission and the Supreme Court.

So the way in which multiculturalism in Canada has been legally defined makes it clear that it does not exist outside the framework of liberal-democratic constitutionalism and human rights jurisprudence, or as an exception to it or deviation from it. Rather, it is firmly embedded within that framework. It is defined as flowing from human rights norms, as embodying those norms and as enforceable through judicial institutions whose mandate is to uphold them. The same is true, I would argue, of federal policies in relation to Aboriginal rights, bilingualism and provincial autonomy. In all of these cases, there has been a conscious decision to

link these policies, at both the conceptual and the institutional levels, to ideals of civil rights liberalism and the protection of human rights norms.

Why has this link between diversity policies and liberalism not been more visible? Part of the explanation is a conceptual confusion about the term "group rights." Diversity policies are often labelled as "group rights" or "collective rights," and on that basis they are considered inconsistent with the individualist foundations of liberalism. But the term "group rights" is misleading, since it covers two very different types of claims. A group may claim countermajoritarian rights against the larger society in order to reduce its vulnerability to the political and economic power of the majority (what I have elsewhere called "external protections"). Or it may claim the right to restrict the basic civil and political liberties of its own members in order to suppress dissent, impose traditional cultural practices or enforce religious orthodoxy (what I call "internal restrictions"). The latter claim is in conflict with liberalism's commitment to individual freedom, but the former need not be — it may actually enhance individual freedom by providing choices that would otherwise be precluded or stigmatized by the larger society.[25]

Whether diversity policies reflect liberal goals therefore depends on whether they are intended to function as external protections or internal restrictions. The legal provisions I discussed earlier demonstrate that, in the Canadian case, these policies are not intended to justify the violation of the human rights of individuals or to restrict their fundamental rights and freedoms. Insofar as these policies empower groups to control resources and exercise decision-making powers, they are expected to do so within the limits set by the Charter and by international human rights norms.

There are, of course, debates about how to define these limits, as occurs in all areas of liberal reform. Just as liberals disagree over when to prohibit pornography in order to protect gender equality, so they disagree over when to prohibit hate speech in order to protect ethnic and racial equality. Just as liberals disagree over when to limit campaign donations to reduce the unequal political influence of wealth, or when to compel private golf clubs or charitable associations to admit women, so they disagree over when to employ affirmative action to overcome barriers facing racial minorities. These sorts of tensions and disagreements are endemic to civil rights liberalism, given its twin goals of reducing inherited status inequalities and upholding individual freedom. To overcome deeply entrenched inequalities, we must pay special attention to the impact of laws and policies on

disadvantaged groups, since even apparently gender-blind or colour-blind laws may have disproportionate effects on such groups, and special protections or preferential status may therefore be needed. But pro-minority policies are themselves limited by principles of fundamental freedoms and human rights. In short, one set of liberal goals may conflict with another set of liberal goals, resulting in ongoing disputes about the appropriate forms and limits of diversity policies. The Supreme Court has a well-established framework for addressing disagreements about which forms of differential treatment, and which limitations on individual civil liberties, are demonstrably justified in a free and democratic society as a way of overcoming inherited inequalities. The key point, for our purposes, is that these familiar disputes are between two dimensions of civil rights liberalism, not between the claims of liberalism and the claims of traditionalism or cultural conservatism.[26]

This is not to say that everyone in Canada is happy about the way in which diversity policies are underpinned by liberal norms.[27] As we will see in the next section, there have been attempts to test the bounds of liberal constitutionalism and to push diversity policies in directions that were not intended for them by their original drafters and supporters. But, at least in their current form, diversity policies in Canada can only be understood as the product of a tidal wave of liberal reform inspired by an international human rights revolution, supported by liberal public opinion and governed by liberal-democratic constitutional norms.

Evaluating the Canadian Models and Their Future Prospects

AT THIS POINT, SOME READERS MAY FEEL IMPATIENT. THEY MAY BE THINKING THAT THE key question here is not what the naive or pious hopes were of the people who advocated or drafted these policies — after all, the road to hell is paved with good intentions. The key question is, rather, how these policies are working in practice. Are they a success or a failure? In order to answer that question, however, we must first determine what they were aiming to achieve. In the story I am telling, they were primarily intended to contest inherited ethnic and racial hierarchies through the recognition and accommodation of ethnocultural diversity, inspired and constrained by norms of human rights and civil rights liberalism. As such, they

fit together with other policies aimed at contesting status hierarchies, such as gender and sexual orientation, as part of a larger package of liberal-democratic reforms.

It should be immediately clear that this goal is not only different from but also contradictory to the goal of preserving cultural identities and heritages intact and unchanged. These diversity policies are, inevitably and intentionally, transformational. They demand that both dominant and historically subordinated groups engage in new practices, enter new relationships, and embrace new concepts and discourses, all of which profoundly transform people's identities and practices. This is perhaps most obvious in the case of the historically dominant British population in Canada, which has been required to renounce fantasies of racial superiority, to relinquish claims to exclusive ownership of the state and to abandon attempts to fashion public institutions solely in its own White Christian image. Much has been written about the transformations this has demanded and the backlash it has sometimes provoked.[28] But Canada's diversity policies are equally transformative of the identities and practices of historically subordinated groups. Many of these groups have their own histories of ethnic and racial prejudice, of anti-Semitism, of caste and gender exclusion, of religious triumphalism and of political authoritarianism, all of which are delegitimized by the norms of liberal-democratic multiculturalism and minority rights.

One way to think of this is to recognize that the human rights revolution is a double-edged sword. It has created political space for ethnocultural groups to contest inherited hierarchies. But it also requires groups to advance their claims in a very specific language — namely, the language of human rights, civil rights liberalism and democratic constitutionalism. This is not necessarily the language that members of minority groups would naturally use. Some people may wish to contest their subordinate status vis-à-vis the British while still asserting their superiority over other groups. Some East Asian groups in Canada, for example, vocally protest against any racism they suffer, yet they show higher levels of racism than British or French Canadians in relation to Black and Aboriginal Canadians. Some upper-caste Hindu immigrants from India decry the fact that Whites have not fully accepted them, yet they desperately try to avoid contact with lower-caste immigrants from their home country. Some North African men object to discrimination in the job market, yet they refuse to hire or work under a woman. One could extend this list indefinitely. It is not only the British in Canada who have had illiberal and undemocratic tendencies.

For all such people, Canada's diversity policies offer both opportunities and challenges. As I noted earlier, these policies provide clear access points and legal tools for nondominant groups to challenge their status. But they must pay a price for this access — namely, they must accept the principles of human rights and civil liberties and the procedures of liberal-democratic constitutionalism, with their guarantees of gender equality, religious freedom, racial nondiscrimination, gay rights and due process. They can appeal to diversity policies to challenge their illiberal exclusion, but those very policies also impose upon them the duty to be inclusive.

Put another way, Canada's diversity policies are centrally concerned with constructing liberal-democratic citizens in a multiethnic state. They are forms of "citizenization," to use sociological jargon. They start from the reality that ethnocultural and religious diversity in Canada has historically been defined by a range of illiberal relationships — including relations of conqueror and conquered, colonizer and colonized, settler and indigene, racialized and unmarked, normalized and deviant, civilized and backward, ally and enemy, master and slave — and that this complex history will inevitably generate group-differentiated ethnopolitical claims. However, they seek to transform this catalogue of uncivil relationships into relations of liberal-democratic citizenship, both in terms of the vertical relationship between the members of minorities and the state, and the horizontal relationships among the members of different groups. And this means filtering and framing these differential claims through the language of human rights, civil liberties and democratic accountability.[29]

With these aims in mind, we can finally ask how well these policies are doing in practice. I will subdivide this question into three parts. First, liberalism: Have these policies succeeded in ensuring that the accommodation of ethnocultural diversity occurs within the boundaries of liberal values, consistent with human rights and civil liberties? Second, equality: Have these policies succeeded in reducing inherited ethnic and racial hierarchies (and preventing new hierarchies from emerging)? Third, sustainability: Are these policies sustainable over time, or are they eroding the sort of trust and solidarity needed to maintain them?

Other papers in this volume address these questions in more detail in relation to particular policies, so here I will only try to make a few schematic points, more as a way of framing the discussion than as an attempt to provide definitive answers. I will address the three questions in turn.

Liberalism

I have repeatedly emphasized that the people who enacted these policies were inspired by human rights and civil rights liberalism and intended them to operate within that framework. But have these intentions been fulfilled? Or have illiberal forces managed to gain control over the powers and resources made available by these policies and use them to restrict human rights and civil liberties? These are crucial questions, but it's important to remember that this problem is not unique to diversity policies. It is a systemic problem that arises from the very structure of liberal democracy. Liberal democracy gives the vote to communists who want to abolish parliamentary democracy, just as it gives free speech to those who would refuse free speech to others. This paradox has been a feature of liberal-democratic theory and practice since its origins in the seventeenth century.

As a result, there is a long history of discussion about how to prevent illiberal and undemocratic forces from abusing the rights and powers that liberal democracy extends. The solution, in all of these cases, is a combination of (1) civic education and political socialization to help develop and sustain a broader political culture of human rights and civil rights liberalism; (2) mechanisms for identifying and publicizing actual or potential abuses — including freedom of speech, freedom of the press, and freedom of information policies, and the requirements for reporting, consultation and accountability — so as to bring issues into the court of public opinion and to expose and marginalize illiberal tendencies; and (3) legal and constitutional safeguards that empower the state to prevent or remedy these abuses. These are the sorts of strategies used in all Western democracies to grapple with the problem of the illiberal and undemocratic abuse of liberal democratic rights, and they apply as well to the case of diversity policies in Canada.

Are these strategies working in Canada? I believe that they are. In the case of multiculturalism, for example, we have seen a series of potential conflicts since the 1980s related to the illiberal and undemocratic practices of various ethnic groups. These have included demands to ban or censor various artistic productions, the use of intimidation to suppress dissent within a community, the customary use of violence against women or children, honour killings, gender discrimination in employment, female genital mutilation and coerced arranged marriages. In each case, the question has arisen of whether illiberal elements within particular communities would attempt to use the discourse and institutions of multiculturalism to defend these practices. Would traditionalists argue

that the *Multiculturalism Act* entitles them to maintain these practices, and would they seek funding under the multiculturalism program, or representation on multiculturalism advisory boards, in order to advocate for these practices? For example, would traditionalist leaders from East Africa sitting on hospital advisory boards demand that female genital mutilation be permitted in the hospital? Would patriarchal conservatives from South Asia sitting on police advisory boards demand that the police not investigate or prosecute cases of family violence, honour killings or coerced arranged marriages?

In all of these cases, illiberal forces have failed completely to gain a foothold in the multiculturalism silo. So far as I am aware, no agency, board or program established or funded under the multiculturalism policy has endorsed any of these practices. If patriarchal conservatives hoped to gain control over the institutions and funding programs created under the multiculturalism policy in Canada they have not succeeded. In one sense, this is what one would expect, given the intentions of the policy. Its underlying philosophy, explicitly stated in the 1971 statement and the 1988 Act, is one of human rights and civil rights liberalism, and the policy is only intended to support organizations and activities that will advance that agenda.[30] However, our concern here is not with intentions, but with (potentially unintended) outcomes. In particular, why haven't illiberal elements been able to capture the infrastructure of multiculturalism? The answer, I think, is that the three safeguard strategies I mentioned earlier work reasonably well in Canada.

First, the processes of civic education and political socialization in Canada work to diffuse and reproduce basic liberal-democratic values. There is, in fact, a remarkably high degree of consensus across ethnic, religious and linguistic lines on human rights norms, and we seem to do a reasonably good job in integrating newcomers into this consensus. The political values of immigrants converge with those of native-born Canadians over time, and the convergence is complete by the second generation. In this sense, it seems there are good grounds for the so-called liberal expectation — that is, the assumption that ethnocultural minorities will come to embrace the basic values and principles of liberal democracy.[31] As a result, there is relatively little support for illiberal forces within most ethnic communities.

Second, because of this political culture, insofar as illiberal forces have attempted to capture the infrastructure of multiculturalism, it is usually possible to stop them in their tracks simply through public exposure. Once it has become

publicly known that a group or organization is seeking to use multiculturalism in a way that could subvert its liberal intentions, there has been widespread public opposition, increased vigilance by public officials and ultimately a retreat by illiberal forces.[32] So long as we have robust mechanisms of public exposure (for example, firm protections of freedom of speech, a free media, accountability rules for publicly funded agencies and institutions), this is likely to be the outcome.

Third, even if these first two safeguards were to fail and illiberal forces gained control over some part of the multiculturalism silo, any attempt to use this control to give legal protection to illiberal practices would quickly be struck down by the courts (or by human rights commissions).[33] The courts represent the final line of defence against abuses of public policy, and since the adoption of the Charter in 1982, the courts have established a clear and consistent record of upholding human rights. As I've repeatedly emphasized, the multiculturalism silo is embedded within, and subordinate to, the Charter, and in the unlikely event that patriarchal conservatives managed to take political control over parts of the silo, they would still be blocked by the ability of citizens to seek judicial protection of their rights.

In short, the familiar strategies that have been developed over many years to safeguard liberal democracy more generally seem to be working in this field too.[34] The same story can be told about the Quebec and Aboriginal silos. The development of a human rights culture, combined with robust mechanisms of public exposure and legal safeguards, have ensured that the interpretation and implementation of diversity policies remain within liberal channels.[35] In fact, the Québécois are now more liberal than English Canadians on issues such as gender equality and gay rights (Grabb and Curtis 2005). They may seek greater autonomy in order to build and sustain a distinct society, but the distinct society they wish to build is, if anything, more liberal than that of the larger Canadian society.

Equality

Let's turn now to the second question: Have the three sets of diversity policies succeeded in reducing inherited racial and ethnic hierarchies? This may have been the intended result, but has it occurred in practice? Critics have expressed skepticism. Some have argued that whatever the policy-makers' intentions, diversity policies have, at best, no effect on ethnic and racial hierarchies and simply paper over their enduring reality; at worst, they actually reinforce these

hierarchies by further stigmatizing the Other as different, dependent and needy (see, for example, Das Gupta 1999). Others argue that diversity policies may indeed remedy some inequalities, but in ways that are under- and over-inclusive, creating new and equally arbitrary hierarchies in the process.

It is difficult to evaluate these criticisms, in part because we have no clear or agreed-upon metric for measuring equality. Equality is a multidimensional concept: it has economic, political and cultural dimensions. Nonetheless, I think we are in a position to make some preliminary judgments about the success of the three diversity silos in reducing inequalities.

The case is clearest, I think, regarding the French Canadian silo — at least with respect to the 80 percent of Canada's francophones who live in Quebec. Since the mid-1960s, francophone Quebecers have achieved a dramatic equal-ization with English Canadians in all dimensions, whether measured in terms of economic opportunities and standard of living, or in terms of effective political representation and voice, or in terms of the public status of language and culture. The historic patterns of economic disadvantage, political subordination and cul-tural marginalization have essentially disappeared. And both dimensions of this diversity silo — that is, federal bilingualism and provincial autonomy — have been central to this process. Indeed, we have reached the point where even some commentators who are sympathetic to Quebec nationalism have started to ask whether we have overcompensated for these historic inequalities, particularly in relation to political representation.[36]

The situation with respect to francophones outside Quebec is more com-plicated. Here too there have been important improvements in terms of access to public services, control over community institutions (such as the right to govern French-language schools), enhanced employment opportunities in the federal civil service, and the public affirmation of French as a defining characteristic of Canada from sea to sea. All of these changes have helped to reduce pressures for linguistic assimilation. However, the long-term future of francophone communities outside Quebec remains unclear. For example, the linguistic retention rate continues to decline in many of these communities. According to the 2001 Census, only 63 percent of people outside Quebec whose mother tongue is French actually use French most often at home (down from 73 percent in 1971), and only 74 percent pass on French as a mother tongue to their children. The Acadian community in New Brunswick is an exception — its territorial concentration and electoral

strength in the province protect it from assimilation. But the numbers in other provinces are alarming; for example, only 25 percent of francophones in Saskatchewan maintain the language (Landry 2005).

Much has been written about the difficulties facing francophone minorities outside Quebec and what can be done to resolve them. But it is worth noting that the tendency for linguistic minorities to survive where they are territorially concentrated, and to assimilate where they are territorially dispersed, is a global one. This linguistic "territorial imperative" is rooted in many sociological and economic factors, and while it can be lessened by pro-minority public policies, it is not easy to fully counteract. In fact, efforts undertaken by the federal government to enhance the linguistic retention rates of francophones outside Quebec are among the most advanced in the world. They include not only funding for minority language schools, services and community organizations, but also (since the passing of the *Immigration and Refugee Protection Act, 2001*) an explicit commitment to use immigration as a tool for strengthening francophone minority communities outside Quebec (Quell 2002). That is, the federal government is committed not only to encouraging native-born francophones to retain their language, but also to recruiting immigrants who would be able and willing to integrate into francophone communities. I am not aware of any comparable policy in other countries.

Under these circumstances, one could argue that federal policies have enhanced the opportunities and status of francophones outside and inside Quebec, although they have not equalized the prospects for long-term ethnolinguistic retention and perhaps cannot do so. There are limits to the ability of government policies to counteract the territorialization of linguistic communities, and while there is more that can and should be done in Canada to assist francophone minorities, the required initiatives often fall under provincial rather than federal jurisdiction.[37]

The Aboriginal silo is more complicated to assess. The package of land claims and self-government agreements has certainly enhanced the political voice and representation of some Aboriginal communities — particularly status Indians with treaties, and the Inuit. And these agreements have also enabled many communities to take the important, if limited steps toward economic improvement and cultural renewal. But the progress of land claims and self-government agreements has been very slow and uneven, particularly in British Columbia. And there are doubts about

whether the kinds of self-governing entities currently being created are capable of providing effective governance and economic opportunities. Many of them are too small and/or remote to provide the services and opportunities needed.

Moreover, this silo is arguably underinclusive, unresponsive to the needs of Aboriginal groups that do not fit the inherited bureaucratic categories and assumptions of the *Indian Act*, such as nonstatus Indians, the Métis and urban Aboriginal people. These groups have suffered just as much from colonialism, but in many respects they fall between the cracks of the Aboriginal diversity silo.[38] One possible response to both of these problems is aggregation: exercising some Aboriginal self-governing powers at a regional or provincial level rather than at a band level (Institute on Governance 2000). This would not only create larger and more viable units of self-government but also make it easier to incorporate off-reserve populations. This is a promising idea, but at the moment it is largely untested.[39]

The immigrant/ethnic silo also has its complexities. It has clearly helped many disadvantaged groups achieve greater equality. It helped remove the glass ceilings and cultural stigmatization affecting the White ethnics who originally demanded the policy in the 1960s, and it has also proven helpful to the newer, non-White immigrant communities whose needs have been the policy's focus since the mid-1970s. There is strong evidence, for example, that the policy has helped to improve the political integration of newcomers to Canada, unlike the more laissez-faire approaches of the United States and Continental Europe.[40] And the fact that Canadians exhibit higher levels of comfort with ethnic diversity and less fear of immigration compared to the citizens of virtually all other Western democracies is likely due, in part, to the policy framework.

However, one could also argue that the policy framework is insufficiently sensitive to the widely varying conditions of different immigrant groups. It may be overinclusive, providing significant benefits to those who are not actually disadvantaged. The most obvious example of this is affirmative action, which extends preferential treatment to all visible minorities — including, for instance, Hong Kong Chinese immigrants who have above-average levels of education, income and wealth. Not only are they not in need of this benefit, but because they already have high levels of human capital they are also better able to take advantage of the benefit, leaving fewer opportunities for truly disadvantaged groups, such as Jamaican Canadians. This is a familiar problem: the people most able to take advantage of newly created opportunities are often those who need them the least.[41]

More generally, the immigration/ethnic silo was built on the assumption that the category of visible minority is coextensive with the category of disadvantaged, stigmatized, discriminated-against or excluded. There are good historical reasons for this association, but I think we need to ask whether it is still valid today. We may need more precise categories that do a better job of tracking the patterns of prejudice, discrimination and disadvantage in society. We need to recognize that anti-Black racism, for example, is qualitatively different from prejudice against other racial groups,[42] and that Islamophobia is qualitatively different from prejudice against other minority religions. Put another way, we need to pay more attention to the potential for increasing inequalities between different visible minorities as well as inequalities between visible minorities in general and White Canadians.[43]

In short, we have unfinished business with respect to equality for all groups, and further progress may require rethinking some of the categories used in these diversity silos.

Sustainability

Finally, let me turn to the third question, which relates to long-term sustainability. I've argued that Canada's diversity policies reflect in part a progressive commitment to reducing inherited ethnic and racial hierarchies. As such, they depend on a sense of pan-ethnic solidarity and responsibility, which in turn depends on some sense of community and shared citizenship. And this raises the question: Are we doing enough to sustain these feelings of solidarity? Indeed, is it possible that diversity policies, by emphasizing our differences, are undermining the feelings of shared citizenship that generated them in the first place?

These are immensely complicated questions, and I can only gesture at an answer here. We first need to clarify what we mean by "feelings of shared citizenship." This goes beyond the sharing of citizenship in the formal legal sense (that is, a common passport) to include such things as: feelings of solidarity with co-citizens, and hence a willingness to listen to their claims, to respect their rights and to make sacrifices for them; feelings of trust in public institutions, and hence a willingness to comply with them (pay taxes, cooperate with police); feelings of democratic responsibility, and hence a willingness to monitor the behaviour of the political elites who act in our name and hold them accountable; and feelings of belonging to a community of fate (that is, of sharing a political community).

Successful diversity policies, and indeed progressive social policies of any sort, depend on developing and maintaining a sufficient level of these feelings among citizens. It is important, therefore, to ask what strategies are available for sustaining these feelings and whether our diversity policies are consistent with them. In many Western democracies, a single basic strategy for encouraging feelings of shared citizenship has been adopted — namely, nation-building. These democracies have essentially nationalized political life. They have created a common national system of mass compulsory public education and used it to inculcate a common national language, identity and loyalty; created a national public sphere centred on national radio and television networks that have the mandate of nurturing a national conversation in the national language; created a common national legal system to replace forms of legal pluralism; created a common national welfare state — and so on. Such nationalizing policies were intended to ensure that all citizens, wherever they live, would have certain identical experiences and expectations of national citizenship, and that these would be the source of feelings of solidarity, trust, democratic responsibility and community of fate.

This strategy was never possible in Canada, given our bilingual and federal structure. We cannot have a single monolingual public sphere, given our bilingualism commitments, and we cannot have a unitary national education system, welfare state or legal system, given the federal structure. We do, of course, employ fragments of the strategy — for example, a common army, flag, passport, currency, postage stamp and set of constitutional rights. Some commentators maintain that these fragments of the standard nation-building model must bear all the weight of promoting shared citizenship. Since we have few such identical citizenship experiences, we need to protect and promote them (for example, by distributing Canadian flags). The idea is to come as close as we can to the standard nation-building model, given our particular circumstances; but we are continually fearful that we can't come close enough.

In my view, this is not the right strategy for Canada, or for any multilingual federal country. These fragments of the standard nation-building model are too few, and they are not in fact experienced in identical ways by all Canadians. Given the bilingual structure of Canada, even pan-Canadian institutions like the CBC and the army are divided along linguistic lines. And given Canada's federal structure, even pan-Canadian constitutional rights reflect provincial idiosyncrasies (consider variation in access to abortion across Canada). In fact, efforts to promote

identical citizenship experience are as likely to be sources of political contestation as efforts to promote group-differentiated experience. As our history demonstrates, the assumption that promoting pan-Canadian institutions inevitably produces harmony and unity, whereas accommodating linguistic/regional diversity produces conflict and division, is generally false.

We need a different way of approaching this issue. If we assume that the only way to promote shared citizenship is to mimic as best we can the standard nation-building model, we are painting ourselves into a corner, blinding ourselves to other possible strategies and condemning ourselves to a state of permanent frustration. What are the alternate strategies available to a multilingual federal state? The experience of other countries suggests a few possibilities, although they are not necessarily applicable to Canada. In the case of Switzerland, for example, a key factor in producing a sense of common citizenship was the threat of war and a shared fear of external enemies — that is, a sense of shared citizenship was built by focusing on a common foe. This may have occurred in Canada, as well — for example, vis-à-vis the US in 1867 — but it is unlikely to occur in the foreseeable future, since we have no neighbouring enemies. In the case of other multilingual federations, like Belgium and Spain, some commentators have argued that the monarchy has played a unifying role. But that is a nonstarter in Canada, no matter how politically astute the choice of governor general. So the experiences of other multilingual federations do not offer any clear formula for addressing this issue.

My suggestion would be to rephrase the question, or at least to change the baseline from which we ask it. I believe that well-functioning liberal-democratic institutions tend to generate their own bases of support. If public institutions are trustworthy, people will trust them. If public institutions coordinate fair schemes of social cooperation, then people will feel a sense of obligation to other participants. If mechanisms for democratic accountability exist, then political leaders who claim to speak in the name of the people will be held accountable by the people. If public institutions provide an effective forum for deliberating and addressing pressing issues, then people will come to view those institutions as the locus of collective agency and so come to feel a sense of common fate with other citizens. In short, well-functioning liberal-democratic institutions have a gravitational pull. History suggests that this pull exerts force not only on the ethnic/national group that initially established those institutions, but also on their descendants,

who are socialized into them, and to immigrants, who often emigrate to a liberal democracy precisely because they want to live in a country with well-functioning public institutions. Immigrants didn't leave unstable countries with dysfunctional public institutions in order to come and destabilize Canadian institutions.

So rather than asking what the instruments for promoting shared citizenship are, I would first ask what the factors are that prevent or weaken this gravitational pull, thereby eroding feelings of shared citizenship in Canada, and what we can do about them. To discuss strategies for promoting shared citizenship without making a specific assessment of the threats to shared citizenship pushes us toward centralizing, homogenizing nation-building policies, and these are a dead end in Canada. Instead we need to ask what the specific factors are that inhibit the everyday gravitational pull by which liberal-democratic institutions generate feelings of solidarity, trust, democratic responsibility and common fate.

Let me mention three such factors that are relevant in the Canadian context. First, while well-functioning liberal-democratic institutions typically exert a strong gravitational pull on the historically dominant group and its descendants (for whom these institutions were initially designed) and on voluntary immigrants, the pull is weaker for conquered and colonized groups. They may view these public institutions as external impositions, part and parcel of an ongoing historic injustice. To uncritically assume that such groups are part of a single community of fate is tantamount to uncritically accepting the legitimacy of that initial act of conquest or colonization. Building a sense of common fate between settlers and indigenous peoples, or between conquerors and conquered, requires its own specific strategy, one that involves turning historic relations of force into relations built on consent. This will not happen spontaneously — it requires acknowledgment of the historically incorporated group as a collective political actor and constituent partner in restructuring the state. This is the principle underpinning theories of multination federalism or of treaty relationships.

These models of multination federalism and treaty relationships are often seen as an obstacle to building shared citizenship, and indeed they drastically reduce the scope for standard nation-building strategies. But to describe this as a conflict between diversity strategies and shared citizenship is misleading: these diversity policies are intended to address the fact that there was no sense of shared citizenship between colonized and colonizer, or between conqueror and conquered.

It is important to note that even when models of multination federalism and treaty relations are implemented, they do not necessarily succeed in building a secure sense of shared fate, as witnessed by high levels of distrust among Aboriginal Canadians and support for secession among francophone Quebecers.[44] The sorts of diversity policies needed to overcome a history of colonization or conquest typically consolidate a sense of nationhood among historic minorities, and states containing such "nations within" are inherently more fragile than mononational states. This remains the most important challenge facing Canada's diversity policies, and there is no magic formula for meeting it. It is a challenge confronting many Western multination federations — think of secessionist movements in Scotland, Catalonia and Flanders — and multination states around the world.

The second factor that erodes feelings of shared citizenship in Canada is that while most immigrants have historically felt the gravitational pull of liberal-democratic institutions — they often express higher levels of commitment than native-born Canadians to paying taxes, learning an official language, voting, informing themselves about political affairs, obeying the law and so on[45] — there can be localized difficulties in generating feelings of trust and solidarity, particularly where immigrants face racism or religious prejudice. When public debate over the welfare state becomes racialized, solidarity is threatened. When public debate over crime becomes racialized, relations with the police and courts are polarized, and some groups start to see the police and courts as agents of oppression, not as upholders of their rights. When a particular religious group is perceived as a security threat, state agencies are likely to have antagonistic relations with that group. All of these are examples of how the normal gravitational pull of liberal-democratic institutions can fail as ethnic relations become polarized around issues of poverty, crime and national security.

A wide range of policies may be needed to prevent the racialization of poverty and crime or the stigmatization of a particular religious group. These include affirmative action, hate-speech legislation, antiracism campaigns, funding of ethnic organizations, multicultural education reforms — in short, many of the policies that are currently found in the immigrant/ethnic diversity silo. Here, again, although these policies are sometimes said to be an obstacle to shared citizenship, they are in fact an attempt to overcome an existing obstacle to shared citizenship.

In addition to these group-specific obstacles to feelings of shared citizenship, a third factor involves more generalized dynamics that may also diminish the sense of solidarity, trust, democratic responsibility and common fate. There may, for example, be a general decline in trust of public institutions, or in the feeling among citizens that they are able to ensure the democratic accountability of political elites. Indeed, there appears to be a problem with declining trust, solidarity, participation and civility across the Western democracies (Putnam and Pharr 2000).

Why are these trends occurring? The answer, I suspect, is not that well-functioning liberal-democratic institutions are losing their gravitational pull, but rather that our institutions simply aren't functioning as well as they used to. For example, money may be corrupting the political process, such that paid lobbyists are displacing democratic input into the policy process. If so, feelings of democratic responsibility are likely to diminish. Or public institutions may be unable to effectively fulfill their mandates due to several years of budget cuts, creating perceptions of arbitrariness or incompetence in the provision of public services. If so, trust in public institutions is likely to diminish.

There are many proposals in the literature for rebuilding feelings of shared citizenship. They include developing new forms of enhancing effective and deliberative public participation (for example, e-democracy, citizens' juries, citizen initiatives and referenda);[46] or developing new forms of citizenship education and citizenship ceremonies that highlight liberal-democratic values and virtues; or embarking on new flagship programs that can be a source of common pride (for example, space missions or Canada Corps); or strengthening public information and accountability requirements to make government less opaque; as well as a more general reinvestment in the institutions of government and civil society.

There is little consensus on the likely effect of these proposed policies on trust, solidarity, civility and participation. However, the key point, from my perspective, is that none of them is inconsistent with any of the three diversity silos in Canada. On the contrary, we have reason to believe that the more active in, and informed about, political life Canadians become, and the more they listen with civility to each other and internalize liberal-democratic values, the more likely they are to endorse the basic principles of our diversity policies.[47] Put another way, insofar as there is a generalized decline in feelings of solidarity, public trust and participation, there is no evidence that this is due to, or exacerbated by,

Canada's diversity policies. There is, in fact, fragmentary evidence that the problem is more acute in countries that have weaker diversity policies (Banting and Kymlicka 2006). And the most plausible and commonly proposed remedies to the problem of declining trust and solidarity are not inconsistent with the main contours of Canada's diversity policies.

In short, there are serious issues related to long-term sustainability: weak feelings of shared fate among Canada's nations within; the danger of racial and religious polarization; and a generalized decline in feelings of solidarity, trust and civility. We need to think long and hard about how to promote shared citizenship in light of these three challenges. But in doing so, we must make sure we are asking the right questions. In particular, it is important for us to contextualize debates about shared citizenship. The goal shouldn't be to promote shared citizenship in the abstract, since this pushes us in the direction of the standard centralizing and homogenizing model of shared citizenship that cannot work in Canada. Instead, we need to identify specific factors that are reducing feelings of shared citizenship, and we must view these factors as challenges or obstacles to the normal gravitational pull of well-functioning liberal-democratic institutions. Under what conditions does this gravitational pull weaken, for which groups, in relation to which aspects of shared citizenship? Once we have identified the specific challenges, we can then think of appropriate instruments for dealing with them. And these will often include diversity policies, along with many other reforms, ranging from labour market policies to antidiscrimination strategies to reinvestment in public services to democratic reforms (and perhaps even flag distribution).

Once we contextualize questions of shared citizenship in this way, it becomes clear that there is no inherent trade-off between diversity policies and shared citizenship policies. In none of these cases is it plausible to argue that diversity policies are the source of the problem, and in many cases they are part of the solution. In fact, it is a mistake even to attempt to distinguish diversity policies from shared citizenship policies as if they belonged to different categories. As I noted earlier, diversity policies are themselves policies of citizenization — turning a historical welter of uncivil relations among ethnic groups into relations of democratic citizenship. As such, promoting diversity policies and promoting democratic citizenship are not competing projects, but rather they stand or fall together.

Conclusion

THIS OVERVIEW OF CANADA'S THREE SETS OF DIVERSITY POLICIES PRESENTS A VARIED picture. The policies have been inspired by legitimate liberal-democratic goals, but they have had mixed success in practice. They have largely operated within liberal parameters, but they remain in danger of misuse by illiberal and undemocratic forces. They have helped reduce some inherited inequalities, but in under- and overinclusive ways, and the benefits have often been reaped by those who were not most in need. The categories and classifications used to identify beneficiaries are crude and out of date and trapped in bureaucratic inertia. And they presuppose a level of trust, solidarity and civility that may be eroding.

Different observers are likely to come to different conclusions about how serious these problems are, or how difficult they may be to remedy. Some will view the glass as half full; others will see it as half empty. However, what strikes me about the problems I've just mentioned is that they are not unique to diversity policies; they are endemic to public policy in general. Everything I have just said — about the dangers of illiberalism, the over- and underinclusiveness of target categories, the tendency for policies aimed at the needy to help those least in need, the tendency to bureaucratic inertia — could be said about every area of social policy in Canada. These are the systemic limitations of public policy in a liberal democracy.

And this brings me back full circle to the start of this chapter. The politics and policies of ethnocultural diversity in Canada today are simply part and parcel of liberal-democratic politics generally — no different in character from any other field of democratic politics. They are inspired by the same overarching principles and subject to the same systemic distortions. And that, in itself, is no small accomplishment, given the illiberal and undemocratic character of ethnic relations in our history, and in much of the world.

Notes

1 For the palimpsest image, see Green (2005). There are no universally accepted terms to designate these types of ethnocultural groups. For the purposes of this paper, I am distinguishing between ethnocultural groups whose roots in Canada predate European colonization (Aboriginal peoples); ethnocultural groups rooted in projects of European colonizing settlement (French and British); and ethnocultural groups that have emerged in Canada as a result of immigration. In Canadian public discourse, the term "ethnic groups" is often reserved for the latter category, although all of them qualify as "ethnic" groups as that term is defined by most academic social scientists. It would be more accurate, therefore, to describe this third category as "ethnic groups formed through immigration." As shorthand, I will often use the term "immigrant/ethnic group," although it's important to emphasize that many members of these groups may be second-, third- or fourth-generation descendants of the original immigrants. It is also worth noting that these groups are rarely if ever called "foreigners," even in the first generation, since they have quick access to citizenship (after three years), and most immigrants naturalize. So immigrants in Canada are seen as citizens — or, at least, as citizens-to-be — not foreigners.

2 See the 2001 Census figures at http://www12.statcan.ca/english/census01/products/highlight/Ethnicity/Index.cfm?Lang=E; a more detailed breakdown of ethnic origins was done as part of the 2002 Ethnic Diversity Survey, available at http://www.statcan.ca/bsolc/english/bsolc?catno=89-593-X

3 This is often called the "Anglo conformity" model of immigration. Historically, only a relatively small number of immigrants integrated into Quebec's French-speaking society, and prior to the 1970s, immigration was not seen as a tool of nation-building in Quebec the way it was in English Canada.

4 These goals are quoted from Prime Minister Trudeau's 1971 statement to the Canadian Parliament in which he declared the multiculturalism policy.

5 When people talk about the "retreat from multiculturalism" in the Netherlands, they often cite the decision to shift funding away from monoethnic organizations to multiethnic ones that promote cultural interchange and political cooperation across ethnic lines. This shift had already taken place in Canada by the late 1970s, but in Canada it has been understood as an evolution guided by the original goals of multiculturalism, not as a retreat from them.

6 For historical overviews of the origins of the multiculturalism policy, see Jaworsky (1979); Pal (1993); Blanshay (2001); and Day (2000). For the 25-year review, see Canadian Heritage (1996), and commentary in Kordan (1997).

7 For a detailed analysis of the types of projects and organizations that have received funding under the multiculturalism directorate, see McAndrew, Helly and Tessier (2005).

8 See Bloemraad (2002) and Kymlicka (2003) for a discussion of the linkage between multiculturalism and citizenship policies in Canada.

9 See Jaworsky (1979) on the reluctance of the CBC and CRTC to adopt multiculturalism reforms.

10 For the latest annual report, see Canadian Heritage (2004); for doubts about the effectiveness of this reporting mechanism, see Kordan (1997).

11 Its main impact has been to buttress the legitimacy of certain laws that probably would have been upheld anyway. For example, the Canadian Supreme Court upheld a law prohibiting hate speech on the grounds that this was a "reasonable limitation" on freedom of speech. It cited section 27 in support of the idea that this law

was a reasonable limitation (*R. v. Keegstra*, [1990] 3 SCR 697). However, most experts agree that the courts would have come to the same decision, even in the absence of the multiculturalism clause, as have most other Western democracies (Elman 1993). Section 27 has also been invoked in defence of the idea that hate-motivated crimes should receive stiffer punishment (Shaffer 1995).

12 This was often a deliberate misinterpretation of the treaties, which were explicitly formulated as determining permanent rights and relationships, not temporary protections ("for as long as the sun shines and the rivers flow," and so on).

13 *Calder v. Attorney General of British Columbia*, [1973] 1 SCR 313. As John Borrows puts it, this decision invited Canadians to "seriously contemplate the possibility that Aboriginal peoples would be a permanent part of the political and legal landscape" (Borrows 2001, 18).

14 The assimilationist approach of the Royal Proclamation of 1763 lasted about a decade, until it was abandoned in the *Quebec Act, 1774*; the assimilationist goals of the *Act of Union, 1841* were abandoned even more quickly, replaced by consociational power-sharing and bilingualism in the legislature, put in place by the late 1840s.

15 The text accompanying this agreement talks about "asymmetrical federalism that respects Quebec's jurisdiction," and about "flexible federalism that notably allows for the existence of special agreements and arrangements adapted to Quebec's specificity." For the debate generated by these "asymmetrical" agreements, see the 2005 Special Series on Asymmetric Federalism on the Web site of the Institute of Intergovernmental Relations, at http://www.iigr.ca/iigr.php/site/browse_publications?section=43

16 It's difficult to set a clear terminus for the consolidation of this third silo. Bilingualism was in place by 1969, but it's more difficult to say when the federal government committed itself to a policy of negotiating Quebec's claims for greater provincial autonomy. The 1964 pension agreement set the precedent, and greater autonomy was part of the negotiations around the (failed) Victoria Charter in 1971. However, it was perhaps only after the election of the first PQ government, in 1976, that it became a clear commitment of the federal government (witness, for example, the immigration agreement of 1977).

17 It did so most spectacularly in its twin Marshall decisions. See *R. v. Marshall*, [1999] 3 SCR 456, which was seen as articulating a very broad understanding of Aboriginal treaty rights, and its hasty "clarification" in *R. v. Marshall*, [1999] 3 SCR 533, which limited those rights. While the Supreme Court's interpretations of Aboriginal rights have clearly expanded since the early 1970s, the court has also been accused of unduly narrowing these rights by requiring evidence of essential continuity with precontact indigenous communities, practices and territories. Given the inevitable disruptions, displacements and adaptations entailed (or "caused") by European colonization, this test makes it difficult for many Aboriginal communities to assert Aboriginal rights in ways that address their current needs and situation.

18 Matthew Coon Come has stated that the proposed *First Nations Governance Act*, introduced by Indian Affairs Minister Robert Nault in 2002, reflected a "neo-colonial, assimilationist and extinguishment agenda" (2003, 72). This is an understandable reaction to Nault's reforms (now withdrawn), which emerged from a deeply flawed consultation procedure, and to the fact that the archaic *Indian Act* still permits such defective processes of unilaterally amending self-government policies. But, notwithstanding their inadequacy, Nault's proposals were not an attempt to return to

the White Paper; they were premised on the recognition that Aboriginal governments are a permanent fixture of the political and legal landscape.

19 This continuity in the basic direction of federal policy from 1975 to 2005 is especially remarkable when one considers that it spans both Liberal and Conservative governments, both majority and minority governments, both economic boom times and economic recessions.

20 Trudeau is sometimes seen as an advocate of multiculturalism, since it was he who introduced the policy in the House of Commons in 1971. However, that was the last time he gave a public talk on multiculturalism, and he showed no interest in the policy afterwards.

21 I develop this argument in more depth in Kymlicka (forthcoming).

22 According to Finkielkraut, the first two stages were "conceived under the implicit patronage of Diderot, Condorcet or Voltaire," whereas the third stage is driven by the chauvinistic and relativistic thinking of Herder and Spengler (1988, 54, 64).

23 Adams subdivides this group into "traditionalists" and "Darwinists"; both share the fear that liberal reforms are undermining the social order, and both cite diversity policies among these destabilizing liberal reforms.

24 The Act is reprinted as an appendix in Kymlicka (1998).

25 For more on this distinction, see Kymlicka (1998, chap. 4).

26 The case of Quebec's language policy may seem an exception to this generalization. Critics argue that by limiting the choice of parents regarding the language of their children's public school education, Bill 101 restricted a basic liberal freedom in the name of cultural preservation, and thereby qualifies as an illiberal internal restriction. However, it is not clear that liberal principles require that parents be permitted to choose the language of their children's public school education. In fact, neither liberal political philosophy nor international human rights standards imply that parents have a right to make such a choice, and most liberal democracies do not offer it. In that sense, the scope for choice under Bill 101 is comparable to that available to the citizens of most Western democracies, and the Supreme Court of Canada has rightly concluded that it meets international human rights standards. For a good discussion, see Carens (1995).

27 The liberal foundations of diversity policies have been criticized not only by cultural conservatives, but also by some radical or postcolonial critics (for example, Day 2000; Dossa 2002, 2005).

28 For a discussion of White backlash against multiculturalism in the British case with comparisons to Canada, see Hewitt (2005) and the chapter by Randall Hansen in this volume.

29 This distinguishes diversity policies in Canada from other forms of multiculturalism that aren't historically tied to ideas and relationships of democratic citizenship — for example, the Ottoman millet system. Critics have suggested that the Dutch model of multiculturalism, while creating patronage relations between the state and various minorities, did not seek to develop relations or practices of democratic citizenship. For a discussion of the Dutch model and the way it has been criticized for neglecting citizenship, see Christian Joppke's chapter in this volume.

30 This helps explain Bloemraad's finding that multiculturalism in Canada has nurtured the development of a more gender-balanced and representative elite within ethnic communities than is found in the United States (2006).

31 For evidence regarding political attitudes within minority communities generally, see Frideres (1997), Ungerleider (1991) and the chapter by Stuart Soroka, Richard Johnston and Keith Banting in this volume.

For a discussion of minority elites, see Howard-Hassman (2003), who emphasizes the way support for multiculturalism among majority and minority elites is connected to broader ideals of human rights. It may have helped, in this regard, that multiculturalism in Canada was initially demanded by, and designed for, long-settled White ethnics (especially Ukrainians), whose liberal credentials were not in doubt. They had served loyally in the Second World War, were staunchly anticommunist during the Cold War and were generally seen as fully integrated into the liberal-democratic consensus at the time when their claims for multiculturalism were first advanced. Subsequent waves of immigrants have therefore inherited a discourse and practice of multiculturalism that are deeply liberal and that offer no encouragement for making illiberal claims. For discussion of the role of White ethnic groups in mobilizing for multiculturalism in the context of (and in response to) the Royal Commission on Bilingualism and Biculturalism and its implications for the policy that was ultimately adopted, see Kymlicka (2004).

32 The recent *sharia* debate in Ontario is an example of this. The public exposure of potential abuses in the name of multiculturalism led to widespread public opposition and a renewed commitment to ensure that norms of freedom and equality are respected. However, I should emphasize that the adoption in Ontario of the *Arbitration Act, 1991*, which created legal space for religious family law tribunals, had nothing to do with the multiculturalism policy and did not emerge from the multiculturalism silo. The establishment of religious family law tribunals was not recommended or funded by the multiculturalism program. While the program has funded many institutional innovations and pilot projects relating to the accommodation of ethnocultural and religious diversity,

this was not one of them. There was no institutional, financial or legal connection between the *Arbitration Act* and the multiculturalism policy. Indeed, had the Ontario government asked for the assistance of the multiculturalism program in drafting the relevant provisions of the Act, the result almost certainly would have been different (or so I argue in Kymlicka 2005). So, while it is not an example of illiberal forces attempting to capture the infrastructure of the diversity silo, the mechanism of public exposure is similar.

33 For the case of female genital mutilation, see Hussein and Shermarke (1995); and Ontario Human Rights Commission (1996).

34 This doesn't mean that various illiberal practices, such as female genital mutilation (FGM) or coerced arranged marriages, don't occur in individual families, hidden from public view, sometimes with the encouragement of conservative community leaders (Azmi 1999; Levine 1999). And this, too, reflects another long-standing and systemic dilemma of liberal democracy — namely, the difficulty in a free and democratic society of protecting vulnerable individuals from family members. This is a structural weakness of liberal democracies, and it exists regardless of whether a country adopts multiculturalism policies. It exists, for example, in Britain with respect to coerced marriages (Phillips and Dustin 2004), and in France with respect to FGM, despite the latter's strident opposition to multiculturalism (Dembour 2001). However, as I noted earlier, any attempt to use the multiculturalism policy to shield such practices, or to inhibit police investigation or prosecution, has failed in Canada. On the contrary, the liberalized form of multiculturalism that is enshrined in public policies clearly delegitimizes these practices and marginalizes any community authorities who publicly support them, and this will shape private attitudes and practices as well.

35 Some Aboriginal leaders have argued that imposing the Charter on Aboriginal governments without their consent is inconsistent with their inherent right to self-determination. There are indeed powerful legal arguments for this position, but these jurisprudential arguments do not necessarily reflect deep disagreement over political values. See Tim Schouls's account of the depth of liberal rights consciousness within Aboriginal communities and the growing expectation among Aboriginal peoples that their leaders respect these values, enforced either through the Charter or some functionally equivalent rights-protecting mechanism (2003, 93, 100-5, 167-71).

36 See Resnick (1994) on the "West Lothian" question (as the British call it in the context of Scottish devolution). If Quebec achieves asymmetric provincial autonomy, should it give up some of its voice at the federal level in return?

37 For example, the federal government has long encouraged various provinces to declare themselves officially bilingual — without success, apart from New Brunswick. At a more practical level, advocates have argued that provincial preschool, early-childhood services should be provided in French. This is not covered by constitutional minority language education rights, and so it falls under the discretion of provincial governments (Landry 2005).

38 On the urban Aboriginal population, see the chapter by Evelyn Peters in this volume.

39 The "made in Saskatchewan" model discussed in the chapter by Joyce Green and Ian Peach moves in this direction.

40 See Irene Bloemraad's fascinating comparison of the integration of Vietnamese and Portuguese immigrants in Canada and the United States (2006). Despite having similar socioeconomic and cultural profiles upon arriving in the two countries, the immigrants' subsequent trajectories differ significantly in terms of levels of political participation and feelings of inclusion.

Bloemraad argues that this is due, at least in part, to the multiculturalism policy.

41 For example, middle-class Canadians make more use of the health care system than lower-class Canadians, despite the fact that they typically have better health to begin with. (In India, this is called the problem of the "creamy layer" — the more advantaged skim off the cream intended for the genuinely needy.)

42 On the specificity of anti-Black racism, see Henry (1994) and the conclusions of the Commission on Systemic Racism in the Ontario Criminal Justice System (1995). There is an argument to be made for distinguishing Blacks as a separate category in the employment equity program, as was initially proposed in the Abella Report (Abella 1984), which recommended employment equity.

43 I am here disagreeing in part with the analysis in Daniel Salée's chapter, which treats the White/non-White distinction as the singular foundational source of inequality and hierarchy. While there is indeed evidence that all visible minorities suffer an ethnic penalty, the severity of this penalty and the extent to which it is passed on to subsequent generations vary.

44 See the data cited in the Stuart Soroka, Richard Johnston and Keith Banting chapter.

45 See the data cited in the Stuart Soroka, Richard Johnston and Keith Banting chapter and in the Paul Howe chapter.

46 This has been the focus of Matthew Mendelsohn's work, first as an academic (Mendelsohn and Parkin 2001), and now as deputy minister for democratic renewal for the province of Ontario.

47 Recall, for example, the citizens' juries for the Charlottetown Accord. When average citizens had an opportunity to sit down and discuss the federal government's proposals for the Accord, with access to the relevant information and expertise, support for the diversity-related clauses increased substantially.

References

Abella, R.S. 1984. *Report of the Commission on Equality in Employment*. Ottawa: Supply and Services Canada.

Abu-Laban, Yasmeen, and Christina Gabriel. 2002. *Selling Diversity: Immigration, Multiculturalism, Employment Equity and Globalization*. Peterborough, ON: Broadview Press.

Adams, Michael. 1997. *Sex in the Snow*. Toronto: Penguin Canada.

———. 2000. *Better Happy than Rich?* Toronto: Penguin Canada.

Armitage, Andrew. 1995. *Comparing the Policy of Aboriginal Assimilation: Australia, Canada, New Zealand*. Vancouver: University of British Columbia Press.

Azmi, Shaheen. 1999. "Wife Abuse and Ideological Competition in the Muslim Community of Toronto." In *Ethnicity, Politics and Public Policy*, edited by Harold Troper and Morton Weinfeld, 164-89. Toronto: University of Toronto Press.

Banting, Keith, and Will Kymlicka, eds. 2006. *Multiculturalism and the Welfare State: Recognition and Redistribution in Contemporary Democracies*. Oxford: Oxford University Press.

Barry, Brian. 2001. *Culture and Equality: An Egalitarian Critique of Multiculturalism*. Cambridge: Polity Press.

Berger, Thomas. 1977. *Northern Frontier, Northern Homeland: Report of the Mackenzie Valley Pipeline Inquiry*. 2 vols. Ottawa: Minister of Supply and Services.

Blanshay, Linda. 2001. "The Nationalisation of Ethnicity: A Study of the Proliferation of National Mono-ethnocultural Umbrella Organisations in Canada." Ph.D diss., University of Glasgow.

Bloemraad, Irene. 2002. "The North American Naturalization Gap: An Institutional Approach to Citizenship Acquisition in the United States and Canada." *International Migration Review* 36 (1): 194-228.

———. 2006. *Becoming a Citizen: Incorporating Immigrants and Refugees in the United States and Canada*. Berkeley: University of California Press.

Borrows, John. 2001. "Uncertain Citizens: Aboriginal Peoples and the Supreme Court." *Canadian Bar Review* 80:15-41.

Cairns, Alan. 2000. *Citizens Plus: Aboriginal Peoples and the Canadian State*. Vancouver: University of British Columbia Press.

Canadian Heritage. 1996. *The Strategic Evaluation of Multiculturalism Progams* (Brighton Report). Ottawa: Canadian Heritage.

Canadian Heritage. 2004. *Annual Report on the Operation of the Canadian Multiculturalism Act, 2003-4*. Ottawa: Public Works and Government Services Canada. Accessed March 27, 2005. http://www.pch.gc.ca/progs/multi/reports/ann2003-2004/multi-ann-2003-2004_e.pdf

Carens, Joseph. 1995. "Immigration, Political Community and the Transformation of Identity: Quebec's Immigration Policies in a Critical Perspective." In *Is Quebec Nationalism Just?* edited by Joseph Carens, 20-81. Montreal: McGill-Queen's University Press.

Commission on Systemic Racism in the Ontario Criminal Justice System. 1995. *Racism behind Bars: The Treatment of Black and Other Racial Minority Prisoners in Ontario Prisons. Interim Report*. Toronto: Queen's Printer for Ontario.

Coon Come, Matthew. 2003. "Charlottetown and Aboriginal Rights: Delayed but Never Relinquished." *Policy Options* 24 (1): 70-2. Montreal: IRPP.

Das Gupta, Tania. 1999. "The Politics of Multiculturalism: 'Immigrant Women' and the Canadian State." In *Scratching the Surface: Canadian Anti-racist Feminist Thought*, ed. Enakshi Dua and Angela Robertson. Toronto: Women's Press.

Dasko, Donna. 2005. "Public Attitudes towards Multiculturalism and Bilingualism in Canada." In *Canadian and French Perspectives on Diversity: Conference Proceedings*, ed. Margaret Adsett, Caroline Mallandain, and Shannon Stettner, 119-25. Ottawa: Minister of Public Works and Government Services Canada.

Davies, Scott. 1999. "From Moral Duty to Cultural Rights: A Case Study of Political Framing in Education." *Sociology of Education* 72:1-21.

Day, Richard. 2000. *Multiculturalism and the History of Canadian Diversity*. Toronto: University of Toronto Press.

Dembour, Marie-Bénédicte. 2001. "Following the Movement of a Pendulum: Between Universalism and Relativism." In *Culture and Rights: Anthropological Perspectives*, edited by Jane K. Cowan, Marie-Bénédicte Dembour, and Richard E. Wilson, 56-79. Cambridge: Cambridge University Press.

Dossa, Shiraz. 2002. "Liberal Imperialism? Natives, Muslims and Others." *Political Theory* 30 (5): 738-45.

———. 2005. "Bad, Bad Multiculturalism!" *European Legacy* 10 (6): 641-4.

Elman, Bruce. 1993. "Her Majesty the Queen v. James Keegstra: The Control of Racism in Canada." In *Under the Shadow of Weimar: Democracy, Law and Racial Incitement in Six Countries*, edited by Louis Greenspan and Cyril Levitt, 149-76. Westport, CT: Praeger Publishers.

Finkielkraut, Alain. 1988. *The Undoing of Thought*. Trans. Dennis O'Keefe. London: Claridge Press.

Frideres, James. 1997. "Edging into the Mainstream: Immigrant Adults and Their Children." In *Comparative Perspectives on Interethnic Relations and Social Incorporation in Europe and North America*, edited by Wsevelod W. Isajiw, 537-62. Toronto: Canadian Scholars' Press.

Grabb, Edward , and James Curtis. 2005. *Regions Apart: The Four Societies of Canada and the United States*. Toronto: Oxford University Press.

Green, Joyce. 2005. "Self-Determination, Citizenship, and Federalism: Indigenous and Canadian Palimpsest." In *Reconfiguring Aboriginal-State Relations*, edited by Michael Murphy, 329-52. Kingston, ON: Institute for Intergovernmental Relations.

Henry, Frances. 1994. *The Caribbean Diaspora in Toronto: Learning to Live with Racism*. Toronto: University of Toronto Press.

Hewitt, Roger. 2005. *White Backlash and the Politics of Multiculturalism*. Cambridge: Cambridge University Press.

House of Commons. 1983. *Indian Self-Government in Canada: Report of the House of Commons Special Committee on Indian Self-Government* (Penner Report). Ottawa: Queen's Printer.

Howard-Hassman, Rhoda. 2003. *Compassionate Canadians: Civic Leaders Discuss Human Rights* Toronto: University of Toronto Press.

Hussein, Lula J., and Marian A.A. Shermarke. 1995. *Female Genital Mutilation: Report on Consultations Held in Ottawa and Montreal*. Research, Statistics and Evaluation Directorate; Civil Law and Corporate Management Sector WD1995-8e. Ottawa: Department of Justice.

Institute on Governance. 2000. *Governance Models to Achieve Higher Levels of Aggregation: Literature Review*. Accessed March 16, 2006. http://www.iog.ca/publications/ AggregationLiteratureReview.PDF

Jaworsky, John. 1979. "A Case Study of the Canadian Federal Government's Multiculturalism Policy." Master's thesis, Carleton University.

Kobayashi, Audrey. 2000. "Advocacy from the Margins: The Role of Minority Ethnocultural Associations in Affecting Public Policy in Canada." In *The Non-profit Sector in Canada: Roles and Relationships*, edited by. Keith Banting, 229-66. Montreal: McGill-Queen's University Press.

Kordan, Bohdan. 1997. "Multiculturalism, Citizenship and the Canadian Nation." *Canadian Ethnic Studies* 29 (2): 135-43.

Kymlicka, Will. 1998. *Finding Our Way: Rethinking Ethnocultural Relations in Canada*. Toronto: Oxford University Press.

———. 2003. "Immigration, Citizenship, Multiculturalism." In *The Politics of Migration*, edited by Sarah Spencer, 195-208. Oxford: Blackwell.

———. 2004. "Marketing Canadian Pluralism in the International Arena." *International Journal* 59 (4): 829-52.

———. 2005. "Testing the Bounds of Liberal Multiculturalism?" Paper presented at "Muslim Women's Equality Rights in the Justice System: Gender, Religion and Pluralism," Canadian Council of Muslim Women, April 9, Toronto.

———. Forthcoming. *Multicultural Odysseys: Navigating the New International Politics of Diversity*. Oxford: Oxford University Press.

Laczko, Leslie. 1994. "Canada's Pluralism in Comparative Perspective." *Ethnic and Racial Studies* 17 (1): 20-41.

Landry, Rodrigue. 2005. "Challenges Facing Canada's Francophone Minority: A Macroscopic Perspective." In *Canadian and French Perspectives on Diversity: Conference Proceedings*, ed. Margaret Adsett, Caroline Mallandain, and Shannon Stettner, 75-86. Ottawa: Minister of Public Works and Government Services Canada.

Levine, Alissa. 1999. "Female Genital Operations: Canadian Realities, Concerns and Policy Recommendations." In *Ethnicity, Politics and Public Policy*, edited by Harold Troper and Morton Weinfeld, 26-53. Toronto: University of Toronto Press.

McAndrew, Marie, Denise Helly, and Caroline Tessier. 2005. "Pour un débat éclairé sur la politique Canadienne du multiculturalisme: Une analyse de la nature des organismes et des projets subventionnés (1983-2002)." *Politiques et Sociétés* 24 (1): 49-71.

Mendelsohn, Matthew, and Andrew Parkin, eds. 2001. *Referendum Democracy: Citizens, Elites, and Deliberation in Referendum Campaigns*. London: Palgrave.

Modood, Tariq. 2003. "Muslims and the Politics of Difference." In *The Politics of Migration: Managing Opportunity, Conflict and Change*, edited by Sarah Spencer. Oxford: Blackwell.

Ontario Human Rights Commission. 1996. *Policy on Female Genital Mutilation*. Toronto: Ontario Human Rights Commission.

Pal, Leslie. 1993. *Interests of State: The Politics of Language, Multiculturalism and Feminism in Canada*. Montreal: McGill-Queen's University Press.

Phillips, Anne, and Moira Dustin. 2004. "UK Initiatives on Forced Marriage: Regulation, Dialogue and Exit." *Political Studies* 52 (3): 531-51.

Putnam, Robert D., and Susan J. Pharr, eds. 2000. *Disaffected Democracies: What's Troubling the Trilateral Countries?* Princeton: Princeton University Press.

Quell, Carsten. 2002. *Official Languages and Immigration: Obstacles and Opportunities for Immigrants and Communities*. Ottawa: Office of the Commissioner for Official Languages.

Resnick, Philip. 1994. "Toward a Multination Federalism." In *Seeking a New Canadian Partnership: Asymmetrical and Confederal Options*, edited by Leslie Seidle, 71-90. Montreal: Institute for Research on Public Policy.

Schouls, Tim. 2003. *Shifting Boundaries: Aboriginal Identity, Pluralist Theory, and the Politics of Self-Government*. Vancouver: University of British Columbia Press.

Shaffer, Martha. 1995. "Criminal Responses to Hate-Motivated Violence: Is Bill C-41 Tough Enough?" *McGill Law Journal* 41:199-250.

Trudeau, Pierre. 1971. "Statement to the House of Commons on Multiculturalism." House of Commons. *Official Report of Debates*, 3rd sess., 28th Parliament, October 8, 1971, pp. 8545-6.

Ungerleider, Charles. 1991. "Identity and Democracy: Issues in the Social-Psychology of Canadian Classrooms." In *Educational Psychology: Canadian Perspectives*, edited by Robert H. Short, Leonard L. Stewin, and Stuart J.H. McCann, Toronto: Copp Clark.

Vallières, Pierre. 1971. *White Niggers of America*. Trans. Joan Pinkham. Toronto: McClelland and Stewart.

Zolf, Dorothy. 1989. "Comparisons of Multicultural Broadcasting in Canada and Four Other Countries." *Canadian Ethnic Studies* 21 (2): 13-26.

Accommodating Canada's Diversity

Commentary

I AM PLEASED TO HAVE THE OPPORTUNITY TO COMMENT ON WILL KYMLICKA'S CHAPTER, "Ethnocultural Diversity in a Liberal State: Making Sense of the Canadian Model(s)." I agree fundamentally with his descriptions of the three vertical silos — relating to Aboriginal peoples, French Canadians, and immigrants — and the disconnects that exist between them.

Kymlicka makes an excellent and vitally important point that accommodating diversity has been central to our history. In fact, Canada's stability, prosperity and survival depend upon it. In that spirit, I will first centre on some current challenges facing Canada in the maintenance of this history of accommodation that preserves shared citizenship. There is, of course, much more to be done toward strengthening the multitude of laws and programs that create Canada's diversity policies.

Specifically, I agree that there are two major current challenges that threaten to undermine the concept of shared citizenship. First, racial profiling threatens to undermine the perceived and substantive equality of both the Aboriginal silo and the immigrant/ethnic silo. Second, access to the justice system remains a significant problem, particularly given the critical role that it has in creating a sense of shared citizenship. The civil justice system, in particular, is becoming increasingly cost prohibitive, and this poses a significant risk of further disenfranchising Aboriginal and immigrant groups from the legal process.

I agree with Kymlicka that measuring equality in the Aboriginal silo is more complicated than doing so in the silos of the French Canadian or the multicultural community. This is an issue that I believe merits additional comment. The government has often failed in its duties to negotiate, consult and act in the best

interests of Aboriginal peoples. Although Kymlicka is correct in saying that gains have been made, the problems facing Aboriginal communities (such as poverty and overincarceration) are unacceptable, and the situation requires more attention.

Before commenting in more detail on Kymlicka's chapter, I will look at each of the silos in light of my own political experience: I was the Ontario attorney general for a decade; I have been a judge for the past 15 years; and I participated in the negotiations that led to the patriation of our Constitution with the Charter of Rights, one aim of which was to strengthen the diversity of our nation.

During my lifetime, I have witnessed the dramatic and positive evolution of Canadian diversity, recognition, accommodation and shared citizenship. I grew up in Toronto, a city whose culture in my early years was overwhelmingly White, Anglo-Saxon and European, a city where the Orange Order was a distressingly strong political force for the first half of the twentieth century. I became particularly aware of the increasing diversity of our nation in the early 1950s, when I worked as a Frontier College labourer-teacher with new immigrants in remote areas of Canada. I laboured with these men during the long workdays and taught English at night. The experience created in me a great respect for these immigrants who embraced the challenges of a new language, a new culture and, sometimes, a hostile climate. I also came to appreciate that Canada was essentially a land of immigrants, and that respect for diversity was essential to our unity.

In 1955, after my first year of law school, I spent three and a half months in Quebec City struggling to become bilingual. This was five years before the so-called Quiet Revolution, and I was therefore well able to appreciate the dramatic changes that took place in Quebec in the years that followed. The Québécois took control of their own destiny after some very difficult decades, during which the Anglophone minority dominated Quebec industry and business, often with great insensitivity toward the French language and culture.

These experiences had significant influence on me when I became Attorney General in the cabinet of William G. Davis in 1975. Issues related to the diversity of our province and official status for the French language in the courts of Ontario became personal priorities. In 1975, the demographics of Ontario were changing dramatically, with a greatly increased flow of immigration from South Asia, Korea, Hong Kong, Africa and the Caribbean. A regrettable dimension of the human predicament is that new immigrant groups often face discrimination, bigotry and blatant racism.

Our government created the first cabinet committee on race relations, which I chaired. A positive dialogue developed with these diverse communities, and law enforcement agencies were encouraged to give a higher priority to combatting acts of racism that breached the Criminal Code. Hate propaganda laws were strengthened, and while some civil libertarians objected to this interference with freedom of speech, it has always been my view that this is justified in a free and democratic society, particularly one that seeks to respect its own diversity. However, the fact remains that some groups have greater access to a truly shared citizenship than others. Members of the Black community, for example, often face major challenges, generally related to systemic discrimination and poverty. I will return to this issue, as it is of immense concern to those of us with responsibilities in the justice system.

Notwithstanding certain challenges, Ontario has become a vibrant, pluralistic society with a high level of civility. Toronto is arguably the most diverse city in the world, and while it is a generally tolerant civil community, its diversity often presents special challenges that are not always adequately addressed by governments, other civic institutions and the private sector.

I agree with Kymlicka that the success stories related to Canada's diversity have been inspired by the ideals of human rights and civil rights liberalism. These ideals also helped in the creation of our Charter of Rights, which has played a major role in the establishment of a culture of respect for individual rights and general diversity. The patriation of Canada's Constitution with an entrenched charter of rights greatly strengthened and increased recognition of Canada's diversity.

While Kymlicka is probably correct that developments during the period 1965 to 1975 helped create the political climate for a progressive new constitution in 1982, it nearly did not happen, given the political divisions in Canada at that time. Space does not here permit an analysis of those conflicting political currents, but in many ways we are simply lucky that our Constitution is not still an act of the British Parliament.

The Charter has also broadened support in Canada for bilingualism in the context of Canada's two official languages. I am certainly proud of the fact that my eldest granddaughter was able to obtain her entire preuniversity education in French, in Surrey, British Columbia. However, when I became the attorney general in Ontario in 1975, official bilingualism was a divisive issue in much of the province. Nevertheless, I was determined that French become an official language

in the courts of Ontario, and I committed the provincial government to creating a bilingual court system. I did this without consulting my cabinet colleagues, as I wanted to avoid a protracted and perhaps futile debate. This initiative did provoke some political controversy, but a decade later it would probably not have made even a ripple. There are now tens of thousands of students in Ontario receiving their entire elementary and secondary education in French. Many francophone friends have also told me that it is now truly possible to "live in French" in Toronto. How different the situation is now from what it was only a few years ago.

In the Aboriginal silo, progress with respect to recognition, accommodation and shared citizenship has been a far bumpier road. A large number of Aboriginal citizens face desperate economic circumstances. While the principle of self-government has been generally accepted by governments, little has been accomplished in this regard. However, there are some encouraging signs as the ranks of Aboriginal professionals increase. There was only one Aboriginal lawyer in Canada when I was called to the Bar in 1958. My Aboriginal colleague on the Ontario Court of Appeal, Justice Harry LaForme, advises me that there were only five Aboriginal lawyers when he entered law school in 1974. It is now estimated that there are about 500 Aboriginal lawyers in Canada. I will return to the Aboriginal silo in the context of the administration of justice. It is in this area that perhaps the greatest challenges for accommodation lie.

Returning to Kymlicka's chapter, I agree that racism and discrimination undermine our shared citizenship. One of the most pressing issues is racial profiling. It is irrelevant whether Canadian institutions actually employ racial profiling; what matters is that there is overwhelming evidence that Aboriginal and immigrant communities perceive that racial profiling exists. Certainly, it is an issue that the legal system has begun to take very seriously. In response to community concerns, the Ontario Human Rights Commission (OHRC) recently conducted an inquiry into the effects of racial profiling. The commission's goal was not to prove the existence of racial profiling, but to respond to community concerns related to the perception of it. However, in its recommendations for final action, the commission identified as a primary barrier to addressing racial profiling the unwillingness of many to admit that a problem exists, or even that the affected communities believe it exists.

I agree with Kymlicka that when immigrants face racism or religious prejudice, it erodes feelings of trust and solidarity. The mere notion that racial

profiling exists in Canada is sufficient to cause this erosion and to threaten shared citizenship. As the OHRC found, racial profiling also creates mistrust in Canadian institutions, alienation and a diminished sense of citizenship. Although much of the media attention to the problem centres on police traffic stops, the OHRC found that racial profiling is a widespread problem that is neither limited to these traffic stops nor confined geographically to the city of Toronto.

A third factor that Kymlicka suggests undermines shared citizenship is a decline of trust in public institutions. As a generally liberal-democratic institution, the justice system plays a critical part in creating this shared citizenship. The public must perceive that all Canadians have equal access to the justice system, and that the system actually achieves justice. The perception that individuals are treated differently in the justice system because of their race, culture or religion can significantly undermine the administration of justice.

Ensuring that the legal profession reflects Canada's diverse ethnic, cultural and religious makeup is one important goal. As Justice Bertha Wilson has argued in addressing gender equality, women often view the world from a different perspective, and equality in the appointment of judges enhances judicial neutrality and impartiality. This is particularly important, Justice Wilson observes, because the "development of the law in some areas may have been influenced by the fact that it was made exclusively by men and reflected what were quintessentially male values."[1] I believe that this reasoning applies equally when it comes to individuals of different ethnic, cultural and religious backgrounds. I also believe that justice is becoming accessible more to the wealthy than to the average Canadian. Cuts to legal aid and the increasing cost of litigation have meant that Canadians with mid-to-low socioeconomic status are, practically speaking, unable to assert their legal rights.

Aboriginal and immigrant/ethnic communities suffer from poverty to disproportionate degrees, and this will, of course, have an impact on their access to an increasingly expensive justice system. If two of the three silos identified by Kymlicka do not have meaningful access to the justice system or have access only to a lower quality of legal representation, this will undermine shared citizenship, given the vital importance of the justice system.

The culture in most large legal firms in Canada — the firms with the talent and resources to help — has, in recent years, largely shifted from one that encourages and expects lawyers to participate in pro bono projects to one that is

strictly focused on financial prosperity. These firms could do more to make justice more affordable and available to disadvantaged groups; they need to cultivate a culture that supports such an endeavour.

Although gains have been made, Aboriginal people in Canada face enormous barriers to substantive equality. Signs that such equality is lacking are widespread. As compared with average Canadians, Aboriginal people are overrepresented as the accused in the criminal justice system, they have lower-quality housing and they inhabit poorer physical environments; they have lower education levels, a lower socioeconomic status, fewer employment opportunities and weaker community infrastructures.

Kymlicka does note that Aboriginal people have achieved some political recognition via land claims and self-government agreements. Indeed, the reconciliation and protection of Aboriginal rights in sections 25 and 35 of the Constitution was a major victory. But Aboriginal equality cannot be achieved through the enforcement of legal rights alone. The government plays a critical role in ensuring that these constitutional guarantees promote Aboriginal equality.

In 2005, Justice Ian Binnie of the Supreme Court of Canada made some important observations: "The fundamental objective of the modern law of Aboriginal and treaty rights is the reconciliation of Aboriginal peoples and non-Aboriginal peoples and their respective claims, interests and ambitions. The management of these relationships takes place in the shadow of a long history of grievances and misunderstanding. The multitude of smaller grievances created by the indifference of some government officials to Aboriginal people's concerns, and the lack of respect inherent in that indifference has been as destructive of the process of reconciliation as some of the larger and more explosive controversies."[2]

There is, regrettably, a widespread lack of trust in our justice system within Aboriginal communities. Aboriginal leaders have explained the reason for this to me in rather stark terms: When Aboriginal people go to court, they expect to lose because they have been arrested by a White police officer, they are prosecuted by a White Crown attorney, and they are tried by a White judge and usually a White jury. In jail, they are supervised by White guards.

The remedy is not a separate justice system, which would be impractical, given the high percentage of Aboriginal people living in urban communities. Instead, we need to ensure that Aboriginal people caught up in the justice system see more faces like their own in the courtrooms, in the police service and among

court workers. We also need to establish more legal aid clinics and more sentencing circles involving Aboriginal communities and, of course, we must alleviate Aboriginal poverty. Finally, we must demonstrate a greater respect for First Nations peoples as political entities, not simply cultural entities. If we do not take these steps, we risk creating a whole generation of angry young people. The challenge is daunting, because there is more than one authentic Aboriginal culture.

A culture of human rights and civil rights liberalism is of little comfort to people marginalized by poverty and racism. Governments have traditionally found it difficult to target the most special needs and to focus on the most disadvantaged citizens. This responsibility should also be shared by many other institutions, such as universities, community colleges and trade unions — and, of course, the private sector.

While Kymlicka writes eloquently and persuasively of the three vertical silos — related to immigrant/ethnic communities, Aboriginal peoples and the French fact in Canada — and of the disconnects between them and the broader society, the larger reality is that modern society is plagued by disconnects on all levels. If we, as Canadians, are to effectively accommodate diversity, we must make major efforts to eliminate, or at least reduce, those disconnects. Only by creating significant effective and sustainable partnerships and coalitions in the public and private sectors will we be able to deal with the increasing challenges faced by our fellow citizens marginalized by poverty, lack of opportunity and racism.

Notes

1 Madam Justice Bertha Wilson, "Will
 Women Judges Really Make a Difference?
 The Fourth Annual Barbara Betcherman
 Memorial Lecture." *Family Court Review* 30
 (1): 13-25.

2 *Mikisew Cree First Nation v. Canada*
 (Minister of Canadian Heritage), [2005] 3
 SCR 388, 2005 SCC 69.

History, Power and
Contradictions in a
Liberal State:
A Response to Will
Kymlicka

Commentary

I T IS MOST APPROPRIATE TO BEGIN A VOLUME DEVOTED TO DIVERSITY AND CANADA'S future with a chapter by an intellectual of the calibre of Will Kymlicka. As those working on diversity issues know, Kymlicka's scholarly contributions form a major collective point of understanding and exchange for academics, researchers and policy-makers, in Canada and globally. His admirably comprehensive chapter, entitled "Ethnocultural Diversity in a Liberal State: Making Sense of the Canadian Model(s)," provides an excellent frame of reference for an informed discussion about Canada's prospects and challenges.

A major strength of Kymlicka's chapter is that it covers such extensive ground, dealing with a multiplicity of groups in Canada: First Nations; francophones; and non-British, non-French and non-Aboriginal ethnic groups. As I read this chapter, three major themes stood out, and I will underscore the significance of each in turn. The first theme is how misleading it is to speak of a single Canadian approach to diversity. Kymlicka highlights three sets of policies — each marked by distinct constitutional provisions — that guide the federal government's varied relations with indigenous peoples, francophones and what he terms "immigrant/ethnic" groups. He invokes the metaphor of the silo to underscore the legal and administrative distinctiveness of the different approaches, as well as the divergent concepts underpinning the claims made by various groups. The silo image is helpful because it illustrates that in Canada there is a multiplicity of groups and discourses surrounding diversity. It even helps to explain why, historically, groups such as francophones and indigenous peoples have not had much interest in multiculturalism. Recall how former Parti Québécois leader René Lévesque once referred to multiculturalism as a "red herring...designed to

give an impression that we are *all* ethnics and so don't have to worry about special status for Quebec" (Lévesque and Chaiton 1977, 178; see also Rocher 1973). The silo metaphor is also useful because there is increasing talk both outside and inside Canada about a "Canadian diversity model" (Jenson and Papillon 2001). Likewise, the term "multiculturalism" is sometimes used as shorthand for a singular, specifically Canadian model (Inglis 1996). In contrast, the focus on silos highlights preexisting divergent policies and legal frameworks.

The second theme Kymlicka advances is that these discrete silos — and the policies that animate them — are all liberal in their goals, formulation and administrative implementation. As he articulates it, "Canada is a consolidated liberal democracy, and one would expect its approach to diversity to be determined by liberal-democratic values." In drawing attention to the seemingly obvious, however, Kymlicka also offers a most intriguing insight: a human rights discourse, and in particular a civil rights discourse, has been critical to various minority rights struggles in Canada. Indeed, it is the rise of what Kymlicka terms "civil rights liberalism" that helps to explain why the period 1965 to 1975 was marked by major developments across all the silos, including the acceptance of forms of differentiated citizenship.

This focus on human rights and civil rights compels us to consider not only the Canadian context, but also the broader international environment. Kymlicka gives close attention to the civil rights struggles of African Americans, pointing out how powerful the influence of these struggles was on many minority groups outside of the United States. (One might also add that civil rights leader Martin Luther King Jr. was heavily influenced by Mahatma Gandhi in articulating his message of nonviolent direct action as a means of social reform [King 1983, 7-8].) Thus, we need to assess the impact of human rights and civil rights discourses in relation to the international flow of ideas. To extend Kymlicka's observation, the continued salience of human rights may also help us to understand why there is so much interest abroad in Canada's policy of multiculturalism. Indeed, on a visit to Canada in January 2002, the Aga Khan described Canada as "the most successful pluralist society on the face of the globe" and an inspiration for divided developing countries in the twenty-first century (cited in Stackhouse and Martin 2002).

Kymlicka's third theme is one that policy-makers and scholars studying diversity need to engage further: despite minority claims for fair treatment, and

despite developments that occurred between the mid-1960s and mid-1970s, the actual impact on equality has been uneven. In particular, as Kymlicka puts it, there is "unfinished business with respect to equality for all groups." His discussion demonstrates sensitivity to the fact that groups are internally differentiated and that the issue of women's equality, particularly, needs to be addressed. This sensitivity serves as a useful reminder for both researchers and policy-makers of the dangers of assuming that one understands the views of any community without having first listened to the voices of women. In combination, these themes relating to the complexity of Canada's approach to diversity, to human rights and international development and to the issue of equality can aid us considerably in structuring an understanding of diversity and the future of this country.

I have three more critical observations to make about Kymlicka's chapter that I believe are relevant to a discussion about diversity and Canada's future because they pertain directly to the claims, concerns and realities confronting Canadian citizens and policy-makers in the early years of the twenty-first century. These relate to history and narratives; social and political power; and the contradictions that permeate life within minority communities and policy-making communities.

Turning first to history and narratives, I would argue that any attempt to look into Canada's present and future must implicitly or explicitly include some examination of Canada's past. Kymlicka's chapter is no exception. It provides what one could call a teleological understanding of Canadian history as moving fairly seamlessly from a troubled past in which relations between ethnic groups were illiberal and undemocratic to a present in which liberalism reigns supreme; 1965 to 1975 was the important transition period. Yet one of the problems inherent in offering a general historical account is that it makes invisible the diverse narratives of minorities.

One such important narrative, articulated by indigenous people and indigenous scholars, concerns Canada's origins as a settler colony and the ongoing role played by the Canadian state in colonization. Thus, for example, the *Indian Act*, still in effect today, is frequently upheld as an important state instrument of colonial rule. Indigenous scholars, such as Taiaiake Alfred, argue that even in the post-1970s era, new discussions of self-government are still being undermined by the vestiges of colonialism, and that considerable changes must be undertaken by the Canadian state and by indigenous people themselves (Alfred 1999, 2005).

Consequently, I think that to understand diversity in Canada and to really dream and scheme a better future, researchers, policy-makers and citizens need to be attuned to the diversity of narratives about Canada. I think that an awareness of these narratives can foster better understanding of what motivates ongoing struggles and claims, and ultimately perhaps more creative responses to such claims. Moreover, some attention needs to be paid to why certain narratives come to be privileged over others — in official state discourses, for example.

This brings me to my second observation, which concerns social and political power. Kymlicka does not consider the issue of power in a sustained way, but it is clearly present in Canada's history and policy responses. As Kymlicka points out, section 27 of the Canadian Charter of Rights and Freedoms, which deals with multiculturalism, has been basically insubstantive in relation to the courts. This is not to say that the section is irrelevant — early on, it was used to modify rights claims related to other sections of the Charter, especially section 2 (religious freedom) and section 15 (equality rights) (Gall 1991). Thus, the unanimous March 2006 ruling of the Supreme Court of Canada overturning a ban that had prevented an orthodox Sikh schoolboy from wearing a kirpan to school provided an interpretation of the meaning of religious freedom in light of Canadian values based on multiculturalism. However, Charter sections 16 through 23, dealing with official languages — or, for that matter, constitutional provisions relating to federalism, which until the advent of the Charter consumed much judicial activity — have greater salience on their own. An understanding of these discrepancies requires some consideration of the historic power of Canadians of British origin, and to a much lesser extent those of French origin (since these two collectivities were never equal), and of the relationships of these groups to others.

I also think that we need to attend to the ways that social relations of power linger. For example, Kymlicka writes, "Since the mid-1960s, francophone Quebecers have achieved a dramatic equalization with English Canadians in all dimensions, whether measured in terms of economic opportunities and standard of living, or in terms of effective political representation and voice, or in terms of the public status of language and culture." Yet this assessment does not accord with that of the commissioner of official languages. The thirty-fifth-anniversary report on the *Official Languages Act*, released in 2005, states that "much remains to be done before equal status for our two official languages is assured." Moreover, the report maintains that while the socioeconomic gap between

francophones and anglophones may be smaller now than it was in the 1960s, anglophones still fare better, even inside Quebec (Canada, Office of the Commissioner of Official Languages 2005, 38, 105-6).

In addition to considering the tenacity of social relations of power, it is important to consider the complex ways in which those relations intersect and interact. Francophones, inside and outside Quebec, are diverse. As Kymlicka notes, since 2001, the federal government has committed itself to recruiting immigrants in a manner that will strengthen francophone communities outside Quebec. Yet it has not matched this with an effort to develop immigrant services for francophones outside Quebec. As it stands, many French-speaking immigrants arriving in a province like Alberta from parts of la Francophonie not only face discrimination because of their skin colour (M'pindou 2002), but they must also deal with a lack of services, let alone jobs, in their language (Razafindrazaka 2002). An intersectional approach can alert policy-makers to the unmitigated disadvantage experienced by unilingual francophone immigrants who reside outside Quebec.

To better understand intersecting relations of power, it would help not only in terms of public policy but also in terms of thinking through individual and collective responsibility to consider how the majority can metamorphose, depending on the context. Thus, in the Canadian context, we can talk of an English-speaking majority (which helps us to understand how francophone Quebecers view the rest of Canada, the experience of francophones outside Quebec and the fact that English-speakers inside and outside Quebec have benefited greatly from official bilingualism). We could speak about a White majority in examining how processes of racialization serve those of European origin. In relation to indigenous peoples, we could speak of the way all non-indigenous people form the majority in the Canadian settler society. Such perspectives can also feed into Olena Hankivsky's call for "diversity mainstreaming" in public policy; this involves recognition of the uneven consequences of policy-making in light of gender and other forms of difference and of more effectively linking policy outcomes to the goal of social justice (2005).

Yet diversity mainstreaming is challenging because, arguably, the space to pursue claims for justice and fair treatment has diminished in recent years. Consider the period Kymlicka highlights as that in which important developments took place — 1965 to 1975. It is important to note that this is the period in which the Canadian welfare state was consolidated. The funding given to

minority groups — indigenous organizations, women's organizations, ethnocultural associations and official languages groups — can be seen as related to the unfolding of the welfare state; that funding also aided such groups to participate politically and to make group claims in the name of being Canadian citizens (Jenson and Phillips 1996).

However, many scholars suggest that on the way to the new century we took a neoliberal turn (Clement and Vosko 2003). As the federal government began to stress individual self-reliance, global markets and economic efficiency in order to justify cuts to social spending, women's groups, ethnocultural associations and other organizations not only faced cuts to their budgets, but they were also confronted by a new discourse: they were no longer groups of citizens, but "special interest" groups whose claims were different from those of ordinary Canadians, and therefore problematic (Jenson and Phillips 1996). This has had particularly negative ramifications for equity in public policies that directly pertain to ethnic diversity, including policies on immigration, multiculturalism and employment equity (Abu-Laban and Gabriel 2002). More broadly, the neoliberal turn has much to do with a repositioning of social power, and it has been argued that the result is the disenfranchisement of the social citizen and a growing gap between rich and poor related to both gender and race (Brodie 2002, 378).

To be sure, this highlighting of neoliberalism, its policy implications and its social ramifications presents a very different picture than the reading of policy provided by Kymlicka, who speaks instead of "day-to-day fluctuations" and "a multitude of advances and retreats." Irrespective of the position one may adopt on neoliberalism, it is nevertheless important to address social power relations in all their diverse and intersecting complexity because this alerts both policy-makers and policy analysts to the differing impacts of specific policy choices.

Finally, the third observation I would make that I believe is helpful to understanding diversity relates to contradictions within collectivities and within policy-making communities. Consider one of the most obvious symbols of colonialism in Canada: the queen. A poll taken in September 2005 found that 71 percent of Quebecers are opposed to retaining the queen as head of state, compared with only 47 percent of people in the rest of Canada. Yet the appointment of Michaëlle Jean as Canada's new governor general was favoured by 71 percent of Quebecers but only 46 percent of Canadians outside Quebec (Laghi 2005). This illustrates the contradictions that permeate Canadian political life.

While Kymlicka recognizes that the liberal norms underpinning multiculturalism have been criticized by scholars from radical and postcolonial perspectives, he posits that the actual practices of minority groups are either liberal or illiberal/conservative. Yet nonliberal (rather than simply illiberal) forms of multiculturalism practice and claims-making have emerged from minority groups, and will likely continue to emerge. These tend to challenge economic inequality and link with more radical forms of democracy (Shohat and Stam 1994; Henry and Tator 1999). As Frances Henry and Carol Tator note, instead of tolerance, some of these practices and claims demand "the dismantling of dominant cultural hierarchies, structures and systems of representation" (1999, 98). Thus there are contradictions not only between liberal and illiberal practices, but also between liberal and nonliberal (yet progressive) claims and practices that deserve greater attention.

Another way to highlight contradictions within minority ethnic communities would involve some closer consideration of attitudes toward certain purported cultural practices. Kymlicka refers to the "illiberal and undemocratic practices of various ethnic groups." He specifically lists such gender-specific practices as "the customary use of violence against women or children...female genital mutilation and coerced arranged marriages." By listing these practices, he intends to make a larger point about the way federal multiculturalism policy sets limits that are sustained through socialization practices in Canada, Canadian public opinion and the Canadian judiciary. Nonetheless, these gender-specific practices, while far from universally embraced in countries of the global South, are associated in the popular imagination with Third World barbarity. (Female body mutilation in the form of plastic surgery is glorified on shows consumed by English-speaking Canadians, like ABC's *Extreme Makeover*, yet this is not typically seen as barbaric.)

My specific concern with the fact that Kymlicka lists these gender-specific practices and that they are also cited repeatedly in the liberal scholarly debate over multiculturalism (see, for example, Cohen, Howard and Nussbaum 1999) is that in the absence of a discussion of contradictions within communities, it plays into an older, colonial portrayal of cultural inferiority. As Sherene Razack has noted, for example, the huge amount of scholarly attention paid within North America to such gendered markers of cultural difference as female genital mutilation is sustained by the incorrect assumption that there exists no debate in countries of the South on these practices, that there is no preexisting debate within diasporic communities and that women in the South are without agency and

thus need to be saved by benevolent Europeans (Razack 1998, 6-7). In short, the contradictions and tensions within any cultural group ought to be considered from the outset. This point cannot be overemphasized in the context of the current revival in essentialist thinking that posits a "clash of civilizations" between Christianity/liberalism/democracy and Islam/illiberalism/undemocracy, precisely because such thinking misses the multiple and contradictory dialogues and practices within "civilizations" (Abu-Laban 2001, 2002).

The contradictions of our time occur within communities, but they also occur within state policies. Yet Kymlicka makes no mention of possible illiberal policies and human rights abuses by governments of consolidated liberal democracies. This contradiction, however, has been poignantly highlighted since September 11, 2001 — a temporal marker that Kymlicka does not consider in his chapter. A racialized terrorist threat is now invoking a security response at local, national and global levels (Abu-Laban 2005). There are more examples of state immigration and security officials profiling those who are, or who are seen to be, Muslim and/or Arab in Canada, the United States and other liberal democracies. Since profiling typically extends to noncitizens and citizens alike, in the Canadian context there is a distinct post-September 11 segmentation of Canadian citizenship (Abu-Laban 2004). The Arar Commission has now brought to public attention the possible collusion between Canadian and US state security officials in the deportation of a Canadian citizen to Syria, where he was imprisoned and tortured. What do human rights and Canadian multiculturalism mean in light of all this? The insights of Kymlicka about Canadian practices, and the effort to contemplate diversity and Canada's future, provide a basis for beginning to address such challenging questions of the twenty-first century.

References

Abu-Laban, Yasmeen. 2001. "Humanizing the Oriental: Edward Said and Western Scholarly Discourse." In *Revising Culture, Reinventing Peace: The Influence of Edward W. Said*, edited by Naseer Aruri and Muhammad A. Shuraydi, 74-85. New York and Northampton: Interlink.

——. 2002. "Liberalism, Multiculturalism, and the Problem of Essentialism." *Citizenship Studies* 6 (4): 459-82.

——. 2004. "The New North America and the Segmentation of Canadian Citizenship." *International Journal of Canadian Studies* 29:17-40.

——. 2005. "Regionalism, Migration and Fortress (North) America." *Review of Constitutional Studies* 10 (1-2): 135-62.

Abu-Laban, Yasmeen, and Christina Gabriel. 2002. *Selling Diversity: Immigration, Multiculturalism, Employment Equity and Globalization*. Peterborough, ON: Broadview Press.

Alfred, Taiaiake. 1999. *Peace, Power, Righteousness: An Indigenous Manifesto*. Don Mills, ON: Oxford University Press.

——. 2005. *Wasase: Indigenous Pathways of Action and Freedom*. Peterborough, ON: Broadview Press.

Brodie, Janine. 2002. "Citizenship and Solidarity: Reflections on the Canadian Way." *Citizenship Studies* 6 (4): 377-94.

Canada. Office of the Commissioner of Official Languages. 2005. *Annual Report, Special Edition: 35th Anniversary, 1969-2004*. Vol. 1. Cat. no. SF1-2005E-HTML. Ottawa: Office of the Commissioner of Official Languages. Accessed November 30, 2006. http://www.ocol-clo.gc.ca/archives/ar_ra/2004_05/2004_05_e.htm

Clement, Wallace, and Leah F. Vosko, eds. 2003. *Changing Canada: Political Economy as Transformation*. Montreal and Kingston: McGill-Queen's University Press.

Cohen, Joshua, Matthew Howard, and Martha C. Nussbaum, eds. 1999. *Is Multiculturalism Bad for Women? Susan Moller Okin with Respondents*. Princeton: Princeton University Press.

Gall, Gerald. 1991. "Multiculturalism and the Canadian Charter of Rights and Freedoms: The Jurisprudence to Date under Section 27." In *Taking Stock: The Jurisprudence on the Charter and Minority Rights*, edited by Lilian Ma, Emilio Binavince, Duncan Boswell, and Gerald Gall, 73-186. Ottawa: Canadian Ethnocultural Council.

Hankivsky, Olena. 2005. "Gender vs. Diversity Mainstreaming: A Preliminary Examination of the Role and Transformative Potential of Feminist Theory." *Canadian Journal of Political Science* 38 (4): 977-1001.

Henry, Frances, and Carol Tator. 1999. "State Policy and Practices as Racialized Discourses: Multiculturalism, the Charter and Employment Equity." In *Race and Ethnic Relations in Canada*, edited by Peter S. Li, 88-115. 2d ed. Don Mills, ON: Oxford University Press.

Inglis, Christine. 1996. "Multiculturalism: New Policy Responses to Diversity." Management of Social Transformations (MOST) UNESCO Policy Paper 4. Paris: United Nations Educational, Scientific and Cultural Organization. Accessed October 9, 2005. http://www.unesco.org/most/pp4.htm

Jenson, Jane, and Martin Papillon. 2001. *The "Canadian Diversity Model": A Repertoire in Search of a Framework*. CPRN Discussion Paper F/19. Ottawa: Canadian Policy Research Networks.

Jenson, Jane, and Susan Phillips. 1996. "Regime Shift: New Citizenship Practices in Canada." *International Journal of Canadian Studies* 14:111-35.

King, Coretta Scott. 1983. Introduction. In *The Words of Martin Luther King Jr.*, by Martin Luther King Jr., edited by Coretta Scott King. New York: Newmarket Press.

Laghi, Brian. 2005. "Quebeckers Embrace New Governor-General." *Globe and Mail*, September 27.

Lévesque, René, and Alf Chaiton. 1977. "Education in a Changing Society: A View

from Quebec." In *Canadian Schools and Canadian Identity*, edited by Alf Chaiton and Neil McDonald, 176-85. Toronto: Gage.

M'pindou, Jacques Luketa. 2002. "La Jeunesse congolaise dans la société canadienne." In *L'Alberta et le multiculturalisme francophone: témoignages et problématiques*, edited by Claude Couture and Josée Bergeron, 33-6. Edmonton: Centre d'études canadiennes de la Faculté Saint-Jean.

Rocher, Guy. 1973. "Les Ambiguïtés d'un Canada bilingue et biculturel." In *Le Québec en mutation*. Montreal: Hurtubise HMH.

Razack, Sherene. 1998. *Looking White People in the Eye: Gender, Race and Culture in Courtrooms and Classrooms*. Toronto: University of Toronto Press.

Razafindrazaka, Janine. 2002. "Les Défis de la vie familiale des nouveaux arrivants francophones en Alberta." *L'Alberta et le multiculturalisme francophone: témoignages et problématiques*, edited by Claude Couture and Josée Bergeron, 27-32. Edmonton: Centre d'études canadiennes de la Faculté Saint-Jean.

Shohat, Ella, and Robert Stam. 1994. *Unthinking Eurocentrism: Multiculturalism and the Media*. London and New York: Routledge and Kegan Paul.

Stackhouse, John, and Patrick Martin. 2002. "Interview with the Aga Khan: Canada 'A Model for the World.'" *Globe and Mail*, February 2.

The Quebec State and
the Management of
Ethnocultural Diversity:
Perspectives on an
Ambiguous Record

S INCE THE 1960s, DESPITE ITS SUBALTERN STATUS WITHIN THE CANADIAN STATE, Quebec has, for all intents and purposes, acted like a full-fledged and sovereign state, largely on account of the francophone majority's strong sense of self and will to be acknowledged as a distinct nation. Successive Quebec governments have managed to shape and control significant aspects of immigration policy and define the criteria for the inclusion of ethnocultural minority groups into mainstream society, either via special federal-provincial arrangements[1] or by making full use of the province's constitutional powers. This has translated over time into an extensive body of legislation, policies and regulations designed in particular for all those who originated outside the Quebec political community and with a view to framing the national civic space clearly and laying out the parameters of political and social membership. Today, Quebec, among all liberal-democratic polities, stands at the forefront of diversity management. Looking at its experience gives us much insight into the possibilities and limitations of the current arrangements put in place to address the challenges confronting plural societies.

Quebec's record on diversity management can easily seem exemplary.[2] In its dealings with members of ethnocultural minorities, Quebec appears to be one of the most open and convivial democratic jurisdictions in the world. The state's discourse and institutions are marked by a commitment — unmatched in virtually all other liberal democracies — to the recognition, respect and accommodation of difference. On the ground, though, the reality of state-minority relations presents a less buoyant image. As will be discussed in this chapter, a number of indicators point to the persistence of the

socioeconomic gap between Eurodescendants and new immigrants, members of racialized groups and First Peoples.[3] Many are growing dissatisfied with the disadvantaged socioeconomic situation that seems to stem from their minority position; they are disenchanted with the state's inability to fulfill its promises of social justice, equality, fairness and self-determination, and they question in the end whether they truly belong to Quebec society. Such sentiments are regularly reinforced by public debates over the hijab, the kirpan, the land claims of First Peoples or, more generally, the impact of ethnocultural diversity in the public sphere, which reveal more often than not the unease of significant segments of the Eurodescendant population with claims and expressions of difference and with the actuality of otherness in the Quebec context.

In truth, despite the state's efforts and initiatives to foster and facilitate the development of a genuine, diversity-sensitive sociopolitical environment, there is appreciable disparity between the expected results of the state's diversity policies and their effective outcomes, particularly in terms of social justice. Quebec is certainly not unique in this regard; other, comparable polities exhibit the same kind of disparity. In matters of diversity management, in most liberal democracies, the problem lies not with the intentions or the principles, which are almost always morally sound, noble and humanistic, but with the apparent inability of the state to deliver on them in ways that truly redress the historical, socioeconomic and political imbalances between Eurodescendants and ethnocultural minority groups. Why is it so? This is a simple question, but one that students of ethnocultural diversity generally tend to overlook. This chapter seeks primarily to address it through the Quebec case, and as such it pursues two principal objectives: to document and consider the reasons for the disparity between the goals of diversity management and its outcomes in Quebec, and, ultimately, to illustrate the inherent limits of the social logic of diversity management in liberal democracies.

This chapter first reviews Quebec's experience and politics of diversity management. It then looks at various sets of empirical data underlying the socioeconomic gap between Eurodescendants and members of ethnocultural minority groups in Quebec and discusses the factors that may account for this situation. Finally, it offers a glance at what lies ahead and considers alternative policy ideas.

The Policy Framework
and the Politics of
Diversity Management in
Quebec

The Quebec State's Evolving Approach to Diversity

THROUGHOUT ITS HISTORY, INDEED FROM ITS VERY BEGINNINGS, QUEBEC HAS INCOR-
porated immigrants, foreigners and racialized individuals into its social fab-
ric. This is not to say that it has done so out of a greater openness to the outside
world, or because of an innate welcoming disposition; nor, for that matter, is it to
say that it has done so better or more humanely than other societies. This is a
mere statement of fact, a result of the province's particular sociohistorical trajec-
tory. Quebec emerged as a society of European settlers — predominantly French,
at first — who established themselves on territories already occupied by indige-
nous peoples by interacting with and eventually co-opting them, by appropriat-
ing their lands and finally by imposing sociopolitical dominion over them. Later,
the descendants of the early French settlers were confronted with the influx of
post-Conquest British newcomers, keeping their distance at first, but mingling
with them after a while and even integrating some newcomers from subsequent
waves through intermarriage and cultural interpenetration. Later still, as interna-
tional migratory movements intensified in the twentieth century, the descendants
of both French and British settlers had to come to grips with growing numbers of
newcomers, the majority of whom hailed from Europe, but also increasingly —
and predominantly, by the last third of the century — from developing countries
and former European colonies.

Quebec's political authorities have a long history of dealing with the pres-
ence of outsiders within the territorial and social boundaries of the Quebec polit-
ical community. Similarly, public debates over the conditions of inclusion of
newcomers have always been part of the province's political landscape (Pâquet
2005). Interestingly, though, the issue of ethnocultural diversity was not an
important dimension of governmental discourse until the 1960s, when the
Quebec state started developing institutional mechanisms and formal policies to
address it. The creation of the Quebec Ministry of Immigration in 1968 officially
put immigration and attendant questions of integration of ethnocultural minori-
ties on the state's agenda for the first time in the province's contemporary history.

From that moment on, the Quebec state has openly reflected not only on the place and role of immigrants in Quebec society, but also, eventually, on its own interface with linguistic, cultural and racialized minorities and with First Peoples. In the process, it has formulated and enacted the legislation and policies that have regulated the sociopolitical dynamic of interaction between the French-speaking majority and the rest of the population. The sustained intensity of the Quebec state's activity and interventions on the diversity front during the past four decades has been largely spurred by the politically pervasive — and as yet only partially realized — project of entrenching Quebec as a distinct and self-determined nation. Though endorsed and promoted with uneven fervour by alternating Liberal and Parti Québécois governments, this undertaking has constantly compelled the state to clarify its position on matters concerning the linguistic and sociocultural predominance of the French-speaking majority, the definition of the Quebec national identity and the conditions of inclusion of minority groups in the broader Quebec political community.

Over the past 10 or 15 years, the key policies, discourses and instruments of the Quebec state related to diversity management have been reviewed and discussed extensively in a number of scholarly works (Fontaine 1993; Helly 1996; Juteau 2002; M. Labelle 1998, 2000; Marhraoui 2004; McAndrew 2001; Pietrantonio 2002; Shiose and Fontaine 1995; Symons 2002). Azzeddine Marhraoui has proposed a three-stage periodization which aptly sums up the evolution of the Quebec state's approach to diversity management (2004, 67-98). The first stage covered a 10-year period, 1968 to 1978, and it was marked by the legal recognition of ethnocultural diversity (the Quebec Charter of Rights and Freedoms) and by the legislative affirmation of the primacy of the French language in the public sphere (Bill 101 and the Charter of the French Language). During the second stage, which spanned all of the 1980s, the state moved to implement more precise measures aimed at facilitating the insertion of immigrants and members of ethnocultural minorities into the mainstream socioeconomic networks of Quebec society, all the while asserting the French language and Quebec's francophone culture as the main vectors of social intercourse and the key building blocks of integration. This approach, described as one of cultural convergence, implied that all cultures present in Quebec society must be preserved and encouraged to express themselves in the public sphere via the French language, thus ensuring intercultural contact and exchange between the

French-speaking majority and all the other cultural and linguistic communities. Finally, since 1990, the state has sought to engage ethnocultural minorities in a "moral contract" whereby they are enjoined both to abide by the fundamental liberal-democratic values that define Quebec's general common public culture and to develop a primary — but not necessarily exclusive — civic and political allegiance to Quebec society.[4] In return, the state commits to stress the central contribution of ethnocultural diversity to the character of contemporary Quebec and to ensure that its institutions adapt to the various cultural, religious and identity imperatives and claims that inevitably permeate a truly plural society.

By the late 1990s, the Quebec state had begun to frame diversity and integration issues in terms of citizenship. In an attempt to invalidate the view of critics who maintained that Quebec's sense of nationhood was geared only to "old stock" francophone Quebecers, the government opted to deethnicize its approach and to emphasize the status of individuals as citizens. Rather than pigeonholing members of ethnocultural minorities in social and administrative categories that "otherized" them,[5] the state henceforth claimed to consider all residing on the Quebec territory as equal citizens deserving of the same attention, regardless of origin, ethnicity, cultural and religious background or historical *enracinement* (rootedness). To mark this change, in 1996, the government modified the name and structure of the Ministry of International Affairs, Immigration and Cultural Communities to create the Ministry of Relations with Citizens and Immigration. This move was meant to assert that beyond social, ethnic and religious distinctions, all residents of Quebec are bound together through citizenship; that they are all unmistakably and unreservedly Quebecers who partake of the same political community, with the same rights and responsibilities vis-à-vis each other and the same commitment to uphold common values.

This constant evolution of approaches to diversity management, from merely acknowledging the existence of distinct ethnocultural communities to incorporating their difference in the very makeup of Quebec's contemporary sense of citizenship and nationhood, testifies to the state's (and the political elite's) concern for the claims of minority groups and its active search for an acceptable, democratic middle road between increasingly urgent difference recognition and the imperatives of national affirmation and cultural self-preservation historically expressed by French-speaking Quebecers. This has translated concretely into a large array of legal benchmarks, institutional norms and policies aimed at

maintaining a level playing field between Quebec's Eurodescendant francophone majority and ethnocultural, racialized and linguistic minorities.

Today, policy-makers, legislators and public officials must abide by Quebec's own Charter of Rights and Freedoms, which, since 1975, has guaranteed fundamental freedoms of religion, of opinion, of expression, of free association and of peaceful assembly to each and every individual living in Quebec without distinction, exclusion or preference with respect to race, skin colour, national or ethnic origin, religious affiliation, sex, sexual orientation, pregnancy, political opinion, language, social condition, physical handicap or marital status. The Canadian Charter of Rights and Freedoms, contained in the *Constitution Act, 1982*, abides by similar principles and provides additional supralegal guideposts, which inform and ultimately determine the nature and content of diversity management. Finally, it is also important to note that in renewed support of the 1983 UN proclamation of the Second Decade to Combat Racism and Racial Discrimination and of the 1978 International Convention on the Elimination of All Forms of Racial Discrimination, the Quebec government solemnly declared in 1986 (Declaration by the Government of Quebec on Ethnic and Race Relations) its unequivocal condemnation of all forms of racism and racial discrimination and vowed to adopt and apply all appropriate measures to counter manifestations of racism and racial discrimination.

The Quebec and Canadian Charters of Rights and Freedoms and the declaration stand together as the cornerstone of diversity management in Quebec. As a result, legislation and programs favouring affirmative action, guaranteeing equal access to employment, imposing antiracist or antidiscriminatory measures and seeking to facilitate inclusion have been implemented for many years and are regularly adjusted to reflect changing realities:

- The Commission des droits de la personne et des droits de la jeunesse (Human Rights and Youth Rights Commission) has been created and operates in conjunction with the judicial system to enforce related legislative and policy dispositions.
- A wide range of services to facilitate the integration of immigrants have been set up, and they are easily accessible.
- Numerous measures for accommodating ethnic, cultural or religious manifestations with special requirements have been devised by most public institutions.

- The Quebec state finances schools, hospitals and other public institutions whose primary target clientele belongs to minority ethnic, cultural or linguistic groups.
- The curriculum of public and state-funded private schools has been frequently modified to reflect the pluralistic nature of Quebec society, to encourage intergroup and intercultural exchange and to foster a spirit of respect and acceptance of difference among members of the French-speaking majority (McAndrew 2001). Following an amendment to section 93 of the *Constitution Act, 1867* in 1998, the historical and constitutionally entrenched division of the public school system along denominational lines (Catholic and Protestant) was ended in 2000 and language-based school boards (French and English) were established. This move was motivated by the Quebec government's desire to confirm the lay character of public schools and, more broadly, of Quebec society, as well as by its commitment to assert Quebec's intrinsically civic face.
- First Peoples present on the Quebec territory were recognized by the Quebec state in 1985 and 1989 as forming 11 separate nations with the right of self-government on the Quebec territory; the right to maintain and develop their cultures, languages and traditions; the right to own and control their land; the right to hunt, fish, harvest and participate in wild-game management; and the right to partake actively in, and benefit from, Quebec's economic development.[6] In recent years, genuine efforts have been made to enhance the administrative capacity and self-government of First Peoples through a number of nation-to-nation agreements and treaties, such as the Agreement Concerning a New Relationship between le Gouvernement du Québec and the Crees of Quebec (2002) (generally known as La Paix des Braves), the Entente Sanarrutik with the Inuit (2002) and the Agreement in Principle with the Innus (2004). In addition, the state regularly sponsors or supports such annual events as Citizenship Week, the Citizenship Awards, Action Week against Racism and the Black History Month Round Table to enhance public awareness of Quebec's constitutive ethnocultural diversity.
- Finally, some may still balk at the language legislation that has imposed French as the main and official language of public transactions, commercial signs and schooling for immigrants since 1977,[7] but the state

has never stopped supporting anglophone institutions and offering key public services in English, and in some cases in languages other than English or French. The Heritage Language Program (Programme d'enseignement des langues d'origine) has even been set in place in public schools, and over a dozen languages are being taught to those who wish to maintain proficiency in their language and culture of origin. In fact, for all its apparent constraints, Quebec's language policy has allowed for greater social and political incorporation of ethnocultural and linguistic minorities into the mainstream of Quebec society.

Critics might point out that some of the aforementioned policies and measures do not work well; do not yield the expected results; are underfunded, poorly managed or ill-advised; or face bureaucratic or popular resistance. While that may be true in specific cases, it does not take anything away from the efforts of the Quebec state over nearly four decades to find effective, democratic and inclusive ways of addressing the social and political challenges of ethnocultural diversity. The management of diversity in Quebec rests on substantial foundations, which may not necessarily satisfy everyone concerned, but which nonetheless reflect the state's sensitivity to society's inherent pluralism and demonstrate its will to make the best of the situation within the liberal-democratic purview that usually characterizes its policy choices.

Political and Ideological Debates over Diversity: Canada's Multiculturalism versus Quebec's Interculturalism

Most observers agree that Quebec's way of dealing with issues of diversity management — like its way of dealing with issues in many other policy areas — is fairly distinctive, particularly in contrast with the multiculturalist model generally applied by the federal government. But Quebec's approach remains delineated by the constitutional parameters set by the Canadian state, and it has evolved largely in response to the latter's own policy framework pertaining to diversity. For one thing, as noted earlier, the supralegal character of the Canadian Charter of Rights and Freedoms unavoidably defines the limits and obligations of the Quebec state with respect to diversity management. More importantly, though, the Canadian state's numerous attempts (reviewed in this volume by Will Kymlicka) to address the challenges posed by Quebec as the "nation within" have clearly weighed on Quebec's own vision of diversity management. Kymlicka

rightly points out the relatively sudden policy shift the Canadian state embraced from the 1960s onward with respect to the institutional and political status of francophone Quebecers in Canada: from second-class citizenship to full linguistic equality, strong provincial autonomy and a certain willingness to accommodate — up to a point — the national and nationalist aspirations of a "distinct society" within the state.

It is important to remember, however, that this shift did not take place without a struggle on the part of Quebec's political elite to assert the linguistic and cultural identity of francophone Quebecers and to uphold the province's full jurisdictional powers against the natural tendency of the federal government to dilute the "French fact" and limit the reach of constitutional guarantees. In fact, for all that the Canadian state's policies of diversity management improved the social and political status of Quebecers within the federation, they also furthered Quebecers' resolve to seek alternative approaches to diversity management — approaches that would reflect Quebec's specificity and its will to instigate a separate sphere of citizenship. As Kymlicka notes in reference to Quebec and First Nations, conquered and colonized groups tend to view the public institutions of liberal-democratic political communities, however fair and well-meaning, "as external impositions, part and parcel of an ongoing historic injustice." Clearly, Canada's policy framework of diversity management spurred Quebec to define its own framework against it and, perhaps more importantly, against the initiator of the framework: the Canadian state.

Not surprisingly, then, most Quebec students of diversity issues and the Quebec state itself have insisted on distinguishing the federal and the Quebec approaches as dissimilar and even incompatible (Bourque and Duchastel 1996; Commission sur l'avenir politique et constitutionnel du Québec 1991; Gagnon and Iacovino 2004; Juteau 2000, 2002; Juteau and McAndrew 1992; Juteau, McAndrew, and Pietrantonio 1998; Karmis 2004; M. Labelle 2000; Labelle and Rocher 2004; Labelle, Rocher, and Rocher 1995; Marhraoui 2004; McAndrew 1995; Quebec, Ministère des Relations avec les citoyens et de l'Immigration 2000). As we will see, they believe that there are qualitative differences between the multiculturalism policies set in place by the Canadian state since the early 1970s and the policy of cultural convergence and interculturalism said to be favoured by successive Quebec governments. Such differences, though, matter more for political reasons than for analytical or taxonomic reasons in the minds

of those who stress them. As both the Canadian and the Quebec states have been preoccupied over the past two decades with the sense, content, nature and long-term sustainability of the national identity of the constituencies they claim to represent, securing the allegiance of Quebec's ethnocultural minority groups to either jurisdiction has become a key political stake. It is underpinned by Quebec's perceived proclivity for sovereignty and the attendant threat it poses to the preservation of the Canadian state and political community. Academics, public intellectuals and state officials on both sides have thus tended to address issues of diversity management in terms of which approach — Quebec's or the Canadian state's — has the most to offer immigrants and members of racialized minorities with respect to their human rights; or, to put it differently, which one would offer them the best guarantee of protection for their linguistic, cultural, religious and political rights should Quebec secede from Canada.

Scholars and commentators with pro-sovereignist sympathies usually note with alarm and irritation that the pluralistic and formally egalitarian bent of the multiculturalist logic propounded by the Canadian state puts French Canadians and Quebec francophones on the same footing as any other ethnocultural minority group, thus neutralizing their historical status as one of Canada's founding nations and delegitimizing the nationalist aspirations of francophone Quebecers. They further argue that the pluralist vision contained in Canadian multiculturalism is limited to a rather simplistic understanding of ethnocultural identity, as it tends to conceive of ethnocultural communities as monolithic, essentialized entities rather than as communities made up of a complex configuration of multiple, changing identities. Under the guise of fostering a pluralist national identity, Canada's multiculturalism policies, they contend, simply juxtapose in the public sphere rigidly defined and all too often competing ethnocultural identities or groups rather than encouraging the expression and development of polymorphous identities. In the end, Canada's multiculturalism only serves to mask the primacy of the White, Anglo-Saxon and Christian normative framework as the primary and most fundamental marker of Canadian national identity.

Sovereignist scholars and commentators find, in contrast, much to praise in Quebec's approach to diversity management. Looking at what is presented as interculturalism by its proponents, they see it as superior to Canada's multiculturalist model. In their view, the Quebec state has developed over the years — particularly under the leadership of the Parti Québécois — a nuanced, fairer and

more suitable vision of diversity management than that of the Canadian state. They are satisfied that this vision ensures that the existence and identity claims of francophone Quebecers are no longer downplayed and diluted among the many others vying for the attention of the state. They believe that the Quebec state has set the francophone majority culture a more honourable, integrative role as a hub toward which minority cultures and identities converge to partake in a common civic culture that rallies all Quebecers, regardless of origin. They insist this role is indeed integrative and not assimilationist, for it does not call for the exclusive allegiance of minority cultures to the cultural norms that define the majority culture. In this sense, they claim that Quebec's intercultural approach to ethnocultural diversity — interculturalism — is a more advanced form of pluralism, for unlike Canada's multiculturalism, it does not rest on the mere factual acknowledgement of ethnocultural diversity and the simple juxtaposition of ethnocultural communities in the public sphere but is founded on an active, inclusive and open dialogue between cultures aimed at shaping a national identity to which all can readily adhere (M. Labelle 2000; Laforest 1995, 51-63; Sarra-Bournet 1998; Seymour 1999, 2000).

However, those who are committed to the idea of a united Canada, or who share at least a certain community of spirit with federal multiculturalist policies, or who are simply weary of the sovereignist discourse on pluralism and integration, remain generally unimpressed with Quebec's efforts at diversity management. Within this group, one finds a rather vehement cluster of writers who remain unabashedly unconvinced that Quebecers can be even remotely open to diversity. The whole sovereignty project and the state's approach to diversity, they argue, are fundamentally nationalistic, ethnically driven, even tribalistic; and they are geared toward fostering the social, economic, cultural and political dominance of the French-speaking majority over all other ethnic, linguistic or national groups in Quebec (Derriennic 1995; Johnson 1994; Khouri 1996, 2000; Richler 1992). Their view is founded on a profound distrust of Quebec's nationalist political elite and of the state's embrace of diversity, which they see as largely rhetorical, politically motivated and, above all, inauthentic.

More balanced analyses, however, have noted instead the difficulty of implementing true interculturalism, and the fact that cultural convergence can be dangerously close to cultural and normative homogenization. The Quebec state, they maintain, has moved toward a thick definition of Quebec citizenship, which

subordinates nonfrancophone forms of ethnic identification to a national community and a common culture primarily defined by the French-speaking majority. In their view, the government's adoption of the notion of citizenship to inform its policies of diversity management and integration, particularly under the Parti Québécois between 1994 and 2003, hardly concealed its will to assert Quebec's nationality and French-speaking political and cultural identity (Juteau 2000, 2002; Robin 1996). They are supported in this by authors who, while critical of or unmoved by the Canadian way, remain nonetheless guarded in their appreciation of the Quebec approach, and who argue that Quebec's pretense of sensitivity to pluralism is in fact pervaded by monistic impulses and a belief in the paramountcy of French-speaking Quebecers' sense of self (G. Labelle 1998; Létourneau and Ruel 1994; Salée 1995, 2001; Trépanier 2001).

In the end, deciding whether Canada's multiculturalism or Quebec's interculturalism is a more appropriate strategy of diversity management is an exercise of questionable utility whose resonance hardly echoes outside the limited context of Quebec politics. One cannot deny that it is a debate shrouded in rich layers of important theoretical considerations that transcend Quebec's political reality (Can nationalism and liberalism be reconciled? Can nationalism be more civic than ethnic? Can liberal societies accommodate multicultural and multinational institutional arrangements?),[8] but it remains, nevertheless, framed essentially by the ideological and politicized compulsion to assert the primacy of one national project over another. In fact, there is no profound difference between Quebec's approach to diversity management and that of Canada. Both are premised on the state's will to foster an all-encompassing, integrative citizenship, which, ideally, would rally all. Both partake of the same liberal vision of individual equality and respect for individual freedoms; though they may apply or interpret it in varying ways, they draw from the same social and cultural normative framework. And, finally, despite the lofty and humanist ideals that are said to inform their respective understandings of diversity management, both are susceptible to straying away from those ideals or implementing them without much conviction.

The most revealing test of any liberal, democratic approach to diversity management is not whether it compares favourably with other approaches or models, but whether it applies concretely the principles of justice, equality, openness to difference and respectful integration it purports to defend — whether, in other words, it provides the level playing field that would eliminate the social hierarchies and the

socio-economic gaps that separate Eurodescendant majorities from racialized and other ethnocultural minorities. Does Quebec's approach to diversity management truly provide that level playing field? One might object that this is an unfair question, for, as history and experience show, the liberal mindset is not necessarily committed to the total eradication of socioeconomic inequalities, but rather to providing individuals with social opportunities that will help minimize the manifestations of inequality. Still, the question is apposite, for today the Quebec state's vision of diversity is intimately tied to a political project premised on the existence of a broadly based and pluralist political community of different-but-equal citizens who are expected to feel a fundamental allegiance to Quebec's nationhood and citizenship. In order to succeed, such a project requires minimally that the state encourage the development of social conditions likely to encourage newcomers and members of racialized minorities to adopt the civic and political objectives that the Eurodescendant majority fosters. Do these conditions now exist in Quebec? To this question I now turn.

Between Policy and Reality: An Ambiguous Record

A FEW YEARS AGO, THE QUEBEC MINISTRY OF RELATIONS WITH CITIZENS AND Immigration released an important study that provided empirical details of key dimensions of the socioeconomic integration process undergone by a cohort of 1,000 immigrants who came to Quebec in 1989 (Renaud et al. 2001). The authors of the study followed this cohort over a 10-year period in order to document its pattern of settlement into Quebec society. They gathered data on housing; spatial and temporal mobility; employment; professional training; French-language acquisition and usage; development of, and involvement in, social networks; and civic engagement. Their findings draw a largely positive picture of Quebec society's integrative dynamics. After 10 years, more than a third of the cohort had managed to buy a home; respondents' weekly income had nearly doubled; three in four had secured a job requiring an equal or higher level of skill than the one they had held in their country of origin; close to two-thirds were using French only as their language of public transaction; almost nine in ten were participating regularly in elections; many had become involved in community groups and local schools; they were massively

buying into Quebec's public culture and normative framework (though to a lesser extent on issues related to individual liberty in sexual preference); and they had become active in social networks of individuals from a variety of ethnocultural backgrounds. Indeed, the authors of the study felt confident enough to conclude that after barely a decade, the members of this cohort were firmly rooted in the mainstream of Quebec society and that their level of social insertion in Quebec was largely comparable to that of native Quebecers and earlier generations of immigrants.

If one were to read only this state-commissioned study of newcomer integration, one could easily be convinced that the management of diversity in Quebec works efficiently to the benefit of immigrant and ethnocultural minority groups and in accordance with the pluralistic, civic, intercultural and integrative objectives of the political authorities. Though based on cautious and proven social-scientific methodology, this longitudinal survey offers a picture of immigrant experience that may well be accurate for the particular sample group under scrutiny, but the impression of smooth societal integration it conveys does not necessarily reflect how the interface between mainstream society and minority groups actually plays out. Other studies more focused on targeted, or sectoral, aspects of incorporation into Quebec society stress, among other things, the poor levels of representation of members of racialized minorities in local political and electoral processes (Simard 2001), the reluctance if not outright unwillingness of many Eurodescendant landlords to rent to recent immigrants and members of racialized minorities (Ledoyen 2001), the increasing difficulty immigrants have had in purchasing their own homes since the 1980s (Leloup 2005) and the lack of convergence between the intercultural vision of the state and those who are entrusted to implement it on the ground, particularly in the school system (McAndrew 2003; Vermette, Jacquet, and McAndrew 2000). A number of qualitative studies have also brought to light individual narratives of uneasy or blocked integration; impeded or delayed upward professional mobility; and economic exclusion and social ostracism experienced by members of long-established immigrant cohorts, second-generation immigrants and racialized minorities. Many of these people, in turn, manifest a very weak sense of belonging and attachment to Quebec society (Helly and Van Schendel 2001; Labelle and Salée 2001; Labelle, Salée, and Frenette 2001; L'Indice 1996; Potvin 2000).

In fact, despite an overall record of diversity management that may seem positive at first glance (there has been no major occurrence of interethnic tension or violence and no overtly racist organized political movement against immigration and

racialized minorities, the state does a lot to facilitate the integration of minorities into the mainstream of society, and a spirit of tolerance generally prevails in most segments of Quebec society), Quebec is confronted with the existence of a significant and growing socioeconomic divide between its minorities and its Eurodescendant majority. Recent statistics reveal that in 2000, low income affected 26.9 percent of immigrant households, in contrast to 12.7 percent of nonimmigrant households.[9] Incidence rates are even higher for the latest immigrant cohorts: 30.8 percent of those who came during the 1980s, 38.7 percent of the 1990-94 wave and 45.4 percent of those who immigrated since 1995 figured in the low-income category. Based on 2000 data again, the average total annual income among the immigrant population 15 years and older was 47 percent lower than that of the comparable nonimmigrant population. Similarly, university-educated immigrants earned on average 18 percent less than nonimmigrants.[10] To a certain extent, one could counter that the existence of an income deficit among immigrants is to be expected: one cannot settle productively into a new country overnight; and it typically takes a generation or two for immigrants' levels of economic attainment to reach those of nonimmigrants. The fact is, the traditional pattern of immigrant income catching up with that of the nonimmigrant within a decade or so no longer prevails. For immigrants who entered Canada in the 1980s and 1990s, the gap has increased, despite periods of economic growth and shrinking unemployment (Picot 2004).

The socioeconomic divide between the majority and ethnocultural minorities takes on a more dramatic aspect when key economic disparities between them are considered. The situation of Afrodescendants is quite telling in this regard. The 2001 Census reported that the unemployment rate of African Canadians of working age in Quebec was 17.1 percent — more than twice as high as the general provincial unemployment rate, which was 8.2 percent. The situation has remained unchanged. While 53.4 percent of the total Quebec workforce was gainfully employed full-time throughout 2000, this was the case for only 42.7 percent of Afrodescendants of working age; a substantial majority of them (57.3 percent) had to rely instead on part-time or temporary employment. As a result, Afrodescendant workers posted an earning deficit of 29 percent in comparison with other Quebec workers; low income touches 40 percent of Afrodescendant families, compared with 14.6 percent of the rest of the population; and nearly two-thirds (64.2 percent) of Afrodescendant individuals living alone find themselves in the low-income category, as opposed to 43.8 percent of the rest of the population. These negative differentials occur in spite of the

fact that Afrodescendants in Quebec are by and large proportionally more educated and more likely to have the capacity to work in both English and French than the general population. In principle, as a group, they are comparatively better prepared to satisfy the requirements of high-quality jobs and meet the demand of the labour market for qualified workers.[11] One might be tempted to invoke immigration as an important factor in this socioeconomic imbalance, for a majority of Afrodescendants in Quebec are indeed immigrants (54.4 percent). But the explanatory scope of immigration is limited if one considers that 60 percent of Afrodescendant immigrants have been living in the province for 15 years or more, and 41 percent of the total Afrodescendant population — an appreciable proportion — were born in Quebec or in Canada. Yet, despite the fact that they are integral to Quebec's social fabric, Quebec-born Afrodescendants earn 59 cents to each dollar earned by Eurodescendants. In all of Canada, nowhere is this income differential between the two groups more significant than in Quebec.

The case of Afrodescendants is a clear illustration of the socioeconomic gap that separates racialized minorities from the Eurodescendant majority in Quebec. Similar and sometimes even more alarming statistics also exist for Quebecers of Latin American, Middle Eastern and Southeast Asian origin, and for First Peoples. The statistical evidence could be cited ad nauseam, but it would only further confirm the inequality of social and economic power between Eurodescendants and minority ethnocultural groups. More unsettling perhaps is the fact that the situation of socioeconomic disparity described earlier is not a new, emerging or marginal phenomenon. Studies done over a decade ago already noted significant differentials in socioeconomic achievement and circumstances between the Eurodescendant majority and immigrant and racialized minorities (Manègre 1993; Groupe de recherche ethnicité et société 1992; Salée 2001, 155-9). Things have not improved. Though the situation is not unique to Quebec,[12] it forces a sober appreciation of the state's ability to foster the development of an intercultural framework and meet the dialogical and egalitarian goals that are said to inform its approach to diversity management and its proclaimed resolve to promote inclusive citizenship.

Satisfying economic inclusion is a fundamental vector of successful, truly democratic and pluralistic diversity management. This is not to suggest that the empathy of minorities, or lack thereof, for the mainstream's normative framework and political project is wholly contingent on economic attainment. Wholehearted insertion into the dominant culture and politics may also depend on a number of

other factors, such as ease of acculturation and linguistic assimilation for immigrants and their children, demonstrated acceptance by the majority of the identity differences (both cultural and physical) of racialized minorities, or the willingness of minorities to endorse the ways of the majority. In the end, though, an absence of economic obstacles undoubtedly provides the kind of social backdrop most likely to facilitate and encourage unproblematic integration. Bryan S. Turner has aptly observed that modern citizenship hinges on the tension between two contradictory principles: solidarity and scarcity (1997). Human societies usually exist on the basis of some form of commonality between their members, a solidarity or bond that helps them cope with question of difference, diversity and conflict. But scarcity is also an undeniable reality of human societies. Insofar as it suggests asymmetry of access to wealth and social resources, it implies socioeconomic inequality in the way individuals are treated and granted status in society, which in many ways invalidates the very objective of solidarity, as it creates spheres of exclusion and weakens the social bond. More often than not, in diverse, plural societies, scarcity will not simply determine class differentials, but it will also follow the contour of identity, thus compounding the difficulties of achieving solidarity.

In the minds of many members of immigrant and racialized minorities, economic attainment is the benchmark for assessing the degree of openness and acceptance manifested toward them by the Eurodescendant majority (Labelle and Salée 2001; Labelle, Salée, and Frenette 2001). The kind of gratifying inclusion that will trigger among minorities sentiments of civic affinity and like-mindedness with the majority group will result only from efficient socioinstitutional mechanisms designed to ensure that the conditions for individual and collective socioeconomic success remain constant for everyone, regardless of origin or historical *enracinement*. As things stand now, Quebec is still quite wide of the mark.

Accounting for the Divide

In Search of Quebec Citizenship

THE RELUCTANCE OF MINORITY GROUPS TO RALLY BEHIND THE SENSE OF NATION AND civic belonging developed over the years by the Quebec state and the concomitant need of the state to woo these groups have largely determined the state's

approach to diversity management. Given this general context, one may wonder why the Quebec state has yet to do away with the socioeconomic deficit that members of immigrant and racialized minority groups (and First Peoples) experience when it is well known that for many of them a sense of belonging and civic attachment hinges in large measure on the quality of their material life. Are Quebec's numerous measures of diversity management inadequate to stop this deficit from growing?

When grappling with this question, students of ethnocultural relations and the politics of citizenship in Quebec rarely link the socioeconomic circumstances of minority groups and their unease with, if not outright rejection of, Quebec's sense of nation and citizenship. Calls for strengthened cultural convergence and more open intercultural dialogue are usually proffered instead as antidotes to the tenuous allegiance of minorities. Such calls reflect, in fact, the dominant influence of a vision of diversity management premised essentially on the cultural interface between majority and minority, and on the psychological dispositions it would be advisable to develop in order to facilitate rapprochement — not on addressing socioeconomic imbalances. This particular understanding of the societal distance between majority and minorities — which is quite prevalent in Quebec's academic and governmental circles — more often than not leads analysts and commentators to point to the institutional dynamics of the Canadian political system as the main stumbling block to the full civic engagement and integration of minority groups into the mainstream of Quebec society. They claim that what is at issue is not so much the inability of the Quebec state to create a level playing field for Eurodescendants and minorities, but the fact that immigrants, racialized groups and First Peoples are pulled in opposite directions by two competing national projects and types of nationhood: Quebec's and Canada's. Should Quebec become sovereign, the argument usually continues, things will be clearer for everyone and minorities will readily support Quebec citizenship and nationhood precisely because there will no longer be any reason to question the legitimacy of Quebecers' will to nation and of Quebec-based citizenship (Bariteau 1998; Labelle and Rocher 2004; Quebec, Ministère des Relations avec les citoyens et de l'Immigration 2000).

Others suggest that minorities' weak support of Quebec-based citizenship and the province's aspirations to sovereign nationhood are attributable to the state's own confusion about the very nature of the citizenship it intends to

champion. Joseph-Yvon Thériault has argued that the Quebec state oscillates between the two fundamental conceptions of citizenship that lie at the core of modernity (2003). Modern citizenship, he contends, is rooted in a basic duality. It manifests itself both as procedural and as substantive citizenship. Procedural citizenship implies that the state is neutral, stands above the fray, includes all identities and thus supports the full and unimpeded development of citizens' freedom. For example, in order to guarantee religious freedom, procedural citizenship welcomes all religious expressions but precludes the state from dwelling on any one in particular. Substantive citizenship, on the other hand, posits the citizen as a political animal, largely defined by his attachment to the political community, to the collective of other citizens with whom he shares a history and a public culture and with whom he feels solidarity. Each of these two forms of citizenship is moved by a different logic and by different imperatives, which are fundamentally at odds. They can coexist in the state, but their coexistence can derive only from perpetual negotiation between their conflicting aims. Thériault contends that the citizenship project put forth by the Quebec state has not yet resolved the inherent tension between procedural and substantive citizenship. It keeps fluctuating between the two, stating that Quebec citizenship is all-inclusive, open to all differences and cultural identities, but also insisting ambiguously that Quebec's francophone heritage be the foundation of the common public culture. In reality, procedural and substantive citizenship cancel each other out in Quebec's citizenship project rather than conveying their respective aspects into a new model of civic existence. As a result, Quebec citizenship appears suspect and ultimately unappealing, particularly to minorities, as it shows its procedural face first but hides its substantivist will to superimpose the cultural and normative vision of the French-speaking majority on the political community.

Though it operates from a different viewpoint, Thériault's analysis also rests on culture as the prime explanation for the distance between the Eurodescendant majority and ethnocultural and racialized minorities in Quebec. Socioeconomic differentials do not figure in his interpretation. The explanatory emphasis on culture is wanting on two grounds: first, it does not account for why the socioeconomic hierarchies that set ethnocultural and racialized minorities apart from Eurodescendants persist in spite of state policies purportedly meant to eradicate them; second, by limiting its search for solutions to virtuous appeals for intercultural dialogue and solidarity, it not only fails to realize that for such dialogue and

solidarity to take shape, there has to be a level social playing field — which minority groups must be confident of accessing — but it also neglects to investigate the structural and systemic causes of the absence of that level playing field.

In documenting the deteriorating material circumstances and the socioeconomic deficit of immigrants, racialized minorities and First Peoples, statisticians and economists pinpoint what is perhaps the most significant factor in the difficult sociopolitical integration of minorities — the very reality diversity policies are meant to "manage." They bring us closer to grasping a fundamental aspect of the social dynamics of majority-minorities relations. However, most of them hesitate to explore the reasons why the state seems unable — or unwilling — to heal the socioeconomic divide. Their explanations for the persistent discrepancies between minorities and Eurodescendants rest generally on proximate causes or effects of conjuncture: length of stay, immigrant status, unrecognized professional credentials, stiffer labour market competition or general economic downturn. They hardly, if ever, consider the impact of systemic social hierarchies, the patterns of social power or the relations of domination that create and maintain socioeconomic imbalances to the advantage of Eurodescendants.

Authors who do (Galabuzi 2001; Kunz, Milan, and Schetagne 2000; Potvin 2004) do not hesitate to mention racism as the root cause of the inequality in social and economic attainment between Eurodescendants and minorities. One can easily appreciate why their argument might seem a compelling one. How else can one explain the substantial difference in the socioeconomic conditions of Eurodescendants and racialized minority groups; or the fact that European and Euro-American immigrants do much better much faster than other immigrants and Canadian/Quebec-born members of racialized minorities; or that 56 percent of racialized people in Canada are victims of discrimination at work?[13] Must we conclude that Quebec's diversity management policies are racist, and that is why the socioeconomic conditions of racialized immigrants and minorities never catch up to those of Eurodescendants?

That would be, no doubt, an expedient assessment — expedient, but inaccurate and simplistic. For it to have any merit, one would have to establish that the Quebec state and the men and women who operate it take irrational pleasure in doing the exact opposite of what the diversity management policies dictate, that indeed the antiracist social ethos that has pervaded Quebec's collective imagination for several decades now is mere window dressing and that the struggle for human

rights has had no impact on Quebec society. This, of course, does not reflect reality. Still, one could rebuff this counterargument by maintaining that what is at work is actually neoracism, which is nothing like the overt hatred, exclusion and annihilation of the Other that traditional racism entails, but a subtle dismissal of cultural norms, values or identities that purportedly fail to satisfy the fundamental liberal-democratic imperatives of equality and social justice. Recent controversies over the hijab, the kirpan and state funding of minority religious schools are cases in point: despite the pluralist credo and injunctions of the state, individuals and even the state apparatus resisted the expression of minority cultural norms in the Quebec public sphere in the name of equality and democracy.

Racism, Eurocentrism and the Modern Dynamics of Power and Domination

It would be misguided to maintain that race and the racialization of social relations have no bearing on the blatant socioeconomic differentials between Eurodescendants and racialized minority groups. But arguing simply that Quebec's approach to diversity management is inherently racist or neoracist would not help us to understand why those differentials persist. Inequality in the socioeconomic conditions of Eurodescendants and racialized minority groups is clearly not a state's objective, but rather the outcome of a deeply entrenched societal logic that cannot simply be willed away or resolved through good intentions or intercultural dialogue. We need to grasp this logic before we can understand the particular nature of the social relations of power and dominance between Eurodescendants and racialized minorities — and, more importantly, before we can gauge the pervasiveness of those relations.

To understand this logic, it is important that we first acknowledge that the modern state is founded on social exclusions. States exist essentially as mechanisms to justify and normalize the domination and the violence (both symbolic and real) that some social groups exercise over others. The state enforces the delineation of the social boundaries unavoidably created by this exercise of power and violence and lays down the conditions of entry and inclusion into the political community. In this sense, race is intimately linked to the establishment, development and consolidation of the modern state. As David Theo Goldberg puts it, "Race marks and orders the modern nation-state, and so state projects, more or less from its point of conceptual and institutional emergence. The apparatuses and technologies employed by modern states have served variously to

fashion, modify, and reify the terms of racial expression, as well as racist exclusion and subjugation" (2002, 4). The modern state in its assorted incarnations is best understood, then, as *racial* state, set to preserve and regulate a key social boundary shaped by the very human tendency to locate outside the purview of one's own identity those (enemies, competitors vying for the same resources) who must be identified as different, as potentially harmful to one's own existence or survival. The modern state's defining purpose is to serve as a tool for dominant groups to enact the necessary process of otherization — the process of marking out, distinguishing, asserting and protecting their own identity and the social space they claim. Racism — the ostracizing of the Other — is in this respect more than a mentality, a deliberate purpose or an ideology; it is a fundamental function of the state meant in large part to specify membership in, and the contents and limits of, the political community.

Michel Foucault has explained that as the modern state moved, in the course of the nineteenth century, from assuming sovereign power (essentially, the right to dispose of life) to being invested with biopower (the duty to guarantee life), it lost its traditional ability to determine who was to live and who was not. This led to a conundrum: How can a power cause a person to die when its objective is primarily to ensure that this person lives? "How can the power of death, the function of death, be exercised in a political system centered on biopower?" (Foucault 2003, 254). According to Foucault, it is at this point that racism intervenes (not that it was invented at this moment — racism was manifest well before the nineteenth century), providing the state with two important tools. First, racism can be used "to separate out the groups that exist within a population...to allow power to treat that population as a mixture of races, or to be more accurate, to treat the species, to subdivide the species it controls, into subspecies known, precisely, as races." Second, and perhaps most significant, it can be used to justify killing (in a real sense, but mostly in the figurative sense of rejecting, excluding, oppressing) others, notwithstanding the fact that biopower dictates that the state should protect life, for "the death of the other, the death of the bad race, of the inferior race (or the degenerate, or the abnormal) is something that will make life in general healthier: healthier and purer" (2003, 255). Racism and, more generally, processes of racialization and otherization, then, constitute a technology of power, a protective mechanism of sorts, designed to preserve and regenerate life; racism returns to the state the mandate to kill, which biopower rendered

problematic; it makes practices of exclusion acceptable again, presumably for the greater benefit of the political community.

It is important to comprehend the fundamental nature of the state as racial in order to understand why socioeconomic differentials between Eurodescendants and racialized minorities persist in Quebec: like that of any modern state, the defining logic of the Quebec state is simply not geared to address this disparity genuinely; it is driven instead by a much stronger compulsion to maintain the social boundary that is essential to the survival of the primarily Eurocentric universe upon which Quebec society is founded.

To Quebecers whose foundational political project is predicated on the will to emancipate francophones from their supposed status as underdogs of Canadian history, this view of the Quebec state will seem offensive and inappropriate. In truth, the fact that the history of French-speaking Quebecers within Canada has been marked by social and political processes of minorization and inferiorization does nothing to minimize the reality that the Quebec state, albeit emblematic of an emancipatory and inclusive political project, derives from an intrinsically Eurocentric mode of thought and understanding of social and cultural hierarchies. As such, its constitutive discourse performs, as Ella Shohat and Robert Stam have pointed out, a number of mutually reinforcing intellectual operations whereby the West is hailed as the main engine of progressive historical change, the seedbed of democratic traditions and institutions whose inherent superiority elides all non-Western or non-European traditions; the West's oppressive practices (colonialism, slave-trading, imperialism) are presented as contingent, accidental or exceptional and unrelated to its disproportionate power in the world; and the West appropriates the cultural and material production of non-Europeans while denying their achievements and its own appropriation. In short, rooted as it is in Eurocentric conceptions of the world, the Quebec state, like all liberal-democratic Western states, is based on a discourse that "sanitizes Western history while patronizing, even demonizing the non-West [and] thinks of itself in terms of its noblest achievements — science, progress, humanism — but of the non-West in terms of its deficiencies, real or imagined" (Shohat and Stam 1994, 2-3).

By virtue of its history as a Eurosettler society, Quebec is immersed, practically by definition, in the West's own sense of superiority vis-à-vis all that does not originate from its Eurocentric framework. The Quebec state is therefore defined by this framework, committed to its axiomatic parameters and bound to

apply it. In other words, it is unlikely that it — or any Western state, for that matter — would implement any measure that could significantly alter the unequal relationship between Eurodescendants and racialized minorities and immigrant groups who do not partake of the dominant Western world view.

How can it be so? Does the pluralist and broad-minded approach to diversity management in Quebec not indicate that the Quebec state is deeply committed to addressing and redressing the effects of racial discrimination and Eurocentric dominance? Australian sociologist Ghassan Hage has compellingly established that state celebrations of multicultural and ethnocultural diversity offer no guarantee of socioeconomic redress to racialized and otherized minorities. "Multicultural tolerance," he argues, "is a strategy aimed at reproducing and disguising relationships of power in society, or being reproduced through that disguise. It is a form of symbolic violence in which a mode of domination is presented as a form of egalitarianism" (Hage 1998, 87). Similarly, Goldberg suggests that multiculturalist policies have mainly served to deflect resistance to the homogenizing exclusions of racist states (2002, 5-6). For Hage, it is important to realize that apparently antiracist or antidiscrimination policies are "not about making the powerful less so, [they are] about inviting them not to exercise their power. [They] invite those who have been uncharitable to be charitable, but it does not remove from them the power to be uncharitable" (1998, 95). The pluralist or multiculturalist rhetoric that informs antiracist policies is not meant to modify the societal imbalances between Eurodescendants and racialized and otherized minorities or to transform the dynamic of power that characterizes their interaction in the public sphere. Rather, it should be understood as a strategy designed to play down the colonial experience and the embeddedness of the Eurocentric world view, making their adverse social effects on racialized and otherized minorities more acceptable. In the end, to the extent that multiculturalist discourses (Quebec's interculturalism is one) are principally articulated and enacted by Eurodescendants and conceived to relegitimize the "White" nation, they clearly signify to minorities that while Eurodescendants may be willing to accept them, they will not relinquish their power and they will continue to determine the conditions of inclusion in the political community and define the sense of nation and citizenship that supports it.

In Quebec, as in all Western societies, the state's championing of minorities' socioeconomic advancement is far from being as genuine as it may first

appear. Its scope is restricted by the overarching social and cultural/normative
domination Eurodescendants have over the makeup of society and by the dynam-
ics of power and the (unspoken but very real) social hierarchies that ensue. There
is thus a foundational limitation inscribed in the social genesis of the state that
precludes perfect socioeconomic equality and social justice. In a capitalist market
society, this situation is invariably compounded by the discriminatory logic of the
market (Lochak 2003), and by its inherent tendency to exclude all those who are
not socially, ideologically or culturally apt to satisfy its imperatives (Latouche
1993). Redressing socioeconomic inequalities to the benefit of racialized and oth-
erized minorities would entail for Eurodescendants abandoning — or at least
compromising — their position of strength in the market. The multiplication of
state-made obstacles to the professional accreditation of foreign-trained immi-
grants and their consequent inability to enter, or thrive on, the labour market as
well as the deep-seated political and bureaucratic resistance to First Peoples' eco-
nomic control over their land (to mention only two examples among many) are
clear indications that this is still an improbable option.

Looking Ahead

WHAT IS TO BE DONE, THEN? IF THE ANALYSIS DEVELOPED IN THIS CHAPTER HAS
any value, why even bother raising the question? If, indeed, state man-
agement of ethnocultural diversity in Quebec is enmeshed in processes of pre-
serving Eurodescendants' social domination and justifying Eurocentric normative
sets, will a level playing field ever be accessible to members of racialized and oth-
erized minorities? Can social relations of power and domination in Quebec soci-
ety be altered enough to improve significantly the social and economic
circumstances of racialized and otherized minorities and instigate a regime of true
social justice?

Answering such questions is largely a matter of perspective. It depends on
the objectives one assigns to diversity management, on one's expectations of what
can reasonably be achieved within a liberal-democratic society. Looking back at
the last four decades of interethnic, intercultural and intergroup relations, we see
that Quebec's francophone Eurodescendant majority has come a long way in a
short time — from the socially dominated, inward-looking and fairly closed

social entity it was until the Quiet Revolution of the 1960s to the cosmopolitan, open to outside influences, multicultural (and even multinational) political community it is prepared to be today. From that point of view, one could easily be satisfied that Quebec's diversity management has worked well so far. Quebecers enjoy a comparatively appreciable measure of intercultural and interethnic harmony, and most segments of Quebec society are generally well disposed toward diversity. Indeed, many, and the state first among them, seem to have embraced it unreservedly. Social change works best when it comes incrementally. Everything in its time, one could argue: judging by past accomplishments, one could conclude that whatever disparities persist between Eurodescendants and the rest of the population will eventually be rectified.

But there are no guarantees that such rectification will occur. Again, it depends on our understanding of social justice. Contemporary liberal societies generally feel that their willingness to recognize difference and to accommodate institutionally the cultural claims and concerns of bearers of difference is proof enough that they are sensitive to modern requisites of social justice. Most consider it unnecessary to commit beyond that point. In Canada, governments and the organic intellectuals who support them regularly boast that their approach to diversity is the fairest and yields the best social results. If and when the situation of socioeconomic inequality with which minority groups are confronted is acknowledged, it is mostly as an unfortunate but rectifiable outcome of the capitalist market economy. The state's social welfare measures and the philosophy of equal opportunity that is said to inform the social ethos are understood as offering sufficient compensation for the inadequacies of the market and the societal imbalances that may result: members of economically disadvantaged minorities do have, after all, recourse and assistance in adverse socio-economic conditions. But as social welfare policies are being questioned and the social safety net is eroding (Boismenu, Dufour, and Saint-Martin 2004), those who have already experienced difficult circumstances are now likely to face harder times. Racialized minorities and recent immigrants are, in this respect, most vulnerable. Still, if one is happy with minimalist goals of social justice and believes it unnecessary for the state and the dominant social ethos to maintain more than the basic conditions of equal opportunity for all members of the political community, then one will see Quebec's approach to diversity management as a success.

If, on the other hand, one considers that social justice entails much more than institutional recognition of cultural difference and identity, that the politics of recognition is also a politics of wealth redistribution, that there cannot be real recognition without first ending the socioeconomic marginalization of racialized and otherized minorities (Fraser 1997, 11-39; Fraser and Honneth 2003), then Quebec's record of diversity management can only seem wanting and problematic. There are at least three reasons for this: first, Quebec's approach to diversity management fails to question the Eurocentric norms and cultural hierarchy that inform the interface between Eurodescendants and minority groups; second, it remains incapable, as a result, of transforming the prevailing dynamics of social relations of power and domination preventing the socioeconomic advancement of minorities; third, it fails to achieve the sense of intergroup solidarity that is crucial to the realization of Quebec citizenship.

Recent policy developments indicate that we should expect little improvement on this score. In spring 2005, the Charest Liberal government (elected in 2003) renamed the Ministère des Relations avec les citoyens et de l'Immigration — it is now the Ministère de l'Immigration et des Communautés culturelles — thereby modifying the nature of the state's intervention with respect to diversity management.[14] The new ministry's mission is now essentially focused on immigration and intercultural relations, and all the functions pertaining to relations with citizens have been reassigned to other ministries. Similarly, fostering a Quebec-based sense of citizenship is no longer included in the ministry's responsibilities. With this reorganization of the ministry, the notion of "cultural communities" has reentered the administrative vocabulary of the Quebec state, which by the same token reethnicizes the social relationship between the Eurodescendant francophone majority and ethnocultural minority groups and re-emphasizes the social otherness of all those whose ethnic or cultural identity is implicitly or explicitly categorized as different.

This change in institutional and administrative purpose came on the heels of a number of measures and policies adopted by the Charest administration on diversity issues up to that point, thus confirming the new Liberal government's will to steer clear of the vision of transcultural and transethnic citizenship progressively developed by previous governments. In its 2004 action plan (titled *Des valeurs partagées, des interêts communs*), the government had already formulated unequivocal policy parameters to that effect: though the tone of the document may give the

impression that the government embraces diversity and celebrates intercultural dialogue, it nonetheless suggests that diversity can be a problem if immigrants and members of ethnocultural communities do not abide by Quebec's social norms and value set; the government is adamant that while Quebecers must make an effort to open themselves to diversity, it is incumbent upon immigrants and members of ethnocultural communities to fit into Quebec's social space, on Quebec society's terms.[15] This new approach constitutes a policy shift away from attempts — particularly those of the previous, Parti Québécois government — to consider all who reside on the Quebec territory as full-fledged Quebec citizens, regardless of their background and the depth of their personal *enracinement* in Quebec society and history. It signals, in fact, a return to the philosophy of otherization that informed diversity management in Quebec until the late 1990s. Rather than treating immigrants and members of racialized minorities as integrated citizens, the government has set up a liaison office responsible for maintaining relationships with the various ethnocultural communities that make up Quebec society. Civil servants have been mandated to liaise specifically with the "Black community" and immigrant communities from the Asia-Pacific region, the Maghrib, the Middle East, Latin America, the United States and Europe. Similarly, in keeping with this vision, the Semaine de la citoyenneté, an annual government-sponsored event aimed at fostering a transcultural and transethnic sense of belonging to Quebec society, has been replaced by the Semaine des rencontres interculturelles.

Though it is true that the Parti Québécois government's latter-day policy emphasis on citizenship and on civic — as opposed to ethnic — belonging did not necessarily succeed in curtailing the socioeconomic gap between ethnocultural minorities and the Eurodescendant majority, it is unlikely that the approach of the Charest government will rectify the situation and set diversity management in Quebec on a more inclusive course or create a more level playing field. Insistence on citizenship implies that members of minority groups can exist as self-possessed social actors empowered with rights through which they can assert and negotiate on an equal footing the terms of their integration into society. But the recategorization of immigrants and members of racialized minorities as "cultural communities" reduces their participation in the political community to a moral trade-off — "We'll let you in as long as you play by our rules" — which leaves unaddressed, and in fact maintains, the social hierarchies that set them apart and ultimately isolate them from the Eurodescendant majority.

Conclusion

WERE WE TO ATTEMPT TO SATISFY THE IMPERATIVES OF A MORE DEMANDING SOCIAL justice in matters of diversity management, what kind of policy platform would we need? Quebec and Anglo-Canadian scholarly works on diversity are replete with wishful thinking underlain by denial of the problematic applications of multicultural or intercultural visions. Consequently, policy prescriptions for a more just diverse society often rely on the goodwill and the ability of citizens and existing institutional mechanisms to make enlightened choices between individual and group rights, between institutional equality and asymmetry, between market freedom and economic security. They assume in so doing the existence of a "strong and healthy public sphere" rooted in ongoing dialogues between stakeholders, a commitment to governmental consultation, inclusiveness and adequate structures for state-society discussions (Jenson and Papillon 2001, 38). While appropriate spaces for civilized deliberation and peaceful conflict resolution do exist in societies like Quebec and Canada, there is no guarantee that there will be full redress of socioeconomic disparities. Deliberations are not free of power plays. The very vocabulary and normative parameters that are imposed to frame the discussion — usually by the strongest interlocutor — are in and of themselves acts of exclusion that perpetuate the imbalances that the recourse to dialogue was supposed to address. In fact, as several authors have shown, the rhetoric of diversity management in Canada (including Quebec), though premised on conversation across cultures, is fraught with deeply entrenched perceptions of immigrants and racialized minorities as outsiders and intruders, as a source of social problems (overcrowding in major cities, urban crime, increased poverty, undue pressure on state services), which, if they are not dealt with, can contaminate the sense of nation and citizenship upon which the country is predicated (Day 2000; Li 2003; Thobani 2000).

The real policy challenge for anyone committed to redressing the socioeconomic deficit of racialized minorities and immigrants is to think outside the box, outside hegemonic Eurocentric categories, notions and goals of unitary nationhood. This implies that a real and pervasive transformation, indeed a rejection, of the social and cultural ascendancy Eurodescendants have imposed and maintained on immigrants, racialized minorities and First Peoples must be initiated and implemented. As paradoxical as it may seem, it also implies that

Eurodescendant majorities must stop thinking in terms of "diversity management" and refrain from posing the Other as a problem to be solved. Given the pivotal role played by Eurocentric views and ways in the socioeconomic marginalization of minorities, it is difficult to see how anything less than a radical departure from Eurocentrism can achieve the type of change that would be desirable. Ironically, such an option is also hard to envisage, precisely because of the centrality of Eurocentric modes of thought to Quebec's sociopolitical imagination. That such a break could occur in any Western society (at least in the short term) is unthinkable; it is most improbable in Quebec. The self-perception of French-speaking Quebecers is still largely shaped by their recent past as an inferiorized and marginalized national minority in the Canadian political context. They have long been kept on the outer edge of Eurocentric hegemony, not reaping its full benefits: they do not think of themselves as participants in the Eurocentric power system, and they feel uneasy about being perceived as an integral part of it by those who sit outside of it. Yet large segments of the French-speaking majority cling to the unrealized dream of one day forming a full-fledged nation-state in which they would be the defining national group, enforcing criteria of political community firmly rooted in the Western political tradition.

This tension between the power the French-speaking majority will not admit to having and its will to exercise power it does not actually have is what makes the emergence of alternative policies of diversity management virtually impossible in Quebec. As the majority does not see itself as buying into the Eurocentric social and political logic, it feels no responsibility for its effects on racialized and otherized minorities, and it is therefore not as deeply moved as it might be by calls for social change that would involve neutralizing that logic. Similarly, driven in part by the desire to exercise sovereign power, Quebecers are unlikely, if they ever achieve that power, to let go of the very vision that guided them to it.

In the end, it is improbable that the state will initiate on its own the kind of changes that a healing of the social divide and a dismantling of the hierarchies separating Eurodescendants from other Quebecers would require. Transformation of this nature can be triggered only by what Michel Foucault has called "contre-conduites" — by the resistance of those who have been marginalized and excluded by Eurocentric practices of power, by the questioning of the very essence of Eurocentric models. Mohawk scholar Taiaiake Alfred

states it unequivocally. In his view, First Peoples are now at the point where they must launch

> a challenging and powerful attack on the very foundation of colonial mentality and Settler society. Euroamerican confidence in their own rectitude and the security of the moral rightness of their civilizing mission must be attacked and destroyed...[First Peoples] must advance an agenda of social equality and political pluralism by shining the light of radical truth through the fog of racial prejudice and overwrought emotional attachments to colonial institutions that make up the state and culture of colonial society...It seems that if we are to move beyond the charitable racism of current policies or paternalist progressivism of liberal reconciliation models, justice must become a *duty* of, not a *gift* from, the Settler. And for this to happen, Settler society must be forced into a reckoning with its past, its present, its future, and itself. White people who are not yet decolonized must come to admit they were and are wrong. (2005, 104, 113)

The history of First Peoples' relationship with Eurodescendants is quite particular, of course, and all racialized and other ethnocultural minority groups may not feel the same compulsion to break free of Eurocentric sociopolitical systems. However, as Alfred indicates, for many who bear the brunt of Eurocentric manifestations of power, a point of no return has finally been reached. If his call is heeded, clearly the conventional ways of diversity management, whether in Quebec or other Western democracies, will have to be seriously reconsidered.

Notes

1 Since the early 1970s, Quebec and Ottawa have signed a number of bilateral agreements detailing the administrative latitude of the Quebec government in matters of immigration. Although several other provinces have also signed immigration agreements with Ottawa, Quebec remains "the only province to have concluded a comprehensive agreement between a province and the Government of Canada for the purpose of facilitating the formulation, coordination and implementation of immigration policies and programs with respect to the admission of foreign nationals to the province" — the 1991 Canada-Quebec Accord Relating to the Immigration and Temporary Admission of Aliens (Singer n.d.; see also Young 2004). The Quebec government thus enacts its own laws regulating the selection of immigrants wishing to settle permanently or temporarily in Quebec.

2 Throughout this chapter, I use the term "diversity management" partly in (reluctant) compliance with widely accepted usage, but mostly because when it comes to ethnocultural diversity, "managing" is largely what most contemporary liberal-democratic states actually do. In my view, though, the idea that diversity must be "managed" is suspect. It suggests that it is something of a problem to be resolved or kept in check. Implicit in the very notion of diversity management is the fact that the situation of ethnocultural plurality that has developed in most liberal-democratic societies appears almost as a social pathology that must be addressed, reined in at times, so as to minimize the threat it poses to the framework of sociopolitical homogeneity and normative uniformity to which politically and culturally dominant groups generally prefer society to conform. However, "diversity management" also implies that a certain social and cultural hierarchy is at work, tracing a dividing line between the mainstream constituents of society and others — the "ethnics," the "visible minorities," the immigrants — whose presence forces us to reconsider and modify the conventional terms and conditions of existence of the political community and who therefore must be dealt with. "Diversity management" thus evokes a political dynamic of tension and power relations between mainstream society and the "Other" (with his/her particular claims and resistances to the norms, values and preoccupations of mainstream society). In this sense, the notion of diversity management can also be an apt descriptor of social reality.

3 I deliberately use the term "Eurodescendant" to identify those who benefit today from the advantageous social hierarchies and relations of power and domination derived from the colonial dynamics and Eurocentric value system brought to Canada first by settlers and later by immigrants from Western and Eastern Europe. The term includes, of course, not only the French-speaking majority but also all Quebecers of European ancestry. Similarly, I use the adjective "Eurocentric" to qualify policies, sociopolitical visions, world views or social attitudes that clearly bear the normative and cultural imprint of Eurodescendants and that reflect the dominance of their societal influence on the Canadian and Quebec political communities. In the context of this chapter, the words "Eurodescendant" and "Eurocentric" are thus meant to underscore the economic and sociopolitical distance that separates people of European origin — who are therefore "invisible" (by contrast to the state category of "visible minority"), nonracialized, nonotherized and presumably politically unproblematic — from all the others — that is, First Peoples and racialized Canadians and racialized immigrants — whom diversity policies actually target, for they represent something of a problem to be resolved in the minds of mainstream Eurodescendants.

4 Quebec's common public culture is said to rest on the following values and parame-

ters: democracy and the principles enshrined in the Quebec Charter of Rights and Freedoms; secularism; the French language as the only official language of public transaction; the peaceful resolution of conflicts; pluralism, including respect for the rights of First Peoples and of the anglophone minority; respect for Quebec's cultural heritage; and equality between men and women.

5 Namely, the term "cultural communities," which was used until then to designate those whose ancestry was neither French nor English.

6 The 11 nations are 10 Aboriginal nations (Mohawk, Huron-Wendat, Algonquin, Innu, Maliseet, Mi'kmaq, Naskapi, Cree, Attikamek and Abenaki) and the Inuit, who are not subject to the *Indian Act* and who see themselves as a people rather than as a First or Aboriginal Nation.

7 One should recall, though, that Robert Bourassa's Liberal government had passed Bill 22 three years earlier, in 1974. This particular legislation limited the right to choose the language in which one's children would be schooled by restricting access to English schools to children with sufficient prior knowledge of English to receive instruction in that language. Though it was legislation that pleased no one, it nonetheless cleared the path for the Parti Québécois government's Bill 101, which forced immigrant children to attend French schools.

8 For an illuminating discussion of these theoretical considerations, see Karmis (2004).

9 The notion of low income is derived from Statistics Canada's low-income cutoff (LICO) measurement. When the LICO was first introduced, in the late 1960s, expenditure patterns indicated that Canadians spent about 50 percent of their income on basic necessities (food, shelter and clothing). It was arbitrarily estimated that families spending 70 percent or more of their income on basic necessities (20 percentage

points more than the average) faced adverse circumstances. Since then, the proportion of income spent on basic necessities has declined. Over the past decade, it has remained fairly stable (at around 35 percent). By adding the original 20 percent difference to the basic level of expenditure on necessities, new low-income cutoffs have been set and updated yearly at income levels differentiated by family size and degree of urbanization. LICOs are not measures of poverty; they reflect a consistent and well-defined methodology meant to identify those who are substantially worse off than average. Incidence of low income is calculated from rounded counts of low-income persons or families and the total number of persons or families (see Jedwab 2004a).

10 The empirical data presented here are drawn from Statistics Canada but are borrowed from special compilations available on the Web site of the Association for Canadian Studies (http://www.acs-aec.ca [click on "polls"]); see Jedwab (2003, 2004a, 2004b, 2004c). Data from the Ministère de l'Immigration et des Communautés culturelles have also been used (2005).

11 Indeed, there is a higher percentage (57.5 percent) of people without postsecondary education in the general population than in the community of Afrodescendants (55.5 percent). Roughly one in three Afrodescendants have completed training and education beyond high school, as opposed to one in four in the general population.

12 In recent years, there has been an abundance of studies documenting the deterioration of the socioeconomic circumstances of immigrant and racialized minorities and the growing discrepancies in access to labour markets and general material well-being between Eurodescendants and minorities, particularly racialized minorities, in Canada. See, among others, Alboim, Finnie, and Meng (2005); Galabuzi (2001);

Kazemipur and Halli (2001); Kunz, Milan, and Schetagne (2000); Pendakur (2000); Picot and Feng (2003); Teelucksingh and Galabuzi (2005).

13 According to Statistics Canada's 2002 Ethnic Diversity Survey, quoted in Sadiq (2005, 69).

14 The name change came into force on June 17, 2005, through an act of the National Assembly (*An Act Respecting the Ministère de l'Immigration et des Communautés culturelles*), adopted a week earlier.

15 They are indeed reminded of this responsibility in no uncertain terms. The 2004 action plan insists that "Cet appel de l'ensemble des Québécois à l'ouverture à la diversité ne doit pas occulter les responsabilités des personnes issues de l'immigration. Toutes ont le droit de choisir leur style de vie, mais toutes ont aussi la responsabilité de respecter les lois. Le Québec est une société démocratique où l'expression des rivalités ethniques, politiques et religieuses n'est pas tolérée, pas plus que la violence conjugale ou familiale. L'indépendance des pouvoirs politiques et religieux est une valeur fondamentale de même que l'égalité des femmes et des hommes et le respect du français — langue officielle du Québec — dans la vie publique. Ces valeurs, énoncées au 'contrat moral,' sont le fondement de la réussite de l'intégration des immigrants et de l'harmonisation des relations interculturelles au sein de la société québécoise" (Ministère des Relations avec les citoyens et de l'Immigration 2004, 80). ("This call for the opening of Quebec society to diversity must not overlook the responsibilities of immigrants. Everyone has the right to choose their mode of living, but they also have the responsibility to respect the law. Quebec is a democratic society in which expressions of ethnic, political or religious rivalries are not tolerated, just as conjugal or family violence is not tolerated. Political and religious freedom is a fundamental value of public life — as are gender equali-

ty and respect for French, Quebec's official language. These values, proclaimed in the 'moral contract,' are the basis for the successful integration of immigrants and for the harmonization of intercultural relations in Quebec society.")

References

Alboim, Naomi, Ross Finnie, and Ronald Meng. 2005. "The Discounting of Immigrants' Skills: Evidence and Policy Recommendations." *IRPP Choices* 11 (2).

Alfred, Taiaiake. 2005. *Wasase: Indigenous Pathways of Action and Freedom*. Peterborough, ON: Broadview Press.

Bariteau, Claude. 1998. *Québec: 18 septembre 2001*. Montreal: Québec Amérique.

Boismenu, Gérard, Pascale Dufour, and Denis Saint-Martin. 2004. *Ambitions libérales et écueils politiques: réalisations et promesses du gouvernement Charest*. Montreal: Athéna.

Bourque, Gilles, and Jules Duchastel. 1996. *L'Identité fragmentée: nation et citoyenneté dans les débats constitutionnels canadiens, 1941-1992*. Montreal: Fides.

Commission sur l'avenir politique et constitutionnel du Québec. 1991. *L'Avenir politique et constitutionnel du Québec*. Quebec: Éditeur officiel du Québec.

Day, Richard. 2000. *Multiculturalism and the History of Canadian Diversity*. Toronto: University of Toronto Press.

Derriennic, Jean-Pierre. 1995. *Nationalisme et démocratie: réflexion sur les illusions des indépendantistes québécois*. Montreal: Boréal.

Fontaine, Louise. 1993. *Un labyrinthe carré comme un cercle: enquête sur le Ministère des Communautés culturelles et de l'Immigration et sur ses acteurs réels et imaginés*. Montreal: Étincelle Éditeur.

Foucault, Michel. 2003. *"Society Must Be Defended": Lectures at the Collège de France, 1975-1976*. Trans. Graham Burchell. New York: Picador.

Fraser, Nancy. 1997. *Justice Interruptus: Critical Reflections on the "Postsocialist" Condition*. New York: Routledge.

Fraser, Nancy, and Axel Honneth. 2003. *Redistribution or Recognition? A Political-Philosophical Exchange*. London and New York: Verso.

Gagnon, Alain G., and Raffaele Iacovino. 2004. "Interculturalism: Expanding the Boundaries of Citizenship." In *Quebec: State and Society*, edited by Alain G. Gagnon. 3rd ed. Peterborough, ON: Broadview Press.

Galabuzi, Grace-Edward. 2001. *Canada's Creeping Economic Apartheid: The Economic Segregation and Social Marginalization of Racialised Groups*. Toronto: CSJ Foundation for Research and Education.

Goldberg, David Theo. 2002. *The Racial State*. Oxford: Blackwell.

Groupe de recherche ethnicité et société. 1992. "Immigration et relations ethniques au Québec: un pluralisme en devenir." In *Le Québec en jeu*, edited by Gérard Daigle and Guy Rocher, 451-81. Montreal: Les Presses de l'Université de Montréal.

Hage, Ghassan. 1998. *White Nation: Fantasies of White Supremacy in a Multicultural Society*. Annandale: Pluto Press Australia.

Helly, Denise. 1996. *Le Québec face à la pluralité culturelle, 1977-1994: un bilan documentaire des politiques*. Sainte-Foy, QC: Institut québécois de recherche sur la culture, Les Presses de l'Université Laval.

Helly, Denise, and Nicolas Van Schendel. 2001. *Appartenir au Québec: citoyenneté, nation et société civile: enquête à Montréal*. Sainte Foy, QC: Les Presses de l'Université Laval.

Jedwab, Jack. 2003. "Taux de chômage des minorités visibles dans le 'melting pot' et mosaïque, 2001." Association for Canadian Studies. Accessed August 8, 2005. http://www.acs-aec.ca/Polls/Poll31.pdf

———. 2004a. "Defining Low Income." Accessed August 8, 2005. http://www.acs-aec.ca/Polls/LowIncome.pdf

———. 2004b. "Melting Mosaic: Money and Ethnics in Canada and the United States at the Turn of the Century." Accessed August 8, 2005. http://www.acs-aec.ca/Polls/08-2004_2.pdf

———. 2004c. "Montreal's Ethnic Groups, Languages and Economy: Is Bilingualism a Must?" Association for Canadian Studies. Accessed August 8, 2005. http://www.acs-aec.ca/Polls/18-03-2004.pdf

Jenson, Jane, and Martin Papillon. 2001. *The "Canadian Diversity Model": A Repertoire in Search of a Framework*. Discussion paper F-19. Ottawa: Canadian Policy Research Networks.

Johnson, William. 1994. *A Canadian Myth: Quebec between Canada and the Illusion of Utopia*. Montreal: Robert Davies.

Juteau, Danielle. 2000. *Les Ambiguïtés de la citoyenneté au Québec*. Collection: Les Grandes Conférences Desjardins. Montreal: Programme d'études sur le Québec, McGill University, November 23. Accessed June 20, 2006. http://www.mcgill.ca/files/qcst/DanielleJuteaupdf.pdf

———. 2002. "The Citizen Makes an Entrée: Redefining the National Community in Quebec." *Citizenship Studies* 6 (4): 441-58.

Juteau, Danielle, and Marie McAndrew. 1992. "Projet national, immigration et intégration dans un Québec souverain." *Sociologie et Sociétés* 24 (2): 161-80.

Juteau, Danielle, Marie McAndrew, and Linda Pietrantonio. 1998. "Multiculturalism à la Canadian and Integration à la Québécoise." In *Blurred Boundaries: Migration, Ethnicity, Citizenship*, edited by Rainer Bauböck and John Rundell, 95-110. Aldershot, UK: Ashgate.

Karmis, Dimitrios. 2004. "Pluralism and National Identity(ies) in Contemporary Quebec: Conceptual Clarifications, Typology, and Discourse Analysis." In *Quebec: State and Society*, edited by Alain G. Gagnon. 3rd ed. Peterborough, ON: Broadview Press.

Kazemipur, Abdolmohammad, and Shiva S. Halli. 2001. "The Changing Colour of Poverty in Canada." *Canadian Review of Sociology and Anthropology* 38 (2): 217-38.

Khouri, Nadia. 1996. "La Panique devant le multiculturalisme." *Cité Libre* 24 (2): 12-16.

———. 2000. "The Decline of the Separatist Empire." *Cité Libre* 28 (4): 68-72.

Kunz, Jean Lock, Anne Milan, and Sylvain Schetagne. 2000. *Unequal Access: A Canadian Profile of Racial Differences in Education, Employment and Income.* Toronto: Canadian Race Relations Foundation.

Labelle, Gilles. 1998. "Le 'Préambule' à la 'Déclaration de souveraineté': penser la fondation au-delà de la 'matrice théologico-politique.'" *Canadian Journal of Political Science* 31 (4): 659-81.

Labelle, Micheline. 1998. "Immigration et diversité ethnoculturelle: les politiques québécoises." *Cahiers du Programme d'Études Québécoises* 13.

———. 2000. "La Politique de la citoyenneté et de l'interculturalisme au Québec: défis et enjeux." In *Les Identités en débat: intégration ou multiculturalisme?*, edited by Hélène Greven-Borde and Jean Tournon, 269-94. Paris: L'Harmattan.

Labelle, Micheline, and François Rocher. 2004. "Debating Citizenship in Canada: The Collide of Two Nation-Building Projects." In *From Subjects to Citizens: A Hundred Years of Citizenship in Australia and Canada*, edited by Pierre Boyer, Linda Cardinal, and David Headon, 263-86. Ottawa: University of Ottawa Press.

Labelle, Micheline, François Rocher, and Guy Rocher. 1995. "Pluriethnicité, citoyenneté et integration: de la souveraineté pour lever les obstacles et les ambiguïtés." *Cahiers de Recherche Sociologique* 25:213-45.

Labelle, Micheline, and Daniel Salée. 2001. "Immigrant and Minority Representation of Citizenship in Quebec." In *Citizenship Today: Global Perspectives and Practices*, edited by T. Alexander Aleinikoff and Douglas Klusmeyer, 278-315. Washington: Carnegie Endowment for International Peace.

Labelle, Micheline, Daniel Salée, and Yolande Frenette. 2001. *Incorporation citoyenne et/ou exclusion? La deuxième génération issue de l'immigration haïtienne et jamaïcaine.* Toronto: Canadian Race Relations Foundation.

Laforest, Guy. 1995. *De l'urgence: textes politiques, 1995.* Montreal: Boréal.

Latouche, Serge. 1993. *In the Wake of the Affluent Society: An Exploration of Post-Development.* London: Zed Books.

Ledoyen, Alberte. 2001. *Le Regard des petits propriétaires sur les demandeurs de logements: étude exploratoire sur les perceptions et les attitudes des petits propriétaires envers les clientèles des minorités ethnoculturelles.* Montreal: Commission des droits de la personne et des droits de la jeunesse, Centre de recherche interuniversitaire de Montréal sur l'immigration, l'intégration et la dynamique urbaine.

Leloup, Xavier. 2005. *Conditions de logement des ménages immigrants au Québec: une réalité contrastée.* Montreal: Société d'habitation du Québec.

Létourneau, Jocelyn, and Jacinthe Ruel. 1994. "Nous autres les Québécois: topiques du discours franco-québécois sur Soi et sur l'Autre dans les mémoires déposés devant la Commission Bélanger-Campeau." In *Mots, representations: enjeux dans les contacts interethniques et interculturels*, edited by K. Fall, D. Simeoni, and G. Vignaux, 283-307. Ottawa: Les Presses de l'Université d'Ottawa.

Li, Peter. 2003. "The Place of Immigrants: The Politics of Difference in Territorial and Social Space." *Canadian Ethnic Studies* 35 (2): 1-13.

L'Indice. 1996. *Étude sur les producteurs de comportements racistes lors de l'insertion à l'emploi des jeunes travailleurs de 15-29 ans.* Quebec: Ministère des Affaires internationales, de l'Immigration et des Communautés culturelles.

Lochak, Danièle. 2003. "Loi du marché et discrimination." In *Lutter contre les discriminations*, edited by Daniel Borillo, 11-37. Paris: La Découverte.

Manègre, Jean-François. 1993. *L'Immigration et le marché du travail: un état de la question.* Quebec: Conseil des relations interculturelles.

Marhraoui, Azzeddine. 2004. "Nationalisme et diversité ethnoculturelle au Québec (1990-2000): divergences et convergences à pro-

pos du projet de citoyenneté québécoise."
Ph.D. diss., Université du Québec à
Montréal.

McAndrew, Marie. 1995. "Multiculturalisme
canadien et interculturalisme québécois:
mythes et réalités." In *Pluralisme et éduca-
tion: politiques et pratiques au Canada, en
Europe et dans les pays du sud: l'apport de l'é-
ducation comparée.* Vol. 1, edited by M.
McAndrew, R. Toussaint, O. Galatanu, and
C. Ciceri, 33-51. Montreal and Paris:
Publications de la Faculté des sciences de
l'éducation, Association francophone d'édu-
cation comparée.

_____. 2001. *Immigration et diversité à l'école: le
débat québécois dans une perspective compara-
tive.* Montreal: Les Presses de l'Université de
Montréal.

_____. 2003. "Immigration and Diversity: Some
Policy Issues Confronting the Quebec
School System." *Policy Options* 24 (8).
Montreal: IRPP.

Pâquet, Martin. 2005. *Tracer les marges de la cité:
étranger, immigrant et État au Québec, 1627-
1981.* Montreal: Boréal.

Pendakur, Ravi. 2000. *Immigrants and the Labour
Force: Policy, Regulations and Impact.*
Montreal: McGill-Queen's University Press.

Picot, Garnett. 2004. *The Deteriorating Economic
Welfare of Immigrants and Possible Cause.*
Analytical Studies Branch Research Paper
Series no. 222. Cat. no. 11F0019MIE.
Ottawa: Statistics Canada.

Picot, Garnett, and Feng Hou. 2003. *The Rise in
Low-Income Rates among Immigrants in
Canada.* Analytical Studies Branch Research
Paper Series no. 198. Cat. no.
11F0019MIE. Ottawa: Statistics Canada.

Pietrantonio, Linda. 2002. "Who Is 'We'? An
Exploratory Study of the Notion of 'the
Majority' and Cultural Policy." *Canadian
Ethnic Studies* 34 (3): 142-56.

Potvin, Maryse. 2000. "Racisme et citoyenneté
chez les jeunes Québécois de la deuxième
génération haïtienne." In *L'Individu et le
citoyen dans la société moderne*, edited by
Maryse Potvin, Bernard Fournier, and Yves

Couture, 185-226. Montreal: Les Presses de
l'Université de Montréal.

_____. 2004. "Racisme et discrimination au
Québec: critique et prospective sur la
recherche." In *Racisme et discrimination: per-
manence et résurgence d'un phénomène
inavouable*, edited by Jean Renaud, Annick
Germain, and Xavier Leloup, 172-95.
Montreal: Les Presses de l'Université Laval.

Quebec. Ministère de l'Immigration et des
Communautés culturelles. 2005. "La Pleine
Participation à la société québécoise des
communautés noires." Document de con-
sultation. Quebec: Gouvernement du
Québec.

Quebec. Ministère des Relations avec les citoyens
et de l'Immigration. 2000. *La Citoyenneté
québécoise: document de consultation pour le
forum national sur la citoyenneté et l'intégra-
tion.* Quebec: Éditeur officiel du Québec.

_____. 2004. *Des valeurs partagées, des intérêts
communs: pour assurer la pleine participation
des Québécois des communautés culturelles au
développement du Québec.* Montreal:
Ministère des Relations avec les citoyens et
de l'Immigration.

Renaud, Jean, L. Gingras, S. Vachon, C. Blaser,
J.F. Godin, and B. Gagné. 2001. *Ils sont
maintenant d'ici! Les dix premières années au
Québec des immigrants admis en 1989.*
Études, Recherches et Statistiques 4.
Quebec: Ministère des Relations avec les
citoyens et de l'Immigration.

Richler, Mordecai. 1992. *Oh Canada! Oh Quebec!
Requiem for a Divided Country.* Toronto:
Penguin.

Robin, Régine. 1996. "L'Impossible Québec
pluriel: la fascination de 'la souche.'" In *Les
Frontières de l'identité: modernité et postmod-
ernisme au Québec*, edited by Mikaël Elbaz,
Andrée Fortin, and Guy Laforest. Sainte-
Foy, QC: Les Presses de l'Université Laval.

Sadiq, Kareem D. 2005. "Race, ethnicité et immi-
gration en milieu de travail." *Canadian
Issues/Thèmes canadiens* (spring): 69-75.

Salée, Daniel. 1995. "Espace public, identité et
nation au Québec: mythes et méprises du

discours souverainiste." *Cahiers de Recherche Sociologique* 25:125-53.

_____. 2001. "De l'avenir de l'identité nationale québécoise." In *Repères en mutation: identité et citoyenneté dans le Québec contemporain*, edited by Alain G. Gagnon and Jocelyn Maclure, 133-64. Montreal: Québec Amérique.

Sarra-Bournet, Michel, ed. 1998. *Le Pays de tous les Québécois: diversité culturelle et souveraineté*. Montreal: VLB Éditeur.

Seymour, Michel. 1999. *La Nation en question*. Montreal: Hexagone.

_____. 2000. "Quebec and Canada at the Crossroads: A Nation within a Nation." *Nations and Nationalism* 6 (2): 227-56.

Shiose, Yuki, and Louise Fontaine. 1995. "La Construction des figures de l'"Autre": les communautés culturelles au Québec." *Canadian Review of Sociology and Anthropology* 32 (1): 91-110.

Shohat, Ella, and Robert Stam. 1994. *Unthinking Eurocentrism: Multiculturalism and the Media*. London and New York: Routledge.

Simard, Carolle. 2001. *La Représentation des groupes ethniques et des minorités visibles au niveau municipal: candidats et élus*. Quebec: Conseil des relations interculturelles.

Singer, Colin R. n.d. "Quebec Immigration Rules." Canadian Citizenship and Immigration Resource Center. Accessed September 5, 2005. http://www.immigration.ca/permres-qc-rules.asp

Symons, Gladys. 2002. "The State and Ethnic Diversity: Structural and Discursive Change in Quebec's Ministère de l'Immigration." *Canadian Ethnic Studies* 34 (1): 28-46.

Teelucksingh, Cheryl, and Grace-Edward Galabuzi. 2005. *Working Precariously: The Impact of Race and Immigrant Status on Employment Opportunities and Outcomes in Canada*. Toronto: Canadian Race Relations Foundation.

Thériault, Joseph-Yvon. 2003. "Le Projet d'une citoyenneté québécoise: un décollage difficile." In *L'Annuaire du Québec 2003*, edited by Roch Côté and Michel Venne, 27-52. Montreal: Fides.

Thobani, Sunera. 2000. "Nationalizing Canadians: Bordering Immigrant Women in the Late Twentieth Century." *Canadian Journal of Women and the Law* 12 (2): 279-312.

Trépanier, Anne. 2001. *Un discours à plusieurs voix: la grammaire du OUI en 1995*. Sainte-Foy, QC: Les Presses de l'Université Laval.

Turner, Bryan S. 1997. "Citizenship Studies: A General Theory." *Citizenship Studies* 1 (1): 5-17.

Vermette, Monique, Mylène Jacquet, and Marie McAndrew. 2000. *Éducation à la citoyenneté et adultes nouveaux arrivants: l'expérience québécoise*. Montreal: Immigration et métropoles.

Young, Margaret. 2004. *Immigration: The Canada-Quebec Accord*. Parliamentary Information and Research Office, Library of Parliament, publication BP-252E. Accessed August 8, 2005. http://www.parl.gc.ca/information/library/PRBpubs/bp252-e.htm

Quebec's Interculturalism Policy: An Alternative Vision

Commentary

R EADING DANIEL SALÉE'S CHAPTER IN THIS VOLUME, "THE QUEBEC STATE AND THE Management of Ethnocultural Diversity: Perspectives on an Ambiguous Record," in order to propose a critical reaction to his depiction of the *grandeurs et misères* of the Quebec state's record on the management of ethnocultural diversity was a very interesting and challenging task. The chapter provides an extremely thorough review of the literature and presents the author's personal and often insightful analysis. It is a complex, comprehensive and balanced account of the origins, development and limits of Quebec's 30-year attempt to build a specific model of integration and intercultural relations.

As an analyst of comparative policies, I agreed especially with the main thesis of the paper — that is, that a common lack of effectiveness characterizes most multicultural/intercultural diversity management policies, whatever nuances they may possess, in combatting ethnic and social inequalities. They make this failure all too obvious, and ironic, when they stress as their primary goal the equality of citizens — consistent with the Republican model — and refuse to accommodate diversity specifically for that reason (Costa-Lacoux and Mc Andrew 2005). But it is certainly a reality no current Western society has escaped, whatever degree of recognition that society may grant to pluralism (Modood et al. 1997; Portes and Rumbaut 2001).

For some time, I have been convinced that this common failure should prompt us, when trying to explain the persistence of interethnic inequalities, to focus less on normative and legal frameworks and more on implementation and the impact of other policies (such as those applying to the selection of immigrants). Which is why I have some reservations — or, at least, some alternative

or complementary hypotheses — about the reasons Salée proposes for the weakness of Quebec's report card on equality. Indeed, although his "racial state" hypothesis may be impressive as a "grand theory," it appears too remote from the reality of the field, where many much less ideological shortcomings can be identified. Moreover, for both policy-makers and members of minorities, it may have a very demobilizing impact: it evokes a dreadful reminiscence of the seventies, when women were told to wait for the fall of capitalism before addressing gender inequalities. But, before I dwell on that shortcoming — which I consider the main fault of the paper — I would like to address two other issues not unrelated to the reader's occasional sense that the author is disregarding reality for the sake of preserving a theory.

The first such issue involves the data quoted to illustrate the persistence of interethnic inequalities across generations, a central point of Salée's hypothesis that it is the racial nature of Western states that is at the root of the problem, not other factors usually linked to individual characteristics of migrants and their descendants, such as mastery of the host language or birth status. In this regard, international and national literature on socioeconomic integration certainly supports the existence of an unexplained racial or ethnic residual, after every other variable has been considered (Portes 1996; Renaud, Piché, and Godin 2002; Picot and Hou 2003). But Salée glosses over differences experienced by racial minorities. To limit my argument to the field I know best — education — a recent comprehensive study of the school careers of Black youths in Quebec clearly shows major differences in the graduation rates among students.

At one end of the spectrum, one can quote the positive educational experience of girls of African descent, born in Quebec, living in Laval in a middle or high socioeconomic milieu, whose mother tongue is French, who entered the school system at the primary level. At the other, one can cite the rather disastrous school careers of West Indian boys, born outside Quebec, living in Montreal in an inner-city milieu, whose mother tongue is Creole or English, who entered the school system during their secondary studies (Mc Andrew, Ledent, and Ait-Said 2005). But even without choosing such an example of additive, negative or positive characteristics, the simple fact of having French as one's mother tongue and of being born in Quebec already reduces the gap between Black youth and the whole school population to a few percentage points. Moreover, social class and gender continue to be the main factors influencing school success: if one had to

choose between competing evils, one would likely elect to be a Black girl rather than a White boy, or a middle-class Black student rather than a working-class White student — especially among youth born in Canada, the group at the core of the racial state argument.

My second point concerns the comparison that Salée draws — or, more accurately, fails to draw — between Canadian multiculturalism and Quebec interculturalism. He states, quite rightly, that these policies are not so different from one another — or, at least, that with some distance, "une chatte n'y reconnaîtrait pas ses petits" (especially if it was a Republican French cat). Although in Salée's chapter I and several of my colleagues have been quoted among those claiming that there are major differences between the policies, I have argued the contrary in most of my writing (see, for example, Pietrantonio, Juteau, and Mc Andrew 1996; Juteau, Mc Andrew, and Pietrantonio 1998; Mc Andrew 1996a, b). But this assessment must be qualified if we do not want to fall into the rather common trap of using concepts to classify policies so dichotomic that most of them fall into the same category, such as pluralist integration opposed to assimilation, exclusion or self-segregation (Berry 1990). Nowadays, there is hardly a Western government that does not promote, when managing ethnocultural diversity, three valuable competing social objectives: cultural maintenance, social harmony and equity (Gagnon and Pagé 1999). And because policies, whether they are implemented or not, play a mainly rhetorical role, they all profess to do so with an equal intensity and without any tension. Nevertheless, when resources are scarce, as they always are, there are ways of slightly privileging one or other of these objectives, and such small differentiations may have, over time, a significant impact on what governments do (Mc Andrew 2003b). Observing the implementation of Canadian multiculturalism and Quebec interculturalism as both an analyst and a social actor, I am convinced that varying the amount of stress put on otherwise shared commitments has had some effect on the mobilization of institutional resources and, most of all, civic resources for fighting interethnic inequalities in Quebec.

Quebec interculturalism has always been more concerned with weighing diversity and fundamental values, as stated in the third principle of the "moral contract" (Quebec, Ministère des Communautés culturelles et de l'Immigration [MCCI] 1990), which links it more closely to many debates held in Europe in the 1980s and 1990s (Lapeyronnie 1993; Modood and Werbner 1997). Canadian

multiculturalism pays much less attention to that complex issue — at least in its public expression (Helly 1999, 2000), although Canada has remained, notwithstanding its multicultural policy, a state where undemocratic practices have never been condoned (despite what some analysts, such as Neil Bissoondath [1994], contend). Thus, at least until recently, we have witnessed a great reluctance to publicly acknowledge that some claims made under the guise of diversity may be incompatible with the very principles that make pluralism possible and allow it to thrive (see Canadian Heritage 2006). In Quebec, the integration of immigrants has also been the object of much more controversy, most likely because it could not be taken for granted, as it can in English Canada; thus, pluralist transformation has been more painful, more intense, more rapid and more thoroughly debated (this may also be characteristic of Quebec culture; after all, to facilitate public discussions, anglophones use a "moderator" and francophones "un animateur"). So, in the 1990s, when linguistic issues slowly became less central, an enormous amount of social resources was devoted to soul-searching about what the new Quebec ought to be. Numerous controversies — regarding, for example, the respective relevance of civic versus substantive culture as a common ground for every citizen of Quebec, or the place of religious diversity in public institutions — mobilized not only the government but also claimed the time and minds of many institutional actors, such as journalists, researchers, teachers and NGOs (see, for example, Harvey 1991; Quebec, Commission des droits de la personne [CDP] 1995; Quebec, Conseil des relations interculturelles [CRI] 1997; Sarra-Bournet 1998).

In my view, the intensity of social debate surrounding diversity management has had numerous positive effects on the capacity of Quebecers to live together. On this I dare to disagree with Salée. Public opinion on immigration in Quebec, which 30 years ago was much less favourable than it was in English Canada, is now more positive and much less polarized (Citoyenneté et Immigration Canada [CIC] 1999; El Haïli 2001; Surveys, Opinion Polls and Marketing [SOM] 2001). (This evolution, though, could also be linked to the sense that immigration is now much more closely managed by the Quebec state, as well as to the change in the linguistic composition of migratory flux.) The level of debate is pretty sophisticated and, in many instances, largely deethnicized. During the 1995 hijab controversy, in particular, citizens from majority and minority groups took competing stances in what was generally a healthy and

democratic exchange over the balancing of gender equality and religious freedom (Mc Andrew and Pagé 1996; Cicéri 1999; Mc Andrew 2006a). It is a complex issue that English Canada, often trapped in an essentialist version of multiculturalism, did not dare face until the Islamic arbitration/Sharia controversy arose in Ontario in late 2003 (see Marion Boyd's chapter in this volume).

However, this hijacking of the Quebec agenda by those with linguistic and cultural concerns has left very little room for public discussion of inequalities. This is the second difference I stress in comparing multiculturalism and interculturalism. Obviously, I do not want to give the impression that multiculturalism is an antiracist policy. Most of the criticisms Salée aims at interculturalism could be, and have been, directed at multiculturalism — especially its very ambiguous record on ethnic inequalities (Stasiulis 1991; Li 2003; Helly forthcoming). But, at least since the 1980s, when ethnic leadership moved from European third-generation Westerners to Ontario's visible minorities, both the government and the general public have demonstrated a greater recognition of the problem and placed a clearer stress on socioeconomic issues. Although most multiculturalism initiatives still support intercultural rapprochement and sensitization of mainstream institutions (Mc Andrew, Helly, and Tessier forthcoming), a specific program targeting racism has been in place since that time, and the Canadian government has announced a more global strategy to deal with the issue (Canadian Heritage 2005). Certainly, Quebec interculturalism also commits itself to equal opportunity, using all the legal instruments and programs Salée describes, but political recognition of the existence of ethnic inequalities and racism is still in its infancy, and public debate has not yet begun. There is also an extremely strong tendency to restate socioeconomic issues as cultural ones. The evolution of the concept of citizenship provides a good example of this trend. It was proposed in 1997 by André Boisclair, then minister of civic relations and immigration, as a common framework for addressing problems of participation affecting groups defined by a variety of markers (gender, age, disability, ethnicity and so on). But this approach slowly transformed — especially under Robert Perreault, who succeeded Boisclair as minister — into a communitarian one in which allegiance to Quebec was posited as antithetical to Canada. This shift largely explains the failure of the 2000 Citizenship Summit, where over 500 stakeholders representing various sectors of society were expected to reach a consensus (Juteau 2000; Quebec, Ministère des Relations avec les citoyens et de

l'Immigration [MRCI] 2000; Table de concertation des organismes au service des personnes réfugiées et immigrantes [TCRI] 2000).

So where does this bring us with regard to Salée's explanation of the ambiguous record of the Quebec state in managing ethnocultural diversity, especially the argument that its racial nature (like that of other Western states) is the main cause of its shortcomings? As I stated earlier, there may be some truth in this grand theory, although the extent of its applicability would be extremely difficult to ascertain. Nevertheless, there are many other factors that we should explore — factors that are more immediate and more closely linked to the specificity of Quebec, and thus more amenable to improvement through policy reform. Salée refers mostly to two of these: the ambiguity of the Quebec national project and the "fragile majority status" hypothesis.

The first factor, based on Yvon Theriault's analysis, appears weak: the argument that the Quebec state's lack of legitimacy and the alienation of visible minorities from the sovereignist movement explains the socioeconomic exclusion of these minorities. Here, again, theoretical model collides with hard fact. The visible minorities experiencing the greatest problems with socioeconomic integration and participation are post-1977 immigrants (Picot and Hou 2003); their mother tongue is French, or French is their language of public use; and, as several political scientists have recently told us (Beaulieu 2004; Gagné and Langlois forthcoming), they are much more evenly split between supporting the Parti Québécois and the Parti Libéral than past generations of cultural communities. In contrast, longer-established, largely anglophone or anglophile communities, which are also the most federalist ones, have a very favourable socioeconomic profile.

The fragile majority status hypothesis is much more convincing. Various studies have illustrated how very difficult it is for Quebecers of French Canadian background — whether they are policy-makers, professionals or ordinary citizens — to fully recognize where they fit into the new pecking order of ethnic relations (Helly 1996; Hohl 1996; Hohl and Normand 2000). This phenomenon has also been documented in other places where there is an ambiguity in ethnic dominance, such as Catalonia (Samper Rasero 1996) and Flanders (Verlot 2000). Obviously, this tendency for francophone Quebecers to see themselves as an oppressed minority, not a dominant majority, is not merely a defensive reaction based on a delusion (although the most extreme expressions of this tendency do flirt with a "besieged ethnic group" mentality). After all, until recently — that is,

before the Quiet Revolution — they were near the bottom of the socioeconomic and educational ladder. This reality reflected not only anglophone dominance but also the quick social mobility that most immigrant groups were able to achieve, at least in the second generation, through integration into the English milieu (Gendron 1972; Quebec, Conseil de la langue française [CLF] 2000). Victim status is, thus, an important aspect of francophone Quebecers' identity and memory, and different studies have shown that this heritage has been passed on to youngsters who did not themselves experience oppression — or, to put it a little more mildly, second-status citizenship (Létourneau and Moisan 2004; Zanazanian 2006).

Quebecers are certainly sophisticated enough to see that some new arrivals experience economic difficulties and also that this inequality touches groups that are largely integrated into the French community linguistically, culturally and, in many instances, politically (Haitians, North Africans, Latino Americans). But, in a process well documented by social psychologists (Bourhis and Leyens 1994; Montreuil, Bourhis, and Vanbeselaere 2004), people often resolve the cognitive dissonance between the value they place on their past victim status and their knowledge of their actual power by negating the current reality and taking refuge in the past. This tendency can be observed in numerous instances, whether in the media, during training programs or in casual conversations between friends and acquaintances. Whenever the issue of racism or ethnic inequality is put forward, someone will almost inevitably cite the adoption of English by newcomers and their refusal to integrate, however outdated and clichéd this observation may be.

Thus, Salée's equating the racial nature of states controlled by major dominant world powers to that of fragile majorities (which do not even enjoy sovereign status) lacks nuance and qualification. But this does not condone the Quebec government's lack of leadership in addressing the issue of ethnic inequality and exclusion. Ironically, Salée's macro-type explanation gives the government too easy a way out. Politicians and policy-makers are certainly not responsible for the legacy that makes recognizing the centrality of social issues (over linguistic and cultural ones) more difficult in Quebec than in English Canada. But they have clearly not helped enough francophone Quebecers to come to terms with their new majority status and the obligations that it entails, especially during the last 15 years when, due to the change in ethnic stratification, they should have done so. All recent public policies — such as *Let's Build Quebec Together: A Policy*

Statement on Immigration and Integration (Quebec 1990) and the School Integration and Intercultural Education Policy (1998) — rhetorically stress equality of opportunity as an objective that is as important as linguistic integration and intercultural rapprochement. However, various assessments of the implementation of these policies show that it has been granted too little attention and too few resources (Mc Andrew 2001, 2003a, 2006b, 2006c).

There is, however, some hope in the recent policy developments under the Liberal government, to which Salée's chapter does not give enough credit. Indeed, it is the first time in Quebec's history of cultural diversity management that in a period of less than two years a government both announces an ambiguous and interesting plan of action regarding socioeconomic integration, now identified as a priority (Quebec 2004), and launches a major consultation to define an antiracist strategy (Quebec 2006). Given that a very small amount of new money has been put into the initiative and that public services for the entire Quebec population are being scaled back, one can certainly question the impact these measures will have. But — at least, at the symbolic level — it is a step in the right direction if one is concerned with increasing awareness of interethnic inequalities and improving the public record on the issue. Thus, what is rather surprising in Salée's analysis of this evolution is his preoccupation with the changes in normative discourses, despite the fact that most of his chapter illustrates the rather insignificant effect these discourses have had on the issue that really matters to him: socioeconomic exclusion. The Liberal Party's uneasiness with any complex discussion of citizenship (as well as some federalists' rejection of the concept itself when applied to Quebec) and its tendency to clientelism are nothing new to long-time observers of the Quebec intercultural relations scene. But, notwithstanding Salée's apt criticism of these shortcomings, this new pragmatic communitarian approach, combined with actual political will, may bring about more improvements in the socioeconomic inclusion of visible minorities than the former sophisticated normative civic framework, which lacked real commitment.

References

Beaulieu, Isabelle. 2004. "Le Premier Portrait des enfants de la loi 101: sondage auprès des jeunes issues de l'immigration récente." In *L'Annuaire du Québec 2004*, edited by Michel Venne. Montreal: Éditions Fides.

Berry, J.W. 1990. "Psychology of Acculturation." In *Nebraska Symposium on Motivation, 1989: Cross-Cultural Perspectives*, edited by J. Berman. Lincoln: University of Nebraska Press.

Bissoondath, Neil. 1994. *Selling Illusions: The Cult of Multiculturalism in Canada*. Toronto: Penguin Books.

Bourhis, Richard Y., and Jacques Philippe Leyens. 1994. *Stéréotypes, discrimination et relations intergroupes*. Liège: Mardaga.

Canadian Heritage. 2005. *A Canada for All: Canada's Action Plan against Racism: An Overview*. Ottawa: Minister of Public Works and Government Services. Accessed October 31, 2006. http://www.pch.gc.ca/multi/plan_action_plan/pdf/action_e.pdf

———. 2006. "What Is Multiculturalism?" Accessed October 31, 2006. http://www.canadianheritage.gc.ca/progs/multi/what-multi_e.cfm

Cicéri, Coryse. 1999. *Le Foulard islamique à l'école publique: analyse comparée du débat dans la presse française et québécoise francophone (1994-1995)*. Montreal: Immigration et métropoles. Accessed November 1, 2006. http://im.metropolis.net/researchpolicy/research_content/ciceri.pdf

Citoyenneté et Immigration Canada. 1999. *Attitudes et tolérance: politiques, planification et recherche stratégiques*. Ottawa: Direction générale des communications, Citoyenneté et Immigration Canada.

Costa-Lacoux, Jacqueline, and Marie Mc Andrew. 2005. "Le Québec et la France: deux histoires migratoires." Dossier Immigration et intégration. *Santé, société et solidarité* 1:5-13.

El Haïli, Haïcha. 2001. "Perspective québécoise." Paper presented at the conference of the Association for Canadian Studies/Association d'études canadiennes, November 2, Halifax.

Gagné, Gilles, and Simon Langlois. Forthcoming. "Étude inédite: l'appui à la souveraineté selon les générations." In *L'Annuaire du Québec*, edited by Michel Venne. Montreal: Éditions Fides.

Gagnon, France, and Michel Pagé. 1999. "Cadre conceptuel d'analyse de la citoyenneté dans les démocraties libérales." *Les Approches de citoyenneté dans six démocraties libérales*. Vol. 2. Ottawa: Canadian Heritage.

Gendron, Jean-Denis. 1972. *La Situation de la langue française au Québec: rapport*. Commission d'enquête sur la situation de la langue française et sur les droits linguistiques au Québec. Quebec: Éditeur officiel du Québec.

Harvey, Julien. 1991. "Culture publique, intégration et pluralisme." *Relations* 574:239-41.

Helly, Denise. 1996. *Le Québec face à la pluralité culturelle, 1977-1994: un bilan documentaire des politiques*. Sainte Foy: Presses de l'Université Laval.

———. 1999. *Citoyenneté, nation et minorités ethnoculturelles: le cas canadien à travers le multiculturalisme, 1971 à nos jours*. Ottawa: Canadian Heritage.

———. 2000. "Primauté des droits ou cohésion sociale: les limites du multiculturalisme canadien, 1971-1999." In *La Différence culturelle: une reformulation des débats*, edited by Michel Wieviorka and Jocelyne Ohana. Paris: Colloque de Cerisy.

———. Forthcoming. "The Policy of Multiculturalism in Canada." In *Multiculturalism: Public Policy and Problem Areas in Canada and India*, edited by C. Raj, Abdul Nafey, and Marie Mc Andrew. Delhi: Manak Publishers.

Hohl, Janine. 1996. "Résistance à la diversité culturelle au sein des institutions scolaires." In *Pluralisme, citoyenneté et éducation*, edited by Michel Pagé, Marie Mc Andrew, and France Gagnon. Montreal and Paris: L'Harmattan.

Hohl, Janine, and Michèle Normand. 2000. "Enseigner en milieu pluriethnique dans une société divisée." In *Relations ethniques et*

éducation dans les sociétés divisées: Québec, Irlande du Nord, Catalogne et Belgique, edited by Marie Mc Andrew and France Gagnon. Montreal and Paris: L'Harmattan.

Juteau, Danielle. 2000. *Les Ambiguïtés de la citoyenneté au Québec.* Les Grandes Conférences Desjardins, November 23. Montreal: McGill University. Accessed October 31, 2006. http://www.mcgill.ca/files/qcst/DanielleJuteaupdf.pdf

Juteau, Danielle, Marie Mc Andrew, and Linda Pietrantonio. 1998. "Multiculturalism 'à la Canadian' and Integration 'à la Québécoise': Transcending Their Limits." In *Blurred Boundaries*, edited by Rainer Bauboeck and John Rundell. Avebury, UK: European Centre.

Lapeyronnie, Didier. 1993. *L'Individu et les minorités: la France et la Grande Bretagne face à leurs immigrés.* Paris: Presses Universitaires de France.

Létourneau, Jocelyn, and Sabrina Moisan. 2004. "Young People's Assimilation of a Collective Historical Memory: A Case Study of Quebeckers of French-Canadian Heritage." In *Theorizing Historical Consciousness*, edited by Peter Seixas. Toronto: University of Toronto Press.

Li, Peter S. 2003. "Deconstructing Canada's Discourse of Immigrant Integration." *Journal of International Migration and Integration* 4 (3): 315-34.

Mc Andrew, Marie. 1996a. "Canadian Multiculturalism and Quebec Interculturalism: Myths and Realities." In *Zeitschrift für internationale erziehungs — und sozialwissenschaftliche Forschung.* Frankfurt: Deutsches Institut für Internationale Pädagogische Forschung.

———. 1996b. "Diversité culturelle et religieuse: divergences des rhétoriques, convergences des pratiques?" In *Pluralisme, citoyenneté et éducation*, edited by France Gagnon, Marie Mc Andrew, and Michel Pagé. Montreal and Paris: Éditions l'Harmattan.

———. 2001. *Immigration et diversité à l'école: le débat québécois dans une perspective compara-tive.* Montreal: Presses de l'Université de Montréal.

———. 2003a. "Intégration, participation, relations interculturelles: bilan (1990-2003) et prospectives." Paper presented at the conference of the Conseil des relations interculturelles and the Ministère des Relations avec les citoyens et de l'Immigration, September 15, Montreal.

———. 2003b. "School Spaces and the Construction of Ethnic Relations: Conceptual and Policy Debates." *Canadian Ethnic Studies/Études ethniques au Canada* 35 (2): 14-29.

———. 2006a. "The Hijab Controversies in Western Public Schools: Contrasting Conceptions of Ethnicity and Ethnic Relations." In *The Making of the Islamic Diaspora*, edited by Saeed Rahnema and Haideh Moghissi. Toronto: University of Toronto Press.

———. 2006b. "La Réussite éducative des élèves issus de l'immigration: enfin au coeur du débat sur l'intégration?" Special issue, *Options CSQ* 1:109-28.

———. 2006c. "Projet national: immigration et intégration dans un Québec souverain: dix ans plus tard, l'analyse proposée tient-elle toujours la route?" *Sociologie et sociétés* 38 (1): 213-33.

Mc Andrew, Marie, Denise Helly, and Caroline Tessier. Forthcoming. "From Heritage Languages to Institutional Change: An Analysis of the Nature of the Organizations and Projects Funded by the Canadian Multiculturalism Program (1983-2002)." *Canadian Ethnic Studies/Études ethniques au Canada.*

Mc Andrew, Marie, Jacques Ledent, and Rachid Ait-Said. 2005. *La Réussite scolaire des jeunes noirs au secondaire.* Montreal: Immigration et métropoles, Chaire en relations ethniques, ministère de l'Éducation, du Loisir et du Sport.

Mc Andrew, Marie, and Michel Pagé. 1996. "Entre démagogie et démocratie: le débat sur le hijab au Québec." *Collectif interculturel* 2 (2): 151-67.

Modood, Tariq, Richard Berthoud, Jane Lakey, James Nazroo, Patten Smith, Satnam Virdee, and Sharon Beishon. 1997. *Ethnic Minorities in Britain. Diversity and Disadvantage: Fourth National Survey of Ethnic Minorities*. London: Policy Studies Institute.

Modood, Tariq, and Pnina Werbner, eds. 1997. *The Politics of Multiculturalism in the New Europe: Racism, Identity and Community*. London: Zed Books.

Montreuil, Annie, Richard Y. Bourhis, and Norbert Vanbeselaere. 2004. "Perceived Threat and Host Community Acculturation Orientations towards Immigrants: Comparing Flemings in Belgium and Francophones in Quebec." *Canadian Ethnic Studies/Études ethniques au Canada* 36 (3): 113-35.

Picot, Garnett, and Feng Hou. 2003. *La Hausse du taux de faible revenu chez les immigrants au Canada*. Cat. no. 11F0019MIF-198. Ottawa: Statistics Canada. Accessed November 1, 2006. http://www.statcan.ca/francais/research/11F0019MIF/11F0019MIF2003198.pdf

Pietrantonio, Linda, Danielle Juteau, and Marie Mc Andrew. 1996. "Multiculturalisme ou intégration: un faux débat." In *Les Convergences culturelles dans les sociétés pluri-ethniques*, edited by Khadiyatoulah Fall, Ratiba Hadj-Moussa, and Daniel Simeoni. Quebec: Presses de l'Université du Québec.

Portes, Alejandro. 1996. "Children of Immigrants: Segmented Assimilation and Its Determinants." In *The Economic Sociology of Immigration: Essays on Networks, Ethnicity, and Entrepreneurship*, edited by Alejandro Portes. New York: Russell Sage Foundation.

Portes, Alejandro, and Rubén G. Rumbaut. 2001. *Legacies: The Story of the Second Generation*. Berkeley: University of California Press.

Quebec. Commission des droits de la personne (CDP). 1995. *Le Pluralisme religieux au Québec: un défi d'éthique sociale*. Cat. no. 7.113-2.1.1 Quebec: CDP.

Quebec. Conseil de la langue française. 2000. *Le Français au Québec: 400 ans d'histoire et de vie*, edited by Michel Plourde, Hélène Duval, and Pierre Georgeault. Montreal: Éditions Fides, Publications du Québec.

Quebec. Conseil des relations interculturelles (CRI). 1997. *Un Québec pour tous ses citoyens*. Avis présenté au ministre. Montreal: CRI.

Quebec. Ministère des Communautés culturelles et de l'Immigration (MCCI). 1990. *Let's Build Quebec Together: A Policy Statement on Immigration and Integration*. Montreal: Direction des communications.

Quebec. Ministère de l'Immigration et des Communautés culturelles (MICC). 2006. *Towards a Government Policy to Fight against Racism and Discrimination*. Consultation document. Quebec: Éditeur officiel, June.

Quebec. Ministère des Relations avec les citoyens et de l'Immigration (MRCI). 2000. *Forum national sur la citoyenneté et l'intégration*. Consultation document. Quebec: Éditeur officiel.

———. 2004. *Shine among the Best: The Government's Vision and Action Priorities*. Quebec: Éditeur officiel.

Renaud, Jean, Victor Piché, and Jean-François Godin. 2002. "Emploi: établissement différent des immigrants arabes et musulmans?" In *Les Relations ethniques en question: ce qui a changé depuis le 11 septembre*, edited by Jean Renaud, Linda Pietrantonio, and Guy Bourgeault. Montreal: Presses de l'Université de Montréal.

Samper Rasero, Lluís. 1996. "Etnicidad y curriculum oculto: la construcción social del otro por los futuros educadores." In *Racismo, etnicidad y educación intercultural*, edited by C. Solé. Lleida: Universitat de Lleida.

Sarra-Bournet, Michel. 1998. *Le Pays de tous les Québécois*. Montreal: VLB Éditeur.

Stasiulis, Daiva. 1991. "The Symbolic Mosaic Reaffirmed: Multiculturalism Policy." In *How Ottawa Spends, 1988-1989: The Conservatives Heading into the Stretch*, edited by K.A. Graham. Ottawa: Carleton University Press.

Surveys, Opinion Polls and Marketing (SOM). 2001. *Sondage sur la perception de l'adaptation des immigrants à la société québécoise.* Montreal: SOM, March.

Table de concertation des organismes au service des personnes réfugiées et immigrantes (TCRI). 2000. *La Citoyenneté québécoise.* Montreal: TCRI.

Verlot, Marc. 2000. "Implementing Intercultural Education in Flanders-Belgium: Patterns and Ambiguities." Paper presented at the Fifth International Metropolis Conference, November 13-17, Vancouver.

Zanazanian, Paul. 2006. "Au-delà des tabous de la conscience historique au Québec: l'indifférence des enseignants d'histoire francophones au sujet de la minorité anglophone dans l'histoire nationale." Paper presented at "Histoire et conscience historique chez les jeunes québécois," Université Laval, February 24, Quebec.

Another Fine Balance:

Managing Diversity in

Canadian Cities

C ANADA DEFINES ITSELF BY ITS DIVERSITY. IN A 2005 POLL THAT ASKED "WHAT
 makes Canada unique?" the dominant response, far outranking "freedom"
or "geography," was "our diverse, multicultural nature" (Evans 2005). This diver-
sity is overwhelmingly an urban phenomenon. By international standards,
Canada's largest cities have highly diverse populations, and the attraction of our
cities to immigrant populations is well known. For instance, the Census
Metropolitan Areas (CMAs) of Toronto and Vancouver have a higher percentage
— over 40 percent in each case — of foreign-born residents than most other
immigrant gateway cities, including New York, Miami, Los Angeles and Sydney
(Statistics Canada 2003).[1] Diversity in Canadian cities is not confined to the pres-
ence of recent immigrants, however. Approximately 50 percent of Canada's
Aboriginal peoples live in cities, both large and small, with the western cities
having particularly visible Aboriginal populations (Peters, this volume).
Furthermore, although Statistics Canada has yet to collect data on sexual orien-
tation, Montreal, Toronto, Ottawa, Victoria and Vancouver all have relatively high
proportions of same-sex couples (Jedwab 2004). Indeed, among Toronto's
tourism marketing strategies is the pitch that the city has the third-largest gay and
lesbian population in North America.
 Diversity is thus a defining characteristic of Canada's big cities. Canada's
claim to being a diverse, multicultural nation is defined by its big cities, where
the vast majority of the population resides. How urban governments are respond-
ing to this diversity is a critical public policy issue. Of course, diversity is not a
new characteristic of Canadian cities. It is important that we recognize the

historic African Canadian population in Halifax; the centuries-old mix of anglo-phones and francophones in Montreal, enriched by vital Jewish and Black communities; the significant Italian population in Toronto, established in the 1950s; the Ukrainian diaspora in Winnipeg; and Vancouver's strong and long-standing Chinese community.

Although issues of diversity related to Canadian cities are not new, they have taken on an increased significance in recent years, and so they demand new types of responses. What is different? Why is the issue of how to address diversity in cities high on the urban policy agenda? At a national and pan-Canadian level, some argue that a distinctly Canadian model of diversity has emerged over the years (Jenson and Papillon 2001; Kymlicka 1998). The distinctiveness of the Canadian model is that it accommodates both liberal freedoms and group identities; it is committed to both equity and special treatment; and it addresses issues of diversity through a mix, and often a partnership, of public, private and voluntary sector action. Does the same model apply to urban governments?

This chapter explores how Canadian urban governments are responding to changing patterns of diversity and to evolving understandings of diversity. To be sure, the increased salience of diversity for urban governments derives in large part from the fact that Canadian cities have become more multi-ethnic and multi-racial over the past several decades, as immigration and residential settlement patterns have changed dramatically. But the policy responses of Canadian cities have not automatically followed from shifting demographics, nor are these responses the same in all of the major cities. Rather, the "problem" or, alternatively, the "asset" of diversity has been constructed and understood in different ways in different cities. In general, we can view the policy responses as reflections of a Canadian model that embodies both individualism and group identity, both equity and special treatment, but that model is arguably put to a tough test in some locales.

Focusing on four major cities — Toronto, Vancouver, Montreal and Winnipeg — we look at how urban governments are grappling with diversity. We provide an overview of the kinds of new policy instruments, programs and institutions that these governments have developed to address diversity, and we describe some of the outstanding and emerging challenges. Toronto, Vancouver and Montreal, respectively, are Canada's major destinations for immigrants, whereas Winnipeg has Canada's largest Aboriginal population. The very

definition of an "urban response" to diversity is problematic, because in metropolitan areas, governance is dispersed among numerous municipal governments. This may not have been a serious situation when diverse populations and urban poverty were largely issues for the core municipality. As we will see, however, greater residential segregation in selected suburbs has put diversity on the agenda of suburban municipalities as well as those of the urban core and increased the need for more coordinated policy responses. Although our focus is on urban governments, the reality is that responsibility for many policy and program areas relevant to diversity is held by, or shared with, provincial and federal governments, a challenge we address in our concluding section. Before turning to urban responses, we briefly sketch the patterns of diversity in the four major Canadian cities and identify certain underlying tensions in the social construction of diversity as a policy problem.

The Changing Diversity of Canadian Cities

ALTHOUGH CANADA WAS BUILT ON IMMIGRATION, AND DIVERSITY IS A LONG-STANDING feature of its major cities, the pace and composition of immigration and the resulting ethnoracial composition of urban populations have changed significantly in a short period, particularly in those cities. Changes in immigration patterns have been felt most dramatically in three centres — Toronto, Vancouver and Montreal — where the vast majority of immigrants have settled over the past 40 years. As illustrated in figure 1, immigration became even more concentrated in these three cities over this period: from the 1970s to the 1990s, the percentage of all immigrants to Canada going to Toronto, Vancouver or Montreal rose from 57 to 73. Only 6 percent of immigrants went to Canada's 11 next-largest cities combined (Statistics Canada 2003). Although other Canadian centres have fairly large foreign-born populations, a much larger percentage of the foreign-born populations of Toronto, Montreal and Vancouver is composed of recent immigrants, as shown in table 1. Indeed, it is a stunning fact that almost 40 percent of Toronto's immigrants arrived in the 1990s (Statistics Canada 2003).

As we well know, not only the level but also the composition of immigration has changed over the past few decades. Beginning in the 1970s, the

Figure 1 158

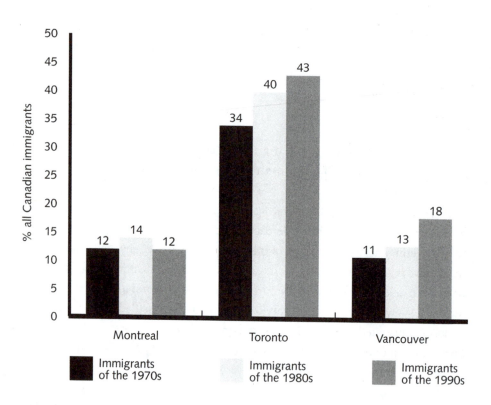

Immigration in Canada's Three Largest Cities, 1970s to 1990s

Source: Statistics Canada, *Canada's Ethnocultural Portrait: The Changing Mosaic* (Ottawa: Statistics Canada, 2003), accessed January 16, 2006, http://www12.statcan.ca/english/census01/products/analytic/companion/etoimm/subprovs.cfm

Proportion of Foreign-Born and Aboriginal Populations in Selected Census Metropolitain Areas

Metropolitan Areas	Foreign-born as % of the population[1]	Recent immigrants as % of the population[2]	Recent immigrants as % of foreign-born population	Aboriginal people as % of the population[3]
Montreal	18.4	6.4	34.6	0.3
Toronto	43.7	17.0	39.0	0.4
Vancouver	40.2	16.5	44.0	1.9
Winnipeg	16.5	4.0	24.1	8.1

[1] Martha Justus, "Immigrants in Canada's Cities," *Our Diverse Cities* 1 (2004): 41-8.
[2] Recent immigrants, 1991-2001.
[3] As of the 1991 census. From Evelyn Peters's chapter in this volume, table 1.

predominant sources of immigration shifted from Europe to Africa, Asia, the Caribbean, and Central and South America, and this gave rise to cities populated by a broader range of cultures, races, religions and languages. In both Toronto and Vancouver, as shown in figure 2, there was an almost threefold increase in the visible minority population between 1981 and 2001 (see also Siemiatycki et al. 2001). Moreover, the effects of in-migration are not all generated from abroad. As Katherine Graham and Evelyn Peters point out, the significant internal migration of Aboriginal peoples to the cities and the much younger average age of this population adds complexity to urban diversity (2002). In this regard, Winnipeg stands out, as more than 8 percent of its population is composed of Aboriginal peoples, compared to less than 1 percent of the populations of Toronto or Montreal.

Place Matters: Differing Patterns of Diversity

In our attempt to understand patterns of diversity, place matters, as there are significant differences in the composition and spatial patterns of ethnoracial diversity across and within the four metropolitan areas. As shown in table 2, the single largest non-White population groups in Toronto and Vancouver are Chinese and South Asian, while in Montreal the largest visible minority groups are Black and Arab (although we should note that Toronto has more than double the Black population of Montreal). In Winnipeg, by far the largest minority population group is Aboriginal peoples.

More than absolute numbers shape the effects of population mixes, however. For example, although in absolute numbers, metro Toronto has a considerably larger Chinese and South Asian population than metro Vancouver (in 2001, 868,000 compared to 490,000), its overall ethnoracial population is much more mixed, with roughly equal proportions of Chinese, South Asians, Blacks and "others." In contrast, Vancouver, particularly the suburban municipalities of Richmond and Surrey, could be described as essentially biracial (Good 2005), with Chinese and South Asians representing over 60 percent of the visible minority population.

Within cities, the spatial pattern of immigrant settlement has changed quite significantly over the past two decades, resulting in increased residential segregation and greater suburbanization of ethnoracial populations (see Fong and Shibuya 2005). Ethnic segregation has always been an element of Canada's urban

Figure 2

Visible Minorities as a Proportion of the Population, Toronto, Montreal, Vancouver and Canada, 1981-2001

% of
population

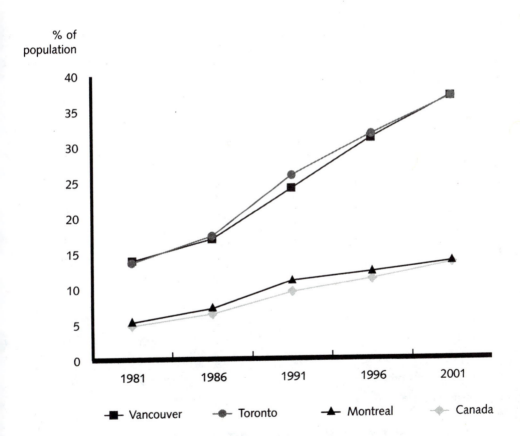

Source: Authors' calculations based on Statistics Canada, *Canada's Ethnocultural Portrait: The Changing Mosaic* (Ottawa: Statistics Canada, 2003).

Table 2 162

Ethnoracial Diversity in Toronto, Vancouver, Montreal and Winnipeg, 2001 (percent)

Population group (proportion of total population)	Toronto	Vancouver	Montreal	Winnipeg
Total population (N)	4,647,960	1,967,475	3,380,645	661,730
White	62.2	61.0	85.4	79.1
Chinese	8.6	16.9	1.5	1.5
South Asian	10.1	8.2	1.7	1.8
Black	6.3	0.7	3.8	1.4
Filipino	2.8	2.8	0.5	4.5
Latin American	1.6	0.9	1.6	0.7
Southeast Asian	1.1	1.4	1.1	0.7
Arab	0.9	0.7	2.0	0.2
West Asian	1.1	1.2	0.3	0.1
Korean	0.9	1.4	0.1	0.1
Japanese	0.3	1.0	0.1	0.7
Other visible minorities	1.4	0.2	0.2	0.3
Aboriginal people (self-reporting)	0.4	1.8	0.3	8.3

Source: Statistics Canada, "Population Groups (28) and Sex (3) for Population, for Canada, Provinces, Territories, Census Metropolitan Areas and Census Agglomerations, 2001 Census — 20 percent Sample Data" (Ottawa: Statistics Canada, 1991).

landscape — witness the concentrations of Italian, Portuguese and Jewish populations in the major cities at various times (see Murdie and Teixeira 2003). As David Ley and Annick Germain note, such segregation can be both negative — if it limits economic opportunities, for instance — and positive — if it provides social support and community-based private financing (2000). Recent research indicates that there has been a significant rise in the tendency of visible minority populations to concentrate in own-group neighbourhoods in Toronto, Vancouver and Montreal, as evidenced by the fact that the number of census tracts with a 30 percent or higher concentration of a particular group rose from 6 to 254 between 1981 and 2001 (Hou 2004). Feng Hou's analysis indicates that this is mainly due to overall increases in the visible minority population (2004, 2), although it also reflects differences among ethnoracial groups and is affected by a city's structural contexts, such as unemployment rates and the proportion of new housing (Fong and Wilkes 2003). In particular, the Chinese in metro Toronto and the South Asians in Vancouver and Montreal tend to have much higher levels of residential concentration than Blacks or other visible minorities.

There has also been a significant, albeit selective, suburbanization of residential segregation. Whereas the central urban core historically tended to absorb most new immigrants, the lack of affordable housing and supportive networks in the core and the attraction to the suburbs by more affluent immigrant groups has created suburban pockets with high concentrations of certain ethnoracial groups (Siemiatycki et al., 2001). The largely biracial (Chinese-White) populations of Markham, north of Toronto, or Richmond, south of Vancouver, contrast in this regard with the more multicultural mix of Mississauga.

In examining such residential concentrations, John Myles and Feng Hou make an important distinction between "immigrant enclaves," which are receiving areas for newcomers, particularly poorer ones, and "ethnic communities," which tend to be culturally homogeneous and economically heterogeneous, with high levels of home ownership (2002). In ethnic communities, longer-term immigrants choose to remain alongside more recent and poorer newcomers rather than dispersing and assimilating as they become more affluent, as forecast by traditional models of urban spatial location. Although there has been an increase in segregation, the overall level of ethnoracial segregation in Canadian cities is still low compared to that in American cities, and even in neighbourhoods of high concentration, the majority of residents are not part of a single group. With a few

exceptions, Canadian cities encompass multi-ethnic neighbourhoods rather than highly segregated enclaves (Ley and Germain 2000; Hou 2004).

We must also remember that the formation of community identity is not simply a function of people being classified as part of an immigrant or visible minority group or living in close proximity to one another. For the purposes of formulating policy and program responses for particular communities, the standard Statistics Canada categories used to describe population groups may be much too blunt an analytical instrument. Within the South Asian community, for instance, the ethnic and cultural differences among those from India, Pakistan or Sri Lanka, or among those of the Hindu, Sikh, Muslim or Christian religions may denote more disparity than community. An important step for urban governments in moving from demographic analysis to policy response, then, is to acquire a good working knowledge of what constitutes community and an understanding of how various population groups and locales are joined and divided by an operative sense of community. Understanding these cultural differences becomes particularly important to urban policy because, as Eric Fong and Rima Wilkes predict, greater sharing of neighbourhoods among immigrant/visible minority and established majority populations, which might foster better interracial relations, is not likely to increase in the foreseeable future (2003, 599).

For Canada's three largest metropolitan areas, the policy challenges relate both to the face of diversity — large portions of their populations are visible minorities — and to the newcomer effects — they have large numbers of recent immigrants. The changing intra-urban patterns mean that as a policy issue diversity is clearly no longer just for the core urban municipalities. The specific differences in ethnic configuration across these cities are also important, because they enable municipal governments to muster nongovernmental allies to build the collective policy capacity to advance multicultural policy goals, a development somewhat more likely to occur, suggests Kristin Good, in biracial settings than in multi-ethnic/multiracial ones (2005, 282).

Finally, it is important to note when talking about urban diversity that the meaning of diversity has changed in recent years; it is no longer understood in simply ethnocultural terms. Disability has been an important basis of identity formation and mobilization across Canada, particularly in the larger urban centres, and most cities include disability as an aspect of their diversity policies. In addition, changing social attitudes toward sexual diversity have made it easier for gay,

lesbian, bisexual and transgendered (GLBT) individuals to be open about their preferences. This has contributed to the rise of gay villages in a number of cities and public activities associated with gay pride. Widespread interest in the work of Richard Florida has further expanded our diversity lens to include bohemians, artists and other creative individuals (see Florida 2002). The implication of the changing nature and meaning of diversity for policy action is that, as Leonie Sandercock notes, "we must understand 'difference' and how it becomes significant in identity politics, in claims regarding multiculturalism, and in spatial conflicts as well as cooperative encounters and exchanges" (2003b, 4).

Different Takes, Competing Paradigms

NOT ONLY HAVE POPULATION MIXES AND LOCATIONS CHANGED IN RECENT YEARS, BUT so too have the meaning and understanding of "diversity" as a policy issue for Canadian cities. Varying public and political views about diversity have produced, we suggest, a certain tension — at times creative and at times divisive — in the responses of urban governments and their voluntary/nonprofit and private sector partners. Several additional factors have shaped the understanding of diversity in Canadian cities, making it more complex than at provincial or national levels of government.

The Intersection of Diversity and Poverty

Historically, Canada's immigrant population tended, after a 10-to-15-year period of adjustment, to do economically as well or even better than the Canadian-born, so that diversity and poverty were not synonymous (with the exception of urban Aboriginal peoples, whose poverty rate has always been high [Royal Commission on Aboriginal Peoples 1996]). That began to change in the 1990s, when the wages of immigrants, even skilled economic immigrants, fell below the Canadian average, and family-class immigrants and refugees, particularly those from Africa and South Asia, began to fare much worse than they once did (Grant and Sweetman 2004; Ornstein 2000). Thus, governments of cities — particularly Toronto, Montreal and Vancouver — with large visible minority populations and cities with large populations of Aboriginal peoples must increasingly deal with the intersection of diversity and poverty.[2]

This challenge was exacerbated by the cuts to social programs and to municipal transfers that occurred in the mid-1990s.[3] The funding of services and programs broadly related to diversity and poverty is a complex undertaking that involves all three levels of government, the United Way, various foundations, private funders and voluntary groups. The downloading of responsibility and the withdrawal of provincial and federal governments from key areas (such as social housing) that affect vulnerable populations has had a disproportionate effect on low-income newcomers and Aboriginal peoples. Some funding has been restored, but negative effects are still felt from the shift from direct investment in the myriad voluntary and nonprofit organizations (which provide the bulk of the services) to managed competition and short-term project funding. The impact has been to significantly diminish the stability and capacity of the service providers by increasing competition, creating higher staff turnovers (due to short-term funding horizons) and reducing a sense of partnership with governments (Sadiq 2004; Scott 2003; City of Toronto 2003). In this respect, there is both a greater demand for policies that address the intersecting issues of diversity and poverty and a strained capacity to implement such policies.

The Original Urban Diversity

Long before the term "diversity" came to denote multiculturalism in the urban context, it had a different meaning: it described the built form of the city (a diversity of styles, public and private spaces and so on). Indeed, in managing diversity, urban governments must not only set policies, plan spending, run programs and regulate in the way that federal and provincial governments do, but they must also accommodate diversity while working with an existing built form. The debate over this meaning of diversity began to heat up in response to the challenge issued by Jane Jacobs in the early 1960s to the dominant, technically oriented planning profession, which sought to impose order and efficiency in cities.

Jacobs saw cities as inherently organic, spontaneous and untidy places in which the intermingling of uses and users is crucial. She argued that cities elude rational planning because they are, to a large degree, a product of market forces, but to the extent that they can be planned, the process should be participatory: "Cities have the capability of providing something for everybody, only because, and only when, they are created by everybody" (1962, 238). Carried through to contemporary planning debates, Jacobs's argument points to our need to consider

the impact of market forces and the cultural biases of the built environment — as well as the biases of planners — and to keep in mind that altering the built environment in major ways may take a long time (Ley 1999; Sandercock 2003a).

An Instrumental View

One of the most recent approaches to diversity is to advocate its advantage for economic competitiveness. From a labour market perspective, Canada needs more immigrants, and the "ethnic advantage" of a linguistically and culturally diverse population will help cities compete in the international marketplace for employment opportunities and skilled workers (Ley 2005, 5). In addition, the celebration of diversity is thought to make cities more attractive as tourist destinations. Cultural events celebrating diversity, such as Toronto's Caribana, have become international attractions. Montreal's gay village is among the premier gay tourist attractions in North America (Ray 2004), which is somewhat ironic, given that it emerged in reaction to the efforts of city officials (most notably Mayor Jean Drapeau) to drive gay businesses out of the central business district in preparation for the 1976 Olympics.

Richard Florida has elevated social diversity to the status of key determinant of economic growth with his argument that knowledge workers are drawn to places where there are critical masses of other creative people, both in their own fields and in dissimilar ones, and to places that provide "authentic" physical environments defined by their historical and cultural content (2002). Such places tend to have high proportions of bohemians and gays, reflecting a tolerance of difference. In contrast to other views of this kind of "cosmopolis" (Sandercock 2003b), which not only value the presence of people from different backgrounds but also stress their right to use city space, Florida and his followers see diversity in an instrumental light. As Susan Fainstein notes, Florida should not be misinterpreted — he does not suggest that diversity promotes equity as well as growth (2005). Florida himself argues that "while the Creative Class favors openness and diversity, to some degree, it is a diversity of elites, limited to highly educated, creative people" (2002, 80).

Competing Policy Paradigms

From this overview, we can see that there are two basic paradigms for thinking about diversity in Canadian cities. The first is that diversity is a problem that city

governments need to manage. This involves not only long-standing issues of how to maintain civil order but also new challenges — dealing with poverty and reaching out to specific communities in order to understand their perspectives, needs and interests as well as to engage their support for developing the common good and shared urban spaces. The second paradigm is both more celebratory and more instrumental. It involves seeing diversity as an asset that enriches the local environment and makes a city more competitive on the world stage. From a policy and program perspective, this view would have municipal governments working with other governments and with the voluntary and private sectors to remove barriers and take advantage of opportunities arising from a city's diverse character.

We argue that there is an inherent tension between these two paradigms, because they have differential implications for how public policy addresses diversity and equity, how it approaches difference and special treatment and how it treats the particular versus the community as a whole. This tension is reflected, we suggest, in the ways that urban governments address diversity.

The first step in our analysis of how Canadian urban governments are addressing diversity is to question the relative prominence of each paradigm in civic discourse. If both paradigms are evident to some degree, it suggests that they constitute a continuum rather than a strict opposition, and so the question becomes "What is the relative emphasis on each view in local debates and governmental action?" The second step is to consider whether, over time, there is a balance or a shift in perspective. To do this, we must acknowledge that there could be short-term spikes as a result of local events (for example, the shootings during Toronto's 2005 Caribana) or international events (the Madrid and London bombings). But the question we are interested in exploring is whether there are long-term trends or possibilities.

The remainder of this chapter addresses these questions, albeit in a tentative way. We have undertaken a review of the secondary literature on diversity in Canadian cities, a Web search and a review of selected reports in order to learn about the ways in which issues of diversity are framed in four Canadian cities and the approaches taken to the issues identified. The results of our search have prompted some conclusions about the challenges that lie ahead. Our primary focus is, unapologetically, on big-city governments. We recognize that managing diversity in an urban setting is a complex task that involves all sectors of society

and, in the context of Canadian federalism, all levels of government. Increasingly, however, city governments are on the front line, and so their approach is worthy of particular attention.

Approaches to Diversity in Four Cities

Policy Repertoires

U NQUESTIONABLY, THE INTEREST IN AND ROLE OF URBAN GOVERNMENTS IN MANAGING diversity have changed over time. What is important to note before we turn to specific examples is that the range of policy tools available to urban governments remains somewhat limited and the strategies are necessarily embedded in the legislative, funding and policy frameworks of the federal and provincial governments. Before the development of the modern welfare state, particular communities were mainly left to manage themselves through benevolent societies and other community-based structures. For many years, the role of government, including municipal government, remained largely regulatory. Its main role lay in rule-making and enforcement related to everything from criminal activity (real and imagined) to public health. Policing and maintaining order was job one for municipal governments. In many respects, in this earlier period managing diversity meant containing it.

Since the announcement of the federal government's multiculturalism policy in 1971 and the advent of the Charter of Rights and Freedoms in 1982, the public policy context within which diversity issues are seen has become much broader (Driedger 2001). This is true at the local as well as at the national and provincial levels — in part because some federal money has trickled down to the local level, and in part because Canadian urban governments appear increasingly willing (or pressured) to broaden their sphere of activity to more positively engage and serve diverse communities.

Beyond those related to symbolic celebration and narrow regulatory roles, municipal governments have several other types of policy tools at their disposal for addressing issues of diversity. These include:

- ◆ *Strategic and corporate policy frameworks*: Within certain provincial legislation constraints, municipalities can address diversity through their

own strategic policy and corporate plans and the bylaws and institutions that support them.

♦ *Involvement and representation*: At the heart of how the urban state recognizes and engages different communities and groups is its ability to structure public participation (in planning and other decisions) and to represent difference on council and in its own workforce. In particular, municipalities can give institutional expression to diversity issues by creating standing committees of councils, advisory committees or task forces.

♦ *Administrative structures*: Institutional embodiment of attention to diversity may also occur at the administrative level in the way departments are configured.

♦ *Planning and resolving conflicts over the urban space and its use*: While municipalities have responsibilities and constraints under provincial planning and municipal acts, so much of the real matter of planning comes down to the specifics of particular spaces. Such place-specific planning involves knowledge of different communities and the cultural sensitivity of planners.

♦ *Funding and the provision of services*: Although most social programs, settlement and immigrant services, and services for Aboriginal peoples are the responsibility of provincial or federal governments, and though many are delivered under contract by nonprofits, municipal governments maintain scope for funding and delivering specific human services that fall through the cracks of these programs. In addition, municipal governments can provide project or core funding to community-based organizations and undertake capital spending.

♦ *Recruiting newcomers*: Immigration is under federal jurisdiction. However, beginning with a 1970s agreement with Quebec, the federal government negotiated agreements with most provinces that give these provinces greater say in planning immigration levels, categories and settlement services. Many of the larger cities are consulted by the provinces or seek formal involvement in such decision-making. Working through more informal channels, Canada's big cities have long been involved in boosterism, advertising, trade missions, twinning with international cities and generally establishing favourable conditions for business to attract newcomers.

Regardless of the policy instrument used, the management of diversity can be approached with different underlying philosophies or intentions. In particular, Christian Poirier (2004) has found a distinction in the approach taken to diversity by different city governments in Canada: there are those that primarily see the question as one of how to build on multiculturalism — celebrating and institutionalizing cultural differences; and there are others that frame the issue as one primarily of intercultural relations — mediating differences to promote harmony. Our review suggests that Toronto and Vancouver have a multicultural orientation (however, Daniel Hiebert notes intercultural tensions in the case of Vancouver [2000]). In contrast, Montreal focuses more on fostering good intercultural relations. While celebrating its rich multicultural roots, Winnipeg maintains a distinctive focus on its population of Aboriginal peoples and on relations between it and the non-Aboriginal population. An overview of the specific approach taken by each city provides the basis for further observations and analysis.

Toronto

"Diversity our strength" is the City of Toronto's motto. Although meant to celebrate the city's demographic, it has become more than a slogan. In her analysis of immigrant populations and urban politics in Canada, Kristin Good contends that this motto reflects a consensus among Toronto's municipal, voluntary and private sector leaders that the city needs to focus on the integration of immigrants. In support of this contention, she cites the fact that the Toronto City Summit Alliance determined that one of the city's major policy goals should be to become a centre of excellence in the integration of immigrants.

When discussing diversity in Toronto, one should first address diversity in the Greater Toronto Area (GTA), the arc-shaped conurbation including and surrounding the City of Toronto that is home to over 5 million people. Recent research suggests that there is significant variation among municipal governments of the GTA in their degree of willingness to deal proactively with diversity issues (Wallace and Frisken 2004; Good 2005). Indeed, Good has found that at least one major GTA municipality, Mississauga, implements policies that put the onus on diverse communities to fit in; another, Markham, has established a task force on intercultural relations in response to alleged incidents of racism. Interestingly, Markham is also the site of some of the most important debates about diversity

and the urban landscape. These debates have focused on the construction of "Asian malls" and on accommodating diverse housing preferences.

Given the variability in policy and practice across the GTA, it is not unreasonable to assert that the City of Toronto remains the key municipal actor in managing diversity. As such, it is awarded the limelight for its policy initiatives and for how it deals with specific problems. We suggest that the city's approach has been to be proactively multicultural — providing political leadership, mobilizing community resources and establishing multiculturalism-friendly governance structures — while dealing in a very focused way with troubling issues that have arisen.

Toronto's response is significant for many reasons. The establishment of the "new" City of Toronto in 1998 as an amalgamated city created by provincial fiat did not foreshadow the municipal reaction. The scale of this amalgamation was unprecedented in Canada, and it gave rise to very heated local opposition. However, as Myer Siemiatycki and Engin Isin observe, this opposition was confined to the managerial and professional classes, and the movement was inaccessible to ethnocultural communities (1997). This is despite the fact that the prospect of amalgamation raised issues of concern to immigrant and minority communities, such as service access and employment equity in city government, as well as issues related to access to public space.[4]

In the aftermath of amalgamation, the new city has been highly proactive in dealing with diversity. In its first year of existence, it established the Task Force on Access and Equity, perhaps partially in response to the mobilization of diverse community-based organizations during the 1997 election for the new city council. Furthermore, the chief administrator's office of the new municipality housed the Diversity Management and Community Engagement Unit, which was created to handle council-community relations on diversity issues (Good 2005). Toronto's government has shown leadership in working with other key actors in the community to build on the assets of diversity. One prime example is the establishment of the Toronto Region Immigrant Employment Council (TRIEC). The Maytree Foundation played an important role in setting up TRIEC, assisted by local private-sector leaders. The City of Toronto participated in working groups that were part of the process. Citizenship and Immigration Canada and the Maytree Foundation provided initial funding for the secretariat and have continued to provide financial assistance for administration and coordination. In addition, TRIEC initiatives have received funding from various sources.

This initiative is consistent with the fact that the City of Toronto is, to our knowledge, the only municipality in Canada to have a formal immigration

and settlement policy framework, passed by council in 2001. Not only does this framework imply outreach within the city, but it also incorporates a substantial intergovernmental dimension. Among other things, the cost of absorbing large inflows of newcomers into the city and its education system is of significant concern.

Looking at the issue of costs, we can see that building on the positive has, of necessity, only been part of the picture in Toronto. M.S. Mwarigha suggests that in Toronto, "the public celebration of ethnic diversity is accompanied by an undercurrent of private disquiet about the emergence of residential neighbourhoods of distinct ethnic character, namely ethnic enclaves" (1997, 7). By 2002, the issue of racism in Toronto had become sufficiently serious to prompt council to establish a reference group of councillors to determine how to deal with the situation. Its 2002 report urged an assertive approach to dealing with racism and discrimination. Council designated one of its members as its official diversity advocate, with crosscutting responsibility to promote awareness of, and positive action on, diversity issues within the city government. The advocate's consultations on the reference group report identified nine areas for specific action: poverty reduction, housing, public transportation, youth leadership and the elimination of youth violence, employment, policing, education, public awareness and community outreach (City of Toronto 2002).

In Toronto, as in other Canadian cities, the challenge of managing diversity is ongoing. Because the GTA is a highly interdependent and integrated space and responses to diversity by municipalities other than Toronto tend to vary, the City of Toronto's share of this task may be increased. The conscious decision to focus on diversity as an asset is noteworthy. The approach to managing diversity in Toronto is influenced by the scale of diversity, the range of necessary policy and program responses, and the limited fiscal capacity of the City of Toronto and community-based organizations, including those that provide settlement and immigration services. The challenge is also magnified by the "private disquiet" to which Mwarigha alludes and by very serious instances of intra- and intergroup conflict (including gang activity) and gun violence, as well as by tension between the police and diverse communities. Since the summer of 2005, when a number of violent incidents occurred, the more extreme aspects of state regulation — including stricter police controls, racial profiling and curfews — have been hot topics of public debate.

Vancouver

When we talk about diversity in Canadian cities, we often mention Vancouver and Toronto in the same breath. The composition of Vancouver's population is different from Toronto's, however, with Chinese and South Asians dominating its recent immigrant and visible minority populations. In addition, its population of Aboriginal peoples is more visible due to the presence of a First Nations reserve in the city centre and the unfortunate concentration of Aboriginal peoples in the infamous Downtown Eastside.

Just as one must begin a study of diversity management in Toronto by looking at the GTA, one has to begin any exploration of the Vancouver case by looking at the BC Lower Mainland Region. Once again, Good's work is informative. She examined the approach to managing diversity taken by the City of Vancouver and the municipalities of Richmond and Surrey, where the Chinese and South Asian populations are particularly concentrated. She found that Vancouver adopted a systematic and proactive approach, while Richmond tended to react to specific issues, including the desire of its large Chinese population to be informed about municipal business and planning proposals in their own languages. The municipality's decision to translate some of its documents was a response to a public uproar over the proposal to locate group homes in a predominantly Chinese neighbourhood; it was not initiated by a more forward-looking impulse. Surrey, however, has taken some tentative steps to explore the impact of its multicultural population, but it has yet to act in policy or program terms (Good 2005).

All of this would appear to indicate that Vancouver shoulders the management of diversity in the Lower Mainland as Toronto does in the GTA. Indeed, the city has long been a leader, and its efforts have been both direct and catalytic in nature. The City of Vancouver began training staff on diversity issues more than 20 years ago, and as early as 1989 it established the Hastings Institute, a nonprofit centre that provides multicultural, diversity, language and equity training for city employees. The Hastings Institute also offers such services to other government agencies and the private sector for a fee. More directly, the city has focused its internal administration on the management of diversity and collaborated with the local voluntary sector in this area. Corporately, it has infused its planning department with a working understanding of the nature and importance of diversity by hiring land-use planners from diverse backgrounds and

ensuring that at least one position in its social planning department has a specific multicultural mandate. In addition, the city has worked to engage voluntary organizations that deal specifically with the needs of different ethnocultural and other minority populations. Organizations that receive grants from the city are required to produce evidence that they are adapting their programs and their governance to reflect the city's diverse reality (Good 2005).

Vancouver has struggled to deal with several hot button issues stemming from diversity. It has also found itself in the position of having to focus concertedly on interracial issues as well as work in a multicultural paradigm. As elsewhere, one hot button issue relates to policing: the varying extent to which the police serve and protect different segments of the population. For example, there were allegations that police were slow to investigate a growing number of homicides among female sex trade workers, many of whom were Aboriginal people (this ultimately erupted in the Robert Pickton case).

The second controversial issue relates to planning and the expression of cultural preferences in urban space. It is epitomized by the well-known "monster-house debate." Long-term residents of some affluent parts of the city vociferously objected to the demolition of stately neighbourhood houses to make way for what they viewed as badly designed, oversized boxes. The debate highlighted the conflicting ideals of inhabitants of a relatively homogeneous urban space and the newcomers who wished to assert their right to realize their personal living space preferences. It has been ably analyzed by David Ley and others (Ley 1995, 2005).

In some respects, the monster-house debate has the characteristics of an interracial issue, if one considers it primarily as a contest between established Anglos and wealthy Hong Kong immigrants. But the imperative of dealing with interracial differences and potential tensions in Vancouver extends beyond the affluent parts of the city. Much has been written about the appalling social and economic conditions of the Downtown Eastside, the poorest postal code zone in all of Canada. What is often omitted is that at least three distinct populations (in addition to Caucasians) inhabit this area: Aboriginal peoples, Chinese and Latinos. All levels of government and several community-based organizations have been working collaboratively under the trilateral Vancouver Agreement, signed in 2000, to improve conditions in this troubled area. They are using models of social intervention that balance meeting broad needs with specific cultural sensitivity. Fostering intercultural understanding among the different groups is a

big part of the city's effort in the Downtown Eastside and elsewhere (McCann and Coyne 2004). One example of this model in action is the establishment by the city, along with the Vancouver United Way, of Collingwood Neighbourhood House, a service centre in a multi-ethnic low-income area. The centre's program combines universal access to services with specific cultural sensitivity. An important goal is to ensure that the centre's communal governance has the support and involvement of all of the people it serves. This approach seems to have been successful, in that Collingwood House now receives funding from a variety of local sources, beyond the initial support provided by the municipal government and the local United Way (Sandercock 2003a).

To the extent that Vancouver has had to confront interracial issues as well as deal with the management of diversity from a multicultural perspective, it represents a bridge between diversity management as a public policy problem and diversity management as a source of celebration and a strategy for economic growth — as exemplified by the following discussions of Montreal and Winnipeg. In the case of Montreal, the dominant emphasis in municipal initiatives has been on intercultural harmony. In the case of Winnipeg, multiculturalism is enthusiastically celebrated through festivals, most notably Folklorama and Aboriginal people's powwows, but the main challenge the city faces is how to engage its Aboriginal population in shaping a better future for itself and the city population as a whole.

Montreal

The City of Montreal began to confront the fact of its diversity in a positive manner in the late 1980s. Until that time, civic officials tended to ignore the diverse character of the population or, as in the case of the removal of gay businesses prior to the 1976 Olympics, suppress diversity outright. By 1988, the challenges of immigrant absorption and, specifically, of dealing with refugees prompted the city to set up special services for refugees. Simultaneously, a standing committee on cultural development was created at the political level, as well as a bureau of intercultural affairs within the civic administration, which in 1992 was elevated to divisional status.

The city issued a formal declaration against racial discrimination in 1989 and then undertook a number of initiatives to foster cross-cultural harmony. These included the establishment of the Montreal Advisory Committee on

Cross-Cultural Affairs, and area-specific initiatives such as the 1991 Petite-Bourgogne Action Plan, designed to address racial tensions in an area with a significant Black population, and projects conducted with a broad coalition of social development organizations in the problem-ridden area of Ahuntsic, home to a large immigrant population (Germain and Gagnon 2000; Dumas 2000; Achour and Tavlian 2004). In 2000, prior to amalgamation, the former City of Montreal's executive committee endorsed a multifaceted action plan. It featured efforts to foster the participation of immigrants in the associative and community life of neighbourhoods, to support immigrants' use of sports and recreational services, to improve immigrants' access to municipal services available at the neighbourhood level, and to foster cultural development in French through projects in municipal libraries and cultural centres (Dumas 2000).

Intercultural harmony in the use of public and private space and intercultural accommodation have been important issues in the management of diversity in Montreal. One persistent question is related to the establishment of places of worship by increasingly numerous religious communities. Thirty-five percent of the places of worship on the island of Montreal are associated with specific immigrant or ethnoreligious groups. These places are often more than places of prayer; they also provide daycare, education and recreational services. Some of these institutions are regional ones serving a membership that is dispersed throughout the metropolitan area, and they often have neighbours who do not share their religious convictions and who object to their presence or expansion. The reluctance of borough officials (who issue permits) to reject these objections is strengthened by the tax-exempt status of places of worship. They bring no direct revenues into municipal or school commission coffers (Germain 2004). Prior to amalgamation, the former City of Montreal had explicit religious heritage conservation policies, which were embedded in the 1994 Montreal Development Plan; an added problem at that time was the illegal establishment of places of worship, which involved breaking zoning regulations (Germain and Gagnon 2000). In recent years, the issue of Orthodox Jews erecting temporary structures on their Montreal balconies and lawns during the fall holiday of Sukkot worked its way through the courts.

Intercultural accommodation has also been a consideration in the design and delivery of recreational services in Montreal. As it is in many municipalities, the front line of recreation in Montreal is community-based organizations. Since

1996, such organizations wishing to use city facilities have had to do so in formal association with the city's Service des sports, des loisirs et du développement social (SSLDS) and in conformity with the principles of universalism and equity that the city has set out for recreation and leisure services. These principles were founded on three types of action: accepting and respecting ethnic and cultural traditions and preferences; actively working on interethnic communication and cooperation; and breaking down barriers to make all activities as accessible as possible (Cecile Poirier 2004). In many respects, then, the challenges inherent in simultaneously implementing all of these actions underlie the broader management of diversity in the City of Montreal.

Winnipeg

As Canada's historic gateway to the West, Winnipeg developed as a stopping point for a diverse population of immigrants, primarily from Western and Eastern Europe. After a period of adjustment and accommodation that spanned the early and middle part of the twentieth century, the city turned to celebrating its history and cultural diversity. Folklorama is one of the most enduring multicultural festivals in Canada. At various times, Winnipeg has also enacted a fine balance between the celebratory and the regulatory aspects of managing diversity. For instance, during his tenure as mayor — 1998 to 2004 — Glen Murray, a Richard Florida enthusiast, led an initiative to dramatically increase funding for arts and culture as a means of attracting more "creatives," and, ironically, he also brought in a strong law and order budget.

The contemporary stress point for Winnipeg relates to its Aboriginal population. The city's approach to this population has, until recently, been based on the notion that it poses a social and economic problem. The aftermath of the 1988 killing of Aboriginal leader J.J. Harper during a confrontation with Winnipeg police exemplifies this attitude. Unanswered questions about the incident and the police department's rapid and full exoneration of the officer involved were determining factors in the establishment of a provincial Royal Commission on Aboriginal justice. The commission's 1991 report concluded that there was widespread fear of police among Aboriginal peoples and that the police demonstrated a woeful lack of understanding of the cultures and policing needs of Aboriginal peoples. Around the same time, the Urban Governance Advisory Group of the Royal Commission on Aboriginal Peoples was informed by the chief

commissioner of the City of Winnipeg (himself a member of the advisory group) that there were no special initiatives within the city government to engage Aboriginal peoples.

The 1990s saw changes in the level of engagement between the City of Winnipeg and its Aboriginal peoples (see Evelyn Peters's chapter in this volume). To a considerable degree, this was driven by the increasingly well-developed institutions in the city that were controlled by Aboriginal peoples (Peters 2002). In 1992, Winnipeg's CPR station was bought by a coalition of Aboriginal service organizations and renamed the Aboriginal Centre of Winnipeg. The Aboriginal Centre Incorporated and the Native Family Economic Development Corporation, among others, have used the centre as a focal point for community development and service delivery. Over time, there has been active engagement with the City of Winnipeg, as well as with the provincial and federal governments, in these initiatives. The Aboriginal Centre was where Mayor Murray chose to deliver an apology for past municipal practices shortly after he was first elected. At the same time, the centre was identified as the anchor of a major redevelopment of the Main strip involving the numerous vacant buildings and the seedy hotels that are home to some of the city's most disadvantaged Aboriginal peoples.

Engagement of the Aboriginal population in urban planning and economic development matters has expanded since the early 1990s. The city employed the innovative practice of reaching out to engage Aboriginal peoples in a dialogue on economic development through city workers, such as public health nurses, who were routinely in touch with members of the Aboriginal population (Fielding and Couture 1998). In 2004, the city, along with Winnipeg Aboriginal organizations and the federal and provincial governments, concluded Canada's first Urban Aboriginal Strategy. The Winnipeg Partnership Agreement focuses on the participation of Aboriginal peoples, neighbourhood renewal and sustainability, downtown renewal, and support for innovation and technology in local development.

The foregoing suggests significant progress on developing civic awareness of the complex and critical role of Aboriginal peoples in Winnipeg's future. Aside from the Aboriginal Centre, there are also public and private spaces devoted to the understanding and celebration of Aboriginal cultures. The city's redevelopment of The Forks, at the junction of the Red and Assiniboine rivers, was done in consultation with Aboriginal peoples, who regard the area as sacred. The Forks contains public spaces that reflect the traditions of Aboriginal peoples, and these

spaces are used frequently for cultural and other events. The Neeganin ("our place") complex is part of the redevelopment around the Aboriginal Centre; it includes the Circle of Life Thunderbird House, a centre for spiritual and cultural affirmation and development. In one interesting initiative, Thunderbird House has undertaken explorations of shared values and practices with people of other traditions. For example, the common celebration of a thanksgiving was the basis for an intercultural dialogue with Winnipeg's Jewish community.

While these developments are salutary, flashpoints and challenges remain. These include high poverty levels among the city's Aboriginal peoples, poor police-Aboriginal resident relations, the presence of violent Aboriginal gangs, the high proportion of Aboriginal peoples among the city's street and sex trade worker populations, and the unsatisfactory participation and achievement rates of Aboriginal peoples in the city's education system. Building on positive initiatives and dealing with these challenges will likely dominate Winnipeg's diversity agenda for the foreseeable future.

Finally, Winnipeg has also been very aggressive in attempting to attract new immigrants. Prompted by federal-provincial nominees agreements that give provinces a more direct role in selecting their immigrants (they can set their own criteria based on specific labour needs) and that allow them to nominate a certain number of applicants (to be approved by Citizenship and Immigration Canada), Manitoba, with the support of the City of Winnipeg, has been particularly active. In addition, in 2002, the city created a fund to financially back private sponsorships of refugees destined for Winnipeg.

Comparative Perspectives

General Observations

THIS QUICK TOUR OF FOUR MAJOR CANADIAN CITIES, AS SUMMARIZED IN TABLE 3, yields a number of more general observations. While each of our case study cities takes multiple approaches to managing diversity, the table displays the most prominent tendency in each city as indicated by our research. It also points to some real future challenges as cities deal with the reality of their current diversity and the evolution of their population profiles.

The first and perhaps most basic observation is that because Canadian cities are diverse in different ways, the nature of their challenges is different. For example, in absolute terms, the number of Aboriginal people in Toronto and Montreal is substantial (20,000 and 10,000, respectively); however, Aboriginal peoples represent only a small fraction of the broad multicultural/multiracial diversity of these cities, and less attention is paid to them there than in places like Winnipeg, where urban Aboriginal issues are very prominent, if not dominant. Kristin Good found no clear correlation between the ethnic makeup of Canadian municipalities (characterized as biracial or multiracial) and policy responsiveness to diversity; rather, she found that the effectiveness of diversity management is dependent upon the nature of relations between municipal governments and community organizations (2005). Nevertheless, the relationship between population and policy often evolves differently under bifurcated versus heterogeneous circumstances. On the one hand, nongovernmental organizations and municipal governments are more likely to find common cause and to develop policy capacity in biracial populations than in more mixed ones. On the other hand, the escalation of tensions and a sense of otherness might be quicker and more intense in the biracial context. What this suggests is that there is no one-size-fits-all policy response to diversity for Canadian urban governments. Rather, urban policy-makers need to know their communities and understand well the differences among segments of the population. Yet evidence suggests that most urban municipalities neither collect much information on diverse communities — beyond the basic census data that comes across their desks — nor make effective use of what is available (Milroy and Wallace 2002).

Our survey suggests that to date most attention to the management of diversity in Canadian cities has been focused on immigrant and visible minority populations, and to a lesser extent on the disability community. Relations with GLBT communities seem to concentrate on policing issues, including issues of public and private space, and on celebrations such as gay pride parades, which have both symbolic value and, more instrumentally, significant economic benefits. To the extent that there is a class of "Floridians" (for example, gays, bohemians, artists and other creative people), it is of interest, but not a central focus of municipal action. One reason may be that while the economic advantage of having a critical mass of knowledge workers and creatives may be recognized, policies to expand the creative classes do not truly deal with issues of equity, difference and poverty, which are intertwined with matters of diversity.

Table 3 182

Policy Responses to
Diversity in Toronto,
Vancouver, Montreal
and Winnipeg[1]

Approaches and responses	Toronto	Montreal	Vancouver	Winnipeg
Main approach				
	Proactive multiculturalism; increased focus	Intercultural harmony	Both proactive and reactive	Celebration of multiculturalism; distinctive approach to Aboriginal peoples
Urban government responses				
Corporate policies/ frameworks	Immigration and settlement policy; plan to eliminate racism; access action plan (with annual reporting)	Charter of Rights and Responsibilities; Declaration against Racism; cultural development policy	Civic policy on multicultural relations	
Representation (council, committees)	Diversity advocate	Standing Committee on Diversity	Standing Committee on Aboriginal relations	
Involvement (task forces, advisory councils)	Task Force on Access and Equity; Aboriginal, disability and other advisory committees	Advisory Committee on Cross-Cultural Affairs	Diversity Advisory Committee; Police Diversity Advisory Committee; a disability advisory committee (disbanded in 2005)	Consultations (for example, on The Forks development
Administrative structures/processes	Diversity management and citizen engagement	Bureau of Intercultural Affairs	Cultural and translation outreach services	

(cont. on p. 183)

Table 3

Policy Responses to Diversity in Toronto, Vancouver, Montreal and Winnipeg[1] (cont. from p. 182)

Approaches and responses	Toronto	Montreal	Vancouver	Winnipeg
Urban government responses				
Planning processes	Training and awareness; translation (for example, a planning guide in 22 languages)	Integrated urban redevelopment program	Recruitment of planners with different backgrounds	
Funding and services	Professional mentoring of immigrants program; celebrations and events	Service des sports, des loisirs et du développement social; promoting a creative capital initiative	Hastings Institute; celebrations (for example, Aboriginal art, Chinatown walks)	Aboriginal Centre; multicultural celebrations; increased arts funding
Collaborative responses				
Intersectoral (voluntary, private sectors)	TRIAC[2]; Aboriginal economic development; Toronto City Summit Alliance	Montreal Summit, 2002	Collingwood House	Urban Aboriginal Strategy
Multigovernmental	Guns and gangs task force		Vancouver Agreement	Urban Aboriginal Strategy; Winnipeg Partnership

Source: Authors' calculations.
[1] The examples provided are illustrative only; they do not constitute a comprehensive list of initiatives in each city.
[2] Toronto Region Immigrant Employment Council.

The locales we examined are large urban agglomerations with numerous municipal governments. This is no less true in the Toronto and Montreal metro regions, postamalgamation. In all cases, it appears that the central cities are still doing the heavy lifting in policy and program terms, in the management of diversity, and in the provision of human services and the other supports on which surrounding areas have historically taken somewhat of a free ride. In some cases, this is a result of history. Central cities have been the traditional receiving grounds for newcomers and those who are "different," and they have responded over time by developing a broad range of services and supports — supports that are increasingly in demand due to the influx of new immigrants. Despite the fact that the traditional patterns of settlement have been replaced by the decentralized residency of certain ethnic groups, central cities still appear to be in the vanguard. They not only continue to provide services, but they also take the lead, in many different ways, when it comes to new policies and practices. The changing patterns of diversity suggest that many suburban municipalities with growing multicultural populations have some catching up to do and that the need for consultation and collaboration among municipalities in the urban agglomeration is more important than ever.

Even in municipalities where there have been major initiatives to manage and build on the fact of diversity, the character of the local population is unlikely to be reflected around the local council table. Karen Bird found that visible minorities are one-third of the way to being proportionally represented on councils in Vancouver, Montreal and Toronto (2004).[5] She concludes that the absence of voting rights for resident noncitizens, the predominance of single-member ward systems and the lack of any form of proportional representation in local elections are impeding factors to greater representation. Some Canadian municipalities do have council members who are openly part of GLBT communities and see their role as, in part, being advocates for these communities.

In many respects, council composition may not be a serious barrier to innovation, because there tends to be fairly strong engagement of community-based organizations with local governments when it comes to diversity issues. This involves both advocacy and service provision. While this engagement in policy and co-production of services may be laudable, it injects a high degree of fragility into local action. This is largely due to the uncertainty of funding for voluntary organizations — be it through donations or government sources — even as service needs are increasing and becoming more complex. Furthermore, the

development of representative local-level voluntary organizations that have the capacity or willingness to engage effectively with governments may be challenging for certain communities.

In terms of funding, the main problem a decade ago was cuts, but that has changed, since many voluntary/nonprofit agencies are experiencing a growth in service-related funding. Today the central issues are the restrictive nature of short-term project and contract funding, the stringent accountability regimes associated with such funding and the introduction of managed competition in many fields (City of Toronto 2003; Phillips and Levasseur 2004). In immigration and settlement services, as well as in other multicultural human services, the current system of competitive bidding established by federal and provincial governments has tended to favour large organizations, both for-profit and nonprofit, over small ones; and it has produced a two-tier system of dependency. Large multiservice agencies, which are often not very representative of, or culturally sensitive to, multicultural communities, use their superior capacity to secure contracts and then subcontract services for particular communities to ethno-specific organizations, which can make use of their ethnic capital — language, shared culture and ethnicity (Sadiq 2004, 6). The large multiservice agencies are highly dependent on government funding, and the small ethno-specific organizations rely on the multiservice agencies. The result, suggests Kareem Sadiq, is a reduction in the supply of ethno-specific organizations; a geographic mismatch of agencies and communities, which limits accessibility; and more difficulties in collaborating with each other and with governments, given the loss of autonomy and bad experiences with forced collaboration (2004). Municipal governments have little control over this contracting regime, however, as it occurs within provincial and federal spheres of responsibility.

A related, serious consequence of the funding regime for all voluntary organizations has been an "advocacy chill" (Scott 2003). Voluntary organizations of all types tend to keep their heads down, rather than criticize or advocate policy change, so as not to jeopardize their next contract or round of project funding. In spite of these constraints, community-based voluntary organizations remain key partners for urban governments in serving diverse populations in Canadian cities.

We also see some early signs of interest in the private sector in managing diversity in Canadian cities — in playing a greater role than its traditional one of philanthropy and shaping the built environment. This is exemplified by the Toronto Region Immigrant Employment Council initiative. It is significant that

this initiative reflects a recognition of the need to integrate recent arrivals in a way that builds the local economy. The role of the private sector in supporting the economic development component of the Winnipeg Urban Aboriginal Strategy is also worth examining. It is clear, however, that there still remains enormous potential for engaging the private sector.

Challenges

These observations suggest that specific challenges lie ahead for municipal governments as they continue to work in a diverse reality. The first challenge is how to deal with interethnic and intra-ethnic tensions. These are real and have a range of manifestations from competition for voice and resources to outright violence. As we have noted, Montreal may be the most advanced in developing approaches that balance respect for different minorities with the service of broader needs. The Downtown Eastside and Collingwood Neighbourhood House initiatives in Vancouver also provide possible salutary examples. But the existence of tensions within and among specific communities may be an ongoing and complicating factor in future local action. The challenge is to invest not only in urban spaces but also in democratic ones — that is, to establish ongoing, institutionalized mechanisms for communication with various groups and communities before tensions arise.

The second challenge relates to the planning and use of the built environment. As we have seen, the use of public and private space by particular communities has been a significant issue in a number of Canadian cities, and the planning profession continues to come under harsh criticism for its lack of cultural sensitivity and openness (Sandercock 2003a; Milroy and Wallace 2002). This raises hard questions for municipal governments, which necessarily have the regulation of natural and built space as one of their chief mandates. The outstanding questions are basic but become increasingly complex when there are different conceptions of individual and collective character and of property rights. To what extent should civic space celebrate or even tolerate different tastes and traditions? What are common needs in terms of civic space? How can the process better engage the relevant communities?

The third challenge concerns policing in a diverse metropolis. Incidents involving police and members of different communities have frequently been flashpoints, and racial profiling by police is highly contentious. These incidents and debates sometimes overshadow innovative efforts by police to engage specific communities, deal with particular incidents and recruit a more diverse workforce.

Police-community relations and inter/intracommunity relations are sometimes conjoined as police and individual communities try to resolve conflicts. This is the most serious hurdle to managing diversity through a positive approach.

Fourth, there is the challenge of representation in Canadian city governments. Electoral and workforce representation provides local institutions with an understanding of the needs and interests of different groups; it also encourages a willingness to consider those needs and interests as legitimate, and a willingness on the part of city councils and their departments to engage different populations in ways that are efficacious for both citizens and government.

The final challenge is to recognize that dealing effectively with urban diversity is both multilevel, involving federal and provincial governments, and horizontal, involving a range of voluntary and private sector partners. No matter how activist a municipal government is, it must still contend with the legislative and regulatory frameworks and funding and contracting regimes established by federal and provincial governments, and it is largely reliant on nonprofits for the delivery of services. In spite of this interconnectedness, municipalities lack access to the policy-making process at the federal and provincial levels and in the intergovernmental arena. This creates a situation where "confusion, rather than coordination, becomes the rule" (Papillon 2002, 24). The challenges of this embeddedness are threefold. First, municipalities need to figure out how to reinvest in community organizations so as to enhance the stability and capacity of the voluntary sector on which they are so dependent. Second, they need to engage more effectively with the private sector, which plays such a large part in shaping urban space. Third, they need to devise a means of participating in intergovernmental decision-making and collaborating with other governments on the myriad policies that affect the management and accommodation of diversity in Canadian cities.

Toward Greater Collaboration

A WIDE RANGE OF POLICY TOOLS, SUBJECT TO PROVINCIAL LEGISLATION AND AGREEMENT, is being used to manage diversity in Canada's big cities. Although we have focused on the policy responses and initiatives of urban governments, the municipal policy environment for the management of diversity is profoundly affected by

provincial and federal policy and the wider policy context. The federal government's policy stance on matters related to Aboriginal peoples, immigration and multiculturalism are cases in point. We think it is important to reflect briefly on the broader intergovernmental policy context for urban governments' management of diversity and on some of the available policy instruments.

Several aspects of the broad intergovernmental policy context are particularly noteworthy. The first is the federal government's interest in, and approach to, having a metapolicy for cities. During the period of the Martin government, this was embodied in the "cities and communities" agenda, which was led by the minister of infrastructure and communities. Early signals from the Harper government suggested some interest in linking infrastructure and communities more explicitly with transportation. Hence we now have a minister of transportation, infrastructure and communities, rather than two separate portfolios. This suggests a somewhat more comprehensive approach to the federal role in infrastructure (although we should remember the prominent place of public transit in the Liberal agenda). But it also begs the question of whether the new government will focus on the community impacts of its transportation and infrastructure initiatives. Will the federal government look beyond physical and political geographic boundaries and consider the impact of future transportation and infrastructure initiatives on diverse communities? This is still an open question.

The second aspect concerns the intergovernmental funding regime. In our recent national political discourse, closing the alleged gap between urban governments' fiscal capacity and fiscal demands has been prominent. Big-city governments have advocated action on this by both the federal and provincial governments. Parallel to this, of course, is the provincial call to address the federal-provincial fiscal imbalance. The provincial chorus now seems to have the federal ear. From the standpoint of managing diversity, the question becomes "What is the best approach to adjusting fiscal relationships?"

Our view is that the transfer of tax room from the federal government to the provinces is not the best approach. Newly endowed provincial governments would have a difficult time determining which cities require the greatest focus on diversity management. Furthermore, selecting particular municipalities *and* diversity management as objects of expenditure over other competing priorities could prove to be an insurmountable problem for both provincial and urban governments. One possible exception is in the area of policing. The best approach,

then, is to employ a predictable system of intergovernmental transfers focusing on policy sectors — such as immigration, labour market adjustment and housing — that have a strong diversity management component. It is still early days, but we see two potential courses of federal action to address fiscal imbalance. One holds more promise than the other in terms of targeting money at issues of urban diversity. It involves a series of bilateral agreements with each province. With this approach, the challenges of immigrant settlement, urban issues related to Aboriginal peoples and social inclusion would be potential factors in shaping the transfer agreements. A more generic, multilateral approach holds less promise for allocating resources in a much-needed place-based manner.

Reliance on sector-focused intergovernmental transfers to assist urban governments in managing diversity poses significant challenges. Beyond money, both vertical and horizontal engagement are needed to address diversity issues in cities. City-focused agreements have demonstrated promise — as shown by the Winnipeg Urban Aboriginal Strategy and the Vancouver Agreement. They engage all three levels of government and, within each level, involve a broad set of appropriate actors in tackling comprehensively defined issues. In both of these cases, diversity issues are prominent. These models suggest, however, that there is nothing to prevent a similar organizational approach to dealing with comprehensive challenges in cities where diversity issues are less prominent. Hence, the singling out of diversity is driven by local circumstances and awareness rather than by federal and/or provincial edict. The local voluntary and business communities have a strong and, as illustrated by the TRIEC case in Toronto, potentially very active role to play.

Finally, recent developments in Toronto provide an example of a new and potentially useful way of enabling city governments to have more of a policy voice and scope of action in dealing with diversity. The recently passed *Stronger City of Toronto for a Stronger Ontario Act* explicitly provides the City of Toronto with the independent authority to enter into agreements with the federal government. The Act also recognizes that the municipal government shares policy interests with the province in many areas of provincial jurisdiction, and so it accords the city "shared policy space" through collaborative provincial-municipal policy development. Since the Act was only promulgated in early 2006, its real impact has yet to be determined. It does, however, suggest a new acknowledgement of the potential of greater urban government leadership in policy-making on complex intergovernmental issues, such as those related to the management of diversity.

Conclusion

WE BEGAN BY ADVOCATING A SHIFT IN VIEW FROM NEGATIVE TO POSITIVE — FROM seeing urban diversity as a problem that needs to be managed (and some-times contained) to considering it an asset that also needs to be managed, but that can confer certain benefits and promote economic growth. Our review suggests that the policy perspectives of a number of large Canadian cities now tilt toward the positive view. For these cities, this positive approach goes beyond celebrations and slogans and tries to engage communities in ways that acknowledge and work with their deep diversity. Diversity management is at various stages of develop-ment in the cities we examined. These cities also make use of different policy and program tools, because the understanding of diversity as both problem and asset varies in each. In general, we see the Canadian model of diversity at work in urban governments. As a consequence, urban approaches to diversity involve a series of balances and trade-offs: between assimilation or integration and the free-dom to be different; between special accommodation and equal treatment; and between roles for the public, private and voluntary sectors. In the urban context, perhaps the most important balance is between building on multiculturalism and managing intercultural relations among minority and majority communities and specific cultural communities. Although many urban governments recognize that diversity has instrumental value for economic growth, most of the focus of diver-sity management is on creating more workable and liveable urban spaces, not simply on enhancing competitive advantage.

Three important challenges make the balance a delicate one and pull the agenda toward the "problem" end of the continuum. Two relate to policing and to intercommunity relations, as expressed largely in planning and in competing views of the use of the built environment. The final challenge is to foster greater recognition that diversity is not simply of concern for central and inner cities or for urban governments alone. Increasingly, it is a collaborative effort involving the federal and provincial governments as well as the voluntary and private sectors. It is indeed a fine balance.

Notes

1 As of the 2001 census, 43.7 percent of
 Toronto residents, 40.2 percent of Vancouver
 residents and 18.4 percent of Montreal resi-
 dents were foreign-born, as compared to
 those of Miami (40 percent), Sydney (31
 percent), Los Angeles (31 percent) and New
 York (24 percent) (Statistics Canada 2003).
 The percentage of foreign-born across all 27
 of Canada's CMAs was 18.4 percent.
 Montreal sat right on the average, while nine
 other CMAs (Toronto, Vancouver, Hamilton,
 Windsor, Kitchener, Abbotsford, Calgary,
 London and Victoria) had a higher than
 average percentage of their population in
 this category (Justus 2004).

2 The assumption has been that newcomers
 move to the largest urban areas —Toronto,
 Montreal and Vancouver — for the eco-
 nomic advantages these locales offer.
 However, as Chantal Goyette shows, the
 primary reason for destination choice is
 family and social support, not perceived
 economic advantage, and recent immi-
 grants in CMAs outside the big three actu-
 ally had higher employment incomes than
 those within them (2004).

3 One debate regarding multiculturalism
 policies is whether in a diverse society that
 employs these policies — policies that sup-
 port the maintenance of different identities
 and practices — it is more difficult to sus-
 tain a robust welfare state. Keith Banting
 and Will Kymlicka provide definitive evi-
 dence on this (2003). In a comparative
 study, Banting finds no connection between
 support for multiculturalism and the main-
 tenance and funding of a strong welfare
 state (2005; see also Banting and Kymlicka
 2003).

4 For example, as Siemiatycki and Isin point
 out, all but 10 of the 165 parade permits
 issued in the old City of Toronto in 1996
 were to ethnic, racial or religious groups
 (1997).

5 Vancouver's current council is perhaps fur-
 ther along in terms of representation of
 minority groups, in part because of its small
 size. Mayor Sam Sullivan, a quadriplegic,
 has been an active advocate for the disabili-
 ty community and is the first mayor of the
 city to speak Cantonese. He is joined on the
 11-member council by three members of
 the Chinese community and Canada's first
 openly gay person to be ordained in a main-
 stream Christian denomination.

References

Achour, Azzedine, and Nayiri Tavlian. 2004.
 "Neighbourhoods under a Microscope:
 Montreal and Toronto. Accessibility in a
 Traditionally Homogeneous Environment."
 Paper presented at the Metropolis Seventh
 National Conference, March 28, Montreal.

Banting, Keith. 2005. "The Multicultural Welfare
 State: International Experience and North
 American Narratives." Social Policy and
 Administration 39 (2):98-115.

Banting, Keith, and Will Kymlicka. 2003. "Are
 Multiculturalist Policies Bad for the Welfare
 State?" Dissent (fall):59-66.

Bird, Karen. 2004. "Obstacles to Ethnic Minority
 Representation in Local Government in
 Canada." Our Diverse Cities 1:182-6.

City of Toronto. 2002. Just Do It: Report of the
 Community Consultations on the Plan of
 Action for the Elimination of Racism and
 Discrimination. Toronto: City of Toronto.
 Accessed July 23, 2005.
 www.city.toronto.on.ca/diversity/pdf/plan_
 report_plain_text.pdf

———. 2003. Cracks in the Foundation.
 Community Agency Survey 2003: A Study of
 Toronto's Community-Based Human Service
 Sector. Toronto: City of Toronto. Accessed
 July 23, 2005. http://www.toronto.ca/divi-
 sions/pdf/cns_survey_report.pdf

Driedger, Leo. 2001. "Changing Visions in Ethnic
 Relations." Canadian Journal of Sociology 26
 (3):421-52.

Dumas, Marie-Claire. 2000. "Municipal
 Perspective." Presentation given at "Urban
 Diversity: Managing Multicultural Cities,"
 Metropolis Canada, March 20, Montreal.

Accessed September 1, 2006.
http://72.14.207.104/search?q=cache:F9BK
1fyGpAJ:canada.metropolis.net/events/
urban-forum/Montreal_E.html+Dumas,
+Marie-Claire.+2000+%E2%80%9CUrban+
Diversity&hl=en&gl=ca&ct=clnk&cd=

Evans, Peter. 2005. "Diversity, Freedoms Make
Us Unique." *National Post*, September 24.

Fainstein, Susan S. 2005. "Cities and Diversity:
Should We Want It? Can We Plan for It?"
Urban Affairs Review (41) 1:3-19.

Fielding, Jeff, and Gerry Couture. 1998.
"Economic Development: The Public's Role
in Shaping Winnipeg's Economic Future."
In *Citizen Engagement: Lessons in
Participation from Local Government*, edited
by Katherine A. Graham and Susan D.
Phillips, 25-48. Toronto: IPAC.

Florida, Richard. 2002. *The Rise of the Creative
Class and How It's Transforming Work,
Leisure, Community and Everyday Life*. New
York: Basic Books.

Fong, Eric, and Kumiko Shibuya. 2005.
"Multiethnic Cities in North America."
Annual Review of Sociology 31:285-304.

Fong, Eric, and Rima Wilkes. 2003. "Racial and
Ethnic Residential Patterns in Canada."
Sociological Forum 18 (4):577-601.

Germain, Annick. 2004. "Religious Diversity: A
Problem for Municipalities?" *Our Diverse
Cities* 1:143-5.

Germain, Annick, and Julie Elizabeth Gagnon.
2000. "Civic Life, Neighbourhood Life: The
Same Story?" Paper presented at the annual
meeting of the Canadian Sociology and
Anthropology Association, May 28-31,
Edmonton.

Good, Kristin. 2005. "Patterns of Politics in
Canada's Immigrant-Receiving Cities and
Suburbs." *Policy Studies* 26 (3-4):261-89.

Goyette, Chantal. 2004. "Does the Concentration
of Immigrants in Major Cities Provide
Greater Economic Benefits?" *Our Diverse
Cities* 1:136-8.

Graham, Katherine A.H., and Evelyn Peters.
2002. *Aboriginal Communities and Urban
Sustainability*. CPRN Discussion Paper F/27.

Ottawa: Canadian Policy Research
Networks.

Grant, Hugh, and Arthur Sweetman. 2004.
"Introduction to Economic and Urban Issues
in Canadian Immigration Policy." *Canadian
Journal of Urban Research* 13 (1):1-24.

Hiebert, Daniel. 2000. *Cosmopolitanism at the
Local Level: Immigrant Settlement and the
Development of Transnational
Neighbourhoods*. RIIM Working Paper 00-
15. Vancouver: Research on Immigration
and Integration in the Metropolis.

Hou, Feng. 2004. *Recent Immigration and the
Formation of Visible Minority Neighbourhoods
in Canada's Large Cities*. Analytical Studies
Branch Research Paper Series. Ottawa:
Statistics Canada.

Jacobs, Jane. 1962. *Death and Life of Great
American Cities*. New York: Vintage Books.

Jedwab, Jack. 2004. "Creative Classification or
Creative Class? The Challenges of Applying
Richard Florida's Formula to Canada's
Cities." *Our Diverse Cities* 1:34-40.

Jenson, Jane, and Martin Papillon. 2001. *The
"Canadian Diversity Model": A Repertoire in
Search of a Framework*. CPRN Discussion
Paper F/19. Ottawa: Canadian Policy
Research Networks.

Justus, Martha. 2004. "Immigrants in Canada's
Cities." *Our Diverse Cities* 1:41-7.

Kymlicka, Will. 1998. *Finding Our Way:
Rethinking Ethnocultural Relations in Canada*.
Toronto: Oxford University Press.

Ley, David. 1995. "Between Europe and Asian:
The Case of the Missing Sequoias." *Ecumene*
2:185-210.

————. 1999. "Myths and Meanings of
Immigration and the Metropolis." *Canadian
Geographer* 43 (1):2-19.

————. 2005. *Post-multiculturalism?* RIIM
Working Paper 05-18. Vancouver: Research
on Immigration and Integration in the
Metropolis.

Ley, David, and Annick Germain. 2000.
"Immigration and the Changing Social
Geography of Large Canadian Cities." *Plan
Canada* 40 (4):29-32.

McCann, Ferrial, and Kathy Coyne. 2004. "Fostering Change from Within: Building Capacity for Change in the Ethnocultural Community of Vancouver's Downtown Eastside." *Our Diverse Cities* 1:195-6.

Milroy, Beth Moore, and Marcia Wallace. 2002. *Ethnoracial Diversity and Planning Practices in the Greater Toronto Area: Final Report.* CERIS Working Paper 18. Toronto: Joint Centre of Excellence for Research on Immigration and Settlement.

Murdie, Robert A., and Carlos Teixeira. 2003. "Towards a Comfortable Neighbourhood and Appropriate Housing: Immigrant Experiences in Toronto." In *The World in a City*, edited by Paul Anisef and Michael Lanphier, 132-91. Toronto: University of Toronto Press.

Mwarigha, M.S. 1997. "The Impact of Cutbacks and Restructuring on the NGO Sector and the Delivery of Immigrant Services." Paper presented at the First National Conference on Immigration, Prairie Centre for Research on Immigration and Integration, March 6-8, Edmonton.

Myles, John, and Feng Hou. 2002. "Changing Colours: Neighbourhood Attainment and Residential Segregation among Toronto's Visible Minorities." Unpublished paper.

Ornstein, Michael. 2002. *Ethno-racial Inequality in Toronto: Analysis of the 1996 Census.* Toronto: City of Toronto.

Papillon, Martin. 2002. *Immigration, Diversity and Social Inclusion in Canada's Cities.* CPRN Discussion Paper F/27. Ottawa: Canadian Policy Research Networks.

Peters, Evelyn. 2002. "Aboriginal People in Urban Areas." In *Urban Affairs: Back on the Policy Agenda*, edited by Caroline Andrew, Katherine Graham, and Susan Phillips, 45-70. Montreal: McGill-Queen's University Press.

Phillips, Susan D., and Karine Levasseur. 2004. "The Snakes and Ladders of Accountability: Contradictions between Contracting and Collaboration for Canada's Voluntary Sector." *Canadian Public Administration* 47 (4):451-74.

Poirier, Cecile. 2004. "Ambiguities in Diversity Management in the Delivery of Sports and Recreation Services." *Our Diverse Cities* 1:160-3.

Poirier, Christian. 2004. "The Management of Ethnic Diversity and Comparative City Governance in Canada." Paper presented at the annual meeting of the Canadian Political Science Association, June 3, Winnipeg.

Ray, Brian. 2004. "A Diversity Paradox: Montréal's Gay Village." *Our Diverse Cities* 1:72-5.

Royal Commission on Aboriginal Peoples. 1996. "Urban Perspectives." *Perspectives and Realities.* Vol. 4 of *Report of the Royal Commission on Aboriginal Peoples.* Ottawa: Minister of Supply and Services Canada.

Sadiq, Kareem D. 2004. *The Two-Tier Settlement System: A Review of Current Newcomer Settlement Services in Canada.* CERIS Working Paper 34. Toronto: Joint Centre of Excellence for Research on Immigration and Settlement.

Sandercock, Leonie. 2003a. *Integrating Immigrants: The Challenge for Cities, City Governments, and City-Building Professionals.* RIIM Working Paper 03-14. Vancouver: Research on Immigration and Integration in the Metropolis.

———. 2003b. *Rethinking Multiculturalism for the 21st Century.* RIIM Working Paper 03-20. Vancouver: Research on Immigration and Integration in the Metropolis.

Scott, Katherine. 2003. *Funding Matters: The Impact of Canada's New Funding Regime on Nonprofit and Voluntary Organizations.* Ottawa: Canadian Council on Social Development, Coalition of National Voluntary Organizations. Accessed August 21, 2006. http://www.ccsd.ca/pubs/2003/fm/index.htm

Siemiatycki, Myer, and Engin Isin. 1997. "Immigration, Diversity and Urban Citizenship in Toronto." *Canadian Journal of Regional Science* 20 (1-2): 73-102.

Siemiatycki, Myer, Tim Rees, Roxanna Ng, and Khan Rahi. 2001. *Integrating Community*

Diversity in Toronto: On Whose Terms? CERIS
Working Paper 14. Toronto: Joint Centre of
Excellence for Research on Immigration
and Settlement.

Statistics Canada. 2003. *Canada's Ethnocultural
Portrait: The Changing Mosaic.* Ottawa:
Statistics Canada. Accessed January 16,
2006. http://www12.statcan.ca/english/
census01/products/analytic/companion/
etoimm/subprovs.cfm

Wallace, Marcia, and Frances Frisken. 2004.
"Meeting the Challenges of Immigrant
Settlement: Is Your Municipality Ready?"
Our Diverse Cities 1:148-52.

Spatial and Scalar
Issues in Managing
Diversity in Canada's
Cities

Commentary

K ATHERINE GRAHAM AND SUSAN PHILLIPS HAVE RANGED BROADLY AND INCISIVELY IN
their contribution to this volume, "Another Fine Balance: Managing
Diversity in Canadian Cities," a discussion of diversity management in Canada's
largest cities. Their review and interpretation are persuasive, and in this brief
response I shall select certain features of their work for emphasis and develop-
ment. In particular, I will focus on the management of immigration, the principal
source of diversity in Canada's large cities, highlighting questions relating to spa-
tial relations and geographical scale.

The National Scale:
Concentration versus
Dispersal

F IRST, WE SHOULD REMIND OURSELVES THAT CANADIANS TYPICALLY SEE IMMIGRATION
as an opportunity, not a problem (Hiebert 2006). Consequently, cities receiv-
ing relatively few immigrants, including Winnipeg, Saskatoon and Quebec City
(and the provinces of Atlantic Canada), are keen to recruit more newcomers. The
current geographical bias of immigration in very few major cities has created a
polarized map of recent immigration across Canada that is historically unprece-
dented; earlier this decade, annual landings destined for the Toronto metropoli-
tan area were actually nudging 50 percent of national totals. Surprisingly, the
reason for this concentration has less to do with employment opportunities and
more to do with preexisting social networks. The large and ongoing Longitudinal

Survey of Immigrants to Canada (LSIC), a panel study of 12,000 immigrants conducted by Statistics Canada, showed that only 23 percent moved to Toronto for employment-related reasons; the presence of friends and relatives in the city was far more important. Job opportunities were cited as the most important reason by only 16 percent of immigrants in Montreal and just 6 percent of immigrants in Vancouver (Statistics Canada 2003). Even for economic migrants, a far greater asset was the presence of friends and relatives in each city.

There is tremendous geographical inertia here, which will not easily be reconfigured. We observe the same spatial polarities in the United States, Australia and most other immigrant-receiving countries. Only with job offers will people move outside the large gateway cities; the slow dispersion of Latinos outside the major centres in the United States since 1990 has occurred only as a result of job contracts in such niches as agriculture, meat-packing and construction. Interestingly, the LSIC has shown that employment prospects were more important, though still secondary to social networks, in directing immigrants to destinations outside Canada's principal gateway cities. But in the rest of Canada, the regions most enthusiastic about immigration are commonly suffering out-migration because of high unemployment levels.

In short, it is hard to see strong motives in the short term for immigrants to settle in significant numbers outside the principal metropolitan centres. Previous Liberal ministers of immigration have wanted to require newcomers to settle outside these urban gateways, but such a demand would present several difficulties. First, it could raise concerns about infringement of Charter rights. Second, European states that have instituted such policies, notably Sweden, have often abandoned them after finding that there was significant secondary migration back to the major centres (Robinson, Andersson and Musterd 2003). Third, policies that steer immigrants to smaller centres and rural areas must, of course, be supported by initiatives to provide local employment opportunities and immigrant settlement services.

Despite these challenges, several inefficiencies in the current state of hyperconcentration encourage the creation of a dispersal policy. Labour market competition between new immigrants and recent immigrants for low-paying service jobs precipitates a race to the bottom in terms of employment conditions. Many of these workers have entered Canada as economic migrants with high levels of human capital, but because their credentials are not recognized and they are given inadequate opportunity to obtain reaccreditation, they find themselves

in demoralizing, low-skilled positions. Focus groups we recently conducted with new immigrants in Vancouver and Toronto, along with some earlier research, reveal a sense of social and economic exclusion, frustrated hopes and unexpected disappointments (Smith and Ley 2006).

A second policy issue is the relationship between urban growth and environmental quality, an issue that becomes acute during summer heat waves and smog alerts. The Greater Toronto Area suffers increasingly from serious traffic congestion, air pollution and high land prices; Vancouver is not far behind. As immigration is the major contributor to population growth, any environmental policy intended to ameliorate the diseconomies of size would have to facilitate immigrant dispersal to other, cheaper centres with less polluted ecologies.

A third national issue supporting a dispersal strategy is the hyperdiversity of gateway cities in contrast with the cultural homogeneity of most other parts of Canada. This creates a very uneven sense of national identity. It is not widely recognized that this situation is aggravated by the out-migration of the Canadian-born from gateway cities. Those who first noted these countervailing population flows — immigrants into gateway cities, native-born out of them — in New York and Los Angeles attributed the phenomenon to racial distancing of the native-born from non-European immigrant clusters. There is probably some truth to this, but my own view is that differential responses to housing market conditions play a larger role: the native-born with lower human capital are shut out of high-priced housing markets, while retirement and preretirement homeowners often cash in their property assets; in contrast, immigrants are more likely to tolerate housing affordability and crowding burdens (Ley 2003).

The Regional Scale: Place Matters

GRAHAM AND PHILLIPS MAKE THE IMPORTANT OBSERVATION THAT DIVERSITY IN Canadian cities takes different forms in different urban settings. Among the three largest metropolitan areas, Montreal has a unique immigrant profile. Provincial policy attracts francophone immigrants from such states as Haiti, Lebanon and Algeria; in other cities, immigrant populations from these nations are tiny. Toronto is global in its reach, receiving newcomers from every continent,

while Vancouver, reflecting its Pacific Rim location, is dominated by arrivals from Asia, who are superimposed upon an earlier European population. But there is an additional line of divergence in terms of the entry class of newcomers, which adds greatly to the character of immigrant diversity in each city. Over the past 20 years, Vancouver has been disproportionately favoured by economic migrants — particularly those who, due to their wealth and business experience, qualify for one of the business entry streams — while it has admitted a relatively low number of refugees. The declared wealth of business immigrants landing in Greater Vancouver from 1990 to 1996 amounted to some $20 billion. As a result, the management issues that are relevant to immigrant settlement there are quite different from those that prevail in Toronto and Montreal, where poor refugees comprise a much larger share of the intake. This regional diversity has been appropriately recognized by the federal government through the devolution of settlement funds to the provinces.

The Metropolitan Scale: Central City versus the Suburbs

I MMIGRANTS WHO MOVE TO THE MAJOR GATEWAY CITIES OF VANCOUVER AND TORONTO enter Canada's most expensive housing markets; they get by through overcrowding and serious affordability burdens. With gentrification removing the traditional affordable housing options in the inner city, and with little new social housing under construction, the move to the suburbs we have seen over the past 20 years will certainly continue.

The suburban movement of immigrant settlement has several troubling correlates. Suburban municipalities are rarely experienced in providing immigrant-friendly services, and their management culture lags behind the fast-changing demographic profile of their new client base. Not only are many culture-specific needs unfamiliar to suburban administrations, but also the poverty of some new immigrants has caught middle-class suburbs unprepared. In suburban Peel, outside Toronto, 75,000 immigrants have settled in the past three years, almost a third of whom are low-income (Keung 2006). As suburbs are generally designed for middle-class automobile owners, members of poorer

households reliant on public transport have difficulty accessing workplaces and schools. Immigrant-specific services are underresourced absolutely and in comparison with the City of Toronto; immigrant per capita funding for services runs at $873 in Toronto, but only at $558 and $179 in suburban Peel and York, respectively (Keung 2006).

Immigrant services remain concentrated in downtown and inner-city Toronto — once the primary areas of new immigrant concentration — which are separated from the new suburban regions of accelerated settlement (Wang and Truelove 2003). The underprovision of services in suburban Scarborough, a municipality where there are serious immigrant needs, points to a spatial mismatch between service demand and service delivery. Focus groups with immigrants in districts like Scarborough and Surrey (a suburb of Vancouver) have raised repeatedly the problem of immigrants being compelled to make long and expensive journeys to access necessary services (Smith and Ley 2006).

The Neighbourhood Scale: The Question of Spatial Segregation

T HE GROWING CONCENTRATION OF IMMIGRANTS IN A FEW METROPOLITAN CENTRES will inevitably sustain moderate degrees of geographical segregation. It is important not to overstate this case; segregation levels in Canadian cities are still modest, and most members of any one national group do not live in highly segregated areas. Moreover, existing segregation levels do not exceed those experienced by postwar European migrants, including those of Italian and Portuguese origin. Of course, the native-born are also segregated — think of Westmount, Rosedale and Shaughnessy, Anglo-dominated for most of the twentieth century — though rarely has this been regarded as a problem. It is a reminder that there can be, as Ceri Peach has noted, both good and bad segregation, the former leading to mutual aid through supportive social networks, the latter to the aggravation of dysfunctional subcultures (1996).

Concerns have periodically emerged in Canada, though much less often than in Europe, about the development of bad segregation — isolated and excluded underclass immigrant districts in urban centres (Halli and Kazemipur

1997; cf. Qadeer and Kumar 2006). The growing association of recent immigrants with poverty since 1990, as Graham and Phillips document, does raise the possibility that concentration will be sustained, even perhaps generationally reproduced, by the inability of some immigrants to vacate low-income enclaves. Since the London bombings of July 2005, followed by the November riots in the Paris *banlieues*, acute new anxieties have arisen about segregation sustaining separate and hostile subcultures. Such anxieties have generated an urgent demand for policies that promote social mixing, and also an often visceral rejection of multiculturalism, which is regarded as too complacent toward cultural difference, if not complicit in perpetuating it. But, as Howard Duncan has noted, the objective of multicultural societies is integration, not separation (2005).

While these anxieties are overstated in Canadian cities, we should be concerned about the entrapment of immigrants in low-income concentrations. During the 1990s, the immigrant share of poverty tracts rose; by 2001, immigrants accounted for 77 percent of the population of low-income tracts in Toronto, and 47 percent of those in Vancouver (Heisz and McLeod 2004). Moreover, half or more of these immigrants had resided in Canada for at least 10 years, raising the prospect of prolonged residence in poverty districts. Statistical analysis reveals the changing power of immigration to predict poverty levels on the census tract scale. The coefficient of determination (r^2) between the two variables in Toronto rose from 0.28 in 1991 to 0.45 in 1996, falling back to 0.40 in 2001 (Smith 2004). The comparable values in Vancouver reflected a steady growth from 0.14 to 0.31; the figure rose slightly to 0.33 in 2001. Bearing in mind the large number of observations (924 in Greater Toronto and 386 in Greater Vancouver), these are robust and troubling relationships.

Governance: Who Provides the Services?

THE MANAGEMENT OF IMMIGRANT DIVERSITY PRESENTS AT BEST A CONVERGENCE, AND not infrequently a collision, of jurisdiction and level of government. Immigrant selection is a federal responsibility (except in Quebec), settlement service delivery is a provincial responsibility paid for by revenue sharing with Ottawa, but service needs are expressed on the ground at the municipal and neighbourhood levels — the management levels with the least capacity to meet

those needs. The contribution of local governments runs primarily to goodwill, facilitation, mission statements and the cultivation of social capital. The provision of hard services is limited by the fiscal realities of existing constitutional arrangements. Graham and Phillips observe that in Ottawa, as in other cities, new cultural diversity needs have to be managed from existing budgets. Resources are sparse. For example, Vancouver — in its region, by far the most attuned municipality to population diversity — has one multicultural planner to manage diversity issues. We might argue that most of the current asymmetry in Canadian revenue sharing is found in relations with the major cities, not the provinces.

Jurisdiction at the municipal level does include land use, policing, transportation and education services, and there is much that can be done in these fields — as Graham and Phillips observe — to demonstrate that the umbrella of multiculturalism provides equal cover to residents of diverse backgrounds. Community centres and neighbourhood houses can offer modest for-fee services and safe public spaces for intercultural encounters, and some seem to have done so with great success (Sandercock 2003). Decision-making in these fields has moved beyond a focus on tolerance and respect for diversity and now demonstrates a concern with fairness; multicultural policy has transcended the celebration of diversity and now has as a principal goal the assurance of citizenship rights.

Settlement services for immigrants are primarily the responsibility of NGOs and the voluntary sector, the latter including faith-based organizations, whose contributions are sometimes overlooked in Canada (Beattie and Ley 2003). Most NGOs are highly committed to the task and are close to the communities they serve. Staff work long hours and have heavy caseloads. By using coethnic volunteers, they also provide some Canadian job experience to recent immigrants — experience that is so important for labour-market recruitment. SUCCESS, one of the largest immigrant-serving agencies in Vancouver, has about 250 staff members, but it also claims close to 10,000 volunteers, almost all of them recent immigrants. To support its programs, SUCCESS engages in regular fundraising activities, most of which involve mobilizing the wealthy Cantonese population of Vancouver. Most other NGOs do not have access to so well-endowed a constituency and endure a gruelling existence of grant applications, cost-cutting and excruciating accountability to provincial ministries. Staff burnout is common. These NGOs are low-cost providers from the provincial perspective, part of the shadow state that neoliberal governments use to contract out services.

At the same time, there is interesting evidence that NGOs in Canadian cities play a broader role than service provision in the settlement process. In a study comparing Canada with the United States, Irene Bloemraad argues that in Canada the devolution of service provision to grassroots NGOs — which engage both paid and volunteer immigrant staff — teaches an important object lesson to new immigrant clients on the national commitment to social inclusion. As such, NGOs generate and distribute the social capital, as well as the social services, that are the basis for a healthy civil society, leading, Bloemraad claims, to higher naturalization rates and a more effective integration policy in Canada than in the United States (2003).

References

Beattie, Laura, and David Ley. 2003. "The German Immigrant Church in Vancouver: Service Provision and Identity Formation." *Die Erde* 134:3-22.

Bloemraad, Irene. 2003. "Institutions, Ethnic Leaders, and the Political Incorporation of Immigrants: A Comparison of Canada and the United States." In *Host Societies and the Reception of Immigrants*, edited by Jeffrey Reitz, 361-402. San Diego: Center for Comparative Immigration Studies, University of California.

Duncan, Howard. 2005. "Multiculturalism: Still a Viable Concept for Integration?" *Canadian Diversity* 4 (1): 12-14.

Halli, Shiva, and Abdolmohammad Kazemipur. 1997. "Plight of Immigrants: The Spatial Concentration of Poverty in Canada." *Canadian Journal of Regional Science* 20 (1-2): 11-28.

Heisz, Andrew, and Logan McLeod. 2004. *Low Income in Census Metropolitan Areas, 1980-2000*. Cat. no. 89-613-MIE, 001. Ottawa: Statistics Canada, Business and Labour Market Analysis Division.

Hiebert, Daniel. 2006. "Winning, Losing, and Still Playing the Game: The Political Economy of Immigration in Canada." *Journal of Economic and Social Geography* 97 (1): 38-48.

Keung, Nicholas. 2006. "Regions Struggle with Ethnic Influx: Poverty, Social Service Issues Soar." *Toronto Star*, 29 July.

Ley, David. 2003. *Offsetting Immigration and Domestic Migration in Gateway Cities: Canadian and Australian Reflections on an "American Dilemma."* RIIM Working Paper 03-01. Vancouver: Research on Immigration and Integration in the Metropolis.

Peach, Ceri. 1996. "Good Segregation, Bad Segregation." *Planning Perspectives* 11:379-98.

Qadeer, Mohammad, and Sandeep Kumar. 2006. "Ethnic Enclaves and Social Cohesion." *Canadian Journal of Urban Research* 15 (2): 1-17.

Robinson, Vaughan, Roger Andersson, and Sako Musterd. 2003. *Spreading the "Burden"?: A Review of Policies to Disperse Asylum Seekers and Refugees*. Bristol: Policy Press.

Sandercock, Leonie. 2003. *Integrating Immigrants: The Challenge for Cities, City Governments and City-Building Professionals*. RIIM Working Paper 03-20. Vancouver: Research on Immigration and Integration in the Metropolis.

Smith, Heather. 2004. *The Evolving Relationship between Immigrant Settlement and Neighbourhood Disadvantage in Canadian Cities, 1991-2001*. RIIM Working Paper 04-18. Vancouver: Research on Immigration and Integration in the Metropolis.

Smith, Heather, and David Ley. 2006. "The Immigrant Experience of Concentrated Urban Poverty in Canadian Cities." Unpublished paper.

Statistics Canada. 2003. *Longitudinal Survey of Immigrants to Canada: Process, Progress and Prospects*. Cat. no. 89-611-XIE. Ottawa: Statistics Canada.

Wang, Shuguang, and Marie Truelove. 2003. "Evaluation of Settlement Service Programs for Newcomers in Ontario: A Geographical Perspective." *Journal of International Migration and Integration* 4 (4): 577-606.

Indigenous
Peoples

First Nations and Métis
People and Diversity
in Canadian Cities

I N THE 1940S, RELATIVELY FEW FIRST NATIONS AND MÉTIS PEOPLE LIVED IN CITIES IN Canada. Since then, the urban First Nations and Métis population has increased steadily. According to the 2001 Census, 49.1 percent of First Nations and Métis people lived in urban areas; about one-quarter of the First Nations and Métis population lived in 10 of Canada's metropolitan areas (Statistics Canada 2003).[1] First Nations and Métis populations comprise the largest minority group in many Prairies cities, and their social and economic conditions are central to the future of these cities. Programs and services available to urban First Nations and Métis people most often define them in terms of their social and economic needs (Peters 2000). However, many First Nations and Métis people arrive in cities expecting their histories and cultures to make a difference. This poses unique challenges with respect to First Nations and Métis people and diversity in cities.

Before we talk about ways of recognizing and accommodating First Nations and Métis diversity in cities, we need to have some understanding of the characteristics of this diversity. This means that we need to address two common themes in writing and research about First Nations and Métis populations. The first theme is that First Nations and Métis people are economically and spatially marginalized in urban areas, and this has separated them from the rest of urban society and created a social divide that continues to grow. The second theme is that First Nations and Métis people have been unable to establish an urban culture and community. As a result, it is difficult for us to think about First Nations and Métis people as part of the cultural diversity of urban areas. Together, these themes can create a sense of paralysis with respect to positive policy responses to the situation of urban

First Nations and Métis people. They create the impression that urban First Nations and Métis people are disconnected from any community, either mainstream or cultural, through which positive change could emerge. In this chapter, I attempt to evaluate critically the assumptions underlying these patterns of thinking about First Nations and Métis people in cities.

I begin by emphasizing the heterogeneity of First Nations and Métis populations and of cities. This is an acknowledgement that, even though I base much of my analysis on aggregate data, there are local differences that need to be taken into account. I go on to address each theme separately, summarizing background materials and providing some data that will help us to interpret the arguments. I conclude by listing the implications of addressing the issue of First Nations and Métis people and diversity in Canadian cities.

Heterogeneity of Cities and Populations

THE URBAN FIRST NATIONS AND MÉTIS POPULATION IS HETEROGENEOUS IN TERMS of history, legal rights, socioeconomic status and cultural identity. Although the Canadian *Constitution Act, 1982* defined "Aboriginal people" as including the Indian, Métis and Inuit people, Aboriginal people living in Canadian cities are subjected to a complicated legal regime. Many people identified in the census and the Constitution as "Indian" prefer the term "First Nations" because of the colonial associations of the term "Indian." First Nations people include both individuals who are registered under the *Indian Act* (registered or status Indians) and individuals who identify as First Nations people but who do not have the rights, benefits or status associated with registration. The federal government has maintained that it is responsible only for registered Indians on reserves, regarding nonregistered Indians and Métis as a provincial responsibility.[2] These categories are further complicated by Bill C-31, passed in 1985, which separated registration and band membership. It's important to remember, then, that the aggregates I present here can hide some important variations.

Moreover, many First Nations and Métis people identify with their cultural community of origin rather than with the legal categories established by the

Canadian state. For example, one Toronto inhabitant interviewed by researcher Kathleen Wilson highlighted the difficulty of accessing ceremonies that reflect the cultural values and beliefs of individual First Nations cultures.

> [T]here are all three [Cree, Mohawk and Ojibway] different nations. Now we all believe in the Creator and we all believe in the medicine wheel and each one is a little different and each one has a different slant on it. But we are all clumped together here in one pot and so...As well we have MicMac and we have Bella Coola. We have Salish. We have all the other...Inuit. We have Plains Cree. We have Northern Cree. We have Algonquin. We have...pick one and they are all here in one place and it is difficult.
> Not politically...um, not so much with the politicians but politically within all of the different nations all coming together...and we can't always give a ceremony open to the immediate world. It can't always be Ojibway. Sometimes it has to be Mohawk and sometimes it has to be MicMac and sometimes it has to...It depends on who is in the circle and so you have to respect all the other nations and where they come from too. Whereas back on the reserve everything is Ojibway and visitors to the reserve will adapt to our way. (Wilson 2000, 245-6)

Cities vary substantially in terms of their cultural composition of First Nations and Métis populations and in terms of their socioeconomic status. Table 1 shows the size of the First Nations and Métis populations in large Canadian cities, the proportion they comprise of the total city population and the change in the size of this population since 1981. Clearly, there are considerable variations between cities. Table 1 also shows the proportion of the population in large Canadian cities who identified themselves as either North American Indian or Métis.[3] Métis people comprise a much larger component of the urban Aboriginal populations in Prairies cities than in large cities elsewhere in Canada. The column that describes the largest First Nations population in each city in 1991 demonstrates that in some cities a large majority of the population came from a single nation of origin, while in other cities the population was extremely diverse. The last two columns describe a different facet of heterogeneity. First Nations and Métis poverty levels are different in different cities, and cities with the highest non-Aboriginal poverty levels do not have the highest First Nations and Métis poverty levels. In other words, the relationships between city economies and urban First Nations and Métis economies are complex and variable. Analyzing differences between cities is beyond the scope of this chapter. Table 1 shows, though, that initiatives have to be designed for particular locations and circumstances.

Table 1 210

	Aboriginal population (2001) (*N*)	Proportion of CMA (2001)	Change 1981-2001	Proportion of Aboriginal population that is North American Indian[1] (2001)	Proportion of Aboriginal population that is Métis (2001)
Halifax	3,525	0.1	--	72.6	22.7
Montreal	11,275	0.3	--[3]	61.9	33.9
Ottawa-Hull	13,695	1.3	213.4	60.9	35.4
Toronto	20,595	0.4	52.6	72.1	25.7
Winnipeg	55,970	8.1	237.8	43.2	56.4
Regina	15,790	8.3	140.2	61.2	38.4
Saskatoon	20,455	9.1	370.2	57.9	41.5
Calgary	22,110	2.3	202.5	50.3	48.5
Edmonton	41,295	4.4	200.3	47.0	51.8
Vancouver	37,265	1.9	131.7	64.6	34.6

Sources: Statistics Canada, Census of Canada, 1991; Aboriginal Peoples Survey, 1991 (catalogue # 94-327); Statistics Canada. Special Cross Tabulations; Statistics Canada, Table 97F0011XCB01047, http://www.statcan.ca/english/Pgdb/demo43b.htm; Canadian Census Tract Profile, 2001 (custom tabulation), Beyond 20/20 ed; *Report of the Royal Commission on Aboriginal Peoples*, 1996, p. 592-7.
[1] The census does not collect information on First Nations. The census category "North American Indian" comes closest to the category "First Nations."
[2] These data come from the *Report of the Royal Commission on Aboriginal Peoples* (1996). They are not available for 2001.
[3] It is impossible to compare change because the reserves are unenumerated.

Table 1

Selected Characteristics of First Nations and Métis Populations in Census Metropolitan Areas (CMAs), 2001 (percent)

Proportion in largest First Nation (1991)[2]	Proportion of population that is poor (2001)	
	Aboriginal	Non-Aboriginal
79.0 (Mi'kmaq)	34.2	15.3
33.9 (Mohawk)	35.4	22.2
29.0 (Algonquin)	24.1	14.9
55.0 (Ojibwa)	26.3	16.6
70.0 (Ojibwa)	47.7	16.6
67.3 (Cree)	52.3	12.1
n/a	51.5	14.6
26.2 (Siksika)	28.8	13.7
63.0 (Cree)	34.7	15.2
13.7 (Halkomelem)	37.1	20.4

Economic and Spatial Marginalization

WHILE THERE HAS LONG BEEN CONCERN ABOUT SOCIAL COHESION IN URBAN areas, in much of contemporary urban theory, the problems of poor people — and especially poor people in poor urban neighbourhoods — are central. Loïc Wacquant, who has written extensively about "new forms of inequality and marginality [that] have arisen and are spreading throughout the advanced societies of the capitalist West" (2001, 479), attributes this inequality to several structural factors: the rise of postindustrial economies that increase inequality even in the context of economic prosperity; the elimination of low-skilled jobs and the degradation of employment conditions; and the retrenchment of the welfare state. The result is a growing social divide that leaves many citizens unable to participate fully in their communities and societies (see Wacquant 1996, 1997, 1999, 2001).

In the US, the concept of the underclass was developed to describe the connections between intense poverty, its prevalence over very large areas and its effect of isolating the poor from mainstream society and values (Hughes 1990; Wilson 1987). William Julius Wilson has described how the movement of employment opportunities to suburban locations drew away working and middle-class families, leaving behind an increasingly isolated and politically powerless underclass (1987, 1996). Inner-city disinvestment and growing welfare and illicit economies — which arose in response to the lack of employment opportunities — resulted in the collapse of public institutions and the development of a set of attitudes and practices that isolated populations from the rest of urban society (Hughes 1989; Jenson 2000; Putnam 1996; Wacquant 1999). Other work has explored neighbourhood effects, suggesting that concentration itself can create negative effects, such as the development of antagonistic cultures and isolation from the rest of urban society (Buck 2001; Mohan 2002). Clearly, these perspectives have their critics.[4] My purpose here, though, is to determine whether the urban First Nations and Métis population undergoes a process of isolation that creates an urban underclass.

There is a literature beginning in about the 1940s that suggests that First Nations and Métis migration to cities would not only pose challenges for migrants but also create poverty-stricken ghettos in the inner cities (Braroe 1975;

Decter 1978; Lithman 1984; Melling 1967; Stymeist 1975). These concerns are echoed in some contemporary research (Drost 1995; Kazemipur and Halli 2000) and supported by a variety of media accounts (Polèse 2002; Stackhouse 2001). Most recently, Hayden likened inner-city US ghetto conditions to those experienced by First Nations and Métis residents of Saskatoon: "Like urban natives in Saskatoon's dilapidated core, working-class blacks in Washington, [American lawyer and journalist] Ms. Dickerson says, 'are living in a different city and a different reality.' A reality that white residents like me rarely visit. Like Washington's primarily black South East quadrant, which I've seen only from the safety of a Habitat for Humanity work site, I pass through Saskatoon's largely aboriginal west-side neighbourhoods only to visit St. Paul's Hospital" (2004).

Recent federal government reports have also raised concerns about urban First Nations and Métis concentration (Canada, Privy Council Office 2002, 8; Sgro 2002, 21). Most researchers argue that Canadian cities do not exhibit the same degree of deprivation, or spatial concentration of poverty, as US cities (Kazemipur and Halli 2000; Ley and Smith 2000; Oreopoulos 2005; Séguin and Divay 2002). However, all of the work on poverty in Canadian cities shows that First Nations and Métis people are overrepresented among the urban poor (Royal Commission on Aboriginal Peoples 1996; Drost and Richards 2003; Graham and Peters 2002; Jaccoud and Brassard 2003; Lee 2000). The urban First Nations and Métis population is also more likely than the non-Aboriginal population to live in poor urban neighbourhoods (Darden and Kamel 2002; Hajnal 1995, 510; Heisz and McLeod 2004, 7; Kazemipur and Halli 2000, 129; Richards 2001, 13). Some authors have drawn on the US underclass literature to argue that living in poor neighbourhoods affects First Nations and Métis people's life changes (Drost 1995, 47; Richards 2001).

However, there are also perspectives that emphasize the socioeconomic progress of First Nations and Métis people — the emerging middle class, lower dropout rates, higher education and income (Wotherspoon 2003). For example, Clifford Krauss recently wrote in the New York Times about a Statistics Canada study on urban Aboriginal people: "Canada's native peoples are often depicted in the news as suffering an array of social afflictions: broken families, glue-sniffing children, violent gangs, alcoholism and homelessness. But a new federal government report comparing census data in 1981 and 2001 shows considerable improvement in the social conditions of...those who live in cities, a growing

category that already represents half of the country's one million indigenous peoples" (2005). The questions I wish to address here, then, are: In large Canadian cities, are First Nations and Métis people increasingly marginalized economically? In urban areas, are First Nations and Métis people increasingly marginalized spatially?

First Nations and Métis People and Economic Marginalization

In order to address issues of economic marginalization, it is important to look at change over time. Moreover, because structures of income and employment shifted in non-Aboriginal as well as in First Nations and Métis populations, it is important to provide a comparative analysis. Comparing the nature of change in non-Aboriginal and First Nations and Métis populations provides an indication of whether the gap is widening or narrowing. Table 2 describes income and labour force characteristics of First Nations and Métis as well as non-Aboriginal populations in large Canadian cities in 1981 and 2001.[5] It is important to note that these data may not fully capture First Nations and Métis perspectives on what constitutes success or progress in urban life (Ten Fingers 2005). Unfortunately, there are relatively few alternative measures that we can employ to compare change over time, and there are few data to help us determine which more culturally appropriate measures we could employ in the case of urban First Nations and Métis people. I argue that these statistics provide a useful foundation for analysis.

If we compare the economic and labour force characteristics of First Nations and Métis people and non-Aboriginal people in 2001, we see clearly that First Nations and Métis people are socioeconomically disadvantaged. A larger proportion of First Nations and Métis people are poor, a smaller proportion earn good incomes, unemployment rates are much higher even though participation rates are similar, and a smaller proportion are in managerial, supervisory and professional occupations. If we look at the change between 1981 and 2001 for First Nations and Métis people, however, it is evident that there have been improvements in their economic and labour force positions. The proportion living in poverty decreased slightly, the proportion earning good incomes increased, unemployment rates decreased slightly, and there were increases in the proportion in managerial, supervisory and professional occupations and in tertiary employment.

An important question, though, is whether the gap between First Nations and Métis people and non-Aboriginal people in cities is narrowing over time. Is there evidence that First Nations and Métis people are part of the new poor, who are increasingly marginalized in urban areas, or is the gap between them and non-Aboriginal people narrowing? A comparison of the changes for both populations between 1981 and 2001 suggests that the gap is not growing, but neither is it shrinking rapidly. The proportion of poor individuals decreased very slightly among First Nations and Métis people, while it increased among non-Aboriginal people. The increase in the proportion of people who earned good incomes was slightly more among First Nations and Métis people than among non-Aboriginal people. The change in unemployment and participation rates was slightly more positive among First Nations and Métis people than among non-Aboriginal people between 1981 and 2001. Both populations saw an increase in managerial, professional and supervisory occupations, but on this measure the increase was larger among non-Aboriginal people than First Nations and Métis people.

Both populations showed an increase in tertiary employment, but the increase was greater among First Nations and Métis populations than non-Aboriginal populations.[6] An interesting trend has to do with changes within the tertiary sector — in business services; finance, insurance, real estate (FIRA); and government and community services. These areas of employment are the most likely to produce good incomes. When the tertiary sector is disaggregated, the statistics show that most of the rise in employment in this sector among First Nations and Métis people came from increasing employment in government and community services. In contrast, most of the employment increase among non-Aboriginal people came from business services and FIRA.[7] The government and community services sector is a rich source of good jobs for urban Aboriginal people (table 2).

Aggregate statistics suggest that the First Nations and Métis population is not increasingly marginalized in urban areas; in fact, there has been some improvement since 1981. However, changes in patterns of self-identification must also be taken into account in interpreting these patterns. The population that newly identified itself as Aboriginal in 2001 (compared to 1981) is disproportionately represented in higher socioeconomic status categories (Siggner and Hagey 2003). As a result, some of the improvements in the situation of urban First Nations and Métis people may reflect changes in patterns of self-identification. Taking this into account, it is

Table 2 216

Socioeconomic characteristic	First Nations and Métis		
	1981	2001	Change
Individuals in private households who are poor[2]	37.4	37.3	-0.1
Individuals with good incomes[3]	12.3	14.9	2.6
Unemployment rate[4]	18.8	17.9	-0.9
Labour force participation rate	65.2	67.3	2.1
Managerial, supervisory or professional occupations[5]	16.2	23.4	7.2
Tertiary sector employment	71.2	79.7	8.5
Business and FIRA[6]	9.4	11.2	1.8
Government and community services	20.6	27.3	6.7

Source: Statistics Canada, Canadian Census Tract Profile, 2001 (custom tabulation), Beyond 20/20 ed.

[1] The cities are Halifax, Montreal, Ottawa-Hull, Toronto, Winnipeg, Regina, Saskatoon, Calgary, Edmonton, and Vancouver.

[2] Poverty is defined as incomes below the Statistics Canada low-income cutoff (LICO). The definition of household is based on 1971 measures to facilitate comparison over time.

[3] A good annual income is defined as $40,000 or more in 2000, and adjusted for inflation for 1981.

[4] Unemployment and participation rates are based on 1971 definitions.

[5] The proportion in particular occupations and sectors is based on individuals who indicated their position.

[6] Finance, insurance and real estate.

Socioeconomic
Characteristics of First
Nations and Métis and
Non-Aboriginal People in
Canada's Large Cities,[1]
1981-2001 (percent)

Non-Aboriginal		
1981	**2001**	**Change**
14.7	15.8	1.1
24.4	26.6	2.2
7.8	7.6	-0.2
70.5	69.8	-0.7
26.6	37.2	10.6
73.8	80.0	6.2
13.0	18.3	5.3
22.0	22.7	0.7

clear that the gap between First Nations and Métis people and non-Aboriginal people is not narrowing quickly. And, given the disadvantaged situation of this population to start with, this slow improvement is cause for serious concern.

First Nations and Métis People and Spatial Marginalization

We can also address the question of marginalization by examining First Nations and Métis settlement patterns in cities. Here there are two dimensions of interest: whether First Nations and Métis people are increasingly confined to a limited number of census tracts; and whether First Nations and Métis people are increasingly found in poor neighbourhoods.

Settlement patterns have most often been measured by five indices proposed in the classic paper by Douglas Massey and Nancy Denton (1988). However, these indices are relative measures, and they depend on a group's absolute and relative size within the city or area employed (Poulsen, Forrest and Johnston 2002). Comparisons are more accurately made by using measures that focus on the absolute percentages (Johnston, Forrest and Poulsen 2001; Peach 1996, 1999; Poulsen and Johnston 2000). An analysis of all large cities would be too complicated for this chapter, so the focus here is on four cities with either the largest absolute number of First Nations and Métis people (Winnipeg and Edmonton) or the largest population proportion of First Nations or Métis people (Regina and Saskatoon). If there are trends toward segregation, they would be found in these cities.

Tables 3 and 4 describe two aspects of segregation: the extent to which neighbourhoods in these cities have mostly First Nations and Métis populations; and the extent to which the First Nations and Métis population is found in only a limited number of neighbourhoods. I use census tracts as a measure of a neighbourhood.[8] Table 3 shows the proportion of census tracts and the proportion of the First Nations and Métis population that fall into different categories of concentration — for example, census tracts where less than 10 percent of the population is First Nations and Métis, census tracts where from 10 to less than 20 percent of the population is First Nations and Métis, and so on. In 1981, First Nations and Métis people comprised less than 10 percent of the population in over 90 percent of census tracts in all of the cities listed. The majority of the First Nations and Métis population in all four cities lived in tracts where they made up less than 10 percent of the overall population, with a range of between

70.6 percent of the First Nations and Métis population living in low-concentration tracts in Winnipeg, and 99.7 percent of the First Nations and Métis population living in low-concentration tracts in Edmonton

By 2001, there were more census tracts containing higher proportions of First Nations and Métis people. In Winnipeg, the First Nations and Métis population of one census tract was slightly higher than 50 percent; and in another tract, First Nations and Métis people comprised between 40 and 49.9 percent of the population. There were also some census tracts with concentrations of 20 to 29.9 percent and 30 to 39.9 percent First Nations and Métis people. However, two-thirds of First Nations and Métis people lived in areas where they comprised less than 20 percent of the population. Saskatoon and Regina distributions were similar to each other, with about two-thirds of the First Nations and Métis population in tracts where they comprised less than 20 percent of the population. There were no census tracts in either Regina or Saskatoon where First Nations and Métis people made up more than 39.9 percent of the population. In Edmonton, almost all of the First Nations and Métis population lived in tracts where they comprised less than 20 percent of the population. There was one tract where First Nations and Métis people comprised between 40 and 49.9 percent of the population, but its total population was only about 50. In other words, although the size of the First Nations and Métis population in these cities increased substantially between 1981 and 2001, and although First Nations and Métis people were more likely to live in census tracts with higher proportions of First Nations and Métis residents, their overall levels of segregation still appeared to be low.

Table 4 measures whether the First Nations and Métis population is limited to a few tracts in the city. It shows the proportion of the total First Nations and Métis population that is found in each census tract. In 1981, Saskatoon had the fewest tracts containing very small proportions of the total city First Nations and Métis population and the most tracts containing relatively larger proportions. Regina was next, followed by Winnipeg and then Edmonton. Nevertheless, even the tracts in Saskatoon with the largest share of the First Nations and Métis population contained only 6.9 percent of the total First Nations and Métis population. In Regina, the census tract with the largest share of the total city First Nations and Métis population contained 14.7 percent of the population. By 2001, the First Nations and Métis population was more dispersed in all of these cities. More

Table 3 220

City (total number of tracts)		Concentration of First Nations and Métis population	
		0-9.9%	10-19.9%
	1981		
Winnipeg (N = 130)	% of tracts in each category	90.7	7.8
	% of Aboriginal population by category	70.6	20.6
Saskatoon (N = 34)	% of tracts in each category	94.1	2.9
	% of Aboriginal population by category	95.3	4.7
Regina (N = 36)	% of tracts in each category	94.4	5.6
	% of Aboriginal population by category	79.3	20.7
Edmonton (N = 125)	% of tracts in each category	99.2	0
	% of Aboriginal population by category	99.7	0
	2001		
Winnipeg (N = 154)	% of tracts in each category	72.4	15.6
	% of Aboriginal population by category	42.0	24.5
Saskatoon (N = 43)	% of tracts in each category	65.1	18.6
	% of Aboriginal population by category	36.5	30.6
Regina (N = 47)	% of tracts in each category	68.1	23.4
	% of Aboriginal population by category	39.3	31.0
Edmonton (N = 161)	% of tracts in each category	87.5	11.2
	% of Aboriginal population by category	70.4	29.5

Source: Statistics Canada, Canadian Census Tract Profile, 2001 (custom tabulation), Beyond 20/20 ed.
[1] A census tract is a unit of between 4,000 and 6,000 people. It is widely recognized as an approximation for a neighbourhood.

Concentrations of First
Nations and Métis
Populations in Four
Prairies Cities,
Measured in Census
Tracts, 1981 and 2001[1]

20-29.9%	30-39.9%	40-49.9%	50% and over
1.8	0	0	0
8.8	0	0	0
0	0	0	0
0	0	0	0
0	0	0	0
0	0	0	0
0	0.9	0	0
0	0.3	0	0
5.9	5.3	0.7	0.7
16.7	11.2	3.2	3.2
7.0	9.3	0	0
7.2	25.6	0	0
4.3	4.3	0	0
11.2	18.5	0	0
0.7	0	0.7	0
< 0.1	0	0.1	0

Table 4 222

City (total number of tracts)		Proportion of total urban Aboriginal population per tract		
		0	**0.1-0.9%**	**1.0-1.9%**
	1981			
Winnipeg (N = 130)	% of tracts in each category	7.7	70.0	11.5
	# of tracts in each category	10	91	15
Saskatoon (N = 34)	% of tracts in each category	2.9	14.7	23.5
	# of tracts in each category	1	5	8
Regina (N = 36)	% of tracts in each category	5.6	22.2	19.4
	# of tracts in each category	2	8	7
Edmonton (N = 125)	% of tracts in each category	3.2	60.0	22.4
	# of tracts in each category	4	75	28
	2001			
Winnipeg (N = 154)	% of tracts in each category	0.7	72.4	14.9
	# of tracts in each category	1	121	23
Saskatoon (N = 43)	% of tracts in each category	0	27.9	34.9
	# of tracts in each category	0	12	15
Regina (N = 47)	% of tracts in each category	0	31.9	25.5
	# of tracts in each category	0	15	12
Edmonton (N = 161)	% of tracts in each category	0.6	74.5	15.5
	# of tracts in each category	1	120	25

Source: Statistics Canada, Canadian Census Tract Profile, 2001 (custom tabulation), Beyond 20/20 ed.

Table 4

Proportion of Total
Aboriginal Population
in Four Prairies Cities,
by City, 1981 and 2001

2.0-2.9%	3.0-3.9%	4.0-4.9%	5.0-5.9%	6.0% and over	Non-residential tracts
3.9	4.6	1.5	0	0	0.8
5	6	2	0	0	1
5.9	17.6	8.8	11.8	11.8	2.9
2	6	3	4	4	1
25.0	5.6	2.8	8.3	11.1	0
9	2	1	3	4	0
6.4	0.8	0	0	0	7.2
8	1	0	0	0	9
3.9	0.7	0	0	0	1.3
6	1	0	0	0	2
14.0	4.7	9.3	2.3	7.0	0
6	2	4	1	3	0
25.5	10.6	2.1	0	4.3	0
12	5	1	0	2	0
3.7	0	0	0	0	5.6
6	0	0	0	0	9

census tracts held smaller shares of the city's total First Nations and Métis population, and fewer tracts held larger shares. Regina, with one tract that held 14.7 percent of the city's total First Nations and Métis population, had the highest concentration measured by this statistic. However, this level of concentration had not increased since 1981. In Saskatoon, the tract with the largest share held 8.5 percent of the city's total First Nations and Métis population. In other words, most census tracts in all of these cities contained a relatively small portion of the city's total population, and the pattern is that urban First Nations and Métis populations in all of the cities were distributed across more census tracts in 2001.

Together, these tables show that the urban First Nations and Métis population is not highly segregated. The growing First Nations and Métis population is spread over a number of neighbourhoods, and there are almost no neighbourhoods where First Nations and Métis people are in the majority.

First Nations and Métis People and Areas of Concentrated Poverty

While there are debates about how to measure areas of concentrated poverty, one commonly used method defines these as areas where 40 percent or more of the population have incomes below the federally defined poverty line (Jargowsky 1997; Jargowsky and Bane 1991; Ricketts and Sawhill 1988). Geographers and others have also emphasized the importance of the spatial extent of areas of poverty in creating the isolation effects of concentrated poverty (Hughes 1990).

Again, the analysis focuses on four Prairies cities. In Edmonton in 2001, there were only four census tracts in which 40 percent or more of the residents had incomes below the poverty line (table 5). While these tracts were in the same general area of the city (north of downtown), they shared only two boundaries. None of the tracts were areas with relatively high proportions of First Nations and Métis people. First Nations and Métis people made up only 11.5 percent of the population of these tracts, and only 8.1 percent of the total city First Nations and Métis population lived in them. There is little evidence to suggest the emergence of areas of concentrated poverty associated with First Nations and Métis populations in Edmonton in 2001.

Regina had five tracts where more than 40 percent of inhabitants had incomes below the Statistics Canada low-income cutoff, but only one tract shared more than one boundary with another high-poverty tract. Slightly more than 30 percent of the population living in high-poverty census tracts were First Nations

Poverty among First
Nations and Métis
Populations in Four
Prairies Cities, 2001

Tracts with 40% or more individuals with incomes below low-income cutoff[1]

City (total number of tracts)	# of tracts	% who are First Nations and Métis	% of total First Nations and Métis
Winnipeg (N = 130)[2]	18	26.6	31.5
Regina (N = 36)	5	30.8	28.6
Saskatoon (N = 34)	3	33.5	17.0
Edmonton (N = 161)	4	11.5	8.1

Source: Statistics Canada, Canadian Census Tract Profile,
2001 (custom tabulation), Beyond 20/20 ed.
[1] Statistics Canada's definition of poverty.
[2] Total number of census tracts in urban areas.

and Métis people, and about the same proportion of the total Regina First Nations and Métis population lived in these areas.

Saskatoon and Winnipeg had the highest levels of concentrated poverty, although the configuration of this poverty differed slightly between the two cities. In Saskatoon, three tracts had 40 percent or more of residents with incomes below the poverty line. However, these tracts contained a smaller proportion of the city's total First Nations and Métis population than in either Winnipeg or Regina. In Winnipeg, there were 18 census tracts that had 40 percent or more of residents with incomes below the poverty line. In one census tract, 79.1 percent of inhabitants had incomes below the poverty line in 2000. These tracts formed an almost continuous area south and north of Winnipeg's central business district (figure 1). Slightly more than one-quarter (26.6 percent) of the population in these high-poverty tracts was First Nations and Métis, and 31.5 percent of the city's First Nations and Métis population lived in these areas.

The concern about isolation caused by concentrated poverty emerged in US cities, where between 30 and 40 contiguous census tracts were characterized by extremely high poverty levels (Hughes 1989). The large scale of these areas of concentrated poverty ensured that many of their residents would have very little contact with less disadvantaged populations. This situation is not reproduced in the cities described here. Clearly, the poverty of First Nations and Métis people is something to be concerned about. However, First Nations and Métis people are in a minority in areas of concentrated poverty, and most of the First Nations and Métis population lives outside these areas. In other words, this is not a situation in which there is an underclass First Nations and Métis population isolated from the rest of urban society by virtue of concentration in areas of high poverty.

There was considerable improvement in the labour force characteristics and incomes of urban First Nations and Métis people between 1981 and 2001. The statistics show some evidence of movement into the middle class. However, the gap between First Nations and Métis people and non-Aboriginal people is narrowing very slowly. Given the intense poverty of much of the urban First Nations and Métis population to begin with, this is an issue of grave concern. With respect to settlement patterns, the trend is one of dispersion rather than segregation. There is no evidence that First Nations and Métis people as a group are producing the conditions that isolate them from mainstream culture and society through the creation of areas of concentrated poverty.

Figure 1

Proportion of
Population in Private
Households with Low
Incomes, Winnipeg,
2000

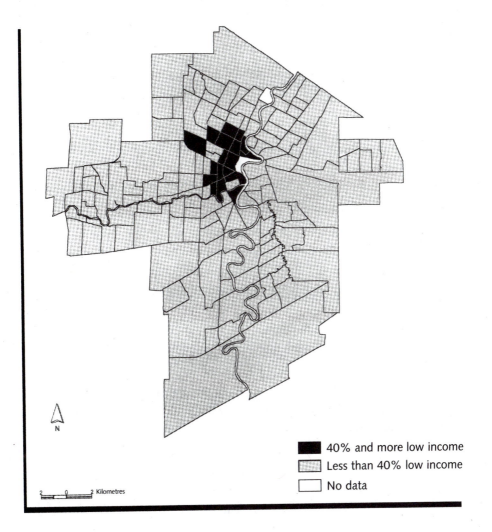

40% and more low income
Less than 40% low income
No data

N

Kilometres

Source: Oksana Starchenko, Department of Geography,
University of Saskatchewan, based on data from Statistics
Canada, Canadian Census Tract Profile 2001 (custom tabulation),
Beyond 20/20 ed.

It may be that these data are describing a First Nations and Métis urban population that is becoming increasingly polarized over time — a population that includes some individuals who are successful in the labour force, who have good incomes and live in good neighbourhoods; and others who live in poverty, who are unemployed and who inhabit poor neighbourhoods. An analysis of this possibility is beyond the scope of this chapter. The existence of poverty and socio-economic improvement combined with dispersion and overrepresentation in poor neighbourhoods suggests that we need more sophisticated ways of thinking about urban First Nations and Métis people and should not merely consider them as homogeneously disadvantaged.

Urban First Nations and Métis Culture and Community

THE SECOND MAIN THEME OF THIS CHAPTER RELATES TO FIRST NATIONS AND MÉTIS culture and community in urban areas. The early academic attitude toward cultural identity was that there was a close relationship between place and identity and that cultural identity gradually changed when people migrated to new places. Since the early decades of the 1900s, though, social theorists have recognized that migrants combine cultural repertoires from their places of origin with influences from their destinations to reassemble their cultural identity (Hall 1995; Gilroy 1987). These ideas are not often found in work on urban Aboriginal people. Perhaps this is because the ways First Nations and Métis people have been defined in Western thought have set up a fundamental tension between the idea of First Nations and Métis culture and the idea of modern civilization (Berkhoffer 1979; Francis 1992; Goldie 1989). Terry Goldie points out that in non-Aboriginal writing, authentic Aboriginal culture is seen to belong either to history or to places distant from urban centres (1989, 16-17, 165).

These ideas were reflected in writings that attempted to understand the significance of increasing First Nations and Métis urbanization at the turn of the century. The decision of First Nations and Métis people to migrate to cities was interpreted to mean that these people rejected their traditional cultures and wished to assimilate. In fact, a common theme in the literature on First Nations and Métis urbanization, even

in the 1970s, was that First Nations and Métis culture presented a major barrier to successful adjustment to urban society. It was assumed that, upon migration, the "cultural values from Native culture" would remain only "until the values of the larger culture" could be adopted (Indian-Eskimo Association of Canada 1962, 13). As a result, government organizations with a mandate to address the situation of urban First Nations and Métis residents emphasized integration (Peters 2002).

Ideas about the incompatibility of urban culture and First Nations and Métis culture have had a long life. Presenters at the urban round table of the Royal Commission on Aboriginal Peoples talked about the challenges First Nations and Métis people face in urban areas because cities are "an environment that is usually indifferent and often hostile to Aboriginal cultures" (Royal Commission on Aboriginal Peoples 1993, 2). The commission itself has been criticized for associating Aboriginal cultures and rights primarily with reserves and rural areas and for viewing cities as places where First Nations and Métis culture and community are lost (Andersen and Denis 2003; Cairns 2000), although I think this view overstates the commission's perspectives. Writings about First Nations and Métis people in Canada most often associate the idea of First Nations and Métis community with rural and reserve First Nations and Métis settlements. In the city, First Nations and Métis populations are seen as heterogeneous, individual and isolated. David Newhouse notes that "the idea of Aboriginal community has been little explored in the literature...Urban Aboriginal research has tended to focus upon the experiences of individuals and their adjustment to urban life, paying only incidental attention to community" (2003, 247).

Assumptions about the incompatibility of urban culture and First Nations and Métis culture, and the focus in research and policy primarily on First Nations and Métis socioeconomic characteristics, make it important to examine the role of culture and community for urban First Nations and Métis people. In the following paragraphs, I address this issue in three ways. First, I examine some material from presentations to the Royal Commission on Aboriginal Peoples and other sources that outlines the role of First Nations and Métis cultures in urban areas. Second, I summarize a recent survey that asked urban First Nations people about their sense of belonging to their Native group in the city. Third, I describe some characteristics of First Nations and Métis institutions in two urban areas as an example of a growing infrastructure that emphasizes the importance of culturally specific programs and services.

The Role of Culture: First Nations and Métis Perspectives

Against notions of the incompatibility of urban culture and First Nations and Métis culture, First Nations and Métis have argued that strong cultures are a prerequisite for success in urban areas. Some quotations from the presentations made to the public hearings of the Royal Commission on Aboriginal Peoples illustrate the general thrust of their argument. For example, Nancy Van Heest, working in a pre-employment program of First Nations women in Vancouver, told the commissioners: "Today we live in the modern world and we find that a lot of our people who come into the urban setting are unable to live in the modern world without their traditional values. So we started a program which we call 'Urban Images for First Nations People in the Urban Setting' and what we do is we work in this modern day with modern day people and give them traditional values so that they can continue on with their life in the city" (1993, 14).

David Chartrand, president of the National Association of Friendship Centres, had this to say: "Aboriginal culture in the cities is threatened in much the same way as Canadian culture is threatened by American culture, and it therefore requires a similar commitment to its protection. Our culture is at the heart of our people, and without awareness of Aboriginal history, traditions and ceremonies, we are not whole people, and our communities lose their strength…Cultural education also works against the alienation that the cities hold for our people. Social activities bring us together and strengthen the relationship between people in areas where those relationships are an important safety net for people who feel left out by the mainstream" (1993, 565).

Instead of seeing First Nations and Métis cultures and urban life as incompatible, presenters to the public hearings of the Royal Commission saw vibrant urban First Nations and Métis cultures as important elements of First Nations and Métis people's success in cities. Reflecting the message of these presentations, the Royal Commission on Aboriginal Peoples recommended that all levels of government initiate programs to increase opportunities to promote Aboriginal cultures in urban areas (1996, 537). Some of the particular areas that the commission identified included support for urban Aboriginal institutions, initiatives concerning Native languages, and access to land and elders.

David Newhouse, head of Native studies at Trent University, argued that the urbanization of the Aboriginal population is occurring in tandem with the reinforcement of cultural identities (2000). In other words, these phenomena are

not mutually exclusive. At the same time, First Nations and Métis cultures in urban areas were not simply transplanted nonurban cultures. Newhouse noted that First Nations and Métis people were reformulating Western institutions and practices to support their cultures and identities and to ensure their survival as distinct people in contemporary societies. This suggests that while moving to cities poses a challenge to Aboriginal cultural identities, it also presents an opportunity for dynamic and resilient innovations. These themes are found in US research as well (see Danziger 1991; LaGrand 2002).

Sense of Belonging to a Community in the City

Unfortunately, the recent Statistics Canada General Social Surveys that focus on volunteering and social cohesion do not support a separate analysis for First Nations and Métis participants. A 2003 EKOS Research Associates survey of over 600 First Nations and Métis people living in urban areas was commissioned by eight federal government departments; it examined impressions of the performance of the federal government and assessed opinions about various issues. The survey did not use a random sample, and First Nations and Métis residents in Prairies cities were overrepresented. Nevertheless, it provides some interesting information about the respondents' sense of community ties.

One set of questions explored participants' sense of belonging to various groups and entities. The results were compared to answers from individuals living on reserves and to responses to similar questions from another study of the general population. Table 6 presents the proportion of individuals who indicated that they felt a strong sense of belonging to particular groups. The results show that while attachment to family is high across all groups, First Nations and Métis participants generally felt less attachment to Canada and to their home provinces than did participants in the general population. Fewer First Nations and Métis participants in urban areas felt a strong sense of belonging to their Native group than reserve residents felt to their First Nation. However, the proportion of urban First Nations and Métis residents who felt a strong sense of belonging to a Native group in the city is quite similar to that of the general population with respect to ethnic group. In other words, while movement from rural to urban locations may reflect or cause a decrease in sense of belonging to a cultural group of origin, there is not much difference between First Nations and Métis people and other urban residents.

Table 6 232

Sense of Belonging
among the First Nations
and Métis Population
and the General
Population (percent)

	Urban First Nations and Métis[1]	On-reserve First Nations population[2]	General population[1]
Your family	85	87	91
Canada	62	56	81
Your province	54	46	71
Your First Nation	n/a	69	n/a
Other Aboriginal people in your city	49	n/a	n/a
Your Native group in your city	48	n/a	n/a
Your ethnic group	n/a	n/a	51
Your town	47	n/a	n/a

Source: EKOS Research Associates Inc. (2003, 41)
[1] Data were collected in 2003.
[2] Data were collected in 2002.

Institutions

Research in US cities suggests that urban Aboriginal institutions are an important mechanism with which Aboriginal people negotiate a collective identity. After interacting for 19 years with Los Angeles Indian organizations, Joan Weibel-Orlando argued that institutions are "structural indicators of community cohesiveness, completeness and inclusiveness, and are characterized by regular, repetitive, grounded activities invoked as cultural tradition…[They are] the social mechanism that binds the otherwise heterogeneous and dispersed Los Angeles Indians into an entity they recognize as community" (1999, 80).

In his recent study of Prairies cities, Calvin Hanselmann reported that many urban Aboriginal people wished to receive programs and services from fellow First Nations and Métis people (2002, 6). Aboriginal-controlled social services generally have greater success in delivering programs that incorporate First Nations and Métis principles, beliefs and traditions. The development of urban institutions enhances the ability of First Nations and Métis people to make significant choices about their own political, cultural, economic and social affairs.

The following paragraphs summarize some of the results of a 2002 study that documented the evolution of First Nations and Métis service organizations in Winnipeg and Edmonton.[9] The study compared selected characteristics of these organizations to the results of a similar study conducted almost a decade earlier, in 1993 (Clatworthy, Hull and Loughren 1995).[10] Both studies described organizations that focused primarily on urban First Nations and Métis populations, that were owned or controlled by First Nations and Métis people, and that had substantial autonomy from governments and provincial and other Aboriginal and non-Aboriginal organizations.[11] Because the focus of the study was on identifying institutions of self-government, the study excluded First Nations and Métis businesses. However, the results provide a glimpse of the characteristics of First Nations and Métis organizations in urban areas.

Clearly, there has been growth in urban First Nations and Métis organizations in Winnipeg and Edmonton since the early 1990s (table 7). The number of organizations in Winnipeg increased from 24 in 1993 to 28 in 2002, and the number in Edmonton increased from 7 to 15 during the same period. Organizations also grew in terms of the number of clients they served. In 1993, Winnipeg organizations served 5,563 clients monthly — approximately 15.8 percent of the city's 1991 First Nations and Métis population. In 2002,

Table 7 234

Profiles of Winnipeg
and Edmonton Urban
First Nations and Métis
Organizations, 1993
and 2002 (percent)

	Winnipeg		Edmonton	
	1993	2002	1993	2002
Age of organization at time of interview				
Less than 3 years	13.6	3.6	0.0[1]	6.7
3-5 years	18.2	10.7	28.6	20.0
6-9 years	36.4	14.3	28.6	13.3
10-19 years	18.2	39.3	14.3	33.3
20 or more years	13.6	32.1	28.6	20.0
Main type of service provided[2]				
Adult education/employment training	11.9	13.0	22.5	11.6
Religious/cultural/spiritual	19.3	20.5	12.5	11.6
Housing	11.9	11.1	10.0	4.7
Economic/community development	4.8	5.6	7.5	9.3
Youth programming/counselling	16.6	14.8	17.5	16.3
Child and family services	7.1	13.0	10.0	19.9
Health services/substance abuse	11.9	13.0	17.5	16.3
Child care	4.8	3.7	2.5	2.3
Correctional services/programs	7.1	5.6	5.0	2.3
Political advocacy	4.8	1.9	0.0	0.0
Street patrols	2.4	0.0	0.0	0.0
Seniors services	0.0	0.0	0.0	4.7
Type of organization(s) that assisted with formation[3]				
Other urban Aboriginal	31.8	34.4	28.6	33.3
Provincial Aboriginal political	18.2	15.6	42.9	33.3
National Aboriginal NGO	4.5	6.3	0.0	0.0
Non-Aboriginal NGO	4.5	6.3	0.0	13.3
Non-Aboriginal government	9.1	0.0	14.3	6.7
Individuals not representing an Aboriginal organization	31.8	37.5	0.0	20.3
Number of organizations	24	28	7	15

Source: Author, unpublished study, 2003.
[1] Date of formation was not available for one organization.
[2] Many organizations indicated they offered services in more than one area. Figures are proportions of all services offered.
[3] Many organizations mentioned more than one assisting organization. Figures are proportions of all organizations mentioned.

9,948 clients were served monthly, representing almost one-fifth (17.8 percent) of the Winnipeg 2001 First Nations and Métis population. Since we were unable to obtain client numbers for some organizations, these statistics underestimate Winnipeg First Nations and Métis community participation in these organizations.[12] In Edmonton in 1993, First Nations and Métis organizations served 3,056 clients, or approximately 10 percent of Edmonton's First Nations and Métis population. In 2002, they served 9,465 clients, representing almost one-quarter (23.1 percent) of the Edmonton First Nations and Métis population. These estimates are similar to Weibel-Orlando's finding that approximately 20 percent of the Los Angeles Aboriginal community regularly participated in Aboriginal institutional life in that city (1999, 41).

The majority of institutions in both cities were less than a decade old in 1993; by 2002, the majority were 10 years old and older. Winnipeg had more older organizations, with the Indian and Métis Friendship Centre established in 1959 and two housing corporations and four other organizations established in the 1970s. Edmonton had the Canadian Native Friendship Centre, which was established in 1962, but none of the organizations established in the 1970s were in operation in 2002.

The range of services provided in both cities was extensive in 1993, and it had expanded by 2002. In other words, First Nations and Métis organizations in the two cities are providing services in an increasing number of policy sectors. What is particularly interesting is the emergence in Winnipeg of organizations that focus on advocacy, political representation and community development rather than on service delivery alone. The Aboriginal Council of Winnipeg, formed in 1991, is a political organization dedicated to improving the lives of all Aboriginal people in the city (Munroe 2002). The council played a central role in the purchase of the CPR station in the heart of the core area, and thus it helped to bring under one roof a variety of Native organizations. The Aboriginal Centre, housed in the station, provides a focal point for the urban First Nations and Métis community. The council was also instrumental in building the Circle of Life Thunderbird House across the street from the centre — a striking building that acts as a cultural and spiritual facility. These are important developments, since they indicate that urban First Nations and Métis organizations have moved beyond simply providing services to members and have begun to address issues of political representation.

While the Friendship Centres played a central role in developing programs and organizations in the early years, these functions have recently been taken over by others. There are differences between the cities, though. In Winnipeg, the Aboriginal Council played a particularly influential role. While provincial First Nations and Métis political organizations — particularly Métis ones — were important in both cities, they played a larger role in Edmonton than in Winnipeg. In Edmonton, the Métis Nation of Alberta had the highest profile, but several organizations also developed from a cooperative initiative between the Métis Nation of Alberta and representatives of provincial Treaty 6 and Treaty 8 organizations.

A core of active First Nations and Métis people living in Winnipeg seems to have been instrumental in the establishment of a wide variety of organizations over several decades (see Loxley 1994). In Edmonton, individuals establishing organizations were more likely to be First Nations and Métis professionals responding to recent government programs developed to meet the needs of urban First Nations and Métis people. In Winnipeg, then, the development of urban First Nations and Métis institutions has been more of a local, grassroots phenomenon. In Edmonton, urban First Nations and Métis institutions have closer connections with government and provincial First Nations and Métis organization priorities. These differences emphasize the importance of taking local circumstances into account in policy initiatives.

The view that strong First Nations and Métis culture facilitates success in urban life, the sense of belonging to one's Native group in the city, and the emergence and growth of urban First Nations and Métis organizations contradicts the long-standing notion that this culture (along with the First Nations and Métis values and sense of community) is incompatible with, or inappropriate in, the urban industrial milieu. Since the 1950s, when First Nations and Métis people began migrating to urban areas in increasing numbers and governments felt a responsibility to respond to this population movement, First Nations and Métis people have emphasized the need for services provided by First Nations and Métis people for First Nations and Métis people (Peters 2002). The growth of urban First Nations and Métis organizations not only reflects government concerns about a marginalized urban population but also the activism of urban First Nations and Métis people. This is not to say that First Nations and Métis institutions exist without government funding. In fact, most depend heavily on government

funding, and this creates concerns about sustainability and the ability to shape aspects of programming to reflect cultural needs (Graham and Peters 2002; Opekokew 1995; Prince and Abele 2003). However, the active involvement of urban First Nations and Métis people in defining ways to meet the needs of migrating populations underlines the importance of First Nations and Métis culture and community in urban areas.

Conclusion

IN NOVEMBER 2005, FIRST MINISTERS AND NATIONAL ABORIGINAL LEADERS MET IN Kelowna, British Columbia, to discuss ways to improve the lives of Aboriginal people in Canada. The federal government announced a 10-year plan, with over $5 billion to be invested within five years to close the gap between Aboriginal peoples and other Canadians. However, relatively little of this was directed toward urban Aboriginal populations. For example, of the $1.8 billion for investment in education, less than $200 million was targeted on urban areas, and most was focused on reserves.

In the first part of this chapter, I asked whether First Nations and Métis people were economically and spatially marginalized in urban areas, creating a growing social divide. The data suggest that the trends are complex. While averages and proportions show that the socioeconomic conditions of First Nations and Métis people are improving, the gap between them and the non-Aboriginal population is being eroded very slowly. Some individuals are having economic success, but a large proportion is extremely poor. The statistics suggest that while there is evidence of positive change in this population, there is also a strong need for initiatives to increase the rate of socioeconomic improvement for urban First Nations and Métis people. In other words, there is a strong need for investment in urban areas in order to improve the lives of Aboriginal people in Canada.

However, public policy for urban First Nations and Métis people cannot be a simplistic adaptation of strategies designed to address underclass situations in the US. While proportionately more First Nations and Métis people than non-Aboriginal people live in poor neighbourhoods, they are not the majority in these areas, and there is no evidence that urban First Nations and Métis people are creating the conditions of isolation associated with the US inner-city underclass populations. Urban

initiatives will likely require strategies that are targeted on poor neighbourhoods and that address the needs of First Nations and Métis residents along with other residents, as well as strategies that address First Nations and Métis residents alone, no matter where they live in cities.

Both sets of strategies must endorse the legitimacy of urban Aboriginal institutions by involving them in planning and policy-making processes. At the same time, innovative approaches to the challenges involved must be developed. For example, Ryan Walker has discussed an approach used by a neighbourhood corporation to involve Winnipeg Aboriginal residents in community planning through the institution of a First Nations advisory council (2003). This was done in recognition of the fact that the local Aboriginal population was not present in large numbers at mainstream neighbourhood consultation venues and that this segment of the community did nonetheless have ideas and perspectives to share. Recent studies of community dynamics in inner-city Winnipeg suggest that it is important to incorporate Aboriginal understandings of community in creating strategies for economic development in these neighbourhoods (Silver et al. 2006). Urban Aboriginal organizations can provide a link with Aboriginal communities for this type of research, and these organizations can be important participants in making programs and policies real on the ground.

In the second part of the chapter, I suggested that First Nations and Métis cultures are dynamic and innovative in cities and can provide an important foundation for social and economic innovation and success. First Nations and Métis institutions create significant economic benefits for First Nations and Métis communities in urban areas (Hylton 1999, 85-6). Labour force data show that much of the increase in tertiary employment for First Nations and Métis people occurred in the government and community services sector. Besides offering greater scope in providing culturally appropriate programs and services, these organizations offer First Nations and Métis people the chance for good jobs. Wotherspoon identifies the importance of employment in government and community services for Aboriginal movement into the middle class, noting that "the rise of the new middle classes historically has accompanied the expansion of state functions to train and maintain a healthy population, manage the marginalized segments of the population, and administer public services" (2003, 156). Support for employment in this sector can begin to address the pressing poverty of many First Nations and Métis people living in cities (Cornell and Kalt 1992; Kalt 1993; Rothney 1992).

At the same time, the analysis of organizational development in Winnipeg and Edmonton suggests that the history and characteristics of organizational development vary substantially, and this has implications for policy development and administration. For example, the focus of some of the proposed expenditure for Aboriginal peoples announced in Kelowna was to be negotiated with Aboriginal organizations, presumably at the national level. Urban First Nations and Métis organizations are not well linked to national-level organizations, so it is not clear how these initiatives will trickle down to urban populations. While many of the Edmonton organizations are linked to provincial political organizations that could exert some influence on national organizations, many Winnipeg organizations are linked to the Aboriginal Council of Winnipeg, which is not affiliated with any provincial Aboriginal political organizations.

In conclusion, there are some real challenges associated with addressing First Nations and Métis diversity in cities. One challenge is to recognize the social and spatial complexity of First Nations and Métis residents' economic position and to explore the characteristics of this particular population instead of adopting perspectives designed to explain the situation of populations in other areas, notably US inner cities. Another challenge is to support urban First Nations and Métis cultures, because they provide an important foundation for positive change. Finally, it is important to recognize the varied histories and characteristics of urban First Nations and Métis populations in particular cities and the need to take these into account in policy development.

Notes

1 For Statistics Canada, urban areas are centres with at least 10,000 residents. A census metropolitan area (CMA) is a very large urban area that encompasses adjacent urban and rural areas that have a high degree of economic and social integration with that urban area. A CMA is delineated around an urban area that has a population of at least 100,000.

2 Some federally funded services are available to registered Indians generally, no matter where they live. The most notable of these are noninsured health benefits and post-secondary educational assistance.

3 The census uses the term "North American Indian" instead of "First Nation." Inuit are omitted because they represent a very small proportion of the population in these urban areas.

4 Some researchers focusing on social cohesion see the dissolution of community bonds and the irrelevance of institutions as being associated with urban life as a whole, and not only with marginalized communities (Castells 1997; Fukuyama 1999). Other scholars have found evidence that rich informal networks and exchange systems take shape as individuals find innovative ways of coping with unemployment (Stack 1974; Williams and Windebank 1998). Still others have pointed out that the neighbourhood effects can be positive as well as negative (Séguin and Divay 2002). For example, if there is a significant concentration of people from a given background (ethnocultural, linguistic or indigenous) in a particular part of the city, then residents benefit from public services that are better suited to their needs.

5 An important focus of this chapter is addressing change over time. Finding data for this comparison is challenging. Most of the data on ethnic and cultural origins in Canada rely on a question that asks individuals about their ancestry. The wording of this question and instructions to enumerators on its administration have changed over the years (Goldmann and Siggner 1995). Beginning in 1991, Aboriginal people were also counted through a question that asked individuals if they identified with an Aboriginal group — North American Indian, Métis or Inuit — but these data are not available at the census-tract level in that year. Kerr, Siggner and Bourdeau found that, with the exception of the nonstatus Indian population, the populations identified by the 1981 Native peoples census question and the 1991 question on Aboriginal identity appeared to be sufficiently similar to support a comparison of some characteristics (1996). Because nonstatus Indians represent a minority of the Aboriginal population, this chapter compares responses to the 1981 ethnic origin question to responses to the 2001 Aboriginal identity question in order to address questions of change over time.

 At the same time, it is important that we recognize that comparability is affected not only by the wording of census questions. Between 1981 and 2001, the Aboriginal population grew at a rate that cannot be explained only by population measures such as fertility, mortality and migration (Guimond 2003). Part of the increase was due to the fact that individuals who did not identify as Aboriginal people in previous census years now chose to do so. There is some evidence that individuals who are in higher socioeconomic status groups are disproportionately represented among individuals newly identifying as Aboriginal people in the census (Siggner and Hagey 2003). Where there are comparisons between urban Aboriginal conditions in 1981 and 2001, the analysis in this chapter attempts to account for inaccuracies created by changes in self-identification.

6 First Nations and Métis and non-Aboriginal people experienced a slight decrease in proportion in primary and secondary industry sectors and a slight increase in proportion

in the tertiary sector. In an attempt to simplify the analysis, table 2 describes only the tertiary sector, which employed approximately four-fifths of both populations.

7 In 1981, 9.4 percent of the urban Aboriginal population worked in the business and FIRA sectors, 20.6 percent worked in government and community services and 41.1 percent in other tertiary sectors. The proportions for 2001 were 11.2, 27.3 and 41.2, respectively. In 1981, 13 percent of the urban non-Aboriginal population worked in the business and FIRA sector, 22 percent in government and community services and 38.7 in other tertiary sectors. The proportions in 2001 were 18.3, 22.7 and 39.

8 Census tracts typically have between 4,000 and 6,000 people, and they are widely recognized as approximations for neighbourhoods. Data are also available for smaller areas, but suppression of data makes the analysis less reliable.

9 The Social Planning Council and the Aboriginal Council in Winnipeg, and the Edmonton Aboriginal Urban Affairs Committee and the Edmonton Aboriginal Coalition provided assistance. Katherin McArdle, Pamela McCoy-Jones and Richard Thompson conducted the interviews for this project. Chris Andersen, School of Native Studies, University of Alberta, and Ryan Walker, Queen's University, managed the study in these two locations. All of these contributions are gratefully acknowledged.

10 Organizations that potentially met the criteria were identified from a variety of lists and with the assistance of key individuals knowledgeable about Aboriginal organizations in the city. A telephone call confirmed which organizations met the screening criteria, and key representatives from these organizations were interviewed. We were unable to interview representatives from several organizations and so attempted to obtain missing information from published materials.

11 This definition excluded organizations that provided services to Aboriginal people as part of a broader mandate to serve urban populations. It also excluded urban offices of provincial or national Aboriginal organizations that were located in the city but that had as their constituency provincial or national Aboriginal populations. However, some provincial organizations had created institutions that attempted to meet the needs of their urban members, and these were included if they met the criteria I have listed here.

12 It is also important to recognize that some organizations are not service organizations (for example, the Aboriginal Centre, the Aboriginal Council of Winnipeg and the Manitoba Métis Federation-Winnipeg Region), and therefore there are no client figures for these organizations.

References

Andersen, Chris, and Claude Denis. 2003. "Urban Native Communities and the Nation Model: before and after the Royal Commission on Aboriginal Peoples." *Canadian Review of Sociology and Anthropology* 40 (4): 373-90.

Berkhoffer, Robert F. 1979. *The White Man's Indian: Images of the American Indian from Columbus to the Present*. New York: Vintage.

Braroe, Niels W. 1975. *Indian and White: Self-Image and Interaction in a Canadian Plains Community*. Stanford: Stanford University Press.

Buck, Nick. 2001. "Identifying Neighbourhood Effects on Social Exclusion." *Urban Studies* 38 (12): 2251-75.

Cairns, Alan C. 2000. *Citizens Plus: Aboriginal Peoples and the Canadian State*. Vancouver: University of British Columbia Press.

Canada. Privy Council Office. 2002. "Urban Aboriginal Strategy: An Analysis." Unpublished paper.

Castells, Manuel. 1997. *The Power of Identity*. Oxford: Blackwell.

Chartrand, David. 1993. *The Electronic Series: Public Hearings*. CD-ROM. Royal

Commission on Aboriginal Peoples, Toronto. Ottawa: Minister of Supply and Services.

Clatworthy, C., J. Hull, and H. Loughren. 1995. "Urban Aboriginal Organizations: Edmonton, Toronto and Winnipeg." In *Aboriginal Self-Government in Urban Areas. Proceedings of a Workshop, May 25 and 26, 1994*, edited by Evelyn J. Peters, 25-82. Kingston, ON: Institute of Intergovernmental Relations.

Cornell, Stephen, and Joseph P. Kalt. 1992. "Reloading the Dice: Improving the Economic Development on American Indian Reservations." In *What Can Tribes Do? Strategies and Institutions in American Indian Economic Development,* edited by Stephen Cornell and Joseph P. Kalt. Los Angeles: American Indian Studies Center, University of California, 1-60.

Danziger, Edmund J., Jr. 1991. *Survival and Regeneration: Detroit's American Indian Community.* Detroit: Wayne State University Press.

Darden, Joe T., and Sameh M. Kamel. 2002. "The Spatial and Socioeconomic Analysis of First Nation People in the Toronto CMA." *Canadian Journal of Native Studies* 22:239-68.

Decter, M. 1978. "Children of the Ghetto...Children of Despair." *Perception* 2:3-4.

Drost, Helmar. 1995. "The Aboriginal-White Unemployment Gap in Canada's Urban Labour Market." In *Market Solutions for Native Poverty: Social Policy for the Third Solitude,* edited by Helmar Drost, Brian Lee Crowley, and Richard Schwindt. The Social Policy Challenge 11. Toronto: C.D. Howe Institute, 13-57.

Drost, Helmar, and John Richards. 2003. "Income On- and Off-Reserve: How Aboriginals Are Faring." *C.D. Howe Institute Commentary* 198. Toronto: C.D. Howe Institute.

EKOS Research Associates. 2003. *Findings of the 2003 Pilot Survey of Aboriginal People Living Off-Reserve.* Ottawa: EKOS Research Associates.

Francis, Daniel. 1992. *The Imaginary Indian: The Image of the Indian in Canadian Culture.* Vancouver: Arsenal Pulp Press.

Fukuyama, Francis. 1999. *The Great Disruption: Human Nature and the Reconstitution of Social Order.* London: Profile Books.

Gilroy, Paul. 1987. *"There Ain't No Black in the Union Jack": The Cultural Politics of Race and Nation.* London: Hutchinson.

Goldie, Terry. 1989. *Fear and Temptation: The Image of the Indigene in Canadian, Australian, and New Zealand Literatures.* Kingston and Montreal: McGill-Queen's University Press.

Goldmann, Gustave, and Andrew Siggner. 1995. "Statistical Concepts of Aboriginal People and Factors Affecting the Counts in the Census and the Aboriginal Peoples Survey." Paper presented at the symposium of the Federation of Canadian Demographers, October 23-25, Ottawa.

Graham, A.H., and Evelyn J. Peters. 2002. "Aboriginal Communities and Urban Sustainability." In *The Federal Role in Canada's Cities: Four Policy Perspectives,* edited by F. Leslie Seidle. CPRN Discussion Paper F/27. Ottawa: Canadian Policy Research Networks, 1-37.

Guimond, E. 2003. "Fuzzy Definitions and Population Explosion: Changing Identities of Aboriginal Groups in Canada." In *Not Strangers in These Parts: Aboriginal People in Cities,* edited by David Newhouse and Evelyn J. Peters, 35-50. Ottawa: Policy Research Initiative.

Hajnal, Zoltan L. 1995. "The Nature of Concentrated Urban Poverty in Canada and the United States." *Canadian Journal of Sociology* 20:497-528.

Hall, Stuart. 1995. "New Cultures for Old." In *A Place in the World? Places, Cultures and Globalization,* edited by Doreen Massey and Pat Jess, 75-213. Toronto: Oxford University Press.

Hamer, David. 1990. *New Towns in the New World: Images and Perceptions of the Nineteenth-Century Urban Frontier.* New York: Columbia University Press.

Hanselmann, Calvin. 2002. *Uncommon Sense: Promising Practices in Urban Aboriginal Policy-Making and Programming*. Calgary: Canada West Foundation.

Hayden, T. 2004. "'That Is Not the Image We Have of Canada.'" *Globe and Mail*, March 6.

Heisz, Andrew, and Logan McLeod. 2004. *Low Income in Census Metropolitan Areas*. Catalogue no. 75-001-XIE. Ottawa: Statistics Canada.

Hughes, Mark Alan. 1989. "Misspeaking Truth to Power: A Geographical Perspective on the 'Underclass' Fallacy." *Economic Geography* 65:187-207.

———. 1990. "Formation of the Impacted Ghetto: Evidence from Large Metropolitan Areas, 1970-1980." *Urban Geography* 11:265-84.

Hylton, John.1999. "The Case for Aboriginal Self-Government: A Social Policy Perspective." In *Aboriginal Self-Government in Canada*, edited by John Hylton. Saskatoon: Purich Publishing, 34-48.

Indian-Eskimo Association of Canada. 1962. Unpublished proceedings of the National Research Seminar on Indians in the City. Stouffer Library, Queen's University, Kingston.

Jaccoud, Mylène, and Renée Brassard. 2003. "The Marginalization of Aboriginal Women in Montréal." In *Not Strangers in These Parts: Urban Aboriginal Peoples*, edited by David Newhouse and Evelyn Peters, 131-46. Ottawa: Policy Research Institute.

Jackson, P. 1992. "Constructions of Culture, Representations of Race: Edward Curtis's 'Way of Seeing.'" In *Inventing Places: Studies in Cultural Geography*, edited by Kay Anderson and Fay Gale, 89-106. Melbourne: Longman Cheshire.

Jargowsky, Paul A. 1997. *Poverty and Place: Ghettos, Barrios and the American City*. New York: Russell Sage Foundation.

Jargowsky, Paul A., and Mary Jo Bane. 1991. "Ghetto Poverty in the United States: 1970-1980." In *The Urban Underclass*, edited by Christopher Jencks and Paul E. Peterson, 235-73. Washington: The Brookings Institution.

Jenson, Jane. 2000. "Backgrounder: Thinking about Marginalization: What, Who and Why." Canadian Policy Research Networks, Ottawa.

Johnston, Ron, James Forrest, and Michael Poulsen. 2001. "Sydney's Ethnic Geography: New Approaches to Analysing Patterns of Residential Concentration." *Australian Geographer* 32:149-62.

Kalt, Joseph. 1993. "Sovereignty and Economic Development on American Indian Reservations: Lessons from the United States." In *Sharing the Harvest: The Road to Self-Reliance*, Report of the National Round Table on Aboriginal Economic Development and Resources, Royal Commission on Aboriginal Peoples, 35-50. Ottawa: Minister of Supply and Services.

Kazemipur, Abdolmohammad, and Shiva S. Halli. 2000. *The New Poverty in Canada: Ethnic Groups and Ghetto Neighbourhoods*. Toronto: Thompson Educational Publishing.

Kerr, Don, Andrew J. Siggner, and Jean-Pierre Bourdeau. 1996. *Canada's Aboriginal Population, 1981-1991*. Ottawa: Canada Mortgage and Housing Corporation.

Krauss, Clifford. 2005. "Canada's Native Peoples Make Strides in the Cities." *New York Times*, July 17.

LaGrand, James B. 2002. *Indian Metropolis: Native Americans in Chicago, 1945-75*. Urbana: University of Illinois Press.

Lee, Kevin K. 2000. *Urban Poverty in Canada: A Statistical Profile*. Ottawa: Canadian Council on Social Development.

Ley, David, and Heather Smith. 2000. "Relations between Deprivation and Immigrant Groups in Large Canadian Cities." *Urban Studies* 37:37-62.

Lithman, Yngve Georg. 1984. *The Community Apart: A Case Study of a Canadian Indian Reserve Community*. Winnipeg: University of Manitoba Press.

Loxley, John. 1994. *Aboriginal People in the Winnipeg Economy: Case Study*. Winnipeg: Royal Commission on Aboriginal Peoples.

Massey, Douglas, and Nancy Denton. 1988. "The Dimensions of Residential Segregation." *Social Forces* 67:281-315.

Melling, John. 1967. *Right to a Future: The Native Peoples of Canada.* Don Mills, ON: T.H. Best.

Mohan, Joan. 2002. "Geographies of Welfare and Social Exclusion: Dimensions, Consequences and Methods." *Progress in Human Geography* 26 (1): 65-76.

Munroe, G., Vice-President, Winnipeg Aboriginal Council. 2002. Interview with the author, July 23.

Newhouse, David. 2000. "From the Tribal to the Modern: The Development of Modern Aboriginal Societies." In *Expressions in Canadian Native Studies,* edited by R.F. Laliberté, P. Settee, J.B. Waldram, R. Innes, B. Macdougall, L. McBain, and F.L. Barron, 395-409. Saskatoon: University of Saskatchewan Extension Press.

———. 2003. "The Invisible Infrastructure: Urban Aboriginal Institutions and Organizations." In *Not Strangers in These Parts: Urban Aboriginal Peoples,* edited by David Newhouse and Evelyn Peters, 243-54. Ottawa: Policy Research Institute.

Opekokew, Delia. 1995. "Treaty First Nations Perspectives on Self-Government for Aboriginal Peoples in Urban Areas." In *Aboriginal Self-Government in Urban Areas,* edited by Evelyn J. Peters, 168-72. Kingston: Institute of Intergovernmental Relations.

Oreopoulos, Philip. 2005. *A Critique on Neighbourhood Effects in Canada.* Working Paper 004. Ottawa: Policy Research Initiative.

Peach, Ceri. 1996. "Does Britain Have Ghettoes?" *Transactions of the Institute of British Geographers* 21 (1):216-35.

———. 1999. "London and New York: Contrasts in British and American Models of Segregation." *International Journal of Population Geography* 5:319-51.

Peters, Evelyn J. 2000. "Aboriginal People in Urban Areas." In *Visions of the Heart:*

Canadian Aboriginal Issues. 2nd ed., edited by David Long and Olive Patricia Dickason. Toronto: Harcourt Canada.

———. 2002. "'Our City Indians': Negotiating the Meaning of First Nations Urbanization in Canada, 1945-1975." *Historical Geography* 30:75-92.

Polèse, Mario. 2002. "What Ails Urban Canada?" *Globe and Mail,* January 7.

Poulsen, Michael, and Ron Johnston. 2000. "The Ghetto Model and Ethnic Concentration in Australian Cities." *Urban Geography* 21:26-44.

Poulsen, Michael, James Forrest, and Ron Johnston. 2002. "Contemporary Ethnic Residential Segregation in Four US Metropolitan Areas." *Cities* 19 (3):161-72.

Prince, Michael J., and Frances Abele. 2003. "Paying for Self-Determination: Aboriginal Peoples, Self-Government and Fiscal Relations in Canada." Paper presented at "Reconfiguring Aboriginal-State Relations, Canada: The State of the Federation, 2003," Institute of Intergovernmental Relations, Nov. 1-2, 2002. Queen's University, Kingston. Accessed July 4, 2006. http://www.iigr.ca/conferences/archive/pdfs3/Prince_Abele.pdf

Putnam, Robert D. 1996. "The Strange Disappearance of Civic America." *American Prospect* 7 (24):340-48.

Richards, John. 2001. "Neighbors Matter: Poor Neighborhoods and Urban Aboriginal Policy." *C.D. Howe Institute Commentary* 156. Toronto: C.D. Howe Institute.

Ricketts, Erol, and Isabel Sawhill. 1988. "Defining and Measuring the 'Underclass.'" *Journal of Policy Analysis and Management* 7:316-25.

Rothney, Russ. 1992. *Neechi Foods Co-op Ltd.: Lessons in Community Development.* Winnipeg: Winnipeg Family Economic Development.

Royal Commission on Aboriginal Peoples. 1993. *Aboriginal Peoples in Urban Centres.* Ottawa: Minister of Supply and Services.

———. 1996. *Perspectives and Realities.* Vol. 4 of *Report of the Royal Commission on Aboriginal*

Peoples. Ottawa: Minister of Supply and Services.

Séguin, Anne-Marie, and Gérard Divay. 2002. "Urban Poverty: Fostering Sustainable and Supportive Communities." In *The Federal Role in Canada's Cities: Four Policy Perspectives*, edited by F. Leslie Seidle. CPRN Discussion Paper F/27. Ottawa: Canadian Policy Research Networks.

Sgro, Judy. 2002. *Canada's Urban Strategy: A Vision for the 21st Century*. Ottawa: Prime Minister's Caucus Task Force on Urban Issues.

Siggner, Andrew, and Janet Hagey. 2003. "Measuring the Demographic and Socio-Economic Conditions of Aboriginal Peoples in Canada Using the 2001 Census." Paper presented at the annual meeting of the Canadian Population Society, May 31-June 5, 2003, Halifax.

Silver, Jim, Parvin Ghorayshi, Joan Hay, and Darlene Klyne. 2006. *In a Voice of Their Own: Urban Aboriginal Community Development*. Winnipeg: Canadian Centre for Policy Alternatives. Accessed April 1, 2006. http://www.policyalternatives.ca/documents/Manitoba_Pubs/2006/In_A_Voice_Of_Their_Own.pdf

Stack, Carol. 1974. *All Our Kin: Strategies for Survival in a Black Community*. New York: Harper and Row.

Stackhouse, John. 2001. "Welcome to Harlem on the Prairies." *Globe and Mail*, November 3.

Stymeist, David H. 1975. *Ethnics and Indians: Social Relations in a Northwestern Ontario Town*. Toronto: Peter Martin Associates.

Ten Fingers, Keely. 2005. *Urban Dakota and Dene Quality of Life Indicators Project*. Winnipeg: Assembly of Manitoba Chiefs and Winnipeg Inner City Research Alliance.

Van Heest, Nancy. 1993. *The Electronic Series: Public Hearings*. CD-ROM. Royal Commission on Aboriginal Peoples, Toronto. Ottawa: Minister of Supply and Services.

Wacquant, Loïc. 1996. "The Rise of Advanced Marginality: Notes on Its Nature and Implications." *Acta Sociologica* 39:121-39.

———. 1997. "Three Pernicious Premises in the Study of the American Ghetto." *International Journal of Urban and Regional Research* 21:341-53.

———. 1999. "Urban Marginality in the Coming Millennium." *Urban Studies* 36:1639-47.

———. 2001. "Logic of Urban Polarization: The View from Below." *Berliner Journal für Soziologie* 4 (11):479-83.

Walker, Ryan. 2003. "Engaging the Urban Aboriginal Population in Low-Cost Housing Initiatives: Lessons from Winnipeg." *Canadian Journal of Urban Research* 12:99-118.

Walks, R.A., and L.S.Bourne. 2005. "Ghettos in Canadian Cities? Racial Segregation, Ethnic Enclaves and Poverty Concentration in Canadian Urban Areas." Paper presented at the annual meeting of the Canadian Association of Geographers, June 2, London, Ontario.

Weibel-Orlando, Joan. 1999. *Indian Country, L.A.: Maintaining Ethnic Community in Complex Society*. Urbana: University of Illinois Press.

Williams, Colin C., and Jan Windebank. 1998. *Informal Employment in the Advanced Economies: Implications for Work and Welfare*. London: Routledge.

Wilson, Kathleen Joan. 2000. "The Role of Mother Earth in Shaping the Health of Anishinabek: A Geographical Exploration of Culture, Health and Place." Ph.D. diss., Queen's University.

Wilson, William Julius. 1987. *The Truly Disadvantaged: The Inner City, the Underclass, and Public Policy*. Chicago: University of Chicago Press.

———. 1996. *When Work Disappears: The World of the New Urban Poor*. New York: Knopf.

Wotherspoon, Terry. 2003. "Prospects for a New Middle Class among Urban Aboriginal Peoples." In *Not Strangers in These Parts: Urban Aboriginal Peoples*, edited by David Newhouse and Evelyn Peters, 147-66. Ottawa: Policy Research Institute.

Culture Matters, but...
Explaining Trends
among Urban
Aboriginal People

Commentary

T HERE IS MUCH ON WHICH EVELYN PETERS AND I AGREE. THERE ARE ALSO SOME
things on which we disagree. First, that on which we agree.

Appropriately, Peters sets the context by pointing out how dramatic the
rural-to-urban migration among Aboriginal people has been over the last half-
century. At the end of the Second World War, less than 10 percent of the
Aboriginal population was urban. By the time of the 2001 Census, fully half lived
in an urban area. A quarter lived in just 10 cities — the 10 with the largest
Aboriginal populations. Since nearly two-thirds of Canada's Aboriginal people
live in one of the four western provinces, it is not surprising that seven of these
ten cities are western. Among the seven are the four that Peters examines in detail:
Winnipeg, Regina, Saskatoon and Edmonton. Between the 1981 and 2001
Censuses, Winnipeg's Aboriginal population increased by 247 percent, Regina's
by 145 percent, Saskatoon's by 382 percent and Edmonton's by 205 percent
(Siggner and Costa 2005).[1]

The obvious reason for this migration is economic. Like other groups that
initially settled in rural areas, Aboriginal people are migrating in search of better
economic prospects for themselves and their children. Off-reserve, Aboriginal
people face many problems — including a sense of cultural loss — but, in gene-
ral, their education levels, employment rates and incomes are considerably higher
than they would be on a reserve.

Schools Matter

PETERS EMPHASIZES THE VALUE OF ABORIGINAL CULTURAL ORGANIZATIONS IN EASING the rural-to-urban transition for Aboriginal people. I think she is right to do so. But cultural organizations are not enough. An important measure of the advances made by any Aboriginal community is employment at good wages, and the key to good wages is formal education.[2]

Figure 1 draws from the 2001 Census to illustrate the link between median income and employment among selected groups of Aboriginal people in their prime earning years, ages 25 to 44. Those in this age group are old enough to have completed their education and training, and young enough to have benefited from the emphasis on formal education over the past four decades; the oldest entered school in the early 1960s, the youngest in the early 1980s. The figure plots the relationship across the six provinces with substantial Aboriginal populations. (Seven of eight Aboriginal people live in one of these provinces.) The on-reserve cohorts are overwhelmingly nonurban; the majority of those living off-reserve are urban. Statistics for non-Aboriginal cohorts are included for comparison. The poorest group is on-reserve Aboriginal people living in the Prairies, where in 2000 median annual incomes were less than $12,000, and employment rates were below 45 percent.[3] The employment rate and median incomes among the wealthiest Aboriginal group, those living off-reserve in Ontario, were nearly twice those of people on Prairie reserves.

The link between employment and formal education has become stronger in recent decades: there are few jobs available for those without at least a high school graduation certificate, and such jobs as exist offer low wages. Figure 2 shows the link between education (measured by the proportion of each group that has completed high school) and median income. The link between education, employment and higher income exists among Aboriginal people as it does among non-Aboriginal people. The explanation for the positive link is essentially twofold. First, higher education levels increase the employment rate; they lead to better-paying jobs, the rewards of which exceed those of nonemployment options, such as social assistance. Second, higher education levels increase earnings among the employed. The slope of the trend line among the 12 Aboriginal groups implies that a 10 percentage point increase in the high school completion rate of Aboriginal people increases annual median income by $2,900. Admittedly, a satisfactory explanation of comparative incomes requires a far more complex

Figure 1

Median Annual Aboriginal Income On- and Off-Reserve and Non-Aboriginal Income, Ages 25 to 44, Selected Provinces, by Employment Rate, 2000

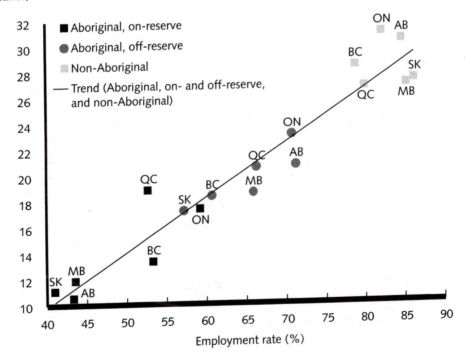

$ (thousands)

Legend:
- ■ Aboriginal, on-reserve
- ● Aboriginal, off-reserve
- ▪ Non-Aboriginal
- — Trend (Aboriginal, on- and off-reserve, and non-Aboriginal)

Employment rate (%)

Source: Author's calculations based on *Aboriginal Peoples Survey (2001)* (Ottawa: Statistics Canada, 2003), accessed September 19, 2006, http://www.cbsc.org/servlet/ContentServer?cid=1081944198231&pagename=CBSC_ON%2Fdisplay&lang=en&c=InfoResources

Note: $y = 418.75x - 6795.2$; $R^2 = 0.9229$

approach than reference to high school completion. Among the on-reserve populations, in particular, there are outliers.

Urban Aboriginal people remain substantially poorer, on average, than their non-Aboriginal urban neighbours, and racial discrimination figures in the explanation. But urban Aboriginal people have made gains, both absolutely and relatively. In the 10 cities of her study, Peters found an increase between 1980 and 2000 in the proportion of the Aboriginal population with annual incomes above $40,000. In their study of 11 cities with large Aboriginal populations, Andrew Siggner and Rosalinda Costa provide additional supporting evidence (2005). Overall, in these 11 cities, the median market earnings of Aboriginal people were about two-thirds those of non-Aboriginal people in 1980, and nearly three-quarters those of non-Aboriginal people in 2000 (see figure 3).

Underlying this closing of the income gap was an increase in the share of young urban Aboriginal people (ages 20 to 24) who had completed high school. Overall, in these cities, the increase in the high school completion rate among young non-Aboriginal people was about 15 percentage points between 1981 and 2001. The increase among Aboriginal women exceeded the increase among non-Aboriginal women in 9 of the 11 cities; the increase among Aboriginal men exceeded the increase among non-Aboriginal men in 6 of the 11 cities.

Are "Very Poor Neighbourhoods" Becoming Ghettos?

I AM LESS SANGUINE THAN PETERS THAT URBAN ABORIGINAL PEOPLE ARE AVOIDING THE problems of racial segregation by neighbourhood and, within certain neighbourhoods, a set of interrelated problems: high crime, low employment, high welfare dependency, poor-quality schools and absent fathers. This syndrome is indelibly associated with urban poverty in large US cities. For her part, Peters categorically concludes: "While proportionately more First Nations and Métis people than non-Aboriginal people live in poor neighbourhoods, they are not the majority in these areas, and there is no evidence that urban First Nations and Métis people are creating the conditions of isolation associated with the US inner-city underclass populations."

Figure 2

Median Annual Aboriginal Income On- and Off-Reserve and Non-Aboriginal Income, Ages 25 to 44, Selected Provinces, by Rate of High School Graduation and Above, 2000

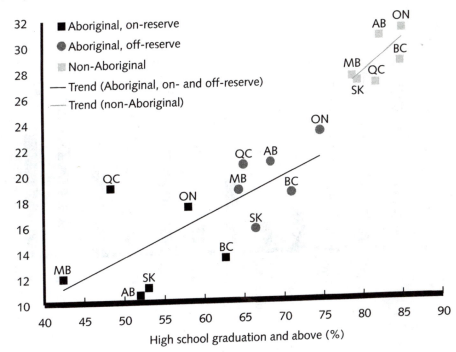

$ (thousands)

High school graduation and above (%)

- ■ Aboriginal, on-reserve
- ● Aboriginal, off-reserve
- ▪ Non-Aboriginal
- — Trend (Aboriginal, on- and off-reserve)
- — Trend (non-Aboriginal)

Source: Author's calculations based on *Aboriginal Peoples Survey*
(2001) (Ottawa: Statistics Canada, 2003), accessed September
19, 2006, http://www.cbsc.org/servlet/
ContentServer?cid=1081944198231&pagename=
CBSC_ON%2Fdisplay&lang=en&c=InfoResources

Figure 3

252

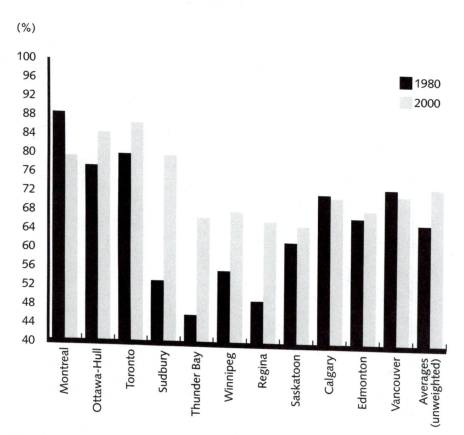

Ratio of Aboriginal to
to Non-Aboriginal
Median Employment
Income, Selected Cities,
1980 and 2000

Source: A.J. Siggner and R. Costa, *Aboriginal Conditions in Census Metropolitan Areas, 1981-2001*, Trends and Conditions in Census Metropolitan Areas, Analytical Studies Branch, cat. no. 89-613-MIE2005008 (Ottawa: Statistics Canada, 2005).

Our disagreement is in part a matter of semantics. When does a poor neighbourhood become a ghetto? Admittedly, no Canadian urban neighbourhood is dominated by poor Aboriginal people to the extent that some American urban neighbourhoods are dominated by poor Hispanic or African American people. But, the question of whether certain neighbourhoods are ghetto-like aside, are urban Aboriginal people concentrated in particular neighbourhoods? Peters's own data reveal a trend toward geographic segregation by race in three of the four cities she examines (see table 1, which reorganizes data from table 3 in Peters' chapter in this volume). In 1981, the great majority of urban Aboriginal people in the four cities she examines lived in census tracts in which Aboriginal people comprised less than 10 percent of the population. Virtually no Aboriginal people lived in a census tract in which the Aboriginal share of the population exceeded 30 percent.

The Aboriginal share of the population in these four cities rose dramatically between 1981 and 2001. (In 2001, the maximum Aboriginal share across these four cities was 9.1 percent — in Saskatoon.) The largest proportionate increases in the Aboriginal population may well be occurring in tracts with initially very low Aboriginal population counts, but the majority of the increase over the two decades has taken place in census tracts that now have Aboriginal population shares above 10 percent.[4] In 2001, the majority of tracts continued to have an Aboriginal population share below 10 percent, but such tracts now account for less than half the Aboriginal population in three of the four cities (all except Edmonton). In three of the four cities, the majority now live in the minority of census tracts having an Aboriginal share above 10 percent. In Regina and Winnipeg, one in six Aboriginal people now live in a census tract with an Aboriginal population share above 30 percent; in Saskatoon, one in four live in such a tract.

Another question to ask is: What is the relationship between census tracts with proportionately large Aboriginal communities and the local poverty rate? Peters's data do not allow us to answer this question, but one can be confident that the correlation is positive. Siggner and Costa provide evidence on various dimensions of ghetto "syndromes" — such as the extent of single parenthood among urban Aboriginal people — that suggests severe distress in many Aboriginal families (2005). But their monograph does not answer this question, because the data are not disaggregated by poor versus nonpoor neighbourhoods. Table 2 offers a

Table 1 254

Geographic Segregation
of Aboriginal
Populations in Four
Western Cities, 1981
and 2001 (percent)[1]

| | Census tracts categorized by Aboriginal share of tract population | | | |
	0-10%	10-30%	Over 30%	Total[2]
Winnipeg				
1981	70.6	29.4	0.0	100
2001	42.0	41.2	17.6	100
Change 1981-2001	*-28.4*	*11.8*	*17.6*	
Regina				
1981	79.3	20.7	0.0	100
2001	39.3	42.2	18.5	100
Change 1981-2001	*-40.0*	*21.5*	*18.5*	
Saskatoon				
1981	95.3	4.7	0.0	100
2001	36.5	37.8	25.6	100
Change 1981-2001	*-58.8*	*33.1*	*25.6*	
Edmonton				
1981	99.7	0.0	0.3	100
2001	70.4	29.5	0.1	100
Change 1981-2001	*-29.3*	*29.5*	*-0.2*	

Source: Author's calculation based on data in Evelyn Peters, "First Nations and Métis People and Diversity in Canadian Cities" (in this volume).

[1] Distribution of Aboriginal population by census tracts categorized in terms of Aboriginal share of census tract population.
[2] Totals may not add up to 100 due to rounding.

partial answer, using data from the 1996 Census — data that are unfortunately a decade old. At the time, Canada was recovering from the early-1990s recession; the 2006 Census will probably reveal less dramatic employment differences across neighbourhoods. In 1996, Aboriginal people were experiencing extremely low employment rates in "very poor neighbourhoods," relative to both Aboriginal people in nonpoor neighbourhoods and non-Aboriginal people in "very poor neighbourhoods." (A "very poor neighbourhood" is defined as a census tract where the LICO poverty rate exceeds twice the 1995 national average of 16.3 percent — that is, a rate above 32.6 percent. This is a somewhat broader criterion for "ghetto-like" tracts than the 40 percent poverty rate criterion used by Peters.)

Several observations are worth making:

◆ Urban Aboriginal people disproportionately live in very poor neighbourhoods, particularly those in western Canadian cities. This was the case for 31 percent of Aboriginal people in the six western cities documented in table 2. By contrast, only 8 percent of non-Aboriginal people in these six cities lived in very poor neighbourhoods. This disparity is most evident in the case of the three cities in Manitoba and Saskatchewan.

◆ The employment rate was, predictably, lower in very poor neighbourhoods than in nonpoor ones across all eight cities. On average, taking into account both Aboriginal people and non-Aboriginal people, the difference was 13 percentage points.

◆ Among Aboriginal people, the difference in employment rates between very poor and nonpoor neighbourhoods was 25 percentage points, a gap much larger than that for non-Aboriginal people. Across the six western cities, the Aboriginal employment rate in very poor neighbourhoods was 30 percent; in nonpoor neighbourhoods, it was 55 percent.

◆ The most acute low employment rates among Aboriginal people were in the very poor neighbourhoods of Winnipeg, Saskatoon and Regina. There, the average rate was 27 percent; this amounted to only half the employment rate among Aboriginal people living outside these neighbourhoods.

Yet another way of approaching this matter is to consider inequality trends in the distribution of the incomes of urban Aboriginal people. As I have already mentioned, Siggner and Costa note an encouraging *decrease* from 1980 to 2000

Table 2 256

Poverty and Employment among Urban Aboriginal and Non-Aboriginal People, by Neighbourhood Category, Selected Cities, 1996[1] (percent)

	Share of the population in very poor urban neighbourhoods	Employment rate	
		Very poor neighbourhoods	Nonpoor neighbourhoods
Montreal			
Aboriginal	29.7	36.8	51.7
Non-Aboriginal	22.4	50.9	59.4
Toronto			
Aboriginal	20.8	40.1	61.9
Non-Aboriginal	13.9	50.9	62.7
Winnipeg			
Aboriginal	48.1	27.7	56.8
Non-Aboriginal	13.5	52.7	64.6
Regina			
Aboriginal	28.2	21.8	49.3
Non-Aboriginal	5.8	49.7	67.1
Saskatoon			
Aboriginal	34.1	24.8	46.5
Non-Aboriginal	7.9	54.0	66.8
Calgary			
Aboriginal	9.2	54.5	61.7
Non-Aboriginal	4.2	60.6	69.7
Edmonton			
Aboriginal	23.0	34.6	51.8
Non-Aboriginal	8.2	53.2	62.4
Vancouver			
Aboriginal	21.9	31.5	57.0
Non-Aboriginal	7.3	53.2	62.4

Source: 1996 Census master file; see J. Richards (2001).

[1] In 1995, the average national family poverty rate, according to Statistics Canada's low-income cutoff, was 16.3 percent. A "very poor neighbourhood" is defined as a census tract having more than twice the prevailing average rate — i.e., above 32.6 percent. This is a broader criterion for "ghetto-like" tracts than the 40 percent poverty rate used by Evelyn Peters elsewhere in this volume. Statistics for Aboriginal people are calculated on the basis of identity as opposed to ancestry (origin).

in the gap between Aboriginal people's and non-Aboriginal people's median annual earnings in 8 of the 11 cities they studied. But they also note a disturbing seven percentage point *increase* over the two decades in the bottom tail (defined as earnings below $20,000) of the earnings distribution of urban Aboriginal people (2005). Admittedly, their data do not refer to any geographic concentration of those in this bottom tail, and a similar if smaller increase in the bottom tail occurs among non-Aboriginal people (see table 3).

At this point, I make the usual academic recommendation: more research. When the 2006 Census data become available, it would be useful to update the evidence on neighbourhood poverty concentration.

Moving About...

I STRESS THE IMPORTANCE OF EDUCATION OUTCOMES IN ADDRESSING URBAN ABORIGINAL poverty. But it is doubtful that problems of urban Aboriginal education can be resolved independently of problems of on-reserve education. As long as the quality of reserve-based schooling remains poor, and as long as churning between reserve and urban communities remains high, a large gap between the education levels of Aboriginal people and non-Aboriginal people will probably persist.

The severity of the on-reserve education problem is evident in figure 4. The evidence from the cohort ages 15 to 24 is obviously incomplete — many are still in school or receiving some form of post-secondary instruction. Among Aboriginal people, the share having completed high school is greater among those identifying as Métis as opposed to Indian. In terms of area of residence, urban results exceed those of rural areas; by far the lowest results are for Indians on-reserve.

Mobility may have positive consequences, but frequent moves are usually harmful to children's education prospects. In turn, failing to complete high school is a strong predictor of severe bouts of unemployment and poverty in adulthood. Urban Aboriginal people change residence much more frequently than do non-Aboriginal people. Many of the moves are to different addresses within the same city; other moves are between the city and a rural, often reserve-based, community. (Most of those identifying as Indian — as opposed to Métis — are registered under the *Indian Act*, and many of them move frequently between an urban

Table 3 258

Average Annual Earnings among Aboriginal and Non-Aboriginal People in Cities, by Income Category, 1980 and 2000[1] (percent)

Annual earnings[2]	Aboriginal		Non-Aboriginal	
	1980	2000	1980	2000
Under $20,000	51	58	38	43
$20,000-$40,000	31	27	33	29
Over $40,000	18	15	29	28
	100	100	100	100

Source: A.J. Siggner and R. Costa, *Aboriginal Conditions in Census Metropolitan Areas, 1981-2001*, figure 17 (Ottawa: Statistics Canada, 2005), accessed October 2, 2006, http://www.statcan.ca/english/research/89-613-MIE/89-613-MIE2005008.pdf

[1] Average across 11 Canadian cities.
[2] Measured in constant 2000 dollars.

Share of Cohorts Ages
15-24 with a High School
Certificate or Higher,
Aboriginal Identity
Groups and Non-
Aboriginal People, by
Area of Residence, 2001

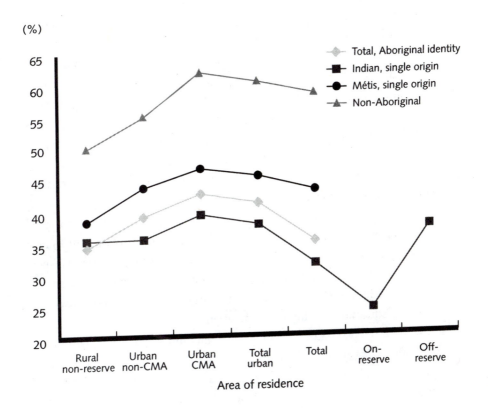

Source: Author's calculations based on *Aboriginal Peoples
Survey (2001)* (Ottawa: Statistics Canada, 2003), accessed
September 19, 2006, http://www.cbsc.org/servlet/
ContentServer?cid=1081944198231&pagename=
CBSC_ON%2Fdisplay&lang=en&c=InfoResources

residence and a reserve community.) Those in very poor neighbourhoods change residence more frequently than do those in nonpoor neighbourhoods, and Aboriginal people in very poor neighbourhoods are the most mobile of all (Richards 2001; Siggner and Costa 2005).

Conclusion

EDUCATION FROM KINDERGARTEN TO GRADE 12 IS ABOUT TRANSMISSION OF CULTURE. Both Peters and I agree that on- and off-reserve school systems throughout western Canada — and wherever large Aboriginal communities exist — should do more to address this dimension of education. Education is also about mastery of the basic academic skills and knowledge necessary for participation in an industrial society. A relevant precedent here was the concern among francophone Quebecers in the mid-twentieth century over their schools. Although provincial schools were at the time preserving language and culture, the dropout rate was unduly high, and they were not graduating students able to match the level of anglophone students, either in Quebec or elsewhere in Canada. Quebec's Quiet Revolution closed that gap. Since that time, the link between a good education and a good job has become even stronger.

When the prime minister, premiers and leaders of the major Aboriginal organizations met in Kelowna, British Columbia, in November 2005, they agreed to address social problems and not to debate their disagreements over the respective powers to be exercised by Ottawa, the provinces and band governments. With regard to education, they committed themselves to "the goal of closing the gap in K-12 educational attainment between Aboriginal learners and other Canadians by 2016" (Canada 2005, 4). It is highly unlikely that they will realize this goal, but stating it is worthwhile. It is an implicit acknowledgement by the prime minister and Aboriginal leaders that past performance on education by both the Department of Indian Affairs and band councils has been woefully inadequate. It is also an acknowledgement by the premiers that provincial education ministries must assume major responsibilities with respect to improving Aboriginal education, and that they can no longer sidestep the difficulties by referring to federal or band responsibility.

Notes

1 Andrew Siggner and Rosalinda Costa
 emphasize that some portion of this dra-
 matic increase in urban Aboriginal popula-
 tions is due to "ethnic migration." With the
 enhanced status of Aboriginal peoples
 among the general population in recent
 decades, some who did not initially self-
 identify as an Aboriginal person in the cen-
 sus now do so. In addition, ethnic
 migration probably explains some portion
 of the dramatic improvement in urban
 Aboriginal education outcomes and the
 closing of the gap in median earnings —
 issues that I will discuss later.

2 This section summarizes the discussion in
 my study Creating Choices (Richards 2006).

3 Money income measures exaggerate the rel-
 ative poverty of reserve-based Aboriginal
 groups, because the data do not include in-
 kind income, a category more important
 on-reserve than off-reserve.

4 Take the case of Winnipeg. To reconcile the
 1981 and 2001 data (see table 1), roughly
 30 percent of the increase in the Aboriginal
 population took place in census tracts that,
 in 2001, continued to have an Aboriginal
 population share below 10 percent; 45 per-
 cent in tracts that, in 2001, had an
 Aboriginal population share between 10
 and 30 percent; and 25 percent in tracts
 that now have an Aboriginal population
 share above 30 percent.

References

Canada. 2003. Aboriginal Peoples Survey (2001).
 Ottawa: Statistics Canada. Accessed
 September 19, 2006.
 http://www.cbsc.org/servlet/ContentServer?c
 id=1081944198231&pagename=CBSC_ON
 %2Fdisplay&lang=en&c=InfoResources
———. 2005. "Strengthening Relationships and
 Closing the Gap." Paper released at the
 First Ministers' and National Aboriginal
 Leaders' Meeting, November 24-25,
 Kelowna, BC.

Richards, J. 2001. "Neighbors Matter: Poor
 Neighborhoods and Urban Aboriginal
 Policy." C.D. Howe Institute Commentary
 156. Toronto: C. D. Howe Institute.
———. 2006. Creating Choices: Rethinking
 Aboriginal Policy. C.D. Howe Institute Policy
 Study 43. Toronto: C. D. Howe Institute.
Siggner, A.J., and R. Costa. 2005. Aboriginal
 Conditions in Census Metropolitan Areas,
 1981-2001. Trends and Conditions in
 Census Metropolitan Areas, Analytical
 Studies Branch, cat. no. 89613MIE2005008.
 Ottawa: Statistics Canada.

Beyond "Us" and
"Them": Prescribing
Postcolonial Politics
and Policy in
Saskatchewan

APPROXIMATELY 15 PERCENT OF SASKATCHEWAN'S POPULATION IS COMPOSED OF Aboriginal people, and that percentage is increasing rapidly. Some analysts project that by the year 2045, Aboriginal people will constitute one-third of the population. Most of them will be young — under the age of 25. This trend toward a young demographic is a distinct departure from the aging tendency of the non-Aboriginal population, which is reproducing more slowly. Thus, Saskatchewan's population profile is a cluster of very young people and a cluster of older citizens, with disproportionately fewer in their middle (and higher-income-earning, tax-paying) years. Furthermore, many young White people leave the province in search of greener pastures, while Aboriginal youth are less mobile. Obviously, Aboriginal youth are of considerable public policy interest, for they are a community that will need housing, health care, education and employment. Provincial economic fortunes are tied to this community's success, stability and health. Yet the great unspoken in Saskatchewan, hidden in the coded rhetoric of "social cohesion," is the fraught relationship between communities — a relationship moulded by the structural and cultural racism of the dominant majority (Green 2006). Thus, focusing public policy and public wealth on the Aboriginal community is both essential and politically problematic. Governments need to understand the context of Aboriginal people in the colonial state and attend to some of the most egregious manifestations of structural and cultural racism if these abhorrent racialized relationships are to be transformed into something more just.

For many, Native-newcomer relationships in Saskatchewan are symbolized by the shocking media images of several Aboriginal men found frozen to death in a snowy field outside of Saskatoon;[1] by the fact that too many Aboriginal women

have gone missing; by the notoriety of Saskatchewan cities for property crime and violent crime; by the shooting murder of Métis Leo LaChance by White gun store owner Carney Nerland in Prince Albert; by the rape and murder of Cree Pamela George by two young White students in Regina; by the rape of a 12-year-old Cree girl by three young White men near Tisdale; and by Statistics Canada's documentation of the shocking socioeconomic inequality afflicting Aboriginal peoples. Yet there are also hopeful signs: evidence of Aboriginal entrepreneurial and political success, some of it supported by federal and provincial public policy decisions;[2] and evidence of more Aboriginal people moving into professional and influential positions. Still, these are a small and marginal set of positive developments in a larger context of contemporary colonialism.

Fundamentally, the state, in both its federal and provincial manifestations, remains a vehicle to perpetuate racist assumptions. Its policy directed at indigenous peoples reflects both colonial assumptions and power relations. Nonetheless, the state, like the intellectual, corporate and cultural elites, understands itself as racially neutral and tolerant of difference. Consequently, it avoids addressing systemic and structural racism, "adopting an entirely uncritical role in the way in which the racial state shapes racial policies and their effects throughout the economic, social, and cultural landscape" (Giroux 2004, 77).

Structural and institutional racism are infused in bureaucratic, political and other processes to perpetuate colonialism through what Henry Giroux calls the "new racism" (2004), which relies on "studied ignorance and privileged innocence" (Kuokkanen 2005, 12). Yet the tools for moving to postcolonial policymaking and to a reflective antiracist political culture exist, even if they are rarely recognized by the dominant culture. For example, the traditions of Canadian federalism represent a far better conceptual framework for securing the inherent right to self-government in practice than do any existing settler-state self-government policies. Achieving this transformation, however, will require political leadership capable of generating a serious reconsideration of the colonial instincts of current public policy.

The Kelowna Accord of November 2005 suggested that at least some non-Aboriginal political leaders were tentatively prepared to rethink the Aboriginal policy status quo.[3] The Accord was promising but too limited, and, given the apparent distaste for it within the Conservative government, it appears to be history.[4] It was promising because it was positive federal and provincial attention to

pressing socioeconomic needs. And it was promising because Premier Gordon Campbell of British Columbia — previously a vociferous critic of Aboriginal rights in a province historically hostile to Aboriginal title — led the meeting in calling for support of the measures before it. Furthermore, he acknowledged that the meeting was being held on Okanagan and Shuswap territory, thus observing an indigenous protocol of recognition and respect. The Accord was too limited because it continued to privilege the status Indian constituency and, indeed, the on-reserve constituency over other categories of Aboriginal peoples, though it also focused for the first time on the Métis. And it was too limited because its focus was exclusively on socioeconomic needs — it gave no consideration to the context informed by colonialism, dispossession, subordination and racism. Hence there was no discussion of land, resources or political and economic power-sharing. There was no acknowledgement that in BC, for example, the treaty tables had been virtually stalled for a decade, and that elsewhere the record was best described as spotty. The Treaty Land Entitlement (TLE) process was moving ahead in Saskatchewan, but progress was not as good in Manitoba; there were no initiatives for Métis land restitution, and little for urban Aboriginal people. Across the country, progress on Aboriginal claims was similarly under-whelming, and the situation remains unchanged.

In this chapter, we suggest that policy-makers and political leaders take a leadership role in confronting and destabilizing the colonial assumptions embed-ded in parliamentary, constitutional and judicial structures and processes, in cor-porate practices and expectations, and, ultimately and most importantly, in the dominant political culture. We trace some of the most evident strands of this knot-ty problem, and we propose some strategies to permit governments and communi-ties to move toward justice, based in part on the practical experience of undertaking self-government negotiations in Saskatchewan. While governments can and should design ameliorative programs to address indigenous misery, there is no substitute for a process of genuine inclusion of indigenous peoples in the state. We propose that both strategies are useful, with the former being a short-term measure and the latter providing a normative objective toward which we can all work. We cannot consider the poverty and immiseration of Aboriginal people without also con-fronting colonialism and, hence, capitalism and racism. Only when governments and all citizens do this will we be able to reconcile the Canadian impulse to justice with the historic and continuing injustice of colonialism.

Demographic Realities

I N CANADA, ABORIGINAL SUFFERING IS MANIFEST IN THE SOCIOECONOMIC DISPARITIES between Aboriginal and settler peoples, including disparities in life expectancy and rates of suicide, infant mortality, poverty and unemployment, as measured by Statistics Canada (see Evelyn Peters's chapter in this volume). In Regina, the labour force participation rate for Aboriginal people 15 years and older was 58.4 percent in 2001, compared with 70.5 percent for the overall population, and the unemployment rate was 20.7 percent, compared with 6 percent for the overall population (Stokes, Peach and Blake 2004, 5; Hawkes 2005, 120-1; Peel 2005). David Hawkes calls the socioeconomic disparity a "public policy powder keg," noting that "the average annual income per capita for the registered Indian population on-reserve is $5,452, compared with $17,231 for the reference population in Saskatchewan" (2005, 120). Alyssa Peel observes, "In Saskatchewan, the unemployment rate for non-Aboriginal people is less than five percent, whereas the unemployment rate for Aboriginal people is more than four times higher at twenty-three percent. The unemployment rate for Aboriginal youth, aged fifteen to twenty-four is at a staggering twenty-nine percent...[O]ver two-thirds of persons incarcerated...are First Nation and Métis, although they form only 13.5 percent of the population" (2005).

Aboriginal people's 13.5 percent of the total population in 2001 is expected to be 20 percent by 2020, and 33 percent by 2045. Together with the disparate demographic trends — the median age for Aboriginal people is much younger than for settler people, at 20 years and 40 years, respectively — it is clear that the future is young and Aboriginal. Of all the country's census metropolitan areas, Regina had the fourth-largest percentage of residents under 20 years of age in 2001; close to half Regina's Aboriginal population is under 20 (Stokes, Peach and Blake 2004, 2-3). The importance of Aboriginal people when it comes to meeting Saskatchewan's current and future workforce needs, and their influence on society as a whole, cannot be overstated. Aboriginal economic development is vital for Saskatchewan's economy. Premier Lorne Calvert has stated, "Their future is our future and we have to walk together every step of the way" (Brownlee 2006). This demographic bulge should move into the labour market, but, as Hawkes notes, "About 30 percent of registered Indians over the age of fifteen have never worked in their lifetime, compared to 7 percent of the reference population

of Saskatchewan" (2005, 120). A synergistic mix of structural barriers — including racism and a lack of training, resources and opportunities — as well as social alienation militate against the rapid transformation of this situation.

Income and earnings indicators reflect the disadvantaged position of Aboriginal people in the workforce. This is tied to lower educational attainment among Aboriginal people and is reflected in the gaps between Aboriginal and non-Aboriginal people in a variety of social indicators. But Aboriginal marginalization is not simply a consequence of a lack of capacity. Factors such as lower educational attainment are the contemporary manifestations of colonial public policy. The failure of governments, including *Indian Act* governments (which have their own problems), to successfully redress these phenomena reflects a policy choice to continue colonial relationships (Irlbacher-Fox 2005); or, at minimum, it amounts to a failure on the part of policy-makers to recognize the colonial relationships that underlie these phenomena.

In order to close the social indicator gap, settler society must undertake a tremendously challenging task — it has to recognize its privileges and the racism and colonialism that have perpetuated those privileges. And governments must create an Aboriginal policy framework that is principled, coherent and designed to respond to Aboriginal people's needs, aspirations and rights, rather than simply paying enough lip service to Aboriginal people's claims to avoid conflict while perpetuating settler society's privileges.[5] Most importantly, governments must lead attitudinal change in society.

There are positive trends on which public policy can be built. The educational attainment of Aboriginal people is steadily improving, boding well for their future in the workforce and in society. There is a growing Aboriginal middle and professional class, whose members include lawyers, judges, accountants, entrepreneurs, academics, police officers and civil servants. Aboriginal people are playing an increasingly important role in Saskatchewan's economy. In northern Saskatchewan, businesses owned by the Meadow Lake Tribal Council and the Prince Albert Grand Council play a vital role in the economy. In an example of corporate leadership, Cameco Corporation committed many years ago to building an Aboriginal workforce, and it has implemented that commitment: 28 percent of its Saskatchewan-based workforce is now Aboriginal (Cameco 2005). The federal and Saskatchewan governments signed the Treaty Land Entitlement (TLE) Framework Agreement in 1992 and have signed 29 specific TLE agreements with

First Nations. As the name indicates, these were outstanding treaty obligations of the settler governments. TLE agreements have provided First Nations with access to valuable lands and capital, allowing them to play a more significant role in Saskatchewan society. Flying Dust First Nation entered a partnership with the Meadow Lake School Division several years ago to comanage kindergarten to grade 12 education in the district. The provincial government signed in 1994, and renewed in 1995 and 2002, an agreement to devolve the operation of several casinos in the province to the Saskatchewan Indian Gaming Authority, a First Nations entity, and to share the profits from casino gaming with First Nations organizations. When the provincial government restructured the Saskatchewan forestry industry in the late 1990s, it provided First Nations and Métis peoples with licences to cut timber so that they could become partners with established forestry companies in the exploitation of the resource.

Still, these are piecemeal actions rather than a coherent policy for decolonization, and even such modest initiatives are met with resistance from some members of the dominant society. The resistance that TLE settlements have been met with in several parts of the province, the unwillingness of many Saskatchewan businesses to build partnerships with Aboriginal peoples, and the tacit tolerance of the behaviour of the Saskatoon Police Service in the Stonechild et al. affairs toward Aboriginal people speak volumes about the gap between Saskatchewan's espoused respect for justice, equality and cultural diversity and the reality of institutional and structural racism.

Policy-Making for Justice

"IN THE BEGINNING," WHEN INDIGENOUS AND COLONIAL POPULATIONS FIRST CAME into politically significant contact, the core assumption of the colonizer ideology was the "inherent inferiority of Aboriginal peoples as peoples" (Russell 2005, 31). This assumption has not changed substantially: behind most public policy pronouncements and most mainstream research on Aboriginal people lurks the notion that Aboriginal deviance from mainstream practices and indicators is best remedied by making Aboriginal people more consistent with dominant populations. As Linda Tuhiwai Smith writes, "The 'indigenous problem'

became embedded as a policy discourse which reached out across all aspects of a government's attempt to control the natives" (1999, 91). Implicit in this assumption of inherent inferiority is the belief that the settler community and the settler state do not have to change — they are benevolently normative. Embedded in colonial law, this "fundamental presumption" permeates law and policy and forms what Peter Russell calls "the major barrier in moving towards a truly postcolonial position" (2005). This racist ideology legitimated the original imposition of state sovereignty and subsequent land theft on the many indigenous nations, and it is on those acts of dispossession that contemporary Aboriginal socioeconomic indicators, markers of oppression, are based (Irlbacher-Fox 2005). Barbara Hudson shows how oppression is characterized by the monopolization of power by the oppressor over the oppressed; she proposes that the eradication of these be the objective of justice (2006, 43). It follows, then, that the suffering is best alleviated by ending oppression, sharing power and returning land and resources. Such steps are fundamental to the process of building a truly new, postcolonial relationship.

In addition to restitution, Canada's postcolonial relationship requires a shift away from the prevailing political culture, which is based on race privilege. It is a White-preferential political culture imbued with positive settlement motifs and negative and fictitious indigenous ones. Confronting race privilege, the racialization of Aboriginal people and minorities and the integral relationship of racism to colonialism is an essential precondition for moving to a genuinely antiracist and postcolonial state of being. As Henry Giroux explains, "Race represents an essential political category for examining the relationship between justice and a democratic society" (2004, 66). Using race discourse to reveal systemic and structural injustice will ultimately strengthen the quality of democracy for all Canadians.

Race discourse is foreign to most policy-makers. Rather, racism is generally considered to exist in individual acts, and little attention is paid to systemic and structural racism. But, as Giroux points out, "racial discourse is not simply about private speech acts or individualized modes of communication; it is also about contested histories, institutional relations of power, ideology, and the social gravity of effects" (2004, 75). It will be impossible for us to create postcolonial policy until policy-makers struggle with our collective entanglement in the racist ideology and practice bequeathed to contemporary Canada by colonialism's architects. This deeply embedded discursive racism is fundamental not just to the

Canadian state but also to the international political economic order. Makere Stewart-Harawira contends that "the integration of indigenous peoples into the existing political structures of Western society was integral to the maintenance of the *status quo* within the world order of nation states, to the territorial integrity norms of the dominant powers and to the continuance of capitalist exploitation and expansion under the ideology of development" (2005, 123).

The problem is compounded by the dominant economic ideology — neo-liberalism — which militates against governments and individuals grappling with systemic and structural processes and with collective state and societal obligations to the marginalized (Giroux 2004, 58-69). As states retreat from social policy, as society is reframed as aggregates of individuals and as citizens are redefined as consumers and producers, we are less able to see racism in its structural and systemic manifestations. Yet if we fail to attack the structural and systemic foundations of racism, then our policy-makers will be left to treat the egregious symptoms rather than the causes of the disease.

Self-Determination and the Federal State

A S ONE MIGHT HAVE EXPECTED, FEDERAL AND PROVINCIAL GOVERNMENTS HAVE BEEN most comfortable with governance that approximates the self-administration of policies made by federal and provincial governments, with the accountability for decisions resting with federal and provincial agencies rather than indigenous communities. Fiscal arrangements are indicative of the political norms that give birth to them. Michael Prince and Frances Abele remind us that "Canada-Aboriginal intergovernmental fiscal relations [are] fundamental to the realization of Aboriginal self-determination. Yet, current fiscal arrangements…are a stumbling block in the process of self-determination…Aboriginal governments in Canada by and large remain in a struggle and are still controlled and dependent" (2005, 237-8).

While fiscal federalism between provincial and federal governments has demonstrated constitutional, bureaucratic and political flexibility, Aboriginal governments have not experienced this. Prince and Abele observe that contemporary fiscal federalism shows patterns of "federal control and rigidity in financial

arrangements, relentless fiscal centralization; and some delegation of administrative authority." As well, funding has been used as a political weapon in some circumstances (2005, 241, 245).

In the early 1990s, the possibility of self-government negotiations held the promise of a new relationship between Aboriginal peoples and settler society. The policies that settler governments have developed to recognize Aboriginal peoples' inherent right of self-government, however, have resulted in the disappointment that accompanies rhetoric unmatched by action. Despite the amount of ink and air expended on "self-government," the models instigated by the federal government (like the much-maligned Community-Based Self-Government Policy of the 1990s and the abandoned *First Nations Governance Act*, 2004-05) are the results of tainted negotiations between indigenous peoples and the federal government (see Irlbacher-Fox 2005; Green 1995); they are administrative regimes that function according to a predetermined colonial game plan and follow a script that actually denies the inherent right of self-determination and perpetuates colonial dominance. As Irlbacher-Fox demonstrates through discourse analysis of contemporary policy rhetoric, the federal government denies that contemporary Aboriginal suffering has historic roots and is perpetuated by continuing practices of colonialism, preferring to pretend that contemporary Canada does not participate in and benefit from the history of colonialism (2005). By using the language of past wrongs, new relationships, capacity-building and certainty, the federal government is able to separate Canada from Aboriginal suffering and blame that suffering on Aboriginal peoples themselves, implying that if they conform to the policy requirements of "new" relationships, they may yet approximate Canadian bureaucratic and political ideals.

Negotiating "Self-Government" in Saskatchewan

SASKATCHEWAN HAS BY NO MEANS BEEN IMMUNE TO THIS PROBLEM. BOTH CANADA and Saskatchewan claim to recognize the inherent right to self-government. The Government of Canada even has an inherent right policy; it is, however, a far cry from a recognition of the right of self-determination, by which First Nations

would govern themselves according to norms, practices and rules that were legitimate and culturally relevant to the various Aboriginal nations. Furthermore, in its reluctance to negotiate self-government arrangements for off-reserve First Nations members, the federal government perpetuates the artificial divide between on- and off-reserve First Nations people that *it created* and relegates First Nations members who reside off-reserve to second-class status, which, in many ways, denies their indigeneity. Finally, it is a policy that focuses only on the First Nations component of the constitutional Aboriginal category that includes Indians, Inuit and Métis.

The key conceptual problem with the Inherent Right of Self-Government Policy, which starkly reveals its colonial bias, is that it operates on a concurrency model, which privileges the existing division of powers between the federal and provincial governments. What this means in practice is that all federal and provincial laws are expected to continue to apply to self-governing First Nations. Even if there were an agreement stipulating that the laws of First Nations were paramount, the federal or provincial law would give way to the paramount First Nations law only in the case of a conflict between the two; where it is possible for First Nations members to obey both the federal or provincial and the First Nations law, they must do so.

In the context of the constitutional division of powers between the federal and provincial governments, concurrency exists at the margins of jurisdictions because the lists of jurisdictional powers contained in sections 91 and 92 of the *Constitution Act, 1867* are quite different. In the context of Aboriginal governments, however, all the jurisdiction that these governments could exercise has already been allocated under the Constitution to either the federal or the provincial government. Every time an Aboriginal government enacts a law, it will be legislating in an area where there is either a federal or a provincial law relating to the same matter, and the concurrency model dictates that First Nations members continue to be regulated by these settler government laws whenever it is possible for them to obey these laws *and* the laws of their own governments (Peach and Rasmussen 2005, 26). Saskatchewan policy was also built on this concurrency model.

For Saskatchewan First Nations, the fundamental objective of negotiating a self-government agreement — a process that began with the signing of a protocol agreement to establish a "common table" between Canada, the Federation of Saskatchewan Indian Nations (FSIN) and Saskatchewan on October 31, 1996[6] —

was to build on the treaty relationship (also referred to as the "nation-to-nation" relationship) between the Crown and First Nations by acknowledging and providing scope for a meaningful exercise of jurisdiction on the part of First Nations over several classes of matters. Thus, the fundamental concern was that the agreement respect the jurisdiction of First Nations governments to make laws exclusively in some areas (Peach and Rasmussen 2005, 29). What the concurrency model does, instead, is continue to impose settler-society laws on allegedly self-governing First Nations unless First Nations draft laws that create operational conflicts; the model does not make jurisdictional space for self-determination by a third order of government within the federation.

A second problem arises from federal-provincial jurisdictional quarrels. The federal government refused to participate in negotiations to extend the benefits of, or capacity for, self-government to off-reserve members. Fearing political and fiscal implications, the provincial government, for its part, was not prepared to allow the federal government to use the self-government negotiations to permanently offload federal responsibilities onto First Nations people who reside off reserves. In Saskatchewan, this policy created an impasse that lasted several years and was, along with the battle over the concurrency model, a significant contributing factor to the eventual suspension of self-government negotiations between the Government of Canada, the FSIN and the Government of Saskatchewan.

A third problem is the reluctance of governments to make resources available to First Nations in conjunction with self-government. This amounts to a failure of governments to create an integrated strategy that would allow Aboriginal peoples to empower and govern themselves as distinct communities of citizens; governments have also failed to reverse the unjust distribution of resources between settler society and Aboriginal societies that has led to the economic and political marginalization and social dysfunction of Aboriginal peoples.

In the self-government negotiations between the Government of Canada, the FSIN and the Government of Saskatchewan, Canada proved to be the barrier to First Nations being provided with the resources they needed to address the social pathologies that decades of colonization had created among their members. Working in conjunction with the self-government negotiations, the negotiators for all three parties were prepared to build an agreement to establish a jointly funded, 20-year socioeconomic development strategy that would give First

Nations the resources to gradually reverse their social and economic disadvantage. The federal bureaucracy, however, was unwilling to assent to this proposal.

As Tom Malloy notes, there exists an extensive bureaucratic infrastructure in the federal government designed to oversee the progress of self-government negotiations. Because it gives all participants a veto over agreements arrived at in the negotiations, this infrastructure puts the bureaucracy — the body that advises elected officials and executes political direction — in the position of making policy decisions for the federal cabinet (Malloy 2000, 47-53). Malloy describes these internal negotiations: "At best, it was time consuming. At worst, it was like pulling teeth to reach a consensus and develop a response that could be brought to the table. But the support of individual departments was critical to the ultimate success of the negotiations, and every member of the negotiating team knew it. Unfortunately, so did every department" (2000, 50).

In Saskatchewan, the negotiations within the federal bureaucracy over the proposal to establish a socioeconomic development agreement did not secure a consensus. Federal officials argued that such an agreement would set a precedent for other self-government negotiations, as though setting a precedent with a good idea (if the socioeconomic strategy were to succeed) were to be avoided. The impasse over the negotiation of the socioeconomic strategy was the third critical factor in the delay and eventual suspension of these self-government negotiations.

At each turn, the self-government policies of the settler society's governments sought to minimize Aboriginal empowerment, avoid meaningful recognition of Aboriginal peoples' rights and perpetuate settler society's privilege and dominance; and all the while these governments claimed to be committed to a just resolution of intersocietal conflict. Such policies support the suspicion that the real agenda of governments is to give Aboriginal peoples just enough hope of progress to make the politics of intersocietal relations manageable but to leave unchanged the underlying relationships that perpetuate colonialism, racism and structural disadvantage for Aboriginal peoples.

But there are better, more just policy options. Achieving political and social consensus for an alternative approach to postcolonial intersocietal relations, however, remains a considerable challenge for political leaders. Any such consensus will force settler society to confront its privilege and the racism that supports it. This consensus will also require political leaders to make a serious

commitment to leading public opinion toward a more just accommodation between Aboriginal and non-Aboriginal peoples.

The key to finding a more just path is to base government policy on principle rather than advantage. Those who were central to the self-government negotiations with the FSIN used the principle of federalism. Federalism, at least in its Canadian form, supports the self-determination of distinct historic communities by providing a vehicle with which those communities can govern themselves in democratically legitimate and culturally appropriate ways within a larger polity. Indeed, the history of building a fully self-governing federation in Canada is characterized by democratic self-determination: the country as a whole secured democratic governance and eventual independence from the British Empire; and subnational political communities sought simultaneously to be part of a nation that had the capacity and resources to establish its place in the world *and* to be distinct and self-governing polities within that nation. The principles of federal governance are thus readily applicable to an Aboriginal self-government policy.

Of course, "federalism" refers to both the structure of divided sovereignty between constitutional orders of government and the bureaucratic, communicative and negotiation processes of these orders of government in the service of policy-making and governing. Federalism's evolutionary capacity is substantial. In Canada, federalism has been transformed from the elite accommodation of 1867, with the Constitution essentially serving as an administrative document divvying up jurisdiction and tax room between two orders of government, into the more complex and less jurisdictionally certain contemporary version, characterized by increased citizenship capacity and engagement and the emerging factor of the third federal order: Aboriginal governments (Prince and Abele 2005; Green 1995, 2005).

Ultimately, federalism will become a tripartite governance arrangement. Aboriginal, federal and provincial governments will be partners, but each will have its own constitutional sphere of jurisdictional autonomy; layers of interdependency will be managed through the processes of intergovernmentalism. Aboriginal governments of this stature are distinct from the delegated administration regimes often put forward as examples of "self-government," for they share in the sovereignty of the state, they hold constitutional rather than delegated power, they have jurisdictional paramountcy, they have a claim on public money through fiscal relations, and they are chosen by an identifiable political constituency and are accountable to that constituency rather than to an enabling

government. They are expressions of the inherent right — and of the fundamental human right — to self-determination.

Though it took negotiators four years of sustained effort, they were eventually able to secure the federal government's agreement to a displacement of laws model, which, unlike the concurrency model, would allow First Nations not only to create their own regulatory regimes through their institutions of government but also to actually be governed by them rather than by federal and provincial laws. The whole point of a self-government agreement is self-determination, and self-determination requires that there be areas of jurisdiction in which First Nations can enact laws that will be relevant to themselves and their culture. If the only laws that First Nations can enact are laws that are already enacted by Canada or a province, there is little point in entering into an agreement (Peach and Rasmussen 2005, 32).

The second advance was in the treatment of First Nations constitutions and institutions of government within the draft agreement. Rather than seeking to dictate the design of First Nations governing institutions within a self-government agreement — which would almost inevitably result in First Nations being forced to replicate settler society institutions — the negotiators in Saskatchewan simply required that the constitutions of First Nations provide for governance institutions and practices that ensured legitimacy, accountability, transparency, responsibility, cultural appropriateness and flexibility (Canada, Federation of Saskatchewan Indian Nations and Saskatchewan 2003, sec. 5.6). Again, this is more consistent with the autonomy provided to self-governing communities by the principles of federalism than the typical approach to self-government policy.

The third major component of a more just policy path raised in the negotiations in Saskatchewan related to the extension of self-governing First Nations programs, services and regulations off reserves. The negotiators agreed that, where numbers warranted, First Nations should be able to extend the services they provide on the reserve to off-reserve locations. The negotiators further agreed that both First Nations members and non-members would be able to decide whether to take advantage of the First Nations services or equivalent provincial services and whether to be subject to First Nations or provincial regulation. This way, First Nations members would also have access to distinct services administered by First Nations, and the risk of intersocietal conflict would be minimized because they would thus avoid the strictly racialized parallel

service provision regime in multiracial urban areas (where off-reserve services were most likely to be situated).

An additional issue arose in the negotiations during discussion of off-reserve service provision — the question of common standards that would allow individuals to move between systems seamlessly and efficiently. Obviously, this is also an important issue for those who move between reserve and off-reserve residences. Generally, provincial government officials insisted on harmonizing standards for service provision because this would simplify administration and ensure that standards they viewed as acceptable would be the benchmarks. The problem with this approach is that it would effectively eliminate the opportunity for policy experimentation, which the displacement of laws model permitted. Furthermore, harmonization would likely force First Nations regulatory regimes toward the norms and standards of the dominant settler society, thereby perpetuating colonial relationships in allegedly self-governing First Nations. The negotiators instead advocated the principle of the mutual recognition of standards, which would focus on the equivalence of objectives rather than on identical standards.

The last critical component of a more just policy framework discussed in Saskatchewan was the previously mentioned proposal to negotiate an agreement on a socioeconomic strategy (and a socioeconomic strategy fund) in parallel with the self-government negotiations. The disadvantage of Aboriginal peoples in Saskatchewan was so clearly a threat to the success of self-government that the negotiators considered a long-term, funded intergovernmental strategy to systematically address it. The proposal would likely have resulted in several billion dollars being allocated over a 20-year period to fund strategic initiatives, and the fund would have been jointly managed by the federal, provincial and First Nations governments. This would have converted the self-government negotiation into the negotiation of a comprehensive First Nations human development policy. As we mentioned earlier, however, federal unwillingness to link socioeconomic development policy and self-government policy in a coordinated human development policy proved to be a major stumbling block, and it contributed to the suspension of negotiations.

While these ideas could serve as a road map for a more just policy for Aboriginal human development and intersocietal relations, they are still no more than observations contained in a draft agreement in principle.[7] No one has yet

determined whether these ideas could achieve the necessary social consensus to be implemented. What, then, would it take to establish a social consensus on the novel idea of instituting a comprehensive, transformative and more just public policy on settler society's relationship with Aboriginal peoples?

Postcolonial Policy: Talking to the Cowboys

ACHIEVING A SOCIAL CONSENSUS FOR AS MAJOR A TRANSFORMATION AS FIRST Nations self-government is essential in a democratic society. In the words of former Yukon premier Tony Penikett, to accomplish real change, governments must "treat with the Indians, but talk to the cowboys" (2006). Several possible strategies could be used to gain a social consensus on major social transformation. Canadian political culture has a strong attachment to the notion of public (that is, government) commitment to a just society and the implementation of fundamental human rights. Those challenging colonial privilege can mount appeals to shared norms and values. Such appeals, though, must overcome the desire of most in the dominant population to retain their privileges and the myth that all advantages accrue to privileged individuals by virtue of their superior merit.

The appeal to Canadians' sense of justice has been used in the past to generate public support for Aboriginal claims. In the aftermath of the Meech Lake Accord, Assembly of First Nations chief Ovide Mercredi and others used the exclusion of Aboriginal peoples from the Meech Lake agenda as the basis for an appeal for justice for Aboriginal peoples. This generated significant public support and led to the recognition of the inherent right of Aboriginal self-government in the failed Charlottetown constitutional accord. However, an appeal to justice is unlikely to overcome the cultural myths upholding White privilege without a sustained effort on the part of political leaders to lead public opinion on the requirements of a just society.

Similarly, the appeal to enlightened self-interest requires a sustained effort on the part of the dominant society's political leaders to educate the White public as to how all of society would be better off if Aboriginal people were better off, even if this requires those in the dominant society to sacrifice their privileges for

the long-term social good. Such a public education effort will meet with resistance from those who see only their immediate self-interest being jeopardized and from others — such as multinational corporations — who have a limited commitment to supporting social harmony. Thus, it will demand political courage in the face of politically significant social opposition.

A third strategy would be to appeal to respect for the rule of law. Political leaders must explain the historical commitments settler society made to Aboriginal peoples in the various treaties and constitutional documents that address Aboriginal rights; they must also seek a social consensus on the importance of a just society abiding by its legal commitments to its citizens. The challenges inherent in this strategy are twofold. First, appeals to historical commitments have been dismissed in the past in the face of appeals to the "ideals" of liberal individualism and superficial notions of equality. Second, the content of Aboriginal rights is sufficiently imprecise that appeals to respect for these rights and for the rule of law could become mired in technical, legalistic debates (however, see Slattery for a set of interpretive principles for contemporary Aboriginal rights [2006]).

A fourth strategy is the appeal to shared principles and norms. Stewart-Harawira seems to advocate such an appeal in suggesting "nested forms of democratic governance within and across nations and states" as one approach to guaranteeing cultural identity and self-determination (2005, 244). Parties to the Canada-FSIN-Saskatchewan self-government negotiations also anticipated using this appeal and constructed an agreement in principle that could be justified on the grounds of federalism and responsible government. The problem with this approach, of course, is that the value of federalism itself (though less so responsible government), especially the explicitly multinational Canadian version of federalism, has been challenged before — in English Canada, and especially in the West. Thus, the first task in any appeal to shared norms and principles is to secure a social consensus that the norms and principles one is appealing to are, indeed, widely shared.

An as-yet-untried strategy is the indigenization of federalism, governance, constitutional arrangements and cultural symbols (Green 2005). What might this mean? Previously, it was assumed that while the governments of the Canadian state might accommodate indigenous nations, those nations had to change to fit the accommodation offered. Indigenization means that the settler

state and its relatively privileged populations must also change to accommodate the reality of indigenous nations and the politicoeconomic and cultural expression of indigenous nations' rights. It means that privilege must give way to conscious recognition that Canada is built on indigenous land, with indigenous resources, with coerced indigenous participation and at the expense of indigenous well-being. New policy and cultural practices must turn Canadians away from an expectation of the fruits of privilege and toward a more just regime structured with and for indigenous peoples as much as for the relative newcomers. This will be a key element in building legitimacy for both settler and Aboriginal communities.

There are indigenous protocols — practices of political governance, legitimization, leadership recruitment, citizenship incorporation and so on — to help with this transformation. Importantly, indigenous political protocols often focus on the maintenance of relationships over time, through specific practices. In an excellent explanation of how a specific cultural protocol operates, Rauna Kuokkanen argues that the indigenous protocol of gift-giving, with its focus on relational responsibility, provides mechanisms to decolonize knowledge production, policy creation and policy implementation and holds out the possibility of creating self-perpetuating postcolonial relationships (2005). The adoption of indigenous symbols and political processes has much potential not only for building trust in Aboriginal quarters but also for decolonizing the Canadian state, to the benefit of us all. This strategy draws on the proposition that for decolonization to occur, the colonizer and the colonial state must change. Policy cannot be a White gesture of generosity to "those people." It must be mutual in ways hitherto unimagined. The central element in implementing this strategy is a sustained commitment on the part of society's leaders to engage citizens through public education and deliberation.

Such commitment to democracy has been sorely lacking in Canada in recent decades, and the vacuum in political leadership has been filled by populist appeals that cloak intolerance in the guise of liberalism. Changing public attitudes toward Aboriginal rights will require political leaders to bring members of the settler society and Aboriginal societies together in a serious deliberation. Leaders and social actors outside political institutions must also be encouraged to actively participate in public debate and to sustain the effort to change public attitudes until social transformation is achieved.

Conclusion

I F ABORIGINAL SUFFERING IS A CONSEQUENCE OF COLONIALISM — AND, IN PARTICULAR, OF oppression and dispossession — then it follows that eliminating the processes of colonialism is a precondition for a just relationship and a new constitutional, federal and citizenship order. If we are to effectively confront contemporary privilege and relations of dominance, then we must first acknowledge the past and name the beneficiaries. Narrowly focused public policies may be helpful in the short term, but if structurally conditioned intergenerational relations of privilege and subordination are to change, the political culture, institutions and economic and political processes of Canada must shift over the longer haul to include Aboriginal peoples, values and priorities. Thus, secondly, oppression and dispossession, and all of the bureaucratic practices that enforce them, must be recognized not as features of Canada's past that have been shaken off in a more enlightened and egalitarian present; they must instead be identified within current policy frameworks founded on assumptions of indigenous inferiority. We must recognize that oppression and dispossession are legitimated within official bureaucratic and legal language — and, more pervasively, within popular culture — rendering contemporary relations of dominance and subordination uncontroversial and causing indigenous peoples to be blamed for their own suffering. It is the colonizer — now the settler state — that must change.

If public policy is to change, so too must public bureaucracies. In their institutional unwillingness to live with risk, senior bureaucrats and, thus, the institutions they operate in simply perpetuate and, worse, justify the colonial relationships of the status quo, as was demonstrated by the federal bureaucracy's approach to the negotiations in Saskatchewan. Undoubtedly, the inclusion of self-governing Aboriginal (or, at least, First Nations) governments in existing federal arrangements will create the risk of policy responses with which some do not agree. But the purpose of federalism is to create a process for political representation of distinct communities. Federalism is fundamentally a commitment to a relationship between "political units that decide to create a new political space and presumes equal partners [as] free to withdraw from, as to enter into, such an association" (Guibernau 1996, 108). As long as risks and responsibilities are aligned within the same government, unwillingness on the part of settler state governments to accept the risk of allowing First Nations to govern themselves is nothing more than the perpetuation of comfortable colonialism.

Decolonization requires political vision, insight and courage. The extensive nationwide public deliberation about national identity and constitutional reform that took place between the failure of the Meech Lake Accord in 1990 and the negotiation of the Charlottetown Accord in 1992 demonstrates that the public can be engaged in a sustained democratic dialogue on important public policy issues, and that such dialogue can educate and change opinion within society. It cannot occur in our democracy, however, unless some reservoir of goodwill toward Aboriginal people and some understanding of the past and present injustices of colonialism, of Canada's legal obligations to Aboriginal and treaty rights and of the benefit for all of us of a postcolonial future is actively constructed. In order to erode racist popular culture and create political support, governments must build stakeholder support — that is, White support.

The current policy environment in Saskatchewan is not primarily postcolonial: it preserves the existing power relations between the settler and indigenous governments and inducts Aboriginal people — especially status Indians — into the dominant economic and bureaucratic-administrative paradigm. It functions to socialize Aboriginal people into mainstream Canadian citizenship, a legal relationship with the state that is only modestly attentive to Aboriginal and treaty rights and is oblivious to the relations of dominance and subordination constructed by colonialism. This policy environment cannot deliver on the right of self-determination or eliminate the socioeconomic disparities that plague too many Aboriginal lives.

Aboriginal and settler populations in Saskatchewan are now inextricably linked by history, politics, law and relationships, though the connection is distorted by the power imbalance designed by and for the settler populations and their state apparatus. The future that is emerging must accommodate all of us. Our leaders, and all members of our society, must dedicate themselves to meeting this challenge of accommodation. Given Saskatchewan's demographic realities and the depth of Aboriginal people's current disadvantage, social exclusion and attendant dysfunction, such an effort is vital to Saskatchewan's well-being.

Notes

The authors are listed alphabetically.

1 The freezing deaths of Neil Stonechild and several others, considered by many to be the responsibility of the Saskatoon police and their unwritten "Starlight Tours" policy, are all part of this chronology (see Green 2006, n2; Reber and Renaud 2005; Wright 2004).

2 Examples of entrepreneurial success are Norsask Forest Products, Kitsaki Development Corporation, WestWind Aviation and the Saskatchewan Indian Gaming Authority.

3 A conference of first ministers and leaders of national Aboriginal organizations held in Kelowna, British Columbia, in November 2005, in the dying days of the federal Liberal government, produced the Kelowna Accord. Representing a consensus among those present, it amounted to a concrete commitment to address in public policy, with public funds, particular socioeconomic, educational and infrastructure needs in the Aboriginal community. Following the election of a Conservative minority government in January 2006, Prime Minister Stephen Harper and Minister of Indian and Northern Affairs Jim Prentice appeared to reject the Accord's commitments. Furthermore, the Conservative government has hinted that it may resurrect the *First Nations Governance Act*, which was initiated by the Liberal government and rejected by First Nations across Canada.

4 Nor has the federal government replaced the Kelowna Accord with comparable commitments. The budgetary measures of fiscal 2006 were minor projects that cannot be compared to the Kelowna package.

5 "Privilege" in the context of critical theory refers to the tool kit of unearned socially beneficial assumptions that accrue to those who fit the template of meritocratic normalcy in class, race, sex and otherwise stratified societies. Those whose attributes deviate from this template never enjoy quite as much privilege and are less likely to benefit from positive social, economic and political assumptions about their worthiness. Privilege is invisible to persons in dominant categories, but it is blindingly evident to those who do not share it and who are disempowered by it (see Olson 2002).

6 While this was the initiation of province-wide self-government negotiations, negotiations with the nine First Nations of the Meadow Lake Tribal Council began several years earlier.

7 The delays caused by the intransigence of the federal bureaucracy, and the federal government's refusal to agree to such critical proposals as parallel negotiations on a socioeconomic strategy, resulted in a change of administration within the FSIN. The newly elected chief of the FSIN reviewed the draft agreement in principle, found it wanting in several critical respects and, in the autumn of 2003, suspended negotiations until his concerns were addressed. As of the completion of this chapter (October 2006), the negotiations had yet to be recommenced.

References

Brownlee, Karen. 2006. "Bright Future Ahead: Calvert." *Leader-Post* (Regina), March 30.

Cameco Corporation. 2005. "Employing Locally." Accessed October 10, 2005. http://www.cameco.ca

Canada, Federation of Saskatchewan Indian Nations, and Saskatchewan. 2003. *Draft Tripartite Agreement-in-Principle*, July 17. Accessed October 10, 2005. http://www.fsin.com/treatygovernance/downloads/TAIP.pdf

Giroux, Henry A. 2004. *The Terror of Neoliberalism: Authoritarianism and the Eclipse of Democracy*. Aurora, ON: Garamond Press.

Green, Joyce. 1995. "Towards a Détente with History." *International Journal of Canadian Studies* 12:1995.

————. 2005. "Self-Determination, Citizenship, and Federalism: Indigenous and Canadian Palimpsest." In *Reconfiguring Aboriginal-State Relations*, edited by Michael Murphy, 329-52. Montreal and Kingston: McGill-Queen's University Press.

————. 2006. "From Stonechild to Social Cohesion: Anti-racist Challenges for Saskatchewan." *Canadian Journal of Political Science* 39 (1): 507-27.

Guibernau, Montserrat. 1996. *Nationalisms: The Nation-State and Nationalism in the Twentieth Century*. Cambridge: Polity Press.

Hawkes, David C. 2005. "Rebuilding the Relationships: The 'Made in Saskatchewan' Approach to First Nations Governance." In *Reconfiguring Aboriginal-State Relations*, edited by Michael Murphy, 119-32. Montreal and Kingston: McGill-Queen's University Press.

Hudson, Barbara. 2006. "Beyond White Man's Justice: Race, Gender, and Justice in Late Modernity." *Theoretical Criminology* 10 (1): 29-47.

Irlbacher-Fox, Stephanie. 2005. "Practical Implications of Philosophical Approaches within Canada's Aboriginal Policy." Paper presented to the Canadian Political Science Association, June 4, University of Western Ontario.

Kuokkanen, Rauna. 2005. "The Responsibility of the Academy: A Call for Doing Homework." Paper presented to the Canadian Political Science Association, June 4, University of Western Ontario.

Malloy, Tom. 2000. *The World Is Our Witness: The Historic Journey of the Nisga'a into Canada*. Calgary: Fifth House.

Olson, Joel. 2002. "Whiteness and the Participation-Inclusion Dilemma." *Political Theory* 30 (3): 384-409.

Peach, Ian, and Merrilee Rasmussen. 2005. "Federalism and the First Nations: Making Space for First Nations Self-Determination in the Federal Inherent Right Policy." Paper presented at "First Nations, First Thoughts," May 5-6, Centre for Canadian Studies, University of Edinburgh. Accessed October 10, 2005. http://www.cst.ed.ac.uk/2005conference/papers/Peach_Rasmussen_paper.pdf

Peel, Alyssa. 2005. "The New Department of First Nations and Métis Relations: Why Saskatchewan Should Pay Attention to the First Report Card." Unpublished paper.

Penikett, Tony. 2006. Personal communication with the authors, January 12.

Prince, Michael J., and Frances Abele. 2005. "Paying for Self-Determination: Aboriginal Peoples, Self-Government, and Fiscal Relations in Canada." In *Reconfiguring Aboriginal-State Relations*, edited by Michael Murphy, 237-63. Montreal and Kingston: McGill-Queen's University Press.

Reber, Susanne, and Robert Renaud. 2005. *Starlight Tours: The Last, Lonely Night of Neil Stonechild*. New York: Random House.

Russell, Peter H. 2005. *Recognizing Aboriginal Title: The Mabo Case and Indigenous Resistance to English-Settler Colonialism*. Toronto: University of Toronto Press.

Slattery, Brian. 2006. "Aboriginal Rights: From Where? Where To?" Paper presented at "Moving Toward Justice," Saskatchewan Institute of Public Policy and First Nations University of Canada, March 1-3, Regina.

Smith, Linda Tuhiwai. 1999. *Decolonizing Methodologies: Research and Indigenous Peoples*. London: Zed Books.

Stewart-Harawira, Makere. 2005. *The New Imperial Order: Indigenous Responses to Globalization*. London: Zed Books.

Stokes, Janice, Ian Peach, and Raymond B. Blake. 2004. *Rethinking the Jurisdictional Divide: The Marginalization of Urban Aboriginal Communities and Federal Policy Responses*. Regina: Saskatchewan Institute of Public Policy.

Wright, Mr. Justice David H. 2004. *Report of the Commission of Inquiry into Matters Relating to the Death of Neil Stonechild*. Regina: Government of Saskatchewan.

Maori and the State:
Diversity Models and
Debates in New Zealand

T HIS CHAPTER EXAMINES HOW NEW ZEALAND RECONCILES POLICIES AND PROGRAMS that recognize and protect the distinctiveness of its indigenous peoples, Maori, along with measures that foster a sense of shared citizenship. Because this material was first presented as a paper to a group of Canadians concerned with diversity in the Canadian context, my challenge was to quantify New Zealand's progress — how successfully it had acknowledged Maori and their role in the country's creation and future — to a foreign audience. To dismiss government attempts to accommodate Maori as purely ideological, politically duplicitous or expedient would be to offer a distorted picture. Conversely, to describe various policy and program initiatives using the laudatory language of their vision and mission statements would be equally misguided. Therefore, in an attempt to present a balanced picture, I opted to highlight certain key events over a 100-year period, with commentary.

Maori are indigenous to New Zealand. They are of East Polynesian origin, and prior to colonization by the British they lived in tribal groups understood variously as *iwi* and *hapu*. All the tribes had a common language and customs, albeit with very distinct regional and dialectal differences (Buck 1950; Ballara 1998). In spite of government policies that put pressure on Maori to individualize, their assets and social structure survived; in the late twentieth century, the tribal system experienced a revival, becoming central to Maori social development (Maaka 2003; M. Durie 2005). Today, *iwi* range in size from 100,000 to 50,000 to fewer than 1,000 members (Statistics New Zealand 2002).

Those who identify themselves as Maori constitute 14.7 percent of the total population and number 526,281 (Statistics New Zealand 2002). A recent and authoritative analysis of trends in the demography of the Maori population notes that one-third of the Maori population is under 15 years of age, and that there has been a significant increase in the 65-and-older age group. Furthermore, there is considerable diversity among the Maori, and while gains have been made in some sectors of the population, there are still considerable social disparities between Maori and the rest of New Zealand's population. For example, in 2003, the unemployment rate for Maori was 15 percent, compared with 5 percent for non-Maori. As of 2000, 35 percent of Maori had left school without qualification, versus 15 percent of non-Maori. Finally, as of 2002, life expectancy for Maori was 69 years for males and 73.2 years for females; for non-Maori, it was 77.2 and 81.9 years, respectively (M. Durie 2005, 34-45).

Since the 1960s, Maori have been drawn to the cities. In 1945, 20 percent lived in urban areas (Poulsen and Johnston 1973, table 1, 150); by 2001 84 percent of Maori were city-dwellers (Statistics New Zealand 2002). This shift resulted in the formation of large urban collectivities that were distinctly Maori. By the close of the twentieth century, these collectivities had gained considerable political influence, and the term "Urban Maori Authority" was introduced as a result of the *Runanga Iwi Act, 1990* (which I will discuss later).

Augie Fleras and I recently argued that while New Zealand has made significant progress in addressing the situation of its indigenous peoples compared with most other countries, the underlying premise on which the relationship between Maori and the Crown is based has not been addressed (Maaka and Fleras 2005).[1] New Zealand still operates on a model established in colonial times. Consequently, the nation continues to support a one-size-fits-all notion of citizenship, one that accommodates diversity only up to a point; that is, absolute authority resides with the government, and there is no power-sharing when it comes to its policies and programs (Maaka and Fleras 2005, 280).[2] Therefore, successive governments continue to develop programs and policy on the basis of what can be done *for* Maori rather than *with* Maori (as summarized in box 1). However, signs of change are beginning to emerge at certain levels of the policy-making apparatus; there are now a number of Maori-initiated programs and policies. Yet the politicking of recent

The New Zealand
Constitutional Order

Organization of society: monocultural rules founded on Eurocentric norms

Status of Maori: one of a number of disadvantaged minorities

Justification for government intervention: needs of a problem "population"

Nature of social contract: junior partners (entrenched in nested hierarchies of placement)

Citizenship status: universal (one size fits all)

Status of diversity: liberal universalism: mono-, bi- and multiculturalism

Type of political association: bi-/multiculturalism

Outcome: constitutional and institutional accommodation

Source: Adapted from Roger Maaka and Augie Fleras, *The
Politics of Indigeneity: Challenging the State in Canada and
Aotearoa New Zealand* (Dunedin, NZ: Otago University
Press, 2005), 280.

national elections suggests that there will be strenuous resistance to any substantive change.

A similar conclusion was drawn in a report on the state of democracy in New Zealand.[3] The report illustrates that while there have been considerable attempts in New Zealand to accommodate and integrate Maori aspirations into the national life, unacceptable social inequities persist, as demonstrated by the high levels of male incarceration and unemployment. "There is wide public agreement on the ideal of a common citizenship without discrimination and this is reinforced by law. Despite this, there are groups, particularly amongst the Maori and Pacific Islander population, which statistics demonstrate clearly suffer from inequalities" (Henderson and Bellamy 2002, 40, 27).

Responses to questions such as "How far are cultural differences acknowledged and how well are minorities protected?" and "How far do constitutional and political arrangements enable major societal divisions to be moderated or reconciled?" as well as similar questions on the rights of Maori as citizens are all considered in terms of the treaty-centred debates: "The issue of Maori sovereignty and self-government remains contentious. The Treaty of Waitangi, between Indigenous Maori people and the British Crown, has assumed considerable constitutional significance and practical value in resolving differences between non-Maori and Maori. The Waitangi Tribunal hears disputes relating to the treaty and makes recommendations to government" (Henderson and Bellamy 2002, 27).

Therefore, working from the premise that the Treaty of Waitangi is the constitutional basis of the relationship between the Crown and Maori, I consider it and the Waitangi Tribunal first, and then I offer a review of the evolution of Maori parliamentary representation. I then describe certain key events to illustrate the evolution of this relationship as reflected through government policy, programs and initiatives — including the *Maori Councils Act, 1900*, which formalized government control over much of Maori society. This is followed by a brief examination of an unsuccessful attempt by Maori politicians to wrest control of programming from the government and vest it in the Maori, and of a seminal government report released in 1960 that established the framework for the Maori policies of successive governments. Finally, I consider policy directions of the mid-1980s and the most recent manifestations of these policies in the twenty-first century.

The Treaty of Waitangi

The Treaty is a foundational constitutional document creating a partnership between Maori and Pakeha that recognized and defined a fiduciary obligation on the Crown to respect the principles of the Treaty (cited in Henderson and Bellamy, 2002)

THE SIGNING OF THE TREATY OF WAITANGI IN 1840 BY 500 MAORI CHIEFS AND REP-resentatives of the Crown signified an ongoing and formal relationship between the two parties. The treaty, written in English and Maori, was a relatively simple document consisting of a preamble, three articles and an epilogue. The preamble states that the treaty is intended to protect the rights of Maori, provide for British settlement and establish a government to maintain peace and order. Article 1 establishes that Maori cede the right to govern to the Crown, subject to a promise of protection and the right to manage their own affairs; article 2 guarantees Maori undisturbed possession of their properties (there are contestable variations of meaning between the English and Maori versions); and article 3 recognizes Maori as British citizens.

In the epilogue, the chiefs acknowledge their understanding of the provisions and the spirit in which the treaty was written (Orange 1990, 265; New Zealand, Department of Justice 1990, 8). Claudia Orange observes, "As the structure of a new colonial society emerged rapidly after 1870, the treaty dropped from the settler consciousness." However, the treaty and its promises remained foremost in the minds of Maori. Orange concludes, "The gap between Maori and European expectations of the treaty remains unbridged" (Orange 1990, 3-5).

The Waitangi Tribunal

ONE WAY IN WHICH NEW ZEALAND ATTEMPTED TO BRIDGE THIS EXPECTATION GAP was by establishing, with the *Treaty of Waitangi Act, 1975*, a permanent commission of inquiry, the Waitangi Tribunal, to investigate Maori allegations of Crown treaty breaches. Claimants must demonstrate that they have been discriminated against by laws and regulations — or by acts, omissions, policies or practices of the Crown — since 1840 in ways that contravene the principles of

the Treaty of Waitangi.[4] Once a claim has been heard, the tribunal publishes its findings in an official report to the minister of Maori affairs. If the claim is substantiated, the tribunal will make recommendations to the government in its report on the inquiry. Except in the case of former Crown-owned land,[5] the government is not bound by the tribunal's recommendations. At this point, the tribunal's work is effectively over, but its reports serve as the basis for negotiations between the Crown and the claimants. These negotiations are the responsibility of the Office of Treaty Settlements (OTS).

The claims that have come before the tribunal can be divided into three categories: historical, contemporary and conceptual. The OTS divides the historical land claims into the following categories: *raupatu* ("confiscations"), pre-1865 purchases and post-1865 purchases. The *raupatu* are lands confiscated from tribes under the *Land Settlements Act, 1863*. The pre-1865 purchases are the land transactions that took place prior to the establishment of the Maori Land Court, and the post-1865 purchases are those that were effected under the jurisdiction of the Maori Land Court (New Zealand, Office of Treaty Settlements 1999, 11-20). Conceptual claims are usually related to contemporary concerns and focus on contemporary interpretations of treaty principles, such as claims for the preservation of the Maori language (Waitangi Tribunal 1986) and indigenous flora and fauna.[6] These claims reflect contemporary concerns over the loss of language and threats to the environment. Their scope varies considerably, from brief, single-issue representations to those that involve a wide range of issues. One of the smaller claims was the Pakakohi and Tangahoe (Waitangi Tribunal 2000), the hearing for which lasted three days; the report for it was produced in 14 days. An example of an extensive claim is the Ngai Tahu (Waitangi Tribunal 1991), which was the first of the large regional claims. For it, 150 years of history were surveyed and 900 submissions from 262 witnesses and 25 corporate bodies were received; the hearing lasted three and a half years (Waitangi Tribunal 1991, xix). It is important to note that the extent and scope of a claim is not indicative of its complexity — small claims can be just as complex as extensive ones.

The Waitangi Tribunal was established in response to a decade or so of Maori political agitation for recognition of their rights as *tangata whenua* ("people of the land," indigenous peoples) and as equal partners to the Treaty of Waitangi. The Act allowed for Maori[7] to launch claims against the Crown

for current breaches of the treaty and established the Waitangi Tribunal to hear them. The tribunal consisted of three people — a judge, a Maori leader and another individual — and the claims it heard were mainly concerned with such issues as pollution of tribal fishing grounds. The tribunal's influence in its early stages was limited in terms of its work capacity (it had just three part-time members) and power (it was restricted to addressing current breaches). It was regarded by many Maori as a token gesture by the Crown to defuse the more radical elements of Maori political activism (Boast 1993, 226; E.T. Durie and Orr 1990). These concerns eventuated in the *Treaty of Waitangi Amendment Act, 1985.*

A decade after it was adopted, the Act was amended substantially in three major ways. First, the range of claims was expanded. As well as considering current breaches of treaty principles, the tribunal could now consider claims related to problems occurring before the 1840 signing of the treaty.[8] Second, Maori membership in the tribunal was ensured. Tribunal members were to be appointed by the governor general on the recommendation of the minister of Maori affairs in consultation with the minister of justice. In recommending members, the minister of Maori affairs was obliged to "have regard to the partnership between the 2 parties of the treaty."[9] This directive was usually interpreted to mean that the tribunal must be 50 percent Maori and 50 percent Pakeha.[10] In addition, the chairperson of the tribunal was the chief judge of the Maori Land Court (an appointment that has in recent times been held by a Maori). The quorum for a tribunal hearing under this amendment was three, one of whom had to be Maori.[11] The third substantive change was in the operation of hearings: "Except as expressly provided in this Act, the Tribunal may regulate its procedure in such manner as it thinks fit, and in doing so may have regard to and adopt such aspects of te kawa o te marae as the tribunal thinks appropriate in the particular case, but shall not deny any person the right to speak during the proceedings of the Tribunal on the ground of that person's sex."[12]

The use of the phrase *te kawa o te marae* ("the customs of the *marae*"[13]) was a notable concession to Maori customary practice. This section of the Act was interpreted as referring to the necessity of hearing the claim at a location of the claimants' choice, and most claimants chose to have their claims heard in their tribal territory, on their own *marae*. This meant that claimants could be heard not only in their own language and in familiar and comfortable surroundings but

also, and even more importantly, under their customary protocols. All of this had a tremendous effect on how the balance of power was perceived. Local people could manage proceedings without leaving their home territories. Legal professionals, at ease in the courtroom, were now outsiders expected to adapt to the rituals of the local people. As this situation was achieved without compromising the due process of law, the tribunal was thus accorded acceptability and credibility. One objective of a claim hearing was to remove the sense of grievance, and this approach helped to realize it by making claimants feel that they had finally been heard — often after many futile attempts made by earlier generations. Because the tribunal was a commission of inquiry, it adhered to an inquisitorial rather than an adversarial procedure (such as in a court of law), and it was thus able to accommodate custom.

Having a claim heard through the tribunal diminished the remoteness of the legal process, as claimants became involved in all aspects of their hearings. As well as hosting the hearings, they planned their claims, instructed legal counsel and helped to research and present evidence. A claim hearing provided a group with the chance to have its history researched in detail and to participate in the presentation of oral and academic versions of its history and traditions in one venue and one sequence. A group's tribal story was also recorded and preserved for future generations. In this sense, the claims process was an empowering experience.

This significant amendment was a direct result of Maori political pressure. In introducing the bill for the amendment, Minister for Maori Affairs Koro Wetere mentioned the "mounting tension" among Maori due to their "grievances" over the injustices of the early colonial period. He also noted that the proposed amendments had come out of a national conference on the Treaty of Waitangi, held a month earlier at Turangawaewae (Walker 1985).[14] The conference had been called by a wide range of organizations: the Maori Council of Churches, the New Zealand Maori Council, the Maori Women's Welfare League, the Race Relations Conciliator, Maori Wardens' Association, Maori Writers and Artists, Mana Motuhake (a political party), Maori university students, the Maori Battalion veterans and the Maori members of Parliament. The Treaty of Waitangi was strenuously reinforced as a prime document of nationhood and Maori rights, and the first recommendation was that the tribunal's jurisdiction be extended back to the signing of the treaty in 1840 ("Recommendations of the National Hui on the

Treaty of Waitangi," cited in Levine and Vasil 1985, 183-5). As this *hui* ("gathering") was held barely a month earlier, the sentiments expressed there would have been carried over to the more public forum of the Hui Taumata (the Maori economic summit conference).

On the introduction of the bill, opposition members, led by the then-spokesperson from Maori Affairs, Winston Peters, expressed some disquiet at the implications of these amendments. Peters described the amendments as being of a "monumental nature," and he added that the Bill had "massive ramifications."[15] While he was supported by other members of his party,[16] debate never developed on the Bill's implications or ramifications. This amendment has had considerable implications for New Zealand, but the comments made at the time by opposition members are now considered alarmist rhetoric.

The tribunal is under considerable pressure from various political parties as well as some Maori leaders. In response, it continues to refine its processes and has reduced the time that it takes to conduct a regional inquiry from several years to, in some cases, months. As of November 2005, claims covering 62 percent of the New Zealand land mass had been completed, and 26 percent are currently under action. By December 2007, it is predicted, 79 percent will be completed and 12 percent will be under action. The tribunal currently estimates that if all goes well, the historical regional inquiries will be completed by 2012; but that date could be extended to as late as 2020 if all parties do not work cooperatively.[17]

Parliamentary
Representation

GIVEN THAT POLICY-MAKING IS THE BUSINESS OF GOVERNMENT, IN CONSIDERING HOW New Zealand has dealt, and continues to deal, with recognizing and protecting Maori distinctiveness, we are faced with this question: How influential are Maori in creating the policies that affect them? A review of Maori parliamentary representation — which has evolved from designated seats in the House to seats won in the recent elections — illustrates that Maori parliamentary representation has direct linkages to Maori policy over the years.[18]

The settler government was established in 1856, with the franchise given to people who held individual title over land and could speak and read English.

Even though Maori were effectively disenfranchised by this move, they still presented a problem to the fledgling colony. As the new colony stumbled toward some form of constitutional stability, the issue of Maori representation had to be faced. Maori constituted approximately half the total population, still owned most of the land and were major contributors to the New Zealand economy (Sorrenson 1986, B-19). The government could therefore not ignore the Maori population, but its need to be inclusive was tempered by its fear that Maori would upset the balance of power in established electorates by swamping — that is, by using their numbers to elect their own candidates, generally disrupting the politics of the settlers and upsetting the balance of power (Jackson and Wood 1964, 84). The solution it chose to this perplexing problem was to create four special seats — Northern, Southern, Western and Eastern Maori — through the *Maori Representation Act, 1867*. The Act effectively gave Maori representation without conceding any real power. Commenting on the Act, Councillor Colonel W.H. Kenny noted its dual purpose: it is "no more than an act of justice, while at the same time it is an act of prudence and expediency."[19]

Providing Maori with four designated seats in New Zealand's majoritarian political system allowed them a degree of representation, but there were a number of systemic weaknesses. These included the size of the electorates, especially as the populations increased dramatically in the latter part of the twentieth century. As former prime minister David Lange remarked, "The most striking feature is the geographic spread of the seats. The Northern Maori electorate covers the equivalent of 18 seats, Western Maori — 17, Eastern Maori — 8, and Southern Maori a huge 45" (cited in Walker 1985). Other commentators observed, "From time to time Maori MPs argued that the number of Maori Seats should be increased to a level that they believed was more closely proportionate to their peoples' share of the total population...The response of successive governments was one of benign neglect" (Jackson and McRobie 1998, 204).

Responsibility for Maori had been ghettoized and easily controlled, meaning that more radical reforms could be neutered or circumvented (M. Durie 1998, 98). However flawed the system, the four Maori seats were the mainstay of Maori relations with government (and, therefore, of Maori influence on policy). Although instituted out of political expediency, the parliamentary seats designated for Maori remained in place for 100 years, until 1996, the year of the first mixed member proportional national election.

Maori and Mixed
Member Proportional
(MMP) Representation

The continued existence of reserved seats for Maoris, which gives those of
registered Maori descent the choice of voting on the reserved or open elec-
toral roll, has also ensured a more representative parliament. (International
IDEA, 2001)

IN A BINDING 1993 REFERENDUM, NEW ZEALAND ADOPTED A PROPORTIONAL SYSTEM
to elect a parliament. In recommending the adoption of a proportional elec-
toral system, the Royal Commission on Electoral Reform also recommended the
abolition of the Maori seats by arguing that Maori would receive fair representa-
tion through proportional representation. Maori leaders were not convinced, and
they successfully lobbied to have special Maori representation retained. Under the
MMP system, people were given two votes, one for the candidate and one for the
party, and so Maori parliamentary representation could be increased in two ways.
The system made the number of Maori seats proportional to the number of peo-
ple registered on the Maori electoral roll; at the same time, political parties could
have Maori representation on their lists. In 1996, the number of people registered
on the Maori roll increased the number of seats from four to five. In addition to
those holding the five Maori seats, nine Maori became MPs through party lists.
One of the objectives of MMP, therefore, had been achieved: to be "more recep-
tive to minority and indigenous Maori voices" (Boston et al. 1996, 10; see also
Boston 2003, 41-2).

Through the MMP electoral computations, the New Zealand First Party
gained 17 seats (including the 5 Maori seats) out of a possible 120, and so became
the strongest minority party (Boston et al. 1996). Overall, the election produced 15
Maori MPs, 7 of whom were part of the coalition government. Maori were now an
influential force in Parliament. The five Maori MPs who held the Maori seats held
the balance of power. Other Maori MPs, especially those in the coalition govern-
ment, enhanced this position, but actual power lay with those who held the Maori
seats. For the first time, Maori MPs wielded real political power, not delegated or
negotiated power. They were central to the highest body of political decision-mak-
ing, the cabinet of Parliament. Another way of expressing this phenomenon is to say
that as a result of the political reform, Maori MPs became an integral element of the

state. One could also say that Maori parliamentary representation had simply caught up with the actual position of Maori in New Zealand society. All political parties were now obliged to interact with the Maori constituency, not merely engage a token Maori representative or adviser. Maori had gravitated to the centre of political power without the abolition of the Maori seats — that is, on their own terms, not because of political expediency or assimilation.

Even though there were proportionally a substantial number of Maori in Parliament, and this was heralded as a historic moment — "For Maori...the 1996 general election will be remembered as the dawning of Maori political might" (M. Durie 1998, 102) — it was only the result of the first election. It was still uncertain whether the Maori ascent to power was a result of proportional representation government or an aberration. The decision of whether to include Maori on a party list still belonged to the party, so Maori representation was reliant on party acceptance. And, through its positioning of Maori members on its list — which would become a public document — a party made its relative support of its Maori members and policy transparent.

In the 1999 and 2002 elections, much the same pattern prevailed. There was an increase of one Maori seat in 1999 and another in 2002, for a total of seven reserved Maori seats. This number remained static for the 2005 election. Along with the Maori list MPs, the Maori members made significant progress under Labour governments, introducing Maori concerns into the mainstream of national politics. However, during the last term, 2002-05, the trend was reversed. In 2002, the government backed off its treaty-centred policy-making by shifting the emphasis to poverty. This pattern continued throughout the term, propelled by opposition charges that the government was implementing race-based policies. Opposition leader Donald Brash upped the ante in his annual state-of-the-nation speech in January 2003. He alleged that the government was sanctioning a form of social apartheid with its special treatment of Maori and that as a result the rights of immigrants and others were being compromised. Another major development was a dispute over the foreshore. In 2003, the Maori Land Court ruled that parts of the foreshore (the land between high- and low-water marks) could be declared Maori customary land. There was an immediate reaction to this ruling. Some demanded that the government declare Crown ownership of the foreshore, thereby extinguishing any Maori claims (Maaka and Fleras 2005, 143-6). In spite of strenuous Maori opposition, the government passed the *Foreshore*

and Seabed Act, 2004, which recognized Maori customary association with the foreshore but denied ownership rights (M. Durie 2005, 104-5).

The turmoil engendered by this nationwide debate entrenched opposition to Maori-centred initiatives to the extent that major opposition parties ran very successful election campaigns promising to end race-based politics. This increased Maori disillusionment with party representation and provided impetus for the creation of a new political party, the Maori Party. Over the years, there had been several attempts to deploy such parties, but none managed to gain independent representation in Parliament.[20] In the September 2005 elections, however, the Maori Party won four of the seven Maori seats.

In spite of Maori ambivalence (and disillusionment) prior to the introduction of MMP representation (Dahlberg 1996; Keenan 1996), MMP has moved Maori MPs from the periphery to the centre of the parliamentary system. It has also countered the conventional wisdom that permitting Maori into the political mainstream would lead to some form of apartheid. In fact, there is a strong argument to be made that MMP has led to greater political integration.[21] There is now a mutual interdependence, demonstrated in 1996 by the need of the conservative National government to negotiate directly with independent Maori MPs in order to attain and retain power.

The combination of guaranteed representation and list seats has provided Maori a window of opportunity to wield considerable political leverage. Time will tell whether they and their MPs will be able to take full advantage of this opportunity. To be effective, Maori must work within the party system. The rapid development and increasing sophistication of Maori society will impose high performance standards on Maori parliamentarians. To date, however, there has been little evidence that Maori MPs are capable of caucusing across party lines. The political relevance of seats is also of importance to Maori. They will not support this type of political representation if they are not taken seriously by political parties. This places the onus on the parties to take their Maori constituencies seriously. Ironically, then, whether Maori politics develop along a separate or an integrated path is largely in the hands of the Pakeha majority. Furthermore, Maori politics are now integral rather than peripheral to New Zealand politics. In the national elections of September 2005, 21 MPs of Maori descent were elected to a 121-member House. Although Labour, in forming a coalition government, refused to negotiate with the Maori Party, Prime Minister Helen Clark included

two Maori MPs in her cabinet and appointed three more as associate ministers outside of cabinet.

Maori parliamentary representation, devised in the nineteenth century as a political expedient, had, by the end of the twentieth century, led Maori to the centre of parliamentary power. Little else could bring Maori more political power. Their position is one that most indigenous minorities in similar postcolonial situations can only dream about. This is not to suggest that MMP has given Maori the political power to realize the promises of the Treaty of Waitangi. In a rather circumspect observation, Margaret Wilson describes the results of MMP for Maori thus: "Although Maori do not have political power, they have political influence" (cited in Coates and McHugh 1998, 251). Despite this cautious observation, and despite its checkered history, Maori parliamentary representation has never been more influential. MMP presents both Maori and Pakeha with an opportunity to engage constructively as political partners. The parliamentary system is always subject to reform, and, consequently, Maori parliamentary representation can never be totally secure.[22] Therefore, the status given to this representation is a barometer of Pakeha/Maori relations.

Incorporation: Maori Policy, 1900-80

THE TWENTIETH CENTURY BEGAN WITH A PERIOD OF FORCED ADJUSTMENT. MAORI were transformed from an independent people into a minority in a developing colonial, capitalist society; they were incorporated into, and consequently dependent on, the government of the day. By 1900, Maori were only partially integrated into the wage economy, and for them subsistence agriculture, fishing and hunting remained essential. The wage work they undertook was related, in the main, to cultivating the wilderness; they did agricultural work and laboured in the primary exploitative industries — bush cutting, road and railway building, gum digging, shearing and potato picking. Their settlements were a mix of transient camp and home village. The net result was that Maori society remained a separate one. It had very little interaction with Pakeha society except at the official level, with government agencies; or in the marketplace, at the point of trade; or in employment.

Consequently, Maori were peripheral to the development of the nation-state of New Zealand. When introducing amendments to the *Maori Councils Act, 1900*, Maori politician James Carroll observed: "Maoris were not to be found on Roads Boards, on County Councils, on Borough Councils, or any lesser bodies. And even their special representation in this house was to his mind, a rather doubtful compliment. Instead of receiving reasonable assistance in the conduct of their affairs and in promoting their interests, the Maoris in this country had been left to grope their way without practical help, without beacon lights to guide them."[23] Maori were, however, of special interest and concern to governments committed to policies aimed at converting bush-covered lands into pasture for settler farms because of the amount of land still owned by Maori.

The dominant attitude that Pakeha officials and MPs of this era displayed toward Maori was benign paternalism, and they regarded communal living as a major impediment to Maori advancement. One official declared, "I am strongly of the opinion that what is wanted is technical schools for the Maori children so that they may learn to be of use in other ways than those which are now open to them. This would be the surest way of breaking up their old communal habits, failing which the Maoris can never prosper."[24] Another remarked that there was "no doubt communism was the trouble that the Maori had to meet in the past, had now, and would have in the future."[25]

The Europeanization, or assimilation, of Maori was seen as both inevitable and desirable. Said yet another official: "Now, there is an opportunity for them to assist in the control of local affairs, and I do not think that I am too optimistic in saying that this will prove to be a great factor in gradually preparing the way to the ultimate elevation of the Maori — viz., their fusion with the white race."[26] And another: "It is an idea of many people that the ultimate fate of the Maori race is to become absorbed in the European."[27]

At the same time, Pakeha were ambivalent and possessed ambiguous attitudes toward special legislation and conditions for Maori, as evidenced by this array of official comments and queries:

> This desirable state of affairs may be brought about by the continuance of the efforts for the prevention of disease, the education of the children, the greater scope allowed them in their local affairs, the goodwill of their fellow British colonists and gradually by legislation.[28]

He proposed to look at the Bill first from the aspect of the Pakeha. The difficulty they had in this kind of legislation was where to let the Maori legislation finish and the Pakeha legislation begin.[29]

[Legislators] must endeavour...to see that no white man should be oppressed in any possible way by [the Bill's] provisions.[30]

Why should there be two laws — one for the Europeans and another for the Maoris?[31]

Why should these Maori Councils have to deal with the management of the social life of the Natives? Why should not that matter be bought under the Health Department?[32]

Clearly, Maori issues constituted an conundrum for government decision-makers, but it was obvious that something had to be done about Maori health and land ownership. The first step was the enactment of the *Maori Councils Act*, the effect of which was to bureaucratize Maori social organization. Community decision-making was Westernized through the adoption of conventions of the Westminster system. Committees ran the community, and these committees were accountable to councils, which, in turn, were responsible to the minister rather than to any notional Maori polity. A lack of resource provision meant that the Act was redundant by the end of the decade. Given that councils were reasonably successful, one might ask why the system was allowed to run itself down. The process by which the council system was undermined is quite clear: lack of funding, the provision of alternative lines of communication with government and the reestablishment of the Native department. All these factors derive from the state's lack of political will to make the system work. With the reestablishment of the Native department, the pattern for Maori development was set for the next 80 years. Maori MPs and tribal/community leaders had no alternative but to operate within the government system.

The next major public development took place some 35 years later. Maori attempted to gain some measure of autonomy by taking control of the delivery of government services to their communities using a network of tribal committees formed as part of the Maori War Effort Organisation (MWEO). Ironically, the MWEO had been established in part because the Native department was, at the time, primarily a land administration agency and incapable of tapping community support for the war among Maori (Orange 1987, 185). By the end of the war, the MWEO had altered its focus, moving from supporting the war effort to embracing broader welfare concerns,[33] and as the war drew to a close, Maori

leaders lobbied vigorously for the MWEO system to be maintained as the basis for Maori development. The MP for Northern Maori, Paraire Paikea, wrote to the minister of defence: "Should the present attempt to reorganise the Maori people around their tribal system and spirit, and to fit them with their rapidly increasing population to compete on equal terms with their Pakeha brothers and sisters in the present and future economic, commercial, industrial and social life of New Zealand, fail, then the outlook can only be viewed in a dim light, with inferiority complex as a dominant feature."[34] To the prime minister, he wrote: "The Maori people feel as the result of their outstanding contribution towards New Zealand's War Effort, that they have earned and established in a practical way, a right to a form of tribal direction and control which, in their opinion, is of utmost importance to their future welfare, Happiness and development...As the War Cabinet has approved the principle of control of the people by the People per medium of the tribal and executive committees, and as it is considered expedient that the MWEO should now be the Organisation through which and by which control of Affairs of the Maori people can and should be directed and controlled."[35]

In spite of these requests, the bid for the organization to become the basis of postwar development failed; opposition from Native department bureaucrats and advisors proved too strong. MWEO functions were absorbed by the Native department and, at the Wellington conference, the prime minister announced that the Native department would henceforward be the primary government vehicle for dealing with Maori issues.[36] During the efforts to maintain the MWEO, the MP for Southern Maori, Eruera Tirikatene, drafted the Maori Social and Economic Reconstruction Bill. The Bill utilized the tribal committees that had been set up by the MWEO and placed authority with Maori-controlled organizations. This bid was unsuccessful, and Minister of Native Affairs Rex Mason drafted another bill that incorporated only aspects of it. A major difference between the two bills was that Mason's, which eventually became the *Maori Social and Economic Advancement Act, 1945*, institutionalized Maori committees within the government system (Love 1977, 392-6).

The Hunn Report

THE NEXT MAJOR PUBLIC PROGRAM/POLICY DEVELOPMENT WAS THE HUNN REPORT, released in 1960. The effects of the postwar baby boom on Maori began to

manifest themselves in the 1960s, and the urbanization of Maori, which had begun in earnest in the previous decade, had made it obvious to government officials that some kind of action was required. An early initiative was to research the status of Maori and the ability of the Department of Maori Affairs to respond to Maori needs and concerns, something that had never been attempted. The result was the *Report on the Department of Maori Affairs, with Statistical Supplement*, known as the Hunn Report. The principal author was Jack Hunn, the department's acting secretary. He had been appointed by Prime Minister Walter Nash in January 1960 and mandated to produce a detailed description of the department. Ralph Hanan, the new minister of Maori affairs, made the report public in January 1961 (Butterworth and Young 1990, 100). In the report's foreword, Hanan stressed the need to know all details concerning Maori. While admitting that he did not know how his own government would receive the report, he confidently predicted that some of the proposals would be enacted quickly: "Many of the recommendations in the Hunn report are of a far-reaching nature and all have a fundamental bearing on the well-being of the Maori people, the well-being of New Zealanders as a whole, and on race relations in New Zealand. This makes it all the more imperative that the public should know the facts of the Maori situation" (Hunn 1960, 3).

The report surveyed Maori in nine categories: population, land settlement, housing, education, employment, health, land titles, legal differentiation and crime (Hunn 1960, 13). From this, Hunn drew several general conclusions upon which he recommended future policy be based. In summary, he concluded that because of their ability to adjust, Maori should be fully integrated within two generations; that the Department of Maori Affairs was not keeping up with the rapid rate of development among Maori and needed to "redouble its activities"; and that Maori urbanization was inevitable, since the land would support only a minority. Hunn also maintained that because urbanization would assist with integration, it should be welcomed rather than deplored. If managed properly, the urbanization of Maori could help prevent a "colour" problem from emerging in New Zealand (Hunn 1960, 14).

After announcing his conclusions, Hunn went on to discuss "racial policy" — the relationship between government policy and Maori development. He reasoned that there were four philosophical alternatives on which to base policy: assimilation, integration, segregation and symbiosis. He supported integration, which he defined as, "To combine (not fuse) the Maori and Pakeha elements to form one nation wherein Maori culture remains distinct." Hunn then explained, "Meanwhile integration,

without the benefit of statutory definition, is the obvious trend and also the conventional expression of policy" (15). After observing that most Maori had made significant adaptations to modern society, he classified them into three groups: group A, "a completely detribalised minority whose Maoritanga (Maori-ness) is only vestigial"; group B, "the main body of Maoris, pretty much at home in either society, who like to partake of both (an ambivalence however that causes psychological stress to some of them)"; and group C, "another minority complacently living a backward life in primitive conditions." The policy objective was to eliminate group C and allow Maori to choose between being part of group A (assimilated) or group B (integrated) (16).

Throughout the report, urbanization was a theme. The elevated birth rate and rural underdevelopment were identified as the prime causes for Maori urbanization. The Maori birth rate was double that of Pakeha, and even if use of Maori-owned resources (primarily land) was maximized, there would not be enough work in rural areas to sustain the growing population. Unemployment, while not an immediate problem, was an incremental one, as population growth in rural areas was outstripping work opportunities (which the report noted as the opposite situation to that in the cities) (Hunn 1960, 28). Maladjustment to urban living was recorded as one of the reasons for the high crime rates, and the report suggested that community centres and group instruction on permissible conduct would assist in lowering those rates. The report called for housing to accommodate the growing Maori population and championed the practice of "pepper-potting," whereby houses would be built for Maori among those of the general population in an effort to avoid creating Maori urban settlements — or ghettos. Ghettos had developed because urban growth had encompassed Maori land, and the report suggested breaking up these ghettos by selling building lots to Pakeha (Hunn 1960, 41).

Under the heading "Population," considerable concern was expressed over the various statutory definitions of "Maori." The report advocated that a blood-quantum measure of half-caste or greater be regarded as Maori, adding that in the future (due to increasing birth rates) the minimum blood-quantum level should be raised to three-quarter caste. This was because the client base of the department would eventually increase to the point at which it would become unmanageable. Tribes, the report suggested, should be given responsibility for "abstract" forms of welfare (such as monitoring and admonition at the community level) and let the department get on with "concrete" forms of welfare (such as case studies) (Hunn 1960, 79-80).

Government Wine, Maori Bottles: Policy Initiatives, 1984-2002

IN THE LATTER PART OF THE TWENTIETH CENTURY (THAT IS, AFTER THE FOURTH LABOUR government came into power, in 1984), the government made clear its intent to reform the welfare state and national economy by introducing wide-ranging, systematic economic measures. The free market strategy was the spearhead of a particular brand of democratic liberalism. Accompanying this initiative was the notion of less government and more community self-sufficiency. This approach to government was radical in New Zealand, and it coincided with Maori aspirations to end state dependency and, for some Maori, to develop its corollary — self-determination — as they demanded treaty rights. The situation was intensified by the fact that Maori were being adversely affected by these government policies that were dismantling the welfare state in piecemeal fashion. By 1990, Maori unemployment had reached 20 percent (M. Durie 2005, 170). The result was a body of policy known as "*Iwi* Development," which required an acceptance of the *iwi* as the basis of future development and signalled a U-turn in government thinking. From early colonial times until this era, the Crown, working from the premise that Maori would ultimately be assimilated into Pakeha society, had displayed a negative approach to the communalism implicit in tribalization.[37] The focal point of the *iwi* development policies was the *Runanga Iwi Act, 1990*.

Upon the election of the new government, on July 14, 1984, a rapid chain of events occurred. In September, the Labour government convened the Economic Summit Conference. In the conference's final session, a communiqué was issued in which it was observed that "the Conference considers that the position of Maori is of concern. The gap between Maori and Pakeha has been widening. Racial tension has been growing and many Maori young people have been alienated from the wider community. The Maori people and their resources continue to be under-utilized and under-developed. To reverse this will require positive initiatives for consultation with Maori communities about their future, policies to deal with Maori unemployment and self-help" (cited in Levine and Vasil 1985, 197).

As a result, one month later, Minister of Maori Affairs Koro Wetere convened the Maori Economic Development Summit Conference, Hui Taumata. Maori participation in the *hui* was substantial. In addition to the great number of representatives

(estimated in the hundreds) who attended, there were chapters from the various *hui* that had been held around the country. The minister was reported as being in a buoyant frame of mind because of the positive nature of the recommendations contained in the final communiqué (Levine and Vasil 1985, 197) — so much so that he labelled the *hui* "a blueprint for the future" (Fleras 1984, 4). The final communiqué echoed the sentiments of the earlier economic conference, spelling out in greater detail the negative economic, educational and social circumstances of Maori. It also contained a number of innovative suggestions for addressing these problems. More importantly, it recommended a change from government-centred service delivery to locally controlled service delivery utilizing tribal structures. After concluding that current government practices "smacked of tokenism," the communiqué noted, "The implications of resource transfer from existing Government programmes towards innovative proposals that meet Maori Tribal/Regional objectives on their terms will mean institutional changes." The communiqué concluded on this optimistic note: "Conference accepts the Minister's challenge to participate in a new Maori renaissance and a new Development Decade for our people" (Levine and Vasil 1985, 197).

After the Hui Taumata, the government proceeded with a number of initiatives to address Maori concerns, including a wide range of consultations with Maori. On April 21, 1988, the minister released the results in a discussion paper, *He Tirohanga Rangapu: Partnership Perspectives* (New Zealand, Minister of Maori Affairs 1988a), in which he outlined the government's view of future development. The essence was that the Maori affairs department would be disestablished and replaced by a ministry that would have an advisory and reporting role similar to that of the Department of Treasury. The service delivery function of the department would be taken over by *iwi*, and to assist them in the transitional period, the department would work to make government agencies responsive to Maori needs and ways of operating.

The sense of urgency was apparent — the response to the radical and far-reaching suggestions in this discussion paper took a mere eight weeks. The discussion paper, or "Green Paper," as it was commonly known, was taken on a tour of the country's major *marae*. People were given until June 13, 1988, to present submissions on the proposals it contained. Although the period was short, 633 submissions were received (New Zealand, Minister of Maori Affairs 1988b, 2). A large majority wanted the department reformed and reorganized, but they did not want it disestablished. There were also strong support for the transfer of programs

to *iwi*, deep suspicion of the government's motives, and a general feeling that the process was a fait accompli and the consultation a sham (New Zealand, Minister of Maori Affairs 1988b, 20).[38] In spite of these major reservations, the minister determined that there was enough support to press ahead.[39] In November 1988, he produced a policy statement, *Te Urupare Rangapu: Partnership Response*.

This policy statement refined the plan proposed in the Green Paper. The agenda of devolution was to immediately phase out the Department of Maori Affairs and replace it with a ministry of Maori policy (Manatu Maori — the Ministry of Maori Development) and an *iwi* transition agency (Te Tira Ahu Iwi), whose role it was to facilitate the transfer of programs to *iwi*. The aim was to complete the process by 1994, at which point the Iwi Transition Agency (ITA) would be disbanded. The government declared that it was "prepared to commit resources for five years to the development of the operational base of the iwi." At the end of this period, it expected the *iwi* to be "fully operational...able to manage their own programmes and negotiate independently with government agencies" (New Zealand, Minister of Maori Affairs 1988c, 14).

The new ministry commenced operations in July 1989, and the ITA in October; in December, the government introduced the Runanga Iwi Bill. There was strenuous Maori opposition to the Bill's proposals — particularly to the idea that the government would devolve responsibility without the accompanying power and resources (Boston et al. 1996, 325). In spite of this opposition, the Bill was enacted in August 1990 as the *Runanga Iwi Act, 1990*. The essence of the Act was to give the tribe a legal identity, which would enable it to enter into formal contracts under its own name. Although not stated in the Act, a supplementary document published by the ministry explained that there was a clear need to conform to government criteria; an application for incorporation would be turned down if the applicant did not possess specified characteristics.

Many Maori were very reluctant to have their tribes or tribal boundaries defined by law for fear of losing control of them. But, to receive government recognition and thus be eligible for public funding, tribes and their boundaries had to be defined in law, which effectively put them under state control. Playing on this fear of government control of tribal institutions, the opposition National Party, reputedly with the support of a number of Maori leaders, repealed the Act in 1991 after defeating the Labour government at the ballot box. The result was the incorporation of the ITA and Manatu Maori into a larger ministry of Maori development, Te

Puni Kokiri (TPK). It was a similar outcome to that of the 1940s Maori attempt, described earlier, to gain control over government Maori programming.

Although the *Runanga Iwi Act* was short-lived, the political and social processes that gave rise to it continued to dominate government thinking on the tribe. The *Resource Management Act, 1991* was passed with the *Runanga Iwi* model in mind, and it included a requirement for consultation with Maori before resource consent could be granted. Whether this was a genuine attempt to acknowledge the special status of Maori or just tokenism is a matter for conjecture. The lasting legacy of these polices was a vocabulary for future policy-making, notably *iwi runanga* ("tribal councils"), urban Maori authorities and *taura here* ("diasporic tribal communities").

New Wine, New Bottles? Visions of Maori Policy, 2003-05

A T THE CLOSE OF THE TWENTIETH CENTURY, THERE WERE CONCOMITANT DEVELOPMENTS in Maori policy and programs. One was a continuation of the old approach and the other a promise of a new one. In 1998, TPK, the Ministry of Maori Development, released a report entitled *Progress towards Closing Social and Economic Gaps between Maori and Non-Maori: A Report to the Minister of Maori Affairs* (Te Puni Kokiri 1998). It confirmed what was widely suspected, if not actually known — that Maori development had somehow stalled, and, in fact, that Maori were worse off than they had been a decade earlier. This gave rise to a body of policy commonly known as "Closing the Gaps" (Maaka and Fleras 2005, 135-6). This approach produced programs to reduce the disparities between Maori and non-Maori by settling treaty claims and supporting local initiatives to help communities address their own concerns (capacity building). As commendable as these objectives appear, the model used was still preoccupied with a needs discourse, and the report itself was remarkably similar to the Hunn Report of the 1960s (Maaka and Fleras 2005; see also M. Durie 2003). Ironically, Closing the Gaps came under fire from the opposition for very different reasons. Members argued that too much emphasis was placed on Maori, to the detriment of other sectors of society. Indeed, the opposition pursued its attack to the extent that the government capitulated and rebranded the approach "Reducing Inequalities" (Young 2003).

As the influence of Closing the Gaps waned, TPK, working in partnership with the New Zealand Institute of Economic Research (NZIER), produced another report, *Maori Economic Development: Te Ohanga Whanaketanga Maori* (Te Puni Kokiri and New Zealand Institute of Economic Research 2003). The rationale for the report was, in part, to counter the negative press that Maori policy had been attracting and to produce a platform from which to move forward (Te Puni Kokiri and New Zealand Institute of Economic Research 2003, III). It was determined that Maori entered the national economy in three waves. The first occurred with the early European contact and subsided with the onset of the 1860s colonial wars. The second wave started in the 1930s with the use of collectively owned assets and gained considerable momentum with recent treaty settlements (the businesses involved are sizable, with annual revenues of at least $1.9 billion). The third wave has been Maori entry into the "knowledge economy." Maori are building their own cultural capital and increasing their skills base, rapidly expanding the Maori service industry with businesses that serve Maori needs or provide access to authentic Maori culture and experiences (Te Puni Kokiri and New Zealand Institute of Economic Research 2003, 5). The report came to three broad conclusions: the Maori economy has a higher savings rate than the New Zealand economy; it is more profitable overall than the New Zealand economy; and its tax contribution is $2.4 billion, while the Maori cost to the New Zealand taxpayer is $2.3 billion (Te Puni Kokiri and New Zealand Institute of Economic Research 2003, 11-13).

According to TPK management and policy-makers, the positive nature of this report on the Maori economy was the catalyst for a new approach to Maori policy.[40] Because of their focus on negative statistics and their attempts to remedy the problems those statistics highlighted, Closing the Gaps and its successor, Reducing Inequities, are regarded as "deficit" models. The shift to creating policy and programs that focus on the potential of Maori as the basis for future development is seen as a move to "potential" policy models. The new approach is encapsulated in the catchphrase "Maori succeeding as Maori." These objectives are clearly stated in the *Statement of Intent, 1 July 2005, Presented to the House of Representatives* (Te Puni Kokiri 2005; see box 2).

One of the clear implications of this policy approach is self-determined rather than government-directed development. Indeed, one of the immediate outcomes was a discussion document, *Nga Tipu Whakaritorito: A New Governance Model for Maori Collectives.* It outlines the deficiencies of current governing structures, observing that

Te Puni Kokiri's

Statement of Intent

Statement of Intent, July 1, 2005

Strategic outcome: "Maori succeeding as Maori"
Te Puni Kokiri's efforts are directed toward its strategic outcome, which recognizes the importance of Maori as individuals, in organizations and in collectives, achieving a sustainable level of success.

Purpose: "Realizing Maori potential"

More emphasis on...	**Less emphasis on...**
Multidimensional Maori potential, strengths and opportunities	Single-dimensional repair of deficit, disparity and dysfunction
Investment in Maori as an integrated, but culturally distinct community	Targeting Maori as a socio-economically disadvantaged ethnic minority
Investment in Maori people	Predominant focus on institutional responses

Source: Te Puni Kokiri, *Statement of Intent, 1 July 2005,*
Presented to the House of Representatives Pursuant to Section
39 of the Public Finance Act (Wellington, NZ: Te Puni Kokiri),
8-9. [NS1]

"effective governance is critical to realizing cultural, commercial and social potential," and that "effective governance will contribute to Maori success" in three ways: "by helping to unlock Maori cultural, economic and social potential; providing a means for Maori to pursue goals and aspirations as Maori; enabling advocacy that represents Maori interests" (Te Puni Kokiri 2004, 4-5).

Since the production of this document, TPK has been working on a relationship framework and governance and representation strategy that will determine the relationship between the Crown and Maori with the aim of furthering the goal of "Maori succeeding as Maori."[41] The details of this and other "potential" policy initiatives are presently being refined and are probably some distance away from being sanctioned. Potential-centred policy is still at the conceptual stage. Should it be sanctioned by government, a framework of financed programs would be required to make it tangible.

While TPK regards itself as the prime Maori policy unit of government (Te Puni Kokiri 2005, 1, 33-4), most, if not all, government agencies provide services to Maori and have their own Maori policies. The Ministry of Health produced *Whakataka Maori Health Action Plan 2002-2005*, which stressed positive working relationships between the ministry, district health boards and Maori, as well as Maori participation in the health and disability sector (New Zealand, Ministry of Health 2002). The Department of Labour also published a Maori strategy, for the period 2001-06. This document echoes many of the sentiments found in that of the Ministry of Health. The Department of Labour's vision statement includes references to Maori, collectively, as a "true partner" of the Crown, and to the department as a "trusted partner" of Maori. It maintains that "by Maori for Maori, is part of our departmental culture and is integrated in everything we do" (New Zealand, Department of Labour 2000, 4).

Conclusion

THIS CHAPTER HAS CONSIDERED MAORI POLICY-MAKING, HIGHLIGHTING THE CENTRALity of the Treaty of Waitangi to government/Maori relations and the work of the Waitangi Tribunal as a contemporary manifestation of this relationship. It went on to trace the evolution of Maori policy from the beginning of the twentieth century to the present, in the process demonstrating that over an 84-year

period (1900-84), government policy was silently underpinned by the notion that the state knew what was best for Maori. This, in turn, gave rise to dependency policy models. With *iwi* development and successive policies, it appeared that the paternalistic policy pattern would change, but history has shown otherwise. Hence, this period is characterized as "government wine, Maori bottles" (from the aphorism "old wine, new bottles"), alluding to the fact that while the policies were packaged and promoted as reflecting Maori values, they remained government-centred.

As New Zealand moves through a period of treaty settlements in which Maori control significant assets and enjoy greater political influence, new forms of policy are emerging. The final section of this chapter — "New Wine, New Bottles?" — poses this question: Are all of these new developments signs of a paradigm shift in Maori policy and programming, from government paternalism to autonomous development? The answer is that it is far too early to say, especially since the government formed in 2005, with its new set of Maori MPs and a Maori party in opposition, has not yet indicated its intentions for Maori policy. In investigating these developments, I spoke with a senior Maori policy analyst outside of TPK, who told me that the proposed policy reforms would amount to very little if they were not supported with adequate budgets. He added that even if the reforms are accepted by the new government, there would have to be a transition period to allow for a phasing out of the deficit model programs, as the sudden cessation of these programs would cause substantial hardship in Maori communities.[42] Will substantive reform take place in a political landscape where Maori-only initiatives are no longer favoured?[43] And will Maori accept an approach that involves state-designed governance models? The answers to such questions will depend on the details of the related policies, the level of consultation with Maori communities and the authenticity of the intent to share power.

The overall aim of He Korowai Oranga is whānau ora — Maori families that are supported to achieve the fullness of health and wellbeing within te ao Maori and New Zealand society as a whole. This aim builds directly from the New Zealand Health Strategy and the seven fundamental principles that should be reflected across the health sector, including: acknowledging the special relationships between Māori and the Crown under the Treaty of Waitangi.

He Korowai Oranga recognizes that both Maori and the government have aspirations for Maori health and will play critical roles in achieving the desired outcome for whānau. Realizing those aspirations requires putting the Treaty of Waitangi principles of partnership, protection and participation into action.

Figure 1

An Example of
Packaging Policy
Incorporating Maori
Symbolism[1]

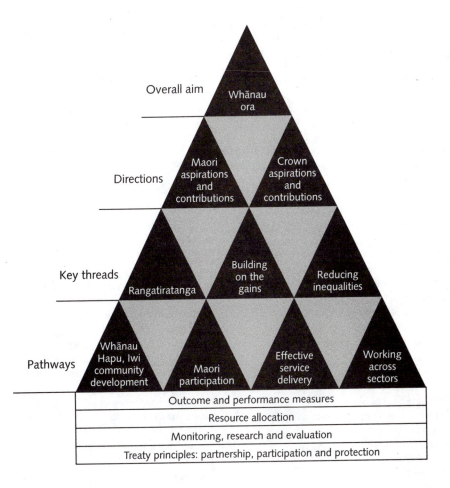

Source: New Zealand, Ministry of Health, *Whakataka Maori Health Action Plan 2002-2005* (Wellington, NZ: Ministry of Health, 2002).
[1] Here are translations of the Maori words in the diagram: *Whanau ora*, "healthy families"; *Rangatiratanga*, "self-determination"; *Whanau*, "family"; *Hapu, Iwi* (tribal formations).

Notes

1 We also consider Canada in the same context.

2 This position was reinforced by Andrew Begg of the Ministry of Foreign Affairs and Trade in his October 20, 2005, address to the United Nations General Assembly (60th sess., Third Committee, item 68: Indigenous issues). He declared that in elaborating the rights of one group of citizens, New Zealand could not agree to a document that suggested two standards of citizenship or two classes of citizen (accessed June 26, 2006). http://www.mfat.govt.nz/speech/pastspeeches/speeches2005/20oct05.html

3 In 2000, New Zealand was one of eight countries that were subjected to a systematic assessment of national political life to determine trends in democracy. The published report was entitled *Democracy in New Zealand* (Henderson and Bellamy 2002). It was a pilot project for a wider study funded and conducted by the International Institute for Democracy and Electoral Assistance (IDEA) of Stockholm, Sweden.

4 *Treaty of Waitangi Amendment Act, 1985*, 6(1).

5 That is, land formerly owned by the government that was passed on to state-owned enterprises to be sold to private buyers. Land once owned by New Zealand Railways falls into this category.

6 The inquiry related to this claim — the Indigenous Flora and Fauna and Intellectual Property Claim (Wai 262) — is still in progress, so the tribunal report on it has yet to be published.

7 A claim can be made by an individual Maori or a group of Maori.

8 *Treaty of Waitangi Amendment Act, 1985*, 6.9(1).

9 *Treaty of Waitangi Amendment Act, 1985*, 4(2A)(a).

10 Although occasionally subject to debate, the term "Pakeha" denotes non-Maori New Zealanders — more specifically, those of Anglo-Saxon descent.

11 *Treaty of Waitangi Amendment Act, 1985*, sched. 2, 5(6)(c).

12 *Treaty of Waitangi Amendment Act, 1985*, sched. 2, 5(9).

13 For Maori, the *marae* is the single most important cultural institution, and they still use it in a symbolic sense as a venue for customary practices. Traditionally, the *marae* was where all important community issues were publicly discussed and decided. In modern usage, the word *"marae"* refers to a piece of land on which stand a meeting house, a dining hall and various other buildings; it also includes the *marae atea*, or the open space in front of the meeting house.

14 *New Zealand Parliamentary Debates* (1984), vol. 460:2702.

15 *New Zealand Parliamentary Debates* (1984), vol. 460:2702.

16 *New Zealand Parliamentary Debates* (1984), vol. 460:2704, 2708, 2710.

17 The issue of being pressured to complete historical claims was subject to intensive and extensive discussion at the members' conference, which I attended, held November 23-24, 2005. Colin James, a respected political journalist, spoke of the non-Maori public's growing unease with the protracted claims process, and Shane Jones, one of the new Maori Labour MPs, expressed his dissatisfaction with the tribunal's lack of progress. I have taken the figures and estimates in this paragraph from notes distributed to the conference by the director of the Waitangi Tribunal.

18 Keith Sorrenson has written a detailed history of Maori parliamentary representation for the Royal Commission on the Electoral System (1986).

19 *New Zealand Parliamentary Debates* (1897), vol. 1:809.

20 The Mana Motuhake Party gained entry to Parliament as part of the Alliance Party in 1999 and 2002 (see Henderson and Bellamy 2002, 31).

21 A 1998 political opinion survey indicated that there was little difference between Maori and Pakeha concerns and political trends (*New Zealand Insight* 1998).

22 The possibility of the parliamentary seats des-
 ignated for Maori being abolished is raised
 periodically according to the national political
 climate. At the Northern Regional Conference
 held on April 29, 2006, National's deputy
 leader and spokesperson on Maori issues,
 Gerry Brownlee, stressed the need for the
 party to negotiate with Maori. He told the
 meeting that under the current electoral
 option, Maori could have up to 10 seats and
 that there was a bill before Parliament to
 reduce the total number of members to 99.
 While he advocates negotiating with Maori,
 Brownlee also continues to support party
 leader Don Brash in his desire to abolish the
 Maori seats (Arotahi News Service 2006b).
 Brash's opposition to the Maori seats has again
 made the news. He was reportedly unhappy
 with the decision of one of his MPs, Georgina
 Te Heuheu, to remain on the Maori electoral
 roll (Arotahi News Service 2006a).

23 *New Zealand Parliamentary Debates* (1903),
 vol. 127:513.

24 *Appendices to the Journals of the House of
 Representatives* (1906), vol. 3 H.26a:21.

25 *New Zealand Parliamentary Debates* (1903),
 vol. 127:516.

26 *Appendices to the Journals of the House of
 Representatives* (1906), vol. 3 H.26a:5.

27 *Appendices to the Journals of the House of
 Representatives* (1906), vol. 3 H.26a:2.

28 *Appendices to the Journals of the House of
 Representatives* (1906), vol. 3 H.26a:5.

29 *New Zealand Parliamentary Debates* (1903),
 vol. 127:516.

30 *New Zealand Parliamentary Debates* (1903),
 vol. 127:516.

31 *New Zealand Parliamentary Debates* (1903),
 vol. 127:515.

32 *New Zealand Parliamentary Debates* (1903),
 vol. 127:518.

33 National Archives of New Zealand, Nash
 Chapters, NP vol. 2067, 0397-9.

34 Paraire Paikea to Minister of Defence,
 January 19, 1943, National Archives of
 New Zealand, Department of Maori Affairs,
 MA ser. 19/1/535.

35 Paraire Paikea to Prime Minister, April 2,
 1943, National Archives of New Zealand,
 Department of Maori Affairs, MA ser.
 19/1/535.

36 National Archives of New Zealand,
 Department of Maori Affairs, MA ser.
 19/1/535, conference minutes, resolution
 7,3.

37 Examples of this anti-communal approach
 are given early in the discussion on the
 Maori Councils Act, 1900 (14-5).

38 This feeling is not surprising, given the
 rapid approach to reform espoused by the
 fourth Labour government.

39 He would have been encouraged by the
 strenuous efforts by various iwi to prepare
 themselves to administer government pro-
 grams. From July 1987 to December 1988,
 the following iwi established trust boards
 and *runanga* ("councils") under the *Maori
 Trust Boards Act*: Ngati Porou, Ngati Awa,
 Hauraki, Ngati Maniapoto, Wanganui and
 Ngati Whatua.

40 Te Puni Kokiri staff, interview with the
 author, May 2005.

41 Interestingly, in addition to TPK, two other
 public institutions are also considering the
 issue of Maori governance: the Office of
 Treaty Settlements and the Law
 Commission. There is very little in the way
 of public documents to help us ascertain
 their respective views on Maori governance,
 and whether there will be any cooperation
 between these institutions to produce a
 comprehensive approach remains to be
 seen.

42 Senior Maori policy analyst, interview with
 the author (May 2005).

43 The mood of opposing Maori policy-mak-
 ing has altered since the September elec-
 tions — even the outspoken leader of the
 National Party has slightly modified his
 position. In October 2005, the *New Zealand
 Herald* quoted him as saying that if people
 were under the impression he did not
 acknowledge a distinct Maori identity, then
 "I failed to explain what I was meaning,

because clearly I have respect for other cultures. I don't want to have a uniform, homogenous approach to New Zealand culture but I think it is important that all of us have equal rights under the law" ("Brash Denies Extremism" 2005). A *Dominion Post* article suggested that the prime minister set up a parliamentary task force on the Treaty of Waitangi in order to "1. Identify the ways in which the original relationship between Maori and Pakeha, as defined in the 1840 treaty, have been modified by 165 years of continuous nation-building; 2. Consider how that relationship might be expressed constitutionally; and 3. Come up with a range of options indicating how such significant constitutional reforms might be accomplished" ("What Helen Clark Must Do" 2005). In spite of these conciliatory approaches, the issue of Maori/Pakeha relations in postelection New Zealand is clearly still prominent in public debate. On (respectively) November 23 and 24, 2005, political journalists Kathryn Ryan and Colin James made presentations to the Waitangi Tribunal members' conference. James observed that in regard to treaty issues, New Zealanders had reached a "threshold of tolerance," but he also maintained that the conservative wing of New Zealand politics was risking "social cohesion" with its strident opposition to government Maori-centred initiatives. He spoke of a sentiment echoed in the *Dominion Post* article, evident in these two quotes: "Any future deterioration of the relationship between Maori and Pakeha will create a huge threat to the future peace and prosperity of New Zealand"; "It is quite simply immoral — and politically unacceptable — to regularly subject the 15 per cent of the electorate which is Maori to the sort of abuse meted out during the election campaign" ("What Helen Clark Must Do" 2005). In her presentation, Ryan addressed the same issues in more general terms.

References

Arotahi News Service. 2006a. "Brash Not Happy with Te Heuheu Stance." Te Kaea, Maori Television, May 9.

———. 2006b. "Time Right to Question Make-up of Parliament." Te Kaea, Maori Television, May 3.

Ballara, Angela. 1998. *Iwi: The Dynamics of Maori Tribal Organisation from c. 1769 to c. 1945.* Wellington, NZ: Victoria University Press.

Boast, Richard P. 1993. "The Waitangi Tribunal: 'Conscience of the Nation,' or Just Another Court?" *University of New South Wales Law Journal* 16 (1): 223-44.

Boston, Jonathan. 2003. "Institutional Change in a Small Democracy: New Zealand's Experience of Electoral Reform." In *Reforming Parliamentary Democracy*, edited by F. Leslie Seidle and David C. Docherty. Montreal: McGill-Queen's University Press.

Boston, Jonathan, Stephen Levine, Elizabeth McLeay, and Nigel S. Roberts. 1996. *New Zealand under MMP.* Auckland, NZ: Auckland University Press.

"Brash Denies Extremism on Race Issue." 2005. *New Zealand Herald*, October 5.

Buck, Peter. 1950. *The Coming of the Maori.* Wellington, NZ: Maori Purposes Fund Board, Whitcombe & Tombs.

Butterworth, G.V., and H. Young. 1990. *Maori Affairs: A Department and the People Who Made It.* Wellington, NZ: Government Printing Office.

Coates, Ken S., and P.G. McHugh. 1998. *Living Relationships: Kokiri Ngatahi.* Wellington, NZ: Victoria University Press.

Dahlberg, Tina R. Makereti. 1996. "Maori Representation in Parliament and Tino Rangatiratanga." *He Pukenga Korero* 2:62-72.

Durie, E.T., and G.S. Orr. 1990. "The Role of the Waitangi Tribunal and the Development of a Bicultural Jurisprudence." *New Zealand University Law Review* 14 (1): 62-81.

Durie, Mason. 1998. *Te Mana Te Kawantanga.* Auckland, NZ: Oxford University Press.

———. 2003. "Maori in Governance: Parliamentary Statutory Recognition and

the State Sector." In *Reforming Parliamentary Democracy*, edited by F. Leslie Seidle and David C. Docherty. Montreal: McGill-Queen's University Press.

——. 2005. *Nga Tai Matatu: The Tides of Maori Endurance*. Melbourne: Oxford University Press.

Fleras, A. 1984. "A Blueprint for the Future." *Tu Tangata* 21:4.

Henderson, J., and P. Bellamy. 2002. *Democracy in New Zealand*. Christchurch, NZ: Macmillan Brown Centre for Pacific Studies, University of Canterbury, International Institute for Democracy and Electoral Assistance.

Hunn, J.K. 1960. *Report on the Department of Maori Affairs, with Statistical Supplement*. Wellington: Department of Maori Affairs, Government Printing Office.

International IDEA. 2001. *State of Democracy: Trends from the Eight Pilot Countries: An Overview of Democracy Assessment Reports in Bangladesh, El Salvador, Italy, Kenya, Malawi, New Zealand, Peru and South Korea*. Stockholm: International Institute for Democracy and Electoral Assistance.

Jackson, Keith, and Alan McRobie. 1998. *New Zealand Adopts Proportional Representation: Accident? Design? Evolution?* Christchurch, NZ: Hazard Press.

Jackson, W.K., and G.A. Wood. 1964. "The New Zealand Parliament and Maori Representation." *Historical Studies: Australia and New Zealand* XI: 383-96.

Keenan, Danny. 1996. "A Permanent Expedient?" *He Pukenga Korero* 2:58-61.

Levine, S., and R. Vasil, eds. 1985. *Maori Political Perspectives*. Wellington, NZ: Hutchinson Group.

Love, Ralph Ngatata. 1977. "Policies of Frustration: The Growth of Maori Politics: The Ratana/Labour Era." Ph.D. diss., Victoria University, Wellington, NZ.

Maaka, Roger. 2003. "Perceptions, Conceptions and Realities: A Study of the Tribe in Maori Society in the Twentieth Century." Ph.D. diss., University of Canterbury, Christchurch, NZ.

Maaka, Roger, and Augie Fleras. 2005. *The Politics of Indigeneity: Challenging the State in Canada and Aotearoa New Zealand*. Dunedin, NZ: Otago University Press.

New Zealand. Department of Justice. 1990. *The Treaty of Waitangi and the Waitangi Tribunal*. Wellington, NZ: Waitangi Tribunal.

——. Department of Labour. 2000. *Department of Labour (DoL) Maori Strategy*. Wellington, NZ: Department of Labour.

——. Minister of Maori Affairs. 1988a. *He Tirohanga Rangapu: A Discussion Paper*. Wellington, NZ: Minister of Maori Affairs.

——. Minister of Maori Affairs Working Group.1988b. "Synopsis of Submissions on 'He Tirohanga Rangapu.'" Report to the Minister of Maori of Affairs. Wellington, NZ: Minister of Maori Affairs.

——. 1988c. *Te Urupare Rangapu: Partnership Response*. Wellington, NZ: Minister of Maori Affairs.

——. Ministry of Health. 2002. *Whakataka Maori Health Action Plan 2002-2005*. Wellington, NZ: Ministry of Health.

——. Office of Treaty Settlements. 1999. *Healing the Past, Building a Future: A Guide to the Direct Negotiation of Treaty of Waitangi Claims*. Wellington, NZ: B & G Print.

Orange, Claudia. 1987. "An Exercise in Maori Autonomy: The Rise and Demise of the Maori War Effort." *New Zealand Journal of History* 21 (1): 156-72.

——. 1990. *The Treaty of Waitangi*. Wellington, NZ: Allen and Unwin.

Poulsen, M.F., and Johnson, R.J. 1973. "Patterns in Maori Migration." In *Urbanization in New Zealand*, edited by R.J. Johnson. Wellington, NZ: Reed Education.

Sorrenson, M.P.K. 1986. "A History of Maori Representation in Parliament." In *Royal Commission on the Electoral System: Towards a Better Democracy*. Wellington, NZ: Government Printing Office.

Statistics New Zealand. 2002. *New Zealand Census of Population and Dwellings, 2001: Maori*.Wellington, NZ: Department of Statistics, New Zealand Te Tai Tatau.

Te Puni Kokiri. 1998. *Progress towards Closing Social and Economic Gaps between Maori and Non-Maori: A Report to the Minister of Maori Affairs.* Wellington, NZ: Te Puni Kokiri.

———. 2004. *Nga Tipu Whakaritorito: A New Governance Model for Maori Collectives: A Discussion Document.* Wellington, NZ: Te Puni Kokiri.

———. 2005. *Statement of Intent, 1 July 2005, Presented to the House of Representatives Pursuant to Section 39 of the* Public Finance Act. Wellington, NZ: Te Puni Kokiri.

Te Puni Kokiri and New Zealand Institute of Economic Research. 2003. *Maori Economic Development: Te Ohanga Whanaketanga Maori.* Wellington, NZ: Te Puni Kokiri, New Zealand Institute of Economic Research.

Waitangi Tribunal. 1986. *Te Reo Maori Report (Wai 11).* Wellington, NZ: Waitangi Tribunal.

———. 1991. *Ngai Tahu Report (Wai 27).* Wellington, NZ: Waitangi Tribunal.

———. 2000. *The Pakakohi and Tangahoe Settlement Claim (Wai 142, Wai 758).* Wellington, NZ: Waitangi Tribunal.

Walker, Ranginui, ed. 1985. *Nga Tumanako: Maori Representation Conference.* Auckland, NZ: Centre for Continuing Education, University of Auckland.

"What Helen Clark Must Do." 2005. *Dominion Post*, September 30.

Young, Audrey. 2003. "Gap-Closing Benefits Hard to Pin Down." *New Zealand Herald*, April 22.

International
Experiences

Immigrants and
Civic Integration
in Western Europe

ERROR IN THE NAME OF ISLAM, WHICH IS NOW BEING RAMMED INTO THE HEART OF
Europe by the children of postcolonial immigrants, has pushed the problem
of failing immigrant integration, particularly with respect to Muslims, to the top
of the political agenda (Khalaf 2005; Leiken 2005). But isn't the linkage between
terror and integration — the dominant, reflex-like response to the July 2005 sui-
cide bombing of the London Underground — misleading? Consider the "sheer
normality of the young men involved, with British citizenship, born in Yorkshire
into lower middle-class families from south Asia" (Peel 2005). Which integration
policy could have helped to prevent evil from such quarters? If Islamic funda-
mentalism is indeed, as a noted French Islam specialist holds, an "expression of
a cultural crisis in the age of globalization," then this is surely too grand a target
for any state policy, whatever the domain (Roy 2005, 3).

However misleading the connection between terror and failing immigrant
integration may be, there is a widespread sense across Europe that some 40 years
after the onset of the great post-Second World War migration, the state policies
set up to accommodate this migration were insufficient, or even harmful. Even in
states long believed to adhere to articulate and coherent national models of immi-
grant integration, such as the multicultural Netherlands and assimilationist
France, this sense of failure is strong. In the Netherlands, a parliamentary inquiry
into government policy toward ethnic minorities between 1970 and 2000 came
to the devastating conclusion that if some migrants in the Netherlands succeeded,
then they did so in spite of, rather than thanks to, government policy
("Parliamentary Report" 2004). In France, a similar review of the French postwar
immigration experience conducted by the Cour des Comptes noted that the state
had always been fixated on refining instruments of immigration control and that

integration policy remained "badly defined in its objectives and principles," "incoherent," "contradictory" and "insufficient" (2004, 9-10).

I argue in this chapter that the key features of the policy solutions offered in response to the integration crisis are the weakening of national distinctiveness and a convergence with respect to the forms and contents of integration policy. The notion of national models no longer makes sense, if it ever did. Gary Freeman rightly notes that the concept of "national models of incorporation...lend[s] too much dignity to the patchwork of institutions, laws, and practices that constitute incorporation frameworks in the West" (2003, 3). The French self-critique through the Cour des Comptes powerfully affirms Freeman's view.

Not plagued by such doubts, much of the scholarly literature nevertheless continues to draw a distinction, within a liberal-democratic spectrum, between difference-friendly multiculturalism and universalist assimilationism; it also identifies segregationism in some guest-worker-receiving countries, which is seen as beyond the liberal-democratic pale.[1] A review of recent policy trends in three countries — the Netherlands, France and Germany — that are commonly taken as representatives of these approaches (multiculturalism, assimilationism and segregationism, respectively) will attest to the implausibility of such classification. In France, it has been *de rigueur* since the early 1990s to reject any presumption of cultural assimilation. The most recent report by the Haut Conseil à l'Intégration (HCI), chaired by philosopher Blandine Kriegel, invokes the Rawls-Habermasian distinction between political and ethical integration to beef up this stance: "[D]ans les républiques démocratiques, l'État n'a pas vocation à imposer des valeurs car il laisse aux citoyens la liberté de les choisir" (2003, 84).[2] Interior Minister Nicolas Sarkozy further illustrates this position: "L'intégration, c'est : 'Je t'accueille dans le creuset républicain comme tu es.' L'assimilation, c'est : 'Je te fais disparaître'" (Barbier and Conan 2004).[3] This is the general creed of liberal democracy, from Canada to France. At the same time, the proverbially difference-friendly, multicultural Netherlands is urging migrants to accept Dutch norms and values in the context of a policy of civic integration that is only an inch (but still an inch!) away from the cultural assimilationism once attributed to the French. And the pariah among migrant-receiving states in the West, segregationist Germany, has recently liberalized its nationality law in a big way, thus including its huge migrant population among its citizenry; and it has adopted (or is about

to adopt) the same civic integration and anti-discrimination policies and laws that are currently taking hold in the rest of Europe. Hence, with respect to the notion of national models, it is apposite to speak of a transformation of immigrant integration in western Europe.

Forces of Transformation

THE FORCES OF TRANSFORMATION ARE ESSENTIALLY TWO: A NEW CONTEXT AND MIND-set conducive to immigration; and Europeanization. With respect to the first, there is a growing awareness that far from being a unique historical episode, immigration is a permanent, even desirable feature of European societies for demographic and economic reasons. This constitutes a fundamental change of position. Well into the early 1990s — the last and perhaps most drastic expression being French Interior Minister Charles Pasqua's martial quest for "zero immigration" — European states sternly rejected new labour migration. The migration that still happened, such as family and refugee migration, was grudgingly accepted for constitutional reasons, but it was certainly not wanted. Exemplified by the "firm but fair" logo that has informed the British approach to immigration since the late 1960s, closure to the outside was often taken as a precondition for being inclusive and accommodating to the migrants that were already inside. This condition for "fair" integration is no longer valid. Perhaps even more than the economic case for choosing "the best and brightest" in globalizing education and labour markets, the demographic case for new-seed immigration is now overwhelming, especially in Europe.

In the late nineteenth century, European demographic decline was already worrying demographers and political elites (see Barraclough 1967), but the alarming difference is that relative decline has since turned into absolute decline. A century ago, the countries that constitute today's European Union still accounted for 14 percent of the world's population; that figure is down to 6 percent today, and it is expected to decrease to 4 percent by 2050. "There has not been such a sustained reduction in the European population since the Black Death of the 14th century," writes noted British historian Niall Ferguson (2004). This augurs badly for the EU's ambitious goal to become "the most competitive and

dynamic knowledge-based economy in the world."[4] We are only beginning to understand the bleak implications of shrinking and aging populations for Europe's economies and welfare states, but the case for new migration has already been understood and accepted by left and right alike. Accordingly, the recently issued declaration of the European Council (the intergovernmental steering body of the European Union) on immigrant integration policy opens with the statement, "Immigration is a permanent feature of European society. If the flow of immigrants…is orderly and well-managed, Member States reap many benefits" (Council of the European Union 2004, 15).

This new context and mindset have important implications for integration policy. First, immigrant integration is elevated from a fringe problem to become a central challenge to the entire society. For the first time, European states are beginning to see the need for a "global and coherent policy of immigrant integration," as the French Cour des Comptes puts it (2004, 17). There is also a clearer distinction being made between different phases of the integration process and an understanding that these require different policy responses. The most pertinent distinction here is between newcomers, who are targeted by new policies of civic integration, and the second- or third-generation offspring of migrants, whose equal participation in society is to be encouraged by anti-discrimination laws and policies.

The second force driving the transformation of immigrant integration is the process of Europeanization. The shift from one-time to recurrent immigration could in principle still be handled in nationally distinct ways; it points to a shared problem, but it does not prescribe a response. Only Europeanization explains why there is convergence in the new integration policies. Europe is burying the national models of old in two ways: through legal mandate and through cultural standardization. With respect to legal mandate, the entire migration function is slowly but steadily coming under the purview of European Community (EC) law. The development of a joint EU immigration policy has been on the agenda since the 1997 Amsterdam Treaty, and with respect to family migration and asylum there are now EC directives that legally bind the member states. In terms of priorities clearly subordinate to migration control, immigrant integration is nevertheless increasingly coming into the ambit of EC law. Milestones in this area are the 2000 race directive, which obliges member states to pass anti-discrimination laws by 2003, and the 2003 directive on third-state permanent legal residents,

which in important respects realizes the long-standing quest to approximate the residence and free-movement rights of non-EU immigrants to those of EU citizens. Finally, in November 2004, the Council of the European Union for the first time agreed on common basic principles for immigrant integration policy in the EU. Though nonbinding, this agreement is likely to further the harmonization of integration policies across Europe.

Perhaps even more than by legal mandate, Europeanization proceeds by means of cultural standardization. There is now a dense network of academics, journalists and policy experts monitoring best practices in other countries and feeding them back into the national debates.[5] One example, which I will discuss, is the civic integration policy, which was pioneered in the Netherlands and has since been adopted across northern and western Europe, most notably in France and Germany. Although the reference point for the diffusion of best practices is not Europe but all liberal democracies, ongoing Europeanization has still provided the most immediate cognitive impetus and organizational cues for this diffusion.

Policy Convergence in the European Union

OF WHAT DOES THE STATED POLICY CONVERGENCE SUBSTANTIVELY CONSIST? Because they were agreed upon by the justice and home ministers of the member states and thus reflect national policy preferences, the November 2004 European Council conclusions on immigrant integration policy offer a unique window on the general direction of integration policies across Europe (Council of the European Union 2004). The first joint feature of these policies, which is no novelty, is to be broadly if imperfectly inclusive. As Freeman points out, this is "counter-intuitive," if one considers that many of Europe's migrants arrived uninvited, and that national electorates are generally hostile toward large-scale immigration, especially of non-European provenance (2003, 3). This inclusiveness is due to the postwar rise of a human rights discourse and its accompanying international and national legal regimes, which extended rights from national citizens to all persons, irrespective of citizenship (Soysal 1994). It is thus no European specificity but germane to all Western liberal democracies.

Inclusiveness is usually formulated in the metaphor of two-way integration. Accordingly, the first of the EU's common basic principles of immigrant integration policy reads: "Integration is a dynamic, two-way process of mutual accommodation by all immigrants and residents of the Member States." This means that not just migrants but also the receiving societies have to change, the latter being mandated to create "the opportunities for the immigrants' full economic, social, cultural, and political participation" (Council of the European Union 2004, 19). This stance has become a platitude, but one should not forget its extreme improbability. Ever since the transition from nomadic to settled life during the Neolithic Revolution, settled populations expected newcomers to adapt to their ways — when in Rome do as the Romans do. The idea that something as complex and massive as the receiving society should change in response to the arrival of numerically inferior migrants — who, as individuals, are ontologically different from a society — is unheard of. That a settled society *would* change as a result of migration is, of course, inevitable, but elevating this to an ethical maxim — a *should* — is an unprecedented stance to take.

The second of the EU's common basic principles offers insight into what is expected of migrants: "Integration implies respect for the basic values of the European Union." What are these values? They are the joint stock of all liberal democracies: "the principles of liberty, democracy, respect for human rights and fundamental freedoms, and the rule of law" (Council of the European Union 2004, 19). All of these are political values, not substantive ethical values. Europe is becoming like America in that — much as John Rawls's "political liberalism" has formulated it — the integration of society can occur only in terms of a procedural consensus on what is right, not in terms of a substantive consensus on what is good. Political liberalism's application in the migration domain is a common preference of integration over assimilation, assimilation meaning the imposition of the substantive culture of the majority society — "comprehensive doctrine," in Rawls's terms — on newcomers (see Rawls 1993); the precise meaning of integration is to abstain from this. Accordingly, the EU's common basic principles include "[f]ull respect for the immigrants' and their descendants' own language and culture" (Council of the European Union 2004, 20).

With respect to migrants' "own language and culture," the crucial question is whether their expression is left to the free play of society, or whether the state becomes involved in their protection and maintenance. Interestingly, only Spain,

under a socialist government bent on setting a progressive counterpoint to its conservative predecessor, wanted to commit the EU states to a multicultural stance on this question, obliging them to proactively further and protect migrant languages and cultures. This quest was rebutted. The compromise formula, "full respect," does not go beyond the classic liberal stance on matters of culture and way of life, leaving these things to the discretion of individuals and not considering them the business of the state. Moreover, while the council document reiterated that "the freedom to practice one's religion and culture" was guaranteed by constitutional law, it emphasized the strings attached to it — respect for the "equality of women," the "rights and interests of children" and the "freedom to practice or not to practice a particular religion" (Council of the European Union 2004, 23). This reservation reflects the most recent difficulties with Muslim integration in Europe, which have caused the pendulum to swing from cultural maintenance to enforcement of liberal core values.

The decreased emphasis on cultural recognition in the EU document, while at one level consistent with the precepts of liberalism, points to an important reorientation of European states' immigrant integration policies. Previous programmatic statements by European states were much stronger in their affirmation of the integrity of migrant cultures and ways of life; and some states — most notably Sweden and the Netherlands — went even further in protecting and supporting them. Instead, the EU's third common basic principle reads: "Employment is a key part of the integration process" (Council of the European Union 2004, 20). In response to the alarming degree of unemployment and welfare dependency among immigrants and their offspring in Europe — which contrasts sharply with that of the United States or Canada, where migrant ethnics are generally employed — socio-economic integration has become the key focus of European states' immigrant integration policies. This reorientation is framed by a new, postnational-model philosophy of migrants' self-sufficiency and autonomy, used in both the Netherlands and France, according to which — paradoxically — the primary task of the state is to make migrants independent of the state.

The inevitable result of the new focus on socio-economic integration is to shift the burden of adjustment onto the individual migrant, particularly in the first phases of entering the new society. Accordingly, the fourth principle in the EU statement on integration policy is: "Basic knowledge of the host society's language, history, and institutions is indispensable to integration" (Council of the

European Union 2004, 20). This refers to the new policy of civic integration, which the Netherlands pioneered in the late 1990s, and which has since been adopted by, among other European states, Finland, Denmark, Austria, Germany and France. The policy obliges newcomers to enrol in civics and language courses immediately after entry (in the Netherlands, lately, even before entry), and noncompliance tends to be met with financial penalties or denial of permanent legal residence permits. The novelty of the civic integration policy is its obligatory character, which has increased notably over time, and this notional "integration" policy has even been transmuted into a tool of migration control, helping states to restrict especially the entry of unskilled and unadapted family migrants. The obligatory, even repressive character of the civic integration policy makes it a prime instance of an illiberal policy "in the name of liberalism" (King 1999), which sets it apart from similar — yet voluntary and humanitarian — civic integration policies in Canada.

However, a liberal counterpoint to increasingly illiberal civic integration policies is the emphasis on anti-discrimination laws and policies, which — forced by direct EU mandate — are now taking hold across Europe. Accordingly, the last of the EU's integration principles I will mention here is: "Access for immigrants to institutions, as well as to public and private goods and services, on a basis equal to national citizens and in a non-discriminatory way is a critical foundation for better integration" (Council of the European Union 2004, 21).[6] Equality of treatment, irrespective of one's ethnic origin or any other ascriptive marker, is certainly the stock-in-trade of all liberal societies and guaranteed by their constitutions. Yet to enforce this by explicit anti-discrimination laws, which lowers the hurdle of claims-making for the victims of discrimination and, above all, expands the reach of the nondiscrimination principle from the public to the private sector, is something new. Though enabled by a unique window of opportunity at the EU level (see Guiraudon 2004), the proliferation of anti-discrimination laws and policies reflects Europe's structural transformation into a multi-ethnic society, as well as a general willingness to tackle the specific inequalities that go along with it.

The remainder of this chapter explores the origins and dynamics of civic integration, which has raised eyebrows because of its illiberal connotations. If one juxtaposes civic integration with the anti-discrimination trend, one will see the interesting complementarities and countervailing, if not contradictory, features exhibited by both policies. Both are complementary in addressing different

phases in the migration process — its beginning (civic integration) and end (anti-discrimination). (Note that the very existence of anti-discrimination proves that civic integration has failed.) On the other side, both civic integration and anti-discrimination adhere to opposite logics. The logic of civic integration is to treat migrants as individuals, who are depicted as responsible for their own integration; civic integration applies to the migration domain the austere neoliberalism that frames economic globalization. The opposite logic of anti-discrimination is to depict migrants and their offspring as members of groups, who are victimized by majority society, thus reintroducing at the tail end of integration the ameliorative group logic that had been thrown out at its beginning by the harsh individualism of civic integration.

The peculiar coexistence of civic integration and anti-discrimination reveals that, in reality, two-way integration consists of two separate one-way processes: at first, the burden of change is all on the migrant; later, the burden of change is all on society. Ever since continental European courts pioneered the constitutionalization of alien rights and thus facilitated the transformation of European societies into immigrant societies (see Marzal 2004), such rights have been seen as incremental, increasing with the migrant's length of stay.[7] The dualism of (obligatory) civic integration and anti-discrimination subtly reinforces this idea, in that the migrant's initial experience in the new society is precarious, and she gradually has to "earn" the rights of full membership. In this, Europe has remained different from the classic immigration nations, in which from the first day the legal immigrant is considered a fully functioning and rightful member of the new society.

The Case of Civic Integration

The Netherlands

WE MUST FIRST LOCATE THE TURN TO CIVIC INTEGRATION WITHIN THE SPECIFIC Dutch context. Beginning in the early 1980s, the Netherlands pursued Europe's most prominent and proudly exhibited multiculturalism policy, which envisaged emancipation for designated ethnic minorities, yet within their own state-supported ethnic infrastructures — including ethnic schools, ethnic

Table 1 330

Absolute and Relative Unemployment Levels among Citizens and Non-EU Foreigners in the Netherlands, France and Germany, 1999-2000

	Unemployment, citizens (%)	Unemployment, non-EU foreigners (%)	Relative unemployment, non-EU foreigners
Netherlands (1999)	3.4	18.5	5.4
Netherlands (2000)	2.6	10.1	3.9
France (2000)	9.6	27.9	2.9
Germany (2000)	7.5	15.5	2.2

Source: Ruud Koopmans, "Tradeoffs between Equality and Difference: The Failure of Dutch Multiculturalism in Cross-National Perspective," paper presented at "Immigrant Political Incorporation," April 22-23, 2005, Radcliffe Institute for Advanced Study, Harvard University.

hospitals and ethnic media. Alas, in the shadow of multiculturalism, one of Europe's biggest socio-economic integration failures occurred. The figures are daunting. Whereas in the majority of EU countries the unemployment rate of non-EU foreigners is about twice that of citizens, in Holland, the unemployment rate among non-EU foreigners, despite great fluctuation, at a minimum has been three times that among citizens in the past seven years; in 1999, it was 5.4 times higher than that among citizens (see table 1).

In 1999, only one-third (33.7 percent) of non-EU foreigners were gainfully employed in the Netherlands; the vast remainder were either not in the labour market at all (like many Muslim women) or dependent on social benefits. In fact, migration to the Netherlands, like migration to many other continental European countries (which, since the late 1970s, has been mostly through asylum and family reunification), is often a direct march into welfare-state dependency. In 1998, 47 percent of all persons on welfare in the Netherlands were immigrants; among non-Western foreigners, 20 percent depended on welfare, which is 10 times higher than the welfare dependency rate of native Dutch. In other sectors, the picture is no better. Again in 1998, high school dropout rates were 2.4 times higher for immigrant children than for native Dutch children (19 percent and 8 percent, respectively), despite the fact that state funding was double for ethnic minority children; the dropout rates were especially bad for the two most problematic groups: Moroccans (39 percent dropout rate) and Turks (35 percent). Furthermore, residential segregation is extremely high in the Netherlands. Whereas only one-third of the population of Berlin-Kreuzberg, Germany's city quarter with the highest ethnic density, is composed of foreigners, the foreign-resident rate in Amsterdam's and Rotterdam's ethnic quarters is above two-thirds, and these two cities — the largest in the Netherlands — are expected to become predominantly foreign-populated within the next few decades. The situation in Dutch prisons is even bleaker. Most European prisons tend to be overpopulated by foreigners (in sharp contrast to those in the US and Canada), and this is especially true in the Netherlands: in 1997, 32 percent of the Dutch prison population was foreign. If one considers the share of foreigners in the population, this makes for an over-representation of 6.3 times, the highest in Europe (see table 2).

Particularly galling with respect to failing socio-economic and civic immigrant integration in the Netherlands was that Germany, the notorious "anti-integration

Table 2 332

Share of Foreigners in
the Prison Population
in the Netherlands,
France, Germany and
Britain, 1997

	Proportion of the prison population (%)	Degree of over-representation
Netherlands	32	6.3
France	26	4.1
Germany	34	4.0
Britain	8	2.3

Source: Ruud Koopmans, "Tradeoffs between Equality and Difference: The Failure of Dutch Multiculturalism in Cross-National Perspective," paper presented at "Immigrant Political Incorporation," April 22-23, 2005, Radcliffe Institute for Advanced Study, Harvard University.

model" (Michalowski 2005), fared much better than the Dutch standard-bearer in this domain (Koopmans 2002). In fact, so dear to the scholarly community was the notion of Dutch leadership in immigrant integration that an earlier report comparing the Netherlands, Germany and France, which showed very much the same figures as Koopmans (2002, 2005), still concluded that "[i]ntegration in the Netherlands seems to be least problematic" (Doomernik 1998, 75).

The Dutch integration failure raises the question of whether it is causally related to the multicultural ethnic minorities policy. No conclusive evidence for either the absence or the existence of a causal link exists. The German experience, in which socio-economic integration has been relatively successful, despite the absence of an explicit integration policy, suggests the unimportance of integration policy — of whatever colour — for integration outcomes. Anita Böcker and Dietrich Thränhardt argue that immigrant integration in Germany occurred above all through the highly organized production sector, with its factory councils (Betriebsräte), strong labour unions and system of dual education (vocational training in private firms combined with formal education in state-run Berufsschulen [vocational schools]). And when, as it did in Berlin, the production sector suddenly collapsed, "even a progressive integration policy could not make a difference" (Böcker and Thränhardt 2003, 11).

On the other hand, Koopmans lists a number of "mechanisms" that link multiculturalism policy with "unintended negative outcomes in the socio-economic domain" (2005, 2). They are all based on multiculturalism's tendency to keep ethnic groups apart and to prevent their participation in mainstream society. The first mechanism was the commitment of the Netherlands, until the mid-1990s, to linguistic multiculturalism, supporting mother-tongue education and providing essential government communication in minority languages. This had the effect of easing access to the welfare state, but it closed access to the labour market and to mainstream education. "[L]inguistic pluralism," argues Koopmans, "allowed immigrants to survive in the margins of the welfare state without knowledge of the Dutch language" (2005, 15). If one adds the extra-low incentives for return-oriented migrants to learn a language that (except in the Flemish part of Belgium) is not spoken anywhere else in the world, the propensity not to learn Dutch is overwhelming, and non-Dutch speakers are excluded from most nonmenial jobs. A second mechanism consists of social networks and social capital formation. As economic sociology has shown, the weak ties that stretch

beyond one's primordial group are strong in terms of procuring jobs and other vital resources — precisely the ties that will not materialize if one stays within one's ethnic group. And, finally, one effect of creating a facade of multicultural tolerance (or, in the view of critics, political correctness) is that it feeds an unarticulated groundswell of resentment and discrimination. An intra-European comparison of majority attitudes toward immigrants noted that the Dutch respondents tended to be superficially more tolerant and welcoming, yet subtly more negatively prejudiced than their European peers (Pettigrew 1998, 84). Moreover, in a way that recalls the populist right's piracy of the right to difference from the multicultural left in mid-1980s France, the public discourse of multiculturalism may generate a "me too" dynamic among those to whom multiculturalism policy was not originally meant to apply. In the Dutch case, the signal received from public policy that segregation was good legitimated and reinforced a complementary tendency toward "white flight." As Koopmans bitingly puts it, "The ethnic Dutch who evaded 'black' neighborhoods and schools could therefore do so with a perfectly good conscience" (2005, 17).

The jury deciding the causes of the Dutch socio-economic integration failure is out. The relevant matter is that the political elites responded by scaling back official multiculturalism and turning to civic integration. Their goal was migrant participation in mainstream institutions (later labelled "shared citizenship") and autonomy, which was to be achieved through Dutch-language acquisition and labour-market integration (see the overview by Han Entzinger, one of the intellectual engineers of the civic integration approach [2003]). The basis for this was the 1998 Newcomer Integration Law: *Wet inburgering nieuwkomers* (WIN). WIN obliges most non-EU newcomers[8] to participate in a 12-month integration course, which consists of 600 hours of Dutch-language instruction, civic education and preparation for the labour market.

When WIN was introduced, the coercive aspect was still subordinate to the service aspect. There were financial penalties attached to noncompliance, but they were relatively minor and hardly ever enforced by the responsible local governments. Moreover, this was a state-paid service with incontrovertibly positive intentions — to get migrants to work, to help them learn Dutch and thus to make them functioning members of Dutch society. However, over time the obligatory, coercive side of civic integration moved to the fore. On the part of the Dutch state, this entailed a paradoxical double movement of withdrawal and increased presence.

On the side of state withdrawal, the philosophy of autonomy and self-sufficiency (*zelfredzaamheid*) underlying civic integration was quickly extended to its actual provision, requiring migrants to pay for the integration courses in full. In addition, the provision of integration courses was farmed out to private organizations, and state involvement in the whole affair was reduced to the holding of standardized final tests. The state does not care whether a migrant actually attends the courses; only the test result counts. It has thus become quite literally true that, in the words of a justice ministry official outlining the spirit of the new integration law, "everyone is responsible for his own integration" (Musso-Van der Velde 2005). As a counterpoint to this privatization of integration, coercive state involvement has massively increased. According to the new integration law, which went into effect in March 2006, not just newcomers but also settled immigrants (so-called *oudkomers*), not a few of them Dutch citizens, are required to pass an integration test, which presents the state with an enormous logistical task — identifying, mobilizing and policing the entire migrant population of the country.

The crucial innovation on the coercive side is to tie the granting of permanent residence permits to the successful passing of an integration test. This creates a linkage between the previously separate domains of migration control and immigrant integration. It also constitutes an entirely new view of immigrant integration. So far, the prevailing view has been that a secure legal status enhances integration; now, the lack of integration is taken as grounds for refusal of admission and residence, and the entire integration domain is potentially subordinated to the exigencies of migration control (see Groenendijk 2004; De Heer 2004). The most drastic expression of this is integration from abroad. According to the new integration law of 2006, applicants for family reunification must take an integration test at a Dutch embassy abroad as a precondition for being granted a temporary residence permit. Integration from abroad is not a Dutch invention. It was first introduced in the context of the German *Aussiedler* policy — a preferential immigration scheme for ethnic Germans — at the moment when the "ethnic" credentials of ethnic German migrants became questionable. However, the crucial difference is that the German government supported German-language acquisition abroad with the massive funding of schools and language courses, while no Dutch education programs exist abroad. Integration from abroad thus boils down to no integration whatsoever, making the integration test a perfect tool for preventing unwanted immigration.

What began as an immigrant integration policy has thus turned into its opposite: a no-immigration policy. What caused this evolution? If one considers that none of the civic integration policies in other European states has gone to such an extreme, then the explanation is obvious: the right-wing populist turn Dutch politics took after the assassination of iconic leader Pim Fortuyn in 2002. Anxious mainstream politicians with a finger on the anti-immigrant public pulse — most notably the tough-minded current minister for immigration and integration, Rita Verdonk — have since pushed for an increasingly restrictive Dutch migration policy.

However, the restrictive turn also has to be related to the demographic profile of the migrant categories targeted by civic integration. In the absence of a significant program for labour migration, the large majority of newcomers are asylum and family migrants, many of whom are low-skilled or unskilled; they have very little if any schooling, and no Dutch-language competence. The harshest measure — integration from abroad — will apply only to family migrants, who are mostly from Turkey and Morocco. Turkish and Moroccan ethnics in the Netherlands (and elsewhere in Europe) have a high propensity for endogamy. In effect, this means that even second- and third-generation migrants look for a marriage partner in their parents' country of origin. A recent Dutch report on imported marriages claims that 70 percent of young Turks marry someone from their parents' home country, while among young Moroccans, 60 percent of females and 50 percent of males do so ("Netherlands" 2005). The offspring of such unions grow up in ethnically closed families, thus reinforcing and perpetuating the ethnic seclusion that characterizes the Turkish and Moroccan communities in the Netherlands. This is the very problem that the civic integration policy was designed to address from the start, but in its restrictive incarnation it is increasingly prominent.

France

The Dutch civic integration policy has quickly become a "model for Europe" (Michalowski 2004a), yet with significant national inflections. In Sweden and Finland, civic integration figures as more a right than an obligation, except when it comes to unemployed and welfare-dependent migrants, and there is no tying of integration programs to residence permits. In Denmark and Austria, the obligatory aspect of civic integration and its linkage with residence permits have been

dominant from the start; the scope of the program has remained limited to new-comers in Denmark, but it includes certain "old" migrants on temporary resident permits in Austria (Michalowski 2004b).

The French version of civic integration takes a middle position, moving from initial voluntarism toward the obligatory and coercive pole, though stopping well short of the Dutch extreme. Its domestic precursors are the *plates-formes d'accueil* (introduction platforms) — a program of voluntary half-day instruction for certain categories of newcomers (originally only family migrants) introduced by the socialist Jospin government in 1998. In July 2003, the Gaullist Raffarin government launched the more ambitious program of "contrats d'accueil et de l'intégration" (CAI), which has evidently taken its cues from the Dutch example (HCI 2001, 47-8). It consists of one day of civics instruction, followed (when deemed necessary) by 500 hours of French-language instruction. Interestingly, only about one-third of the 150,000 expected newcomers in 2006 (the first expected year of full operation of the new policy) are targeted for enrolment in a French-language course (Tabet 2004). The francophone background of the majority of newcomers to France is evidently an asset that positively distinguishes the French from the Dutch or German civic integration challenges. While this might lead to less emphasis on the earliest phase of immigrant integration, there is also an opposite consideration. As the Cour des Comptes outlined, with an eye on the French distaste for ethnic-origin classification, *accueil* (reception) constitutes the only moment in the integration process "where the targeted public can be easily designated without creating a legitimacy problem for public action" (2004, 125).

CAI and the reform of *accueil* constitutes one of two pillars of a comprehensive re-founding of the French politics of integration; the other pillar is the struggle against discrimination in terms of anti-discrimination policy. The first targets the beginning, the latter the end of the integration process (HCI 2003).

In an interesting counterpoint to the Dutch case, the obligatory aspect of the French integration contract was much slower in moving to the fore. While about 90 percent of applicable newcomers sign an integration contract, only 65 percent of those who are prescribed a French-language course follow up on it (Tabet 2004). This has provided impetus for making CAI obligatory. The Sarkozy Law of November 2003, which drastically restricts access to legal permanent residence, makes the receipt of a 10-year residence card dependent on "l'intégration républi-caine," which the law defines as "connaissance de la langue française et des

principes que régissent la République française" (quoted in Lochak 2004).[9] Most importantly, family migrants (spouses and minor children), who previously had direct access to a 10-year residence card (or at least the same residence status as the sponsor), now receive only a one-year card, and only after two years can they apply for the all-important 10-year card, subject to the *intégration républicaine* proviso.

As in the Netherlands, the intention is to fight ethnic endogamy, referred to by Sarkozy as "communautarisme parfaitement clanique" (perfectly clannish communitarianism). Sarkozy elaborates the rationale: "Ce que nous voulons, c'est obliger celui qui fait venir, dans le cadre du regroupement familial, une personne, laquelle est généralement sa femme, à lui permettre d'apprendre le français et de s'insérer dans notre société" (quoted in Lochak 2004, 4).[10] Criticized by Lochak as a "perversion de la logique et de l'équité" (a perversion of logic and equity), this amounts to a double illiberalism in pursuit of a liberal goal: it does not just directly oblige a person to become autonomous, which is the usual rationale of civic integration, but it employs patriarchy and third-party pressure (a husband) to oblige another person (his wife) to be free (2004, 4). While the Sarkozy Law does not specify how *l'intégration française* is to be formally determined, the next logical step is to determine such integration in terms of the integration contract (CAI), and to make the latter obligatory for a 10-year residence card. This promptly occurred in the 2006 immigration law, passed under Sarkozy's second spell as interior minister.

If the obligatory turn of civic integration has been slow in coming, one reason is that the notion of "contract," which is rather casually deployed for the civic integration schemes in the Netherlands and other European countries, is taken rather more seriously in France. For the president of the Haut Conseil à l'Intégration (HCI), Blandine Kriegel, the integration contract is "inscribed in the French tradition of the *contrat social*" (Kriegel 2004). Thus approximated to the foundation of the French Republic, the integration contract could not be forced upon the migrant; otherwise, it would not be a "contract." A contract creates obligations but logically cannot be an obligation in itself. Accordingly, the Haut Conseil's initial proposal for an integration contract, which would "show the willingness of immigrants to fit into the receiving society," insisted that it had to be voluntary (HCI 2001, 60).

The French couching of civic integration in terms of the *contrat social* is interesting in a second respect: the foreign (Dutch) sources become invisible. For

Kriegel, the integration contract is a continuation of the French model, untainted by foreign influences: "Il ne faudrait pas qu'en important des methods fonctionnant parfois dans d'autres pays, nous coupions notre lien vivant avec l'héritage de l'integration républicaine" (Kriegel 2004).[11] The unspoken purpose of this nationalization of civic integration was to rebut calls on left and right alike for "positive discrimination" (on the anti-discrimination front), which posed an even bigger threat to the French model. Whatever the intention, the will to paint in national colours what is undoubtedly a foreign import (or, rather, the common European *démarche* in matters of immigrant reception) is unmistakable. When first launching the idea of integration contracts, the HCI (under a different president) was less reluctant to express the postnational spirit of civic integration, calling it a policy that was "pragmatic" and that had a "precise goal: to permit newcomers to become rapidly autonomous in the receiving society" (HCI 2001, 49). These could also have been the words of a Dutch or German integration pundit.

Germany

While there was some denial of the nondomestic roots of the *contrats d'intégration* in France, reference to the Dutch model lent even more legitimacy to the introduction of similar *Integrationskurse* (integration courses) in Germany. Faithful to its postnationalism, Germany, in an opposite move to that of France, repressed the indigenous sources of the new approach in its *Aussiedler* policy. Since the 1990s, Germany had offered language courses to would-be ethnic migrants in Eastern Europe and Russia, which prepared them for a status test that they had to pass before they would be entitled to immigrate to Germany; and after arrival there was additional state-funded language instruction and civic orientation for a period of six months. The new *Integrationskurse*, the focus of which is likewise on language acquisition, simply extend to non-EU, non-ethnic migrants a program that was already in place for ethnic Germans. The true novelty of the *Integrationskurse* is that ethnic and non-ethnic migrants are now enrolled in the same program of 600 hours of German-language instruction and 30 hours of civics instruction. This is also the last stab against the old notion that ethnic migration is not immigration but rather a homecoming of co-ethnics, to be processed in a separate legal regime.

However, the influence of the *Aussiedler* paradigm shows in the reluctance to follow the obligatory and coercive tilt of the Dutch model. Since the idea of the *Integrationskurse* was first introduced by the Süssmuth Commission of 2001

(which prepared the ground for the 2004 German immigration law), immigrants' right to participate was stressed, though it was never in doubt that their attendance would also be obligatory. The Süssmuth Commission wanted to have its cake and eat it too: "[T]he courses should be obligatory; however, penalties in the case of non-attendance...cannot be implemented and are not practicable" (2001, 260). How can there be an obligation without penalty? The same twisted logic is found in the few clauses of the 2004 immigration law (*Zuwanderungsgesetz*) that deal with the promotion of integration and lay out the design of the integration courses. Article 43 creates an "entitlement" to participate for non-EU newcomers; article 43a, in turn, creates an "obligation" to participate for those who are "entitled" according to the preceding clause but who "cannot hold a simple oral conversation in the German language," and for settled migrants who are dependent on welfare. According to this bizarre construct, newcomers are at the same time "entitled" and "obliged" to enrol in an integration course.

If there was debate surrounding the new policy, it focused on the question of sanctions (positive or negative?) and who would pay (the migrant or the state, and if the latter, the federal state, the subfederal states or Länder, or the communes?). The dividing line on both questions was obvious — the conservative Christian Democratic Union/Christian Social Union pushing for a hard line of negative sanctions and user payment; and the majority in the ruling Social Democratic Party and the Greens, in line with the recommendations of the Süssmuth Commission (2001, 260-5), favouring positive incentives and having the federal state and the Länder pay. In the end, a compromise was reached on both questions. The bulk of the costs are now carried by the federal state, and migrants are required to pay only a modest fee of one euro per hour (if any euro at all, due to generous opt-out clauses). An element of the positive sanctions remains, in the sense that the residence requirement for as-of-right naturalization will be lowered from eight to seven years for those migrants who successfully complete the integration course. There is a larger catalogue of negative sanctions. When it comes to financial penalties, there is a (modest) reduction of social benefits. With respect to the denial of residence permits, an elastic formula was inserted in the 2004 immigration law: noncompliance "can" lead to the non-renewal of a temporary residence permit or the denial of a permanent one, provided that these permits are discretionary (article 8.3). This is a "can" with considerable strings attached (existing family and other social ties in the Federal Republic must

especially be considered), so it is not likely to cut much ice (see Heinen 2004). Most importantly, family migrants are not at all affected by this, because their entitlement to a residence permit is not discretionary but grounded in constitutional law. As the majority of newcomers to Germany arrive as family migrants, the rough edges of the civic integration policy do not apply to them (see Beauftragte der Bundesregierung für Migration, Flüchtlinge und Integration 2005a, 208).

The European Union

The Dutch model of civic integration not only has spread horizontally to other European states but it has also had a vertical effect on the emergent European Union law on immigrant integration. Most notably, the November 2003 directive on long-term third-state residents carries its imprint. For many years, this measure was one of the main demands of the pro-migrant lobby in Europe; its original thrust was to align the status of settled immigrants in Europe with that of EU citizens, especially with respect to free-movement rights within the EU. During the long negotiations over this directive, Germany and Austria (with the Netherlands supporting them) pushed for a new restriction that would tie the acquisition of secure residence status — which, in turn, would allow free movement in Europe — to compliance with the "integration conditions" set by national law. Replacing the term "integration measures," used in the old text, with "integration conditions" allows member states to have migrants pay for the integration courses (see Groenendijk 2004, 122-3). More importantly, the directive allows a multiplication of the civic integration obligation for moving non-EU citizens: having complied with the civic integration requirement in the first state, the migrant may be asked to comply with a similar integration requirement in the second state (though only with respect to language acquisition). This constitutes a barrier for intra-European mobility that does not exist for EU citizens, thus partially defeating the original purpose of the directive.

Illiberal Policy in a Liberal State

While there is considerable national variation with respect to the scope and the level of restrictiveness of civic integration policies across Europe, a focus on "obligation" (and a reverse de-emphasis on "rights") is a feature they all share. Desmond King argued that a balance between rights and duties is inherent in "liberal contractualism," and that at times this balance could shift decidedly toward

"duties" (1999, 18). Civic integration is an instance, like eugenics and workfare policies, of illiberal social policy in a liberal state. King's important insight is that such policies are not born of sources extrinsic to liberalism, such as nationalism or racism, but are inherent in liberalism itself. For instance, liberalism's core tenets of freedom and equality presuppose that "members of the polity possess the necessary reasoning powers or ability to...plan for their future" (King 1999, 8). This creates illiberal temptations with respect to those who do not meet these criteria.

By the same token, it would be wrong to interpret civic integration of immigrants as a rebirth of nationalism or racism. These policies carefully observe the dividing line between integration, which leaves the ethical orientation of the migrant intact, and assimilation, which does not. As the French Haut Conseil à l'Intégration put it, "l'intégration civique doit respecter l'identité de chacun et se marquer de l'assimilation"; it is limited to "enseigner aux nouveaux arrivants...la loi commune, autrement dit la Constitution" (2003, 106, 85).[12] Whereas the Netherlands has recently become more aggressive in disseminating "Dutch norms and values" (Musso-Van der Velde 2005, 2), the only provocative part of this campaign — when disseminated in the form of an instructional video for integration abroad — was pictures of kissing men, rock concerts and women with naked breasts, and these images were promptly censored for Islamic viewers. A Manual for Germany, distributed to newcomers by the German commissioner for foreigners' affairs, remarks under the rubric "Art and Culture" that "[c]afés serve espresso, cappuccino and café au lait," that "[p]otatoes are served as a side dish along with French baguettes and Turkish flatbread" and that "German popular music is heavily influenced by American music" (Beauftragte der Bundesregierung für Migration, Flüchtlinge und Integration 2005b, 28). Not only is the diction of these statements cognitive rather than normative, with no presumption that newcomers share such preferences, but it is also clear that every attempt has been made to dilute distinctive German traits.

The paradox of civic integration is still that it involves pursuing liberal purposes (shared citizenship, autonomy) through illiberal means. A normative judgment on this is beyond the scope of this chapter. Consider, however, that this is only part of a larger paradox of liberalism: the realization of liberal values always depends upon states, which are by nature exclusive and illiberal institutions with borders and (generally) ascribed rather than freely chosen membership.

Discussion

C ONVERGENCE IN IMMIGRANT INTEGRATION IN WESTERN EUROPE IS NOT EXHAUSTED by the trend toward civic integration. A second convergent trend is the rise of anti-discrimination, partially in response to European Union law; a third convergent trend is toward more inclusive citizenship laws by means of facilitating naturalization and introducing conditional *jus soli* citizenship for the descendants of immigrants; a fourth trend is the reinforcement of state neutrality in questions of cultural difference, and a parallel retreat from multicultural recognition.

In reviewing the entire field of western European immigrant integration, one notices the confluence of two very different, perhaps contradictory, types of liberalism. On the one hand, there is Rawlsian liberalism, with its emphasis on equality, individual rights and neutrality; this is the liberalism that has moved states from assimilation to integration and that requires states to assure a modicum of equality for all members of society. On the other hand, recent policies of civic integration, in particular, have revealed the parallel existence of a liberalism of power and disciplining, which has attracted much attention in a Foucault-inspired literature on governmentality and neoliberalism (see, for example, Rose 1999; Dean 1999). In the optic of this Foucauldian liberalism, the contemporary state, hollowed out by economic globalization, is coercing individuals, as well as the communities of which they are a part, into releasing their self-producing and self-regulating capacities as an alternative to the redistribution and public welfare that fiscally diminished states can no longer deliver. Civic integration for immigrants is equivalent to workfare policies for the general population — policies that have arisen in the context of shrinking welfare states (see Handler 2004). Both seek to make people self-sufficient and autonomous by illiberal means.

Because immigrants stand at the intersection of different nation-state societies, one is inclined to interpret repressive policies toward them in nationalist or racist terms. However, this has the smell of yesteryear — liberal constitutionalism rules out these possibilities. Instead, the repressive impulse, at least at the level of state policy, now stems from liberalism itself; this is the distinct contribution of the Foucault-inspired reading of liberalism. John Stuart Mill had already limited liberalism to "human beings in the maturity of their faculties," thus excluding all those who were not; and those not "in the maturity of their faculties" could be induced to achieve that state through — by definition — illiberal means.

Accordingly, for "barbarians" "despotism" was a "legitimated mode of govern-ment," provided its purpose was their improvement (Dean 1999, 133). Contemporary civic integration or workfare policies are of the same kind, because they involve putting illiberal means to the service of liberal goals.

A difference, however, exists with respect to the *context* of repressive liberal-ism then and now. We no longer have nationally bounded societies (the context of empire, as in Mill's example of the "good despot," did not much change this) but a globally unbounded society. This changes the meaning of "integration" — we have shifted away from the old notion that integration had to be integration into a nation-state society. In her intriguing analysis of changing public school curricula in Britain, Canada and the US, Katharyne Mitchell found that the vision of good citizenship inculcated by public education was no longer centred on the national, if "multicultural," self but on the "strategic cosmopolitan," who could function in any national setting (2003). The perceived need to master global com-petition is indeed one reason why old group narratives of multiculturalism — perhaps nationalism's historical rearguard (see Favell 1998 on Britain) — are giv-ing way to a new focus on the individual and her autonomy and self-sufficiency.

Symptomatic, in this respect, is the centrality of employment in Europe's contemporary immigrant integration policies. As the European Commission observed in its *First Annual Report on Migration and Integration*, "access to employ-ment" has become "the most important political priority within national integra-tion policies" (2004, 5). On one level, this priority is as old as the hills, consonant with Brecht's belly-centred ethic of "Erst kommt das Fressen, dann kommt die Moral" ("First comes a full stomach, then come ethics"). However, on a more sub-tle level, this also displays a novel sense of integration in the postnational state as social inclusion, which is itself subordinate to the exigencies of globalization. In the European Union, for instance, the combat against social exclusion is not free-standing but tied to the global competition goal, formulated within the so-called Lisbon Strategy, of making the EU "the most competitive and dynamic knowl-edge-based economy in the world" by 2010. From this perspective, anti-discrimination laws and policies, as envisioned in the EU race directive, do not so much aim at equality as allow a full utilization of society's resources in the global competition. As Eberhard Eichenhofer puts it, women, the handicapped, the elderly and ethnic minorities "are to be fully included in the society and labour market of the member states, not least in order to reduce the costs for

social protection or welfare" (2005, 2). Overall, social inclusion becomes narrowly tied to the labour market rather than to the nation-state at large, motivated by the image of society as a "machinery of performance" (Haahr 2004, 225).

In its economic instrumentalism, integration as social inclusion is a world apart from old notions of cultural assimilation and nation-building. However, there is still a perfectionist dimension to it, and one with paternalist, obligation-imposing possibilities, in the sense that being in work is not just having an income; it is of intrinsic importance to an individual's well-being, and thus to be pursued, or imposed, for its own sake. The main purpose of social inclusion is social cohesion — that is, order, not justice. This distinguishes social inclusion, as a Foucauldian liberalism, from the Rawlsian liberalism of equal opportunities, which was the lodestar of the classic welfare state: "Whereas the aim of equality of opportunity [is] to put people in a position in which they are able to participate in the economy and other aspects of social life, the aim of social inclusion also seems to include an element that sometimes requires people to become included. There are no rights without responsibilities" (Collins 2003, 24-5). Social inclusion is *not* about equality: "Social inclusion does not seek the same…outcomes for citizens. It concentrates its attention…on the absolute disadvantage of particular groups in society" (Collins 2003, 22). Social inclusion thus justifies group-specific policies of the state; it is indeed the prime justification of anti-discrimination policies that violate the equal-treatment principle, such as positive action. If France is being pushed toward colour-conscious anti-discrimination policies, thus mellowing its traditional rejection of communitarianism, the reason is that, like all states in the European Union today, it is under the sway of the social inclusion and cohesion objectives.

At the same time, one should beware of taking a Foucauldian perspective of repressive liberalism too far. Rather than springing from generic features of a neoliberal state that is seen as comprehensively engaged in a coercive privatization of social reproduction, civic integration policies, as we have seen, are not all of a piece. The different contours of these policies in different states also reflect something other than statist variables — the left-right balance of the political forces or the demographic profile of migrants, among other possibilities. In Europe, the Netherlands, pressured by a uniquely strong populist movement, went further than other European states in expanding the repressive dimension of civic integration; in other states, such as Germany, the obligatory thrust of this

policy exists on paper only, and in reality it bears more resemblance to remedial settlement aids for newcomers. Moreover, only in the Netherlands did the entire policy become truly privatized, as neoliberalism would have it, by making the migrant fully responsible and paying for her integration. By contrast, in France there was no question that in instituting integration policy, the state had to retain its traditional role in guaranteeing national unity. The contractual element of civic integration even permitted the policy to be associated with a rejuvenation of French republicanism; the attempt to push the obligatory and repressive side of the policy has therefore been weaker (though eventually not unsuccessful).

If we ask why civic integration in Canada, practised since 1950 under the blander guise of settlement programs (Bloemraad 2005), has retained its entirely optional aspect while in Europe it has been marked by a repressive tone, the plausible answer draws us even further away from political or state-related variables. While an explanation can only be hinted at here, an important role must be attributed to the different demographic and sociological profiles of migrants to Canada and Europe. Canada predominantly selects highly skilled and resourceful immigrants, which naturally eases their adjustment. The majority of migrants to Europe, by contrast, are not selected at all but enter on the basis of rights, either family or refugee rights. Because a majority of these migrants are unskilled and (with the exception of those entering France) not proficient in the language of the receiving society, and since they often become immediately dependent on welfare, they face serious adjustment problems. The obligatory and repressive dimension of civic integration in Europe cannot be uncoupled from the unselected status of most of its migrants.

The comparison of civic integration policies in the Netherlands, France and Germany reveals significant divergence in their respective national interpretations and implementations. Does this confirm the persistence of national models of integration and thus refute the central claim of this chapter? Unsurprisingly, the answer must be no. Most of the observed variations run counter to what the national models (or, rather, the accumulated stereotypes of a given country and its policy) would predict. The multicultural Netherlands adopted the most repressive variant of civic integration. Republican France, where the degree of articulation of its philosophy of integration is without parallel in the world, now submits to Rawlsian political liberalism, while its pragmatic stress on the principle of "becoming rapidly autonomous" betrays an acceptance of the otherwise

despised tenets of neoliberalism (HCI 2001, 49). And segregationist Germany has adopted the mellowest, least control-minded, most "Canadian" variant of civic integration. Overall, the withering of national models of immigrant integration in western Europe is unsurprising, because if anywhere, this is the part of the world in which neatly bounded nation-states no longer exist.

Notes

1 To avoid engaging in the academic blame game, I will not cite some of the earlier formulations. The most sophisticated contemporary formulation, which responds to some of the shortcomings of older approaches, and which operates with four instead of three possibilities, is Koopmans et al. (2005, chapter 2).

2 "In democratic republics, the State has no vocation to impose values, because it grants its citizens the liberty to choose them."

3 "Integration is: 'I welcome you as you are to the republican melting pot.' Assimilation is: 'I will make you disappear.'"

4 In EU jargon, this is the "Lisbon Strategy" (as if any strategy could ever achieve that much), and it was formulated at the EU Lisbon summit in March 2000.

5 Such soft integration has now been put to the service of legal integration in terms of the "open method of coordination" enunciated in the European Commission's 2001 *European Governance: A White Paper*.

6 Other common basic principles of integration policy not further discussed here are education, intercultural dialogue, political participation (especially at the local level), the mainstreaming of integration policies in other policy portfolios and the development of better indicators and evaluation mechanisms.

7 The motif of incremental rights is also invoked in the European Commission's communication to the council of June 3, 2003, which laid the ground for the November 2004 council conclusions on common principles of European integration policy (European Commission 2003, 5).

8 EU migrants are exempted through European Community law (because it would constitute discrimination on the basis of nationality), and the citizens of most developed OECD countries (such as the US, Canada, Australia, New Zealand and Japan) are exempted through bilateral treaties.

9 "Knowledge of the French language and the principles that govern the French Republic."

10 "What we want is to oblige the person who sponsors another person, generally a wife, within the family regrouping framework, to permit that person to learn French and to fit into our society."

11 "No matter how these methods sometimes function in other countries, we must not sever our living bond with the heritage of republican integration." Close to Chirac, Kriegel is clearly the rearguard of French immigration reform, in contrast to previous presidents of the HCI.

12 "Civic integration must respect the identity of the individual and be differentiated from assimilation"; "teaching new arrivals the common law...otherwise known as the Constitution."

References

Barbier, Christophe, and Eric Conan. 2004. "Sarkozy : 'ce que je veux pour la France.'" *L'Express*, January 19, 30.

Barraclough, Geoffrey. 1967. *An Introduction to Contemporary History*. Harmondsworth: Penguin.

Beauftragte der Bundesregierung für Migration, Flüchtlinge und Integration. 2005a. *Sechster Bericht über die Lage der Ausländerinnen und Ausländer in Deutschland*, BT-Drs. 15/5826. Berlin: Bundeszentrale für politische Bildung.

———. 2005b. *A Manual for Germany; Ein Handbuch für Deutschland*. Berlin: Bundeszentrale für politische Bildung.

Bloemraad, Irene. 2005. *Becoming a Citizen*. Berkeley: University of California Press.

Böcker, Anita, and Dietrich Thränhardt. 2003. "Erfolge und Misserfolge der Integration: Deutschland und die Niederlande im Vergleich." *Aus Politik und Zeitgeschichte* B26:3-11.

Collins, Hugh. 2003. "Discrimination, Equality and Social Inclusion." *The Modern Law*

Review 66: 16-43.

Council of the European Union. 2004. *Immigrant Integration Policy in the European Union*, 14615/04 (presse 321), November 19. Brussels: Council of the European Union. Accessed April 5, 2006. http://ue.eu.int/ueDocs/cms_Data/docs/pressData/en/jha/82745.pdf

Cour des Comptes. 2004. *L'Accueil des immigrants et l'intégration des populations issues de l'immigration*. Rapport au président de la République suivi des réponses des administrations et des organismes intéressés. Paris: Cour des Comptes. Accessed April 5, 2006. http://www.ccomptes.fr/Cour-des-Comptes/publications/rapports/immigration/immigration.pdf

Dean, Mitchell. 1999. *Governmentality: Power and Rule in Modern Society*. London: Sage.

De Heer, Jan-Coen. 2004. "The Concept of Integration in Converging Dutch Minority and Migration Policies." *IMIS-Beiträge* 24:177-88.

Doomernik, Jeroen. 1998. *The Effectiveness of Integration Policies towards Immigrants and Their Descendants in France, Germany and the Netherlands*. International Migration Papers 27. Geneva: International Labour Organization.

Eichenhofer, Eberhard. 2005. "Stellungnahme zu dem 'Entwurf eines Gesetzes zur Umsetzung europäischer Antidiskriminierungsrichtlinien.'" In *Deutscher Bundestag: Ausschuss für Familie, Senioren, Frauen und Jugend*. A.-Drs. 15 (12) 440-I: 1-5.

Entzinger, Han. 2003. "The Rise and Fall of Multiculturalism: The Case of the Netherlands." In *Toward Assimilation and Citizenship: Immigrants in Liberal Nation-States*, edited by Christian Joppke and Ewa Morawska. Basingstoke: Palgrave-Macmillan.

European Commission. 2001. *European Governance: A White Paper*, July 25, COM(2001) 428 final. Brussels: European Commission.

————. 2003. *Communication on Immigration, Integration and Employment*, June 3, COM(2003) 336 final. Brussels: European Commission.

————. 2004. *First Annual Report on Migration and Integration*, July 16, COM(2004) 508 final. Brussels: European Commission.

Favell, Adrian. 1998. *Philosophies of Integration: Immigration and the Idea of Citizenship in France and Britain*. London: Macmillan; New York: St. Martin's Press.

Ferguson, Niall. 2004. "Eurabia?" *New York Times Magazine*, April 4, 13.

Freeman, Gary. 2003. "Incorporating Immigrants in Liberal Democracies." CMD Working Paper 03-09d. Princeton: Center for Migration and Development, Princeton University.

Groenendijk, Kees. 2004. "Legal Concepts of Integration in EU Migration Law." *European Journal of Migration and Law* 6:111-26.

Guiraudon, Virginie. 2004. "Construire une politique européenne de lutte contre les discriminations : l'histoire de la directive 'race.'" *Sociétés Contemporaines* 53:11-32.

Haahr, Jens Henrik. 2004. "Open Co-ordination as Advanced Liberal Government." *Journal of European Public Policy* 11 (2): 209-30.

Handler, Joel. 2004. *Social Citizenship and Workfare in the United States and Western Europe: The Paradox of Inclusion*. Cambridge Studies in Law and Society. New York: Cambridge University Press.

HCI (Haut Conseil à l'Intégration). 2001. *Les Parcours d'intégration*. Paris: La Documentation Française.

————. 2003. *Le Contrat et l'intégration*. Paris: La Documentation Française.

Heinen, Guido. 2004. "Die Integrations-Industrie." *Die Welt*, July 7.

Khalaf, Roula. 2005. "Muslims' Integration in Europe Is Urgent Challenge." *Financial Times*, July 15.

King, Desmond. 1999. *In the Name of Liberalism: Illiberal Social Policy in the USA and Britain*. Oxford: Oxford University Press.

Koopmans, Ruud. 2002. "Good Intentions Sometimes Make Bad Policy: A Comparison

of Dutch and German Integration Policies."
Unpublished paper.

———. 2005. "Tradeoffs between Equality and
Difference: The Failure of Dutch
Multiculturalism in Cross-National
Perspective." Paper presented at "Immigrant
Political Incorporation," April 22-23,
Radcliffe Institute for Advanced Study,
Harvard University.

Koopmans, Ruud, Paul Statham, Marco Giugni,
and Florence Passy. 2005. *Contested
Citizenship: Immigration and Cultural
Diversity in Europe*. Minneapolis: University
of Minnesota Press.

Kriegel, Blandine. 2004. "Le Souci d'une France
commun." Interview by Alexis Lacroix. *Le
Figaro*, December 4.

Leiken, Robert. 2005. "Europe's Angry Muslims."
Foreign Affairs, July-August, 120-35.

Lochak, Danièle. 2004. "L'Intégration, alibi de la
précarisation." *Plein Droit* 59-60. Accessed
August 15, 2005.
http://www.gisti.org/doc/plein-droit/59-
60/alibi.html

Marzal, Elia. 2004. "Constitutionalising
Immigration Law." Ph.D. diss., European
University Institute, Florence.

Michalowski, Ines. 2004a. "Integration
Programmes for Newcomers: A Dutch
Model for Europe?" *IMIS-Beiträge* 24:163-
75.

———. 2004b. *An Overview on Introduction
Programmes for Immigrants in Seven
European Member States*. Amsterdam:
Adviescommissie voor
Vreemdelingenzaken.

———. 2005. "Das niederländische
Integrationsmodell als Vorbild und die
Debatte über sein 'Scheitern.'" *Netzwerk
Migration in Europa* 1:1-5.

Mitchell, Katharyne. 2003. "Educating the
National Citizen in Neoliberal Times: From
the Multicultural Self to the Strategic
Cosmopolitan." *Transactions of the Institute
of British Geographers* n.s., 28:387-403.

Musso-Van der Velde, Sandrine. 2005.
"Immigrant Integration Policy: The Case of

the Netherlands." Unpublished paper.

"Netherlands." 2005. *Migration News Sheet*, July
26, 26.

"Parliamentary Report on 'Failing' Dutch
Immigration Policy." 2004. *Migration News
Sheet*, February 25.

Peel, Quentin. 2005. "Rootless Bombers and a
Faceless Cause." *Financial Times*, July 14.

Pettigrew, Thomas F. 1998. "Reactions toward the
New Minorities of Western Europe." *Annual
Review of Sociology* 24:77-103.

Rawls, John. 1993. *Political Liberalism*. John
Dewey Essays in Philosophy 4. New York:
Columbia University Press.

Rose, Nikolas. 1999. *Powers of Freedom:
Reframing Political Thought*. Cambridge:
Cambridge University Press.

Roy, Olivier. 2005. "Wiedergeboren, um zu
töten." *Die Zeit*, July 21, 3.

Soysal, Yasemin. 1994. *Limits to Citizenship:
Migrants and Postnational Membership in
Europe*. Chicago: University of Chicago Press.

Süssmuth Commission. 2001. *Zuwanderung
gestalten: Integration fördern*. Bericht der
Unabhängigen Kommission
"Zuwanderung." Berlin: Süssmuth
Commission.

Tabet, Marie-Christine. 2004. "Le contrat d'inté-
gration a peine à se mettre en place." *Le
Figaro*, September 27.

———. 2004. "Moins de contrats d'intégration."
Le Figaro, May 19, 10.

Diversity, Integration
and the Turn from
Multiculturalism in
the United Kingdom

T HE UNITED KINGDOM BECAME A COUNTRY OF IMMIGRATION AFTER THE SECOND
 World War, with the large-scale immigration from its former colonies. For
most of the postwar period in the UK, the entry of new migrants has been a
volatile political issue, and interest in it has tended to increase or wane along with
the flow of new arrivals. Thus, peak periods of immigration — 1958 to 1962,
1967 to 1975, and 1997 to 2002 — have prompted public hostility, press hyste-
ria and party politicization of the issue. Throughout these periods, migrants were
viewed as a problem for the reasons that had been cited for decades by immigra-
tion's opponents: immigrants were competitors for scarce jobs, housing and social
services; and they threatened to alter the character of existing communities. More
recently, critics of immigration have expressed two fresh concerns: that immigra-
tion undermines social solidarity and thus the welfare state; and that not only
older generations of immigrants but also their children are failing to identify suf-
ficiently with Britain and British values. The fact that three of the four suicide
bombers who blew themselves up on London's transport system in July 2005
were British Muslims has exacerbated these fears, and it has served to call into
question the country's commitment to multiculturalism.

 Neither of these sets of concerns is unique to Britain. Both postwar migra-
tion to Britain and the recent "return to integration" (Brubaker 2003) have their
analogues across Europe. Postwar migration to the UK followed a classic colo-
nial pattern (Hansen 2005): labour shortages generated by Britain's relative post-
war affluence were filled by colonial workers who took advantage of privileged
immigration channels created by the country's citizenship laws (Hansen 2000).
Until the mid-1960s, migration was a market-driven phenomenon sanctioned

by an imperial citizenship regime. From then on, the number of migrants entering the UK for the purposes of family reunification was high compared with those entering for other reasons (despite several efforts to rectify the imbalance). Migration patterns were stable from the early 1970s until the 1990s, though they were punctuated by several mass influxes caused by the expulsion of East African Asians (in 1973 and 1975). Starting in the mid-1990s, the number of skilled migrants began ticking up, and by 2002 the UK was issuing record numbers of work permits (some 125,000 in 2004). At the same time, applications for asylum under the 1951 UN convention skyrocketed, increasing from some 20,000 to a 2002 peak of almost 100,000. This migration trilogy — young male workers, joined later by their families, followed by asylum seekers — played itself out across Europe.

In Britain, as in other European countries, events since the mid-1990s have undermined public confidence in the government's ability to integrate visible minorities and in the efficacy of its multiculturalism policies. In 2001, gangs of Asian and White youths fought in England's northern cities; in July 2005, four suicide bombers attacked London and four others failed in their attempts to do so; and in October 2005, riots broke out between members of Birmingham's Black and Asian communities. These events, widely covered by the media, occurred against the backdrop of the continuing socioeconomic deprivation of some sectors of the UK's visible minority population, and they have led high-profile figures to question multiculturalism and even immigration itself. In April 2004, Trevor Phillips, head of the UK Commission for Racial Equality (the body overseeing the implementation of race relations legislation), declared multiculturalism "dead." In the same year, the editor of *Prospect* magazine, David Goodhart, made national headlines by arguing that excessive levels of immigration would undermine social solidarity. Diversity, he concluded, was going "too far" (2004).

This chapter provides an overview of multicultural Britain — the policies the country has adopted to accommodate diversity and the outcomes on the ground. It asks how visible minorities have fared in education, employment, income and social integration, and it compares the answers to those that apply in other countries in Europe. Integration is understood in this chapter to mean socioeconomic integration — the extent to which visible minorities are indistinguishable from the broader population in their economic and educational

achievements. The assumption is that the smaller the gap between visible
minorities' employment, pay and education, the greater the degree of integra-
tion. This socioeconomic understanding of integration is distinct from what
might be called cultural integration, or the degree to which migrants are
accepted by and are involved in the broader society. Finally, the chapter asks
how robustly the UK has embraced multiculturalism and whether it is retreating
from this commitment. It advances three sets of arguments. First, against most
measures, the economic integration of visible minorities is a comparatively suc-
cessful failure. It is comparatively successful because the UK does better than
most Continental European countries; it is a failure because (with two important
exceptions) visible minorities continue to suffer socioeconomic deprivation.
Second, this deprivation is not constant among visible minorities or over time.
Some ethnic minorities do better than others; against some measures, second-
generation migrants have done better than first-generation, and against others
they have done worse. Third, the country's retreat from a commitment to multi-
culturalism reflects a significant change in rhetoric and mood, but only a limited
change in policy. The turn from multiculturalism in the UK has resulted in mod-
est coercive changes, particularly in the area of citizenship reform, but it has not
altered the basic principles and policies underlying the UK's approach to diver-
sity and integration.

Ethnic Diversity in the United Kingdom

TODAY, 10 PERCENT OF THE POPULATION (5.75 MILLION PEOPLE) HAVE
"community backgrounds" outside the UK (Parekh 2000). Some 5.7 per-
cent (3.25 million people) have community backgrounds in Africa, the
Caribbean or Asia. Visible minorities are concentrated in England's cities, and
above all in London: 57 percent of all African-Caribbean people live in Greater
London, as do 82 percent of all Africans, 49 percent of Bangladeshis, 42 per-
cent of Indians and 29 percent of Pakistanis. There are also substantial visible
minority concentrations in the West Midlands (including Birmingham) and in
West Yorkshire (including Bradford). Table 1 summarizes visible minority dis-
tribution across the country.

Table 1 354

Visible Minority
Population, by Region
and Local Area, United
Kingdom, 2002-03

Region and local area	2001 census (%)	2002-03 Annual Labour Force Survey (%)	Number of areas in region[1]	Proportion with non-White population of 2% or greater
United Kingdom	7.9	8.0		
Great Britain			407	43
England	9.1	9.3	353	48
Northeast	2.4	2.1	23	17
Tyne and Wear	3.2	2.7	5	40
Rest of Northeast	1.8	1.7	18	11
Northwest	5.6	5.5	43	42
Greater Manchester	8.9	9.2	10	90
Merseyside	2.9	2.4	5	20
Rest of Northwest	3.9	3.7	28	29
Yorkshire and the Humber	6.5	6.8	21	48
South Yorkshire	4.8	4.3	4	75
West Yorkshire	11.4	12.4	5	100
Rest of Yorkshire and the Humber	1.6	1.6	12	17
East Midlands	6.5	6.1	40	30
West Midlands	11.3	11.3	34	44
West Midlands[2]	20.1	20.6	7	100
Rest of West Midlands	3.0	2.5	27	30

(cont. on p. 355)

Visible Minority
Population, by Region
and Local Area, United
Kingdom, 2002-03
(cont. from p. 354)

Region and local area	2001 census (%)	2002-03 Annual Labour Force Survey (%)	Number of areas in region[1]	Proportion with non-White population of 2% or greater
East	4.9	4.6	48	52
London	28.9	30.7	33	97
Inner London	34.3	36.9	14	93
Outer London	25.4	26.7	19	100
Southeast	4.9	4.6	67	64
Southwest	2.3	2.3	44	20
Wales	2.1	2.4	22	18
Scotland	2.0	1.9	32	16
Strathclyde	2.4	2.7	12	17
Rest of Scotland	1.7	1.3	20	15
Northern Ireland	0.7	0.6	n/a	n/a

Source: Annual Local Labour Force Survey, in Technical Report: Labour Market Data for Local Areas by Ethnicity, by Keith Brook (London: Office for National Statistics, October 2004).
[1] Excludes the Isles of Scilly.
[2] West Midlands metropolitan county.

British Immigration Policy

BRITISH IMMIGRATION POLICY HAS THREE PILLARS: LABOUR MIGRATION POLICY, REFUGEE policy and family reunification policy. The bulk of labour migration policy occurs through the work-permit scheme. Under it, an employer applies to the Home Office on behalf of a worker who is not from a European Economic Area (EEA — the European Union plus Norway, Iceland and Lichtenstein). The permit (known as "limited leave to remain") is usually granted for four years, after which the individual may apply personally for permanent leave to remain, or permanent residency. Since 2004, individuals already in the UK have had to apply separately to the Home Office for further leave to remain; before 2004, the work-permit application was taken as the application for further leave to remain. Work-permit holders may bring their dependants with them. In 2006, it cost £153 (about C$310) to apply for a work permit. As table 2 indicates, the Home Office has issued between 65,000 and 85,000 work permits every year since 2000.

In addition to the work-permit scheme, Britain operates its own version of the Canadian points system: the Highly Skilled Migrant Programme (HSMP). Under it, individuals may apply directly to the Home Office, and they are given points in four categories: education (with extra points for an MBA from an elite university); work experience; past earnings; achievement in their chosen field, and their husband's, wife's or unmarried partner's achievements. If applicants obtain 65 points or more, they are granted leave to enter for one year. If they are economically active, they can stay for a further three years and then apply for permanent leave to remain. The application fee is £150.

The program was introduced in 2002 and was designed to improve the competitiveness of the British economy by increasing the skill level of migrants to the UK. The flow of immigration under it has, however, been light relative to that under the work-permit scheme. Between January 2002 and June 2004, nearly 20,000 applications had been submitted and 6,363 had been approved. The UK government is proposing to fold both schemes into a single, Canadian-style points scheme.

Family migrants account for a substantial portion of immigration to Britain. Work-permit holders have the right to bring spouses and dependants, and each year permanent residents and citizens apply to bring dependants to the UK. Because the flow is split into these various streams, it is difficult to determine the exact number of

family migrants the UK takes in, but Home Office statistics on settlement (which show how many family members become permanent residents) suggest that some 50,000 to 60,000 family members migrate permanently to Britain every year (table 3).

British refugee policy is governed by the United Nations convention relating to the status of refugees and its 1967 protocol, which the UK has signed. Until the late 1980s, the UK was not a popular destination for asylum seekers. According to United Nations High Commissioner for Refugees (UNHCR) statistics, in 1988, only 5,700 people lodged applications in asylum. This situation changed in the 1990s: applications rose sharply, reaching a peak of almost 100,000 in 2000, and the UK overtook Germany as the most popular destination for asylum seekers. Migration once again rose to the top of the political agenda, and the tabloids led a demonic campaign against "scrounging" asylum seekers. In response to this pressure, the UK adopted a range of measures designed to deter asylum seekers: reduced social benefits, time limits for lodging applications, reduced appeal rights, and the fast-tracking of claims deemed "manifestly unfounded." The UK also participates in European efforts to harmonize asylum policy, including the Dublin conventions requiring asylum seekers to apply for refugee status in the first EU state they reach. In recent years, the number of asylum applications has fallen, and the Home Office recorded 34,000 applications in 2004.

In addition to these three categories of migrants, an unknown number of EU workers and their families move to the UK each year. As they have full migration and residence rights, their arrival is not recorded, but anecdotal evidence suggests that the strong British economy lured large numbers of such workers, particularly to the service sector. Britain was also one of only three countries that granted citizens of central and eastern EU members the right to work following the EU enlargement of May 1, 2004.

Accommodating Diversity in the United Kingdom

ALTHOUGH POSTWAR MIGRATION WAS NOT ANTICIPATED OR WANTED (HANSEN 2000), British governments have articulated a series of policies designed to accommodate the nation's diverse population. These policies can be grouped into four categories: antidiscrimination, education, policing and citizenship.

Table 2 358

	All states (including accession states)		
	2000[1]	2001[1]	2002
Work permit category			
Employment for 12 months or more	36,290	50,280	51,525
Employment for less than 12 months	30,785	30,785	34,095
Dependants of work-permit holders	24,970	27,760	34,495
Issuees' region of origin			
Europe	9,880	10,040	14,090
Americas	33,855	31,375	31,900
Africa	9,160	14,100	15,695
Indian subcontinent	13,915	19,750	22,810
Rest of Asia	17,960	23,645	26,030
Oceania	7,175	9,785	9,370
Other regions	105	125	220
Total	**92,050**	**108,825**	**120,115**

Source: J. Dudley, M. Roughton, J. Fidler, and S. Woollacott, *Control of Immigration: Statistics United Kingdom, 2004* (London: Office for National Statistics, 2005).

[1] A change in procedure may have resulted in some under-recording for the fourth quarter of 2000 and the first quarter of 2001.

[2] These are provisional figures. They include nationals of the Czech Republic, Cyprus, Estonia, Hungary, Latvia, Lithuania, Malta, Poland, Slovakia and Slovenia before May 1, 2004, but exclude them from this date on.

[3] These figures exclude nationals of the Czech Republic, Cyprus, Estonia, Hungary, Latvia, Lithuania, Malta, Poland, Slovakia and Slovenia (countries that became part of the EEA on May 1, 2004) for the whole of 2003 and 2004.

Table 2

"Limited Leave to Remain"
Work Permits Issued, by
Work Permit Category and
Issuees' Region of Origin,
United Kingdom, 2000-04

		Excluding accession states	
2003	2004[2]	2003[3]	2004[3]
44,480	42,265	40,715	41,360
36,870	40,450	33,560	38,490
37,830	41,595	37,005	41,490
17,785	15,520	9,890	12,450
29,250	29,465	29,250	29,465
14,400	13,860	14,400	13,860
25,580	35,795	25,580	35,795
24,935	23,570	24,935	23,570
7,070	5,950	7,070	5,950
160	145	160	145
119,180	124,310	111,280	121,235

Table 3 360

Family category[2]	Total number		
	2000[3]	2001	2002
Husbands[5]	14,495	16,915	15,520
Wives[5]	24,265	26,835	25,120
Children	6,870	6,795	6,355
Parents and grandparents	2,435	1,760	1,750
Other unspecified dependants	5,000	4,570	4,015
Total family grants	**53,065**	**56,875**	**52,760**

Source: J. Dudley, M. Roughton, J. Fidler, and S. Woollacott, *Control of Immigration: Statistics United Kingdom, 2004* (London: Office for National Statistics, 2005).

[1] These figures exclude nationals of the Czech Republic, Cyprus, Estonia, Hungary, Latvia, Lithuania, Malta, Poland, Slovakia and Slovenia (countries that became part of the EEA on May 1, 2004).

[2] Spouses and dependants joining British citizens or people granted settlement.

[3] Excludes reconsideration cases (cases that were rejected but later reviewed and approved).

[4] These are provisional figures. May include a small number of cases in which a decision is recorded twice when an individual has dual nationality. Includes nationals of the Czech Republic, Cyprus, Estonia, Hungary, Latvia, Lithuania, Malta, Poland, Slovakia and Slovenia before May 1, 2004.

[5] Includes unmarried partners.

Grants of Settlement for
Family Formation and
Reunion, Excluding EEA
Nationals, by Family
Category, United
Kingdom, 2000-04

		Excluding accession states[1]	
2003[3]	2004[4]	2003	2004
17,380	8,190	17,105	8,140
30,795	12,925	28,950	12,395
8,955	5,855	8,770	5,805
3,090	1,985	3,070	1,985
5,855	5,945	5,745	5,905
66,075	**34,905**	**63,640**	**34,230**

The core of Britain's integration policy is an antidiscrimination framework gradually developed since the 1960s, always under a Labour government. Until 1962, Commonwealth immigrants, as British subjects, enjoyed unimpeded access to the United Kingdom (Hansen 2000, chapter 2); and in the 1950s, some 500,000 non-White migrants — mostly young, single men — travelled to the UK. A Conservative government enacted the first immigration controls in 1962, and the Labour opposition bitterly denounced the measure as populist and racist. Two years later, the Labour Party was in power, and it quickly recognized that family reunification meant that every pre-1962 migrant would bring to the UK two to four of his family members. It abandoned its previous commitment to open borders and extended immigration controls in 1965 (Hansen 2000, 136-7). At the same time, there had long been pressure from backbenchers (above all, the indefatigable Fenner Brockway) to enact antidiscrimination legislation, and the Home Secretary of the day, Frank Soskice, argued that immigration restrictions would be more palatable to his left-wing party if accompanied by legislation against racial discrimination. These liberal and illiberal sympathies were synthesized in 1965: labour immigration from the Commonwealth was halved, and race relations legislation was passed.

Erik Bleich usefully distinguishes between "expressive racism" (in which racial hatred is incited through the oral or written word) and "access racism" (in which an ethnic group's access to public or private goods is blocked on racist grounds) (Bleich 2003, 50-2). The *Race Relations Act, 1965* concentrated largely on expressive racism. The legislation criminalized the use of threatening, abusive or insulting written or spoken expressions designed to stir up hatred against others on the grounds of race, colour, or ethnic or national origin. Those convicted faced a maximum fine of £1,000 sterling (the equivalent of roughly £10,000, or C$20,000, in 2000) and a maximum sentence of two years' imprisonment. Prohibitions on access racism were limited to public places (hotels, pubs) and did not include discrimination in employment, the banking and insurance sectors or the private housing market. Heavily influenced by thinking in the United States and Canada (Bleich 2003, 52-5), access racism was subject to civil rather than criminal sanction: it was dealt with by conciliation backed up by recourse to the civil courts.

The legislation was timid, difficult to enforce and limited in its application (Bleich 2003, 59), but it had three implications for subsequent antidiscrimination policy. First, civil rather than criminal law was the basis of the UK's

antidiscrimination law. Second, the legislation created the three-member Race Relations Board, which would eventually become the Commission for Racial Equality, the administrative enforcer of Britain's race relations law. Finally, the legislation confirmed and reinforced an association between integration, accommodation and diversity on the one hand, and race and integration on the other. As many critics have noted, policy-makers defined immigration-related problems in the 1960s as problems of race rather than problems of racism. More specifically, politicians took for granted that race was a meaningful sociological category, defined the problem of integration as one that (as in the US) was basically a problem of race, and took as their leitmotif the pursuit of the somewhat nebulous goal of "good race relations."

The 1965 legislation has been extended several times in the last 40 years. In 1968, following a think-tank report highlighting extensive discrimination in employment and housing, the *Race Relations Act, 1968* extended the prohibition on discrimination to employment, housing, credit and insurance facilities. The legislation also increased funding for the Race Relations Board and empowered it to investigate independently instances of racial discrimination. Although the legislation was an improvement on its ineffective 1965 predecessor, those implementing it faced three difficulties: direct discrimination was difficult to prove, the administrative procedures invoked in cases of suspected discrimination were cumbersome and the English civil courts were conservative in their judgments. The 1976 Race Relations Bill addressed all three: it allowed individuals to appeal directly to the civil courts or to employment tribunals, it replaced the previous two-tiered structure (a race relations board supported by the Community Relations Commission) with the Commission for Racial Equality (CRE), and, most ambitiously, it expanded the definition of discrimination to include direct *and* indirect discrimination. The latter covers requirements or conditions that are formally nondiscriminatory but that disproportionately penalize members of a particular racial group.

Individuals who believe they have suffered racial discrimination have three months to take the complaint to an industrial tribunal and six months to take it to a county court.[1] There are 1,500 to 2,000 complaints per year (mid-1990s figures), and the majority are settled by industrial tribunals; 80 to 90 percent of complaints are withdrawn (usually when the employer makes some satisfactory offer) or decided against the plaintiff. In addition, there are about 200 cases that go to the courts; in 1997, 50 were decided against the plaintiff, 100 were settled out of

court and 50 were dismissed (Lieberman 2005). In addition, the CRE may itself get involved. In 2004, it received 556 applications for assistance (up 38 percent from 2003) and provided advice and assistance in 485 cases (CRE 2004, 27). The nature of that advice and assistance varies, but in these cases it fell short of representation. The CRE can also launch a formal investigation. Conducting such investigations requires a large staff, substantial financial resources and a great deal of time, so the CRE rarely does it: in 2004, the body closed one formal investigation (against Ford) and launched another. That the CRE can intervene at all creates a powerful incentive to comply with British antidiscrimination law, and often a simple letter from the CRE informing a company that the body is considering a named formal investigation will lead that company to amend its practices (Bleich 2003).

Alongside the civil sanctions against discrimination, the UK has — and always has had — provisions on the incitement to racial hatred, against which criminal charges can be brought. The incitement provisions are invoked in some 80 cases per year.

The behaviour of the police, particularly the London Metropolitan Police, toward visible minorities has long been a source of controversy, above all the practice of stopping and searching suspected criminals without providing justification or pressing charges. This power dates to the nineteenth century: under sections 4 and 6 of the *Vagrancy Act, 1824*, it is "illegal for a suspected person or reputed thief to frequent or loiter in a public [place] with intent to commit an arrestable offence." The ambiguity of the phrases "suspected person" and "reputed thief" effectively gave the police the power to stop anyone they chose. When the law (commonly referred to as the "sus" law) was dusted off in the 1960s, those whom the police stopped were disproportionately members of visible minorities: a 1976 study (sample size 2,112) found that 42 percent of those arrested under the law were Black (Layton-Henry 1992, 127). In response to violent interactions between the police and the Black community in 1981, the 1824 law was repealed, but stop and search continued. Visible minorities are to a disproportionate degree the target of the policy: according to Home Office statistics, in 2001-02, Black people were eight times more likely than White people to be stopped and searched (United Kingdom, Home Office 2003, chap. 6).

The most significant developments in relations between the police and minorities occurred in the wake of the Stephen Lawrence affair, in which the Metropolitan Police Service bungled an investigation into the racist murder of a Black Londoner

named Stephen Lawrence. After years of pressure from Lawrence's parents, Home Secretary Jack Straw announced in July 1997 an inquiry into the police handling of the investigation. The body conducting the inquiry reported in early 1999.

The 1999 Stephen Lawrence inquiry, chaired by Sir William Macpherson, led to several changes in thinking about, and police policy toward, visible minority inclusion. Analytically, its clearest contribution was the introduction into public debate of the concept of institutional racism — a concept first defined in the 1960s by Stokely Carmichael as racist acts committed by the total White community against the Black community. The issue was already familiar to sociologists, and the report brought it to a wider public. Macpherson defined racism as "the collective failure of an organisation to provide an appropriate and professional service to people because of their colour, culture or ethnic origin" (Home Office 2003). Since then, antiracists have applied the term to so many different organizations in the UK that they have made it more a term of abuse that a concept for social inquiry. The government, the Church of England, football clubs, the English theatre and schools, to name but a few, have all been declared institutionally racist. The original analysis, however, identified racism-generating mechanisms that are particular to police work. As one contributor to the inquiry, Robin Oakley, wrote, "Police work, unlike most other professional activities, has the capacity to bring officers into contact with a skewed cross-section of society, with the well-recognised potential for producing negative stereotypes of particular groups. Such stereotypes become the common currency of the police occupational culture. If the predominantly white staff of the police organisation have their experience of visible minorities largely restricted to interactions with such groups, then negative racial stereotypes will tend to develop accordingly" (Home Office 2003, chap. 6).

In other words, police work can make racists out of those who would not otherwise be. After initially resisting the admission, the chief of the London Metropolitan Police finally conceded that the police service was institutionally racist. The admission, and above all the report that forced it, occasioned a series of changes in policies on policing and in the UK's wider antidiscrimination policy.

The Macpherson Report led to a number of administrative changes in police policy, though not to a revolution. An end to stop and search was never on the agenda, but the police agreed to a phased implementation of the report's recommendation (number 61) that the reasons for stopping a person, the outcome

of the encounter and the self-defined identity of the person be recorded by the police. The MPs also created the Minority Members Network for visible minority police officers, provided race-awareness training for officers and cracked down on the use of racist language within the police force. The police now define a racist crime as one perceived by the victim or by any other person as racist. At the same time, the Crown Prosecution Service reinforced its presumption that racist crimes would be prosecuted and removed the possibility for prosecutors to plea bargain away racist crimes in exchange for a guilty plea to another crime. It is too soon to judge whether these efforts have improved relations between police and minorities. These relations have come under renewed strain — on July 22, 2005, police gunned down an unarmed and innocent Brazilian, Jean Charles de Menezes, whom they mistook for a suicide bomber.

Race Relations Act, 2000

THE MOST IMPORTANT CONSEQUENCE OF THE MACPHERSON REPORT, AND THE MOST important change in antidiscrimination policy in decades, was the *Race Relations Act, 2000*. Although enacted in response to the failings of the police service, it affected a much broader range of institutions. It extended the 1976 race relations legislation to all public bodies — the police, the universities, the National Health Service — and to all private bodies exercising public functions, with the exception of Parliament, the security services and immigration officers. It also placed a general duty on public authorities to work toward the elimination of unlawful discrimination and to promote equality of opportunity and good relations between people of different racial groups. The employment duty thus requires public employers to monitor, by racial group, staff in post and applicants for employment, training and promotion. Organizations with 150 employees or more are to monitor, by racial group, staff members who receive training, benefit or suffer as a result of performance assessment procedures, are involved in grievance procedures, or leave their jobs. In addition, the Home Secretary also imposed specific duties on public bodies. Institutions of further education, for instance, have to fulfill eight duties:

1. Prepare a written statement of their policy for promoting race equality.

2. Have in place arrangements for fulfilling, as soon as is reasonably practicable, their duties under paragraphs 5 and 6.
3. Maintain a copy of the statement.
4. Fulfill those duties in accordance with such arrangements.
5. Assess the impact of their policies, including their race equality policy, on students and staff of different racial groups including, in particular, the impact on attainment levels of such pupils.
6. Monitor, by reference to those racial groups, the admission progress of students and the recruitment and career progress of staff.
7. Include in their written statement an indication of their arrangements for publishing that statement and results of their assessment and monitoring.
8. Take such steps as are reasonably practicable to publish annually the results of their monitoring under this article. (CRE 2005)

These post-2000 changes amounted to an important evolution in anti-discrimination legislation. Whereas previous policies targeted access and opportunity, the new measures are concerned with outcome. Public bodies are compelled to consider their ethnic makeup and to question whether insufficient ethnic minority representation reflects their policies. That said, the measures only touch one part of the economy. They do not affect the private sector, and still less do they affect the ill-paid, precarious and often undocumented sector of the job market in which migrants and visible minorities are concentrated.

Religion and Diversity

THE UNITED KINGDOM IS IN THE CURIOUS POSITION OF HAVING AN ESTABLISHED CHURCH while being among the most secular societies in the Western world. Religion plays a central role in Northern Ireland (it once played a bloody role there as well), but on the mainland it has rarely, if ever, extended beyond local politics. The concentration of Irish Catholics in Liverpool, for instance, has sometimes resulted in abortion being an issue in local elections. Nationally, however, religion was a nonissue throughout much of the postwar period. The UK had no equivalent to the head-scarf affair in mid-1980s' France. This situation changed drastically in 1988, when Salman Rushdie published *The Satanic Verses*. In 1989, the Ayatollah Ruhollah Khomeini of Iran issued a fatwa sentencing the author to death. The fatwa made international headlines, but of

greater local interest was the reaction of British Muslims: large demonstrations were staged against Rushdie in Trafalgar Square, replete with an effigy of the author with his throat slashed; and copies of his book were burned in northern England.

The question of religion (particularly Islam) and integration again became a national issue following the 9/11 attacks on the United States. These attacks and the July 7, 2005, bombings in London were followed by an increase in racially motivated attacks (Independent Race and Refugee News Network 2005), and by a general climate of suspicion of and hostility toward Muslims. In confronting it, Muslims enjoyed civil law protections as visible minorities; when denied an apartment, job or access to public services, they had recourse to the *Race Relations Act*. But here they were protected as a racial rather than religious group. They also enjoyed protection under more recent legislation. Thus, when Mark Norwood, a British National Party activist, displayed in his window a poster bearing the words "Islam out of Britain" and a photograph of the burning World Trade Center, he was tried and convicted under a 2001 amendment to the *Crime and Disorder Act, 1998* (Ash 2005). The amendment extended the offence of causing alarm or distress to include cases that are "racially or religiously aggravated." It reflected a new concern with what Bleich calls "physical racism," or racism that expresses itself in the form of violence against the person. The 1998 Act thus created new offences of racially aggravated assault and racially aggravated criminal damage, as well as adding a penalty for crimes motivated by racial animus and allowing the courts to take evidence of racism into account at the sentencing stage of all crimes (Bleich 2003).

Despite these provisions, what Muslims lacked were the criminal law sanctions initiated under the *Criminal Justice and Public Order Act*. So if Norwood did not himself commit an act of physical violence but incited someone else to violence, then that person could be charged but Norwood could not. At the same time, UK case law has determined that the racial incitement provisions *do* apply to Jews and Sikhs, creating a legal anomaly. To address it, and to provide greater protections to Muslims, the government adopted the Racial and Religious Hatred Bill, which amended the Serious and Organised Crime and Policy Bill by making it an "offence for a person to knowingly use threatening, abusive, or insulting words or behaviour with the intention or likelihood that they will stir up religious hatred against a group of people based on their religious beliefs." When it was first introduced in Parliament in early 2005, the legislation was much broader: it criminalized speech, publication or performance that is "likely to be heard or seen by any person in

whom they are…likely to stir up racial or religious hatred" (Ash 2005). Intellectuals and artists argued that the bill itself was misconceived — while there can be no reasonable objections to "Blackness," there are many reasonable objections to religion, whether Jewish, Muslim or Christian. They also pointed out that it was likely to deter artists, writers and filmmakers from risking offensive portrayals of Islam or other religions (Ash 2005). As a backdrop to these arguments, in December 2004, a Birmingham theatre cancelled a play portraying sex abuse and murder in a temple following violent Sikh protests ("Theatre Ends Play" 2004).

In the face of these criticisms, the Bill was withdrawn and reintroduced, and the Bill as passed sets a high bar for legal action: actions can be brought only by the Attorney General, not by individuals or groups, and the whole measure is subordinate to the European Convention on Human Rights, article 10 of which entrenches freedom of expression. Critics nonetheless argue that the measure disrupts the fine balance between liberty and security and inappropriately places racism on the same level as hatred of religion. As liberal *Guardian* commentator Will Hutton put it, "I am simultaneously respectful of Islamic value and its achievements, but intensely critical of the way in which the Islamic religious belief system condemns the civilization to pre-modernity, together with an embedded sexism. I find the hijab offensive; it is a symbol of female oppression and relegation of women to second-class status that offends universal principles of human rights…When the bill becomes law, I and many others will be exceptionally wary of expressing any such view" (2005). Following a lobbying campaign led by high-profile British artists and actors, even the amended legislation failed to secure House of Commons support. The bill that was finally passed incorporated further House of Lords revisions. Someone charged with an offence would have to be shown to have used "threatening" language rather than "threatening, insulting and abusive" language (the test in race cases). Most importantly, the prosecution would have to prove an intention to incite racial hatred.

Education Policies

S CHOOLING HAS A DECISIVE IMPACT ON VISIBLE MINORITIES' INTEGRATION AND LIFE chances. For historical reasons, the education system has tended to replicate rather than remove race-based differences in educational outcomes. In the 1960s, the ruling Labour Party had a vision of a Procrustean equality that could be achieved

by abolishing the old three-tiered education system. Since 1944, students had taken an exam at age 11 (the dreaded "11 plus"), the results of which were used to stream them into grammar schools (for the academically gifted), secondary modern schools or technical schools. The "secondary mods" were nominally more academic than the technical schools, but graduates went from them into working-class jobs. Parallel to these were the public schools, where fee-paying parents sent their children. The system tended to reproduce the class structure by funnelling working-class children into the secondary mods and middle-class children into the grammar schools. Grammar schools were either fully state-funded or direct-grant institutions, former independent schools that took state funding on the condition that 25 percent of their places would be reserved for poor but able students. The education secretary of the day, Anthony Crossland, sought to change this situation by means of "comprehensivization": transforming grammar schools into comprehensive schools. The program was continued under the next government. In the end, all secondary mods became comprehensives and only 164 grammar schools avoided comprehensivization. The 1974-79 Labour governments gave direct-grant schools the choice of becoming comprehensives or losing their funding, and most (including the famous Manchester Grammar School) became independent, fee-paying private schools.

Though well-intentioned, the reform had at best a limited effect on class equality in Britain for two reasons. First, the reform failed to touch the public schools, leaving a large private sector to which affluent parents could resort in the face of inadequate schools. Moreover, the fact that many direct-grant schools opted out of the state sector caused the private sector to expand. Second, comprehensivization involved having local education authorities draw up plans for turning secondary mods and grammar schools into comprehensives. Central governments did nothing about the quality of those schools. The result was that good grammar schools either went private or became good comprehensives, and poor secondary mods became poor comprehensives. To make matters worse, property determined access. Whereas before comprehensivization a bright working-class boy from a poor inner-city neighbourhood could secure a spot in a good grammar school, after it he had no choice but to attend his generally mediocre local school. Oversimplifying only slightly, access to good schools is purchased in the UK either through high school fees or high property prices. In 2003, estate agents estimated that access to a good state school added £47,000 (about C$95,000) to the price of a house. For particular schools, the figure can be closer to £150,000 (C$303,000), or double the price of the average UK house.

These developments are of particular concern to visible minorities, as those with the worst school results — Pakistanis and Bangladeshis — tend to live in areas with the worst comprehensives. Although causality is difficult to establish, there can be little doubt that their fairly dreadful school results are inseparable from the quality of inner-city schools. Whereas their White working-class peers of 40 years ago could have escaped the system with a good "11 plus" result, they have no exit option. The problem was exacerbated by New Labour's authoritarian efforts to improve school results: students deemed emotionally and behaviourally disturbed were removed from the mainstream education system and placed in a Pupil Referral Unit, with the putative goal of returning them to the mainstream education system. At least in the early years of New Labour's term in office, visible minorities were largely excluded (Tomlinson 2005, 163).

Against this background of class-based and (partially) race-based structural inequality, the government enacted two reforms to education policy. Beginning in the year following the 2001 riots, the Home Office made citizenship education a mandatory part of the national curriculum. As is so often the case in British discussions of citizenship, the concept is never defined; and even at their most advanced, the lessons are vague and only tangentially related to citizenship. In stage three, students are to be taught about "the origins and implications of diverse national, regional, religious and ethnic identities in the UK and the need for mutual respect and understanding," "how the economy works," and "the opportunities for individuals and voluntary groups to bring about social change locally, nationally, in Europe, and internationally" (Home Office 2003). Teachers are given no further instructions or training, and the National Curriculum (broadly equivalent to Canada's provincial exams) itself has not been changed to make multicultural Britain a core history or social studies subject. The result is that teachers who have no particular knowledge of Britain's ethnic makeup, the history of British multiculturalism or contemporary politics are instructed to teach a highly sensitive and complex subject. An ICM poll conducted in early 2005 revealed that more than half of UK students could neither define citizenship nor offer examples of what they had learned (Curtis 2005).

The introduction of citizenship training was largely uncontroversial. The same cannot be said of another New Labour initiative: expanding faith-based schools. Religious schools are nothing new in the UK. There are approximately 7,000 Christian schools receiving state funding. By contrast, only 5 of some 110 full-time Muslim schools in the UK receive state funding, a situation described by

the House of Lords as "institutionally racist." The government's response to this has been to propose funding for Muslim schools. The argument is that the relatively poor exam results of Muslim students reflect the educational system's failure to attend to their particular needs. The hope is that Muslim schools will provide an environment in which Muslims students can excel.

Faith-based schools hold two further attractions for New Labour: they satisfy the demands of a core constituency and they expand choice. In keeping with the party's post-Thatcher ideology, market solutions, choice expansion and government-business partnerships — in short, everything that was anathema to the socialist Labour Party of old — instinctively appeal to the Labour Party leadership. Thus the Labour government has proposed to establish academies for which private sponsorship of £2 million is matched by government funds of £25 million and the right to appoint a majority of the board members. Critics fear that these academies will provide choice to affluent middle-class parents, and that few private sponsors will seek to establish academies in poor inner-city neighbourhoods made up disproportionately of visible minorities.

Citizenship Policies

Until very recently, the United Kingdom provided liberal access to a thin citizenship. Though viewed as inclusionary today, citizenship by birth — *jus soli* — has its origins in feudalism (what's within the realm of the lord belongs to the lord) and imperialism. From the early seventeenth century on, anyone born within the realm of the British monarch was a subject of that monarch, and British-subject status was the basis of British nationality right up to 1981. This basic principle was carried over into the age of Empire, and all those born within the British Empire were British subjects who enjoyed, in theory, full rights within the UK. This system was reaffirmed in 1948, and it meant that the 500,000 non-White British subjects who entered the UK before 1962 did so not as immigrants but as citizens. The UK ended pure *jus soli* (which no longer exists anywhere in Europe) in 1981, but there has otherwise been a high degree of continuity in citizenship policy. All those born in the UK to permanent residents, citizens or recognized refugees are citizens at birth. Others may naturalize after three years of marriage to a UK citizen or after five years of residence in the UK. Dual citizenship is fully accepted.

In summary, then, the UK's diversity-accommodation framework is made up of three elements: antidiscrimination legislation, educational policies and police policies. All of these are, in various ways, race-conscious. The core was, and is, antidiscrimination legislation backed up by civil law and overseen by a prominent public body, the Commission for Racial Equality, laid against a relatively open and thin citizenship.

Integration Outcomes

SINCE THE 1991 CENSUS, THE NATIONAL OFFICE OF STATISTICS HAS RECORDED visible minority unemployment, income levels and educational attainments. Overall, the visible minority unemployment rate has remained double that of the White population. Unemployment rates are highest among in the Bangladeshi community, at 38 percent, or over nine times the national rate of 4.1 percent (2001-02 figures). The Pakistani and Black communities (both African and Caribbean) also suffer from high unemployment. Only the Chinese and Indian communities enjoy employment levels similar to those of the White population. Figure 1 provides data on unemployment levels among various ethnic groups.

With the exception of Indian men (who earn slightly more on average than White men) and Chinese men, visible minorities earn lower wages than Whites. In 1998-99, Black men earned £1 per hour less on average than White men, whereas Bangladeshi and Pakistani men earned £1.50 less. The average wage for Whites was £9.24 per hour. Assuming a 40-hour work week and 52 weeks of work per year, the average White man earned £19,219; the average Black man, £17,130; and the average Pakistani/Bangladeshi man, £16,099. Women of all ethnic backgrounds, including White, earned less than men. A broad range of studies have confirmed these patterns of race-based disadvantage (Berthoud 1998).

These economic outcomes do not correlate perfectly with educational achievement. In the primary sector, Black students start at the age of five at the same broad level as the national average. By the age of 10, they have fallen behind, particularly in mathematics, and Black students are far less likely than others to secure five GCSEs (General Certificate of Secondary Education, broadly equivalent to the North American high school diploma; five are generally necessary to secure a place at university) (Parekh 2000, 146). Indian students, by contrast, achieve

results above the national average, particularly in their GCSEs. At the university level, the results are more positive overall. In terms of entry into university, Indian, Pakistani and Afro-Caribbean women exceed the national average, as do Indian, Pakistani and Bangladeshi men (Parekh 2000, 147). They are, however, disproportionately placed at the least prestigious universities: 70 percent of Afro-Caribbean men and 60 percent of Indian, Pakistani and Bangladeshi students study at universities that were once polytechnics (technical schools or community colleges), compared with 35 percent of the general population (Parekh 2000, 148). These institutions consistently fare worse than older universities when it comes to placing job candidates. Finally, within these averages there is substantial polarization: Bangladeshi and Pakistani students are overrepresented among both university entrants and 16 year olds with the poorest qualifications.

Evidence of any race-based gap in achievement is worrying, but two more questions need to be asked. First, to what degree does the gap reflect inadequate human capital (language skills, education), which can be remedied, at least between generations? Second, are these gaps narrowing or increasing over time? Taking into account personal characteristics (skills and education), sociologists working on the first question note the disparity that persists between the chances of ethnic minorities securing employment or higher-level jobs or income and the chances of others doing so; they refer to it as the "ethnic penalty" (Heath and Yu 2005). It thus includes, but is broader than, the concept of discrimination. Separate studies have concluded that Pakistanis and Bangladeshis (and particularly Pakistani and Bangladeshi women) pay the highest ethnic penalty, while Indians (and particularly Indian men) pay the lowest. Black men and women fall between these two groups. The literature is, however, less clear on why they pay this penalty, simply restating the question. Scholars have suggested that discrimination in hiring and promotion practices accounts for the distinction (Carmichael and Woods 2000; Berthoud 2000). In the 1960s and 1970s, field experiments (which involved having White British, White non-British and visible minority applicants apply for the same job) demonstrated high levels of racial discrimination (Hansen 2000, 226). These have not been repeated, but surveys on perceptions of discrimination suggest that discrimination declined between 1968 and 1974 yet remained constant over the next 20 years (Heath and Yu 2005). It is certainly plausible that discrimination partially accounts for higher unemployment and lower wages among visible minorities, but this explanation cannot easily account for

Unemployment Rates,
by Ethnic Group and
Age, United Kingdom,
2001-02

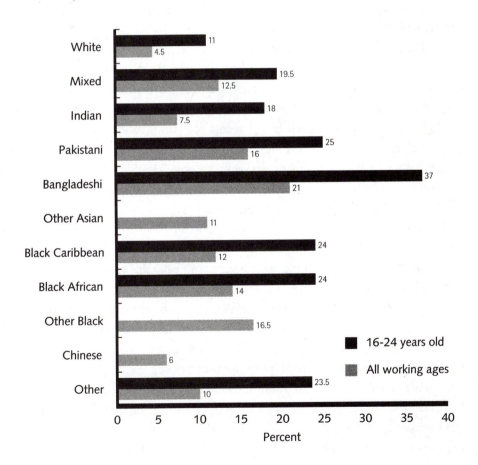

Source: Annual Local Area Labour Force Survey, UK Office for National
Statistics, accessed April 24, 2006, http://www.statistics.gov.uk/
downloads/theme_labour/ALALFS_2002_03.Pdf

variance in ethnic minority performance. It is not obvious why one group of South Asians (Bangladeshis) pays a high ethnic penalty while others (Indians) pay a low one. Drawing on Robert Putnam's distinction between bonding social capital (which links members of a social group with each other) and bridging social capital (which links members of a group with the wider society), a recent study has suggested that Pakistanis and Bangladeshis have high bonding but relatively low bridging social capital (Heath and Yu 2005). This would mean that while they have the networks necessary to ensure employment in family businesses and/or the informal economy, they lack the networks that play a decisive role in securing employment and promotion outside their community.

The issue can be further explored by considering visible minorities' experiences in education and the labour market over time. Working on the Canadian case in their chapter of this book, Reitz and Banerjee present evidence that recent migrants, despite the fact that they have better skills, are faring worse in terms of employment and earnings. There is no UK data comparing recent migrants' experience with that of earlier generations of migrants (partly because the concern is with racial minorities, migrants or not), but Anthony Heath and Soojin Yu use multivariate analysis to compare the ethnic penalty between first- and second-generation migrants in three areas: access to the salariat, education and employment (2005). The first generation was born between 1940 and 1959, and most would have been migrants to Britain. The second generation was born between 1960 and 1979, and most would have been born in Britain. Heath and Yu find that while the first generation has enjoyed increased access to the salariat over time, it has failed to close the gap with Whites. By contrast, in the second generation, Indians have overtaken Whites in access to the salariat, and Pakistanis and Bangladeshis have closed the gap. Given the last two groups' high unemployment levels, this is an important finding. As the statistics suggest, the most notable cross-generational changes have been in education. Whereas the first generation had notably lower education levels than the population at large, the second generation has closed the gap, and Indians have overtaken Whites. The authors do not mention it, but this conclusion should be qualified by noting visible minorities' concentrations in less prestigious universities. Finally, it is in the area of employment that outcomes are the worst. Although the first generation paid no ethnic penalty in the form of higher unemployment, there is a large one for the second — particularly, as noted, for Pakistanis and Bangladeshis. If the authors'

argument about bridging social capital is to hold, it has to be the case that bridging social capital either declined in these groups or became more important than it was in the job market.

Both developments are possible, but the authors do suggest another explanation: discrimination is class based. For each election from 1974 until 1979, British Election Studies provided the percentage of respondents who felt that "attempts to give equal opportunities to black people and Asians in Britain have gone too far." The results show a consistent pattern of greater prejudice among managers and employers in small businesses than among professionals or managers in large organizations. The evidence supports the authors' hypothesis that there is greater discrimination at the lower levels of the labour market than the higher ones, and it might explain why there are continuing ethnic penalties in unemployment but not in access to the salariat. Similarly, as Indians (and Chinese) are overrepresented in the salariat while Pakistanis and Bangladeshis are overrepresented in manual positions, class-based discrimination would explain the varying ethnic penalties they have paid.

British Integration in a Comparative Context

WHILE I HAVE EMPHASIZED ABSOLUTE INTEGRATION FAILURES, IN A COMPARATIVE context there are relative successes. Visible minorities in the UK have unemployment levels as good as their counterparts in Germany and Austria, better than minorities in the Netherlands and Sweden, and notably better than minorities in Belgium and Switzerland (Koopmans 2005, 26). Based on the 2000 Programme for International Student Assessment (PISA) study, the gap in the UK between migrant children and other children in reading, mathematics and science knowledge was smaller than in any other European country, and much smaller than in Germany or the Netherlands (Koopmans 2005, 27). That said, the PISA results should be read with caution. Migrants are defined as people with two foreign-born parents. The study would thus not capture poor educational attainment among, for instance, third-generation Bangladeshis, but it does suggest that more recent migrants are doing relatively well at school.

Tables 4 and 5 summarize visible minorities' employment and educational attainments in select European countries.

Table 4 measures relative employment levels among visible minorities across Europe, or the ratio between the overall unemployment rate and the ethnic minority unemployment rate. It shows that visible minorities in the UK and Germany have the lowest relative unemployment rates in Europe. Table 5 uses data from the 2000 OECD Program for International Student Assessment (PISA) study to measure the gap between migrants and nonmigrants in school results. This gap is smallest in the UK (the data cover second- but not third-generation migrants).

By these measures, visible minorities in the UK do well, though not consistently better, relative to their European counterparts. The data are revealing in that there is no consistent relationship between the pursuit of multicultural policies and visible minority achievement. The Netherlands was among the first countries in Europe to officially embrace the concept, in the early 1980s, and — drawing on structures employed during the pillarization era — encouraged migrant groups to organize along ethnic lines. The Dutch government subsidized a wide spectrum of migrant organizations founded on ethnic and religious lines, co-opted their leaders in ethnicity-based representative councils, aired children's programs in four languages, fully funded education in migrants' own language and culture, and allowed Muslims and Hindus to establish dozens of separate denominational schools (Koopmans 2005). At the same time, the country did not pursue, in common with much of Europe, avowedly integrationist policies. The results were unimpressive: visible minorities in the Netherlands have the second-highest relative unemployment rate in Europe and the worst educational outcomes. As Ruud Koopmans has argued in an important paper, against almost every important measure, visible minorities in the Netherlands have done worse than their counterparts in Germany, a country that, formally at least, long refused to recognize its own status as a country of immigration (Koopmans 2003; see also Christian Joppke's chapter in this book).

The Turn against Multiculturalism in the United Kingdom

FOLLOWING THE ELECTION OF THE LABOUR PARTY IN 1997, "MULTICULTURALISM" became a fashionable term in the UK. Cabinet members used it frequently; the Home Office commissioned reports on the topic and organized conferences

Table 4

Absolute and Relative Unemployment among EU Nationals and and Non-nationals in Immigration Countries, European Union, 2000 (percent)

Country	Absolute unemployment		Relative unemployment
	EU nationals	EU non-nationals	EU non-nationals
Belgium	5.8	30.7	5.5
Netherlands[1]	3.4	18.5	5.4
Switzerland	1.9	9.6	5.2
Sweden	5.1	22.0	4.3
France	9.6	27.9	2.9
Austria	4.3	9.9	2.3
Great Britain[2]	6.4	15.0	2.3
Germany	7.5	15.5	2.2
Great Britain	5.4	12.0	2.2

Source: R. Koopmans, "Tradeoffs between Equality and Difference: The Failure of Dutch Multiculturalism in Cross-National Perspective," paper presented at "Immigrant Political Incorporation," Radcliffe Institute for Advanced Study, April 22-23, 2005, Harvard University (compiled from Eurostat 1999, 2000, CBS 2002; EU employment observatory, Nationale Arbeitsmarktpolitiken, Vereinigtes Köenigreich, www.eu-employment-observatory.net/ersep/trd32_d/00300235.asp).

[1] These data are for 1999.
[2] These data are for 1998.

Table 5 380

Gap between Immigrant[1]
and Nonimmigrant
Children in Reading, Math
and Science Scores,
Selected OECD Countries,
2000 (percent)

Country	Reading	Math	Science	Average across the three subjects
Netherlands	- 77.5	- 89.7	- 99.9	- 92.4
Germany	- 82.3	- 80.0	- 91.3	- 84.5
Switzerland	- 83.6	- 83.8	- 83.2	- 84.2
Sweden	- 57.8	- 62.9	- 58.1	- 59.6
France	- 46.9	- 43.8	- 65.4	- 52.0
United Kingdom	- 33.6	- 36.7	- 35.0	- 38.3

Source: R. Koopmans, "Tradeoffs between Equality and Difference: The Failure of Dutch Multiculturalism in Cross-National Perspective," paper presented at "Immigrant Political Incorporation," Radcliffe Institute for Advanced Study, April 22-23, 2005, Harvard University.
Note: The assessment is done by the Program for International Student Assessment (PISA), a survey of 15-year-olds in industrialized countries, conducted by the OECD, that assesses "how far students near the end of compulsory education have acquired some of the knowledge and skills that are essential for full participation in society."
[1] Defined as those with two foreign-born parents.

around it; and ministers came back from trips to Canada with glowing words for its immigration and multiculturalism policies. Eight years later, the term had almost become a dirty word. The major newspapers ran articles and editorials denouncing the balkanizing effects of multiculturalism, and the Home Office placed the accent once again on integration in and loyalty to Britain. To be sure, the realization that three out of four of the July 2005 bombers were born in Britain and had relatively affluent backgrounds was a profound shock to the national psyche; it had an effect comparable to that which the murder of filmmaker Theo van Gogh had on the Netherlands. The rhetorical shift began, however, before this. In the summer of 2001, riots broke out in northern English cities between Asian (that is, of Pakistani, Bangladeshi or Indian descent) and White youths. Although the rioting Asians were UK citizens, Home Secretary David Blunkett framed the riots as a problem of immigration and integration. Since then, the government has stiffened requirements for citizenship with the goal of ensuring that naturalized migrants are better integrated: a US-style citizenship ceremony with an oath of allegiance to the queen and the UK was introduced in 2004; and since 2005, naturalizing migrants have had to pass language and citizenship tests.

All of these measures were enacted or set in motion before the bombings. Even the Commission for Racial Equality (CRE), the official voice of visible minority concerns in the UK, has joined the integrationist chorus. In 2004, CRE's Black director, Trevor Phillips, made national headlines by insisting that "multiculturalism is dead." He has since warned of a drift toward US-style segregation and urged a greater emphasis on accentuating common Britishness. In his foreword to CRE's 2004 report, Phillips defines the commission's leitmotif as an "integrated Britain where we are all equal" (CRE 2004, 5).

These British developments are part of a broader trend across Europe. In the Netherlands, policy-makers have officially declared multiculturalism a failure and explicitly embraced integration as a policy aim. New *and* settled immigrants are now forced to pass an integration test, which includes a language component; those who fail to do so within five years are fined. Rules on family reunification have also been tightened: the minimum age for spousal immigration was raised to 21, and the sponsoring party must earn 120 percent of the minimum wage (Koopmans 2003). This new emphasis on civic integration, particularly language acquisition, can be found in policy reforms in Finland, Denmark, Austria, Germany and France (see the chapter in this volume by Christian Joppke).

In his chapter in this volume, Christian Joppke interprets these changes and the "integration crisis" that precedes them as "the weakening of national distinctiveness and a convergence with respect to the forms and contents of integration policy." Driven by demographic concerns (Europe faces aging, and in some cases declining, populations) and Europeanization, European states are converging on a new model of integration. This model views integration as a two-way process (migrants *and* the receiving society have to change) bound by political (liberty, democracy, respect for human rights) rather than cultural values and focusing on socioeconomic integration. Drawing on the work of Desmond King, Joppke concludes that the last concern illustrates the illiberal thrust that inheres in liberalism: European integration policy has an "obligatory, even repressive character...which sets it apart from similar — yet voluntary and humanitarian — civic integration policies in Canada".

How well does Joppke's model account for changes in Europe, and above all in the UK? He is certainly right to reject the framing of immigration and integration in terms of sharply contrasting national models. There is a great deal of common ground in the migration experience of different European countries and in their responses to migration. It is also the case that European countries are facing very similar problems, including demographic challenges, and have multiple EU forums in which to exchange ideas on them. That said, two qualifications might be added to Joppke's argument. The first is that, despite this commonality, important differences in integration policy (and, in some cases, immigration policy) remain. Although France and Britain do share liberal values, the ban on wearing head scarves in school is considered entirely justified in France but not in Britain. Large legalization provisions have the support of the left in Spain, but not in Germany. Excessive emphasis on convergence can encourage scholars to overlook such differences. Second, Joppke overemphasizes the importance of Europe and Europeanization in transmitting integration policies across the continent. Obligatory or semiobligatory civic integration policies resulted not so much from EU discussions or directives as from the failure of earlier policy. In France, Germany, the Netherlands and the UK, a combination of triggering events (riots in the UK and France, high-profile murders in Germany) and government-commissioned research highlighted consistent patterns of socioeconomic disadvantage among certain visible minorities. The policies are designed to address this phenomenon, and they reflect a common concern with language: failure to speak

the national language fluently limits sharply the migrant's opportunities in the postindustrial European economy.

British Multiculturalism Redefined

D O THESE CHANGES MARK THE END OF MULTICULTURALISM IN THE UK? ON MANY levels, they cannot. The rights of ethnic minorities to practice their religion, speak their language, join ethnic associations and lobby for group-based causes are fundamental to liberal democracy in the UK and elsewhere. At the same time, in Britain it is widely viewed as illegitimate (in a way that it was not before the Second World War) to force a dominant culture onto minority groups. It is not at all clear what that culture would be, anyway: a devotee of London's leather scene would share few cultural references with a deeply religious, unionist-voting Northern Irish Orangeman.[2] Their only point of agreement would be that each has the right to live his life the way he sees fit and should not attempt to deny that right to others. To this degree, multiculturalism flows from liberalism: it manifests itself in group-based claims and activities, but these claims and activities derive their logic and justification from individual rights grounded in national constitutions and defended by the courts.

More to the point, while there has been a shift in policy-makers' emphasis and mood,[3] resulting in a greater focus on the need for loyalty and commitment to Britain on the part of visible minorities, there has been no dramatic change in policy. There are more obligations involved in acquiring citizenship, and its acquisition is meant to reflect a meaningful attachment to Britain (which is hardly an unreasonable expectation). That this threatens multiculturalism is doubtful: it is not at all clear that requiring citizens to speak the national language violates multicultural principles; only denying them the right to speak their own language would do that. At the same time, the government has for several years paid attention to ethnic penalties in education and unemployment, and — equally importantly — to variations in who pays them. In modest recognition of these variations, Indian and Chinese students have been excluded from the Ethnic Minority Grant, which supports programs designed to improve ethnic minority achievement.[4] Otherwise, the major reforms in police, race relations and

education policy have actually gone further toward recognizing difference: policing has paid much more attention to racial difference; public bodies must now employ and justify inclusive practices; and more education will be provided by faith-based schools. Local multicultural polices, such as the publication of official leaflets in different languages, have been maintained.

In contrast with the Canadian government, the UK government has provided no national funds for sustaining different cultures; in contrast with their counterparts in the Netherlands, visible minorities in the UK have not been encouraged to organize politically along ethnic lines (indeed, such efforts within the national political parties have been resisted). Supporters of multiculturalism in the UK never envisioned the separation of life into ethnic minority and White spheres, and they never sought to have ethnic minorities organize around their ethnic identities. The government does not address the leaders of the Indian, Pakistani and Bangladeshi communities, or those of the Muslim and Hindu communities. Rather, the CRE speaks for all ethnic minorities. Multiculturalism in the UK has three components. The first is the recognition that Britain is a society made up of many cultures. The second is a general sense — widely if not universally shared — that multiculturalism is a good thing. The third is the understanding that in order to become British, migrants should not have to abandon their native cultural attachments and practices. All three of these components remain intact, and the two changes that have occurred are consistent with them. Policy-makers are attempting to ensure that members of all visible minority groups achieve full socioeconomic integration, that there is no ethnic penalty, and that the pursuit of their own cultural practices does not conflict with migrants' commitment to Britain or with the exercise of the liberal democratic freedoms enjoyed by every UK resident. When it does — and it rarely does — diversity reaches, as it should, it limits.

Notes

1 I am grateful to Erik Bleich for providing me with these statistics.
2 On the absence of a common culture, see the introduction to Joppke and Morawska (2003).
3 I borrow this phrase "emphasis and mood" from Shamit Saggar of the University of Sussex, who used it in a conversation we had in January 2006.
4 Shamit Sagger raised this point in our January 2006 conversation.

References

Ash, T.G. 2005. "Stop This Folly Now." *Guardian*, February 17.

Berthoud, R. 2000. "Ethnic Employment Penalties in Britain." *Journal of Ethnic and Migration Studies* 26 (3): 389-416.

Bleich, E. 2003. *Race Politics in Britain and France: Ideas and Policymaking since the 1960s.* Cambridge: Cambridge University Press.

Brubaker, R. 2003. "The Return of Assimilation? Changing Perspectives on Immigration and Its Sequels in France, Germany, and the United States." In *Toward Assimilation and Citizenship: Immigrants in Liberal Nation-States*, edited by C. Joppke and E. Morawska. Basingstoke: Palgrave Macmillan.

Carmichael, F., and R. Woods. 2000. "Ethnic Penalties in Unemployment and Occupational Attainment: Evidence for Britain." *International Review of Applied Economics* 14 (1): 71-98.

Commission for Racial Equality (CRE). 2004. *Annual Report of the Commission for Racial Equality, 1 January 2004-31 December 2004.* London: Commission for Racial Equality. http://www.cre.gov.uk/downloads/AR04main.pdf

———. 2005. *The Race Equality Duty: Further and Higher Education.* London: Commission for Racial Equality. http://www.cre.gov.uk/duty/pa_specific_fehe.html

Curtis, P. 2005. "Faith Schools 'Failing to Teach Obligation to Society.'" *Guardian*, January 17.

Goodhart, David. 2004. "Too Diverse?" *Prospect* 95:30-7.

Hansen, R. 2000. *Citizenship and Immigration in Postwar Britain.* Oxford: Oxford University Press.

———. 2005. "Colonial Migration." In *Immigration and Asylum from 1900 to the Present*, edited by M. Gibney and R. Hansen. Santa Barbara, CA: ABC-CLIO.

Heath, A., and S. Yu. 2005. "Explaining Ethnic Minority Disadvantage." In *Understanding Social Change*, edited by A.F. Heath, J. Ermisch, and D Gallie, British Academy Centenary Monographs. London: Oxford University Press, British Academy.

Hutton, W. 2005. "A Gagging Order Too Far." *Guardian*, June 19.

Independent Race and Refugee News Network. 2005. IRR News. "Incidents of Racial Violence and Harassment in This, the Eleventh Week since the London Bombings," September 22.

Joppke, C., and E. Morawska. 2003. "Integrating Immigrants in Liberal States: Policies and Practices." In *Toward Assimilation and Citizenship: Immigrants in Liberal Nation-States*, edited by C. Joppke and E. Morawska. Basingstoke: Palgrave Macmillan.

Koopmans, R. 2003. "How National Citizenship Shapes Transnationalism: Migrant and Minority Claims-Making in Germany, Great Britain and the Netherlands." In *Toward Assimilation and Citizenship: Immigrants in Liberal Nation-States*, edited by C. Joppke and E. Morawska. Basingstoke: Palgrave Macmillan.

———. 2005. "Tradeoffs between Equality and Difference: The Failure of Dutch Multiculturalism in Cross-National Perspective." Paper presented at "Immigrant Political Incorporation," Radcliffe Institute for Advanced Study, April 22-23, Harvard University.

Layton-Henry, Z. 1992. *The Politics of Immigration: "Race" and "Race" Relations in Post-War Britain.* Oxford: Basil Blackwell.

Lieberman, R. 2005. *Race, State, and Policy: American Race Politics in Comparative Perspective*. Princeton: Princeton University Press.

Parekh, B. 2000. *The Future of Multi-ethnic Britain: The Parekh Report*. London: Profile Books.

"Theatre Ends Play in Sikh Protest." 2004. BBC News, September 24. Accessed April 22, 2006. http://news.bbc.co.uk/1/hi/england/west_midlands/4112105.stm

Tomlinson, S. 2005. "Race, Ethnicity and Education under New Labour." *Oxford Review of Education* 31(1): 153-71.

United Kingdom. Home Office. 2003. *Stephen Lawrence Inquiry: Home Secretary's Action Plan. Fourth Annual Report on Progress*. London: HMSO.

Diversity,
Multiculturalism and
Social Cohesion:
Trust and Ethnocentrism
in European Societies

THIS CHAPTER INVESTIGATES HOW RISING ETHNIC AND RACIAL DIVERSITY INFLUENCES social cohesion in Western democracies and how policies for immigration and the integration of visible minorities might shape this relationship.[1] In recent years, the popular media have zoomed in on the issue of immigration, the increase in the numbers of refugees and asylum seekers in Europe, the growing visibility of ethnic and racial minorities and the increasing socioeconomic inequalities in North America. This focus has triggered debate about the consequences of diversity for community and social cohesion in Western democracies. Journalists, policy-makers and ideologues have repeatedly expressed their fears about an increasingly complex and multiethnic, diverse world.

Such fearful expressions — most of which do not emanate from Canadian media and policy circles — have recently found reluctant support in academic analyses. A number of studies suggest that increasing social diversity could have detrimental effects on social cohesion (Alesina and La Ferrara 2002; Hero 2003; Delhey and Newton 2005). According to this research, in more diverse societies, generalized trust is more difficult to foster, resulting in the loss of a sense of community. At the same time, we know that generalized trust is a key element of social capital, a societal resource that fosters collective action. The research indicates that generalized trust tends to be lower in ethnically fractionalized communities or in geographic areas with large ethnic or racial minorities. This relationship also holds when we compare census tracts with varying concentrations of immigrants in Canada. Trust levels are not just lower among the ethnic minorities themselves, but they are also suppressed among the dominant groups within society. However, these alleged effects of ethnic and racial diversity have

only rarely been studied outside North America, and they have not been contextualized with the host of policies in which immigration and diversity are embedded. Immigration regimes and policies might mitigate the potentially divisive effects of living in heterogeneous societies. The resulting question, then, is how these policy differences and the wide range of autonomy offered to various groups within the population influence social cohesion in democratic societies.

In this chapter, we use European data to investigate two questions. First, we examine whether the relation between ethnic and cultural diversity is indeed as negative as it is assumed to be in most of the current literature. It is by no means self-evident that these findings in the US or the North American contexts can be generalized and applied to other societies. Second, we want to ascertain the effect of integration regimes. Are there significant differences between countries that adopt a policy of assimilation and countries that are open to the recognition of difference? This insight into the role of integration regimes would be of particular value for Canadian policy-makers, as Canadian society has become increasingly diverse, both culturally and ethnically, and the country's multicultural nature has become a defining characteristic of national identity (Driedger 1996). Canadian public policy on immigrants and various ethnic and religious groups encourages ethnic and cultural minorities to maintain their own distinct cultures, and it recognizes their right to affirm their own identities. If the proponents of multiculturalism are correct, then social cohesion in societies adopting an open policy with regard to migration and cultural minorities will not be easily undermined by social diversity. The following analysis examines this question in more depth.

The chapter proceeds with a review of the available literature on the relation between social diversity and social cohesion. We then present the data on Europe, and we close with some suggestions for future research.

The Current Research on Diversity and Social Cohesion

IN MOST OF THE CURRENT LITERATURE, IT IS ASSUMED THAT DIVERSITY AND SOCIAL cohesion are negatively related: the more diverse a society or a community, the

less inclined its members will be to develop close ties with their fellow community members (Alesina and La Ferrara 2002). To put it differently, social capital is eroded by increasing diversity within a given society. Generalized trust is usually a reliable indicator of social cohesion (Stolle 2002). If many people have the feeling that most others cannot be trusted, it will be more difficult for a community to pursue collective-action efforts and to provide for collective goods. Mainly in the American literature it has been shown that increasing racial and ethnic diversity in communities tends to reduce generalized trust. To some extent, this negative relation can be expected, as the growing presence of minority groups might threaten the dominant group. It is surprising, however, that trust is even being undermined by diversity among ethnic minorities (Rice and Steele 2001; Leigh 2006). Apparently, members of minorities find it easier to develop trust if they do not live in diverse-interaction contexts (Soroka, Johnston and Banting 2005). In short, the current North American literature suggests that diversity leads to less cohesive societies.

These findings should not come as a surprise. Sociopsychological research and the theoretical literature indicate that trust prospers in homogeneous settings (Uslaner 2002). We find it easier to develop trust when we are familiar with the people around us, and particularly when they seem similar to us. The influx of immigrants from unknown cultures might make it more difficult for us to predict the behaviour of our neighbours, friends and colleagues (Messick and Kramer 2001, 100), and this might reduce our general trust levels. Within the current research, there are only a few exceptions to these negative findings. In a US study based on surveys collected in the 1970s, Melissa Marschall and Dietlind Stolle did not find any evidence for the occurrence of negative effects of diversity (2004). On the contrary, African Americans, especially, were more trusting when they lived in diverse neighbourhoods. We must remember, however, that in that era, spatial segregation in the US was more prevalent than it is today — there were fewer diverse neighbourhoods in the 1970s. J. Eric Oliver shows that political mobilization tends to be greater in mixed neighbourhoods and regions than in homogeneous ones (2001). However, we could question whether political participation is a good indicator of social cohesion. Higher levels of political participation and mobilization might be caused by more intense competition between ethnic or racial groups who disagree about public policy outcomes in their communities.

Whatever the findings, the current literature on the relation between social diversity and social cohesion has a number of shortcomings. First, most of this research has been conducted in US settings, and US society exhibits a distinctive pattern of race relationships (Sniderman and Piazza 1993). Furthermore, the US is not a typical Western society in other ways; for example, its income inequality is particularly strong, with a Gini coefficient of .408, which is far above the average for Western democracies (see Uslaner 2002). The Gini coefficients of countries such as Germany (.283), France (.327), Belgium (.250) and Sweden (.250) typify those of the industrialized world (United Nations Development Programme 2005, 270); and they are closer to Canada's (.331). This difference in (in)equality patterns in the US is relevant, because income inequality — as another form of diversity — has strong negative effects on generalized trust and other indicators of social capital and social cohesion (Uslaner 2002). Therefore, any findings on the US situation should be supplemented with analysis of other Western countries.

Second, most of these studies focus exclusively on generalized trust as the main measurement of social cohesion, while other aspects of this construct remain untapped. However, we propose that in diverse settings, social cohesion could also be captured by attitudinal indicators of outsider-group hostility. One can argue that in societies with high levels of ethnocentrism, it will become more difficult to maintain cohesion and to ensure solidarity between all members (Hooghe 2003; Sniderman et al. 2000).

Third, by focusing on just one country, most studies fail to detect policy influences. While most Western countries are confronted with the same phenomenon of increasing ethnic and cultural diversity, they have developed a wide array of policies in response (Joppke 1999). Some countries have clearly opted for a politics of multiculturalism, allowing — or even encouraging — minorities to develop their own distinct cultures instead of expecting them to adapt to the mainstream culture (Banting and Kymlicka 2003; Kymlicka 1995; Kymlicka and Norman 2000). Other countries are hostile to multicultural policies, forcing newcomers to abandon at least part of their cultural heritage and integrate into the receiving society (Koopmans et al. 2005). In order to ascertain whether multicultural policies have an effect on the relation between diversity and social cohesion, researchers must not limit themselves to a single case; they must adopt a comparative approach (Citrin and Sides 2006).

From a policy point of view, the most pressing question is whether these different integration regimes actually matter. It is a general expectation that multicultural policies reduce tensions between the traditional and the new groups in a society, while at the same time addressing the feeling among minorities that they are being discriminated against and oppressed. Multiculturalism is usually considered an unbiased approach to governing multicultural and diverse societies (Kymlicka 2001). The basic expectation is that in countries pursuing multicultural and group rights policies, diversity can be handled successfully by effectively mitigating its alleged negative effects. Countries in which the dominant group tries to impose its own culture on the newly arrived might witness more tensions among their ethnic groups and see those groups excluded from mainstream society. However, critics of multicultural policy are more skeptical. They point out that such policy might also lead to cultural isolation of new ethnic groups; less majority-minority social interaction; or deepening social cleavages, indifference and distrust (Barry 2001). In the following analyses, then, we will test the relationship between diversity, government policy and social cohesion.

Most of the analyses are based on the first European Social Survey (ESS), which was conducted in 2002-03 in 21 European countries. Because of the wide variety of integration regimes and policies related to social conditions in Western Europe, our analysis can better test whether there is a relationship between diversity, policy and social cohesion than could previous analyses based on just one country. We proceed in two steps. First, we examine whether there is a relation between ethnic diversity and the levels of trust and ethnocentrism within these countries. Second, we ascertain whether the integration policies that have been adopted by these countries relate to outcomes of ethnocentrism or generalized trust.

Trust and Ethnocentrism in Europe

THE EUROPEAN SOCIAL SURVEY WAS SET UP SPECIFICALLY TO CONDUCT HIGH-QUALITY comparative research. Unlike other major data collection efforts, the ESS has a central coordinating team responsible for the quality of the fieldwork in all the countries involved. Most theoretically relevant concepts have been measured using solid and cross-culturally equivalent scales (Jowell et al. 2003). To make

comparisons easier, we summarized both trust and ethnocentrism in a standardized scale, with a range of 0 to 10. We use the cultural component of ethnocentrism, a summated rating scale with four items, because this aspect of ethnocentrism captures more closely the concept of social cohesion. A typical item on this scale is the Likert item "If the country wants to reduce tension, it should stop immigration." The generalized trust scale is based on three items measuring the belief that "most people can be trusted" (see details in appendix 1 and in the technical report in Hooghe, Reeskens and Stolle 2005).

The results reveal a distinct pattern: ethnocentrism scores tend to be much lower in the Scandinavian countries and in other parts of northern Europe than in southern, central and eastern Europe. The trust scores have exactly the opposite pattern: high trust levels are found in the north of the continent and low scores in the south and east. In short, trust and ethnocentrism are strongly related: the more trusting a society is, the lower its level of ethnocentrism. In the first two columns of table 1, the average generalized trust and ethnocentrism scores for all of the countries in the survey are summarized.

Our main objective was to find out whether there is indeed a negative relationship between ethnic diversity and social cohesion indicators across countries. Ethnic diversity, however, is not an easy concept to measure, and as far as we know there is no indicator that could be considered a fully reliable measurement. We therefore combined a number of indicators. First, the fourth column in table 1 presents the percentage of the foreign population as an indicator of diversity.[2] There is a possibility, however, that communities will respond negatively, not so much to a stable pattern of otherness, but rather to increasing diversity as a result of migration. The arrival of newcomers might create tension and increase competition in the labour, housing and education markets. Therefore, we calculated the rise in the influx of immigrants by assessing the growth of annual immigration between 1995 and 2003 (column 5). Finally, we used the ethnic fractionalization index calculated by Alberto Alesina and colleagues (2003), which measures the variety of groups in a given society (column 6). Table 1 reveals no strong patterns linking the measurements of diversity and social cohesion.

This pattern linking the measurements of diversity and social cohesion is illustrated in figure 1, in which generalized trust levels and the percentage of the population born outside the country are plotted together. When diversity is measured by the percentage of the foreign population, the most diverse

Table 1

Ethnocentrism and Trust
Levels in Selected
European Countries,
2002-03

Country	Trust level[1]	Ethno-centrism level[1]	N[2]	Percentage of foreigners[3]	Influx ratio 2003/1995[3]	Ethnic fractionali-zation index[3]
Austria	5.3	2.8	2,255	9.4	1.31	0.107
Belgium	5.0	3.1	1,897	8.2	1.24	0.555
Czech Republic	4.5	3.5	1,345	2.4	5.71	0.322
Denmark	6.8	3.1	1,503	5.0	0.71	0.082
Finland	6.3	2.6	1,998	2.1	1.29	0.132
France	4.8	3.1	1,500	5.6	1.83	0.103
Germany	5.1	3.0	2,916	8.9	0.76	0.164
Greece	3.5	3.9	2,565	7.0	0.62	0.158
Hungary	4.3	3.4	1,683	1.3	1.12	0.152
Ireland	5.8	3.2	2,041	5.6	2.43	0.121
Italy	4.4	2.9	1,204	3.8	5.69	0.115
Netherlands	5.7	2.9	2,364	4.3	1.10	0.105
Norway	6.5	2.8	2,036	4.5	1.62	0.059
Poland	3.8	3.0	2,107	0.1	0.86	0.118
Portugal	4.3	2.8	1,511	4.2	2.76	0.047
Spain	4.8	2.8	1,712	4.0	22.03	0.417
Slovenia	4.3	3.2	1,510	2.3	1.18	0.222
Sweden	6.3	2.6	1,998	5.3	1.26	0.060
United Kingdom	5.3	3.3	2,051	4.8	1.78	0.121

[1] Average trust and ethnocentrism scores, 0-10 range, from R. Jowell et al., *European Social Survey 2002/2003: Technical Report* (London: Centre for Comparative Social Surveys, City University, 2003).
[2] Number of respondents in the 2002-03 European Social Survey (Jowell et al. 2003).
[3] Diversity measures at the country level: column 4, percentage of foreigners in the total population in 2002; column 5, the growth in the annual influx of foreigners between 1995 and 2003 (influx 2003/influx 1995), figures taken from Organisation for Economic Co-operation and Development, "Statistics Portal: Home" (Paris: OECD, 2005) and our own calculations; and column 6, fractionalization index, from Alesina et al., *Fractionalization*, NBER Working Paper 9411 (Cambridge: National Bureau of Economic Research, 2003), accessed September 1, 2006, http://www.nber.org/papers/w9411

Figure 1 394

Presence of Foreigners
and Generalized Trust[1]

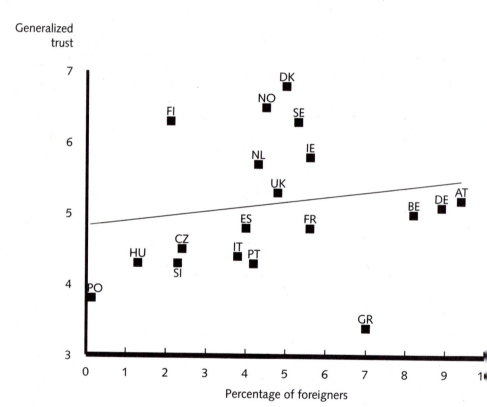

Generalized
trust

Percentage of foreigners

Sources: Percentage of foreigners in the population are adapted
from Organisation for Economic Co-operation and Development,
"Statistics Portal: Home" (Paris: OECD, 2005); generalized trust lev-
els aggregated at the country level are adapted from R. Jowell et al.,
European Social Survey 2002/2003: Technical Report (London:
Centre for Comparative Social Surveys, City University, 2003).
Note: AT = Austria; BE = Belgium; CZ = Czech Republic; DK =
Denmark; FI = Finland; FR = France; DE = Germany; UK = Great
Britain; GR = Greece; HU = Hungary; IE = Ireland; IT = Italy; PO =
Poland; PT = Portugal; NL = the Netherlands; NO = Norway; SI =
Slovenia; ES = Spain; SE = Sweden.
[1] Percentage of foreigners in population and generalized trust levels
aggregated at the country level. Overall correlation: 0.173 ($p =$
0.478).

societies (Germany, Austria and Belgium) tend to have average trust levels. On the other extreme of the graph, we see that Poland, Hungary and the Czech Republic are quite homogeneous, but they do show very low trust levels (Letki and Evans 2005). As a result, in figure 1 the general trend line is even slightly positive: more diverse societies are more trusting, although the relationship is not statistically significant. As we can see in table 2, some other indicators of diversity show a negative relationship with trust or ethnocentrism — not a significant one, however.

Excluding the formerly communist countries from the analysis — as they are known to be low-trust societies for various other reasons — brings no significant change in results (these results are not shown). In sum, by utilizing various measurements of diversity, we have uncovered a similar pattern among a large number of European countries: there is no negative relation between any conceivable measurement of ethnic diversity and the two social cohesion indicators of trust and ethnocentrism.

Multicultural Policies

IN EUROPE, AT LEAST, DIVERSITY DOES NOT SEEM TO CAUSE NEGATIVE REPERCUSSIONS for societal unity or cohesion. But is this perhaps an outcome of specific immigration or multicultural policies? As the second step of this research, we ascertain whether the multicultural and other immigration policies pursued in some countries have an effect on social cohesion indicators like trust and ethnocentrism. Information about various immigration and multicultural policies from a number of different data sources on all these countries is included.

First, we relied on the index of multicultural policies (MCP) developed by Keith Banting and Will Kymlicka (2003). This index measures whether national governments are willing to grant ethnic minority group rights in the various arenas of culture, education, politics and religion (for example, multicultural policies in school curricula, representation of ethnic minorities in politics and the media, funding of ethnic group activities, funding of bilingual education), or whether they are inclined to impose a uniform national culture on these groups.

Second, we included information on whether governments grant the right to vote to foreign nationals. Extending voting rights to those who do not

Table 2 396

Relationships between
Social Cohesion and
Measures of Diversity
in Selected European
Countries, 2002-03

Variable	Generalized trust	Ethnocentrism
Percentage of foreigners	0.173 (0.478)	-0.017 (0.944)
Inflow ratio 2003/1995	-0.128 (0.600)	-0.174 (0.476)
Fractionalization index	-0.265 (0.274)	0.214 (0.379)

Source: Authors' calculations based on Jowell et al., *European Social Survey 2002/2003: Technical Report* (London: Centre for Comparative Social Surveys, City University, 2003). Note: Entries are correlation coefficients with generalized trust and ethnocentrism scores; *p* values are in parentheses; data available for 19 countries.

have citizenship status sends a clear message that these people are accepted as full members of society (Davy 2001); it is therefore — in juxtaposition to multicultural policies — an approach that focuses on similarities and inclusion instead of appreciation of difference and otherness. Harald Waldrauch offers an elaborate overview of voting rights granted to non-EU citizens. He details not only whether foreigners have the right to vote at the municipal or other levels of government but also the conditions under which foreigners can vote, and whether this right has been granted (Waldrauch 2005). Based on this review, we distinguish three groups of countries: those that gave the right to vote to non-EU citizens early (before 1992, and usually with few conditions); those that gave the right to vote to non-EU citizens late (after 1992, usually with restrictions and only at the municipal level); and those that do not give non-EU citizens the right to vote.

Third, we included information on naturalization policies. Unfortunately, no comprehensive review of naturalization policies exists. Of course, the law on naturalization tells only a part of the story (Baubock 1994; Davy 2001). In a lot of countries, there is a large distance between the text of the law on naturalization and actual practice. Ulrike Davy therefore suggests that rather than examining the laws on naturalization and citizenship, one should analyze practices of granting citizenship rights and recognition (2001). We did so by calculating the ratio between the number of naturalizations being granted in the period 1998-2001 and the number of immigrants in the period 1997-2000. For example, while Norway received 86,700 immigrants in 1997-2000, only 28,300 of them were naturalized in 1998-2001, which corresponds to a ratio of 0.33. In Belgium, however, there were 187,800 immigrants and 149,400 naturalizations, or a corresponding ratio of 0.80. These ratios demonstrate that it is, in practice, much easier to acquire Belgian citizenship than it is to acquire Norwegian citizenship. The indicators of these policies are summarized in appendix 2.

The three selected policy measures purposefully emphasize different aspects and characters of immigration regimes. Based on the logic of these implemented policies, one could argue that countries that allowed foreigners the right to vote early on, that make it easier to acquire full citizenship status and that promote policies of multiculturalism will be more successful in creating social cohesion among majority and minority groups and therefore in overcoming any adverse effects of increasing diversity. In that sense, such

policies might be particularly successful in reversing the potentially negative relationship between diversity and social cohesion in societies with many minority groups.

Results

ARE MULTICULTURAL AND OTHER IMMIGRATION POLICIES RELATED TO HIGHER LEVELS of trust and lower levels of ethnocentrism? How might these policies influence the relationship between diversity and social cohesion? It is clear that these are quite complex questions, and in addressing them we require an adequate method of analysis. Elsewhere, we have developed a full, multi-level model, taking numerous indicators into account, at both the micro and macro levels (Hooghe, Reeskens and Stolle 2005). For the purposes of this chapter, we present the same analysis in a more straightforward manner. Nevertheless, the multi-level and the single-level models yield similar results. Despite the inclusion of almost 20 countries, the number of cases remains very limited. Therefore, results are presented in a step-by-step way. First, for both generalized trust and ethnocentrism, bivariate correlations with policies are estimated; and only for promising relationships are multivariate models developed.

Closer inspection of tables 3 and 4 reveals no significant relationship between any of the policies and ethnocentrism, so we did not pursue a multivariate model for this indicator of social cohesion. Ethnocentrism scores do not seem to be related to the multicultural indicator or to naturalization rates (table 3); and although ethnocentrism is lower in countries that early on adopted voting rights for foreigners, this relationship is statistically insignificant (see table 4). The results for generalized trust are more conclusive. It is particularly high in countries that early on adopted voting rights for foreigners (see also appendix 3A and 3B).

Therefore, we built a multivariate model for generalized trust in order to see whether voting rights matter, even when controlling for some other important characteristics of countries that might cause high trust levels. The model in table 5 controls for various forms of diversity and GDP per capita and confirms that voting rights are important policies, at least for this indicator of social cohesion; whereas other immigration policies do not exhibit such a relationship.

The Relationship
between Policies and
Attitudes

	Bivariate correlations		
	Generalized trust	**Ethnocentrism**	*N*
Multicultural policies	0.049 (0.862)	0.088 (0.756)	15
Naturalization ratio[1]	0.475 (0.101)	-0.150 (0.626)	13

Sources: First row: K. Banting and W. Kymlicka, "Do Multiculturalism Policies Erode the Welfare State?" (paper presented at the meeting of the International Sociological Association, August 21-24, 2003, Toronto); second row: the naturalization ratio is the number of naturalizations in 2001 divided by the inflow of foreigners in 2000.

Note: Entries are correlation coefficients; *p* values are in parentheses. Dependent variables: country levels of generalized trust and ethnocentrism.

Table 4 400

The Relationship
between Voting Rights,
Trust and Ethnocentrism

Countries with...	Means for trust	Means for ethnocentrism
Early voting rights	6.244	2.869
Late voting rights	4.865	3.288
No voting rights	4.498	3.036
F-value	18.16	1.93
P-value	< 0.0001	0.182
N	17	17

Source: Calculations by the authors based on H. Waldrauch,
"Electoral Rights for Foreign Nationals: A Comparative
Overview" (paper presented at "Citizens, Non-citizens and
Voting Rights in Europe," June 2-5, 2005, University of
Edinburgh).
Note: Entries are country means for indicated dependent vari-
ables that both scale from 0 to 10. The values for voting rights
have been recoded into three categories (see appendix 2).

Multivariate Model for Generalized Trust

	Multivariate model[1]	
	Parameter estimate	**T-value**
Intercept	3.415*	3.31
Foreign population percentage	0.080	0.66
Inflow ratio 2003/1995	0.056	1.13
Fractionalization index	-1.978	-1.02
GDP per capita	0.033	0.78
Multicultural policies	-0.108	-0.84
Voting rights:		
Early voting rights	1.712*	2.96
Late voting rights	1.345	1.57
Ref.: no voting rights[2]		
Adjusted R squared	0.6531	
N	15	

Source: Calculations by the authors based on R. Jowell et al.,
European Social Survey 2002/2003: Technical Report
(London: Centre for Comparative Social Surveys, City
University, 2003).
[1] Results are from an OLS regression on ESS countries.
Dependent variable: aggregate levels of generalized trust.
[2] The countries without voting rights for foreigners are used
as a reference category.
*$p < 0.05$.

Discussion

WITH A COMPARATIVE DATASET, WE WERE ABLE TO PERFORM A SIMPLE TEST OF whether specific policies targeted at the integration and inclusion of foreign citizens in any way relate to social cohesion in European societies. There were two noteworthy results that push the analysis of social cohesion further. First, we found that those respondents who live in countries where foreigners are given the most extensive voting rights and where these rights were established at an early stage of rising immigration were the most trusting. Yet voting rights did not have the same effects on feelings of ethnocentrism. In addition, other policy initiatives, such as naturalization practices or broader multicultural policies, do not influence social cohesion in significant ways. As it turns out, only certain universal aspects of immigration policies and selected indicators of social cohesion in Western democracies are intimately linked. There does not seem to be any relation between various integration policies and the level of ethnocentrism in the population. Only for generalized trust do voting rights of foreigners seem to matter.

This finding is very interesting for the policy community, as it suggests that policies may have ameliorating effects on tensions in increasingly diverse societies. However, before we draw any causal conclusions, we need to do more research. At the moment, we do not have any evidence for the causal direction of this relationship. It is certainly plausible that high-trust societies attend to the rights of minorities earlier and in a more encompassing way because they are generally more oriented toward equality in the first place. At the same time, we find it just as plausible that policies that are egalitarian in character and targeted at integrating minorities into everyday political and social life help to break down tension and distrust between societal groups. The causal mechanisms here derive from the symbolic and actual effects that these policies have on the status of foreigners. At the symbolic level, granting foreigners the right to vote signals that they are indeed full and equal members of society. At the same time, voting rights enhance the social status of immigrants and perhaps positively influence their trust levels, increase their participation in social-political life and afford them a better association with majority populations. Therefore, from a policy perspective, our research suggests that in the interest of social cohesion, granting voting rights is a step in the right direction. The issue is not as compelling in Canada because of the high rate of naturalization, which brings full voting rights to most immigrants after a

comparatively short period. However, the idea of early voting rights in municipal elections might still be worth considering. But the final verdict on diversity, diversity policy and social cohesion will have to wait until we proceed to the next stage of our research project, in which we will try to better understand the extent to which the gap between immigrant and majority populations narrows in countries that have active policies for the integration of immigrants.

An interesting finding here is that no other policy we investigated had any bearing on social cohesion. This is particularly intriguing, as we would consider voting rights a simple subset of overall multicultural policies that address issues of immigrant integration beyond political participation and voting. Our hunch is that voting rights work particularly well for establishing social cohesion because these are universal egalitarian policies, implemented to put other citizens on an equal footing with majority groups. This interpretation complements earlier research on institutional characteristics that seem to foster aspects of social capital and trust in our societies; such research emphasizes that impartial institutions built on the principle of procedural justice are particularly successful in building generalized trust and solidarity (Rothstein and Stolle forthcoming; Tyler 1998). The more encompassing multicultural policies, however, might be more controversial since in some aspects they adhere to the equality principle, but in others they adopt the principle of preferential treatment with the overall goal of achieving equality. The distinction between these institutional principles and their consequences for social cohesion certainly deserves further investigation.

Furthermore, despite several such findings in the US, in Europe it was not confirmed that rising ethnic diversity or even the influx rate of foreign citizens had any significant detrimental effect on social cohesion. On the contrary, the higher the share of foreigners, the less ethnocentrism and the more trust we find in European societies, although not significantly so. Some other measures of ethnic diversity showed negative relationships with generalized trust, but, again, they did not reach a level of statistical significance. This finding in itself is important for the discussion about the negative effects of diversity, particularly within North America. In Canada, for example, it has been found that people who live in diverse census tracts with a higher share of immigrants are overall less trusting than those in homogeneous environments (Soroka, Johnston and Banting 2005). In order to interpret our results vis-à-vis previous findings and draw any final conclusions, we still need to know whether specific immigration policies,

patterns of social interaction between minorities and majorities, geographic patterns of minority settlement, the origins of the immigrants and the fragmentation of the ethnic minority population or any other factors are behind these divergent results. It is also plausible that our results are not directly comparable to those of many North American studies, as we examine the effect of diversity at a much higher level of aggregation — namely, the country (as opposed to smaller units, such as neighbourhood or census tracts). Nevertheless, it seems clear that the conclusion about ethnic diversity exerting negative effects on social capital, which dominates the US literature, was drawn too early.

1A. Generalized Trust Questions and Factor Loadings

Indicator	Factor loading[1]
Most people can be trusted, or you can't be too careful.	0.74
Most people try to take advantage of you, or they try to be fair.	0.78
Most of the time people are helpful, or they mostly look out for themselves.	0.66

1B. Ethnocentrism Questions and Factor Loadings

Indicator	Factor loading[2]
The country's cultural life is undermined or enriched by immigrants.	0.76
Immigrants make the country a worse or better place to live.	0.74
It's better for the country if almost everyone shares customs and traditions.	0.54
If the country wants to reduce tension, it should stop immigration.	0.63

Source: Calculations by the authors based on R. Jowell et al., *European Social Survey 2002/2003: Technical Report* (London: Centre for Comparative Social Surveys, City University, 2003).
[1] Cronbach's alpha: 0.604.
[2] Cronbach's alpha: 0.732.

Distribution of Various
Characteristics in
Selected European
Countries

Country	GDP per capita[1]	Multi-cultural policies	Naturali-zation ratios	Early voting rights	Late voting rights	No voting rights
Austria	30.09	0.5	0.413			x
Belgium	28.34	3.5	0.800		x	
Czech Republic	16.36	n/a	n/a	n/a	n/a	n/a
Denmark	31.47	0.0	0.668	x		
Finland	27.62	1.0	0.391	x		
France	27.68	2.0	0.546			x
Germany	27.76	0.5	0.318			x
Greece	19.95	0.5	n/a			x
Hungary	14.58	n/a	0.389		x	
Ireland	37.74	1.5	n/a	x		
Italy	27.12	1.5	0.048			x
Netherlands	29.37	4.5	0.737	x		
Norway	37.67	0.0	0.327	x		
Poland	11.38	n/a	n/a			x
Portugal	19.15	0.0	0.082			x
Spain	22.39	1.0	n/a			x
Slovenia	19.15	n/a	n/a	n/a	n/a	n/a
Sweden	26.75	3.0	1.043	x		
United Kingdom	27.15	5.0	0.226		x	

Sources: GDP per capita: United Nations Development Programme,
*International Cooperation at a Crossroads: Aid, Trade and Security in an
Unequal World*, Human Development Report (New York: UNDP, 2005); natu-
ralization ratios: OECD, *Trends in International Migration* (Washington: OECD,
2003); multicultural policies: Banting and Kymlicka (2003); voting categories:
Waldrauch (2005).
[1] GDP per capita, highest value (PPP US$) 1975-2003.
[2] The naturalization ratio is the number of naturalizations in 2001 divided by
the inflow of foreigners in 2000.

3A. Relationship between Voting Rights for non-EU Citizens and Generalized Trust

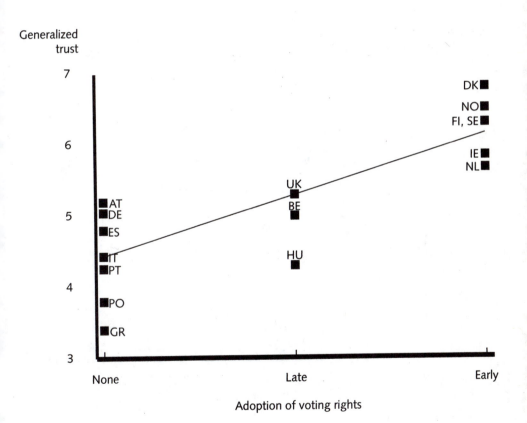

Source: Values for voting rights are adapted from H. Waldrauch,
"Electoral Rights for Foreign Nationals: A Comparative Overview"
(paper presented at "Citizens, Non-citizens and Voting Rights in
Europe," June 2-5, 2005, University of Edinburgh). For a list of the
country-name abbreviations used here, see the note to figure 1.

3B. Relationship
between Multicultural
Policies Score and
Generalized Trust

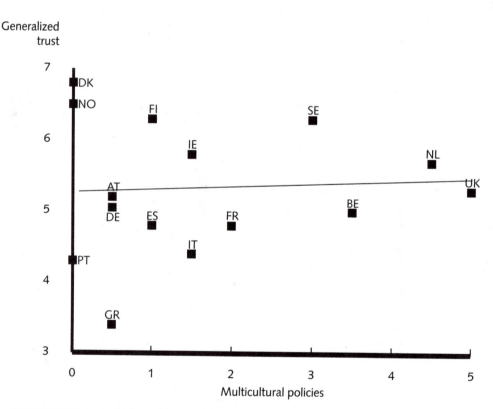

Source: Values for immigrant multicultural policies are adapted
from K. Banting and W. Kymlicka, "Do Multiculturalism Policies
Erode the Welfare State?" (paper presented at the meeting of the
International Sociological Association, August 21-24, 2003,
Toronto). For a list of the country-name abbreviations used here,
see the note to figure 1.

Notes

1 The authors' names are in alphabetical order and they share equal responsibility for the manuscript.

2 This measure of the stock of foreigners is provided by the Organisation for Economic Co-operation and Development (OECD), which depends on a country-specific understanding of "foreigner." By definition, a foreigner doesn't have citizenship status, yet who is and who is not granted citizenship status varies by country. For example, in some countries there are people with permanent immigrant status even though they were born in that country (OECD 2004).

References

Alesina, A., A. Devleeschauwer, W. Easterly, S. Kurlat, and R. Wacziarg. 2003. *Fractionalization*. NBER Working Paper 9411. Cambridge: National Bureau of Economic Research. Accessed September 1, 2006. http://www.nber.org/papers/w9411

Alesina, A., and E. La Ferrara. 2002. "Who Trusts Others?" *Journal of Public Economics* 85:207-34.

Banting, K., and W. Kymlicka. 2003. "Do Multiculturalism Policies Erode the Welfare State?" Paper presented at the meeting of the International Sociological Association, August 21-24, Toronto.

Barry, B. 2001. *Culture and Equality: An Egalitarian Critique of Multiculturalism*. Oxford: Polity Press.

Baubock, R. 1994. *Transnational Citizenship: Membership and Rights in International Migration*. Aldershot: Edward Elgar.

Citrin, J., and J. Sides. 2006. "European Immigration in the People's Court." In *Immigration and the Transformation of Europe*, edited by C.A. Parsons and T.M. Smeeding, 327-61. Cambridge: Cambridge University Press.

Davy, U. 2001. *Die Integration von Einwanderern. Rechtliche Regelungen im europäischen Vergleich*. Frankfurt: Campus Verlag.

Delhey, J., and K. Newton. 2005. "Predicting Cross-National Levels of Social Trust: Global Pattern or Nordic Exceptionalism?" *European Sociological Review* 21 (4): 311-27.

Driedger, L. 1996. *Multi-ethnic Canada: Identities and Inequalities*. Toronto: Oxford University Press.

Hero, R. 2003. "Social Capital and Racial Inequality in America." *Perspectives on Politics* 1:113-22.

Hooghe, M. 2003. "Value Congruence and Convergence within Voluntary Associations: Ethnocentrism in Belgian Organizations." *Political Behavior* 25 (2): 151-76.

Hooghe, M., T. Reeskens, and D. Stolle. 2005. *Integration Regimes in European Nation-States: An Analysis of Generalized Trust and Ethnocentrism in the European Social Survey*. Leuven: Centre for Citizenship and Democracy.

Joppke, C. 1999. *Immigration and the Nation-State*. Oxford: Oxford University Press.

Jowell, R., and the Central Co-ordinating Team. 2003. *European Social Survey 2002/2003: Technical Report*. London: Centre for Comparative Social Surveys, City University.

Koopmans, R., P. Statham, M. Giugni, and F. Passy, eds. 2005. *Contested Citizenship: Immigration and Cultural Diversity in Europe*. Minneapolis: University of Minnesota Press.

Kymlicka, W. 1995. *Multicultural Citizenship: A Liberal Theory of Minority Rights*. Oxford: Oxford University Press.

———. 2001. *Politics in the Vernacular: Nationalism, Multiculturalism, and Citizenship*. Oxford: Oxford University Press.

Kymlicka, W., and W. Norman, eds. 2000. *Citizenship in Diverse Societies*. Oxford: Oxford University Press.

Leigh, A. 2006. "Trust, Inequality, and Ethnic Heterogeneity." *Economic Record* 82 (258): 268-80.

Letki, N., and G. Evans. 2005. "Endogenizing Social Trust: Democratization in East-Central Europe." *British Journal of Political Science* 35 (3): 515-29.

Marschall, M., and D. Stolle. 2004. "Race and the City: Neighborhood Context and the Development of Generalized Trust." *Political Behavior* 26 (2): 125-54.

Messick, D., and R. Kramer. 2001. "Trust as a Form of Shallow Morality." In *Trust in Society*, edited by Karen Cook, 89-117. New York: Russell Sage Foundation.

Oliver, J.E. 2001. *Democracy in Suburbia*. Princeton: Princeton University Press.

Organisation for Economic Co-operation and Development (OECD). 2004. *Trends in International Migration*. Paris: OECD.

———. 2005. "Statistics Portal: Home." Paris: OECD. Accessed September 25, 2005. http://www.oecd.org

Rice, T., and B. Steele. 2001. "White Ethnic Diversity and Community Attachment in Small Iowa Towns." *Social Science Quarterly* 82 (2): 397-407.

Rothstein, B., and D. Stolle. Forthcoming. "An Institutional Theory of Social Capital." In *Social Capital: A Reader*, edited by J. van Deth and D. Castiglione. Oxford: Oxford University Press.

Sniderman, P., P. Peri, R.J.P. De Figueiredo Jr., and T.L. Piazza. 2000. *The Outsider: Prejudice and Politics in Italy*. Princeton: Princeton University Press.

Sniderman, P., and T. Piazza. 1993. *The Scar of Race*. Cambridge: Harvard University Press.

Soroka, S., R. Johnston, and K. Banting. 2005. "Ethnicity, Trust, and the Welfare State." In *Cultural Diversity versus Economic Solidarity*, edited by P. van Parijs, 33-57. Brussels: De Boeck Université.

Stolle, D. 2002. "Trusting Strangers: The Concept of Generalized Trust in Perspective." *Österreichische Zeitschrift für Politikwissenschaft* 4 (4): 397-412.

Tyler, T. 1998. "Trust and Democratic Governance." In *Trust and Governance*, edited by V. Braithwaite and M. Levi, 269-314. New York: Russell Sage Foundation.

United Nations Development Programme (UNDP). 2005. *Human Development Report 2005*. Oxford: Oxford University Press.

Uslaner, E.M. 2002. *The Moral Foundations of Trust*. Cambridge: Cambridge University Press.

Waldrauch, H. 2005. "Electoral Rights for Foreign Nationals: A Comparative Overview." Paper presented at "Citizens, Non-citizens and Voting Rights in Europe," June 2-5, University of Edinburgh.

The Challenges of
Immigration to Race-
Based Diversity Policies
in the United States

T HE UNITED STATES PRIDES ITSELF ON BEING A NATION OF IMMIGRANTS. THE SUC-
cessful integration of millions of immigrants in the eighteenth, nineteenth
and twentieth centuries remains a great and celebrated national accomplish-
ment. The current immigration flows, which began in the 1960s and continue
at very high levels (1.2 million per year), pose some of the same challenges the
country faced before, as well as new issues and dilemmas. Indeed, much of the
scholarly and public policy debate over the integration of new immigrants is
related to whether immigrants today will be assimilated into American society as
successfully as earlier immigrants from Europe were, or whether new policies are
now required to address a series of factors: different immigrant populations
(non-Whites from the Caribbean, Latin America, Asia and Africa); different ide-
ologies about integration (a stress on multiculturalism and an acceptance of
diverse cultures); and changes in technology and transport that make sustained
transnationalism more viable (Foner and Frederickson 2004; Foner 2005).
There is no doubt that immigrants are making the United States more diverse
each year. But US policies directed at managing diversity generally do not target
immigrants per se. Rather, they target America's racial divisions — most princi-
pally, that affecting the 12 percent of America's population who are African
American descendants of slaves.

Immigration policy in the United States tends to focus almost exclusive-
ly on determining whom to let in and how to deal with illegal immigrants. Only
refugees are eligible for government assistance and integration programs. Most
immigrants are not given any government assistance as immigrants (although

legal immigrants can qualify for government assistance if they are poor). For the most part, cultural, social, civic, economic and political integration of immigrants and their descendants has been left to market forces, the immigrants themselves and voluntary organizations.[1] Thus, specific policies to help immigrants integrate are very rarely directed at immigrants qua immigrants. Instead, there are policies directed at racial and ethnic minorities, including a large number of immigrants and their children; policies directed at low-skilled, uneducated workers, which prompt debate about who is eligible for welfare state provisions; and policies that affect immigrants through the institutions that have an impact on their lives, such as the educational, housing and health care systems.

Current debates about managing diversity related to immigration in the United States focus on the prevalence of English-language use, the relationship of different categories of immigrants to the welfare state, and policies to manage racial diversity and end racial inequality. In this chapter, we review developments in each of these policy areas. We argue that the debates over language are largely irrelevant — a very clear case of political grandstanding on an issue that has little empirical reality. The United States has always been, and continues to be, extremely effective at stamping out any language other than English within one or two generations. We also review recent changes to the welfare system that deny the social service safety net to immigrants, legal and illegal alike. These policy changes are important, because they have begun to create different categories among legal immigrants. Previously, legal permanent residents were indistinguishable from citizens in most categories of US law. The new distinctions created by welfare laws could have long-term effects on how the nation thinks about and reacts to immigrants.

We then discuss the challenges current immigration poses for race-based diversity policies. Current immigration, which is composed of mostly non-White immigrants, complicates debates over managing racial diversity in our society. The cultural acceptance and full integration of immigrants and their descendants in the past stand in rather sharp contrast to the caste-like separation of Blacks from Whites and the systematic oppression of Blacks throughout American history, as well as the legal discrimination and exclusion faced by other non-Whites — Mexicans, Puerto Ricans, Asians, Pacific Islanders and American Indians. Specific policies developed to change the racial hierarchy in the United States —

the *Voting Rights Act*, antidiscrimination laws and affirmative action policies — were not designed to address the issue of integrating and absorbing immigrants. They instead address long-standing patterns of racial inequality. As Nathan Glazer puts it in his ironically titled book *We Are All Multiculturalists Now*, "Multiculturalism is the price America is paying for its inability or unwillingness to incorporate into its society African Americans, in the same way and to the same degree it has incorporated so many other groups" (1997, 147). Yet the liberalization of the immigration law in 1965 and the resulting demographic shift in the sources of immigrants have meant that policy designed for one purpose — changing the relative standing of native minorities — has come to be used as policy for managing current diversity.

We argue that immigrants and their descendants, because they are defined in the US as non-Whites, are both being helped by and, ironically, undermining the US's most far-reaching diversity policy: affirmative action. Because they are identified as Black, Hispanic or Asian, first- and second-generation immigrants qualify for race-based advantages in hiring and university admission. But this program was designed and sold to the American public as a way to help African Americans overcome the crippling effects of slavery and the state-sanctioned repression that existed until the 1960s, when it was finally laid to rest by the American civil rights movement.

Over time, this program has come to be interpreted less as a policy to redress past harm and more as a policy to guarantee diversity by race in the country's key institutions — corporate workplaces, universities, hospitals and courts. This diversity has increasingly been represented by first- and second-generation immigrants. The growing demographic complexity of the non-White population, the relative success of first- and second-generation immigrants and their offspring, and the increase in blended identities (the result of intermarriage) fuelled by successful immigrant integration create problems in terms of the race-based diversity policies that we lay out in this chapter.

We conclude by arguing that while diversity policies do help somewhat in the integration of immigrants, the most important policy issue affecting immigrant integration is the future shape of the American economy. We maintain that the economic incorporation of immigrants and the lack of a specific policy of immigrant incorporation have led to an openness and acceptance of immigration among native-born Americans and have facilitated the cultural assimilation of

immigrants and their children. However, rising income inequality, wage stagnation among poorly educated workers and the huge problem of undocumented workers and their children will present significant challenges in the years to come. These challenges threaten American cultural incorporation of newcomers much more than issues of language or other cultural differences, despite the attention given to these issues in popular debates.

Demographics

NEW IMMIGRANTS MAKE THE UNITED STATES MORE DIVERSE IN TERMS OF RACE AND ethnicity; in terms of social class, as measured by educational attainment; in terms of linguistic background; and in terms of religion. Most attention has been directed toward ethnic, racial and linguistic diversity; less attention has been paid to social class and religion. The 2000 US Census counted 281 million people, of whom 31.1 million, or 11.1 percent, were foreign-born. Another 10 percent were the children of immigrants, so that currently at least one in five Americans are first or second generation. Only 14 percent of the foreign-born in the United States are from Europe. The largest group (43 percent) is from Latin America (including Central America, South America and the Caribbean), while 25 percent are from Asia and 8 percent are from other regions of the world, such as Africa and Oceania. Mexicans are the largest single group of the foreign-born, and they now constitute 27 percent of all foreign-born. In addition to Mexico, the top countries of birth of the foreign-born are China, India, Korea, the Philippines, Vietnam, Cuba, the Dominican Republic and El Salvador. At the beginning of the current wave of immigration, which was triggered by the liberalization of the immigration law in 1965, the United States was primarily a nation divided between Blacks and Whites. In 1970, 88 percent of the US population was White, 11 percent was Black and less than 1 percent consisted of American Indians, Asians and Hawaiians. Hispanics, who are counted differently in the census and can be of any race, accounted for only 5 percent of the total 1970 US population. By 2000, the effects of immigration were readily apparent in the demographics of the country — 75 percent of the population was White, 12 percent Black, 4 percent Asian and 13 percent Hispanic. American Indians increased in number over the 30-year period (through new people claiming or

discovering their Indian heritage), but they still made up less than 1 percent of the population.

In addition to changing the relative numbers of the different races and ethnic groups in the United States, immigration has also changed the generational distribution within American race and ethnic categories. Table 1 shows the generational distribution of each of the nation's major race/ethnic groups. As Roberto Suro and Jeffrey Passel point out, in the mid-twentieth century, the US Latino population was dominated by the third-and-later generation — a group that was generally distant from the immigrants who could be considered a native minority (2003, 6). By 2000, the majority (68 percent) of Latinos were first or second generation. Indeed, only Blacks and American Indians in 2000 were a majority nonmigrant stock. Even Blacks — the group whose experience most racial policies in the United States were designed to address — were now 10.2 percent first or second generation.

Immigration not only has affected racial diversity in the United States but has increased class and religious diversity as well. Immigrants are overrepresented among those with low levels of education. According to the census, among people aged 25 and over, 85 percent of native-born Americans have completed high school or have a higher degree, while the figure is only 67 percent for immigrants. The foreign-born are especially overrepresented among those with low levels of education. Approximately 7 percent of the foreign-born have less than five years of schooling, 15 percent have between five and eight years, and another 10.8 percent have between 9 and 11 years. In terms of employment, immigrants are concentrated among low-wage workers. While immigrants account for one in nine US residents, they account for one in five low-wage workers (defined as those who earned less than twice the minimum wage in 2001). Thus the fortunes of low-wage workers in American society disproportionately affect immigrants and their families.

Immigration also adds to the country's religious diversity; 75 to 80 percent of Americans are Christian and 5 percent are of a non-Christian religion. Among new immigrants there is more religious diversity: two-thirds of new immigrants are Christian, the majority being Catholic; 20 percent report a non-Christian faith; and one in six report no religious identity at all. In contrast to Western Europe, the US has received very little Muslim immigration. Muslims in the United States total about 3 million, less than 1 percent of the total population (Warner 2004).

Table 1 416

Race and Ethnicity in
Three Generations,
United States, 2000
(percent)

Generation	Black	Asian	Hispanic	Non-Hispanic White	Proportion of ethnic population that is of this generation
1st	6.3	61.4	39.1	3.6	10.4
2nd	3.9	26.6	28.5	7.3	10.0
3rd	89.9	12.1	32.4	89.1	79.6
	100.0	100.0	100.0	100.0	100.0
Total number in group (millions)	35.5	10.9	32.8	193.6	

Source: Adapted by the author from A. Dianne Schmidley, *Profile of the Foreign-Born Population in the United States: 2000*, US Census Bureau Current Population Reports ser. P23-206 (Washington, DC: Government Printing Office, 2001), figure 9.1, p. 25.
Note: Totals may not add up to 100 because of rounding.

Language Diversity in
the US

L ANGUAGE IS ONE OF THE MOST CONTROVERSIAL ISSUES RELATED TO IMMIGRATION. The ability of immigrants and their offspring to speak English is a potent political matter. In his attack on Mexican immigration to the United States, political scientist Samuel Huntington argues that today's Latino immigrants and their children form "linguistic enclaves" and do not learn English (2004). Responding to a 1996 General Social Survey (GSS) question, 63 percent of Americans supported passage of "a law making English the official language of the United States, meaning government business would be conducted in English only." To a 2000 GSS question, 75 percent of Americans replied that they agreed with the statement "Speaking English as the common national language is what unites all Americans." Twenty-seven states have responded to this perceived threat by passing laws requiring that all government activity be conducted in English (National Opinion Research Center various dates).

These "English only" laws vary by state. Some states just symbolically declare English their official language. Others employ more far-reaching measures, mandating that all ballots be in English, banning courtroom translations or restricting bilingual education. At the same time, the federal government, with the *Civil Rights Act, 1964,* mandated that federal agencies ensure all of their services are available to people who have limited proficiency in English. In practice, this means that most federal services and programs do provide translation for large language groups, such as Spanish-speakers. The last US census, for example, was printed in five commonly used languages in addition to English, and enumerators and call centre staff were multilingual.

Despite the sometimes heated nature of public debate about language use by immigrants and their children and the related debate about bilingual education, the fear is unfounded. While the absolute number of people who speak a language other than English in their homes is quite high — 47 million — language-use changes documented over time point to high levels of language assimilation. Frank Bean and Gillian Stevens, using data from the 2000 US Census, point out that among immigrants from non-English-speaking countries, only 10 percent did not speak English. They find a strong positive association between the length of time the foreign-born spend in the US and their English fluency (Bean and Stevens 2003).

The United States has always been very efficient at stamping out other languages and quickly assimilating the children of immigrants linguistically. And the consensus among immigration researchers is that the standard three-generation model of linguistic assimilation prevails in the US. This model of language assimilation — the immigrant generation makes some progress, but their native tongues remain dominant; the second generation is bilingual; the third generation is monolingual English — appears to hold for most of today's immigrants. Using 1990 Census data, Richard Alba, John Logan, Amy Lutz and Brian Stults find that among Mexicans and Cubans, by the third generation two-thirds to three-quarters (respectively) of the groups do not speak any Spanish (2002). Suro and Passel analyzed data from the 2002 National Survey of Latinos and showed that among Spanish-speakers, by the third generation no one is Spanish dominant (2003) (see table 2).

A vivid example of the disconnect between knowledge of this issue among social scientists and the concerns of the general public is the recent social science speculation that some linguistic assimilation can happen too quickly. Alejandro Portes and Ruben Rumbaut argue that when children abandon their parents' language too quickly, the parents lose authority over the children (2001). This dissonant acculturation leads to a situation in which communication between parents and children is impeded — parents cannot understand English well, and children cannot understand the immigrant language well. Portes and Rumbaut also maintain that children who stay fluently bilingual will do best academically. Other researchers have found a correlation between fluent bilingualism and academic achievement among second-generation-immigrant schoolchildren (Zhou and Bankston 1999; Warren 1996). In a study of Asian and Latino youth using 1990 Census data, Cynthia Feliciano found that bilingual students are less likely to drop out of school than English-only speakers, students living in bilingual households are less likely to drop out than those in English-dominant or English-limited households, and students living in immigrant households are less likely to drop out than those in nonimmigrant households (2003).

Why are Americans so worried about the preservation of English, when careful data analysis shows such rapid language assimilation? The high levels of immigration mean that much language assimilation is invisible to the average American. While immigrants who have been in the US for many years acquire English, and while their children grow up fluent in English, they are quickly

Table 2

Language Use in Three Generations of Spanish-Speakers, United States, 2002 (percent)

Generation	Spanish-dominant	Bilingual Spanish and English	English-dominant
1st	72	24	4
2nd	7	47	46
3rd	0	22	78

Source: Roberto Suro and Jeffrey S. Passel, *The Rise of the Second Generation: Changing Patterns in Hispanic Population Growth*, Pew Hispanic Center Study, October 14, 2003 (Washington, DC: Pew Hispanic Center, 2003), 8. Accessed August 4, 2006. http://pewhispanic.org/reports/report.php?ReportID=22

replaced by new arrivals who speak only their native languages. The large cohort of Spanish-speakers in the US is particularly obvious because of its concentration in certain cities and regions and because of the growth of Spanish media — radio and TV. US-produced Spanish programming not only serves immigrants to the US, but it is also disseminated throughout Latin America. Language is thus a highly visible and emotional issue for those Americans who fear elevated levels of immigration. Their fear is understandable, given the constant replenishment of foreign-language speakers through immigration; but it is not justified or rational, given the rapid language assimilation that is occurring over time and across generations.

Different Categories of Immigrants and the Welfare State

As CHRISTIAN JOPPKE POINTS OUT, INTEGRATION POLICIES IN THE EUROPEAN UNION are shifting toward civic integration, with the underlying agenda of making immigrants less reliant on the welfare state and more socioeconomically integrated in the host society (see Joppke's chapter in this volume for a review of integration policies in the European Union). This is done through both obligatory and voluntary language and civics courses. In contrast, the United States — for better or worse — has no policies aimed specifically at facilitating the integration process. Immigrants to the US — with the exception of refugees — are left on their own when it comes to integration. In the majority of cases, the route to integration is through the labour market, as immigrants obtain jobs and attempt to climb the social ladder. This self-integration process also entails the strategic use of existing race-based policies to gain entry into key American institutions. Access to social and welfare benefits is, perhaps, the only area where there are immigrant-specific public policies. However, these policies are not intended to regulate and distribute societal goods — rather, they are meant to control and limit immigrants' access to societal resources. By bracketing immigrants in citizen/noncitizen categories via legal/illegal residency status, the government shows that it is not really concerned with incorporating immigrants per se but rather with policing immigrants' penetration of the welfare state.

In the United States, immigrants are grouped into five main categories: legal permanent residents; naturalized citizens; undocumented immigrants; refugees, asylees and parolees; and legal nonimmigrant residents. Legal immigrants, or immigrants admitted for permanent residence (LPRs), constitute about 9.3 million (or 30 percent) of America's 30 million foreign-born residents. Naturalized citizens make up another one-third (or 9.2 million) of the immigrant population, while undocumented immigrants constitute about 28 percent of the foreign-born (Fix and Passel 2001). Wayne Cornelius estimates that of the one million immigrants who enter the United States annually, approximately 500,000 are undocumented (2005).

This categorization not only denotes residency status but also determines what kinds of social welfare benefits immigrants are entitled to. In 1996, immigrant eligibility for public benefits was drastically curtailed by the *Personal Responsibility and Work Opportunity Reconciliation Act, 1996* (PRWORA) and the *Illegal Immigration Reform and Immigrant Responsibility Act, 1996* (IIRAIRA). PRWORA denies most types of federally funded means-tested assistance to non-citizens who arrived after the legislation was signed and limits the eligibility of many noncitizens already living in the United States (Borjas 2002, 2). Federal public benefits, which have not yet been identified by all of the relevant federal agencies, are defined generally by statute as "any grant, contract, loan, professional license or commercial license provided by" a US agency and "any retirement, welfare, health, disability, public or assisted housing, postsecondary education, food assistance, unemployment benefit or any similar benefit" (Broder 2005, 761). What constitutes a means-tested federal public benefit is left to the individual agency to define, however. For example, the US Department of Health and Human Services defines the services in box 1 as being "public funded benefits" (2004).

The 1996 welfare reform legislation created three categories that serve as the basis for determining eligibility for most benefit programs: "qualified" immigrants; "not qualified" immigrants; and persons who are lawfully present in the United States (Broder 2005, 759). Immigrants who qualify for federal benefits and services include legal permanent residents; asylees; refugees; immigrants paroled into the US for at least one year;[2] immigrants whose deportations are being withheld; immigrants granted conditional entry (prior to April 1, 1980); battered immigrant spouses, battered immigrant children, the immigrant parents

Box 1 422

Benefits Funded by the United States Department of Health and Human Services

- Administration on Developmental Disabilities (ADD) — Special Projects (direct services only)
- ADD — State Developmental Disabilities Councils (direct services only)
- ADD — University Affiliated Programs (clinical disability assessment services only)
- Adoption Assistance
- Adult Programs/Payments to Territories
- Agency for Health Care Policy and Research Dissertation Grants
- Child Care and Development Fund
- Clinical Training Grant for Faculty Development in Alcohol and Drug Abuse
- Foster Care
- Health Profession Education and Training Assistance
- Independent Living Program
- Job Opportunities for Low-Income Individuals (JOLI)
- Low-Income Home Energy Assistance Program (LIHEAP)
- Medicaid (except assistance for an emergency medical condition)
- Medicare (except that an alien who is lawfully present and was authorized to be employed with respect to wages used to establish his or her Medicare Part A entitlement, is eligible for Medicare benefits)
- Mental Health Clinical Training Grants
- Native Hawaiian Loan Program
- Refugee Cash Assistance
- Refugee Medical Assistance
- Refugee Preventive Health Services Program
- Refugee Social Services Formula Program
- Refugee Social Services Discretionary Program
- Refugee Targeted Assistance Formula Program
- Refugee Targeted Assistance Discretionary Program
- Refugee Unaccompanied Minors Program
- Refugee Voluntary Agency Matching Grant Program
- Repatriation Program
- Residential Energy Assistance Challenge Option (REACH)
- Social Services Block Grant (SSBG)
- State Child Health Insurance Program (CHIP)
- Temporary Assistance for Needy Families (TANF)

Source: US Department of Health and Human Services, *Summary of Immigrant Eligibility Restrictions under Current Law* (Washington, DC: Department of Health and Human Services, 2004), 5-6.

of battered children and immigrant children of battered parents who fit certain criteria; Cuban or Haitian entrants; and victims of a severe form of trafficking (National Immigration Law Center 2005b). These qualified immigrants are, however, subject to certain time-limited eligibility criteria. For example, even qualified immigrants face a five-year waiting period before they can become eligible for food stamps and Supplemental Security Income (SSI).[3]

All noncitizens who do not fit into one of these categories are considered "not qualified." Unqualified immigrants are those who either entered without documents or overstayed their visas and who have no basis for obtaining lawful status. Also unqualified are some applicants for immigration benefits, such as applicants for cancellation of removal, adjustment of status, asylum and registry, as well as persons who are otherwise lawfully present in the United States. Unqualified immigrants are barred from receiving federal public benefits (Broder 2005, 761).

Despite the changes in legislation, most states have chosen to continue providing some form of state-funded benefits to unqualified immigrants (Borjas 2002). Approximately 20 states use state funds to provide Temporary Assistance for Needy Families (TANF), Medicaid and/or the State Children's Health Insurance Program (SCHIP) to some or all of the immigrants who are subject to the five-year bar on federally funded services (National Immigration Law Center 2005b). The 1996 legislative reforms did manage to achieve one of their objectives — that is, they reduced the time many immigrants spent on the welfare rolls. Borjas noted that there was a precipitous nationwide decline in the welfare participation rates of immigrant households relative to that of the households of the US-born (2002). But most of the decline is attributable to the decreased welfare participation of immigrants in California. Elsewhere in the country, the welfare participation rates for immigrant and native households are similar.

Not surprisingly, undocumented immigrants have the least claim to social benefits. They are ineligible for federal means-tested programs such as SCHIP, TANF and SSI. They may, however, receive the following benefits and services, which are deemed necessary for health and survival: US-born children of undocumented immigrants are eligible for food stamps; undocumented immigrants who cannot pay or who have no medical insurance receive emergency Medicaid at public hospitals, and those who can pay get discounted medical care; the children of undocumented immigrants attending public primary and secondary

schools are given free breakfasts and lunches; undocumented immigrants who have been abused or whose children have been abused by their US-citizen or law-ful-permanent-resident-status partner may be eligible for public benefits and for green-card status. Social welfare benefits for undocumented immigrants can also vary from state to state. In New York, for example, immigrants are eligible for ser-vices such as public housing, Medicaid, prenatal care or workers' compensation, irrespective of their legal residency status (Children's Aid Society 2003).

Despite the fact that undocumented immigrants have free access to public primary and secondary schools, they are not guaranteed access to higher educa-tion at public institutions. Section 505 of the *Illegal Immigration Reform and Immigrant Responsibility Act* prohibits undocumented immigrants from receiving in-state tuition rates at public institutions of higher education. The law further imposes financial penalties on states that provide in-state tuition for undocu-mented immigrants by requiring the states to provide the same benefit to US cit-izens in the same circumstances, regardless of their residence (National Immigration Law Center 2005a). Michael Fix and Randy Capps estimate that 65,000 undocumented children graduate each year from American high schools (2005). Yet, because of their illegal status, the majority of these children do not qualify for federal aid or scholarships (most scholarships, including federal aid, require US citizenship or a green card), and thus they do not have the financial means to pursue a college degree. Less than 10 percent of undocumented high school graduates go on to college (National Immigration Law Center 2005a).

Human rights and immigrant advocates point out the irrationality of sec-tion 505, which actually penalizes hard-working, academically oriented immi-grant youth wishing to increase their human capital. Proponents of the law argue that the US government should not reward clandestine immigration by providing reduced tuition rates to undocumented immigrants, even if these people spent most of their childhood and adolescence in the same schools as US-born and LPR children. The debate over in-state tuition for undocumented immigrants is high-ly publicized and politically charged because it speaks to the very heart of the US's ongoing love-hate relationship with immigration.

Despite the objection to "rewarding" clandestine immigration, some states have decided that the social benefits of providing affordable higher education to undocumented immigrant youth far outweigh the costs. Currently, nine states — Texas, California, New York, Utah, Illinois, Washington, Oklahoma, New Mexico

and Kansas — allow undocumented immigrant students to pay in-state tuition fees (National Immigration Law Center 2005a, 1). In order to qualify for in-state tuition, undocumented immigrant students must have attended primary and/or secondary school within the state. Specific school residency requirements vary from state to state. Legislation to allow in-state tuition rates for undocumented immigrants is pending in 14 other states.

An important pending bill in the Senate that might change the fate of undocumented immigrant students wishing to pursue higher education is the *Development, Relief and Education for Alien Minors (DREAM) Act*. The *DREAM Act* would repeal section 505 of the *Illegal Immigration Reform and Immigrant Responsibility Act*. The legislation would also provide a mechanism for undocumented students to become legal permanent residents and to qualify for federal student aid. Hence, the *DREAM Act* may be a key pathway for undocumented immigrants to obtain legal residency status. It would also end the penalization of states that provide in-state tuition to undocumented immigrant residents. Although the *DREAM Act* would eliminate the federal penalty, it does not mandate that states provide in-state tuition to undocumented immigrants. Therefore, even if the *DREAM Act* passes, each state would ultimately have discretionary power to allow or disallow undocumented immigrants to benefit from in-state tuition rates (National Immigration Law Center 2005a, 3).

Note that the debate in the US about social welfare and immigration is hardly ever framed as relating to how immigrants can best be assimilated or integrated into the society. Instead, it focuses on the withholding of benefits from immigrants based on their visa and citizenship status.

The Redesign of the Citizenship Test

WHILE NOT ORDINARILY CLASSIFIED AS DIVERSITY MANAGEMENT POLICY, THE SET OF regulations governing citizenship does actually manage the diversity resulting from immigration. Citizenship is one public policy strategy through which the United States government attempts to unify racially, ethnically, religiously and linguistically diverse groups by encouraging a common American civic identity. Peter Schuck notes that US naturalization laws "promote diversity

by providing eligibility requirements that are easy to satisfy relative to the [more rigorous] naturalization statutes in Europe and Japan" (2003, 96). For example, the English and literacy tests are very easy to pass and have many exemptions. Nonetheless, there is still an underlying expectation that individuals living on American soil, and particularly those wishing to partake in the benefits of American citizenship, will subsume some aspects of their ethnic identity in an American identity emphasizing a shared ideology that reflects a "commitment to a set of civic ideals that speak in universal terms and are accessible to all of humanity" (Schuck 2003, 98).

It has not been widely discussed in the media or in public policy circles, but the test immigrants take to gain citizenship is undergoing revision. When the proposed changes are made public, it may become a topic of public debate.[4] Each year, approximately 600,000 people apply to become naturalized citizens of the United States. In 2004, 662,794 petitions were filed for citizenship. Of these, 537,151 (or 81 percent) were granted naturalization (Center for Immigration Studies 2004). The racial and ethnic diversity of these newly naturalized citizens is reflected in table 3. The majority came from non-European regions, such as Asia (41 percent), North America (28 percent) — of which 36 percent, 42 percent and 16 percent were from the Caribbean, Mexico and Central America, respectively — and South America (7 percent). These figures lend support to Schuck's argument that citizenship and naturalization laws both engender and serve as a means for managing diversity (2003).

The recent government initiative to redesign the naturalization exam and standardize its administration may increase diversity even more by making the naturalization process less cumbersome for applicants. Currently, there are grave inconsistencies in the testing experience (from the content of the exam to the ways in which it is administered). The motivation for the redesign is to minimize disparate test-taking experiences. The United States Citizenship and Immigration Services are working with the National Academy of Sciences on this initiative. The role of the latter organization is to monitor the development of the redesign.

There are three proposed changes to the naturalization test. The first is a reevaluation of the content covered in the civics component. The goal is to encourage naturalized persons to acquire a deeper understanding of American history and government (as opposed to just memorizing dates and facts). The second change is recasting the English exam (reading, writing and speaking) to

Newly Naturalized
Citizens of the United
States, by Region of
Origin, 2004

Region/country	Number of persons
Europe	89,014
Asia	218,974
Africa	34,531
Oceania	3,551
North America	
Caribbean	54,811
Canada	7,682
Mexico	63,840
Central America	24,677
Other	37
South America	38,676
Other/unknown	1,358
Total	537,151

Source: United States, Department of Homeland Security,
Yearbook of Immigration Statistics: 2004 (Washington,
DC: Department of Homeland Security, Office of
Immigration Statistics, 2006). Accessed August 4, 2006.
http://www.uscis.gov/graphics/shared/statistics/
yearbook/Yearbook2004.pdf

reflect comprehension of the English language. This redesign will ensure that examination questions are appropriate to each applicant's English proficiency level. For example, staff will present highly educated applicants who are proficient in English with more complex sentences than the ones they will present to applicants with less education and limited English abilities (Center for Immigration Studies 2004).

These attempts at redesigning the naturalization exam may have important implications for the socioeconomic and demographic profile of naturalized citizens. For example, by synchronizing the English and literacy exam with an applicant's English proficiency or educational attainment level, the redesign could increase the naturalization rates of limited-English applicants. Thus, one can foresee the possibility of a greater diversity of education and English proficiency within the pool of naturalized Americans. Conversely, the naturalization redesign could also have a homogenizing effect by causing only highly educated and English-proficient applicants to be selected. It is only when the new design is made public that we can assess the full implications of the change.

Dual Citizenship/ Transnationalism

IN ADDITION TO THIS PENDING CHANGE TO CITIZENSHIP, THERE IS THE QUESTION OF dual citizenship, which provokes further debate about whether new immigrants assimilate in the same way that earlier immigrants did. Dual citizenship and naturalization challenge governmental attempts to unify the American people on the basis of allegiance to one polity — that is, the United States. Despite the existence of the 1790 naturalization statute, which requires naturalized residents to denounce all allegiance to previous nations, Americans can still obtain dual citizenship by other means. Dual citizenship can be acquired through:

- Birth in the US to immigrant parents (thus, the US-born child can claim citizenship of the parents' country of birth)
- Birth abroad to a US parent and a foreign parent (thus, the child can claim citizenship of both parents' countries of birth)
- Marriage to a foreigner (thereby transmitting his/her nationality to the spouse)

- ◆ Naturalization in another country *after* having acquired US citizenship
- ◆ The ineffectiveness of the renunciation oath required of the naturalized citizen by the 1790 statute (hence the individual's citizenship in the country of origin may still be legally valid) (Schuck 2003, 97-8)

Approximately 90 percent of legal immigrants in the United States originate from countries that allow dual citizenship. In some countries — such as Mexico — where remittances account for a larger percentage of the GNP, there are strong economic incentives to acquire dual citizenship, even among US-born children of nationals.

How or if dual citizenship and the transnational ties that it encourages will affect the management of racial and ethnic diversity in the United States is an empirical question still to be answered. On the one hand, the diminished salience of transnational activities among second- and later-generation immigrants in the United States suggests that transnationalism poses challenges to diversity management only among the foreign-born population (Levitt and Waters 2002). On the other hand, globalization and the increasing interdependency and interconnectivity of world nations, coupled with the growing trend of international marriage, suggest that dual citizenship will be a much more pervasive phenomenon in the future. Therefore, polyglot nations that rely on fragile bases of national identity — such as the American civic identity — may find themselves in need of identity reconceptualization (Schuck 2003).

Policies to Deal
with Race

IN 1903, W.E.B. DU BOIS FORESHADOWED THAT "THE PROBLEM OF THE TWENTIETH Century is the problem of the color line" (1953, vii). More than a hundred years later, Du Bois's characterization of the main division in American society still holds true, with perhaps the qualification that the problem is now more complex and more far-reaching than the "colour line."[5] Yet, despite the changing meanings and divisions of race and shifting racial boundaries, the historical practice of depicting and organizing American society along racial lines persists. And inequality in the US is still very much tied to racial identity. For instance, in 1969, 10 percent of Whites were living in poverty; the rate for Blacks was 3.6 times

higher, at 36.7 percent; and the rate for Hispanics was 2.6 times higher than for Whites, at 26.5 percent. By 1999, poverty had declined, but the differences according to race persisted. In 1999, 6.5 percent of non-Hispanic Whites were poor; and 21.2 percent of Blacks and 19.2 percent of Hispanics were poor (Danzinger and Gottschalk 2005, 57-8).

The centrality of race in American society today is reflected in the ways in which diverse immigrant populations are accommodated. As immigrants assimilate into American society, they also incorporate the American racial lens. For example, ethnographic research on West Indians reveals that Black immigrants are often surprised when they encounter American racialization. They may find their newly acquired status as "Black" shocking, because in their country of origin they did not necessarily consider themselves so (Waters 1999). Indeed, as Orlando Patterson shows, in many regions of the world from which Blacks and Hispanics emigrate, categories of race are much more fluid (2005).

The racialization process that many ethnic and racial minority immigrants undergo in the United States, coupled with the laws and policies that govern the distribution of societal goods along racial lines, serve as strong incentives for immigrants to seek membership in established racial groups and engage in racial identity politics. We now discuss two race-based policies that have enabled immigrants to partake in the distribution of societal goods in the United States: nondiscrimination and affirmative action.

Nondiscrimination

The *Civil Rights Act, 1964* was aimed at dismantling institutionalized discrimination against African Americans. The Act (and later the *Voting Rights Act, 1965*) was the result of the hard-fought struggles of the American civil rights movement. According to John David Skrentny, "Despite the inclusion of sex, religion, and national origin, the early discussion of other ethnic minorities by Truman's Civil Rights Committee, and the presumably broad meaning of the prohibition on racial discrimination…American citizens and political elites saw Title VII [which covers antidiscrimination in employment] and the entire Civil Rights Act of 1964 as being a law for African Americans" (2002, 100).

It was only later, during the late 1970s and early 1980s, that antidiscrimination policies were expanded to cover other racial and ethnic minorities, such as Hispanics, Asians and Native Americans, as well as women and people with

disabilities (Skrentny 2002). Since the *Civil Rights Act, 1964* also includes national origin as a protected characteristic, immigrants can obtain antidiscrimination protection on the basis of other protected characteristics (for example, gender, race, ethnicity, disability status), irrespective of their noncitizen status. Thus, immigrants and citizens who have one or more of these characteristics enjoy legal protection against discrimination in many spheres of public and private life — ranging from voting rights to injunction relief against discrimination in places of public accommodation, desegregation of public facilities, desegregation of public education, nondiscrimination in federally assisted programs and equal employment opportunity. In the case of immigrant accommodation, we focus on education and employment.

Title VII of the *Civil Rights Act, 1964* bars discrimination in employment based on race, colour, religion, sex or national origin and prevents employer retaliation against employees who take action against discriminating businesses. The law applies to employers with at least 15 employees, employment agencies and unions. Title VII also created the Equal Employment Opportunity Commission (EEOC), which fights discrimination in employment by monitoring private employers and investigating individual allegations of employment discrimination. Title IV of the *Civil Rights Act, 1964* regulates the assignment of students to public schools (at all levels, ranging from elementary to post-secondary) and within such schools without regard to race, colour, religion or national origin. Thus, racial and ethnic immigrants and their children are theoretically protected against relegation to racially segregated, inferior schools (US Department of Justice 2005).

Antidiscrimination policies enjoy considerable support from the American people. They jibe with the American ideology of equal opportunity and do not contradict notions of meritocracy. But antidiscrimination laws allow for the redress of individual injustices only after they have been incurred and do not necessarily prevent them (Harper and Reskin 2005). Furthermore, since discrimination against a person on the basis of any of the specified characteristics is illegal, racial and ethnic minorities *and* Whites can seek protection under antidiscrimination laws. In contrast, affirmative action, a more controversial race-based policy that has sparked much political protest at both ends of the political spectrum, is aimed at preventing exclusion in the first place by ensuring that protected minority groups are included in various spheres of economic, educational and political life.

Affirmative Action

Similar to the various antidiscrimination laws that came out of the *Civil Rights Act, 1964*, affirmative action policies owed their existence to the American civil rights movement and were initially intended to redress the injustices against the descendants of African American slaves (Skrentny 2002). As we shall illustrate later, the initial logic of the policies challenges immigrants' claims to affirmative action benefits. The volume of immigrants who could potentially enjoy such benefits is enormous. Hugh Davis Graham notes that in the year 2000, "16 million of the 24.6 million foreign-born residents were non-citizens, yet they remained eligible for minority preferences under many affirmative action programs" (2001, 64). Immigrants who are noncitizens or who have yet to naturalize can claim affirmative action benefits by merely gaining membership in one of the protected minority groups.

In their simplest and least contested form, affirmative action policies are almost indistinguishable from antidiscrimination policies. This is referred to as "soft" affirmative action, and it entails activities such as outreach to protected minority communities, providing career advancement training and conducting fair assessments for promotions. At the other end of the spectrum is "hard" affirmative action, which is usually implemented as preferential or compensatory treatment. The most extreme and controversial form of affirmative action is quotas. But, despite public perception that affirmative action always translates into quotas, this rarely occurs (Graham 2001).

Affirmative action in education and employment and among federal contractors or small businesses is covered by different regulations, executive orders and statutes. Here, there are also differences in implementation. For example, not all employers are required to apply affirmative action policies. In the private sector, only large companies with substantial government contracts must do so (Harper and Reskin 2005, 365). The bulk of affirmative action regulations in education, particularly higher education, have been, for the most part, voluntary. Assessment of exclusion is usually based on proportional representation — that is, on whether a minority group is represented in schools or companies in proportion to its numbers in the general population (Harper and Reskin 2005).

Preferential treatment policies have not garnered much public support; they did not even do so initially. The General Social Survey is a good gauge of the American public's attitudes toward affirmative action. During the early stages of

affirmative action — in the 1970s and 1980s — public support for preferential treatment was much higher. As shown in table 4, between 1972 and 1982, approximately one-quarter of Americans agreed or strongly agreed that the government should give special treatment to African Americans. By 1998, this figure had dropped to just over 17 percent. Note, however, that between 1972 and 1982, more than half of Americans believed that the government should not give special treatment to Blacks. The percentage of Americans opposed to the government giving special treatment to Blacks has hovered around 50 percent over the past two decades. Furthermore, more than half of Americans have consistently and strongly opposed racial preference in hiring and promotion. Part of the diminished support for affirmative action has to do with the belief among Americans that conditions for Black people have improved. In the 1970s and 1980s, less than half of Americans believed that conditions for Blacks had gotten better. In comparison, in 1998, 66 percent felt that conditions for Blacks had improved. Moreover, and consistent with notions of meritocracy, Americans feel that Blacks should try to pull themselves up by their own bootstraps (as Jews, Italians and other ethnic groups have done) (see table 5). As illustrated by table 6, Americans tend to attribute the relative lack of socioeconomic success of Blacks to motivational deficiencies and less to institutional barriers such as discrimination; hence their opposition to government intervention.

Despite the public's limited support for affirmative action, these policies have enabled members of racial and ethnic minority groups, many of whom are immigrants, to make remarkable strides in education, particularly post-secondary education. In a review of the impact of affirmative action on higher education, Shannon Harper and Barbara Reskin show that despite claims that affirmative action harms minority students by placing them in competition with better-prepared White students, thereby increasing minority dropout rates, minorities who attend more selective schools actually have higher graduation rates than their counterparts at less selective schools. Furthermore, minority retention rates were higher at schools that practised hard affirmative action (as opposed to those that implemented softer forms). More revealing, however, is the decline in minority student applications at public universities in states, such as California and Washington, where voter referendums ended affirmative action in public employment and education (Harper and Reskin 2005, 363-4). The empirical evidence indicates that affirmative action has been instrumental in ensuring racial and ethnic minority immigrants' inclusion in American society.

Table 4 434

	1972-82	1983-87
Preference in hiring and promotion		
Strongly favours		
Strongly opposes		
Neither strongly favours nor strongly opposes		
Government should give special treatment to Blacks		
Agree or strongly agree that government should give special treatment	25.3	19.1
Agree or strongly agree that government should not give special treatment	53.2	51.8
Agree with both	21.5	29.1

Source: National Opinion Research Center, *General Social Survey* (Chicago: National Opinion Research Center, University of Chicago, various years).
Note: The data for years 1972-1993 was absent from the GSS survey. Some items were discontinued in subsequent GSS waves, while others were not introduced into the survey until later waves.

Table 4

Changes in Support
among Americans for
Affirmative Action,
1972-98 (percent)

1988-91	1993	1994	1996	1998
		9.8	10.0	8.3
		57.3	56.3	59.9
		32.9	33.6	31.7
20.0	17.6	16.0	17.2	17.3
48.9	49.7	53.9	53.0	50.4
31.1	32.6	30.1	29.8	32.2

Table 5 436

	1972-82	1983-87
Chance that Blacks with the same education/ qualifications as Whites get a good job		
Almost always	14.3	
Sometimes	48.0	
Almost never	37.7	
Whether conditions for Black people have improved		
Improved	49.3	47.4
Got worse	28.6	33.6
Stayed about the same	22.1	19.0
Blacks should pull themselves up by their own bootstraps		
Agree strongly		
Disagree strongly		

Source: National Opinion Research Center, *General Social Survey* (Chicago: National Opinion Research Center, University of Chicago, various years).
Note: The data for years 1972-1993 was absent from the GSS survey. Some items were discontinued in subsequent GSS waves, while others were not introduced into the survey until later waves.

Table 5

Opinions about
Discrimination against
and Mobility of Blacks,
United States,
1972-98 (percent)

1988-91	1993	1994	1996	1998
		54.4	59.7	65.7
		12.4	9.7	5.3
		33.2	30.6	29.0
		44.6	44.5	43.1
		6.0	5.7	6.2

Table 6 438

	1972-82	1983-87
Mainly due to discrimination		44.98
Blacks have less inborn ability to learn		20.89
Blacks don't have the chance for the education that it takes to rise out of poverty		53.84
Blacks don't have the motivation or willpower to pull themselves out of poverty	65.83	

Source: National Opinion Research Center, *General Social Survey* (Chicago: National Opinion Research Center, University of Chicago, various years).
Note: The data for years 1972-1993 was absent from the GSS survey. Some items were discontinued in subsequent GSS waves, while others were not introduced into the survey until later waves.

Table 6

Opinions about Why
Blacks Have Worse
Jobs, Income and
Housing than Whites,
United States, 1972-98
(percent)

1988-91	1993	1994	1996	1998
42.35	43.36	42.85	39.71	37.54
17.75	13.01	13.41	10.21	9.96
53.84	54.94	51.13	46.19	45.08
59.61	52.54	52.22	50.66	46.33

Yet the success of the previously mentioned race-based public policies has also undermined the monoracial and monoethnic classification schemes that form the basis of these laws. In the absence of immigrant-specific integration policies, the US government has relied on affirmative action and antidiscrimination laws, as well as other public policies intended to remedy discrimination against African Americans. But the correlation between racial and ethnic categories and social disadvantage or exclusion has grown weaker (Schuck 2003). The case of Asians aptly illustrates this weakened connection between race and social exclusion. Although Asians (and Pacific Islanders) have protected minority group status and qualify for affirmative action benefits, not all Asian ethnic groups are socio-economically disadvantaged enough to merit preferential treatment. For example, East Asian groups such as the Chinese, Koreans and Japanese have income and education levels similar to those of Whites. South Asians — namely, Indians — have incomes that surpass those of Whites (Waters and Eschbach 1995).

High intermarriage rates between Hispanics and Whites and Asians and Whites have also led to a substantial multiracial population that refuses to self-identify as monoracial or monethnic. The government recognized these changes by allowing respondents, for the first time, to check more than one race on the 2000 Census form. Seven million people, or 2.4 percent of the population, indicated that they identified with two or more races. This number is bound to increase, because interracial marriage has been increasing steadily. In 1970, less than 1 percent of couples in the United States were interracial; by 2000, the figure was 5 percent. Intermarriage rates are generally shaped by group size, with smaller groups having higher outmarriage rates than larger ones. Among Asians and Hispanics, the foreign-born have lower intermarriage rates than the American-born; among Whites and Blacks, the foreign-born are more likely to outmarry. Among American Indians, a very small number — 57 percent — have outmarried. Yet American Indians are a small group – less than 1 percent of the entire population. Among Asians, the outmarriage rate is 16 percent; among Blacks, 7 percent; and among Whites, 3 percent. But 44 percent of US-born Asian women have a non-Asian spouse; for US-born Asian men, the figure is 32 percent. In the case of US-born Hispanic women, 31 percent have a non-Hispanic husband; and 29 percent of US-born Hispanic men have a non-Hispanic wife.

Intermarriage is on the rise, and yet the current system for allocating social benefits ignores this phenomenon. In fact, for purposes of affirmative action

programs, the government top-codes multirace and multiethnic self-identifications on the census and forces them into monoracial and monoethnic categories (Perlmann and Waters 2004). The Office of Management and Budget issued guidelines for allocating mixed-minority and White individuals to the minority race. This inflated the proportional representation estimates and projections of how many minority group members would be eligible for affirmative action benefits. The growth of the multiracial population and the rise in intermarriage have made the boundaries between groups more permeable and harder to define. This has legal implications for all kinds of anti-discrimination laws. If people can be counted as both White and Black, and if discrimination in voting, for instance, is measured according to how the voting population matches the underlying demographics, how does one determine the base number for the denominator? And how much legitimacy can a system based on so many permutations of multiple-race reporting have in determining access to special treatment in hiring and promotions? (Goldstein and Morning 2002; Harrison 2002; Prewitt 2002). Intermarriage has reached a level unprecedented in American history, and few would deny that this is a very good thing — it's the success story of American diversity. Yet the resulting ambiguity about the boundaries and definitions of our standard racial groups undermines our system of laws and policies for protecting and ensuring that diversity.

The United States is heralded for maintaining stability and unity within a context of great racial, ethnic, religious and linguistic diversity. Scholars such as Peter Schuck attribute the success of America's diversity management to codified laws that regulate the distribution of scarce societal goods to diverse groups of people (2003). Policies such as affirmative action are one avenue by which racial and ethnic minority immigrants can partake in the American dream. But this pathway to inclusion in American society is contingent on continued public support for affirmative action. As the situation currently stands, that support is waning. The seemingly arbitrary expansion of affirmative action to include racial and ethnic minority groups that may not have historically suffered injustice raises questions about affirmative action's legitimacy. Opposition to conferring affirmative action benefits on other racial and ethnic groups — including immigrants — stems mainly from the public understanding that, at its inception, affirmative action was intended to remedy only African American exclusion.

By allowing voluntary immigrants (that is, noncitizen racial and ethnic minorities) to take advantage of affirmative action benefits, the government may

in effect be further undermining the intentions of affirmative action, because it will be ignoring the continued exclusion of African Americans now that Black representation in employment and education is on the rise (albeit due to the high participation rates of foreign-born Blacks) (Graham 2001). Indeed, in the summer of 2004, an article appeared on the front page of the *New York Times* entitled "Top Colleges Take More Blacks, But Which Ones?" The article reported on the deep consternation among Black alumni of Harvard University, pointing out that a majority — perhaps two-thirds — of the institution's "Black" students are first- or second-generation immigrants or the children of interracial couples. There was a meeting on the issue, at which this point was debated: "African-American students whose families have been in America for generations were being left behind" (Rimer and Arenson 2004). This is not an issue faced by Harvard alone — a study by Douglas Massey and colleagues found that 41 percent of "Black" students at 28 selective colleges and universities nationwide were of immigrant stock or had multiracial backgrounds (Massey et al. 2003). Recent empirical studies of the young adult children of immigrants in the US have found that they are doing better in terms of educational attainment and labour market achievement than native-born Americans of the same racial background (Kasinitz, Mollenkopf, and Waters 2002). Affirmative action may indeed be good for immigrants and their children, but it may still leave behind the group it was designed to lift up: African Americans. This is a challenge that America will have to confront in the years to come.

Future Challenges: Immigration, Education and the Changing United States Economy

IN CLOSING, WE WOULD LIKE TO SUGGEST THAT SPECIFIC IMMIGRATION POLICIES — including race-based policies, such as affirmative action — while important, may have only marginal effects on the long-range success of immigrants and their descendants. Current immigrants to the United States are overrepresented among the less-educated and the working poor. Policies developed in the last decade have been designed not to ease their integration into American society but rather

to further restrict their access to the welfare provisions that remain for poor Americans. As Joppke and Morawska point out, the traditional view of immigrant incorporation is that there is a covenant between the immigrant and the host society; the sustained openness of American society is offered in exchange for the immigrant's self-sufficiency (2003; see also Aleinikoff 2003). Historically, the United States has been very successful in accommodating immigrants because of the relative openness of its labour market and the social mobility achieved by immigrants and their descendants.

In recent decades, the openness of America's higher-education system has also played a role. The large network of community colleges, the availability of general educational development (GED) degrees to older students and the variety of second chances the educational system provides have been an important source of opportunity and economic and social integration for first and second generations. This feature of American public policy has gone largely unrecognized, but the US system stands in sharp contrast to the often rigid educational systems of Western European countries. Cultural acceptance and full integration of immigrants followed this sometimes brutal but, over the long run, rather successful incorporation of the descendants of immigrants into the labour market.

But European immigrants in the twentieth century passed into an economy that had entered a long period of expansion after the Depression. The rising economic tide lifted them and their children and made good on the implicit bargain they were offered: an open economy with the possibility of real social mobility for a majority of the newcomers and their descendants. The cost of giving up past allegiances in order to join the American mainstream was worth it. But, since the 1970s, income inequality has been growing; the fortunes of those at the bottom of the educational distribution chain have been declining.

Many immigrants now fall into the category of workers who have seen their economic fortunes decline over the last few decades. Income inequality grew rapidly between 1973 and 2001. As Sheldon Danzinger and Peter Gottschalk conclude, "Inflation adjusted annual earnings of male high school dropouts were 23 percent lower in 2002 than in 1975, and earnings for male high school graduates were 13 percent lower" (2005, 50). Economists have been debating the causes of this rise in income inequality, but most agree that immigration itself, especially illegal immigration, played a part by increasing the supply (and thus lowering the price) of unskilled labour. In addition, most labour

economists point to the rise in international trade and the loss of manufacturing jobs to offshore sites, the decline in unionization and the falling real value of the federally mandated minimum wage. The consensus is that there has been a sharp rise in the returns to education in the labour market, leading to diminished prospects for those with extremely low levels of education, who are disproportionately immigrants (Lenz 2003).

The premium put on education in the current hourglass economy — with its many low-wage dead-end jobs and lack of jobs between these low-wage ones and higher-paying ones requiring at least a college education — means that immigrants and their children face a difficult future. This may upset the link between economic mobility and cultural incorporation that has worked so well in the past. If the US does not provide the children of immigrants with the kinds of opportunities it allowed past immigrant generations, then the incentive for individual immigrants to assimilate into the American economy and culture may be lost. This challenge to the Americanization of immigrants and their children is far greater than those issues that usually emerge in such discussions — issues such as dual citizenship, transnationalism, linguistic or religious diversity. It is a challenge best met through economic policy changes and investments in education and social welfare for poor Americans, regardless of their race or immigration status. Diversity management may just be a giant distraction from the bigger issue facing Americans: making opportunities for advancement consistently available to the poor and the working class.

Notes

1 A major exception to the government's laissez-faire policy is found in local primary and secondary schools; these public institutions have devised a wide variety of ways of dealing with immigrant children who do not speak English.

2 "Paroled" immigrants are those admitted to the United States under the claim that they face persecution in the country they are leaving. These immigrants, however, may not have official refugee or asylum status and would have to petition for such status after arriving in the United States (North Carolina Justice Center 2006; Wasem 2005).

3 Certain qualified immigrants — refugees, asylees, Amerasian immigrants and Cuban or Haitian entrants — are exempt from the five-year ban. Also, immigrants who entered the US prior to August 22, 1996, and acquired qualified status prior to or after that date are exempt from the time limitations (Broder 2005).

4 The National Research Council of the National Academies published an interim report on the redesign of the US naturalization test in 2004. A final report will not be issued, however, due to a decision on the part of the US Citizenship and Immigration Services of the Department of Homeland Security not to renew the contract.

5 Scholars of race and ethnicity such as Herbert Gans have hypothesized that the emergent division in the twenty-first century may be not between Blacks and Whites but rather between Blacks and non-Blacks (1999). Other scholars, like Mia Tuan, contend that certain racial groups, such as Asians, remain "forever foreigners" as they are not easily absorbed on either side of the colour line (1998).

References

Alba, Richard D., John R. Logan, Amy Lutz, and Brian J. Stults. 2002. "Only English by the Third Generation? Loss and Preservation of the Mother Tongue among the Grandchildren of Contemporary Immigrants." *Demography* 39:467-84.

Aleinikoff, T. Alexander. 2003. "Between National and Postnational: Membership in the United States." In *Toward Assimilation and Citizenship: Immigrants in Liberal Nation States*, edited by Christian Joppke and Ewa Morawska. New York: Palgrave.

Bean, Frank D., and Gillian Stevens. 2003. *America's Newcomers and the Dynamics of Diversity*. New York: Russell Sage Foundation.

Borjas, George J. 2002. *The Impact of Welfare Reform on Immigrant Welfare Use*. Washington, DC: Center for Immigration Studies. Accessed August 7, 2006. http://www.cis.org/articles/2002/borjas.pdf

Broder, Tanya. 2005. "Immigrant Eligibility for Public Benefits." *American Immigration Lawyers Association Immigration and Nationality Law Handbook* 759:759-82. Washington, DC: American Immigration Lawyers Association.

Center for Immigration Studies. 2004. "Testing for Citizenship: Update on the Redesign of the Naturalization Exam. Panel Discussion Transcript," July 13. Washington, DC: Center for Immigration Studies. Accessed August 7, 2006. http://www.cis.org/articles/2004/exampanel071304.html

Children's Aid Society. 2003. "Know Your Rights: Benefits for Undocumented Immigrants." New York: Children's Aid Society.

Cornelius, Wayne A. 2005. "Controlling 'Unwanted' Immigration: Lessons from the United States, 1993-2004." *Journal of Ethnic and Migration Studies* 31:775-94.

Danzinger, Sheldon, and Peter Gottschalk. 2005. "Diverging Fortunes: Trends in Poverty and Inequality." In *The American People: Census 2000*, edited by Reynolds Farley and John Haaga. New York: Russell Sage Foundation.

Du Bois, W.E.B. 1953. *The Souls of Black Folk: Essays and Sketches*. New York: Blue Heron Press.

Feliciano, Cynthia. 2003. "The Benefits of Biculturalism: Exposure to Immigrant

Culture and Dropping Out of School among Asian and Latino Youths." *Social Science Quarterly* 82:866-80.

Fix, Michael E., and Randy Capps. 2005. "Trends in US Immigrant Integration." Paper presented at the German Marshall Fund Transatlantic Workshop, March, Berlin.

Fix, Michael E., and Jeffrey S. Passel. 2001. "US Immigration at the Beginning of the 21st Century." New York: Urban Institute. Accessed August 7, 2006. http://www.urban.org/publications/900417.html

Foner, Nancy. 2005. *In a New Land: A Comparative View of Immigration*. New York: New York University Press.

Foner, Nancy, and George Frederickson, eds. 2004. *Not Just Black and White: Immigration, Race and Ethnicity Then to Now*. New York: Russell Sage Foundation.

Gans, Herbert H. 1999. "The Possibility of a New Racial Hierarchy in the Twenty-First-Century United States." In *The Cultural Territories of Race: Black and White Boundaries*, edited by Michèle Lamont. Chicago: University of Chicago Press.

Glazer, Nathan. 1997. *We Are All Multiculturalists Now*. Cambridge: Harvard University Press.

Goldstein, Joshua, and Ann Morning. 2002. "Back in the Box: the Dilemma of Using Multiple-Race Data for Single-Race Laws." In *The New Race Question: How the Census Counts Multiracial Individuals*, edited by Joel Perlmann and Mary C. Waters, 119-37. New York: Russell Sage Foundation.

Graham, Hugh Davis. 2001. "Affirmative Action for Immigrants? The Unintended Consequences of Reform." In *Color Lines: Affirmative Action, Immigrants, and Civil Rights Options for America*, edited by J.D. Skrentny. Chicago: University of Chicago Press.

Harper, Shannon, and Barbara Reskin. 2005. "Affirmative Action at School and on the Job." *Annual Review of Sociology* 31:357-79.

Harrison, Roderick. 2002. "Inadequacies of the Multiple Response Data in the Federal Statistical System." In *The New Race Question: How the Census Counts Multiracial Individuals*, edited by Joel Perlmann and Mary C. Waters, 137-60. New York: Russell Sage Foundation.

Huntington, Samuel P. 2004. *Who Are We? The Challenges to America's National Identity*. New York: Simon and Schuster.

Joppke, Christian, and Ewa Morawska. 2003. *Toward Assimilation and Citizenship: Immigrants in Liberal Nation States*. New York: Palgrave.

Kasinitz, Philip, John Mollenkopf, and Mary C. Waters. 2002. "Becoming Americans/Becoming New Yorkers: Immigrant Incorporation in a Majority Minority City." *International Migration Review* 36:1020-36.

Lenz, Gabriel. 2003. *The Policy-Related Causes and Consequences of Income Inequality*. Russell Sage Foundation Working Paper, January 2003. Accessed August 7, 2006. http://www.russellsage.org/programs/main/inequality/050516.755142/

Levitt, Peggy, and Mary C. Waters. 2002. *The Changing Face of Home: The Transnational Lives of the Second Generation*. New York: Russell Sage Foundation.

Massey, Douglas, Camille Z. Charles, Garvey Lundy, and Mary Fischer. 2003. *The Source of the River: The Social Origins of Freshmen at America's Selective Colleges and Universities*. Princeton: Princeton University Press.

National Immigration Law Center. 2005a. "Basic Facts about In-State Tuition for Undocumented Immigrant Students." Washington, DC: National Center for Immigration Law.

———. 2005b. "Overview of Immigrant Eligibility for Federal Programs." Washington, DC: National Center for Immigration Law.

National Opinion Research Center. Various dates. *General Social Survey*. Chicago: National Opinion Research Center, University of Chicago.

North Carolina Justice Center. 2006. "Immigration Legal Assistance/ Immigration

Case Types." Raleigh: North Carolina Justice Center. Accessed August 7, 2006. http://www.ncjustice.org/cms/ index.php?pid=74

Patterson, Orlando. 2005. "Four Modes of Ethno-somatic Stratification: The Experience of Blacks in Europe and the Americas." In *Ethnicity, Social Mobility, and Public Policy: Comparing the US and UK*, edited by G.C. Loury, T. Modood, and S.M. Teles. Cambridge: Cambridge University Press.

Perlmann, Joel, and Mary C. Waters. 2004. "Intermarriage Then and Now: Race, Generation and the Changing Meaning of Marriage." In *Not Just Black and White: Historical and Contemporary Perspectives on Immigration, Race, and Ethnicity in the United States*, edited by Nancy Foner and George Fredrickson, 262-77. New York: Russell Sage Foundation.

Portes, Alejandro, and Ruben Rumbaut. 2001. *Legacies: The Story of the Immigrant Second Generation*. Berkeley: University of California Press.

Prewitt, Kenneth. 2002. "Race in the 2000 Census: A Turning Point." In *The New Race Question: How the Census Counts Multiracial Individuals*, edited by Joel Perlmann and Mary C. Waters, 354-62. New York: Russell Sage Foundation.

Rimer, Sara, and Karen W. Arenson. 2004. "Top Colleges Take More Blacks, But Which Ones?" *New York Times*, June 24.

Schuck, Peter H. 2003. *Diversity in America: Keeping Government at a Safe Distance*. Cambridge: Belknap Press, Harvard University Press.

Skrentny, John David. 2002. *The Minority Rights Revolution*. Cambridge: Belknap Press, Harvard University Press.

Suro, Roberto, and Jeffrey S. Passel. 2003. *The Rise of the Second Generation: Changing Patterns in Hispanic Population Growth*. Pew Hispanic Center Study, October 14. Washington, DC: Pew Hispanic Center. Accessed August 4, 2006. http://pewhispanic.org/reports/ report.php?ReportID=22

Tuan, Mia. 1998. *Forever Foreigners or Honorary Whites? The Asian Ethnic Experience Today*. New Brunswick: Rutgers University Press.

US Department of Health and Human Services. 2004. "Summary of Immigrant Eligibility Restrictions under Current Law." Washington, DC: Department of Health and Human Services.

US Department of Justice. 2005. "Civil Rights Division, Employment Litigation Section: Frequently Asked Questions." Washington, DC: Department of Justice.

Warner, Steven. 2004. "Immigrants and the Faith They Bring." *Christian Century*, February 10, 20-3.

Warren, John Robert. 1996. "Educational Inequality among White and Mexican-Origin Adolescents in the American Southwest: 1990." *Sociology of Education* 69:142-58.

Wasem, Ruth E. 2005. "US Immigration Policy on Haitian Immigrants." CRS Report for Congress, January 21. Accessed August 7, 2006. http://www.ndu.edu/library/ docs/crs/ crs_rs21349_21jan05.pdf

Waters, Mary C. 1999. *Black Identities: West Indian Immigrant Dreams and American Realities*. Cambridge: Harvard University Press.

Waters, Mary C., and Karl Eschbach. 1995. "Immigration and Ethnic and Racial Inequality in the United States." *Annual Review of Sociology* 21:419-46.

Zhou, Min, and Carl Bankston. 1999. *Growing Up American*. New York: Russell Sage Foundation.

Faith-Based Communities and Diversity

Religious Allegiance
and Shared Citizenship

THE AIM OF THIS CHAPTER IS TO PRESENT A CONTEXT IN WHICH TO REFLECT UPON the issue of religious allegiance and shared citizenship. I shall do this in three stages. First, by way of introduction, I shall try to bring the whole matter to the fore, by answering these questions: What is the problem? Why is there a problem? Why is it legitimate to raise the question of religious allegiance within Western society, and what implications does it have for our understanding of citizenship and the commitment of the citizen?

Next I will consider two main topics: Muslim identity and citizenship. What is Muslim identity? How is it expressed? What are its implications in relation to civic commitment? I then will discuss what citizenship comprises and implies, and what it requires by way of concrete conditions and consequences within the extended meaning of Muslim identity. I will conclude with a reflection on the relationship between these two topics and the requirements of shared citizenship.

What Is the Problem?

RAISING THIS QUESTION TAKES US STRAIGHT BACK INTO HISTORY. NEW IMMIGRANT COMmunities, especially Muslim ones, should never underrate the importance of the history of the country in which they find themselves. The history of the West in general and of Europe in particular can be dealt with under the umbrella of secularism. Secularism corresponds to the solution, in the context of a specific history and civilization, to the problem of satisfying demands for mutual respect and pluralism. Consequently, the religious sphere is considered a private domain that should not

impinge on the public domain, at least with regard to commitment. This approach ensures that religious allegiance does not revive old demons — that is, religious conflict, intolerance, the domination by political means of one religion over another — which could entail the kinds of discrimination that have historically arisen.

One cannot raise the question of religious allegiance and citizenship without recognizing that in so doing one will call to mind, for people living in the West, vivid scenes of past struggle. But we must still address the question. We must also remember that anyone who examines the issue while ignoring its historical context will fail to understand their audience. They will fail to reach that audience, because they will be speaking in a language that is foreign. In other words, in order to respond to a problem effectively, we must comprehend the terms in which it is formulated.

The problem has three dimensions. The first is that whenever religion has been too prominent in the public domain, it has been the source of conflict. Therefore, the outward expression of religion in the public sphere must have its boundaries. The second dimension is the question of community. In fact, when we equate religious affiliation and affiliation with a community, the question becomes clear-cut: to speak of a citizen is to speak of an individual in relation to a constitution or a common legal framework, not of a community in relation to a constitution, which could entail communitarianism. (The latter is often discredited, particularly in France and sometimes in Quebec.) The third dimension, which appears fundamental to the whole problem, is whether, in the case of conflict, religious allegiance or allegiance to the state takes precedence. I shall deal with this dimension last, since it is the most misunderstood. It is an expression of questions sometimes put to Muslims in the West: "Are you first and foremost Muslim or Canadian, American or French?" "Does the law of your religious allegiance take precedence over your allegiance as a citizen?" On the face of it, such questions seem clear — "Are you first and foremost Canadian or French and then Muslim?" or, indeed, "Are you Muslim and then Canadian or French?" — but they have caused headaches to some Muslims.

We must be aware of these three dimensions and have a precise and clear response to each. And our responses should be comprehensible to those who hear them. Too often we assume our questioners know things that in fact they do not. They often know all too little about Islam, which is not entirely their fault. It is just as much the grave responsibility of Muslims who have not known, do not know or continue not to know how to explain their religion and their

allegiance to it. Muslims must respond appropriately — that is, they must consider the history of the people they address, consider their circumstances and problems, and realize that for many in the West, religion has meant conflict.

When one says that one is a Muslim who wishes to have a role as citizen, what does it mean? The question may seem simple, but in light of all the points that I have put forward, it becomes clear that it is complex.

Muslim Identity

T HE HEART OF THE QUESTION IS THAT WE CANNOT CHALLENGE THE SOCIETY IN which we live without having declared, translated and understood who we are. Along with the necessity of contextualization — knowing the history of our country and its legislation, for example — goes the necessity of describing who we are. The collective "we" on which a society is built must know who its members are and where they live, as much as these members should know how they understand and define themselves. This double perspective is necessary.

I would like here to digress on one point. On the Muslim issue, a large number of Western intellectuals are raising some surprising questions. In fact, these questions are only surprising because they have not been placed in the context of history. We must never underestimate the great and very real fear of both a painful past to which we could return and a difficult present, when the question of religious allegiance or of religion itself is raised. We must bear in mind that certain questions may seem aggressive, but they have the honesty of fear. It is a great mistake, in relation to these questions coloured by genuine fear, to consider only their aggressiveness. This is also true for Muslims: they can be aggressive because they are on edge, and some people see only their aggression when they should also see their tension and understand their crisis. There is a real problem of perception on both sides.

As for Muslim identity, I am going to make a proposal, which I also make to people connected to Islam. Nothing in what I am about to say is definitive. My aim is to express Muslim identity outside its traditional interpretation — that is, to extricate the basic principles of Muslim identity from their purely cultural sphere, from the way they are lived by a Moroccan, an Algerian or an Egyptian. I want to define that identity itself — its substratum, its essence in philosophical terms.

There are four elements of Muslim identity to consider:

1. To be a Muslim is to bear a faith. I say "bear," because the Arabic term *imân*, from the root *amana*, is something that is carried. So, Muslims carry a faith, live a practice and nourish a spirituality. None of the terms I am using is a matter of chance: faith is a conception of life and death; practice and daily behaviour spring from this conception; and spirituality is the personal deepening of this dimension. These correspond in Islam to three well-known principles, spelled out in the prophetic tradition *hadîth*: *al-imân* (faith), *al-islâm* (five pillars of practice) and *al-ihsân* (excellence, spiritual dimension).

2. To be a Muslim is to take into account both the scriptural texts and the context — the social, political and cultural environment. This is a significant dimension on an intellectual level. It is a question of intelligence, and thus of understanding the text in context. In other words, it is impossible to understand the text if one sees oneself outside the actual context.

3. To be a Muslim is to educate and transmit. The term "educate" contains the idea of spiritual reform, in the sense of purifying oneself. This is fundamentally the aim of revelation. To be a Muslim is, in essence, to be an educator of oneself and others. As for transmission, one should be a witness before people. I do not mean someone who proselytizes, but one who hands on; to hand on is to bear witness, and to witness is to live what one says and what one believes.

4. To be a Muslim is to act and participate. This dimension involves a conception of those who believe, who bear the faith and who act. Faith relates to action, and in participation we find the relation of action to community — the community of people, of citizens. It is a matter of acting and participating in a social way. We find this dimension in the terms "act" and "participate," but it is not about action alone. This is a subtle but very significant dimension.

My aim here is to detach the essence of identity from its traditional interpretation. These four elements are unchangeable, wherever one lives. As soon as this is established, three points emerge about which one must also be extremely precise. First, everything I have put forward concerning Muslim identity shows us that it is a conception of life in the widest sense. This can be expressed, for those

who reject transcendence, as a philosophy of life. One will accept this term the moment one accepts the idea of a philosophy of life that, for Muslims, starts with faith and ends with participation. Second, Muslim identity is a conception, and this conception includes social behaviour; it involves at one and the same time education, participation and understanding the context. Identity extends to the social dimension of the individual, to society. This is why the question of religious allegiance and citizenship is interesting and crucial. The third point, also very important, is that many sociologists — and in this they are right, to some extent — put the issue thus: Those who talk about identity often give us the impression that they are speaking of an identity confined within itself, a protective identity ("I am this in order not to become that"), an identity that closes one off from the world.

Identity, in the way I have expressed it here, involves understanding text and context — it does not come to an end in adapting to its context. Also, just as much, it involves educating and transmitting; and education does not take place on the moon, but in the West, in Canada or elsewhere. This is therefore a very dynamic definition of identity. As for action and participation, we take part in the society in which we live, and in particular in matters that concern us. Thus, three of the elements of identity, as I have expressed them, emphatically do not say that this is an identity that is confining, but one that gives direction.

Having said that, I can offer a clear answer to the question "Are you first and foremost Muslim, or are you first and foremost Canadian or French?" If I speak at the philosophical level, out of a philosophy of life (which I have expressed as a conception of life), I belong to God and will return to him. If I speak like this, I resemble any human being who defines himself within a philosophy of life; and philosophy, when one speaks of the conception of life, is primary. Therefore, as regards the meaning that I give to my life and to my death, I am a Muslim, and then I am a citizen — Canadian or French or British.

But if I now speak of the dimension of citizenship — that is, my participatory activity (the fourth element of Muslim identity) — then I am Canadian, French first. That does not prevent my being a Muslim, but I am a Canadian or a French citizen with a Muslim background. In fact, the question is badly put (and that is why it has evoked such unsatisfactory replies). To the question "Are you French first and then Muslim, or Muslim first and then French?" I reply that it depends on the area or the field referred to: if you speak of my conception of life, I am a Muslim first; if you speak of citizenship and social affiliation, I am Canadian first, like any other citizen.

Why should this bother anyone? No one has the slightest difficulty accepting a similar answer from a humanist, a Jew or a Christian. Why should a response such as mine create a debate? Because the question has been badly put, and this is not simply the fault of those who observe the Muslim world, but also of the way Muslims speak about themselves. Through fear of assimilation, some Muslims refuse to say that they are Canadian, British or French first. In saying they are Muslim first, they feel they are respecting the order of their priorities. But this, the chief fear of Muslims, does appear legitimate. We must construct a framework for discussion, and in my opinion it must be done from the perspective I just described.

I must add that every one of us has multiple identities, not just one or two. I am used to saying that I am Swiss by nationality, Muslim by religion, Egyptian by memory, European by culture and universalist by principle. One dimension of my manifold identity can take precedence according to the context, but this is not a problem. It is a richness, not a liability.

Citizenship

I NOW COME TO MY THIRD POINT, WHICH CONCERNS THE NOTION OF CITIZENSHIP. WHAT does citizenship presuppose? First, it assumes recognition of a constitution or of legislation that refers to the place where one lives. Obviously, one cannot be a citizen if one does not agree with the constitution and the structures of one's society. The second element is that one should have a relationship of loyalty in conscience and in ethics to this constitution. Having loyalty in conscience means that having accepted the constitution as a context, one acts within this context in loyalty and in good conscience, aware of the framework; one's acceptance must not be untrue. There is thus a pact of conscience, which one could describe as philosophically ethical, between the constitutional framework and one's commitment within it. This does not imply a blind loyalty: the only true and ethical loyalty is a critical loyalty, through which one is able to express critical thoughts when one disagrees with a governmental decision, for instance. We have seen this recently in the wars in Afghanistan and Iraq, as well as in domestic issues related to security and immigration policies.

The third element consists of participation: considering oneself an active member of a community linked by a constitution. Here, we have the whole dimension of democracy and citizenship. It is the obligation to act. The worst

thing for a republic is for its people to give up. The great challenge for democracy today is to reinvigorate citizen participation, or at least to maintain an awareness that a citizen should take part.

We now have to study the immediate repercussions of one's identity upon one's allegiance as a citizen. What impact will our religious affiliation have upon our citizenship commitment? We must here endeavour to formulate very clear answers. The first precondition of citizenship is the constitutional framework, the framework within which one lives. Considerable debate has already taken place concerning this question: How does one define the country one inhabits — that is, Canada — when one is in a minority situation? Without going into detail, I will say that it is the opinion of Muslim scholars who have spoken on this subject, and there is now a sort of consensus, that if one finds oneself in a country whose nationality one bears or where one is a resident, one should respect its constitution. Thus, one sets out on a path of conscience and of loyalty to the agreement that one has accepted. This is a kind of social contract.

The second dimension is that once one has recognized that context, one must not betray the terms of the contract, for we shall be held to account for every pact, and the pact we have with a constitution or a legal framework is very significant. We shall be held to account for our loyalty to what we have accepted. There is, therefore, from the Muslim point of view, a reinforcement of the social pact by our religious conscience, a reinforcement of the pact of conscience by our faith: if we believe in God, our faith keeps our conscience loyal to the pact we have agreed to.

Finally, the third element — and this is the crux of the matter — concerns the civic participation of the individual in relation to the constitution: How will this participation be implemented? Will it be in the name of religion — that is, will Muslims living in the West say to themselves, "We are Muslims, and we act together as a community," or will what is called individual integration emerge, in which one plays the role of a citizen-individual, each with one's own civic conscience to develop?

At this point, I will take the opportunity for a second digression and reply to a very clear question regarding which we must also be very clear if we are to resolve this last question of participation. A Muslim cannot fail to speak of "spiritual community," so it is necessary to be very clear about these terms. If I know that in my religion to pray alone is 27 times less valuable than to pray in community; if I know that to give the social tax that purifies (zakât) is to adopt a twofold stance before the transcendence of God and the community of men; if, at the same time, I know that

my daily life and the whole community of the Prophet are cradled by this dimension of community, that in the love developed within the community there is the greatest victory after death; if I know that those who love each other in God will meet again in the shelter of God on the day when there will be no shelter but His – in short, if I know all this, I cannot say there is no community to build. But we must be careful: it is a community of spirituality, a community of faith, a community of practice, a community of presence, an affective community, a community not in legal terms but a spiritual community of people following the same path. It is a true community of the heart. Islam, to a Muslim, means in the nature of things developing this community dimension. It does not at all mean that we must go in the other direction, which is communitarianism. It is a community that reaches out, not a communitarianism that closes in on itself. This is where the difference lies; that is, when Muslims lay claim to the dimension of their religious affiliation that develops the feeling of community, they claim one of the treasures of their religion, one that transforms them into beings who play a part in a living body. But this living body is not going to turn into an occupied house, an entrenched position! Muslims must totally reject the idea of moving from community to communitarianism. To do so would be to put themselves into a ghetto, to confine themselves, to prevent themselves from communicating with their surroundings, to demand laws specific to the place where they are. That is the wrong path. Nobody, except perhaps a few small groups, embraces this kind of discourse. We do not hold it, we do not defend it, we do not want any part in it. Muslims are members of a community of faith with influence, not a community existing in an enclosed space. That is the whole difference.

Now, what is meant by religious allegiance, allegiance as citizen? Each of the points I have raised addresses the need for responsible citizenship, and this is the great challenge for all Muslim associations in the West. There are two options. The first is that Muslims understand that, in accordance with their very identity as Muslims, they must stress citizen action; they must understand that in the West being a Muslim means seeing to it that civic education forms part of Islamic education and training, that our faith adds to our social responsibility — in which case we have understood what a true Islamic training is. The second is that we carry out a schizophrenic type of training; that is, a training completely disconnected from its context, and then we cut off our identity. The word, then, will be "act" and not "participate," because it will be "educate" but not "transmit," because it will be "understand the text" but understand nothing in context.

In fact, for many, our Islamic training has for years cut off the reality of Muslim identity from the context in which we live because it has not taken account of the context, because it has not insisted on participation, because it has not in effect stated what transmission means. Our religious allegiance will reinforce each of the positions that Western societies have the right to expect every citizen to adopt. What are these positions? The first is to be aware of the context. In other words, I do not know of a civic education that says one must vote without knowing which civic structure one is voting in. Knowledge of context is also what I have named as the second element of Muslim identity, and I have not done this just to reassure my fellow citizens — far from it! I have done it simply to remind myself of my responsibility before my own conscience of what I have to do: if I say I understand the text *and* understand the context, but I understand nothing of the context, what do I really understand of the text? What am I going to understand of the text destined for the whole world and for all ages, the text that is for me the universal dimension? Can it speak to me, in 2006, in the heart of Montreal, London or Paris, if I understand nothing of how these cities work? Civic education is an education in understanding context. But it is still more complex than that: civic education is not simply knowing how Canadian, British or French laws operate; it is knowing the history of the people with whom one lives, understanding their sensitivities, understanding how they function, understanding their language; and to know a language is to know its emotional overtones and collective psychology. You may know English or French perfectly and yet not touch or understand those with whom you speak because you have not penetrated the emotional heart of these languages. In this case, a real education in the context is necessary, one that combines the political structure and the social, historical and cultural contexts. As regards citizenship, this form of education is equally necessary. Thus, a responsible citizen knows, or should know, a little of the history of his or her country and a little, even a good deal, of the political and institutional workings of that country and is committed to its reform.

Religious allegiance — as soon as one has accepted the framework, as soon as one considers oneself Canadian or French — is an encouragement to be a better Canadian or French citizen. When Muslims say "we," as Muslims, it must hold an ethical guarantee of being better Canadian or European people. They are not, in doing this, intending to reassure; they are saying that they have understood the reference to their own religion. Muslims speak not in order to please their fellow

citizens but to express their understood principles. All this is far too important for anyone to play at appearing to participate, because Muslims are working out their own destiny and the future of the Western societies.

The second element of Muslim identity — taking account of the context — supports what I have said about educating and transmitting: to educate and transmit, as a citizen, is to bear witness. What does it mean for a Muslim man or woman to bear witness? It means that, in every one of your social actions, in every commitment, you should hold to what you say, your word should carry weight, your honesty should be visible, your conscience should be tirelessly active — this is very important. Our religious allegiance will emphasize a dimension of honesty, of lively conscience, of rigorousness, of transparency. A person who in their social and political activity develops a discourse of honesty bears witness. This is why it is essential that we not only speak of citizenship, but also commit ourselves to an ethics of citizenship. Western societies need to be reconciled with the political act, to be able to place more trust in politics and politicians.

In considering the third element of Muslim identity — to educate and transmit, in the sense of bearing witness — it is important that we recognize that our religious allegiance, in its extended form, influences citizens' behaviour; it does not confine them, and no one can ask that it should not have an influence. Olivier Abel, a Protestant theologian and university professor, affirms that it is quite absurd to insist that there should be a watertight partition between religion and citizenship. It certainly is unreasonable to ask this, but it is just as important to know that if we are afraid of the one invading the other, it is because we are afraid that the one will confine the other — or, rather, that religious allegiance will become a kind of strait-jacket. This must not happen. Religious allegiance should be the inspiration for sincere civic behaviour; it should not shut itself up in a partisan or ghettolike structure. The need is, then, for a behaviour marked by honesty, a behaviour that is allied with a moral-ethical stance. When this is achieved, there is a dimension of commitment that for us should be one of honesty: one's religious affiliation tells one to be an honest citizen, which is the same thing, the constitution tells us, but one's awareness of faith adds to one's civic conscience, in the best sense of the term.

The final element of Muslim identity in the context of civic commitment — participation — has an important influence. To be a citizen with a passive attitude to society should be inconceivable for a Muslim. Participation is what is required of us if we are to live in accordance with our identity. Participation in everything

that involves participation, and in what concerns the citizen — voting, under-standing problems, solidarity on the local level, interaction with the various agents of society, politics and the media — should be a part of a correct understanding of participation, if the context has been understood. Such participation is funda-mental; it is part of one's identity. In fact, it is the influence of allegiance that affects civic behaviour without confining it, for we reject that dimension of confinement.

Before concluding, let me make a third brief digression, concerning parti-san allegiance. What does this mean? It is an extension of communitarianism. It is saying, "I am a Muslim, and I am going to vote for the Muslim man or woman who is standing for election." This really does happen! You may not do it yourself, but others do. We have seen that, in certain parties, a name that sounds vaguely Arab or somewhat exotic will be placed fifth on its list in order to gain votes — some-thing that is completely against our ethic. We recognize three qualities when we vote: competence, integrity and accountability. We must not fall into practices of this kind, for there are certain parties who start to go out to meet the "Muslim community" saying they will put forward one of its members, thus attracting votes by using people. We do not want that. We should support ability and citizen par-ticipation to the fullest extent: if a non-Muslim offers himself for a position and is more competent than another who may be a Muslim, whatever may be the name and its attractive connotations, we must choose competence over religious affilia-tion. From the early days of Islam, the Prophet Muhammad and the first Companions, such as Umar, chose for certain positions people of ability, and not necessarily Muslims. They gave ability and integrity the priority they should have. It is not enough to be called Muhammad or Karim to be able to gain Muslims' votes, simply by playing on a shared membership in the community.

Nor is it acceptable that we should be told two contrary things: "We do not want communitarianism" (as in France or in Quebec), while encouraging Muslims to vote as a community for candidates who are like them. What *is* like "them" must be candidates' ability and honesty. In this regard, it is vital for us to develop a very strict attitude, which means saying that we are going to look only for ability and integrity, to put searching questions to politicians about their ability, and let them know they must not play games with Muslims on this or that electoral roll by includ-ing one or two people of North African or Pakistani origin to give the impression of having responded to their demands. The Muslim demand, as Muslim Canadian or French citizens, is above all for competence and uprightness. Sometimes, political

parties offer Muslims "representative people" who are incompetent and none too honest, expecting Muslims to be satisfied because they have slightly exotic names. This is a serious matter, because in the future the Muslim community, because of its numbers, could topple a majority through its political awareness. Muslims must be clear that these are the stakes. What interests Muslims is the quality of the body politic, not its numbers, nor theirs.

I would prefer to see no Muslims in the political arena rather than to have Muslims represented by a name and not by honesty and ability. Our strength lies in our commitment to questioning politicians regarding their program, their ability and their honesty. If a politician promises us a mosque in return for votes and that politician is dishonest, then we are doubly dishonest, and prayers must not be offered in a mosque that has been built by dishonest means. Nor must one pray in a mosque that is part of a political stake, but in a mosque founded upon God consciousness and in a lawful way. One sees and hears things — sometimes Muslims enter into discussions that are not honest, and that, as they know, is not morally right. If politicians can buy Muslims before elections, they will be able to sell them afterwards. This is by no means the right way to deal with politics.

Conclusion

IN CONCLUSION, THE INFLUENCE OF OUR ALLEGIANCE LIES IN A CLEAR CIVIC PARTICIPATION. There is no confinement involved here, and none is wanted, to the extent that we will raise questions based on our values and our conscience and put them to all politically active people — questions regarding the genuineness of their commitment. And we will even question ourselves. On the local level, this implies adopting a civic stance and following it to its logical conclusion, accepting the framework within which it functions. This means two things: there is no brick wall between religious allegiance and citizenship, but neither does one constrain the other; there is a dynamic, an inspiration, recognized by the more secular people in Western societies. This is an interesting phenomenon, which can be used, in a certain sense, in a conscious, conscientious and vigilant manner: the religious allegiance of many young people motivates them to want enhanced civic participation, something that is lacking in many other populations. We now see Muslims arrive in a new country and become involved in the name of their religious conscience, which encourages them

to adopt a much more complete citizenship. But we must stay alert. It must be a complete citizenship resulting from belonging to a religion, and not a closing of ranks, which, because it is a confinement, contradicts their whole identity. If one votes for someone one knows is incompetent and dishonest just because that person is a Muslim, this has to be criticized.

As citizens, Muslims must stop speaking of themselves as a minority. There is no minority citizenship in Western countries. Faithful to their values, bearing multiple identities, Muslims must be committed to their society as citizens and share this commitment with their fellow citizens. The future relies on our understanding that we have common universal values and citizenship. It is time to get out of our respective intellectual, religious, cultural, social and political ghettos and come together; it is time to create new dynamics in the name of our common hopes and ethics. This is the future of our pluralistic societies. We all must recognize that every citizen must be free to travel the road toward this understanding according to her/his universe of reference, religious allegiance or atheism, or memory. No one should be forced to pretend that they are indifferent to these things. These are the central questions of today, and shared citizenship takes effort.

What can this bring us in the future? Above all, a change in Muslim self-perception — and I do insist on this. Muslims must not huddle together to find out where their place is, or whether they will be granted a place; in fact, they are in the West, and their place is in the West. So now they must ask how to make their contribution a positive one — one that will be civic and at the same time philosophical (civic through an increase in civic training, which will impel young people to carry out their obligations as citizens). This is a social, political and cultural contribution, a true civic commitment. It is also one of a philosophical nature, because, due to the tendency to withdraw, we Muslims must accompany our commitment with some fundamental questions.

The first question is central for us: as a citizen, I put the question of values to my society. Which values are our values? Which values do we defend together? In the name of political logic, can one do everything and anything? What things should be reformed? Are there not limits and rules, things that need to be reformed? Can we accept racism and discrimination? Can we mistreat immigrants? Torture suspects? Close our borders? Wage war against terrorism and terror? The Muslim presence should give rise to questions about values, dignity, respect for living beings and things. At the domestic level, Muslims must also maintain a position on all

issues related to education and educational methods. One of the great problems of our modern society is education and the school. We must not wait for secondary school students to take to the streets before we acknowledge that there are very real problems when there are 40 students to a class, or too few teachers. To act on this is to engage in true and shared citizenship in action.

The Muslim presence in the West should raise questions about fundamental values. This is, after all, the basis and the potential richness of their presence. True questions about human dignity and the reality of spirituality must be raised. I am quite happy that this society has said that one's religious allegiance is a private matter, that what one knows, what one chooses, is private; but I cannot, in accepting that, also accept that this should result in a total ignorance of my religion and of other religions. I learned one thing living in Europe, where I was born, and that is the fear others have of me is due to their ignorance of what they are themselves. I cause fear not because I exist, but because many of my fellow citizens do not know who they are.

There is no question that religious allegiance should be a private choice, no question that it should be a personal choice, no question that confinement on the social and political level should not be encouraged. But this does not mean that one should be unaware of religious belief. Is true freedom founded on ignorance? There is no freedom where there is ignorance; there is only an illusion of freedom. Students who read Nietzsche and are completely without the wherewithal to understand why he rebelled and against what in his cultural references are people without cultural roots who do not know the foundation. We must study cultures and civilizations. We will not bring about the meeting of civilizations and citizens in a kind of artistic haze, by saying, "I belong to the world, I am part of internationalization, I am part of the globalization movement, I am 'in.'" If we do so, we are in fact "out," because the reality lies in critical study, in true awareness of one's own belonging. I do not know anyone who can carry on a dialogue with another if he is not first able to do so with himself, if he does not already know a little about who he is.

Religion-Based Alternative Dispute Resolution: A Challenge to Multiculturalism

T HE BASIC TENSION INHERENT IN MULTICULTURALISM IS HOW TO BALANCE THE RIGHTS of minority groups within a multicultural society and yet protect the rights of individuals who are members of these groups. Family law is often a litmus test for how a jurisdiction interprets multiculturalism, as it serves to determine who belongs in a community and who does not according to the community's own norms. Family law also has a distributive function, as it allocates rights and obligations, including financial security, to members of the community. Delegating complete power over family law to a minority group would not only empower that group to determine the boundaries of its own inclusion and exclusion, but it would also allow those in power to determine the level of enfranchisement of individual group members.

This is extremely problematic when a community is seen by some to have little regard for the rights of certain members, such as women. Similarly problematic, however, is the prospect of cultural and religious minorities being suddenly deprived of the right to deal with family law matters before religious tribunals — a right they have enjoyed for decades and one that they firmly believe is guaranteed by the Charter of Rights and Freedoms. In this context, the controversy that emerged in 2003 over religion-based alternative dispute resolution in family law in Ontario led to widespread questioning of Canada's multicultural policies and how they affect vulnerable individuals with respect to family law.

The Issue

IN OCTOBER 2003, A GROUP CALLED THE ISLAMIC INSTITUTE OF CIVIL JUSTICE (IICJ) announced in rather grandiose terms its intention to incorporate a business that would offer arbitration of family law matters based on Islamic principles. Its major proponent, Syed Mumtaz Ali, claimed the IICJ was "the beginning of a *sharia* court in Canada." Well known as an advocate for Islamic political identity, Ali had written articles proposing that Muslims have the same right as Aboriginal nations to develop their own legal system, and he had also defended the right of Quebecers to separate from Canada on the basis of cultural self-determination (Ali and Whitehouse 1991). He claimed that once Islamic-based arbitration was available, all "good Muslims" would be expected to have family matters resolved only in this forum as opposed to the secular courts of Canada (Ali 2003). His implication was that the law in Ontario had recently changed and that his institute would henceforth offer a parallel legal system based on Sharia law.

These pronouncements precipitated immediate and vocal opposition within the Muslim community and Canadian society as a whole. Under the mistaken impression that the Ontario government had taken, or planned to take, specific action to allow Canadian laws to be superseded by Sharia law, opponents worked with the media to perpetuate this myth. Recognizing the volatility of the issue, the Ontario government asked me to conduct a review of the use of arbitration in family law in general, and specifically to consider the impact on vulnerable individuals of alternative dispute resolution using religious laws. The review received almost 50 written submissions from a wide variety of groups and individuals. Among the submissions were presentations by religion-based arbitration organizations in the Jewish, Muslim and evangelical Christian faiths, which have operated in Ontario for many years — albeit dealing with quite small numbers of clients — without significant judicial intervention. Also presenting submissions were groups strongly opposed to any role for religion in the design or application of the laws of Canada. The review conducted consultations with 250 people and considered the policy implications of various options. The full report of the review was released on December 20, 2004. It included an overview of the applicable laws; a summary of the positions of proponents and opponents, including their suggested remedies; an analysis of the policy issues; and recommendations to government for legislative, regulatory and program measures to address the issues raised during the review (Boyd 2004).

The History of
Arbitration in Ontario

A S DO MOST JURISDICTIONS, ONTARIO HAS A SYSTEM OF FAMILY LAW THAT ENCOUR-
ages a wide range of dispute resolution methods to provide alternatives to
the adversarial win-lose forum of the courts. Large numbers of family law dis-
putes are resolved through separation agreements, voluntarily agreed to by both
parties, often with the assistance of independent legal advice and/or mediation.
These agreements may or may not come to the attention of the courts, depend-
ing upon the specific remedies sought. Ontario law has always allowed parties to
choose arbitration as a means of resolving family law and inheritance matters, as
long as both parties agree to it freely, without coercion. Under the law, the parties
can agree on an arbitrator (or arbitrators) they feel will hear the matter fairly, and
both parties can agree on the form of law — including religious law — that the
arbitrator will use in making a decision. The enabling legislation, the *Arbitration
Act*, originated in the nineteenth century, and it was updated in 1991. Ontario is
one of seven provinces to adopt a uniform arbitration act developed by the
Uniform Law Conference of Canada, a group dedicated to modernizing and har-
monizing laws across Canada. British Columbia and Quebec amended their leg-
islation prior to the conference's report, and they have different provisions.

The *Arbitration Act* applies only to civil matters that are subject to provincial
jurisdiction (such as separation, property division and support of dependent spouses
and children) and provincial matters that the Act does not specifically exclude (such
as labour law). Matters under federal jurisdiction, such as criminal law or civil
divorce, cannot be arbitrated. Arbitrators can order the parties to do only things they
could have agreed to do independently; they cannot order a remedy that is illegal
under Canadian law, since parties cannot lawfully agree to break the law. The courts
retain the right of judicial review with respect to the fairness and equity of the process,
and the parties cannot waive their right to such review. The courts can also overturn
decisions that are found to be egregious or not in the best interests of children.

Increasingly, over the past 20 years, jurisdictions have implemented alter-
native dispute resolution methods in response to research and reviews. The ratio-
nale for doing so includes the swifter time frame for resolution of disputes; the
lower cost, both to the state and the individual; the reduction of emotional stress;
the fact that specialized expertise is needed to deal with the sensitive issues of

family law; and the sense of personal agency it gives disputants. Many mediators and arbitrators point out that parties who engage actively in the resolution process are more likely to respect the outcome, even if it is not the one they had hoped for. Those advocating religion-based alternative dispute resolution argue that diverse parties must be given the right to choose to have their matters heard by those who understand their religious priorities, who respect their traditions and who speak their language (both literally and figuratively). The results of such arbitration would have both legal and religious authority, thus encouraging compliance on both secular and religious grounds.

Discussion

MANY OPPONENTS OF ARBITRATION CAME TO CANADA TO ESCAPE THE OPPRESSIVE yoke of states like Iran, Afghanistan or Pakistan, where Islamic law governs every aspect of life. They expressed fear that the use of Muslim family law principles in family law arbitration would just be the thin edge of the wedge — that allowing such practices would open the door to the gradual implementation of full Sharia law, applicable to all Canadian Muslims. Feminist organizations claimed that religious principles are inherently conservative and prejudicial to women, and that arbitration based on Muslim family law, in particular, would erode the individual equality rights women have striven to have enshrined in Canadian law over decades of political action. Some of these groups suggested that Muslim women would not have the knowledge or the strength to assert their own rights when they conflicted with the communal rights of Islamic society. Secular humanists, believing in the complete separation of church and state, deplored what they depicted as a further intrusion of religion into the realm of the state. They demanded that the government take immediate steps to remove the right of any religious group to arbitrate family law matters using religious laws. All these groups raised questions about the status of women in Muslim states and the vulnerability of women and children to violence within Islamic culture. Those opposed to Canada's multicultural policies seized upon this issue as an example of why Canada should limit the expression of cultural diversity and insist that, however heterogeneous our population, everyone adhere to the same laws and processes (Boyd 2004, sec. 4).

The responses to the review revealed a wide range of opinion on multiculturalism in Canada. A minority advocated for full jurisdiction for religious/cultural minorities over family law and inheritance matters with minimal state intervention. These respondents believed that a minority group should be able to apply religious laws even when they seriously conflicted with the laws or policy imperatives of the state, and that the state should have little power to act on behalf of an individual member of the group, even if the process contravened that individual's rights. This has been described as a policy of "noninterventional accommodation" (Shachar 1998b, 83). At the other end of the scale, some respondents vigorously advocated for a complete separation of church and state, with religious and cultural minorities having no authority whatsoever over matters subject to state laws. This has been termed the "secular absolutist" position (Shachar 1998b, 81).

The noninterventionist approach "renders invisible those violations of members' basic individual rights which occur under the shield of an identity group" (Shachar 2001, 73). When the right of the minority group to protect itself from external influences is prioritized, individuals within the group whose rights are violated must bear a disproportionate share of the burden of protecting the culture within the dominant society. As a result, individual autonomy is sacrificed for the sake of group survival. Where, as in Ontario, the existing family law regime is available to all residents but is not mandatory, there are limited state-guaranteed protections, aside from the right to avail oneself of a particular set of laws. It is simply not tolerable that an individual could lose legal rights and protections because of the exercise of power by a minority group. It is therefore essential that these laws continue to be available to all, regardless of the community to which they belong, and that no community is given the right to prevent access to the laws.

However, the proposal that cultural and religious minorities lose the ability they have enjoyed to arbitrate family matters according to religious law is equally contentious, given the religious and multicultural rights enshrined in the Charter of Rights and Freedoms. The secular absolutist approach is based on the assumption that secular laws treat everyone equally. The primary shortcoming of this position is that it fails to acknowledge that some people live their lives in a manner more closely aligned to their faith than others and experience secularism as a constraint. Ontario laws are framed by the combined influence of the Judeo-Christian tradition and the Enlightenment focus on the individual as opposed to

the community and are grounded in English common law. As a result, the laws of the province and their application are more easily embraced by some cultures than others, making their impact disproportionate on those who do not belong to the dominant culture. This may serve to alienate from the mainstream those who do not see themselves reflected in our laws. Many opponents of arbitration in family law urged the government to make the resolution of family disputes possible only through the secular court process. Those who identify primarily with their religion, and whose religious rules require them to seek mediation and arbitration of disputes rather than litigation in the secular courts, would find such a requirement oppressive and discriminatory. Undoubtedly, this position would drive the practice of religious arbitration underground, leaving vulnerable women and children with no recourse under Ontario law.

Ayelet Shachar suggests that instead of choosing one of these two polarized approaches to multicultural accommodation, we seek to achieve "transformational accommodation" by balancing group religious and cultural freedoms with individual rights and freedoms (1998b, 83). This notion is based on the understanding that individuals stand at the intersection of various identities. Not only are they members of a collective, but they also have dimensions of gender, ability, age and so on. As Shachar writes:

> The intersectionist view of identity…would acknowledge the multidimensionality of insider's experiences and would capture the potential double or triple disadvantages that certain group members are exposed to given their *simultaneous belongings*. Moreover, an intersectionist view would recognize that group members are *always* caught at the intersection of multiple affiliations. They are group members (perhaps holding more than one affiliation) and, at the same time, citizens of the state. (1998a, 285)

Commitment to individual rights lies at the core of the legal and political organization of any liberal democracy. It underpins freedom of religion and expression and the right of minorities to enter into dialogue with the broader society. It is illogical and untenable to claim minority rights and then entrench religious or cultural orthodoxies that would undermine the individual rights of select others. Toleration and accommodation must be balanced against a firm commitment to individual agency and autonomy.

Incorporating cultural minority groups into mainstream political processes remains crucial for multicultural, liberal, democratic societies (Kymlicka 1995,

50). By utilizing provincial legislation that other religious groups were already using, the Muslim community was drawing on the dominant legal culture to express itself and engage in institutional dialogue. In using the existing law, the community was inviting the state into its affairs — since state intervention, in the form of judicial oversight, is specifically set out in that law — while at the same time creating a forum in which to meet its religious obligations. The Muslim proponents of religion-based arbitration consistently pointed out that, according to the Koran, Muslims living in a non-Islamic country are required to follow the laws of that country.

The recommendations flowing from the review attempted to strike a balance by allowing religion-based arbitration to continue, but only if the process and the decisions are consistent with the *Ontario Family Law Act*. Arbitration agreements and decisions would be included under part IV of the Act. Recommendations offered by proponents from both the Muslim and the mainstream communities include provisions for the regulation of arbitrators and mediators, requirements for record keeping, written decisions with reasons and monitoring of decisions in an anonymous form. The review also recommended that resources be allocated to ensure that individuals within all communities understand their rights and obligations under the law and that we commence a genuine public dialogue about how we can build a shared sense of identity in an atmosphere of peace and mutual respect. The review challenged the government to seize this opportunity to create transformational accommodation in family law arbitration and thus protect the choices of all individuals while promoting the inclusion of minority groups in our society.

The Outcome

THROUGHOUT THE SPRING AND SUMMER OF 2005, THE CONTROVERSY CONTINUED TO swirl, not only in Ontario but also across Canada, and even in Europe. The issue was a favourite of journalists, who often grounded their observations in blatant anti-Islamic or antimulticultural sentiment; they continued to repeat misinformation about the "dangers" of Sharia, even when their own editorial pages thoughtfully considered divergent views. The opponents of arbitration in family law waged an effective campaign to put pressure on the government; the

government assured citizens that it would act to ensure that family matters were resolved in accordance with Ontario and Canadian law. Without warning, on September 11, 2005, the premier of Ontario stated to a reporter that he had decided to ban all religious courts in the province. Immediately, the pressure on the government eased, and the story fell out of the spotlight. All sides waited to see what the legislation would actually entail.

On November 15, 2005, the government introduced the *Family Statute Law Amendment Act*, designed to ensure that all family law arbitrations are conducted only under Canadian law, which includes all provincial statutes. The legislation provides that family law resolutions based on any other laws or principles, including religious principles, will have no legal status and will amount to advice only. People will still have the right to seek advice from any source in matters of family law, including religious leaders. However, such advice will not be enforced by the courts. Virtually all the other legislative and regulatory provisions recommended by the review were incorporated into the Act. In addition, the government added a long-awaited amendment to the *Children's Law Reform Act* to ensure that violence and abuse are taken into account in determining the best interests of a child with respect to custody and access. Finally, it announced that it would develop new community outreach and education programs to better inform Ontarians about family law and arbitration. The *Family Statute Law Amendment Act* has been passed by the Ontario Legislature but not yet proclaimed, and regulations are still being drafted.

We can predict that some religious groups will challenge the legislation under section 2 (religious freedom) and possibly section 27 (enhancement of multiculturalism) of the Charter. Others are examining their options within the context of the law. The controversy has encouraged wide-ranging examination and debate within the Muslim community about its role and image in a multicultural Canada. It has also challenged all Canadians to pay more attention to how the concept of multiculturalism is actualized in their day-to-day lives. Only time will tell whether the law will alienate communities and isolate the vulnerable individuals within them, or whether it will contribute to the transformational accommodation of religious groups in Canada.

References

Ali, Syed Mumtaz. 2003. "Islamic Institute of Civil Justice and Muslim Court of Arbitration." Canadian Society of Muslims. Accessed November 23, 2006. http://muslim-canada.org/DARLQADAMSHAH2.html

Ali, Syed Mumtaz, and Anab Whitehouse. 1991. "Oh! Canada. Whose Land, Whose Dream? Sovereignty, Social Contracts and Participatory Democracy: An Exploration into Constitutional Arrangements." Canadian Society of Muslims. Accessed November 23, 2006. http://muslim-canada.org/ocanada.pdf

Boyd, Marion. 2004. "Dispute Resolution in Family Law: Protecting Choice, Promoting Inclusion," December 20. Accessed November 23, 2006. http://www.attorneygeneral.jus.gov.on.ca/english/about/pubs/boyd/

Kymlicka, Will. *Multicultural Citizenship: A Liberal Theory of Minority Rights.* Oxford: Clarendon Press, 1995.

Shachar, Ayelet. 1998a. "Group Identity and Women's Rights in Family Law: The Perils of Multicultural Accommodation." *Journal of Political Philosophy* 6 (3): 285-305.

———. 1998b. "Reshaping the Multicultural Model: Group Accommodation in Individual Rights." *Windsor Review of Legal and Social Issues* 8:83-111.

———. 2001. *Multicultural Jurisdictions: Cultural Differences and Women's Rights.* Cambridge: Cambridge University Press.

The Ontario Sharia Debate: Transformational Accommodation, Multiculturalism and Muslim Identity

Commentary

M ARION BOYD'S "RELIGION-BASED ALTERNATIVE DISPUTE RESOLUTION: A Challenge to Multiculturalism" raises a number of issues that will reverberate in the years to come. But before I discuss Boyd's chapter, I should note that the application of Islamic law in arbitration was first proposed in Quebec in 1994, when a Sharia council was formed in Montreal for the purposes of settling civil disputes between Muslims in areas such as family, contract and labour law. The council's organizers made it clear that the body would serve local Muslims in a manner analogous to the way in which rabbinical courts serve the Jewish community. They added that the council's solutions would "probably not be any different" from those produced by Quebec courts, but they would be arrived at in a more conciliatory, less costly manner (Norris 1994). They also stressed that the arbitration panel, modelled after Britain's Islamic Sharia Council, did not identify with fundamentalist movements seeking to set up theocratic states elsewhere. All of the six imams who presided over the council had formal training in Islamic studies — both outside and within Canada. Notably, however, none of the imams held a degree in Islamic law.

As it did in Ontario, the announcement in Quebec heralding the potential use of Islamic principles in alternative dispute resolution triggered an avalanche of media hyperbole. The politics of fear was used by some, who alleged that the council was merely the first step in an Islamist plan to set up a "state within a state" (Berger 1995). Beneath the hyperbole, however, lay the fundamental question of the place of religion within a secular system, precipitated by a wider debate on the place of the hijab (Islamic head scarf) in Quebec society. Under public pressure, the Quebec government announced that it would review the

application of Sharia in matters of arbitration. No formal government report ensued, and the council itself dissolved shortly thereafter.

The issue lay dormant in Canada until October 2003, when the Islamic Institute of Civil Justice (IICJ) announced the planned establishment of a Sharia court in accordance with the Ontario *Arbitration Act, 1991*. In response to intense public pressure, the Ontario government first commissioned former attorney general Marion Boyd to conduct a review of the use of religious laws in family arbitration; it then adopted the *Family Statute Law Amendment Act, 2006*, designed to ensure that all family law arbitrations are conducted only under Canadian law. While the issue may be dormant for now, it has engendered rich discussion about topics such as religious rights within a secular framework, the limits of multiculturalism and the compatibility of Islamic law and Western democratic norms. These are topics of great interest to the many European countries struggling to meet the demands of their growing Muslim populations within the framework of their national diversity policies and constitutions.

Multiculturalism and Religion-Based Alternative Dispute Resolution

As Boyd indicates, the amendments introduced by the Ontario government in 2006 are not the final word on the issue. The legislation may still be challenged under sections 2 (religious freedom) and 27 (preservation and enhancement of Canadians' multicultural heritage) of the Charter. In looking ahead, it is worthwhile to review the Ontario Sharia debate within the paradigms of "transformational accommodation" (Shachar 1998a, b), Canadian multiculturalism (see Will Kymlicka's chapter in this volume) and Muslim identity within citizenship (Ramadan 2001, 2004).

"Transformational accommodation," as identified by Ayelet Shachar, is a complex process whereby the religious and cultural freedoms of a collective are balanced with the rights and freedoms of the individual. In particular, the review advocated such an approach in family law arbitration, arguing for the need to protect the choices of all individuals while promoting the inclusion of minority groups.

Will Kymlicka has maintained that the liberal foundations of the Canadian multiculturalism model are inherently transformational in that they compel groups to "engage in new practices, enter new relationships, and embrace new concepts and discourses, all of which profoundly transform people's identities and practices." The human rights revolution is at the core of such transformations: "It has created political space for ethnocultural groups to contest inherited hierarchies. But it also requires groups to advance their claims in a very specific language — namely, the language of human rights, civil rights liberalism and democratic constitutionalism. This is not necessarily the language that members of minority groups would naturally use."

This was evident throughout the Sharia debate. When the IICJ announced the formation of a Sharia court, it took pains to stress that its decisions would not contradict the Charter in order to demonstrate its commitment to democratic constitutionalism. Nonetheless, quite a few of the submissions made by Muslim groups to the review asserted the opposite: that Sharia provisions regarding women were inherently unequal and therefore contradicted the Charter's requirement of equality between men and women. The IICJ never responded publicly to these criticisms, leaving fundamental questions on the compatibility between Islamic law and the Charter unanswered.

Within the Muslim community, different language was used in the various debates that ensued. IICJ president Syed Mumtaz Ali declared that "good Muslims" would have no choice but to avail themselves of this court — with obvious implications for those who opposed such a project (Hurst 2004). If Ali intended to attract Muslims to the project with this definition of a "good" Muslim, his plan backfired, for it created resentment among Muslims who had never heard of the IICJ, or who had serious reservations about the practicality of such a project.

Kymlicka further asserts that the transformation to which he refers occurs not only in the vertical relationship between minorities and the state, but also horizontally, among members of a minority group. Canada's diversity policies supply the tools for nondominant groups to challenge their status, provided they accept the principles of human rights — gender equality, religious freedom and so on. It is, however, a two-way street: diversity policies can be used to challenge exclusion, but they also demand inclusion. This was evident within Canadian Muslim communities. One can argue that the debate itself was a positive

phenomenon, as it provided a means for Muslim communities to mature and to integrate into the Canadian mosaic.

In particular, discussions were not framed solely by imams in mosques, but also by ordinary women and men who questioned the place of Islamic law within a Canadian framework. Muslim women's groups came forward to express their concern for the well-being of the most vulnerable members of the Muslim community: women and children. It was a rich and complex debate, and it involved discussion of many issues. Religious debate, which had often come under the aegis of the clergy, was democratized — which, in and of itself, is no small feat. The discussion allowed many Muslims to learn more about Sharia — its complexity, its nuances, its flexibility. With regard to issues pertaining to women, many people who had been schooled in cultural misogyny (masquerading as faith) were exposed to more equitable interpretations of Islamic law.

Democratization within the Muslim community also extended beyond it. Ordinary individuals participated in numerous community forums; local radio, television and newspaper discussions; interfaith gatherings; and Internet chat groups. Once the IICJ's arbitration initiative became public, Muslim organizations mobilized to offer a plethora of positions to the government and the media, thereby exhibiting the tremendous diversity within the Canadian Muslim community. This was most apparent in the numerous submissions published in the review.

In her chapter, Boyd argues that the IICJ proposal was an example of transformational accommodation: "By utilizing provincial legislation that other religious groups were already using, the Muslim community was drawing on the dominant legal culture to express itself and engage in institutional dialogue." However, it was not so much the Muslim community, but rather a small group of conservative-minded individuals within that community who decided to propose the Sharia court. As Kymlicka observes in his chapter, "Once these policy structures were in place, conservative and patriarchal elites within various communities attempted to gain control over them — or at least influence their implementation and direction. This is a universal phenomenon...It is even possible that these policies have sometimes, unintentionally, served to strengthen the hand of conservative elites against the forces of liberal reform within various communities."

Relatively few Muslims had heard of the IICJ, which had undertaken this initiative without broad-based consultation with the community. Its conservative approach was in keeping with the overall views of its president, Syed Mumtaz Ali,

who has endorsed "Purdah and the Status of Women in Islam," a misogynist tract written by Abu Ala Maududi, an influential Muslim personality from the Indian subcontinent (Ali 2003). In the months following the initial announcement, IICJ spokesmen refused to comment further to the media or participate in public forums, leaving much of the Muslim community in the dark about the specifics of the project. As some in the community saw it, the IICJ had created a mess, failed to take responsibility for publicly defending its policy and left it to an unprepared Muslim community to deal with the fallout. In the aftermath of 9/11, Muslims were contending with issues of religious discrimination, profiling and suspicion. The Sharia controversy only seemed to add to the list of contentious issues faced by the beleaguered community. The lack of widespread support for the IICJ initiative is perhaps a fulfillment of what Kymlicka identifies as the "so-called liberal expectation — that is, the assumption that ethnocultural minorities will come to embrace the basic values and principles of liberal democracy [with] relatively little support for illiberal forces within most ethnic communities."

One can therefore argue that while the Sharia court proposal arose from conservative elements within the diverse Canadian Muslim community (rather than from the community as a whole), reaction to this proposal engaged the wider community and democratized its religious discourse.

Muslim Identity and Citizenship

THE ONTARIO SHARIA DEBATE CAN BE SEEN AS PART OF A MORE FUNDAMENTAL QUESTION for Muslims living in liberal, secular societies: How does one maintain a Muslim identity while participating in a democracy? Tariq Ramadan has studied this issue at length and proposes three points from which a foundation can emerge. The first is that one should recognize the constitution or charter of the country in which one lives. According to Islamic norms, Muslims are required to respect and live within the law of the land. The second point is that one should have "loyalty in conscience" to the nation's constitution — that is, citizenship is a pact that one enters with full conscience. Islamic norms require Muslims to honour this pact; they will be held accountable by God for it. The third point is that one should participate in the broader society. These three points form the basis of an "ethic of citizenship" (Ramadan 2004).

For Ramadan, the crux of the matter is the question of how Muslims will participate, if at all, in the wider society. He warns that the community should be on guard against communitarianism. Ramadan is a strong proponent of including civic education in the formation of Muslim identity, since faith necessarily implies social responsibility. This further implies that one should acquire a knowledge of the history of the country in which one resides in order to understand the local context, for context is essential in developing a Muslim identity that is whole and in harmony with the immediate environment.

The proponents of the Sharia court seemed to focus on a very narrow issue: the right of groups to use religious principles in alternative dispute resolution. The IICJ saw well-established models in the Quebec proposal and in the provincial rabbinical courts. However, Sharia proponents did not address other fundamental contextual matters, such as gains made by the women's movement, the secular framework of society, widespread ignorance and fear of Sharia and the lack of community consensus on the need for such an institution. Without an in-depth analysis of contextual issues, the IICJ (and its supporters) could not answer many of the criticisms aimed at their initiative.

Contextual Issues of the Sharia Debate

NOT SURPRISINGLY, THE LOUDEST VOICES OPPOSING THE IICJ PROPOSAL WERE THOSE of women. Those who have fought for women's rights will not give way to laws they perceive are at odds with gender equality. Such concerns were raised in the UK, where the establishment of a Muslim personal law system was rejected by the government (Fournier 2004).

In particular, how would a Sharia court reconcile the traditional Sharia ruling of inheritance (whereby a son's share is twice that of a daughter's) with the Charter? And how would such a court follow traditional Islamic jurisprudence requiring a husband to provide only four months of maintenance to his divorced spouse? Since arbitration could not be used to decide custody, would a Sharia court apply Islamic law in a piecemeal fashion (that is, issue rulings with regard to divorce but not children)? Furthermore, in more conservative Muslim circles, it is conceivable that female arbitrators would not be allowed to settle disputes.

And while the Sharia debate focused on matters pertaining to family law, little attention was paid to commercial contracts, which are also under the purview of the *Arbitration Act*. Traditional Islamic jurisprudence stipulates that a male witness is required by each party of a commercial contract; if a male witness is not available, then two female witnesses should be present. How would a Sharia court deal with contracts in which such a condition is not met (for example, in which only one female is witness to the transaction)?

While critics of the Sharia court focused primarily on equality, many also raised concerns about the place of religion in a secular society. Some were opposed to all types of religion-based tribunals, arguing that in a secular society, the government should not be enforcing arbitration decisions based on religious laws. The Sharia debate highlighted the fact that rabbinical, Aboriginal and Ismaili tribunals had been in operation for some time in Ontario. With the *Family Statute Law Amendment Act*, decisions rendered by these tribunals will no longer be enforced by the province. In the arena of religious freedom, the Act may be challenged legally by groups that have traditionally used tribunals to settle disputes in a manner consistent with their religious beliefs.

Ignorance and fear of Sharia were prevalent in much of the media coverage of this issue. The word "Sharia" conjured up images of the Taliban in the minds of many who knew nothing of the subject, whereas for many Muslims, the Taliban were antithetical to Sharia. Some went even so far as to opine that the use of Islamic principles in family arbitration would hasten the demise of secular democracy as we know it. Quebec National Assembly member Fatima Houda-Pépin warned of an international Islamic conspiracy that had targeted Canada in order to establish Sharia in the West.[1] Yet others decried the inevitable advent of the kind of punishment meted out to convicted criminals in Nigeria, Iran and Saudi Arabia. Some, who had left Sharia-based systems elsewhere, were fearful that these systems would be replicated in the heart of Ontario. *Globe and Mail* columnist Lysiane Gagnon equated Sharia with incest: "In her infamous review of Ontario's Arbitration Act, former Ontario attorney-general Marion Boyd said that, since religious arbitration in family matters is already going on, it's better to regulate it. This reasoning makes no sense. To take an extreme example, incest is committed every day behind closed doors. Should the state step in and draw up rules to limit the damage?" (2005).

The IICJ made no attempt to answer these concerns, thereby failing to provide any reassurance about potential conflicts. Its silence only heightened concerns

about the viability of such a project. Finally, the IICJ seemed to ignore the histori-
cal (albeit brief) reality of Canadian Muslims, many of whom had arrived from dif-
ferent countries. Due to the diversity of the Muslim world, there are at least five
schools of Islamic jurisprudence in operation today. Many Muslims raised concerns
about how a Sharia court would handle the diversity and complexity of each of
these schools. These concerns have also been raised in the United Kingdom
(Fournier 2004). Another legitimate area of concern was the lack of formal training
of imams. Unlike rabbis and priests, imams have no college in Canada to provide
them with accreditation. There are no institutes to train jurists in Muslim family law.
It is therefore fair to ask how practical it is, given the lack of bona fide training and
education in Islamic jurisprudence, to speak of a "Sharia court."

Future Considerations

W HILE THERE IS A CHALLENGE FOR MUSLIMS TO NEGOTIATE IDENTITY WITH CITIZEN-
ship, there is a reciprocal challenge for their fellow citizens to confront the
ignorance and prejudice that surround Islam. Many in the Muslim community who
did not agree with the IICJ proposal were nonetheless stung by the shrill language
(often bordering on Islamophobia) of the debate. Very little attention was paid to
the nature and history of "Sharia," an Arabic word that means "a path to water." For
Muslims, Sharia is a comprehensive framework of justice based on the Koran and
the example of the prophet Muhammad. Its aim is fivefold: protection of life, faith,
wealth, intellect and progeny. Sharia has spanned 14 centuries and numerous cul-
tures, and it covers such disparate fields as economics, criminal justice, interna-
tional relations and family matters. The study of Sharia is so important that in the
1990s, Harvard Law School launched an Islamic legal studies program.

Such information is not merely academic. It is important for policy-mak-
ers in Western liberal democracies with emerging Muslim populations. Two
recent surveys published by the Pew Global Attitudes Project indicate that a
majority of Muslims in the UK, France, Spain and Germany have a strong sense
of Muslim identity, and that they believe it is important to consult local and inter-
national religious scholars on matters pertaining to Muslim identity (2006a, b).
Furthermore, many believe that this sense of identity is growing stronger. In addi-
tion, these Muslim minorities see no conflict between being devout and living in

a secular liberal democracy — although the majority of residents of the UK, France, Spain and Germany disagree. Another divergence lies in the perception of a growing sense of Muslim identity: a majority of Muslims in these European countries view it as a good thing, while a majority of the countries' general populations believe that it will lead to difficulties in integrating Muslims into the broader society. It will be interesting to see how a stronger sense of Muslim identity among European Muslims will affect family law matters in each country. (The Pew surveys did not poll Canadians.)

Undoubtedly, there will be a growing need for the courts to understand Islamic principles when dealing with Muslims in family law disputes. In Ontario, since the passing of the *Family Statute Law Amendment Act* in February 2006, resolutions based on laws and principles that differ from Canadian law have no legal effect and are not enforceable by the courts. The new law allows both parties in a dispute to consult religious advisers — it therefore does not abolish recourse to broad religious principles — but it is unclear whether this will have any meaningful effect on Muslims (and, in fact, on adherents of other faiths) intent on abiding by faith-based rulings. Some have warned that the practice will go underground, become unregulated and unaccountable. While few statistics exist, we know that informal Sharia tribunals are already in place, and they will be largely unaffected by the new statute. In the area of divorce, provincial settlement guidelines are far less favourable to men than traditional Sharia rulings. It is conceivable that some women will be coerced into forgoing provincially regulated arbitration in favour of informal Sharia tribunals. Furthermore, those who choose to abide by provincial arbitration will have to forgo specific, traditional Sharia rulings (if they violate the Charter) in favour of broad religious principles of equity and justice.

In summary, one can argue that transformational accommodation of Muslims was achieved in part by the very process of consultation for the review. Many of the recommendations made by Muslim groups regarding the Ontario *Arbitration Act* itself — for better accountability, transparency in the arbitration process, regulation and training of arbitrators and education about Charter rights — were adopted by both the review and the *Family Statute Law Amendment Act*. This reflects a maturation of diverse elements within the Muslim community, many of whose members responded within a broad, general framework rather than in narrow parochial terms. The participation of Muslim individuals and institutions in the Sharia debate reflects a growing trend of engagement through

established democratic institutions. In particular, comprehensive participation in the Arar Commission and submissions before the Supreme Court of Canada in the case of controversial security certificate legislation represent milestones in the evolution of Canadian Muslims. And it is this type of engagement — within our diversity policies and established institutions — that will be the key to further integration.

Note

1 Assemblée nationale de Québec. 37e législature, 1re session, *Assemblée Cahier* no 156, May 26, 2005, pp. 8716-8.

References

Ali, Syed Mumtaz. 2003. "What Is Really Behind the Veil? A Tantalizing Look..." Canadian Society of Muslims. Accessed December 12, 2006. http://muslim-canada.org/purdah.htm

Berger, François. 1995. "Le Canada devient la cible des Islamistes." *La Presse*, May 20.

Boyd, Marion. 2004. "Dispute Resolution in Family Law: Protecting Choice, Promoting Inclusion," December 20. Accessed November 28, 2006. http://www.attorneygeneral.jus.on.ca/english/about/pubs/boyd

Fournier, Pascale. 2004. "The Reception of Muslim Family Law in Western Liberal States." Sharia/Muslim Law Project. Gananoque, ON: Canadian Council of Muslim Women, September 9.

Gagnon, Lysiane. 2005. "The Folly of Sharia in Ontario." *Globe and Mail*, September 5.

Hurst, Lynda. 2004. "Ontario Sharia Tribunals Assailed." *Toronto Star*, May 22.

Norris, Alexander. 1994. "Muslims Seek to Settle Own Disputes." *Gazette* (Montreal), January 20.

Pew Global Attitudes Project. 2006a. *The Great Divide: How Westerners and Muslims View Each Other*. Washington, DC: Pew Research Center, June 22.

———. 2006b. *Muslims in Europe: Economic Worries Top Concerns about Religious and Cultural Identity*. Washington, DC: Pew Research Center, July 6.

Ramadan, Tariq. 2001. "Religious Allegiance and Citizenship." Trans. Penelope Johnstone. Centre for the Study of Islam and Christian-Muslim Relations, Department of Theology Occasional Papers 8. Birmingham: University of Birmingham, September.

———. 2004. "Islam in Europe," September 27. Accessed May 31, 2006. http://www.tariqramadan.com/imprimer.php3?id_article=73

Shachar, Ayelet. 1998a. "Group Identity and Women's Rights in Family Law: The Perils of Multicultural Accommodation." *Journal of Political Philosophy* 6 (3): 285-305.

———. 1998b. "Reshaping the Multicultural Model: Group Accommodation in Individual Rights." *Windsor Review of Legal and Social Issues* 8:83-111.

Ethnocultural Communities: Participation and Social Cohesion

Racial Inequality, Social
Cohesion and Policy
Issues in Canada

I MMIGRATION HAS SUBSTANTIALLY INCREASED THE RACIAL DIVERSITY OF THE CANADIAN
population. Since the 1960s, when discriminatory selection policies were
eliminated, questions about immigration's impact on the cohesiveness of
Canadian society have become more prominent. Although few predict a break-
down in social cohesion as a result of racial diversity, concerns about racial ten-
sions have been expressed from a variety of political standpoints by a number of
commentators, including advocates for minority rights (Lewis 1992; Omidvar
and Richmond 2003) and advocates of reductions in immigration (Economic
Council of Canada 1991; Stoffman 2002; Collacott 2002; Francis 2002). In this
chapter, we review some research findings specifically related to racial inequality
and discrimination in Canada as well as to the social integration of racial minori-
ties in Canadian society; we then examine the relation between the two. Our
review suggests that racial inequality is a significant issue in Canada, and that the
extent of discrimination is a point of dispute between racial groups. This creates
a potentially significant racial divide and prompts us to ask whether existing pol-
icy responses are adequate to bridge the gap.

The shift toward non-European sources of immigrants to Canada after the late
1960s was marked. Immigrants arriving before 1970 were overwhelmingly from
Europe, and in the 1950s and 1960s, many came from southern and Eastern Europe,
as well as northern Europe, the United Kingdom and the United States. Of those
arriving in the 1960s or before, only 10.2 percent were racial or visible minorities
(based on 2001 Census data). However, this figure rises dramatically to 51.8 percent
for 1970s arrivals, 65.4 percent for 1980s arrivals and nearly 75 percent for 1990s
arrivals. As a result, racial or visible minorities have grown from constituting less

than 1 percent of the population in 1971 to 13.4 percent in 2001. The largest groups are Chinese (3.4 percent), South Asians (3.1 percent) and Blacks (2.2 percent).

The increasing impact of racial diversity in Canada is magnified because of the concentration of minorities in certain immigrant-intensive cities, especially Toronto and Vancouver. In the Toronto Metropolitan Area, racial minorities constituted only about 3 percent of the total population of 2.6 million in 1971, but by 2001 the figure had grown to 36.8 percent of 4.6 million. A recent Statistics Canada study has projected that by 2017, when racial minorities will make up 20 percent of the Canadian population, both Toronto and Vancouver will likely be "majority-minority" cities (Statistics Canada 2005b; see also Kalbach et al. 1993).[1]

Ethnoracial diversity may adversely affect a society's cohesiveness in two ways. When diversity results in inequality, it may undermine the sense of fairness and inclusion among individuals and groups. Racial diversity may also weaken the commonality of values, commitments and social relations among individuals and groups, thereby affecting their capacity to cooperate in the pursuit of common objectives. Each dimension is important in its own right, and they may have a combined effect on social cohesion.

Given the long history of ethnic and linguistic diversity in the Canadian population, both issues have always been of great significance. However, in many countries, breakdowns in interracial relations have most often been seen as linked to the former — racial inequality and discrimination. Witness the United States in the 1960s (Kerner Commission 1968) or Britain in the 1980s (Scarman 1986). And in Canada in recent years, responses to increasing racial diversity have gradually shifted; more attention is being paid to equality issues than to cultural commonalities. For example, although equality has always been an objective of Canada's multiculturalism initiative, it was sought initially through an emphasis on culture — specifically, recognition of the cultural contribution of various ethnic groups and the promise of government support for culture. This was intended to help break down barriers to equal participation in society (as Prime Minister Pierre Trudeau suggested in his speech announcing the policy [Canada, House of Commons 1971, 8545-6]). But since the 1980s, multiculturalism has included an explicit antiracism component. Racial equality is now a focus of other policies, as well, such as the federal employment equity policy adopted in 1986.

In this chapter, we examine evidence of racial inequality and discrimination and consider their relation to the social integration of racial minorities in Canada. In doing so, we have used very helpful data from Statistics Canada's landmark *Ethnic Diversity*

Survey (EDS).[2] The survey, conducted in 2002, is the best source of information on the social integration of minorities yet produced in Canada, partly because its primary focus is on intergroup relations. The survey's large sample permits analysis of specific minority groups and of the emerging Canadian-born generation of minorities.

The analyses we present in this chapter distinguish recent immigrants, immigrants with longer experience in Canada and the children of immigrants — the so-called second generation. Most racial minorities in Canada are immigrants, but a born-in-Canada generation is emerging: by 2001, it constituted 29.4 percent of the racial minority population. As the children of relatively recent immigrants, most of these Canadian-born members of racial minorities are young: 63.3 percent are under 16; only 16.2 percent are over 25. Still, because they constitute an emerging young adult population with a perspective that differs from that of immigrants, this second generation is critical to an assessment of the long-term impact of immigration (Boyd 2000; Reitz and Somerville 2004). On the one hand, as Canadian-born, they will not confront many of the obstacles their parents faced as arriving immigrants. On the other hand, their expectation of social acceptance, economic opportunity and equal participation may be greater than that of their parents.

An analysis of the existing literature and EDS findings indicates that racial minority immigrants integrate into Canadian society relatively slowly, and that discriminatory inequalities are at least part of the reason.[3] This prompts a consideration of existing Canadian policies on racial inequality and their adequacy to address this challenge to the cohesiveness of Canadian society.

Racial Inequalities and Discrimination

I N THE FOLLOWING SECTION, WE DESCRIBE THE OVERALL ECONOMIC SITUATION OF racial minorities in Canada, including employment earnings and the trend toward lower earnings for recent immigrants. We go on to review evidence of perceptions of inequality and discrimination in different segments of the population.

Overall Economic Situation and Employment of Racial Minorities
Generally speaking, visible minorities have much lower relative household incomes and higher poverty rates than do ethnic groups of European origin

(Kazemipur and Halli 2001, 2000, 107-9; Ornstein 2000; Reitz and Banerjee 2005). Data from the EDS (table 1, column 1) show mean individual-equivalent household incomes for ethnic groups,[4] relative to the mean for the census metropolitan area of residence. For visible minorities, the incomes are $7,686 less than the local average, while for Whites, they are $1,895 above the local average; thus, the gap is $9,581. In relation to the national mean individual-equivalent household income of $41,330, this gap is 23.2 percent. Relative household incomes of virtually all racial minority groups — including Chinese, South Asians and Blacks, as the largest groups — are substantially lower than those of almost all White groups (for further details, see Reitz and Banerjee 2005).[5] In 2001, the poverty rate for racial minorities was nearly double that for the rest of the population (table 1, column 2, from census data):[6] 26.6 percent compared with 14.2 percent; some racial minorities had higher rates than others.[7] White immigrant groups experience inequality as well, but not nearly to the same extent.

The main economic problem for new racial minority immigrants is, of course, finding adequate employment (Li 2000). There are a number of reasons they experience difficulties in doing so. Some of these difficulties — but by no means all — are associated with the period of adjustment or "entry effect" that all immigrants must confront. Entry problems may be particularly severe for immigrants arriving during a recession, as was the case for many in the early 1990s. Experience shows that all immigrants do better as they settle in and become more accustomed to their new environment. Furthermore, adverse experiences linked to economic recession may be offset by a later rebound in the economy, as the immigrants who arrived in the early 1980s discovered (Bloom, Grenier, and Gunderson 1995; Grant 1999). In short, economic disadvantage and high rates of poverty may attenuate over time, and the entry effect will disappear.

There are a number of other reasons for immigrants' employment difficulties.[8] Perhaps the most important are urban settlement, the discounting of qualifications, and race. With respect to the first reason, in seeking employment, immigrants find that any educational advantage they might have due to Canada's skill-selective immigration policy is offset by the fact that most settle in major urban areas where jobs are plentiful but competition is intense from new native-born labour market entrants, who tend to be young and also highly educated (Reitz 2004b). In terms of the second reason, immigrants' skills tend to be discounted in the labour market, while those of the native-born are not (Reitz

Objective and Perceived Ethnoracial Inequality in Canada, by Ancestry

	IE income (mean $)[1]	Poverty rate (%)[2]	Perceived discrimination (%)	Perceived vulnerability (%)	N
Nonvisible minorities (by ancestry)[3]					
Canadian	1,258.7	16.4	10.7	14.3	10,293
French	750.5	16.6	9.1	19.2	592
British	3,386.1	11.8	10.7	15.0	1,744
Northern and Western European	2,238.2	12.5	10.0	11.2	4,356
Russian and Eastern European	405.7	16.2	12.5	16.5	299
Other Southern European	-2,778.6	14.3†	14.7	16.8	2,098
Jewish	11,637.7	13.3†	20.0	38.7	276
Arab and West Asian	-6,058.4	29.2	18.9	21.2	125
Latin American	-7,416.6	25.1	24.2	23.8	5,893
Greek	-617.4	16.3†	13.6	15.6	291
Italian	1,278.0	12.2†	11.5	19.2	207
Portuguese	-5,832.7	12.8†	8.9	15.9	568
Other European	9,453.1	12.5	16.2	16.0	4,109
Total nonvisible minorities	1,895.3	14.2	10.6	16.0	30,851
Visible minorities (all ancestries)					
Chinese	-6,730.2	26.9	33.2	33.6	513
South Asian	-5,815.8	21.7	33.1	38.7	1,424
Black	-10,607.2	31.1	49.6	43.0	2,421
Filipino	-5,063.5	16.4†	35.8	48.8	653
Latin American	-10,270.3	29.3	28.6	30.0	362
Southeast Asian	-6,829.3	25.6	34.5	37.7	148
Arab and West Asian	-13,359.4	40.8	29.8	27.0	386
Korean	-17,145.0	40.8†	40.5	49.0	209
Japanese	4,079.5	n/a	42.8	34.2	1,892
Other visible minorities	-7,114.5	23.7	33.3	36.8	331
Multiple visible minorities	-4,304.2	n/a	41.5	28.7	283
Total visible minorities	-7,686.4	26.6	35.9	37.3	8,622
Total					39,473

Source: Ethnic Diversity Survey 2002 (Ottawa: Statistics Canada, 2003).
[1] Individual-equivalent household income, relative to the census metro-politan area (CMA) mean. The individual-equivalent income adjusts household incomes for household size, and is calculated by dividing household income by the square root of household size.
[2] Data on poverty rates are from the 2001 Census Public Use Microdata File, 2.7 percent sample, for people aged 15 and over, and are based on Statistics Canada's low-income cutoff. In those data, visible minorities are identified only as Black, South Asian, Chinese, and other visible minorities. In this table, "other visible minorities" are further identified as Filipino, Latin American, Southeast Asian, Arab and West Asian, and Korean, based on ancestry.
[3] The origins of the groups in the "nonvisible minorities" category include Arab, West Asian and Latin American, and these also appear in the "visible minorities" group. Those who are considered in the "nonvisible minorities" category described themselves as White in the visible minority question. Those who did not identify any ancestry or visible minority group or did not report household income or perceived inequality were excluded.
† Data exclude Maritime provinces.

2001a; Li 2001); as for the third reason, racial minority immigrants face more obstacles than immigrants of European origin or native-born workers (Pendakur and Pendakur 1998, 2002). Other possible reasons for employment difficulties include isolation in minority occupational enclaves and the fact that minority group social networks lack the linkages necessary to find good jobs.

The obstacles to immigrant success appear to have increased, and the greatest impact has been felt by those arriving most recently, even though the late 1990s and early 2000s were a period of strong labour demand. In fact, underlying the ups and downs of several business cycles, there has been a downward trend in the employment rates and earnings of successive cohorts of newly arrived immigrants, both male and female (Frenette and Morissette 2003; see also Baker and Benjamin 1994; Reitz 2001b).[9] Whereas immigrant men arriving in the five-year period before the 1981 Census earned 79.6 percent of the earnings of native-born men, by 1996 this figure had dropped to 60 percent. For women, it dropped from 73.1 percent to 62.4 percent. By 2001, as a result of the improved labour demand of the late 1990s, relative earnings for the most recently arrived immigrants were higher than they had been in the mid-1990s, but they remained about 15 percentage points below 1970 levels (Frenette and Morissette 2003, 7). Notably, despite earnings mobility experienced by immigrants as their time in Canada increases, the general trend toward declining earnings also affects immigrants who have been in Canada longer.

New immigrants have seen reduced employment success even though immigrant education levels are at an all-time high (Frenette and Morrisette 2003; see also Statistics Canada 2003; Citizenship and Immigration Canada 1998). Marc Frenette and René Morissette show that the proportion of immigrant men arriving in the late 1990s who possessed at least the equivalent of a bachelor's degree was over 40 percent, more than twice the figure of 18.6 for native-born Canadian men; the corresponding figures for women were 37.5 percent and 21.7 percent (2003, 4). Yet, as we have mentioned, this has not translated into employment success. Overall, these downward trends in employment have resulted in higher poverty rates and reduced standards of living (Picot and Hou 2003).[10]

Only some of the reasons for these trends are well understood.[11] The shift toward immigrants originating from outside Europe, with the resulting change in the racial composition of immigration, explains some of the reduced employment success, particularly during the 1970s and 1980s. Abdurrahman Aydemir and

Mikal Skuterud show that when we consider immigrant trends throughout the period following the policy changes of the 1960s focusing on earnings in relation to levels of education, we see that the decline in earnings to 2000 is as much as 50 percent for both men and women (2005, 648-9). As much as one-third of this decline stems from origin shifts and the disadvantages associated with racial minority status.[12]

Broader labour market changes affect immigrants, as well — particularly racial minorities. David Green and Christopher Worswick have shown that, to some extent, the downward trend in immigrant employment parallels the trend among the native-born entering the workforce for the first time, in the sense that both groups fared worse in the 1990s than in earlier decades (2004). While the causes of the trend may or may not be the same for immigrants and the native-born, the consequences are greater for immigrants, since a larger proportion are pushed into poverty, and racial minorities are disproportionately affected.

Increased difficulties for immigrants may also be related to the move toward a knowledge economy, the transformation of the occupational structure and an overall increase in earnings inequality. One aspect of this is the rise in native-born education levels, which, since the 1970s, has been generally faster than the rise in immigrant education levels. Reitz shows that the discounting of the foreign-acquired education of immigrants in the labour market compounds their difficulties in keeping pace (2001b). Furthermore, the increased earnings disadvantages of immigrants are related to their reduced access to professional-level employment (Reitz 2003b), and to their growing difficulty in obtaining well-paying jobs outside professional fields, where educational qualifications are becoming more important. Finally, there is a noticeable decline in the value of foreign experience in the labour market, though the origins of this decline are not yet known (Green and Worswick 2004; Aydemir and Skuterud 2005; Reitz 2006).

In addition, the economic situation of immigrants may be affected by broader institutional changes in Canadian society (Reitz 1998). Specifically, social services have been reduced, affecting immigrants who are in the early stages of settlement, and costs for public services are rising, including costs for retraining and educational upgrading.

Clearly, the racial dimension of economic inequality in Canada today is significant, and its social implications require scrutiny. In any society, a noticeable association of racial status and economic success over extended periods raises

questions about social and political integration. A critical aspect of this, which we will now consider, is the significance of discriminatory treatment.

Perceptions of Racial Prejudice and Discrimination: A Racial Divide?

The fact that immigrants experience inequality and disadvantage may not in itself be divisive if it is regarded as the result of understandable circumstances — such as newcomer status, lack of sufficient language skills or training that does not match Canadian job requirements. Simply stated, inequality may not become a social problem if it is perceived as legitimate. However, racism, prejudice and discrimination are another matter. Not surprisingly, discriminatory treatment is more likely to be perceived as unjust and to lead to serious intergroup antagonism, as Gunnar Myrdal has noted. In his classic — and prescient — examination of US racial inequality, Myrdal points out the significance of the contradiction between the ideal of equal opportunity and the reality of inequality reinforced by discrimination (1944).

But how significant is racial discrimination in Canada? To what extent does it affect access to employment, education or housing? Let us begin by considering the way this problem is perceived in Canadian society. Within certain minority groups, perceptions of racial discrimination are fairly widespread. In the 2002 *Ethnic Diversity Survey*, which includes reports of personal experiences of racial and ethnic discrimination, respondents were asked, "In the past 5 years [or, for more recent immigrants, since arriving in Canada], do you feel that you have experienced discrimination or been treated unfairly by others in Canada because of your ethnicity, race, skin colour, language, accent, or religion?" To capture perceptions of vulnerability to discrimination, two other questions were asked. The first concerned the respondent feeling "uncomfortable or out of place in Canada" because of race or cultural background;[13] the second concerned the respondent worrying about becoming a victim of a hate crime.[14] Respondents who felt uncomfortable or out of place at least some of the time, or who were at least somewhat worried about being a victim of a hate crime, are considered to have felt vulnerable to discrimination based on race or cultural background.

As table 1 shows, of the members of visible minorities who responded to this survey, 35.9 percent reported experiences of discrimination, compared with 10.6 percent of Whites (see p. 5). The highest rate is for Blacks, at 49.6 percent, but there are substantial rates also for the other visible minority groups, including

Chinese, at 33.2 percent, and South Asians, at 33.1 percent. Among most White groups, experiences of discrimination are reported by fewer than 15 percent.[15] Experiences of perceived vulnerability are reported by 37.3 percent of visible minority groups and 16 percent of White groups. These are personal experiences, and the EDS does not report perceptions of discrimination against the group as a whole. However, earlier surveys indicate that individuals are even more likely to perceive discrimination against their group as a whole than against themselves personally: over one-third of Chinese respondents felt that way, as did a clear majority of Black ones.[16]

Despite improvement in the economic circumstances of immigrants as they adjust to Canadian society and labour markets and the generally more positive employment experiences of the second generation, a racial gap in perception of discrimination is notable among immigrants with longer experience in Canada. This gap is even greater among the children of immigrants. Data from the EDS, reported in table 2, show that among recent immigrants (those arriving during the previous 10 years), 33.6 percent of racial minorities report having experienced discrimination, compared with 19.2 percent of those of European origin. Among immigrants arriving earlier, perceptions of discrimination are less common for those of European origin; at a rate of 10.2 percent, it is about the same as it is for the children of European immigrants and for the broader Canadian population of third generation and greater. But among racial minority immigrants who arrived earlier, perceptions of discrimination are, if anything, more common, at 35.5 percent; and among the children of racial minority immigrants, the percentage experiencing discrimination is still greater, at 42.2 percent. The racial gap in perceptions of discrimination, which is 14.4 percent for recent immigrants, is 25.3 percent for earlier immigrants, and 31.3 percent for the children of immigrants. In other words, greater experience in Canada seems to lead to a larger racial gap in the perception of discrimination. This widening racial gap is observed among Chinese, South Asians, Blacks and other visible minority groups. In these groups, the percentage of those born in Canada who report experiences of discrimination varies between 34.5 percent for Chinese, 43.4 percent for South Asians and 60.9 percent for Blacks, compared with 10.9 percent for the children of immigrants of European origin.

Members of minority groups also express serious concerns about the non-recognition of immigrant qualifications. In some cases, the educational qualifications

Objective and Perceived
Inequality by Origin,
Immigration Cohort and
Generation, 2002

	Immigrants		Second generation[3]	Third generation and higher[4]
	Recent[1]	Earlier[2]		
IE income (mean $)[5]				
White	-8,467.5	2,190.6	3,497.2	3,656.7
All visible minorities	-14,630.7	-1,535.2	-1.6	
Chinese	-16,500.8	1,523.3	4,670.0	
South Asian	-13,103.3	1,938.1	417.9	
Black	-15,872.1	-6,840.0	-3,782.8	
Other visible minorities	-13,726.9	-3,779.5	-1,680.3	
Perceived discrimination (%)				
White	19.2	10.2	10.9	9.9
Visible minorities	33.6	35.5	42.2	
Chinese	35.4	30.9	34.5	
South Asian	28.2	34.1	43.4	
Black	44.8	47.7	60.9	
Other visible minorities	32.5	34.8	36.2	
Perceived vulnerability (%)				
White	26.2	17.0	14.8	16.1
Visible minorities	41.8	37.8	27.0	
Chinese	40.8	32.3	20.2	
South Asian	40.7	39.9	28.4	
Black	49.8	44.5	37.2	
Other visible minorities	41.0	37.6	25.2	

Source: *Ethnic Diversity Survey 2002* (Ottawa: Statistics Canada, 2003).
[1] Immigrated between 1992 and 2002. *N*'s (depending on the outcome measure): Whites 740-770; Chinese 603-622; South Asians 455-479; Blacks 174-181; other visible minorities 563-585; all visible minorities 1,795-1,867.
[2] Immigrated in 1991 and before. *N*'s (depending on the outcome measure): Whites 4,992-5,186; Chinese 758-769; South Asians 643-675; Blacks 401-425; other visible minorities 999-1,032; all visible minorities 2,801-2,928.
[3] *N*'s (depending on the outcome measure): Whites 11,949-12,069; Chinese 889-897; South Asian 713-723; Black 677-691; other visible minorities 1,062-1,073; all visible minorities 3,341-3,384.
[4] *N*'s for Whites of third generation and higher (depending on the outcome measure): 14,247-14,375. Third-generation visible minorities are excluded.
[5] Mean individual-equivalent household income, relative to the census metropolitan area (CMA) mean: The individual-equivalent income adjusts household incomes for household size, and is calculated by dividing household income by the square root of household size.

of immigrants may be equivalent to those of native-born Canadians yet not recognized by employers. Complaints about barriers to licensed trades and professions have been voiced for many years, and the first wave of the *Longitudinal Survey of Immigrants to Canada*, based on interviews with approximately 12,000 immigrants arriving between October 2000 and September 2001 and released in 2003 (Statistics Canada 2005a), shows that the lack of recognition of foreign credentials or experience is one of the most commonly reported employment problems — along with lack of Canadian job experience and official language knowledge. The earnings lost due to this long-standing problem are potentially quite large, amounting to about $2 billion annually (Reitz 2001a; Watt and Bloom 2001).[17] These estimates may capture one significant result of racial discrimination.

The broader Canadian population remains skeptical of the significance of racial discrimination affecting minorities, and there is a prevailing view that racism is marginal in Canada (Reitz and Breton 1994). Even so, many members of the majority population recognize that discrimination exists. A CRIC-*Globe and Mail* survey entitled *The New Canada* shows that about three in four Canadians — both White and visible minority — agree that "there is a lot of racism in Canada" (Centre for Research and Information on Canada [CRIC]-*Globe and Mail* 2003; see also Breton 1990, 210-1). However, there are differences with respect to how significantly prejudice affects opportunities in key arenas such as employment. The survey shows that 42 percent of visible minorities think that prejudice affects opportunities, compared with 30 percent of Whites.[18] Moreover, the actual racial divergence in perceptions of the significance of discrimination is greater than is reflected in this difference in percentages, because some Whites say it is Whites who lose opportunities because of discrimination (17 percent) — sometimes called "reverse discrimination" — whereas this perception is less common among visible minorities (7 percent).

The view that racial discrimination is not a significant problem in Canada undoubtedly contributes to a belief that existing government policies on the subject are adequate, so that further action is not needed. Official policies on multiculturalism and human rights are seen as sufficient to maintain what most Canadians would describe as a favourable environment for immigrants and minority groups, particularly by international standards. Only a minority of the White population think that prejudice is something that the Canadian government should address with more determination.[19]

Evidence of Discrimination Against Racial Minority Immigrants

These are the perceptions, but what are the facts? In some ways, the research community is as divided as the general population. While the available research confirms that racial discrimination does exist, it allows for divergent interpretations of its significance.

Four types of evidence are cited in discussions of the extent of discrimination: prejudiced attitudes; evidence of discrimination in human rights cases; field tests of discrimination; and discrimination as revealed by statistical analysis of earnings gaps in labour market surveys. While each is useful, each is also problematic. Prejudiced attitudes could lead to discrimination, but not necessarily. Human rights case evidence may be persuasive, and the circumstances of a particular case may be suggestive of broader patterns, but it remains case-specific. Field trials show patterns of discrimination but not its consequences in the aggregate for minority inequality. Finally, statistical analyses of labour force data are open to diverse interpretations. However, when considered together, the four types of evidence suggest that the possibility of significant discrimination should be taken seriously. We deal with each in turn.

1) Attitude research reveals prejudice in Canada and a corresponding potential for discrimination. Not all attitudes toward minorities are negative, of course. Attitudes toward immigration in general tend to be more favourable in Canada than in societies receiving fewer immigrants (Simon and Lynch 1999). Gallup polls conducted almost every year between 1975 and 2001 have shown majority support for either maintaining or increasing Canada's emphasis on immigration (the exception being 1982, a recession year [Reitz 2004a, 111]). Yet research also makes it clear that racial boundaries are a reality of Canadian social life. For example, while most Canadians deny harbouring racist views, they maintain a "social distance" from minorities — that is, they say they prefer not to interact with members of other racial groups in certain social situations (Reitz and Breton 1994). Although an Environics Focus Canada poll showed that a large majority (93 percent in 2000) reject the proposal that "non-whites should not be allowed to immigrate to Canada" (Esses, Dovidio, and Hodson 2002, 72), there is much evidence that Canadians are more comfortable with groups of European origin than with non-European groups, and these preferences carry

implications for group status (Angus Reid Group 1991; Berry and Kalin 1995; Esses and Gardner 1996).

Racism and racial bias help determine attitudes toward immigration (Henry et al. 1998; Satzewich 1998), and concerns about the threat to jobs are related to racial attitudes (Palmer 1991, 1996; Esses et al. 2001; Kalin and Berry 1994; Berry and Kalin 1995). Some research suggests that Canadians see immigrants as posing an economic threat, and this view fuels a prejudicial backlash (Esses et al. 2001). If the political acceptability of immigration derives from the economic success of immigrants, then a dip in that success rate could politically undermine the program of immigration. There is little evidence as yet that this is occurring in Canada, demonstrating that the economic problems of the newly arrived do not quickly affect the overall tone of intergroup relations.

The potential impact of racial attitudes on discrimination is complex, however. Although prejudicial attitudes do not necessarily lead to discriminatory behaviour, they may be associated with such behaviour. For example, psychological research by Victoria Esses, Joerg Dietz and Arjun Bhardwaj shows that assessments of foreign qualifications tend to be lower among persons who show other evidence of racial bias or prejudice (2006). Discrimination may be displayed by persons who are not overtly prejudiced because of social pressure. For example, systemic discrimination arises when established practices in an organization exclude minorities. A complex phenomenon, systemic discrimination is only beginning to be understood, and its significance is being debated. A 1997 Canadian Human Rights Tribunal decision that found systemic racial discrimination in the federal public service illustrates the complex nature of evidence required for legal proof (Beck, Reitz, and Weiner 2002).

2) The Human Rights Tribunal decision just cited serves as an example of the kind of evidence we can draw from human rights complaints, but, while compelling, it is only one case. It involved allegations that there was a glass ceiling for minorities in a particular federal department — that is, that systemic discrimination was practised by those responsible for promoting staff to senior managerial positions. There was evidence of statistical underrepresentation of minorities at the senior management

level; evidence derived from a survey on human resource practices of discrimination in the promotion process; and testimony about the attitudes of officials responsible for promotion decisions. The case is remarkable, partly because the respondent was a mainstream employer — the Government of Canada — generally considered an opponent of racial bias and discrimination.

3) Field tests have been conducted to find out if there is a variance in employer responses to people from different racial groups applying for the same jobs and presenting the same qualifications, and the results have offered persuasive evidence of discrimination. In Canada, the most cited study is still an early one conducted by Frances Henry and Effie Ginsberg (1985); their field tests reflected Whites receiving three times as many job offers as Blacks. The Economic Council of Canada repeated the field trials and produced different results: some interpret this as indicating a reduction in the significance of discrimination; others disagree (Reitz 1993; Reitz and Breton 1994, 84). It is unfortunate that such information is not kept current and readily available. Arguably, such studies should be repeated regularly and on a larger scale, in the manner of the program organized by the International Labour Office in Geneva (Zegers de Beijl 2000). Yet even this program does not address the question of the extent to which discrimination accounts for the overall economic inequalities experienced by racial minorities.

4) A large number of statistical studies show that within the labour force as a whole — relative to measured job qualifications, such as education or work experience, and with differences in knowledge of official languages taken into account — visible minority immigrants have lower earnings than their European counterparts or native-born Canadian workers of European origin. Some studies are Canada-wide (Li 1992; Boyd 1992; Christofides and Swidinsky 1994; Baker and Benjamin 1994); others are specific to immigrant-intensive settings, such as Toronto (Reitz 1990; Reitz and Sklar 1997). In either case, the amount of earnings disadvantage varies among minority groups and between genders. For immigrant men, it varies between 10 and 25 percent. Inequalities are greater for Blacks than for some Asian groups. Earnings disadvantages exist for immigrant women, although the amounts are

less, as the comparison group is native-born Canadian women, themselves a disadvantaged group compared with men.[20]

Such analyses are useful in identifying potential discriminatory earnings gaps, but the earnings disadvantages of minorities are open to interpretation not just in terms of discrimination but also in terms of deficiencies in qualifications that cannot be measured in the survey data. Foreign-acquired educational qualifications might be of lower quality, foreign experience might not be relevant in Canada or language skills might be deficient in subtle but significant ways.

Education and Employment for the Children of Immigrants

The education and employment experiences of Canadian-born children of immigrants (or of immigrants who arrive so young that their formative experiences occur in Canada) are regarded as critical to the long-term integration of racial minorities. In fact, their experiences may be a better test of the prevalence of racial discrimination. Earnings disadvantages for immigrants, even when controls for years of formal education or experience are applied, may be attributed to differences in the quality or Canadian relevance of foreign-acquired education or experience, or to language difficulties that are difficult to measure. Hence, several studies of discrimination have focused on experiences of racial minorities born in Canada, as their labour market experiences would not be affected by such characteristics.

Overall, the education levels of the racial minority second generation in Canada are fairly high — even relative to parental education levels — despite complaints of cultural and racial bias in Canadian schools, including universities. Since the federal government introduced multiculturalism as a policy framework, provincial authorities responsible for education have addressed this issue with multicultural, and then antiracist, policies (Davies and Guppy 1998; Dei 2000). While education researchers still point to racial biases among teachers and in the curriculum (Henry et al. 1998; James 1998), Scott Davies and Neil Guppy show, using the 1991 Census, that among persons 20 years of age and older, both immigrant and native-born visible minorities have significantly higher rates of high school graduation than the majority population (1998, 136).[21]

It is important, however, to distinguish descriptive findings on educational attainment from findings that bear on equality of opportunity in the school system. The emerging second generation are children of relatively well-educated

immigrants, many of whom arrived with the earlier minority immigrant cohorts of the 1970s and, despite difficulties, earned relatively high incomes. The education levels attained by their children do not necessarily reflect equality of opportunity, and barriers hidden in the analyses may subsequently come to light.[22]

Possible variations in educational attainment by origin group may be important. For example, Davies and Guppy suggest that Black men have lower educational attainments (1998, 134-40). Alan Simmons and Dwaine Plaza conducted an age-specific analysis in Toronto of the university attendance of young adult immigrants and the native-born, distinguishing Blacks, South Asians and others. Whereas rates for the mainstream population are about 40 percent for women and 36 percent for men, for Blacks born in Canada, the figures are 40 and 27; for South Asians, they are 72 and 67. Simmons and Plaza conclude that young Black men in Canada show a modest disadvantage (1998).

Regarding the critical question of employment discrimination, analysis of the employment experiences of the children of immigrants has been hampered by statistical problems. One such problem stems from the small size of the second-generation population (de Silva 1992; Wanner 1998). Derek Hum and Wayne Simpson suggest that among native-born racial minorities, only Black men suffer employment discrimination (1999). By contrast, Krishna Pendakur and Ravi Pendakur have found that the racial disadvantage for native-born racial minorities is significant, albeit less so than for racial minority immigrants (1998, 2002; see also Li 2000; Reitz 2001a).

Another problem is the complexity of statistical models. Two studies illustrate these complexities by producing different results from the same data using different models. In one, Pendakur and Pendakur use long-form records for the 1971, 1981, 1986, 1991 and 1996 Censuses in a statistically robust analysis of the labour market position of native-born racial minorities (2002). To capture the impact of discriminatory access to employment sectors, as well as discriminatory access to the best jobs within sectors, their analytic model includes age, schooling, marital status, household size, official language and urban area, but not occupation, industry or hours. Earnings disadvantages for visible minorities are larger for men than for women, and among men, earnings disadvantages apply to Blacks, South Asians and, in most years, Chinese. The net earnings disadvantages of native-born visible minorities grew for both men and women from 1971 to 1996, leading Pendakur and Pendakur to conclude that "inequity is seen to be on

the rise" (2002, 510). Robert Swidinsky and Michael Swidinsky use the same 1996 data but a smaller public-use sample, a different model in which the criterion is weekly wages, and a different group of control variables, not including occupation. They find less discrimination and a different pattern of group differences (Swidinsky and Swidinsky 2002). While the differences between the two studies illustrate the complexities of analysis, it is useful to note that in both, Black males experience the greatest earnings disadvantages, and this is the group that most often reports discrimination in interview surveys.

Summary

Among the various ethnic groups in Canada, racial minorities have the lowest incomes and highest rates of poverty, and many members of these groups believe they have experienced discrimination based on their minority racial origins. Although the economic situation is somewhat better for those who have been in Canada longer and for the Canadian-born generation, the perception that they have been affected by discrimination is more widespread among the latter two groups. In fact, there is a racial divide over perceptions of discrimination. In this context, the research on the extent of discrimination — although it does not conclusively point to discrimination as a significant cause of racial inequality — does not conclusively resolve the question.

Social Cohesion and the Social Integration of Racial Minorities

A NALYSIS OF THE SOCIAL CONSEQUENCES OF RACIAL INEQUALITY AND PERCEPTIONS OF discrimination may have many different aspects. Ultimately, our concern in this chapter is with the cohesion of society and the impact of minorities on that cohesion. Here, "cohesion" refers to the capacity of society to set and implement collective goals.[23] Lack of cohesion may be reflected in conflict, sometimes violent conflict. Instances of civil disorder involving immigrants or minorities in other countries — most recently, France and the United Kingdom — have reinforced these concerns. We should remember, however, that conflict does not necessarily detract from cohesion: it may actually help resolve problems of intergroup relations and, hence, be an

essential part of social life in a cohesive society. Finally, lack of social cohesion is man-ifested in other less dramatic but equally important ways, including lack of partici-pation in decision-making, withdrawal of support for decisions and lack of organizational capacity to participate in constructive social activities.

The following discussion focuses on the integration of racial minorities as an important aspect of the Canadian social fabric. It also considers the impact of inequality and discrimination on minority social integration. Here, "social inte-gration" refers to the extent to which individual members of a group form rela-tionships with people outside the group — relationships that help them to achieve individual economic, social or cultural goals. Social integration, in this sense, is relevant to the broader question of social cohesion: groups whose mem-bers look to the broader society as a means to private ends are more likely to become engaged in common objectives; similarly, groups that are well integrated into society become resources for the constructive resolution of conflicts.

The integration of minority groups into society is a matter of individual attitudes and behaviour, and of social organization and resources. In the *Ethnic Diversity Survey*, which provides data on individuals, the analysis focuses on those attitudes and behaviours that are expected to reflect integration into soci-ety. Three of these seem especially relevant here: strength of individual ties to the group, overall satisfaction with life (presumably a reflection of a sense of having achieved personal goals) and extent of civic participation.

Several EDS survey questions tap into these aspects.[24] Regarding individ-ual ties to Canadian society, there are measures of sense of belonging to Canada, trust in others, self-identification as Canadian and acquisition of Canadian citi-zenship. The first two measures are broad indicators of the strength of interper-sonal relations, whereas self-identification as Canadian is a more specific indication of belonging in the national society;[25] and acquisition of citizenship, though it may reflect a number of motives, is a concrete expression of belonging in Canadian society.

Regarding the second aspect — overall life satisfaction — there is a single question. The third aspect — civic participation — is reflected in the following two items: participation in voluntary organizations and voting in federal elec-tions. The survey question on participation in voluntary organizations probes deeper than simple membership, asking whether the respondent contributes on a voluntary basis to the activities of the organization. The question on voting asks

about federal elections.[26] Voting is a meaningful indicator of participation in the Canadian community, but as citizenship is a prerequisite to voting, and acquisition of citizenship reflects various circumstances, it is important to restrict analyses of voting to an examination of those who are Canadian citizens and were eligible to vote in the last federal election prior to the survey date.[27]

Table 3 compares the results for all seven indicators for Whites and visible minorities. On six of the seven indicators, visible minorities appear less integrated. The greatest gap between visible minorities and Whites is in self-identification as Canadian (30.7 percentage points). There are also significant gaps in citizenship (18.3 percentage points) and in voting (11.1 percentage points). The gap in citizenship undoubtedly reflects, at least in part, the significantly higher proportion of immigrants among visible minorities. There are smaller racial gaps in life satisfaction (5.5 percentage points) and volunteering (7.2 percentage points). On two indicators — sense of belonging and trust in others — there does not appear to be a significant overall racial difference. Visible minorities, in fact, express a somewhat stronger sense of belonging than Whites.

Some of these generalizations apply to most visible minorities; others do not. The most pervasive pattern affecting all visible minorities is the substantially lower level of Canadian identity and voting. All also have lower rates of citizenship. Regarding life satisfaction and trust, there are clear variations among groups. Lower life satisfaction affects Chinese in particular, while the other groups are closer to the White average. Less trust in others affects Blacks, while South Asians and other visible minorities are near the White average; Chinese are more than 10 percentage points above the White average. Some groups have lower levels of integration in most aspects, particularly Blacks and Chinese. Blacks have the highest rate of volunteer work, followed by South Asians and other visible minorities; Chinese are lower than Whites.

Recency of Immigration, Trends over Time and the Second Generation

Most visible minorities have a high proportion of recent arrivals in Canada. Hence, the question arises: How is the social integration of racial minorities related to the recent arrival of these groups in Canada? Moreover, to what extent, if at all, are racial minorities slower to integrate than immigrants of European origin? To respond, we begin by examining three groups by immigrant cohort and generation: recent immigrants, immigrants arriving 10 or more years before the survey

Table 3 508

Integration of Visible
Minorities into
Canadian Society,
2002 (percent)

	Belonging[1]	Trust[1]	Canadian identity[1]	Citizenship[1]	Life satisfaction[1]	Volunteering[1]	Voted in federal election[2]
Whites	54.8	49.9	64.3	97.30	47.2	33.8	81.9
All visible minorities	58.6	47.9	33.6	78.96	41.7	26.6	70.8
Specific minority origins							
Chinese	52.7	60.1	40.5	83.90	30.8	20.7	68.1
South Asian	64.9	49.0	30.5	73.30	48.4	29.1	76.1
Blacks	60.6	30.6	29.0	80.80	43.5	34.6	71.8
Other visible minorities	58.3	45.5	32.0	78.00	45.2	26.1	69.5

Source: *Ethnic Diversity Survey 2002* (Ottawa: Statistics Canada, 2003).

[1] *N*'s (depending on the outcome measure): Whites 31,341- 32,660; all visible minorities 8,149-8,622; Chinese 2,267-2,421; South Asians 1,755-1,892; Blacks 1,347- 1,424; other visible minorities 2,757-2,885.

[2] The analysis of voting is restricted to eligible voters, namely, citizens and those at least 20 years old. *N*'s: Whites 28,250; all visible minorities 5,581; Chinese 1,646; South Asians 1,159; Blacks 888; other visible minorities 1,888.

and the second generation, born in Canada. Next, we analyze these groups using statistical methods to adjust for specific years of residence in Canada and for age (this is particularly important for the second generation).

The results show two interesting trends. On the one hand, recent arrival helps explains some of the racial differences in social integration in Canada. On the other hand, in a number of instances, the racial gap is larger in the categories representing longer experience in Canada. It is smallest for the recent arrivals, but larger for immigrants in the country at least 10 years and for the second generation. In figures 1 through 5, data are presented graphically for visible minorities in total and for specific groups for five of the seven indicators where the racial gap is most pronounced. Detailed figures for all seven indicators are in appendix 1.

There is a large racial gap in self-identification as Canadian — about 30 percentage points. Figure 1 shows that for recently arrived immigrants, there is no racial gap; indeed, the Chinese group is more likely to identify as Canadian than are groups of European origin. For earlier immigrants, the extent of Canadian identification is higher for both Whites and racial minorities, presumably reflecting their higher sense of commitment to Canada, but the difference is greater for Whites than for racial minorities. For earlier immigrants of European origin, Canadian identification is higher than it is for newcomers by almost 32 percentage points, whereas for earlier immigrants who are racial minorities Canadian identification is higher than for newcomers by only 13 percentage points. Thus, a racial gap of 19 percentage points in the acquisition of self-identification as Canadian is evident for the earlier immigrants. Overall, racial minorities are slower to acquire a sense of identification as Canadian than are immigrants of European origin; this difference can be observed for all racial minority groups, including Chinese. Perhaps equally significantly, among the second generation, for Whites, the rate of Canadian identification is quite high — 78.2 percent — while for racial minorities, it lags by over 20 percentage points.[28]

We see a similar pattern with regard to citizenship and voting. In the case of citizenship, the lower rate for visible minorities is indeed strongly related to their recent arrival; and, in fact, among visible minorities, there is no difference in citizenship acquisition for recent immigrants, and a somewhat higher reported rate of citizenship acquisition for immigrants in the country 10 or more years. This is true particularly for Chinese, but it is also true for the other major racial minorities.

Figure 1 510

Canadian Identity

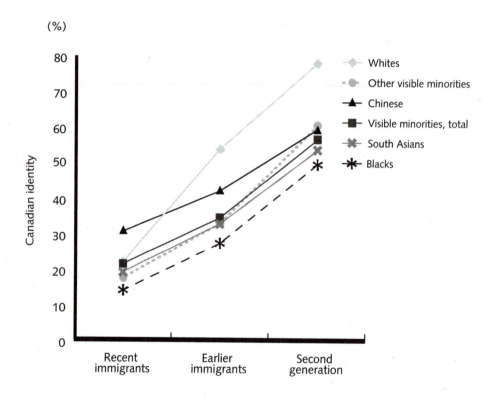

(%)

Source: Appendix 1.

The analysis of voting (figure 2) shows that the lower rate of voting for racial minorities is partly a result of more recent arrival. For the most recently arrived immigrants, there is no difference in voting between racial minorities and those of European origin. When we look at the voting rates for earlier visible minority immigrants, however, we find that they fall short of the rate for Whites, suggesting that these people are voting less than one might expect based on citizenship eligibility (which is higher for racial minorities than for Whites). But it is among the second generation that the most obvious racial differences arise. Among second-generation Whites, the rate of voting is 84 percent, compared with 69.9 percent for Chinese, 66.9 percent for South Asians, 63.3 percent for other visible minorities and 55.5 percent for Blacks. Among racial minorities, the rate of voting is 64.3 percent, and the racial gap in voting in the second generation is about 20 percentage points.

Regarding the sense of belonging to Canada (figure 3), which overall is higher for visible minority groups than for Whites, generational analysis shows that this higher rate is most pronounced for immigrants, particularly recent immigrants. Among the second generation, all visible minorities have less of a sense of belonging than Whites. This is most striking in the case of Blacks, but is quite pronounced for Chinese and other visible minorities, and it is significant even for South Asians.

Regarding life satisfaction (figure 4), the overall racial difference is not really a function of recent arrival, since recent visible minority immigrants are not less satisfied than Whites. Among recent immigrants, except for Chinese, racial minorities report higher levels of satisfaction than do those of European origin. High levels of satisfaction for recent immigrants may be expected based on comparisons they make between life in their homeland and the future they expect in Canada. However, this is different for immigrants who have been in the country longer and for the second generation. For the earlier immigrants, the racial difference is minimal (again, with low levels for Chinese), and for the second generation, levels of satisfaction are lower for all racial minorities than for Whites. In comparing the three categories, then, levels of satisfaction become less, relative to Whites, when one moves from recent immigrants to earlier immigrants to the second generation.

Regarding trust (figure 5), low levels for Blacks are evident in all groups, including the second generation; low levels are also evident for South Asians and other visible minorities. As appendix 1 shows, the high levels of volunteering for

Figure 2 512

Voting

(%)

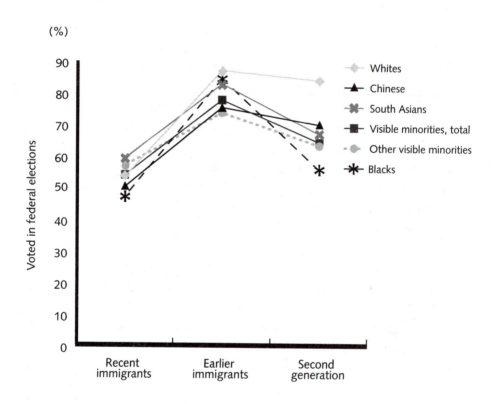

Source: Appendix 1.

Figure 3

Belonging

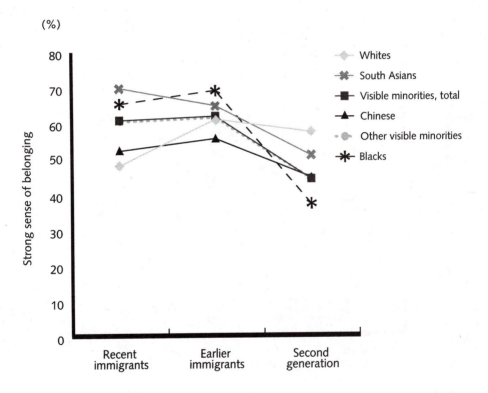

Source: Appendix 1.

Figure 4 514

Life Satisfaction

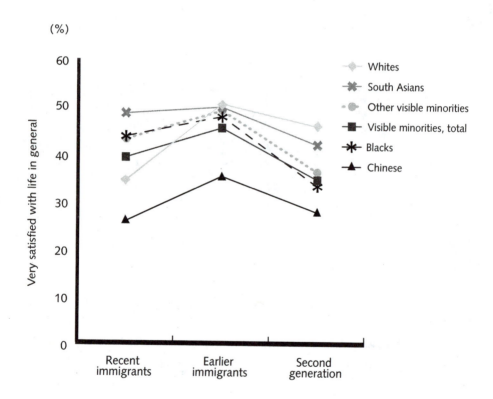

(%)

Source: Appendix 1.

Figure 5

Trust

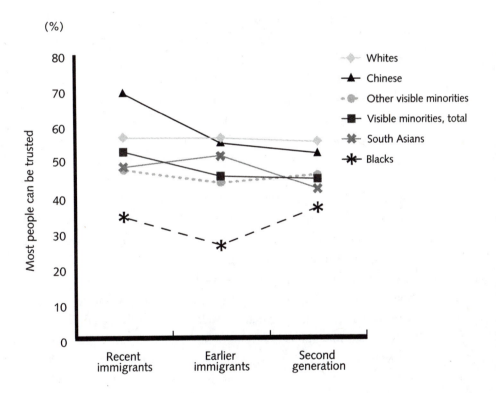

(%)

Source: Appendix 1.

Blacks relative to Whites are evident among the immigrants, but not the second generation. In the second generation, there are few group differences on this indicator.

Patterns of integration are time-sensitive, and the categories recent immigrants, earlier immigrants and second generation contain certain time-related variations. Among the earlier immigrants, the Whites arrived significantly earlier than the racial minorities; among the second generation, the Whites tend to be older than the racial minorities. Because of these patterns, we conducted a further analysis within each of the three categories, using regression procedures,[29] in which the impact of racial origins was examined controlling for recency of immigration (for the two immigrant groups) and for age. The results are presented graphically in figure 6 (for the dichotomous indicators, and presenting odds ratios based on logistic regression) and figure 7 (for indicators with more categories, and based on ordinary least squares [OLS] regression coefficients); detailed figures are in appendix 2 (which includes regression results for racial minorities overall, and separate regression results for specific minority groups included as dummy variables).

For four indicators — Canadian identity and voting (figure 6), and belonging and life satisfaction (figure 7) — the impact of visible minority status becomes more negative as one moves from recent immigrants to earlier immigrants and the second generation. It is interesting that racial minority immigrants have a stronger sense of belonging than White immigrants, but the trend is to a smaller gap favouring racial minorities (for the earlier immigrants compared with recent immigrants), and then to a gap favouring Whites (for the second generation). When it comes to voting, except for the most recent immigrants, rates among racial minorities are less than for Whites, contrary to what might be expected based on citizenship. This indicates that the lack of an overall racial difference in voting among earlier immigrants is a result of higher rates of citizenship (logistic regression coefficient of 1.3, translating into an odds ratio of 3.8), then lower rates of voting among those who are citizens. In the second generation, the effect of racial minority status on voting is even more substantially negative, after controlling for age. The regression results for individual groups show that the negative effect is particularly significant for Blacks and also for other visible minorities (appendix 2).

In the case of trust, the effect of visible minority status is negative for recent immigrants, and then more strongly negative for earlier immigrants. However, among the second generation, the effect of visible minority status on

Figure 6

Effect of Visible Minority Status on Indicators of Integration (odds ratio)

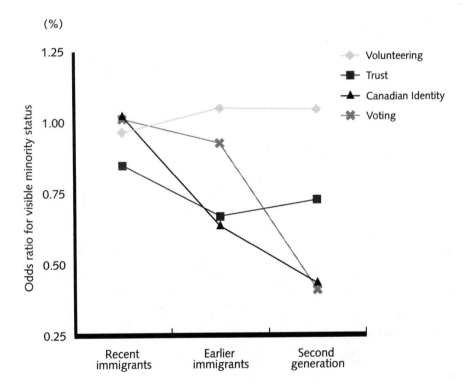

(%)

Odds ratio for visible minority status

1.25
1.00
0.75
0.50
0.25

Recent immigrants
Earlier immigrants
Second generation

- Volunteering
- Trust
- Canadian Identity
- Voting

Source: Appendix 2.
Note: Based on logistic regression analysis for effect of visible minority status with controls for age and, for immigrants, years since immigration. Results expressed as odds ratios; see note to appendix 2. Odds ratios greater than 1 indicate that effect of visible minority status is positive, while those less than 1 indicate that effect of visible minority status is negative.

Figure 7 518

Effects of Visible
Minority Status on
Indicators of
Integration[1]

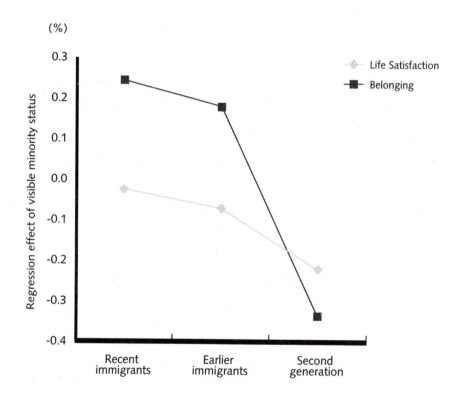

(%)

0.3

0.2

0.1

0.0

-0.1

-0.2

-0.3

-0.4

Regression effect of visible minority status

◆ Life Satisfaction
■ Belonging

Recent
immigrants

Earlier
immigrants

Second
generation

Source: Appendix 2.
[1] Standardized OLS regression coefficients for effect of visible
minority status with controls for age and, for immigrants, years
since immigration.

trust is less negative than it is among the earlier immigrants, though still more negative than it is for the most recent arrivals.

The pattern for volunteering is different; the effect of visible minority status is more positive for earlier immigrants and the second generation than it is for the recent immigrants. It also varies greatly by group. Chinese immigrants tend to volunteer less often than their White counterparts, while Black immigrants are more likely to volunteer. For recent South Asian immigrants and other visible minority immigrants, there is no significant difference in the likelihood of volunteering compared with Whites; earlier South Asian immigrants are somewhat more likely to volunteer. Among the second generation, there is little racial difference in the likelihood of volunteering. Second-generation South Asians are the only racial minority significantly more likely to volunteer than their White counterparts.

A finding of negative trends in social integration for racial minorities compared with White immigrant groups in Canada, most evident among those with greater experience in the country, may be important. Although social integration of minorities might be expected to reduce the significance of group differences among those with experience in Canada, the impact of racial boundaries actually seems larger. This suggests that certain experiences in Canada produce racial differences in integration and raises the question of what these experiences may be.

Impact of Inequality and Perceptions of Inequality

What is the impact of inequality and perceptions of inequality on these relatively slower rates of integration for visible minorities in Canada? To answer this question, we regressed three indicators of inequality — household income, perceptions of discrimination, and perceptions of vulnerability — on the seven indicators of integration for visible minorities separately by immigrant cohort and generation, and controlling for time-related variables. From the results (see appendix 3),[30] it is evident that low income in itself has relatively modest effects on slowing integration. The most statistically significant effects (in this direction) are for the earlier immigrants, particularly effects on the sense of trust. Experiences of discrimination are a more important influence on life satisfaction, trust and sense of belonging, while perceived vulnerability is a more important influence on life satisfaction, trust in others and Canadian identity. But these effects are limited and apply to immigrant groups rather than to the second generation, among whom lower rates of integration are most evident.

The modest size of the effects of low income on social integration for visible minorities suggests that low income itself is unlikely to explain differences in social integration between visible minorities and Whites. Since the effects of perceived discrimination and vulnerability are more often significant for the integration of visible minorities, they may play a larger role in accounting for their slower integration compared with Whites — but again, this is unlikely to be a complete explanation.

We explored these implications in further regression analyses, which show how the effects of visible minority status on various attachments are affected by controls for household income, and then for perceived discrimination and vulnerability (detailed regression results appear in appendix 4). Regarding Canadian identity and the sense of belonging, the three indicators of inequality explain only a small part of the racial difference in integration, and of these three, the most relevant are perceived discrimination and vulnerability. Consider the analysis of Canadian identity (third panel in appendix 4). For recent immigrants, there is no effect of visible minority status (after controls for time-related variables), and further controls for income level or perceptions of discrimination and vulnerability do not alter this relation. For earlier immigrants, the effect of visible minority status is -0.4542 (after controls for time-related variables). In the next two regressions, we address the question of how this is affected by low income or perceptions of discrimination or vulnerability. We see that the effect is about the same after taking account of the effect of low income (-0.4528), and only somewhat weaker after taking account of the effect of perceived discrimination and vulnerability (-0.3499). For the second generation, the negative effect of visible minority status on Canadian identity is stronger (-0.8382), but in this case, again, there is virtually no effect of control for incomes (the coefficient remains about the same, at -0.8478), and very little effect of control for perceptions of discrimination and vulnerability (the coefficient is only slightly weaker, at -0.7867).

For sense of belonging (the first panel in appendix 4), the effect of visible minority status is positive for immigrants, and controls have little impact on this. For the second generation, the effect of visible minority status on sense of belonging is negative (-0.3374), virtually unaffected by the control for low income (-0.3340), and made only slightly weaker by the control for perception of discrimination and vulnerability (-0.2690).

Inequality also explains little of the racial difference in trust in others and life satisfaction, and, again, income matters less than perceived discrimination or vulnerability (the second and fifth panels in appendix 4, respectively). Regarding trust in

others, the racial effects are not explained by income levels, but they are partly (or, in the case of recent immigrants, entirely) explained by perceived discrimination and vulnerability. Regarding life satisfaction, the significant racial difference is in the second generation, and this difference is not at all explained by income levels, but it is partly accounted for by perceived discrimination and vulnerability. In terms of the remaining indicators, the regressions offer explanations in only a few instances. High rates of citizenship for visible minority immigrants are not related to inequalities. The racial difference in voting is not at all related to income levels. In the second generation, the racial difference in voting is even greater after the control for income; it is only slightly reduced when perceived discrimination or vulnerability is taken into account.

The foregoing analysis was repeated with the effect of each of the four racial minority categories separately examined. We find that regarding Canadian identity and voting, inequalities do not explain the lower levels for any of the minority groups. The same is true regarding sense of belonging among the second generation. In the case of trust and life satisfaction, in the groups where there are lower levels, perceived discrimination again matters more than lower income, and there is a residual negative effect unexplained by any of the inequality-related variables.

Implications

These data from the *Ethnic Diversity Survey* permit us to make a systematic assessment of the integration of visible minorities, and it is the first such evidence detailing the situation of the second generation. We can summarize our findings under three points. First, Whites with greater experience in Canada are better integrated into society than are visible minorities. The negative trends with greater experience in Canada are most pronounced with regard to self-identification as Canadian and voting, but they are also found in sense of belonging, trust in others and life satisfaction. Yet visible minorities are more likely than Whites to become citizens, and there are no major differences in volunteering.

Second, although visible minority immigrants have lower earnings than Whites, at an individual level, low earnings in and of themselves contribute little or nothing to these trends in social integration. Rather, negative trends in integration reflect more pronounced experiences of discrimination and vulnerability, which become, or remain, pronounced for the second generation.

Third, many of the most important trends affect all visible minorities. Perhaps most significantly, in the second generation, all visible minority groups

are more negative on all indicators. Nevertheless, some groups consistently show more negative patterns than others. In the second generation, Blacks and South Asians are least likely to self-identify as Canadian; Blacks and other visible minorities are least likely to vote; Blacks, Chinese and other visible minorities are least likely to have a sense of belonging in Canada.

In sum, improvement in immigrants' earnings may contribute to successful integration, but higher earnings alone do not smooth the path to integration. The analysis here suggests that experiences of discrimination and vulnerability remain, slowing the social integration of minorities. Furthermore, these effects may be intensified for the children of immigrants, whose expectation of equality may be greater than was the case for their parents.

Among visible minorities, Blacks consistently experience the greatest inequality, and their integration into Canadian society is slower. However, the fact that none of the indicators of inequality fully explains the slower integration of visible minorities suggests that the awareness that one's group standing is problematic may affect how individuals feel about society, even those not focusing on specific disadvantages. This requires further analysis.

Policy Issues: Managing Diversity under Conditions of Inequality

THESE FINDINGS ON RACIAL INEQUALITY AND THE SOCIAL INTEGRATION OF MINORITIES carry implications for broader issues of multiculturalism and pluralism in Canada. If the racial gap in perceptions of equality and the slower integration of racial minorities are significant, then we may well ask whether existing policies are adequate to address the potential threat to social cohesion. The following discussion points to one feature of existing policy that may affect that potential threat — namely, policy goals and the processes of setting them.

Goals of Canadian Multiculturalism and Antiracism

Multiculturalism is the centrepiece of Canada's policy on interethnic relations, and its focus is on broad ideals rather than specific goals and objectives. Canada has been an innovator in multiculturalism policies, which have been embraced at

all levels of government since their initial proclamation, in 1971 (Quebec does not embrace the label "multiculturalism," even though its policies have similar goals). The initial formulation articulated very broad equity objectives (Canada, House of Commons 1971, 8545-6), but there were few specifics. Reactions to the policy of multiculturalism have been varied: some have supported it as the essence of modern conceptions of equality (Kymlicka 1995); others have criticized it as divisive (Bissoondath 1994; Schlesinger 1992). Despite the lack of consensus, since the Canadian policy has developed with the passage of explicit legislation and the multicultural character of the country is protected in the Constitution, the emphasis on broad ideals has held firm.

Racial barriers have been identified across a range of institutions in Canada, and many policy arenas touch on this issue of race relations. These include immigration and settlement policy; human rights policy; employment policy, including that which addresses discrimination and recognition of immigrant qualifications; policies for minority equality in public services; and policies for policing and the administration of justice in minority communities. But policies designed to address the special needs of visible minorities and to promote racial equality have been developed without an emphasis on specifics and with perhaps an even smaller consensus on objectives. When race relations was introduced under the rubric of multiculturalism in the 1980s, it was not recognized in principle as a separate concern.[31]

Governments have responded to race issues as they have arisen, but with little coordination or continuity. In the 1970s, instances of violence against racial minorities in Toronto resulted in a municipal task force report entitled *Now Is Not Too Late* (Task Force on Human Relations 1977). In the 1980s, the federal government responded to racial issues with a report called *Equality Now! Participation of Visible Minorities in Canadian Society* (Canada, House of Commons 1984). This prompted some policy development; the *Employment Equity Act, 1986* included provisions for visible minorities. More recently, *A Canada for All: Canada's Action Plan against Racism* has attempted to coordinate existing policies directed at racial equality rather than initiate new ones (Department of Canadian Heritage 2005). Like previous efforts, this one has very broad goals and offers few specifics.

Policy related to racial minorities is spread throughout agencies and levels of government. One example of lack of coordination is the policies that address the deteriorating employment situation of newly arrived immigrants (Reitz 2005).

A number of relevant policies are in place, but they have not been developed in a coordinated way. At the federal level, Citizenship and Immigration Canada is responsible for immigrant selection and settlement; Canadian Heritage, Human Resources and Social Development Canada and various other departments are responsible for related policies. Most policies involve activities for which responsibility is divided among various levels of government, and the responsible parties have taken approaches that are in some respects complementary and in others diverse — even contradictory. A recent example is the federal plan, announced by the Harper government, to create an agency to assess foreign-acquired credentials; it takes little account of existing provincial agencies. Instead, we need a comprehensive policy initiative that addresses such issues as immigrant employment, settlement programs, recognition of immigrant qualifications, bridge training and employment discrimination. And all of this should be considered in relation to the ongoing success of the immigration program. Coordination might be enhanced by the creation of a unit within the federal government (perhaps directed by a cabinet minister) responsible for immigration-related policies and with the authority to initiate discussions with provincial and municipal governments to promote greater consistency and effective policy-making.

Provincial governments have not considered race relations in a consistent manner. In Ontario, an Anti-racism Secretariat advisory group within the Ministry of Citizenship was abolished by the Harris government, which also abolished the provincial *Employment Equity Act* on the grounds that it gave undue preference to racial minorities. Similarly, a network of Toronto municipal committees on community and race relations functioned for many years but disappeared in the wake of municipal amalgamation and budget reductions mandated by the province in the late 1990s.

Illustrative of the lack of policy specificity (at all levels of government) regarding goals is the absence of provision for their formal evaluation. Evaluation requires explicit goals, and these are not in place. Multiculturalism policy itself has never been evaluated in the specific social sciences sense of the word, which implies direct observation of program impact. Jeffrey Reitz and Raymond Breton have shown that intergroup relations involving immigrants (including racial minority ones) in Canada are not markedly different from those in the US, a finding that casts doubt on the notion that Canada's multiculturalism has a dramatic impact (1994). In fact, a perception of multiculturalism as largely symbolic and

incapable of creating a major social impact has been reinforced by the fact that program expenditures are very small. Whatever the impact of policies such as multiculturalism on paving the way for the social integration of immigrants, the findings here suggest that they may have worked less well for racial minority groups than for White immigrant groups.

Public Information and Goal Setting

Canadians agree on the primacy of equal opportunity in principle but differ on the question of putting it into practice. The gap between the widespread perception among racial minorities of problems with equal opportunity and skepticism among political leaders about the need to address such problems is, to some extent, a gap in perception of fact; hence, consensus might be assisted by clarification of relevant facts. In this context, the lack of credible research information on which to base political decision-making poses difficulties.

Universities, research centres, public foundations and interest groups could provide an adequate research base from which to address these needs, but university-based research on immigration and race relations is a low-priority activity, often conducted with few resources. And the recently established network of immigration research centres (part of the Metropolis Project) provides resources for only small-scale research. The Canadian Race Relations Foundation is another resource that could be tapped, but government departments have been reluctant to do so, possibly because they are concerned that such research will exacerbate rather than resolve controversies. In the past, royal commissions have focused attention on topics of national priority, and the Commission on Systemic Racism in the Ontario Criminal Justice System made significant contributions to knowledge, though follow-up reforms have been slow.

However, the most significant subject — employment equality and discrimination — lacks a solid research base. In the final analysis, public authorities should confront the issue of the perception of discrimination directly, thereby avoiding criticism for sidestepping the issue.

Political Participation

Immigrants have high rates of citizenship acquisition, but minority access to electoral office has been limited (Black 2000, 2001). Their small size in any political constituency and low voting rates contribute to this. In Toronto, urban

amalgamation and reduction in the size of the Ontario Legislative Assembly has increased the size of constituencies, thereby exacerbating the problem of representation (Siemiatycki and Isin 1998; Siemiatycki and Saloogee 2000). Avenues of access to political decision-making for minority groups include the ethnic community itself — through its leaders' connections to individual politicians — or advisory groups established to provide minority input into decision-making (Breton 1990). The effectiveness of such means of representation is debated.

These problems of access may be related to the low rates of voting among racial minorities, as shown by the EDS data cited earlier. If racial minorities experience distinctive problems but have difficulty gaining a voice within Canada's political institutions, then proactive measures are needed to ensure that their viewpoints are reflected in decision-making. Here, a national advisory council would be useful. Such a council could address concerns about the impact of immigration on race relations and social cohesion. An effective council would have the means for independent fact-finding, which would allow it to explore the most divisive issues in an authoritative manner. One such issue is racial discrimination in employment.

Conclusions

THIS DISCUSSION HAS COMBINED EXISTING RESEARCH ON RACIAL INEQUALITY IN Canada with an analysis of the social integration of racial minorities based on the 2002 EDS, raising questions about Canadian policies directed at racial minorities and arriving at three basic conclusions. First, the rapidly growing racial minority populations in Canada experience much greater inequality than do traditional European-origin immigrant groups, and discrimination is a widespread concern for racial minorities. The debate among researchers over the significance of racial discrimination, so far inconclusive, is paralleled by a broader debate across society, and this debate seems to divide racial groups.

Second, social integration into Canadian society for racial minorities is slower than it is for immigrants of European origin, partly as a result of their sense of exclusion, represented by perceived discrimination. It is striking that indications of lack of integration into Canadian society are so significant for second-generation minorities, since they are regarded as the harbinger of the future. Educational and

employment success for many within these racial minority groups may not be the only matter of social and political relevance. The evidence suggests that economic integration does not guarantee social integration, although it may contribute to such integration.

Third, based on a brief overview, we conclude that it is far from clear that existing policies are adequate to address the evident racial divide in Canadian society. Policies have emphasized the laudable ideals of equal opportunity and opposition to racism, but they lack the features that would enable them to effectively bridge that racial divide. More specifically, existing policies are weakened by their failure to present clear objectives, reflecting a lack of interracial consensus on the significance of the problem of discrimination and a lack of will to create such a consensus. These policies also lack the means to ensure effective implementation, intergovernmental coordination or evaluation.

Underlying these circumstances is a lack of effective participation by racial minorities themselves in the political decision-making process. Given the salience of equality issues for these groups, such issues may require more attention in the future. Without a new recognition of the significance of racial equality issues within the majority population, the most important precondition for improved policy may be the creation of more effective means for minority group participation.

Social Integration of Whites and Visible Minorities, by Immigrant Cohort and Generation, 2002 (percent)

		Immigrants		Second generation[3]	Third generation and higher[4]
		Recent[1]	Earlier[2]		
Belonging	Whites	47.9	60.9	57.3	53.3
	Total visible minorities	60.7	61.8	44.1	
	Chinese	52.1	55.5	44.6	
	South Asian	69.8	64.8	50.7	
	Black	65.3	69.1	37.0	
	Other visible minorities	60.3	61.4	44.1	
Trust	Whites	56.4	56.3	55.2	47.4
	Total visible minorities	52.5	45.6	44.8	
	Chinese	69.0	54.9	52.0	
	South Asian	48.2	51.4	42.0	
	Black	34.1	26.2	36.7	
	Other visible minorities	47.4	43.7	46.0	
Canadian Identity	Whites	21.9	53.8	78.2	63.4
	Total visible minorities	21.4	34.4	56.6	
	Chinese	30.6	42.0	59.5	
	South Asian	19.1	32.7	53.6	
	Black	13.9	27.2	49.6	
	Other visible minorities	17.4	32.8	60.6	
Citizenship	Whites	48.2	85.6		
	Total visible minorities	51.1	92.0		
	Chinese	61.7	96.9		
	South Asian	43.9	88.8		
	Black	45.6	88.2		
	Other visible minorities	48.6	92.0		
Life Satisfaction	Whites	34.4	50.6	45.9	47.4
	Total visible minorities	39.3	45.5	34.6	
	Chinese	25.8	35.3	27.7	
	South Asian	48.6	49.9	42.0	
	Black	43.7	47.9	33.3	
	Other visible minorities	43.1	49.2	36.3	

(cont. on p. 529)

Belonging? Diversity, Recognition and Shared Citizenship in Canada

Social Integration of
Whites and Visible
Minorities, by
Immigrant Cohort and
Generation, 2002
(percent)
(cont. from p. 528)

		Immigrants		Second generation[3]	Third generation and higher[4]
		Recent[1]	Earlier[2]		
Volunteering	Whites	22.1	28.6	36.5	34.5
	Total visible minorities	21.0	27.6	36.2	
	Chinese	17.7	19.2	32.4	
	South Asian	22.3	31.2	42.1	
	Black	34.3	35.2	37.1	
	Other visible minorities	18.9	28.4	35.2	
Voting[5]	Whites	53.4	87.1	84.0	81.0
	Total visible minorities	54.0	77.8	64.3	
	Chinese	50.2	75.4	69.9	
	South Asian	59.2	82.9	66.9	
	Black	47.1	84.6	55.5	
	Other visible minorities	57.0	73.8	63.3	

Source: *Ethnic Diversity Survey 2002* (Ottawa: Statistics Canada, 2003).
[1] *N*'s for recent immigrants: Whites 715-770; Chinese 580-622; South Asians 433-479; Blacks 167-181; other visible minorities 543-585. *N*'s for total visible minorities (depending on the outcome variable): 1,734-1,867.
[2] *N*'s for earlier immigrants: Whites 4,843-5,186; Chinese 714-769; South Asians 609-675; Blacks 396-425; other visible minorities 978-1,032. *N*'s for total visible minorities (depending on the outcome variable): 2,697-2,928.
[3] *N*'s for second generation: Whites 11,766-12,069; Chinese 874-897; South Asians 703-723; Blacks 664-691; other visible minorities 1,040-1,073. *N*'s for total visible minorities (depending on the outcome variable): 3,281-3,384.
[4] *N*'s: 13,572-14,375, depending on the outcome variable.
[5] The analysis of voting is restricted to eligible voters, namely, citizens and those at least 20 years old. Correspondingly, *N*'s will be lower than for other variables. The impact of citizenship on voting analysis may be inferred from citizenship rates shown in the table. Detailed *N*'s are available from the authors.

Social Integration of
Visible Minorities, with
Controls for Time-
Related Variables

Dependent variable	Explanatory variable	Immigrants		Second generation
		Recent	Earlier	
Belonging (OLS)	Visible Minority (coeff.)	0.2443***	0.1809***	-0.3374***
	Chinese (coeff.)	-0.0127 ns	-0.0143 ns	-0.2851***
	South Asian (coeff.)	0.5335***	0.3213***	-0.2321***
	Black (coeff.)	0.4547***	0.3393***	-0.5156***
	Other Visible Minority (coeff.)	0.2001**	0.1592***	-0.3355***
Trust (logistic)	Visible Minority (coeff.)	-0.1625 ns	-0.4013***	-0.3202***
	(Odds ratios)	0.8500	0.6694	0.7260
	Chinese (coeff.)	0.5680***	-0.0009 ns	-0.0504 ns
	South Asian (coeff.)	-0.3734**	-0.1575 ns	-0.4221***
	Black (coeff.)	-0.9162***	-1.2761***	-0.6554***
	Other Visible Minority (coeff.)	-0.3688**	-0.4664***	-0.2769**
Canadian Identity (logistic)	Visible Minority (coeff.)	0.0221 ns	-0.4542***	-0.8382***
	(Odds ratios)	1.0223	0.6350	0.4325
	Chinese (coeff.)	0.4676**	-0.1100 ns	-0.7729***
	South Asian (coeff.)	-0.0437 ns	-0.5499***	-0.9084***
	Black (coeff.)	-0.5540 ns	-0.8691***	-1.1347***
	Other Visible Minority (coeff.)	-0.2461 ns	-0.4862***	-0.6592***
Citizenship (logistic)	Visible Minority (coeff.)	0.2520*	1.3442***	n/a
	(Odds ratios)	1.2866	3.8351	n/a
	Chinese (coeff.)	0.7931***	2.4325***	n/a
	South Asian (coeff.)	0.1405 ns	1.0093***	n/a
	Black (coeff.)	-0.2939 ns	0.7433***	n/a
	Other Visible Minority (coeff.)	0.0288 ns	1.4008***	n/a

(cont. on p. 531)

Social Integration of Visible Minorities, with Controls for Time-Related Variables (cont. from p. 530)

Dependent variable	Explanatory variable	Immigrants		Second generation
		Recent	Earlier	
Life Satisfaction (OLS)	Visible Minority (coeff.)	-0.0248 ns	-0.0712*	-0.2220***
	Chinese (coeff.)	-0.1829**	-0.2269***	-0.2299***
	South Asian (coeff.)	0.1160 ns	0.0447 ns	-0.0902 ns
	Black (coeff.)	-0.0490 ns	-0.0812 ns	-0.4027***
	Other Visible Minority (coeff.)	0.0209 ns	-0.0228 ns	-0.1845***
Volunteering (logistic)	Visible Minority (coeff.)	-0.0358 ns	0.0483 ns	0.0427 ns
	(Odds ratios)	0.9648	1.0495	1.0436
	Chinese (coeff.)	-0.2584*	-0.4307***	-0.1439 ns
	South Asian (coeff.)	0.0587 ns	0.2186*	0.3012***
	Black (coeff.)	0.6477***	0.4005***	0.0925 ns
	Other Visible Minority (coeff.)	0.1736 ns	0.0802 ns	0.0006 ns
Voting (logistic)[1]	Visible Minority (coeff.)	0.0120 ns	-0.0762 ns	-0.8932***
	(Odds ratios)	1.0121	0.9266	0.4093
	Chinese (coeff.)	-0.1055 ns	-0.2103 ns	-0.6869***
	South Asian (coeff.)	0.2493 ns	0.2601 ns	-0.7446***
	Black (coeff.)	-0.3809 ns	0.2368 ns	-1.2270***
	Other Visible Minority (coeff.)	0.1162 ns	-0.2764**	-0.9447***

Source: *Ethnic Diversity Survey 2002* (Ottawa: Statistics Canada, 2003).
Note: Controls include age and, for immigrants, year of immigration. Coefficients represent the effect of visible minority status and specific visible minority group status. Logistic regression is used in cases of dichotomous dependent variables (Trust, Voting, Volunteering, Canadian Identity and Citizenship), and OLS regression is used in cases of dependent variables having more categories (Life Satisfaction and Belonging). In order to interpret the coefficients from the logistic regression results as odds ratios, the logistic coefficients must be exponentiated (presented only for visible minorities overall). Regression N's (depending on the outcome variable): recent immigrants 2,484-2,640; earlier immigrants 7,796-8,031; second generation 15,185-15,445.
[1] The analysis of voting is restricted to eligible voters, namely, citizens and those at least 20 years old. Correspondingly, N's will be lower than for other variables. The impact of citizenship on voting analysis may be inferred from citizenship rates shown in the table. Detailed N's are available from the authors.
*$p < 0.10$ **$p < 0.05$ ***$p < 0.01$
ns = not significant

Effect of Household
Income, Perceived
Discrimination, and
Perceived Vulnerability
on Social Integration
among Visible
Minorities

Dependent variable	Regression equations[1]	Immigrants		Second generation
		Recent	Earlier	
Belonging	1 IE Household Income	-0.03474 *ns*	-0.09985***	0.02691 *ns*
	2 Perceived Discrimination[2]	-0.10842***	-0.11650***	-0.07037**
	3 Perceived Vulnerability[2]	-0.01005 *ns*	-0.04024 *ns*	-0.05714*
Trust	1 IE Household Income	0.0314 *ns*	0.1096***	0.0532***
	2 Perceived Discrimination	-0.1203***	-0.0748**	-0.0718***
	3 Perceived Vulnerability	-0.1718***	-0.1654***	-0.0834***
Canadian Identity	1 IE Household Income	0.0358 *ns*	0.0205 *ns*	0.0295*
	2 Perceived Discrimination	0.0184 *ns*	-0.0384 *ns*	-0.0147 *ns*
	3 Perceived Vulnerability	-0.1088*	-0.1339***	-0.0280*
Citizenship	1 IE Household Income	-0.00275 *ns*	0.1158 *ns*	n/a
	2 Perceived Discrimination	0.0108 *ns*	0.0761 *ns*	n/a
	3 Perceived Vulnerability	-0.0728***	-0.00723 *ns*	n/a

(cont. on p. 533)

Effect of Household Income, Perceived Discrimination, and Perceived Vulnerability on Social Integration among Visible Minorities (cont. from p. 532)

Dependent variable	Regression equations[1]	Immigrants		Second generation
		Recent	Earlier	
Life Satisfaction	1 IE Household Income	0.02917 ns	0.06886**	0.04456 ns
	2 Perceived Discrimination	-0.23849***	-0.20134***	-0.14099***
	3 Perceived Vulnerability	-0.15010***	-0.14949***	-0.18680***
Volunteering	1 IE Household Income	-0.0859 ns	0.0721**	0.00897 ns
	2 Perceived Discrimination	0.1458***	0.1142***	0.0597***
	3 Perceived Vulnerability	0.0346 ns	0.0428 ns	0.00735 ns
Voting[3]	1 IE Household Income	-0.0236 ns	0.0670**	0.0370 ns
	2 Perceived Discrimination	0.0573 ns	-0.0099 ns	-0.0259 ns
	3 Perceived Vulnerability	-0.0281 ns	0.0074 ns	0.0006 ns

Source: *Ethnic Diversity Survey 2002* (Ottawa: Statistics Canada, 2003).
Note: Coefficients represent the effect of (a) IE (individual-equivalent) Household Income (b) Perceived Discrimination and (c) Perceived Vulnerability for visible minorities after controlling for age and, for immigrants, years in Canada. Logistic regression is used in cases of dichotomous dependent variables (Trust, Voting, Volunteering, Canadian Identity and Citizenship), and OLS regression is used in cases of dependent variables having more categories (Life Satisfaction and Belonging). In order to interpret the coefficients from the logistic regression results as odds ratios, the logistic coefficients must be exponentiated. All regression coefficients are standardized.
[1] Unweighted *N*'s: Regression 1 – recent immigrants 1,748-1,856; earlier immigrants 2,748-2,830; second generation 3,281-3,349. Regression 2 – recent immigrants 1,688-1,784; earlier immigrants 2,641-2,718; second generation 3,243-3,307. Regression 3 – recent immigrants 1,665-1,757; earlier immigrants 2,582-2,659; second generation 3,242- 3,308.
[2] Whereas a negative sign for Perceived Discrimination or Perceived Vulnerability indicates that these variables reduce social integration, it is a positive sign for IE Household Income, which indicates that low income reduces such integration.
[3] The analysis of voting is restricted to eligible voters, namely, citizens and those at least 20 years old. Correspondingly, *N*'s will be lower than for other variables. The impact of citizenship on voting analysis may be inferred from citizenship rates shown in the table. Detailed *N*'s are available from the authors.
*$p < 0.10$ **$p < 0.05$ ***$p < 0.01$
ns = not significant

Effect of Visible
Minority Status on
Various Attachments
(Seven Measures),
Controlling for
Inequality, Perceived
Inequality, Recency of
Immigration and Age

Dependent variable	Regression equations[1]	Immigrants		Second generation
		Recent	Earlier	
Belonging	1	0.2443***	0.1809***	-0.3374***
	2	0.2303***	0.1787***	-0.3340***
	3	0.2661***	0.2300***	-0.2690***
Trust	1	-0.1625 *ns*	-0.4013***	-0.3202***
	2	-0.1326 *ns*	-0.3999***	-0.3359***
	3	0.0037 *ns*	-0.2229**	-0.1216*
Canadian Identity	1	0.0221 *ns*	-0.4542***	-0.8382***
	2	0.0226 *ns*	-0.4528***	-0.8478***
	3	0.0717 *ns*	-0.3499***	-0.7867***
Citizenship	1	0.2520*	1.3442***	n/a
	2	0.2502 *ns*	1.3591***	n/a
	3	0.2971*	1.3162***	n/a

(cont. on p. 535)

Effect of Visible
Minority Status on
Various Attachments
(Seven Measures),
Controlling for
Inequality, Perceived
Inequality, Recency of
Immigration and Age
(cont. from p. 534)

Dependent variable	Regression equations[1]	Immigrants		Second generation
		Recent	Earlier	
Life Satisfaction	1	-0.0248 *ns*	-0.0712 *ns*	-0.2220***
	2	-0.0148 *ns*	-0.0685 *ns*	-0.2273***
	3	0.1051 *ns*	0.0477 *ns*	-0.0857*
Volunteering	1	-0.0358 *ns*	0.0483 *ns*	-0.12162 *ns*
	2	-0.0359 *ns*	0.0569 *ns*	0.0365 *ns*
	3	-0.1259 *ns*	-0.0470 *ns*	-0.0551 *ns*
Voting[2]	1	0.0120 *ns*	-0.0762 *ns*	-0.8932***
	2	0.0265 *ns*	-0.0743 *ns*	-0.9371***
	3	-0.0328 *ns*	-0.1334 *ns*	-0.8358***

Source: *Ethnic Diversity Survey 2002* (Ottawa: Statistics Canada, 2003).
[1] Regression equations: 1 = time-related controls only; 2 = IE (individual equivalent) Household Income, plus time-related controls; 3 = IE Household Income, Perceived Discrimination, Perceived Vulnerability and time-related controls. Unweighted *N*'s: Regressions 1 and 2: recent immigrants 2,484-2,640; earlier immigrants 7,796-8,031; second generation 15,185-15,445. Regression 3: recent immigrants 2,340-2,463; earlier immigrants 7,323 to 7,529; second generation 14,924-15,173.
[2] The analysis of voting is restricted to eligible voters, namely, citizens and those at least 20 years old. Correspondingly, *N*'s will be lower than for other variables. The impact of citizenship on voting analysis may be inferred from citizenship rates shown in the table. Detailed numbers are available from the authors.
$*p < 0.10$ $**p < 0.05$ $***p < 0.01$
ns = not significant

Notes

This paper is part of a larger project on multiculturalism in Canada involving Professors Raymond Breton and Karen Dion, and doctoral candidate Mai Phan. It is supported by the Social Sciences and Humanities Research Council of Canada. The authors wish to thank IRPP reviewers and also Douglas Palmer for comments on earlier drafts of this chapter.

1 Data are based on the census metropolitan area (CMA). Municipalities within CMAs vary in their ethnic concentrations.

2 The *Ethnic Diversity Survey* was a postcensus telephone survey conducted between April and August of 2002 using a sample of 41,695 persons aged 15 and over, excluding Aboriginal persons. One of its prime objectives was to "better understand how people's backgrounds affect their participation in Canada's social, economic and cultural life" (Statistics Canada 2002, 2), and so it included topics of direct relevance to overall social cohesion. The sample is a two-phase stratified sample, designed to enhance representation of ethnic minorities, including racial minority immigrants and the second generation. Data reported here are based on sample weights to compensate for sampling disproportions, with bootstrap weights used to assist in statistical assessment. The computer-assisted telephone interviews lasted an average of 35 to 45 minutes and were conducted in English or French, where possible, or in one of the following languages: Mandarin, Cantonese, Italian, Punjabi, Portuguese, Vietnamese or Spanish. The interview schedule had 14 modules containing detailed questions about ethnicity, immigration status and other aspects of demographic background; about socioeconomic activities; about attitudes toward life in Canada; and about civic participation and other aspects of interaction with society.

3 A more detailed presentation of the EDS data is available in Reitz and Banerjee (2005).

4 Individual-equivalent household incomes adjust household incomes for household size and are calculated by dividing household income by the square root of household size.

5 Among racial minorities, Japanese are the sole exception in having relatively high incomes. Of those identifying as White, the ones belonging to either a Latin American group or an Arab/West Asian group have relatively low incomes. In these two categories, the majority actually do not identify as White. In the census data, these two groups appear both as White and as visible minorities. The categories Latin American and Arab/West Asian are based on responses to census questions on ethnic origins. Some of those who indicate that they have these origins give the response "White" on the visible minority question and are considered not to be visible minorities for this table; the rest are considered visible minorities. Among White ethnic groups, these two have by far the highest poverty rates, although these rates are lower than those of the two categories of people who do not consider themselves White. Apart from these exceptions, all White groups have higher incomes than the most affluent racial minorities (see Reitz and Banerjee 2005).

6 These data refer to the proportion below the low-income cutoff, based on relative income and taking into account family size and urban area of residence. Statistics Canada does not describe this as a poverty measure, but it is commonly interpreted as such.

7 Michael Ornstein notes in his widely cited analysis of 1996 Census data on racial inequalities that while a "socio-economic polarization" exists between European and non-European groups in Toronto, there are significant variations among minorities. Rates of poverty are relatively high for the largest visible minorities — Blacks (44.6 percent), Chinese (29.4 percent) and South

Asians (34.6 percent) — but they are highest for Ethiopians, Ghanaians, Afghans and Somalis, among whom poverty rates reach 50 to 80 percent and higher (Ornstein 2000).

8 Reitz (2006) provides an extensive overview of determinants of immigrant employment success in Canada, including the trend toward declining immigrant earnings discussed later in this chapter.

9 Reitz's analysis shows that the decline in employment rates has the greatest impact on the most recently arrived; it has a continuing impact on women, in particular (2001b). However, most noticeable is the decline in the earnings of those who have found employment.

10 The decline in immigrant earnings in Canada has been steeper than the parallel decline reported in the US by George Borjas (1999). In the US, the decline appears to be primarily attributable to an increase in the proportion of immigrants of Mexican or Latin American origin. For immigrants of similar origin, labour market success in Canada has declined to levels previously seen in the US. In effect, the convergence of the US and Canadian educational systems, particularly at the postsecondary level in the 1970s and 1980s, has produced a marked convergence in the labour market circumstances faced by immigrants and in their earnings (Reitz 2003a).

11 See the reviews by Reitz (2006) and Picot and Sweetman (2005).

12 The hypothesis that the language skills of immigrants have been poorer in recent years has not received support (Ferrer and Riddell 2004). Existing data suggest that the official language skills of immigrants who arrived in 2000 were about the same as those who arrived a decade earlier.

13 The question was, "How often do you feel uncomfortable or out of place in Canada now because of your ethnicity, culture, race, skin colour, language, accent or religion? Is

it all of the time, most of the time, some of the time, rarely, or never?" ("Now" was emphasized because the previous question was similar but focused on the time before respondents turned 15.)

14 The respondent was read the following statement and question: "In Canada, hate crimes are legally defined as crimes motivated by the offender's bias, prejudice or hatred based on the victim's race, national or ethnic origin, language, colour, religion, sex, age, mental or physical disability, sexual orientation or any other similar factor. Using a scale from 1 to 5, where 1 is not worried at all and 5 is very worried, how worried are you about becoming the victim of a crime in Canada because of someone's hatred of your ethnicity, culture, race, skin colour, language, accent or religion?"

15 One exception is the Jewish group: 20 percent reported experiences of discrimination. The other exceptions are Latin Americans and Arabs/West Asians. These two are mixed categories in the sense that some of their members identify themselves as visible minority and others as White. Their reported experiences of discrimination occur at rates between the extremes represented by other visible minorities and other Whites.

16 The 1992 *Minority Survey* conducted in Toronto showed that 78 percent of Blacks believed that their group was the target of employment discrimination (Dion and Kawakami 1996; see also Breton 1990, 208).

17 In Ontario, a task force on access to trades and professions presented a report on the subject over a decade ago (Cumming, Lee, and Oreopoulos 1989), and a recent report by the Ontario Ministry of Training, Colleges and Universities shows that immigrants still report difficulties (Goldberg 2000).

18 The question was, "If two equally qualified people applied for a job, one White and one a visible minority, who do you think would be more likely to get it? The White

person, the visible minority person, or would both have an equal chance?"

19 In surveys, it appears that the role of government in addressing discrimination has not been a topic since the 1980s, when governments in Canada were actively concerned with equity issues. In 1987, the Charter Study found that 63.3 percent agreed that "while equal opportunity to succeed is important for all Canadians, it's not really the government's job to guarantee it" (Reitz and Breton 1994, 87). Since that time, racial discrimination per se has been a much less frequently discussed topic. We pursue this matter in the concluding section of this chapter.

20 It is noteworthy that the disparities confronting immigrants in Canada are comparable in magnitude to those experienced by immigrants in other jurisdictions. For example, although immigrant earnings are higher in Canada than they are in the US (Borjas 1999), Canadian immigrants do not have higher earnings relative to qualifications. In fact, in Canada, as in the US and Australia, immigrants from certain groups — mainly non-European — have performed less well relative to qualifications (Reitz 1998). Black immigrants and those of various Asian groups may therefore expect it to take longer for them to become fully integrated into the Canadian workforce. These patterns are roughly similar in Canada and the US (Reitz and Breton 1994), and, if anything, immigrant earnings relative to qualifications are slightly higher in the US (Baker and Benjamin 1994).

21 For native-born men of European origin, the rate is 51.3 percent; for visible minority immigrant men, it is 64.5 percent; and for visible minority native-born men, it is 68.6 percent. The overall patterns reported by Davies and Guppy show that high school completion rates vary considerably among specific native-born visible minority groups. Among men, they reach a high of 92.5 percent for Koreans, followed by

Chinese at 79.4 percent, Filipinos at 73.3 percent, South Asians at 72.6 percent, Arabs/West Asians at 70.8 percent, Japanese at 69.1 percent, Latin Americans at 64.1 percent, Blacks at 55.4 percent, other Pacific Islanders at 54.2 percent and Southeast Asians at 50.0 percent; the latter is the only group for which the rate is lower than for nonvisible minority men. Among visible minority women, the rank order is almost identical: Koreans, 83.3 percent; Chinese, 80.4 percent; Filipinos, 78.1 percent; South Asians, 75.5 percent; Arabs/West Asians, 73.2 percent; Latin Americans, 71.4 percent; Japanese, 69.2 percent; other Pacific Islanders, 61.3 percent; Blacks, 57.6 percent; and Southeast Asians, 53.3 percent.

22 A few studies have focused on educational opportunity and the accessibility of education to the second generation. Because of the need to regress educational attainment onto characteristics of parents, these studies cannot use census data; instead they employ special-purpose surveys. Consequently, samples are small, and there is little detail on groups of particular origins. The studies suggest that educational opportunities for native-born racial minorities in Canada are comparable to those for the native-born population in terms of levels of education attained (Boyd and Grieco 1998, based on the *General Social Survey*; Boyd 2002, based on the *Survey of Labour and Income Dynamics*), academic performance based on parent and teacher assessments, and formal testing (Worswick 2001, based on the *National Longitudinal Survey of Children and Youth*). These analyses have been interpreted as suggesting that educational attainment for immigrant children in Canada is better than it is for their counterparts in the US (see, for example, Boyd 2002), though explicit empirical comparison has not been done. The US studies that have shown the most negative trends in this regard have focused on groups, such as

Mexicans and Cubans, that are not prominent among immigrant groups in Canada (for example, Portes and Rumbaut 2001).

23 Social cohesion, in this sense, is similar to social capital, which is defined as collective resources that facilitate action. Robert Putnam's observation that ethnic diversity in the US reduces social capital is thus quite relevant (2003). The significance of inequality for recent immigration in the US underscores its potential role in the analysis and suggests that disentangling the relations of diversity, inequality and social commitments is essential (Letki 2005), since they relate to the strength and resilience of the social fabric.

24 The specific wording of the seven questions was:

- ◆ Feelings of belonging: "How strong is your sense of belonging to Canada?" This followed a section in which respondents were asked to rate their sense of belonging to family, ethnic or cultural group, municipality and province on a five-point scale, from not strong at all to very strong.
- ◆ Trust in others: "Generally speaking, would you say that most people can be trusted or that you cannot be too careful in dealing with people?" This was followed by an assessment of the trustworthiness of family members, people in the neighbourhood and people at work or school.
- ◆ Canadian citizenship: "Of what country, or countries, are you a citizen?"
- ◆ Canadian identity: "What is your ethnic or cultural identity?" This was asked after a series of questions on ancestry, which was prefaced by this statement: "I would now like you to think about *your own* identity, in ethnic or cultural terms. This identity may be the same as that of your parents, grandparents or ancestors, or it may be different."
- ◆ Life satisfaction: "All things considered,

how satisfied are you with your life as a whole these days?" Respondents were asked to reply using a scale of 1 to 5; 1 means not satisfied at all, and 5 means very satisfied.

- ◆ Volunteer activity: "At any time in the past 12 months, did you volunteer your time to help with the activities of your organization?" These were organizations of which the respondent was a member or in whose activities the respondent had taken part — sports clubs, religious groups, hobby clubs, charitable groups and the like. Interviewers were instructed that only unpaid work, and not financial contribution, could be considered.
- ◆ Voting: "Did you vote in the last federal election?" Respondents were also asked about provincial and municipal elections; the responses were highly correlated, and the analysis here focuses on federal election participation.

25 As indicated in the previous note, the question used to tap self-identification as Canadian asked about ethnic or cultural identity, and for this question up to six responses were coded. Here, the analysis looks at whether respondents give "Canadian" as any one of the six responses, with a view to determining the extent to which the identity of Canadian is salient among the various ethnic identities significant to respondents.

26 Reported rates of voting in the EDS are higher than the actual voter turnout in federal elections, which is expected in a survey if voting is considered socially conforming behaviour. In any case, group differences are meaningful in the present context. For a discussion of voting in nonofficial language groups, see Jedwab (2005).

27 In this study, individuals who reported that they were not eligible to vote were removed from the voting analysis. Others appear to have responded "No" to the question on voting when in fact they were ineligible at

the time of the last federal election before the survey (November 2000). To eliminate all those who were ineligible, voting analyses are based on individuals over the age of 20 (as the EDS was conducted in 2002).

28 Note that for reference, the figures for third and higher generations of European origin are presented. In the case of self-identification as Canadian, third-and-higher-generation respondents are *less* likely to report a Canadian identification than second-generation respondents of European origin. For these persons, self-identification as Canadian is very likely taken for granted, and in this context it is not relevant to the question asked. Hence, the second-generation respondents of European origin are the most meaningful benchmark for comparison with the racial minority second generation.

29 Logistic regression is used in cases of dichotomous dependent variables (trust, voting, volunteering, Canadian identity and citizenship), and OLS regression is used in cases of dependent variables having more categories (satisfaction and belonging). In order to interpret the coefficients from the logistic regression results as odds ratios, we must exponentiate the logistic coefficients (see appendix 2).

30 Again, logistic regression is used in cases of dichotomous dependent variables (trust, voting, volunteering, Canadian identity and citizenship), and OLS regression is used in cases of dependent variables having more categories (satisfaction and belonging). All coefficients shown are standardized.

31 As well, there may be a perception that enthusiasm for multiculturalism waned as the emphasis shifted from culture to equity.

References

Angus Reid Group. 1991. *Multiculturalism and Canadians: Attitude Study 1991*. Ottawa: Multiculturalism and Citizenship Canada.

Aydemir, Abdurrahman, and Mikal Skuterud. 2005. "Explaining the Deteriorating Entry Earnings of Canada's Immigrant Cohorts, 1966-2000." *Canadian Journal of Economics/Revue canadienne d'économique* 38 (2): 641-72.

Baker, Michael, and Dwayne Benjamin. 1994. "The Performance of Immigrants in the Canadian Labour Market." *Journal of Labor Economics* 12 (3): 369-405.

Beck, J. Helen, Jeffrey G. Reitz, and Nan Weiner. 2002. "Addressing Systemic Racial Discrimination in Employment: The Health Canada Case and Implications of Legislative Change." *Canadian Public Policy/Analyse de politiques* 28 (3): 373-94.

Berry, John W., and Rudolf Kalin. 1995. *Multicultural and Ethnic Attitudes in Canada: An Overview of the 1991 Survey. Canadian Journal of Behavioural Science* 27 (4): 17-49.

Bissoondath, Neil. 1994. *Selling Illusions: The Cult of Multiculturalism in Canada*. Toronto: Penguin Books.

Black, Jerome. 2000. "Ethnoracial Minorities in the Canadian House of Commons: The Case of the 36th Parliament." *Canadian Ethnic Studies* 32 (2): 105-14.

_____. 2001. "Immigrants and Ethnoracial Minorities in Canada: A Review of Their Participation in Federal Electoral Politics." *Electoral Insight* 3 (1): 8-13.

Bloom, David E., Gilles Grenier, and Morley Gunderson. 1995. "The Changing Labour Market Position of Canadian Immigrants." *Canadian Journal of Economics/Revue canadienne d'économique* 28 (4b): 987-1005.

Borjas, George J. 1999. *Heaven's Door: Immigration Policy and the American Economy*. Princeton: Princeton University Press.

Boyd, Monica. 1992. "Gender, Visible Minority and Immigrant Earnings Inequality: Reassessing an Employment Equity Premise." In *Deconstructing a Nation: Immigration, Multiculturalism and Racism in the 1990s Canada*, edited by Vic Satzewich, 279-321. Toronto: Garamond Press.

_____. 2000. "Ethnicity and Immigrant Offspring." In *Perspectives on Ethnicity in Canada*, edited by Madeline A. Kalbach and

Warren E. Kalbach, 137-54. Toronto: Harcourt Canada.

_____. 2002. "Educational Attainments of Immigrant Offspring: Success or Segmented Assimilation?" *International Migration Review* 36 (4): 1037-60.

Boyd, Monica, and Elizabeth M. Grieco. 1998. "Triumphant Transitions: Socioeconomic Achievements of the Second Generation in Canada." *International Migration Review* 32 (4): 521-51.

Breton, Raymond. 1990. "The Ethnic Group as a Political Resource in Relation to Problems of Incorporation: Perceptions and Attitudes." In *Ethnic Identity and Equality: Varieties of Experience in a Canadian City*, edited by Raymond Breton, Wsevolod W. Isajiw, Warren E. Kalbach, and Jeffrey G. Reitz, 196-255. Toronto: University of Toronto Press.

Canada. House of Commons. 1971. *House of Commons Debates*, 3rd sess., 28th Parliament, October 8, vol. 8. Ottawa: Queen's Printer.

————. Special Committee on Participation of Visible Minorities in Canadian Society. 1984. *Equality Now! Participation of Visible Minorities in Canadian Society*. Ottawa: Supply and Services Canada.

Centre for Research and Information on Canada (CRIC). 2003. "A New Canada? The Evolution of Canadian Identity and Attitudes to Diversity." Ottawa: CRIC.

Centre for Research and Information on Canada (CRIC)-*Globe and Mail*. 2003. *The New Canada*. Montreal and Toronto: CRIC, Globe and Mail, Canadian Opinion Research Archive.

Christofides, Louis N., and Robert Swidinsky. 1994. "Wage Determination by Gender and Visible Minority Status: Evidence from the 1989 LMAS." *Canadian Public Policy/Analyse de politiques* 22 (1): 34-51.

Citizenship and Immigration Canada. 1998. *The Economic Performance of Immigrants: Immigration Category Perspective*. IMDB Profile Series. Ottawa: Citizenship and Immigration Canada, December.

Collacott, Martin. 2002. *Canada's Immigration Policy: The Need for Major Reform*. Vancouver: Fraser Institute.

Cumming, Peter A., Enid L.D. Lee, and Dimitrios G. Oreopoulos. 1989. *Access! Task Force on Access to Professions and Trades in Ontario*. Toronto: Ministry of Citizenship.

Davies, Scott, and Neil Guppy. 1998. "Race and Canadian Education." In *Racism and Social Inequality in Canada: Concepts, Controversies and Strategies of Resistance*, edited by Vic Satzewich, 131-56. Toronto: Thompson Educational Publishing.

de Silva, Arnold. 1992. *Earnings of Immigrants: A Comparative Analysis*. Ottawa: Economic Council of Canada.

Dei, George J. 2000. *Removing the Margins: The Challenges and Possibilities of Inclusive Schooling*. Toronto: Canadian Scholars' Press.

Department of Canadian Heritage. 2005. *A Canada for All. Canada's Action Plan against Racism: An Overview*. Ottawa: Minister of Public Works and Government Services Canada.

Dion, Kenneth L., and Kerry Kawakami. 1996. "Ethnicity and Perceived Discrimination in Toronto: Another Look at the Personal/ Group Discrimination Discrepancy." *Canadian Journal of Behavioural Science* 28 (3): 203-13.

Economic Council of Canada. 1991. *Economic and Social Impacts of Immigration*. Ottawa: Supply and Services Canada.

Esses, Victoria M., Joerg Dietz, and Arjun Bhardwaj. 2006. "The Role of Prejudice in the Discounting of Immigrant Skills." In *Cultural Psychology of Immigrants*, edited by Ramiswami Mahalingam. Mahwah, NJ: Lawrence Erlbaum, 113-30.

Esses, Victoria M., John F. Dovidio, and Gordon Hodson. 2002. "Public Attitudes toward Immigration in the United States and Canadian Response to the September 11, 2001, 'Attack on America.'" *Analyses of Social Issues and Public Policy* 2:69-85.

Esses, Victoria M., John F. Dovidio, Lynne M. Jackson, and Tamara L. Armstrong. 2001. "The Immigration Dilemma: The Role of Perceived Group Competition, Ethnic

Prejudice, and National Identity." *Journal of Social Issues* 57 (3): 389-412.

Esses, Victoria M., and Robert C. Gardner. 1996. "Multiculturalism in Canada: Context and Current Status." *Canadian Journal of Behavioural Science* 28 (3): 145-52.

Ferrer, Ana, and Craig Riddell. 2004. "Education, Credentials and Immigrant Earnings." Unpublished paper.

Francis, Diane. 2002. *Immigration: The Economic Case.* Toronto: Key Porter Books.

Frenette, Marc, and René Morissette. 2003. *Will They Ever Converge? Earnings of Immigrant and Canadian-Born Workers over the Last Two Decades.* Analytical Studies Branch Research Paper Series. Cat. no. 11F0019MIE B no. 215. Ottawa: Statistics Canada.

Goldberg, Michelle. 2000.*The Facts Are In! Newcomers' Experiences in Accessing Regulated Professions in Ontario.* Toronto: Ontario Ministry of Training, Colleges and Universities, Access to Professions and Trades Unit.

Grant, Mary L. 1999. "Evidence of New Immigrant Assimilation in Canada." *Canadian Journal of Economics/Revue canadienne d'économique* 32 (4): 930-55.

Green, David, and Christopher Worswick. 2004. "Earnings of Immigrant Men in Canada: The Roles of Labour Market Entry Effects and Returns to Foreign Experience." Accessed November 7, 2006. http://www.econ.ubc.ca/green/chrfexp4.pdf

Henry, Frances, and Effie Ginsberg. 1985. *Who Gets the Work? A Test of Racial Discrimination in Employment.* Toronto: Urban Alliance on Race Relations, Social Planning Council of Metropolitan Toronto.

Henry, Frances, Carol Tator, Winston Mattis, and Tim Rees. 1998. *The Colour of Democracy: Racism in Canadian Society.* 2d ed. Toronto: Harcourt Brace.

Hum, Derek, and Wayne Simpson. 1999. "Wage Opportunities for Visible Minorities in Canada." *Canadian Public Policy/Analyse de politiques* 25 (3): 379-94.

James, Carl. 1998. "'Up to No Good': Black on the Streets and Encountering Police." In *Racism and Social Inequality in Canada,* edited by Vic Satzewich, 157-76. Toronto: Thompson Educational Publishing.

Jedwab, Jack. 2005. "Others' Languages and Voting in Canada: Recent Findings on Political Participation and Perceptions of Non-official Language Groups." *Canadian Issues/Thèmes canadiens* (Summer): 64-8.

Kalbach, Warren E., Ravi Verma, M.V. George, and S.Y. Dai. 1993. *Population Projections of Visible Minority Groups, Canada, Provinces and Regions, 1991-2016.* Ottawa: Statistics Canada, Working Group on Employment Equity Data, Population Projections Section, Demography Division.

Kalin, Rudolf, and John W. Berry. 1994. "Ethnic and Multicultural Attitudes." In *Ethnicity and Culture in Canada: The Research Landscape,* edited by John W. Berry and Jean A. Laponce, 293-321. Toronto: University of Toronto Press.

Kazemipur, Abdolmohammad, and Shiva S. Halli. 2000. *The New Poverty in Canada: Ethnic Groups and Ghetto Neighbourhoods.* Toronto: Thompson Educational Publishing.

_____. 2001. "Immigrants and New Poverty: The Case of Canada." *International Migration Review* 35 (4): 1129-56.

Kerner Commission. 1968. *Report of the National Advisory Commission on Civil Disorders.* Toronto: Bantam.

Kymlicka, Will. 1995. *Multicultural Citizenship: A Liberal Theory of Minority Rights.* New York: Clarendon Press.

Letki, Natalia. 2005. "Does Diversity Erode Social Cohesion? Social Capital and Race in British Neighbourhoods." Unpublished paper.

Lewis, Stephen. 1992. *Report to the Office of the Premier.* Toronto: Government of Ontario.

Li, Peter S. 1992. "Race and Gender as Bases of Class Fractions and Their Effects on Earnings." *Canadian Review of Sociology and Anthropology* 29 (4): 488-510.

_____. 2000. "Earnings Disparities between Immigrants and Native-Born Canadians." *Canadian Review of Sociology and Anthropology* 37 (3): 289-311.

_____. 2001. "The Market Worth of Immigrants' Educational Credentials." *Canadian Public Policy/Analyse de politiques* 27 (1): 23-38.

Myrdal, Gunnar. 1944. *An American Dilemma: The Negro Problem and Modern Democracy.* New York: Harper and Row.

Omidvar, Ratna, and Ted Richmond. 2003. *Immigrant Settlement and Social Inclusion in Canada.* Laidlaw Foundation Working Paper Series, Perspectives on Social Inclusion. Toronto: Laidlaw Foundation.

Ornstein, Michael. 2000. *Ethnoracial Inequality in Metropolitan Toronto: Analysis of the 1996 Census.* Toronto: Institute for Social Research, York University.

Palmer, Douglas. 1991. "Prejudice and Tolerance in Canada." In *Social and Economic Impacts of Immigration*, 103-19. Ottawa: Economic Council of Canada.

_____. 1996. "Determinants of Canadian Attitudes toward Immigration: More than Just Racism?" *Canadian Journal of Behavioural Science* 28 (3): 180-92.

Pendakur, Krishna, and Ravi Pendakur. 1998. "The Colour of Money: Earnings Differentials among Ethnic Groups in Canada." *Canadian Journal of Economics/Revue canadienne d'économique* 31 (3): 518-48.

_____. 2002. "Colour My World: Have Earnings Gaps for Canadian-Born Ethnic Minorities Changed Over Time?" *Canadian Public Policy/Analyse de politiques* 28 (4): 489-512.

Picot, Garnett, and Feng Hou. 2003. *The Rise in Low-Income Rates among Immigrants in Canada.* Analytical Studies Branch Research Paper Series. Cat. no. 11F0019MIE B no. 198. Ottawa: Statistics Canada.

Picot, Garnett, and Arthur Sweetman. 2005. *The Deteriorating Economic Welfare of Immigrants and Possible Causes: Update 2005.* Analytical Studies Branch Research Paper Series. Cat. no. 11F0019MIE B no. 262. Ottawa: Statistics Canada.

Portes, Alejandro, and Rubén G. Rumbaut. 2001. *Legacies: The Story of the Immigrant Second Generation.* Berkeley: University of California Press.

Putnam, Robert D. 2003. "Ethnic Diversity and Social Capital." Paper presented at the Ethnic Diversity and Social Capital, ESRC Families and Social Capital Research Group Seminar, British Academy, June 24, London.

Reitz, Jeffrey G. 1990. "Ethnic Concentrations in Labour Markets and Their Implications for Ethnic Inequality." In *Ethnic Identity and Equality: Varieties of Experience in a Canadian City*, edited by Raymond Breton, Wsevolod W. Isajiw, Warren E. Kalbach, and Jeffrey G. Reitz, 135-95. Toronto: University of Toronto Press.

———. 1993. "Statistics on Racial Discrimination in Canada." *Policy Options* 14 (2): 32-6. Montreal: IRPP.

_____. 1998. *Warmth of the Welcome: The Social Causes of Economic Success for Immigrants in Different Nations and Cities.* Boulder, CO: Westview Press.

_____. 2001a. "Immigrant Skill Utilization in the Canadian Labour Market: Implications of Human Capital Research." *Journal of International Migration and Integration* 2 (3): 347-78.

_____. 2001b. "Immigrant Success in the Knowledge Economy: Institutional Change and the Immigrant Experience in Canada, 1970-1995." *Journal of Social Issues* 57 (3): 577-611.

_____. 2003a. "Educational Expansion and the Employment Success of Immigrants in the United States and Canada, 1970-1990." In *Host Societies and the Reception of Immigrants*, edited by Jeffrey G. Reitz. San Diego: Center for Comparative Immigration Studies, University of California, 151-80.

_____. 2003b. "Occupational Dimensions of Immigrant Credential Assessment: Trends in Professional, Managerial, and Other Occupations, 1970-1996." In *Canadian Immigration Policy for the 21st Century*, edited by Charles Beach, Alan Green, and Jeffrey G. Reitz, 469-506. Kingston: John Deutsch Institute for the Study of Economic Policy, Queen's University.

_____. 2004a. "Canada: Immigration and Nation-Building in the Transition to a

Knowledge Economy." In *Controlling Immigration: A Global Perspective*, edited by Wayne A. Cornelius, Philip L. Martin, James F. Hollifield, and Takeyuki Tsuda. 2d ed. Stanford: Stanford University Press, 97-133.

_____. 2004b. *Social Risks for Newcomers to Canada: Issues Respecting the Role of Government in Ontario*. Panel on the Role of Government in Ontario Research Paper 11. Accessed November 7, 2006. http://www.law-lib.utoronto.ca/investing/reports/rp11.pdf

_____. 2005. "Tapping Immigrants' Skills: New Directions for Canadian Immigration Policy in the Knowledge Economy." *IRPP Choices* 11 (1): 1-18.

_____. 2006. "Recent Trends in the Integration of Immigrants in the Canadian Labour Market: A Multi-disciplinary Synthesis of Research." Unpublished paper. Accessed December 12, 2006. http://www.utoronto.ca/ethnicstudies/trends.pdf

Reitz, Jeffrey G., and Rupa Banerjee. 2005. *Racial Inequality and Social Cohesion in Canada: Findings from the Ethnic Diversity Survey*. Paper presented at the Canadian Ethnic Studies Association meeting *Social Trends and Social Justice: Analysis of the EDS Survey*, October 13-16, Ottawa.

Reitz, Jeffrey G., and Raymond Breton. 1994. *The Illusion of Difference: Realities of Ethnicity in Canada and the United States*. Toronto: C.D. Howe Institute.

Reitz, Jeffrey G., and Sherrilyn M. Sklar. 1997. "Culture, Race, and the Economic Assimilation of Immigrants." *Sociological Forum* 12 (2): 233-77.

Reitz, Jeffrey G., and Kara Somerville. 2004. "Institutional Change and Emerging Cohorts of the 'New' Immigrant Second Generation: Implications for the Integration of Racial Minorities in Canada." *Journal of International Migration and Integration* 5 (4): 385-415.

Satzewich, Vic, ed. 1998. *Racism and Social Inequality in Canada: Concepts, Controversies and Strategies of Resistance*. Toronto: Thompson Educational Publishing.

Scarman, Leslie George. 1986. *The Brixton Disorders, 10-12 April 1981. The Scarman Report: Report of an Inquiry by the Right Honourable the Lord Scarman*. Harmondsworth, UK: Penguin Books.

Schlesinger, Arthur M., Jr. 1992. *The Disuniting of America: Reflections on a Multicultural Society*. New York: W.W. Norton.

Siemiatycki, Myer, and Engin Isin. 1998. "Immigration, Diversity and Urban Citizenship in Toronto." *Canadian Journal of Regional Science* 20 (1-2): 73-102.

Siemiatycki, Myer, and A. Saloogee. 2000. "Ethno-racial Political Representation in Toronto: Patterns and Problems." Paper presented at the Fifth International Metropolis Conference, November 13-17, Vancouver.

Simmons, Alan, and Dwaine Plaza. 1998. "Breaking through the Glass Ceiling: The Pursuit of University Training among African-Caribbean Migrants and Their Children in Toronto." *Canadian Ethnic Studies* 30 (3): 99-120.

Simon, R.J., and J.P. Lynch. 1999. "A Comparative Assessment of Public Opinion toward Immigrants and Immigration Policy." *International Migration Review* 33 (2): 455-67.

Statistics Canada. 2002. *Ethnic Diversity Survey B User Guide*. Ottawa: Statistics Canada.

_____. 2003. *Earnings of Canadians: Making a Living in the New Economy*. 2001 Census Analysis Series. Cat. no. 96F0030XIE2001013. Ottawa: Statistics Canada.

_____. 2005a. *Longitudinal Survey of Immigrants to Canada: A Portrait of Early Settlement Experiences*. Cat. no. 89-614-XIE. Ottawa: Statistics Canada.

_____. 2005b. *Population Projections of Visible Minority Groups, Canada, Provinces and Regions, 2001 to 2017*. Cat. no. 91-541-XIE. Ottawa: Statistics Canada.

Stoffman, Daniel. 2002. *Who Gets In: What's Wrong with Canada's Immigration Program —*

and How to Fix It. Toronto: Macfarlane
Walter and Ross.

Swidinsky, Robert, and Michael Swidinsky. 2002.
"The Relative Earnings of Visible Minorities
in Canada: New Evidence from the 1966
Census." *Relations industrielles/Industrial
Relations* 57 (4): 630-59.

Task Force on Human Relations. 1977. *Now Is
Not Too Late*. Toronto: Municipality of
Metropolitan Toronto.

Wanner, R.A. 1998. "Prejudice, Profit, or
Productivity: Explaining Returns to Human
Capital among Male Immigrants to
Canada." *Canadian Ethnic Studies* 30 (3):
24-55.

Watt, Douglas, and Michael Bloom. 2001.
*Exploring the Learning Recognition Gap in
Canada. Phase 1 Report. Recognizing
Learning: The Economic Cost of Not
Recognizing Learning and Learning
Credentials in Canada*. Ottawa: Conference
Board of Canada.

Worswick, Christopher. 2001. *School Performance
of the Children of Immigrants in Canada,
1994-98*. Research Paper 178. Cat. no.
11F0019MIE. Ottawa: Statistics Canada.

Zegers de Beijl, Roger. 2000. *Documenting
Discrimination against Migrant Workers in the
Labour Market: A Comparative Study of Four
European Countries*. Geneva: International
Labour Office.

Diversity and Equality:
The Vital Connection

Commentary

A LEGAL PRACTITIONER READING "RACIAL INEQUALITY, SOCIAL COHESION AND POLICY Issues in Canada" cannot help but be struck by how significant this chapter is from a human rights perspective.[1] Jeffrey Reitz and Rupa Banerjee have not only written an important sociology document (although more qualified persons than I should make that assessment), but they have also demonstrated what many human rights scholars and practitioners in Canada have long suspected to be true.

The purpose of this commentary is to set out the reasons why I believe Reitz and Banerjee's contribution to this volume matters and to translate the sociological research into a legal and normative framework for equality seekers and legal scholars in the area of racial and ethnic discrimination. At the core of their chapter is the following assertion: "An analysis of the existing literature and [Ethnic Diversity Survey] findings indicates that racial minority immigrants integrate into Canadian society relatively slowly, *and that discriminatory inequalities are at least part of the reason*. This prompts a consideration of existing Canadian policies on racial inequality and their adequacy to address this challenge to the cohesiveness of Canadian society" (emphasis added).

Reitz and Banerjee inform and connect two critical areas of social discourse in Canada that until now have had independent orbits: inequality and discrimination. The human rights movement in this country now has empirical data to support arguments that have been made for years about the connection between race, inequality and discrimination. The essence of these (mostly unsuccessful) arguments has been that racial discrimination is a likely contributor to social inequality for racialized groups and recent immigrants. However, they have failed to carry much weight with policy-makers, usually because of the difficulty of showing causation. As

a result, human rights arguments have gone nowhere in the large departments, like Human Resources and Social Development Canada, that are responsible for designing and implementing our most important social programs, or in the transfer programs that implement them at the provincial level.

Reitz and Banerjee's chapter also offers compelling evidence of the need for more targeted and specific social policies. Beyond the broad averages of social success in Canada, certain groups are falling behind, and the chapter speaks to inequalities that are, in some instances, growing rather than receding with the passage of time. The failure to meet these challenges head-on could have a negative impact on social cohesion based on objective measures — such as employment and income — and on subjective measures — such as perceived discrimination. In short, Reitz and Banerjee provide the empirical tools for legal researchers and human rights practitioners to make the connection between the empirical data on social trends, the reality of lived discrimination and the policy relevance of the research for the Canadian government.

Connecting the Dots: Empirical Data, Equality and Discrimination

F OR YEARS, EXPERTS ON POVERTY AND HUMAN RIGHTS HAVE BEEN TRYING TO CONNECT the dots between socioeconomic indicators for certain groups (recent immigrants and some ethnoracial minorities) on the one hand, and discrimination and racism on the other (Jackman 1994; Day and Brodsky 1999). Representatives of NGOs have been trudging to Geneva for years to argue before various international UN bodies that the disproportionate impact of certain social policies in Canada has racial and discriminatory implications (United Nations Economic and Social Council 2006). Nonetheless, policy-makers at the government level have either failed to understand the implications or been unsure of what to do. Canada, as a rule, has shrugged its shoulders and assumed that at an institutional level, no one would care enough to raise a fuss. These issues were relegated to the insulated chamber inhabited by legal scholars, human rights commissions, international treaty bodies and resource-strapped NGOs. There has certainly been no policy-relevant spillover into broad-based social policy instruments at the federal level.

Those who are knowledgeable about the practice of social policy in Canada will know that there is a great deal of discussion and debate about norms in social policy development generally. However, it is rare to see constitutional norms and legal policy perspectives explicitly driving, or even feeding, horizontal policy development at the federal level, especially in the early stages — unless, of course, the issue "belongs" to a department with a legal mandate, such as Justice Canada.[2]

Why has this happened? There are likely several reasons. First, law and constitutional guarantees are viewed as an end-of-pipe exercise, designed to assess the lawfulness of policy proposals once basic directions are set by policy-makers. It is true, of course, that the normative content of law does, in fact, have end-of-pipe consequences if a government gets it wrong. These can range from public disapproval to litigation to criticism from international forums. However, to use norms as systematic drivers of public policy is a different matter altogether, and not one that has much leverage with government. The second reason is that we have already set the major norms for Canada as a country, so perhaps there is really no point in talking about them anymore. However, many of the established norms that underpin the welfare state, for example, were in place in the 1960s, 1970s and early 1980s, before the entrenchment of the Canadian Charter of Rights and Freedoms. Social policy debate at that time focused on norms in narrow contexts, such as point-in-time income equality; or access to basic public goods, such as education, health care and human rights (the latter having a supporting role). Another surge in debate about the normative underpinnings of Canadian society took place around the time of the development of the Charter, but this did not fundamentally alter Canada's social policy structures.

We in Canada assume a stable normative foundation (at least with regard to those strong norms that make up our legal structures). Policy researchers have therefore been content to couch their findings primarily in the empirical language of equity, equality of opportunity and efficiencies, with an emphasis on statistical measurements of trends, such as low-income or demographic patterns. This has had the effect of creating a perception of law as a policy output, or lever of change, after social policy is set (and as one of a variety of instruments intended to change behaviours), rather than as a major policy driver.

A third reason is evident in the Reitz and Banerjee chapter itself: the terms "equality" and "inequality" are used almost 70 times, yet there is not one

mention of section 15 of the Charter's constitutional guarantee of equality. I do not view this as a substantive (in the sense of deliberate) oversight, mostly because Reitz and Banerjee are so clear about what they have set out to do. It does, however, constitute an omission that, from the perspective of a legal writer, indicates a lack of reflexive use of norms as a way of thinking about and articulating the fundamental values in social policy writing — at least the subspecies that is empirically focused.

Multiculturalism and Equality: Great Expectations

THE AUTHORS ASSERT, "ULTIMATELY, OUR CONCERN IS WITH THE COHESION OF society and the impact of minorities on that cohesion." They define "cohesion" as the capacity of society to set and implement collective goals, and they link it to social capital and its relationship to diversity. Then they describe the weakening beneficial impact of multiculturalism and the fading promise of diversity. However, Canada's basic concern is equality; it is not cohesion — nor should it be. We know this for two reasons. First, a cohesive society that is capable of effectively implementing collective goals may be implementing the wrong ones. If examples are required from the last hundred years or so, one can easily point to Nazi Germany (highly cohesive, highly effective) and the anti-Tutsi movement in Rwanda that culminated in the genocide of 1994. The second reason is that cohesion is conspicuously absent from our constitution. Social policy writers have been so bowled over by Robert Putnam's work that they have not absorbed into their research the fact that the preeminent values in Canada are those that are actually stated in our own constitution, including the equality rights contained in section 15(1) of the Charter.

An analysis of equality and fairness should start with — and be squarely framed by — the equality rights contained in section 15 of the Charter, not in social cohesion or diversity (or inclusion or exclusion), as is so frequently the case in Canadian writings (including Reitz and Banerjee's chapter). Social cohesion and diversity do not even have a base in our constitution, and they are incapable of doing the heavy lifting needed to identify underlying values, let alone to

resolve diverging or conflicting social claims. Section 15 of the Charter, however, explicitly guarantees equality and is capable of settling competing claims.

This brings us to multiculturalism. Multiculturalism is a weak, almost empty norm, as section 27 of the Charter itself makes clear: "This Charter shall be interpreted in a manner consistent with the preservation and enhancement of the multicultural heritage of Canadians."[3] In short, multiculturalism has, at best, interpretive value. The real objective, from both instrumental and teleological perspectives, is equality. It is almost inexplicable to a legal writer that social scientists go on about this policy as if it had free-standing value. To the extent that perceptions of equality are central to achieving a fair society, human rights and equality rights offer a more promising avenue than multiculturalism alone ever could.[4] Janice Stein has written about the diminishing success of multiculturalism and its inability to sort out fundamental claims (2006). She is right, because real social conflicts — related to the ability to live one's life according to one's religion, or to have access to work on a fair footing with other Canadians, or to get a religious divorce — should be played out on the field of equality, not multiculturalism. When multiculturalism is unhinged from equality, it tends to career off in unpleasant and increasingly unacceptable directions, as it did in 2005, when Ontario nearly approved religious arbitration in family matters.

Even the architects of multiculturalism have sounded alarms about the possible irrelevance and increasing ineffectiveness of multiculturalism. In 2005, Bernard Ostry, one of the drafters of the Canadian multiculturalism policy in the 1970s, stated that a full review of this policy should be a priority for the next government (Ostry 2005). Reitz and Banerjee's own research suggests strongly that multiculturalism is not having the same beneficial effects on new immigrants (and on racialized groups generally) as it did on their European-stock predecessors. This is because they are more likely to be subject to discrimination, and multiculturalism cannot do a thing for them. Equality can.

Section 15 of the Canadian Charter of Rights and Freedoms is central to understanding the relationship between exclusion and equality in the Canadian constitutional framework. It came into force in 1985.

> 15. (1) Every individual is equal before and under the law and has the right to the equal protection and equal benefit of the law without discrimination and, in particular, without discrimination based on race, national or ethnic origin, colour, religion, sex, age or mental or physical disability.

(2) Subsection (1) does not preclude any law, program or activity that has as its object the amelioration of conditions of disadvantaged individuals or groups including those that are disadvantaged because of race, national or ethnic origin, colour, religion, sex, age or mental or physical disability.[5]

In Canada, the current authoritative test for section 15 was set out in *Law v. Canada*:

[T]he proper approach to...s. 15(1) of the *Charter* involves...three broad inquiries. First, does the impugned law (a) draw a formal distinction between the claimant and others on the basis of one or more personal characteristics, or (b) fail to take into account the claimant's already disadvantaged position within Canadian society resulting in substantively differential treatment between the claimant and others on the basis of one or more personal characteristics? If so, there is differential treatment for the purpose of s. 15(1). Second, was the claimant subject to differential treatment on the basis of one or more of the enumerated and analogous grounds? And third, does the differential treatment discriminate in a substantive sense, bringing into play the *purpose* of s. 15(1) of the *Charter* in remedying such ills as prejudice, stereotyping, and historical disadvantage?[6]

Historically, the third part of the test has caused the most difficulty, since the assessment of substantive differential treatment cannot be easily quantified or articulated in a clear standard. In the third part of the test, courts look to the impact of exclusion in terms of its effect on human dignity. According to *Law*, a plaintiff's demonstration "that a legislative provision or other state action has the effect of perpetuating or promoting the view that the individual is less capable, or less worthy of recognition or value as a human being or as a member of Canadian society..., will suffice to establish an infringement of s. 15(1)."[7] Section 15 protects essential human dignity and freedom; it promotes a society in which all persons enjoy equal recognition and are seen as equally capable and deserving of concern, respect and consideration. Measures for achieving equality are not just a way to identify things that would be "nice to do" for people living with historic and social disadvantage. Rather, section 15 provides a constitutional imperative to ensure the equality of Canadians before and under Canadian law. The strong emphasis on equality and its link to discrimination is important because it is more likely to make equality gaps actionable before the courts: while diversity, inclusion and cohesion are intellectually interesting, they cannot be used to strongly encourage, let alone force, a government to do anything. Equality,

however, is clearly equipped to trigger judicial intervention and to force a leg-
islature to do its job.

It is true that there are long-standing traditions of judicial conservatism in
this country. Following the entrenchment of equality rights in 1985, and even
after the balance between the judicial and the legislative arms of government was
modified by the Charter, some courts still perceived themselves to be subject to
the view that public policy is the fruit of an enlightened exercise of discretion
rather than the direct result of obligations on the part of government. The courts
should therefore intervene only with great caution.[8] While the enlightened-exer-
cise-of-discretion approach is problematic in the post-Charter era, there is much
to be said for the existence of judicial restraint in righting these sorts of wrongs.
This is, in part, because of the need to retain faith in the courts and to allow leg-
islatures the space to do their work, and because of the importance of maintain-
ing a dialogue between the judiciary and the other branches of government.

Despite this restraint, case law in Canada has shown some tendency to
view equality rights in the context of social inclusion. In several cases, Canadian
appellate courts have specifically assessed government action based on whether
minority groups are experiencing exclusion from membership and participation
in Canadian society. The test of what constitutes a violation of equality rights is
slowly being accorded greater meaning and specificity by the courts. Social poli-
cy literature on diversity and social cohesion should mention and incorporate
these important legal milestones to ensure that the promise of equality in the
Charter is fulfilled (McIntyre and Rodgers 2006).

There is also a uniquely Canadian understanding of equality, which took
hold in the 1980s: it is perceived as substantive rather than formal. Substantive
equality acknowledges the impact of historic disadvantage and discrimination
and requires that it be considered and accommodated. It also takes into consid-
eration the impact of law in its factual context, ensuring that government actions
promote full participation. This concept is well accepted in the courts, including
the Supreme Court of Canada, and it has had a profound effect on how equality
seekers formulate and claim their rights.[9]

Given the importance of putting equality (as I defined it earlier) squarely
in the sights of empirical work on discrimination, what can be said about the
research record cited by Reitz and Banerjee, and what are the implications for
future research and policy development?

A Second Look at the Research Record

R EITZ AND BANERJEE CITE FOUR IMPORTANT TYPES OF EVIDENCE IN DISCUSSIONS ON the extent of discrimination: prejudiced attitudes, evidence of discrimination in human rights cases, field tests of discrimination and discrimination as revealed by statistical analysis of earnings gaps in labour market surveys. The authors more or less dismiss the second type of evidence entirely, because "human rights case evidence may be persuasive, and the circumstances of a particular case may be suggestive of broader patterns, but it remains case-specific." The evidence is much more compelling and useful than the authors suggest — or, at least, it is more worthy of in-depth inquiry.

Evidence of Discrimination in Human Rights Cases

One way to begin to consider how discrimination is perceived in Canada is to look at the lived experience of equality in Canada. Reitz and Banerjee examine carefully whether individuals feel that they have personally experienced discrimination or unfair treatment due to their membership in a protected group, using, for example, the 2002 Ethnic Diversity Survey (EDS). The EDS included questions about whether respondents felt they had been discriminated against or treated unfairly in Canada because of ethnicity, race, skin colour, language, accent or religion, and whether they felt "uncomfortable or out of place" in Canada.

However, the number of human rights cases filed in Canada is easily as telling as this survey data. Human rights cases provide a useful marker of how people perceive discrimination against themselves — for one thing, a person must make the effort to file a complaint, as opposed to simply responding to a survey question. In fact, there are about 7,000 human rights complaints filed every year in Canada and, over a 10-year period, this has formed a rich vein of administrative data that has never been comprehensively studied.

A critical development in equality rights language is the emergence of "systemic discrimination." This key concept underpins many of the claims being raised by racialized groups. It is given short shrift by Reitz and Banerjee, who make only a passing reference to a decision of a "human rights tribunal." The real impact of systemic discrimination did not, of course, come from the tribunal per se, but from the Supreme Court of Canada. Systemic discrimination gained

currency in 1984 with the Abella Report on employment equity (Abella 1984), and it was formally recognized by the Supreme Court of Canada in the 1987 decision *Canadian National Railway Co. v. Canada (Human Rights Comm.) and Action travail des femmes*.[10]

The concept of systemic discrimination and its significance have been affirmed in dozens, if not hundreds, of human rights and equality cases and have fundamentally transformed the way in which minority and other groups approach their equality claims. Systemic discrimination is especially important in the employment context — which Reitz and Banerjee examine in some detail — because when it is taken into consideration, the plaintiff does not have to prove discriminatory intent. A finding of racially based discrimination can result from the utilization of established procedures of recruitment, hiring and promotion, none of which is necessarily designed to promote discrimination (Ontario Human Rights Commission 2005). The courts, sensitive to concerns about the difficulty of proving racial discrimination, have specified that it is not necessary to prove that discrimination is racially motivated. If the evidence points to differential treatment and an affront to human dignity (as distinct from motive or personal animus) on the basis of race, then the plaintiff's case will likely succeed.[11]

Police and Race Relations

There are few thornier areas in social policy research than that of race relations and the police. That may be why Reitz and Banerjee barely touch upon it, but if their thesis is that discrimination is at the root of perceived unfairness and social exclusion, then it is an indispensable line for future research. Certainly, it is a controversial area, but courts have pointed out that something may be controversial in the sense that people and institutions don't like being called racist, but such objectives have no persuasive or evidentiary value in the face of evidence of race-based practices, as was clearly stated by the Ontario Court of Appeal in the 2003 *Brown* case.[12]

Several reports and cases in the area of criminal law and the administration of justice demonstrate that the perception of unjust treatment is borne out by actual experience and findings of fact.[13] Of particular significance is the 1995 *Report of the Commission on Systemic Racism in the Ontario Criminal Justice System* (Gittens and Cole 1995), which is briefly mentioned by the authors. It is worth mentioning, however, how troubling the report's findings were. In addition to the now notorious finding of overrepresentation of Blacks and Aboriginal persons in

the prison system, there were these revelations: police stop Blacks twice as often as Whites; Blacks are detained more often and for longer periods than Whites; Whites are less likely to be detained before trial than Blacks, particularly on drug charges (Whites have a 10 percent chance, whereas Blacks have a 31 percent chance); Blacks are denied bail more frequently, and the conviction rate of Black men is higher (69 percent, as opposed to 57 percent for White men; even for simple possession, 49 percent of Black men compared with 18 percent of White men are sentenced to prison).

Racial profiling has gained even greater significance as a social issue on the heels of two more recent decisions of the Ontario Court of Appeal; there was a finding of fact that racial profiling does occur as a practice.[14]

Human Rights Apparatus

If it is true that discrimination lies at the heart of social exclusion from many of our basic social goods, then human rights commissions are, or should be, an increasingly important form of redress. As a matter of compliance with the rule of law — including international obligations contained in a range of instruments — human rights commissions are a response to myriad international covenants and conventions that require states parties to set up national institutions to ensure meaningful redress for human rights violations, including those related to equality rights.[15] Human rights commissions should be a key strategy in this new world of increasing immigration and the decreasing effectiveness of multiculturalism. But the exact opposite seems to be the case in Canada.

In 2005, the Ontario government tabled Bill 107, which would significantly reduce the powers and role of the Ontario Human Rights Commission and create direct access to a tribunal, leaving the commission with a weak policy and education mandate. Amendments to that legislation were tabled in late 2006; debate swirled around the issue, and the community was divided. In British Columbia, perceived increases in costs, unacceptable delays and management squabbles led to the commission being eliminated altogether. The results of the system that replaced it — so-called direct access to the tribunal or the courts — have been, to say the least, mixed. Meanwhile, the Quebec commission — the only other relatively large one in the country — has been eyeing these developments with trepidation, having just emerged from its own internal turmoil and a series of court cases that have whittled down its jurisdiction and, arguably, its impact.

So, at a time when rising immigration and heightened ethnic tensions make the Reitz-Banerjee thesis a matter for urgent attention, the country's principal social policy instrument for disseminating information on matters of discrimination is being paralyzed.

Conclusion

REITZ AND BANERJEE ARE ON THE RIGHT TRACK WITH THEIR APPROACH, WHICH LOOKS squarely at the data in terms of equality. Indeed, this aspect of the work, given both authors' prominence as scholars of diversity and immigration, is an important contribution to the literature. It is true that they are hardly the first to make the observations and draw the conclusions discussed here. Several noted researchers are gradually assembling the pieces and sounding the alarm: the picture in Canada, while better than in, say, Burkina Faso, is actually more troubling than we are typically willing to countenance. For example, evidence has existed since at least 2001 of a demonstrated and well-entrenched disadvantage for racialized groups and recent immigrants in Canada (Hatfield 2001, 2004), and of widespread intolerant attitudes related to "social distance," to borrow the term used by Reitz and Banerjee. But theirs is the first work that I am aware of in Canada to bring together the strands of evidence on socioeconomic status, immigrant status and ethnoracial background and link them to inequality and discrimination by making a strong statement about causality. And it so happens that the identified causal factor — discrimination — is also the object of constitutional guarantees of equality under the Canadian Charter of Rights and Freedoms.

At the end of the day, the real impact of equality can be principally assessed and interpreted in the remedial capacity of human rights laws and their enforcing institutions (the courts, human rights commissions). Social cohesion and social peace require a minimum of procedural and substantive justice, and developments in the courts and in other forums where legal norms are developed are an indispensable part of the equation. Indeed, in light of the increases of annual immigration targets announced by one federal political party and then the other — some going as far as to suggest increases of about 100,000 — many people might also conclude that getting at the discrimination that underpins inequality in Canada for many of our citizens is an urgent project, not just a theoretical one.

Notes

1 This commentary draws on previously published material, including Eliadis (2006).

2 For example, the Policy Research Initiative (PRI), which was created by the clerk of the Privy Council in 1996, was responsible for developing and coordinating policy for the medium term in the federal public service for the Privy Council Office. During its 10-year existence as an independent entity, it issued a number of publications on a range of policy-relevant topics. With the exception of one major report, written by this author on the question of norms (Eliadis 2004), none of the products was informed by a legal policy perspective or treated constitutional norms as policy drivers. The early PRI reports that were widely considered as setting the policy agenda over that period — namely, *Growth, Human Development and Social Cohesion* (1996) and *Canada 2005: Global Challenges and Opportunities* (1997) — were devoid of normative approaches based on constitutional rights. PRI was folded into Human Resources and Social Development Canada (HRSDC) in 2006 by the Harper government.

3 *Canadian Charter of Rights and Freedoms*, s. 27, Part I of the *Constitution Act, 1982* (UK), 1982, c. 11.

4 This is probably the reason why section 27 of the Charter has received so little judicial scrutiny as a free-standing constitutional principle, as compared with section 15, which is easily the most examined section of the Charter in social policy matters.

5 *Canadian Charter of Rights and Freedoms*, s. 15, Part I of the *Constitution Act, 1982* (UK), 1982, c. 11.

6 *Law v. Canada (Minister of Employment and Immigration)*, [1999] 1 SCR 497, para. 39.

7 Ibid., at 64.

8 *Symes v. Canada*, [1993] 4 SCR 695, citing with approval Décary J.A., at 785.

9 See, for example, the Supreme Court of Canada's decision in *Eldridge v. British Columbia (Attorney General)*, [1997] 3 SCR 624.

10 *Canadian National Railway Co. v. Canada (Human Rights Comm.) and Action travail des femmes* (1987), 8 CHRR D/4210 (SCC).

11 For the development of the dignity test, see *Law v. Canada (Minister of Employment and Immigration)*, [1999] 1 SCR 497; and *M. v. H.*, [1999] 2 SCR 3. For a discussion of the burden on the plaintiff in a race discrimination case, see *Smith v. Mardana Ltd. (c.o.b. as Mr. Lube) et al.*, [2005] OJ No. 377 (Ont. Div. Court).

12 *R. v. Brown* (2003), 64 OR (3d) 161 (CA). See also *Johnson v. Halifax Regional Police Service* (2003), 48 CHRR D/307 (N.S. Bd. Inq.), a Nova Scotia case in which the board of inquiry found evidence to support allegations of racial profiling. Johnson had requested two institutional remedies: that the Halifax Regional Police Service begin collecting and maintaining statistics on the race of all drivers of motor vehicles stopped by police officers; and that the police service hire consultants to conduct a needs assessment of its policies and practices on antiracism education and diversity training. The board of inquiry established a clear, time-limited process for engaging the services of consultants to conduct the needs assessment; it laid out the advertising process and the preferred qualifications, including knowledge of the local Black, other minority and First Nations communities.

13 Most of the key reports originated in Ontario and Quebec. An excellent list can be found in appendix A of the Ontario Human Rights Commission's 2003 report on racial profiling, *Paying the Price*, and on the Web site of the African Canadian Legal Clinic (http://www.aclc.net).

14 See *R. v. Richards* (1999), 26 CR (5th) 286 (Ont. CA) and *R. v. Brown* (2003), 64 OR (3d) 161 (CA). The definitive interpretation in Canada comes from the Ontario Court of Appeal in *R. v. Richards*, as set forth in the reasons of Justice Rosenberg: "Racial profiling is criminal profiling based on race. Racial or colour profiling refers to that phe-

nomenon whereby certain criminal activity is attributed to an identified group in society on the basis of race or colour resulting in the targeting of individual members of that group. In this context, race is illegitimately used as a proxy for the criminality or general criminal propensity of an entire racial group" (at p. 295). Counsel for the Crown admitted the practice of racial profiling, and reference was made to extensive social science research.

15 Human rights commissions are often referred to internationally as "national institutions," and they are acknowledged as playing a pivotal role in the protection of human rights around the world. The United Nations has developed guidelines for appropriate standards and goals for such institutions. These efforts culminated in the 1993 Paris Principles of the UN General Assembly, which affirm that state institutions are to be vested with competence to promote and protect human rights and given as broad a legislative mandate as necessary to fulfill this aim. Canada was a cofounder of, and signatory to, the Paris Principles.

References

Abella, Rosalie S.1984. *Report of the Commission on Equality in Employment*. Ottawa: Minister of Supply and Services Canada.

Day, Shelagh, and Gwen Brodsky. 1999. *Women's Economic Inequality and the* Canadian Human Rights Act. Ottawa: Status of Women Canada. Accessed December 19, 2006. http://www.swccfc.gc.ca/pubs/0662281578/199909_0662281578_4_e.pdf

Eliadis, F. Pearl. 2004. "Poverty and Exclusion: Normative Approaches to Policy Research." *Horizons: Policy Research Initiative* 7 (2): 34-9.

——. 2006. "Normative Approaches to Policy Development: Inscribing Charter Values in the Policy Process." In *Diminishing Returns: Inequality and the Canadian Charter of Rights and Freedoms*, edited by Sheila McIntyre and Sanda Rodgers. Markham, ON: LexisNexis Butterworths.

Gittens, Margaret, and David Cole. 1995. *Report of the Commission on Systemic Racism in the Ontario Criminal Justice System*. Toronto: Queen's Printer for Ontario.

Hatfield, Michael. 2001. "The Lens of Long-Term Low Income." Paper presented at "A New Way of Thinking," Canadian Council on Social Development, November 8-9, Ottawa.

——. 2004. "Vulnerability to Persistent Low Income." *Horizons: Policy Research Initiative* 7 (2): 19-26.

Jackman, Martha. 1994. "Constitutional Contact with the Disparities of the World: Poverty as a Prohibited Ground of Discrimination under the Canadian Charter and Human Rights Law." *Review of Constitutional Studies* 2 (1): 76-122.

McIntyre. S., and S. Rodgers, eds. 2006. *Diminishing Returns: Inequality and the Canadian Charter of Rights and Freedoms*. Toronto: LexusNexis.

Ontario Human Rights Commission. 2003. *Paying the Price: The Human Cost of Racial Profiling. Inquiry Report*. Toronto: Ontario Human Rights Commission. Accessed November 22, 2006. http://www.ohrc.on.ca/english/consultations/racial-profiling-report.shtml

——. 2005. *Policy and Guidelines on Racism and Racial Discrimination*. Toronto: Ontario Human Rights Commission. Accessed November 22, 2006. http://www.ohrc.on.ca/english/publications/racism-and-racial-discrimination-policy.shtml

Ostry, Bernard, 2005."Digging Up Identity Issues." *The Globe and Mail*, November 15.

Stein, Janice Gross. 2006. "Living Better Multiculturally." *Literary Review of Canada*, September, 3-5.

United Nations Economic and Social Council (ECOSOC). 2006. "Concluding Observations of the Committee on Economic, Social and Cultural Rights." E/C.12/CAN/CO/5. Accessed June 25, 2006. http://www.ohchr.org/english/bodies/cescr/docs/E.C.12.CAN.CO.5.pdf

Ties That Bind?
Social Cohesion and
Diversity in Canada

G ROWING ETHNIC DIVERSITY HAS GENERATED TWO INTERSECTING POLICY AGENDAS IN Western democracies.[1] One agenda celebrates diversity. From this perspective, the most compelling challenges facing governments are to respect cultural differences, expand the room for minorities to express their distinctive cultures and construct new and more inclusive forms of citizenship. The second agenda focuses on social cohesion or social integration. From this perspective, the challenge before diverse societies is to reinforce the bonds of a common community. Here the need is to incorporate newcomers into the economic and social mainstream, to sustain a sense of mutual commitment or solidarity in times of need and to build a common national identity.

Both of these agendas are important in diverse societies, and there is no logical reason why they cannot be pursued simultaneously. Nevertheless, the historical record in Western democracies is that political attention shifts back and forth between these intersecting agendas. Throughout much of history, ethnic diversity was seen primarily as a threat to social and political order, and it was actively discouraged by the state. Immigrants, national minorities and indigenous peoples were subject to a wide range of policies designed to assimilate them into the dominant cultural community or to marginalize them. In the last quarter of the twentieth century, however, many Western democracies embraced a more accommodating approach to ethnic diversity, adopting a wide range of programs designed to extend some level of public recognition and support for ethnocultural minorities to maintain and express their distinct identities and practices. With a few notable exceptions, this more multiculturalist approach represented the dominant trend in Western democracies in the closing decades of the last century.

In the first decade of this new century, the balance of debate is shifting again. There is renewed concern about social integration in diverse societies. Historically, concern about integration tends to surface during periods of rapid social change, reflecting anxiety about the sources of social order and the avoidance of conflict. Many liberal democracies seem to be living through such a period now. In late 2005, riots and burning cars in Paris dramatized the failure to integrate the young from minority communities. A few weeks later, race riots broke out on Australia's beaches, raising questions about that country's reputation for peaceful multiculturalism. And then newspaper cartoons depicting Muhammad were published in Denmark and other European countries, sparking protests from Muslims around the world. In the spring of 2006, intense political battles were fought in the United States over immigration policy and the status of undocumented migrants, prompting marches by migrants and their supporters across the country. In this context, it is perhaps not surprising that commentators worry about the integration of minority communities into the mainstream of economic and social life.

While demonstrations and violent clashes provide the most dramatic evidence of tension, other commentators point to a quieter erosion of social integration in the face of diversity. In the United States, Samuel Huntington asks "Who are we?" and worries that American national unity is threatened by immigration and the twin "cults" of multiculturalism and diversity (2004). In the Netherlands, and elsewhere in Europe, critics of multiculturalism insist that illiberal and intolerant strands within some minority communities are going unchallenged, weakening commitments to such values as gender equality and tolerance for diverse sexual preferences.[2] In Britain, some analysts worry that the celebration of difference is corroding the social solidarity that underpins the welfare state, contributing to a slow decline in the redistributive role of the state (Goodhart 2004); and even some spokespersons for British minorities argue that an emphasis on respecting their cultural difference has diverted attention from solving their economic and social problems.[3]

The integrationist momentum has been further reinforced by the new salience of the security agenda since 9/11. In Europe, for example, concern has been intensified by the emergence of radical elements within the Muslim community in some European cities, the murder of filmmaker Theo Van Gogh in the Netherlands and bombings in London by young Muslim men born and raised in

the United Kingdom. The worry is that an emphasis on multiculturalism and respect for diversity has unintentionally created space for radical religious and political movements intent on attacking the liberal-democratic order.

These trends are reshaping political debates, shifting priority to social integration. In the United States, members of an "official English" movement and others have sought to roll back accommodations for immigrants established in earlier decades (Hero and Preuhs 2006; Citrin et al. 1990). In Europe, governments increasingly converge on a model of civic integration that emphasizes the need of immigrants to adopt the language, norms and culture of the receiving country (see Christian Joppke's chapter in this volume; Entzinger 2006). Knowledgeable analysts write about a "retreat from multiculturalism" (Joppke 2004), and "the return of assimilation" (Brubaker 2001). A closer look often reveals that governments are less involved in dismantling multicultural programs than they are in supplementing them with nation-building or integrationist measures (Banting and Kymlicka 2006). At a minimum, however, a shift in policy discourse is under way.

Until recently, these debates have had limited resonance in Canada, and Canadians have often been puzzled by the intensity of debates elsewhere. Core policies on immigration and multiculturalism have enjoyed substantial political consensus, and occasional challengers have gained little traction in political debates. To be sure, Canada faces its own crises of integration. However, these have flowed from tensions among the historic or founding peoples of the country, as evidenced by the near-death experience of the referendum on Quebec separation in 1995 and clashes between Aboriginal people and the wider society. In contrast, the integration of new Canadians has seemed to be a success story, and most debate has continued to focus on fostering respect for minority differences rather than the erosion of the ties that bind.

But cracks in Canadian equanimity seem to be appearing. Recent cohorts of immigrants have fared less well in the labour market, despite having higher levels of education and training than their predecessors. Evidence of greater residential segregation is emerging in some of our cities. The emergence of gang-related violence in some cities and the arrest of a number of second-generation immigrant men in Toronto on suspicion of plotting terrorist acts are disquieting. And the sharp debate about the role of Sharia law in Ontario has demonstrated how quickly flashpoints can emerge. These warning signals, together with the

images of sectarian tension in other countries flashing across our television screens, have raised questions about social integration here as well. For example, on the basis of a survey of tensions in other countries, Allan Gregg argues that Canadians have no reason to be complacent, asserting that "as is the case in England, France, and other advanced liberal democracies, national unity in Canada is increasingly threatened by the growing atomization of our society along ethnic lines" (Gregg 2006, 4; see also Bennett-Jones 2005).

Do Canadians really have reason to worry about social cohesion? Clearly, the historic divisions among the founding peoples continue to pose powerful challenges. But is immigration creating new fault lines in the terrain of Canadian life? If a nation is an imagined community, is there evidence that newcomers are not integrated into the imagined community we call Canada? In this chapter, we seek to shed light on these questions by exploring differences across ethnic and religious groups in a variety of sensitive social linkages, including a sense of pride and belonging in Canada, levels of interpersonal trust, the balance between liberal and socially conservative values, the extent of engagement in social networks that bridge cultural divides and participation in electoral processes.

In conducting this analysis, we draw on two opinion surveys. We rely primarily on the second wave of the *Equality, Security and Community Survey (ESCS)*, conducted in Canada in 2002-03. This survey is strong on measures of pride, belonging, trust, associational memberships and voting. It is weak, however, on social values. For these, we rely on the 2004 *Canadian Election Study (CES)*.[4]

In the next two sections, we explore our understanding of the core ideas of diversity on the one side and social cohesion or integration on the other. We consider the meanings of these two terms and introduce the survey variables we use to capture them. Then we present our analyses and consider their implications. To anticipate, all of our dependent variables show important differences across ethnic groups, and in some cases across religious groups as well. But only part of the ethnic difference is the product of ethnicity per se. Much of the apparent difference is driven by the fact that many members of many ethnic minorities are first-generation immigrants. The differences between immigrant and native-born Canadians narrow considerably the longer newcomers are in Canada. While time does not eliminate all of the differences between newcomers and native-born Canadians, as we shall see, the impact is substantial. Indeed, the largest challenges to social cohesion in Canada remain rooted not in the attitudes, beliefs and

565

Ties That Bind?
Social Cohesion and Diversity in Canada

attachments of relative newcomers but in the historic fault lines between the oldest nations that make up this country.

What Forms of Diversity?

WE START WITH ETHNICITY, THE MOST COMMON CATEGORY IN THE DIVERSITY debate. Here, we define ethnicity in terms of national ancestry and refer to the founding peoples of Canada as well as more recent newcomers. We therefore group Canadians into eight categories: Aboriginal people; French; British and northern European (from Austria, Germany, the Benelux countries and Scandinavia); Eastern European; southern European; South Asian (plus Middle Eastern); East Asian; and Caribbean and African. The choice of categories is driven by our sense of the relative salience of ethnic differences, tempered by data limitations.[5] The combination of South Asian and Middle Eastern exemplifies the latter — there are too few people claiming a Middle Eastern background to stand as an independent group, but exploratory work indicated that they did not belong with the reference category. As it stands, we are skating close to the statistical edge for some of the groups.

Throughout the analysis that follows, the British/northern European group stands as the reference category or comparison group (but see the further refinement in note 7), not because it is seen as more representative of Canada than any other component of the population but because it is the largest group.[6] Because the attitudes of Quebec francophones and French Canadians outside of Quebec often differ on such issues as national identity and feelings about Canada generally, we must represent both ethnolinguistic identity and province of residence. We do so by focusing on Quebec francophones.[7]

Recent debate also features a religious dimension. Much of it centres on Islam, of course. But it is useful to bear in mind that religious diversity is an important feature of historically mainstream ethnic groups, and the *Constitution Act, 1867* recognizes religious diversity as well as linguistic variation. Recently, these religious differences have become more politically salient. Evangelical Protestants among old and new Canadians have been a target for conservative mobilization, as are practising Catholics and non-Christian groups perceived to be traditional-minded on

sexuality and the place of women in society. Hence we compare Catholics, Protestants, Muslims, Hindus, Sikhs and Buddhists. For some of these groups, again, the numbers are small. For Catholics and Protestants, we further distinguish those who say religion is important in their lives from those who do not. The reference category in this case is people with no religious identification.

Although our substantive interest is primarily in ethnic diversity and secondarily in religious orientation, we also include controls, with the result that differences that initially appear as ethnic in nature sometimes turn out to reflect other factors. Most critical is a complex of three demographic factors: immigrant status (that is, whether the respondent is an immigrant or Canadian-born); for immigrants, the number of years of residence in Canada; and, finally, the respondent's age. In our set-up, the first variable contrasts native-born Canadians with immigrants who have just arrived; the second captures the extent to which immigrants' attitudes change as they remain in Canada. But age is a necessary further control, as it is potentially a confounding factor: the number of years in Canada is correlated with age, and it may only indicate age effects by the back door. Controlling for age also allows us to unpack the native-born community.

Finally, we also look for a second-generation effect. In the case of the estimations based on the *ESCS* (but not the *CES*), we identify second-generation members of immigrant communities — the children of immigrants — to gauge the extent that differences in immigrants' beliefs and behaviour persist in the second generation. Essentially, we find very limited distinctiveness for such Canadians. To the extent that recency of arrival produces ostensible ethnic differences, our data suggest that it is a story primarily of the first generation. Accordingly, we do not highlight these results in the figures, but interested readers can find the details in appendix 2. We do, however, summarize our findings on the second generation at the end of our general discussion.

What Is Social Cohesion?

THEORIES OF THE SOURCES OF SOCIAL COHESION ARE AS OLD AS THE SOCIAL SCIENCES themselves. Indeed, Émile Durkheim insisted in the 1880s that the core question facing the emerging discipline of sociology was, "What are the bonds

567

Ties That Bind?
Social Cohesion and Diversity in Canada

which unite men one with another?" (cited in Lukes 1973, 139). In the contemporary era, three distinct approaches to Durkheim's question command attention. The first approach sees social cohesion as being rooted fundamentally in a common body of norms and shared values, or what Durkheim himself called a "collective conscience." From this perspective, a society cannot endure without a common body of norms adhered to by most people, and this collective conscience is especially critical when members of a society are called upon to make sacrifices for the common good. This Durkheimian tradition continues to resonate in contemporary debates. The assertion that shared values underpin the unity of the country is perennial in Canadian politics; and an emphasis on common values, especially the value of gender equality, fuelled recent controversy about Sharia law in Ontario and elsewhere. However, the main focus in this tradition is the concept of national identity. Here the essential question is "Who are we?" Many analysts have argued that a common sense of identity is critical to the capacity of a society to undertake collective endeavours and to sustain itself over time. This view has emerged, for example, in recent debates about the relationship between ethnic diversity and the welfare state. A number of analysts have suggested that redistribution is much easier in homogeneous communities, and that ethnic diversity weakens the willingness of the cultural majority to redistribute resources to newcomers they see as "others." Political theorists such as David Miller reply, however, that ethnic diversity is problematic only if governments fail to implement policies that nurture a common sense of national identity (1995, 2000).

A second approach to social cohesion places much less emphasis on shared values and identities and argues that widespread engagement and participation are the keys to social integration. Here the key question is not "Who are we?" but rather "How are we to live together?" Analysts in this tradition insist that there is no return to some distant past of normative consensus, if such a past ever existed. Contemporary societies are characterized by multiple identities and diverse values, and they cannot hope to find the wellspring of cohesion in common attitudes. According to this perspective, however, a society can function perfectly adequately as long as there is a general consensus on the institutions and procedures through which tensions can be mediated and conflicts adjudicated (Berger 1998). In democratic countries, this essential minimum centres on the institutions of liberal democracy and the political values on which they rest (see Will Kymlicka's chapter in this volume; Baubock 2003).

Other analysts extend this approach, arguing that the key to social cohesion is the active engagement of diverse groups in a society and in debates about that society's future. Here the priorities are to ensure that different identities are recognized as legitimate, that newcomers are incorporated in the economy, that citizens bring their diverse values and identities into the political life and that all groups engage in the political institutions that manage the tensions inherent in modern diversity. Thus, when Jane Jenson breaks the concept of social cohesion into constituent units, shared values and a common political identity are noticeably absent. In her world, the key dimensions are belonging versus isolation, inclusion versus exclusion, participation versus noninvolvement, recognition versus rejection and legitimacy versus illegitimacy (1998).

These two approaches do not exhaust contemporary usage. A third approach is taken by analysts who equate social cohesion with social capital, represented by social networks and norms of trust (Osberg 2003; Organisation for Economic Co-operation and Development 2001). The idea of social capital has captured the imaginations of many scholars in recent years, and a large volume of research has asserted its importance. One strand of the rapidly growing literature assures us that interpersonal trust fosters cooperation among people and facilitates collective action, with powerful implications for economic, cultural and political life (Putnam 1995, 2000, 2004; Uslaner 2002). Given the wide range of social benefits associated with trust, it is not surprising that the apparent decline in levels of trust has set off alarm bells, especially in the United States. From the perspective of this chapter, it is important that a number of analysts have concluded that ethnic diversity is one factor eroding interpersonal trust in that country (Alesina and La Ferrara 2002). A second strand in this literature celebrates the importance of membership in civic associations. For Robert Putnam, trust is an asset that grows with use, and participation in associations builds interpersonal trust because it encourages interaction (1995, 2000). However, not all memberships are created equal, and Putnam distinguishes between bonding groups, which bring people of the same cultural background together, and bridging groups, which span cultural divides. Much would therefore seem to depend on the balance between bridging and bonding in increasingly diverse societies.[8]

Clearly, the concept of social cohesion or integration admits of multiple understandings, and much depends on the conception of the sources of integration that prevail in public discourse, both for the interpretation of the problems

facing us and for the policy responses to them. Part of the underlying shift in the Netherlands, for example, turned on this issue: "More than before, immigrant integration appears to be defined in terms of their loyalties to and identification with 'Dutch values and norms,' rather than in terms of their social and institutional participation" (Entzinger 2006, 186).

From our perspective, however, there is no reason to choose definitively between these views at the outset. The various approaches point to different dimensions of solidarity and the need for a multi-indicator approach to its analysis (Friedkin 2004). This chapter therefore draws from all three conceptions to identify a set of attitudes and behaviours for examination. In the concluding section, we return to the different theories of the sources of social cohesion and reflect on their distinct implications for Canada.

In exploring social cohesion in Canada, we examine six types of dependent variable. The first two relate to a sense of national identity; the second two tap social values and attitudes; and the last two measure forms of social and political participation (see appendix 1 for exact question wording):

1. *Pride in country*. Pride in one's country is surely an important indication of cohesion and solidarity. Here we examine whether individuals responded "very proud" to the simple but telling question "How proud are you to be Canadian?"[9]

2. *Sense of belonging*. Here we look at whether respondents feel they belong completely in Canada (that is, scoring themselves 10 on a scale of 1 to 10).[10] Sense of belonging is a more complicated matter than pride. It turns not just on how much the person wants to be part of the place but also on how well accepted that person is by other denizens of the place.

3. *Interpersonal trust*. Trust plays a central role in the social capital literature. Some analysts distinguish between generalized trust, reflecting a conviction that most people can be trusted most of the time, and a more strategic or specific trust, rooted in personal experience and specific to the nature of the event and the people whose trustworthiness is being evaluated (Uslaner 2002; Soroka, Helliwell, and Johnston 2007). We examine measures of both forms of trust. Generalized trust is measured through the standard question in the literature, which asks respondents whether in general people can be trusted. Strategic trust is measured through a "wallet question," which taps whether respondents believe

that a lost wallet or purse would be returned with the money in it.

4. *Social values.* As we mentioned earlier, analysts in some European societies fear that new waves of immigrants are bringing illiberal values with them, potentially weakening a public consensus in support of norms such as gender equality and tolerance for diverse sexual preferences. Obviously, there is no such thing as Canadian values in the sense of values that are shared so widely and deeply as to constitute some essentialist definition of Canadianness. Both native-born Canadians and immigrants are divided on issues related to the role of women in society and sexual preferences. Our interest here is simply whether there are significant differences in the balance of values among ethnic communities in Canada. We use the 2004 *CES* and focus on whether respondents agreed that society would be better off if more women stayed home with their children and that gays and lesbians should be allowed to marry.

5. *Social networks.* Participation in social networks is a form of engagement highlighted in the social capital literature that is seen as playing a potentially important role in the bridging of different ethnic communities and the integration of immigrant groups. Following Putnam (2004), we distinguish between bonding groups, which bring together people of the same ethnicity, and bridging groups, which span ethnic divides. Our own past work with the *ESC* survey suggests a difference between religious and ethnic groups, which are more clearly bonding, and groups that are more likely to be bridging (Soroka, Johnston, and Banting 2007). Bridging groups are more important in building interpersonal trust, and they are likely more important in facilitating the incorporation of newcomers into a society. Accordingly, we focus on membership in these bridging groups — specifically, membership in any one of the following: service clubs, recreational groups, political groups, youth-oriented groups and groups providing cultural services.[11]

6. *Voting.* Finally, we turn to voting, the most elemental form of political engagement in a democratic society. Voting is not the only means of participating in democratic politics, and the pluralist nature of Canadian politics opens up many avenues for groups and movements engaged in political action and advocacy. Nevertheless, the vote remains central to democratic politics. We therefore examine whether members of

different ethnic groups report that they exercise the franchise in equal measure. In this case, of course, the sample of respondents is narrowed to those people who are eligible to vote by virtue of being citizens, either by birth or by naturalization, and being 18 years of age or older.[12]

The Data: Social Cohesion across Ethnic and Religious Groups

O UR PRIMARY INDICATOR OF DIVERSITY IS ETHNICITY, AND WE FOLLOW THE SAME stages for each of our six indicators of social cohesion. The first step is to focus on the mean probability of each individual, by ethnicity, affirming the high-cohesion value — for instance, expressing pride in Canada. This is indicated by the top (black) bar in the set of horizontal bars for each ethnic group in figures 1 through 8. These bars indicate the magnitude and direction of each ethnic group's response relative to the comparison group, and the top bar in each group's set therefore describes the landscape of ostensible ethnic differences.

The remaining steps introduce an increasing number of controls, adding them to the analysis, one group of controls at a time. The second step controls for the most obvious correlate of ethnicity — immigration. The controls at this stage have three components: whether the respondent is an immigrant or native-born; for immigrants, the duration of residence in Canada; and, for native-born, whether at least one parent was born abroad. To the extent that a group's distinctiveness reflects the relative recency of its members' arrival in the country (rather than ethnicity per se), these controls should push the difference between it and the comparison group toward zero. The third step adds a control for age as a further check on the residence effect and as a factor in its own right. The fourth and final step introduces religious controls to see if a given group's apparent distinctiveness really reflects its religious centre of gravity. Each of these steps is represented by a subsequent bar in figures 1 through 8.

Probability differences in the figures are calculated from binary probit estimations; the detailed estimations appear as tables in appendix 2. However, in the text we focus primarily on the factors most relevant to ethnic differences, which are captured in the figures that follow.

Identity: Pride and Belonging. Figures 1 and 2 tap various dimensions of the extent to which members of different ethnic groups identify with the country and see themselves as part of the imagined community called Canada.

Figure 1 is in many ways paradigmatic, and it therefore bears description in some detail. We start with the solid black bars at the top of each ethnic group's block of bars. For each group but two — southern Europeans and people from South Asia and the Middle East — the direction of this solid black bar is negative: other groups are less likely to express pride in Canada than British/northern European respondents do. Only for Quebec francophones and East Asians is the difference clear and statistically significant by the usual test and criterion. People of Caribbean and African heritage are also less closely identified with the country — the difference is smaller, but significant nonetheless. This is indicated by the bar's size relative to the 95 percent confidence interval, labelled "significant."[13]

The first stage of controls tells most of the rest of the story. Once immigrant status and duration of stay are controlled, the new Canadian groups cease to be distinct, and in some cases they even reverse their relative positions. East Asians, who initially appeared less committed to Canada, become, in effect, just like the reference group. Caribbean/African Canadians shift from being relatively alienated to relatively enthusiastic about the country. South Asians emerge as the most proud of the country, relatively speaking. In contrast, the ambivalence about the country within its two oldest communities, Aboriginal people and francophone Quebecers, is relatively unaffected by immigration controls. Indeed, when immigration status is controlled, these groups turn out to be even less proud of Canada. In general, newcomers from other parts of the world are prouder to be Canadian than the reference group.[14]

Figure 2, which focuses on a sense of belonging, provides a somewhat less rosy picture. Results indicate that all groups feel less "belonging" in Canada than do British/northern European respondents, though clearly to varying degrees. We should not lose sight of the fact that on a 10-point scale of belonging, the median response for every group is 8 or above. We find no group that clearly feels it does not belong. Even so, there are differences in individuals' propensity to say they "belong completely." In many particulars, these differences echo figure 1. While the distinctiveness of francophone Quebecers and Aboriginal people is not affected by immigration, immigration does play a big role in explaining the

Pride in Canada, by
Ethnicity, Adding
Cumulative Controls

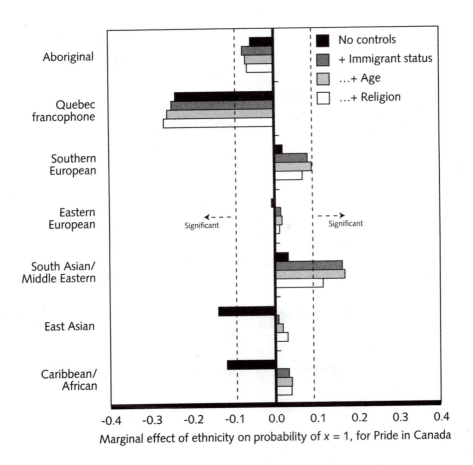

Marginal effect of ethnicity on probability of $x = 1$, for Pride in Canada

Source: Calculations by the authors, based on *Equality, Security and
Community Survey* (2002-03), wave II.
Note: Comparison category is British/northern European/
francophones outside Quebec.

Figure 2 574

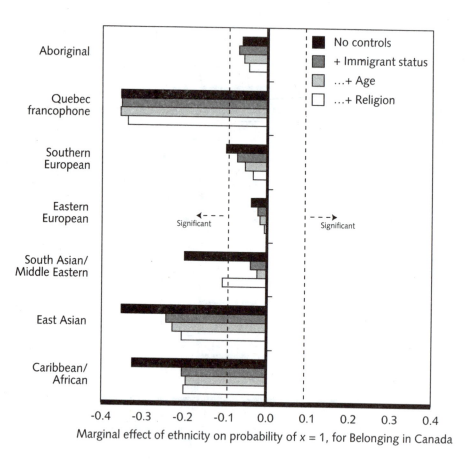

Belonging in Canada,
by Ethnicity, Adding
Cumulative Controls

Source: Calculations by the authors, based on *Equality, Security and Community Survey* (2002-03), wave II.
Note: Comparison category is British/northern European/francophones outside Quebec.

apparent distinctiveness of the newer groups, exactly as before. Here, the apparent ethnic difference is nearly halved once immigration status is taken into account. But even with controls, *all* distinct groups feel a weaker sense of belonging than British and northern European respondents, and this is especially true among visible minority newcomers. This reminds us that belonging is different from pride. It is not just about the new groups — witness the position of Aboriginal people and francophone Quebecers. But it is clearly about an aspect of the relationships among groups. If time in the country increases the sense of belonging for new Canadians, gaps do not close completely.

Shared values: interpersonal trust and social values. Figures 3 to 6 examine the extent to which important attitudes and values are shared by Canadians of all ethnicities. Figures 3 and 4 present two measures of trust and can be discussed together. The results here are somewhat sobering. Every group is less trusting than the British/northern European group. Moreover, the impact of controls is generally weak. In this domain, the length of time newcomers have been in Canada does not have as dramatic an impact as in other areas.

These findings are in line with other work on ethnic differences in interpersonal trust, within Canada and cross-nationally. Research suggests that income and education, as well as contextual factors such as ethnic diversity, can affect both generalized and strategic trust (for example, Glaeser et al. 2000; Soroka, Helliwell, and Johnston 2007). To the extent that these factors co-vary with ethnicity, they may account for part of the interethnic difference. Much of the variance in trust across ethnic groups remains unaccounted for, however. Eric Uslaner argues that the generalized trust question captures a predisposition that is mainly moralistic, rooted in our beliefs about others rather than actual experience (2002). The stability of trust responses over time and across ethnic groups supports this notion, though actually explaining the differing levels of trust across ethnic groups clearly requires further study. The extent to which trust bears on various social or political outcomes is, of course, another question — where support for redistribution is concerned, for instance, our own work suggests that the link is rather weak (Soroka, Johnston, and Banting 2004). Regardless, trust is one dimension of social cohesion where significant and durable ethnic differences are apparent.

The pattern is quite different in the case of social values, as indicated by support for same-sex marriage and for women staying at home. These appear in figures 5 and 6. The outstanding fact about both indicators is that differences are weak: the

Figure 3 576

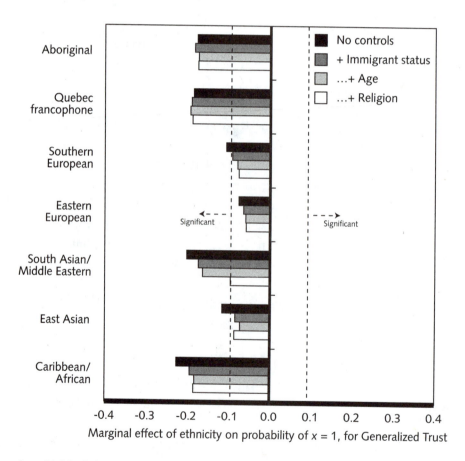

Generalized Trust, by
Ethnicity, Adding
Cumulative Controls

Marginal effect of ethnicity on probability of x = 1, for Generalized Trust

Source: Calculations by the authors, based on *Equality, Security and Community Survey* (2002-03), wave II.
Note: Comparison category is British/northern European/ francophones outside Quebec.

Figure 4

Strategic Trust, Wallet
Measure, by Ethnicity,
Adding Cumulative
Controls

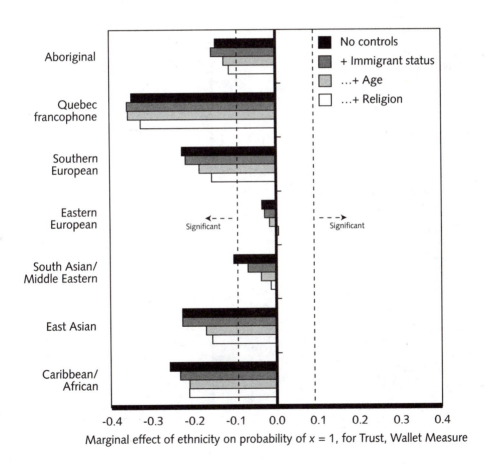

Marginal effect of ethnicity on probability of *x* = 1, for Trust, Wallet Measure

Source: Calculations by the authors, based on *Equality, Security and
Community Survey* (2002-03), wave II.
Note: Comparison category is British/northern European/
francophones outside Quebec.

Figure 5 578

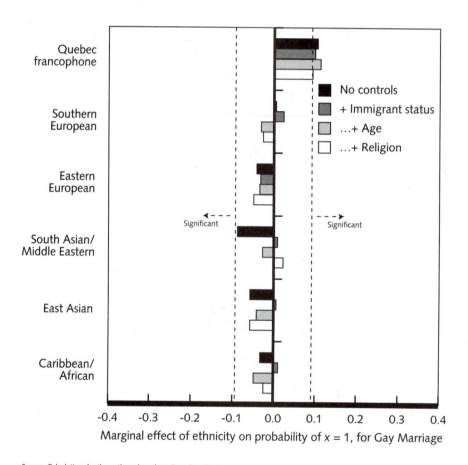

Support for Gay
Marriage, by Ethnicity,
Adding Cumulative
Controls

Marginal effect of ethnicity on probability of *x* = 1, for Gay Marriage

Source: Calculations by the authors, based on *Canadian Election
Study* (2004). The data do not distinguish Aboriginal Canadians.
Note: Comparison category is British/northern European/
francophones outside Quebec.

Support for Women
Staying at Home, by
Ethnicity, Adding
Cumulative Controls

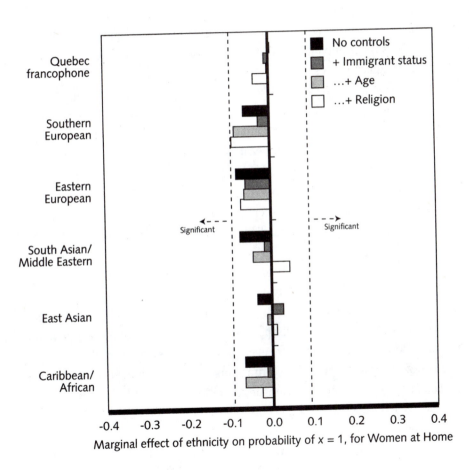

Source: Calculations by the authors, based on *Canadian Election
Study* (2004). The data do not distinguish Aboriginal Canadians.
Note: Comparison category is British/northern European/
francophones outside Quebec.

(horizontal) range of effects is narrow, and only one probability difference is significant, statistically speaking. To the extent that findings are interpretable, they suggest the following: Quebec francophones are the most supportive of same-sex marriage. New groups are the least supportive. For such groups, however, the pattern is almost completely explained by recency of arrival.[15] Differences over the place of women have a similar structure, except among Quebec francophones, who are no longer the distinctively liberal group (here their views are the same as the British/northern Europeans), and among southern and Eastern Europeans. Controls do not, in general, make these groups less distinct. Despite these complexities, the central message is clear. Differences in social values are weak and statistically insignificant. The arrival of newcomers is not tipping the balance of attitudes in the country on fundamental questions of equality rights.

Participation: Networks and Voting. While the evidence on identities and on values points in different directions, our indicators of participation in social and political life point in a consistent direction. For membership in bridging groups (figure 7), differences are weak as compared with other indicators of cohesion. For the few new ethnic groups that tend to underparticipate, the big story is immigration: once immigration factors are controlled, most of the group differences collapse. No such collapse occurs among Quebec francophones or among Aboriginal Canadians, but even here, none of the differences is statistically significant.

The pattern in voting is basically similar (figure 8). As noted earlier, the sample of respondents here is restricted to those eligible to vote by virtue of holding citizenship and being at least 18 years of age. Differences that appear important in the first instance largely disappear when one controls for the length of time in Canada (for immigrants) and for age (all respondents). None of this should be surprising, since we know that turning out to vote is influenced by age for Canadians in general, and that younger generations in particular appear to be voting less. When these factors are taken into account, only the Aboriginal respondents stand out as less likely to vote.

Before turning to a wider discussion of these results, it is worth adding a word about second-generation effects, which are presented in the tables in appendix 2. Traditionally, Canadians have believed that while immigrants might retain distinctive views as a legacy of their homelands, the second generation — the children of those immigrants — tend overwhelmingly to adopt the attitudes of

Figure 7

Membership in Bridging Groups, by Ethnicity, Adding Cumulative Controls

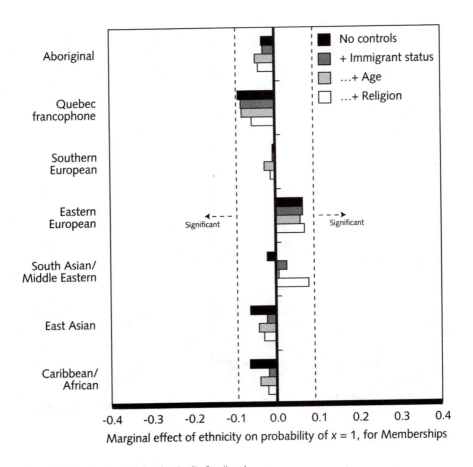

Source: Calculations by the authors, based on *Equality, Security and Community Survey* (2002-03), wave II.
Note: Comparison category is British/northern European/ francophones outside Quebec.

Figure 8 582

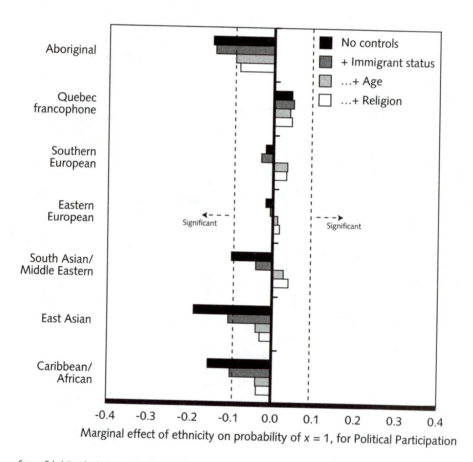

Reported Turnout in
2000 Election, by
Ethnicity, Adding
Cumulative Controls

Marginal effect of ethnicity on probability of *x* = 1, for Political Participation

Source: Calculations by the authors, based on *Equality, Security and
Community Survey* (2002-03), wave II.
Note: Comparison category is British/northern European/
francophones outside Quebec.

583

Ties That Bind?
Social Cohesion and Diversity in Canada

the country of their birth. Our evidence necessitates only a partial modification of this picture. As we have seen, over time, the values and attitudes of newcomers do increasingly resemble those of the reference group, although the gap does not completely disappear.[16] In the case of the second generation, the evidence from coefficients in the tables points in similar directions. In the estimations related to sense of identity (pride in Canada and belonging in Canada), this coefficient is essentially null, signalling no significant difference from the reference group. In the two estimations related to trust, there are hints of persistent second-generation differences. In the case of the specific trust measured by the wallet question, it seems clear that the second generation is less trusting, less so even than first-generation immigrants. But with the two measures of engagement in Canadian life, the evidence tips back to an integrative pattern. In the case of participation in bridging groups, second-generation Canadians participate more, *ceteris paribus*, than older Canadians do; and in the case of voting, we find no difference from the reference group.

Discussion and Conclusions

WHAT DO OUR RESULTS SUGGEST ABOUT THE RELATIONSHIP BETWEEN DIVERSITY and social cohesion? Our evidence points to important differences across ethnic groups for several indicators of social cohesion, and it would certainly be possible to paint an alarming picture by focusing only on the top black bars in the figures. Nevertheless, for all the complexities inherent in the analysis, we should not lose sight of one basic fact. With the exception of our measures of trust, and to a lesser extent of belonging, ethnic differences between newcomers and our reference group — British/northern Europeans — are relatively weak to begin with. Moreover, differences associated with groups of relatively recent arrival are a product of exactly that: recent arrival. For immigrant Canadians, it is the length of time in Canada that drives what at first glance appear to be strong ethnic differences. The longer new immigrants are in Canada, the more their sense of pride and, to a lesser extent, of belonging comes to equal or exceed that of the largest ethnic group. Thus, the integrative power of Canadian life for newcomers is impressive.

There are limits to the integrative power of time, to be sure. Although newcomers from southern and Eastern Europe eventually come to feel they belong almost as much as those with ancestry in the United Kingdom and northern Europe, racially distinct minorities remain less confident that they fully belong. And, of course, the groups that are the least integrated are, as often as not, the ones that have been here longest — two of the founding peoples of the country. National unity thus remains problematic, but it is not ethnic groups of recent vintage that pose the primary challenge.

What can we conclude, then, about diversity and social cohesion in this country as a whole, incorporating both new and old Canadians? At the outset, we outlined different theories of the sources of social cohesion in modern societies, two of which seem especially relevant here. The first theory assumes that real social cohesion is built on the foundation of a common national identity and shared social values. The second theory assumes that we cannot rely on shared identity and values to hold together our increasingly diverse societies, but that inclusive patterns of engagement and participation can build social cohesion and help societies manage diversity. Viewing our findings through the dual lens of these interpretations produces different pictures of the prospects and challenges of social cohesion in Canada.

A conception of social cohesion as rooted in a common identity and shared values highlights the enduring challenges facing Canada. Many newcomers may be proud of Canada — prouder even than people who trace their ancestry to the United Kingdom and northern Europe. But Quebec francophones and arguably Aboriginal people remain ambivalent about the country for reasons deeply embedded in Canadian history. And while all groups score high on the belonging scale, intergroup differences in belonging show the same pattern as pride, though more strongly. Here, Quebec francophones are significantly less attached to Canada (in terms of both the pride and belonging measures) than others. They are joined by racially distinct newcomers, who are also less sure of their place here.

Shared attitudes and values are only slightly less problematic. As we have seen, there are persistent ethnic differences in the levels of trust Canadians have in each other. Generalized interpersonal trust is not affected by time in Canada, lending further support to Uslaner's thesis (2002) that this form of trust is essentially moralistic — culture-bound, bred into individuals at a young age and essentially unchanging over time. Even our wallet question, which measures a more

585

Ties That Bind?
Social Cohesion and Diversity in Canada

strategic version of trust, shows robust interethnic differences. However, there are virtually no differences in the balance of liberal and conservative social values across ethnic groups in Canada. The Canadian experience may in this case contrast sharply with that of some European countries, where critics of diversity worry that new minorities are injecting illiberal values into their culture. Here, in fully controlled models of support for either women staying home or gay marriage, there are very few significant differences across ethnic groups.

In sum, however, if social cohesion is well rooted only in a common sense of national identity and shared values, then Canada faces enduring challenges, especially in integrating its historic communities. The issues here have been addressed over the years by many commentators, and we can only underscore their continuing centrality to Canadian life. Crafting effective policy responses is a subtle art, since nurturing a common identity and shared values is problematic in a multination, multicultural country. We have already handed out a lot of Maple Leaf flags. Indeed, seeking to build a single, overarching sense of identity may well be counterproductive; in the case of the relationship between Canada and francophone Quebec, the most feasible strategy is probably to try to strengthen the sense of attachment to a Canada that incorporates distinctive identities.[17] Moreover, this thinner sense of a Canadian culture among the historic communities may actually have benefits in a multicultural era, making it easier for new Canadians to feel comfortable here. In the final analysis, however, faith in the future of Canada as a single state assumes that the first theory of social cohesion, with its emphasis on common national identity and shared values, is simply too narrow to capture the social realities and potential of the modern world.

The second conception of social cohesion generates a more optimistic view of Canada's prospects. Our measures of engagement in the social and political life of the country find virtually no significant differences across ethnic communities. Membership in groups that are likely to bridge social backgrounds does not differ across ethnic communities; and initial differences in the probability of voting collapse when controls are added (with a partial exception in the case of Aboriginal people). If the true source of social cohesion in today's multicultural world is to be found in the engagement of ethnic groups in community life and in the democratic processes through which we manage our diverse identities and values, then Canada seems to be reasonably positioned for the future. Moreover, this conception of social cohesion generates a policy agenda that can be reasonably tackled

within Canadian political life — an agenda of removing the remaining barriers to political participation and of strengthening the effectiveness of democratic institutions and accountability (see Will Kymlicka's chapter in this volume).

We end, therefore, on a note of restrained optimism. For newcomers, we find little evidence of vast, enduring ethnic differences across a variety of social cohesion indicators. With the exception of trust and, for some visible minorities, belonging, commonalities outweigh differences. Recency of arrival certainly matters, but this is simply a question of time. These findings should not, however, be seen as sounding an all-clear. The remaining differences across newer ethnic groups underscore the continued importance of our multicultural strategies. Strengthening the sense of belonging among visible minority immigrants, for example, will undoubtedly be a big challenge. Moreover, the greater difficulty experienced by recent cohorts of immigrants in entering the labour force is worrisome, and it has the potential to blunt wider forms of social and political participation. The fact that integrative processes have worked in the past is no guarantee that they will work as well in the future. Nevertheless, our findings do forestall hyperbole about the problems we face. They also stand as a warning against importing evidence from Europe or the United States and assuming it applies equally well in Canada. In the case of immigrant minorities, our findings do not justify fears that they threaten social cohesion.

On the field of identity, the fundamental divisions are not "new" Canadians versus "old" ones but within the ranks of the old. Quebec francophones and Aboriginal Canadians have a weaker sense of pride and belonging in Canada as a whole. These divisions are clearly not fading with time. They are as old as the country and deeply embedded in who we are as a people. It is not surprising that these founding peoples, who have come to see themselves as distinct peoples or nations within a multination state, do not exhibit as unqualified an identification or sense of belonging as others do. Indeed, it would be remarkable if Quebec francophones and Aboriginal people ever came to exhibit the degree of these orientations that new Canadians are likely to, for the latter have an affinity with Canada that is essentially elective. So far, at least, the country seems to be successfully facing the challenges of postmodernity. The bigger challenges stem from its premodern phase.

Dependent Variables, Question Wording

Pride in Canada (*ESCS*)

◆ "How proud are you to be Canadian: very proud, quite proud, not very proud, or not at all proud?"

Belonging (*ESCS*)

◆ "Using a scale from 1 to 10 where 1 means you feel like you do not belong at all and 10 means you feel that you belong completely, what number best describes how you feel about Canada?"

Trust (*ESCS*)

◆ Generalized trust: "Generally speaking, would you say that most people can be trusted, or that you cannot be too careful in dealing with people?"

◆ Strategic trust: "If you lost a wallet (or purse) that contained $200, how likely is it to be returned with the money in it if it was found…would you say very likely, somewhat likely, or not at all likely?" Our measure combines the following four responses: "…by someone who lives close by"; "…by a clerk at the nearest grocery store"; "…by a police officer"; "…by a complete stranger."

"Bridging" Memberships (*ESCS*)

◆ "I am going to read a list of different types of groups and organizations. For each of them, I would like you to tell me how many groups of that type, if any, you are a member of."

◆ "How many service clubs, such as the Lions Club or Meals on Wheels, do you belong to?"

◆ "How many recreational groups, such as sports leagues or clubs, music or hobby clubs, or exercise classes are you involved in?"

◆ "How many organizations active on political issues, such as the environment or taxpayers' rights, do you belong to?"

◆ "Sometimes people give time to various types of organizations. How many youth-oriented groups, such as Girl Guides or minor hockey, have you volunteered time to in the last 12 months?"

- "How about organizations providing cultural services to the public, such as a museum or music festival. How many of these have you volunteered time to in the last 12 months?"
- "How about organizations that help people, such as the Cancer Society or a food bank? How many of these have you volunteered time to in the last 12 months?"

Charter Values (*CES*)

- "Society would be better off if more women stayed home with their children. Do you strongly agree, somewhat agree, somewhat disagree, or strongly disagree?"
- "Gays and lesbians should be allowed to get married. Do you strongly agree, somewhat agree, somewhat disagree, or strongly disagree?"

2A. Pride in Canada
(N = 4,872)[1]

Ethnic/demographic characteristic	Dependent variable: Pride in Canada							
Aboriginal	-.056	(.058)	-.076	(.059)	-.068	(.059)	-.064	(.059)
Quebec francophone	-.238***	(.023)	-.248***	(.024)	-.250***	(.024)	-.266***	(.026)
Southern European	.019	(.037)	.070*	(.035)	.080**	(.035)	.067*	(.037)
Eastern European	-.007	(.031)	.013	(.031)	.017	(.031)	.011	(.031)
South Asian/Middle Eastern	.031	(.034)	.160***	(.029)	.167***	(.029)	.114**	(.050)
East Asian	-.137***	(.029)	.008	(.031)	.018	(.031)	.029	(.032)
Caribbean/African	-.117**	(.049)	.030	(.047)	.039	(.046)	.038	(.047)
Immigrant (first generation)			-.275***	(.034)	-.264***	(.035)	-.267***	(.035)
Years in Canada			.004***	(.001)	.003***	(.001)	.004***	(.001)
Immigrant (second generation)			-.014	(.019)	-.020	(.019)	-.016	(.019)
Age					.001***	(.000)	.001**	(.000)
Catholic, not important							.068***	(.019)
Catholic, important							.044**	(.022)
Protestant, not important							.016	(.021)
Protestant, important							.081***	(.023)
Muslim							.085	(.057)
Hindu							.144**	(.060)
Sikh							.081	(.080)
Buddhist							.060	(.067)

Source: *Equality, Security and Community Survey* (2002-03), wave II.
[1] Cells contain marginal effects from a binary probit estimation.
Standard errors are in parentheses.
*p < .10; **p < .05; ***p < .01

2B. Belonging in Canada ($N = 4,869$)[1]

Ethnic/demographic characteristic	Dependent variable: Belonging in Canada							
Aboriginal	-.061	(.060)	-.069	(.060)	-.056	(.060)	-.045	(.061)
Quebec francophone	-.354***	(.020)	-.352***	(.020)	-.355***	(.020)	-.337***	(.022)
Southern European	-.099**	(.039)	-.072*	(.041)	-.053	(.041)	-.034	(.042)
Eastern European	-.038	(.033)	-.022	(.033)	-.017	(.033)	-.006	(.033)
South Asian/ Middle Eastern	-.198***	(.034)	-.039	(.042)	-.023	(.042)	-.107	(.065)
East Asian	-.352***	(.023)	-.242***	(.032)	-.227***	(.033)	-.205***	(.034)
Caribbean/African	-.325***	(.039)	-.204***	(.051)	-.190***	(.052)	-.199***	(.052)
Immigrant (first generation)			-.304***	(.033)	-.289***	(.033)	-.302***	(.034)
Years in Canada			.007***	(.001)	.006***	(.001)	.006***	(.001)
Immigrant (second generation)			.026	(.020)	.016	(.020)	.016	(.020)
Age					.002***	(.000)	.002***	(.000)
Catholic, not important							.010	(.022)
Catholic, important							-.023	(.025)
Protestant, not important							.038*	(.023)
Protestant, important							.075***	(.026)
Muslim							.147**	(.064)
Hindu							.170**	(.075)
Sikh							.061	(.095)
Buddhist							-.088	(.088)

Source: *Equality, Security and Community Survey* (2002-03), wave II.
[1] Cells contain marginal effects from a binary probit estimation.
Standard errors are in parentheses.
*$p < .10$; **$p < .05$; ***$p < .01$

2C. Generalized Trust
(N = 4,783)[1]

Ethnic/demographic characteristic	Dependent variable: Generalized Trust			
Aboriginal	-.176*** (.059)	-.182*** (.059)	-.173*** (.059)	-.174*** (.059)
Quebec francophone	-.184*** (.024)	-.189*** (.024)	-.192*** (.024)	-.187*** (.026)
Southern European	-.106*** (.040)	-.091** (.041)	-.078* (.041)	-.075* (.042)
Eastern European	-.070** (.032)	-.064 (.033)	-.059* (.033)	-.058* (.033)
South Asian/ Middle Eastern	-.201*** (.037)	-.173*** (.042)	-.162*** (.042)	-.095 (.063)
East Asian	-.110*** (.029)	-.084** (.034)	-.072** (.034)	-.086** (.035)
Caribbean/African	-.220*** (.049)	-.193*** (.053)	-.182*** (.053)	-.184*** (.054)
Immigrant (first generation)		-.048 (.035)	-.036 (.035)	-.026 (.035)
Years in Canada		.001 (.001)	-.000 (.001)	-.000 (.001)
Immigrant (second generation)		-.024 (.019)	-.030 (.019)	-.032 (.020)
Age			.001*** (.000)	.001*** (.000)
Catholic, not important				-.012 (.021)
Catholic, important				-.002 (.023)
Protestant, not important				.003 (.022)
Protestant, important				-.003 (.025)
Muslim				-.035 (.068)
Hindu				-.161* (.085)
Sikh				-.021 (.093)
Buddhist				.105 (.068)

Source: *Equality, Security and Community Survey* (2002-03), wave II.
[1] Cells contain marginal effects from a binary probit estimation. Standard errors are in parentheses.
*p < .10; **p < .05; ***p < .01

2D. Strategic Trust
(Binary, $N = 4{,}894$)[1]

Ethnic/demographic characteristic	Dependent variable: Strategic Trust			
Aboriginal	-.146*** (.055)	-.150*** (.055)	-.126** (.056)	-.113** (.057)
Quebec francophone	-.349*** (.018)	-.350*** (.018)	-.357*** (.018)	-.326*** (.021)
Southern European	-.228*** (.034)	-.219*** (.035)	-.186*** (.037)	-.156*** (.040)
Eastern European	-.034 (.032)	-.028 (.032)	-.016 (.033)	.005 (.033)
South Asian/ Middle Eastern	-.103*** (.035)	-.069* (.041)	-.036 (.041)	-.013 (.064)
East Asian	-.228*** (.025)	-.200*** (.030)	-.171*** (.032)	-.156*** (.033)
Caribbean/African	-.259*** (.040)	-.234*** (.044)	-.211*** (.047)	-.213*** (.047)
Immigrant (first generation)		-.067* (.035)	-.033 (.035)	-.030 (.036)
Years in Canada		.002 (.001)	-.001 (.001)	-.001 (.001)
Immigrant (second generation)		-.018 (.020)	-.038* (.020)	-.039** (.020)
Age			.004*** (.000)	.004*** (.000)
Catholic, not important				-.003 (.022)
Catholic, important				-.011 (.025)
Protestant, not important				.102*** (.022)
Protestant, important				.103*** (.025)
Muslim				.090 (.070)
Hindu				-.013 (.084)
Sikh				-.007 (.097)
Buddhist				.079 (.080)

Source: *Equality, Security and Community Survey* (2002-03), wave II.
[1] Cells contain marginal effects from a binary probit estimation. Standard errors are in parentheses.
*$p < .10$; **$p < .05$; ***$p < .01$

2E. Gay Marriage[1]

Ethnic/demographic characteristic	Dependent variable: Gay Marriage			
Quebec francophone	.105*** (.022)	.099*** (.022)	.113*** (.022)	.090*** (.026)
Southern European	.002 (.042)	.024 (.043)	-.031 (.041)	-.026 (.043)
Eastern European	-.041 (.035)	-.032 (.036)	-.034 (.036)	-.048 (.035)
South Asian/ Middle Eastern	-.080 (.061)	.008 (.077)	-.027 (.073)	.022 (.095)
East Asian	-.057 (.051)	.006 (.063)	-.041 (.058)	-.057 (.053)
Caribbean/African	-.032 (.074)	.011 (.084)	-.047 (.075)	-.024 (.076)
Immigrant (first generation)		-.139*** (.051)	-.208*** (.042)	-.178*** (.044)
Years in Canada		.001 (.002)	.006*** (.002)	.005*** (.002)
Age			-.008*** (.001)	-.006*** (.001)
Catholic, not important				-.115*** (.022)
Catholic, important				-.214*** (.020)
Protestant, not important				-.144*** (.021)
Protestant, important				-.258*** (.017)
Muslim				-.197*** (.068)
Hindu				-.180** (.083)
Sikh				-.256*** (.053)
Buddhist				-.132* (.074)
Observations (N)	4,171	4,102	4,102	4,102

Source: *Canadian Election Survey* (2004). The data do not distinguish Aboriginal Canadians.
[1] Cells contain marginal effects from a binary probit estimation. Standard errors are in parentheses.
*p < .10; **p < .05; ***p < .01

2F. Women at Home[1]

Ethnic/demographic characteristic	Dependent variable: Women at Home							
Quebec francophone	.004	(.022)	-.010	(.022)	-.004	(.023)	-.038	(.027)
Southern European	-.063	(.044)	-.027	(.044)	-.086*	(.045)	-.092*	(.047)
Eastern European	-.083**	(.038)	-.061	(.038)	-.064*	(0.038)	-.072*	(.038)
South Asian/ Middle Eastern	-.075	(.068)	-.017	(.072)	-.044	(.072)	.040	(.088)
East Asian	-.035	(.060)	.027	(.066)	-.011	(.070)	.010	(.071)
Caribbean/African	-.067	(.088)	-.014	(.092)	-.067	(.101)	-.026	(.098)
Immigrant (first generation)			-.101*	(.061)	-.196***	(.061)	-.159**	(.062)
Years in Canada			-.001	(.002)	.003**	(.002)	.002	(.002)
Age					-.007***	(.001)	-.006***	(.001)
Catholic, not important							-.033	(.027)
Catholic, important							-.160***	(.032)
Protestant, not important							-.063**	(.028)
Protestant, important							-.207***	(.029)
Muslim							-.243*	(.125)
Hindu							-.211	(.128)
Sikh							-.215	(.143)
Buddhist							-.223*	(.115)
Observations (N)	4,164		4,096		4,096		4,096	

Source: *Canadian Election Survey* (2004). The data do not distinguish Aboriginal Canadians.
[1] Cells contain marginal effects from a binary probit estimation. Standard errors are in parentheses.
*$p < .10$; **$p < .05$; ***$p < .01$

2G. Membership in Bridging Groups ($N = 4{,}903$)[1]

Ethnic/demographic characteristic	Dependent variable: Membership in Bridging Groups						
Aboriginal	-.031	(.056)	-.028	(.056)	-.046	(.057)	-.039 (.057)
Quebec francophone	-.089***	(.023)	-.082***	(.023)	-.079***	(.023)	-.056** (.025)
Southern European	-.005	(.037)	-.004	(.038)	-.026	(.039)	-.011 (.040)
Eastern European	.065**	(.029)	.065**	(.029)	.059**	(.029)	.069** (.029)
South Asian/ Middle Eastern	-.021	(.035)	.026	(.037)	.007	(.039)	.078 (.053)
East Asian	-.062**	(.028)	-.020	(.032)	-.041	(.033)	-.029 (.033)
Caribbean/African	-.064	(.048)	-.019	(.049)	-.039	(.050)	-.021 (.050)
Immigrant (first generation)			-.083**	(.033)	-.105***	(.034)	-.097*** (.035)
Years in Canada			.002*	(.001)	.003***	(.001)	.003*** (.001)
Immigrant (second generation)			.046***	(.018)	.058***	(.018)	.059*** (.018)
Age					-.003***	(.000)	-.003*** (.000)
Catholic, not important							-.007 (.020)
Catholic, important							.014 (.022)
Protestant, not important							.054*** (.020)
Protestant, important							.058** (.022)
Muslim							-.087 (.070)
Hindu							-.012 (.080)
Sikh							-.201** (.099)
Buddhist							.024 (.071)

Source: *Equality, Security and Community Survey* (2002-03), wave II.
[1] Cells contain marginal effects from a binary probit estimation.
Standard errors are in parentheses.
*$p < .10$; **$p < .05$; ***$p < .01$

2H. Reported Turnout in the 2000 Election $(N = 4,645)$[1]

Ethnic/demographic characteristic	Dependent variable: Reported Turnout			
Aboriginal	-.147*** (.056)	-.141** (.055)	-.093* (.052)	-.082 (.051)
Quebec francophone	.043** (.018)	.048*** (.018)	.039** (.017)	.043** (.018)
Southern European	-.018 (.033)	-.029 (.036)	.033 (.028)	.031 (.029)
Eastern European	-.017 (.027)	-.005 (.026)	.011 (.024)	.016 (.024)
South Asian/ Middle Eastern	-.098** (.039)	-.039 (.039)	.026 (.031)	.038 (.045)
East Asian	-.180*** (.030)	-.105*** (.030)	-.038 (.029)	-.029 (.029)
Caribbean/African	-.152*** (.053)	-.099* (.053)	-.037 (.046)	-.035 (.046)
Immigrant (first generation)		-.231*** (.043)	-.167*** (.041)	-.159*** (.042)
Years in Canada		.008*** (.001)	.003*** (.001)	.004*** (.001)
Immigrant (second generation)		-.001 (.015)	-.027* (.016)	-.023 (.016)
Age			.007*** (.000)	.006*** (.000)
Catholic, not important				.041*** (.015)
Catholic, important				.053*** (.016)
Protestant, not important				.071*** (.014)
Protestant, important				.073*** (.015)
Muslim				.037 (.048)
Hindu				.042 (.061)
Sikh				-.023 (.084)
Buddhist				.083** (.037)

Source: *Equality, Security and Community Survey* (2002-03), wave II.
[1] Cells contain marginal effects from a binary probit estimation. Standard errors are in parentheses.
*$p < .10$; **$p < .05$; ***$p < .01$

Notes

1 Research for this chapter was made possible by the Social Sciences and Humanities Research Council of Canada. We are grateful for comments from Professor Bonnie Erickson, other participants in "The Art of the State III: Diversity and Canada's Future," an anonymous reviewer and the editors of this volume. However, we remain solely responsible for any errors of fact or interpretation. This chapter builds on several related works: Soroka, Johnston, and Banting (2004, 2007); Soroka, Banting, and Johnston (2006); and Banting and Kymlicka (2004). For a synthesis of this work, see Banting (2005).

2 On the extent to which the Dutch reaction against immigration and multiculturalism, including the early opposition led by Pim Fortuyn, has reflected concern about illiberal attitudes among the minority population, see Entzinger (2006, 183-7); see also Sniderman, Hagendoorn, and Prior (2004).

3 In the United Kingdom, for example, Trevor Phillips, chair of the Commission for Racial Equality — and himself a Black person — has argued that multiculturalism is no longer an appropriate goal: "Multiculturalism suggests separateness," and "we need to assert that there is a core of Britishness." Phillips continues: "What we should be talking about is how we reach an integrated society, one in which people are equal under the law, where there are some common values — democracy rather than violence, the common currency of the English language, honouring the culture of these islands, like Shakespeare and Dickens" (cited in Baldwin 2004).

4 The ESCS dataset combines a national probability sample of residents (including noncitizens) aged 18 and over with a Montreal-Toronto-Vancouver metropolitan oversample drawn disproportionately from telephone exchanges known to overrepresent visible minorities. This boosts the absolute numbers of visible minority respondents, and it compensates for the endemic underrepresentation of such groups in telephone samples. The sample is thus not a probability one overall, but no weighting is necessary as all groups that are systematically over- (or, by implication, under-) sampled are represented by a parameter in the multivariate estimation. The CES uses a national probability sample of voting-age citizens. Both the ESCS and the CES are telephone surveys and were conducted in English or French, which may bias the sample of immigrants toward those at least partially integrated into Canadian society.

5 In a small number of cases, the imputation may deploy several queries: multiple ethnic probes, place of own or parents' birth, as well as (in about 15 cases) religion. For example, a respondent of Caribbean birth but of Hindu religion would be assigned to the South Asian category. As another example, "French" denotes either language or ancestry. On the latter, preliminary analyses suggested that ancestry was as important as current language mastery in predicting attitudes. The British/northern European group includes respondents who identify themselves as of British or northern European descent, as well as those respondents who identify themselves only as Canadians and whose first language is English. Those of British and northern European origin are combined because their responses to the questions we have an interest in here are essentially indistinguishable. To report them separately in each figure and table would simply be to introduce clutter. The rules of assignment were, frankly, inductive.

6 The imperative here is methodological. The critical objective is to define a reference group that is never empty. In multivariate estimation, the reference group for the whole equation comprises all respondents who score zero on all variables for which

zero is an available value. Given the number of dimensions in the set-up, at least some of the reference categories must be big by construction, otherwise we risk having an empty base. If the reference group is empty, the variance-covariance matrix is not invertible, and the equation cannot be identified.

7 This is equivalent to entering "French" and "Quebec" as dummy-variable main effects, the product of the two as an interaction, and then summing up all the coefficients. In our simple set-up, francophones outside Quebec are included in the British/northern European reference category.

8 Interestingly, the *Social Capital Benchmark Survey* in the US suggests that participation in both bridging and bonding groups tends to decline in more diverse communities. Americans in such communities seem to be retreating not only from groups that include people of other ethnic backgrounds, but also from groups made up of people of their own background. Putnam argues that Americans in diverse communities seem to be "hunkering down" in personal rather than civic space (2004).

9 The vast majority of respondents say either "very proud" (66 percent) or "quite proud" (28 percent). We accordingly focus on "very proud" on its own, as it better divides our sample.

10 We do this for the same reasons outlined in the previous note — on the belonging scale, the vast majority of respondents selected a number above seven.

11 We recognize that at best our indicator captures the potential for network diversity, not the actuality. Bonnie Erickson has presented a sensitive discussion of indicators of bridging as part of the sociology of weak ties. She recommends using a "position generator," an example of which is publicly available in the 2000 *CES* (Erickson 2004). We elected to stay with the *ESCS* indicator because of the *ESCS* data set's richer set of demographic variables and because bridging imputations are possible for no more than 1,539 respondents in the 2000 *CES* (42 percent of the total sample), as the position generator was the last question on the third, mail-back wave.

12 Although this is an electoral question, we used the *ESCS* data again because of its rich demographics, in particular its capture of second-generation status. The election in question is the 2000 one.

13 The 95 percent confidence interval is slightly different for each ethnic group, as it is related to sample size, and the sample size for each group is different. The line shown in these figures is thus based on the average 95 percent confidence interval for the seven ethnic groups. It consequently tends to overestimate the limit for larger groups, so southern and Eastern Europeans will have significant differences even when they are a little below this line; conversely smaller groups such as East Asians and Caribbean/Africans will have differences that are insignificant even when they marginally exceed this line. We nevertheless opt for this single-line strategy here: the use of a 95 percent confidence interval is a subjective decision rather than a hard-and-fast rule anyway, and a single line — even with its minor inefficiencies — provides a useful reference point to compare results across groups. The exact significance of each coefficient is reflected in the appendix 2 tables.

14 Controlling for religion complicates the South Asian/Middle Eastern story a bit, as the coefficients shrink back toward zero at this stage. This mainly reflects the fact that Hindus and Muslims are especially proud of Canada, so the ethnic coefficient now captures something intrinsic to the region that is independent of its complex makeup; there is nothing intrinsic to the region that distinguishes it as a source of pride in Canada.

15 The effect of immigration is complicated somewhat by the fact that age is negatively related to support but positively related to

number of years in the country. Controlling for age thus causes the ethnic coefficients to bounce back to negative values: by implication, for instance, a South Asian of a given age will be more conservative than a northern European of the same age. But the average South Asian is younger than the average northern European, and this pushes toward liberal values.

16 For instance, coefficients (see appendix 2, tables 2B, 2C and 2D) suggest that the considerably weaker sense of belonging felt by new immigrants dissipates entirely in about 55 years. This obviously exceeds the lifespan of many immigrants, but even within their lifetime, a considerable portion of the difference disappears.

17 On the distinction between identity and attachment, see Mendelsohn (2002).

References

Alesina, Alberto, and Eliana La Ferrara. 2002. "Who Trusts Others?" *Journal of Public Economics* 85:207-34.

Baldwin, Tom. 2004. "I Want an Integrated Society with a Difference: Interview with Trevor Phillips." *Times* (London), April 3.

Banting, Keith. 2005. "The Multicultural Welfare State: International Experience and North American Narratives." *Social Policy and Administration* 39 (2): 98-115.

Banting, Keith, and Will Kymlicka. 2004. "Do Multiculturalism Policies Erode the Welfare State?" In *Cultural Diversity versus Economic Solidarity*, edited by Philippe van Parijs. Brussels: De Boeck Université.

———. 2006. "Introduction: Multiculturalism and the Welfare State: Setting the Context." In *Multiculturalism and the Welfare State: Recognition and Redistribution in Contemporary Democracies*, edited by Keith Banting and Will Kymlicka. Oxford: Oxford University Press.

Bauböck, Rainer. 2003. "A Closer Look at Unity: What Social Cohesion Does and Does Not Require." *Responsive Community* 13 (2): 31-42.

Bennett-Jones, Owen. 2005. "Europe's Ticking Time Bomb." *Globe and Mail*, September 3.

Berger, Peter. 1998. "Conclusion: General Observations on Normative Conflicts and Mediation." In *The Limits to Social Cohesion: Conflict and Mediation in Pluralist Societies: A Report of the Bertelsmann Foundation to the Club of Rome*, edited by Peter Berger. Boulder, CO: Westview Press.

Brubaker, Rogers. 2001. "The Return of Assimilation?" *Ethnic and Racial Studies* 24 (4): 531-48.

Canadian Election Study. 2004. Principal investigators: André Blais, Elisabeth Gidengil, Neil Nevitte, Patrick Fournier and Joanna Everitt. Distributor: Université de Montréal. Accessed November 29, 2006. www.ces-eec.umontreal.ca

Citrin, Jack, Beth Reingold, Evelyn Walters, and Donald Green. 1990. "The 'Official English' Movement and the Symbolic Politics of Language in the United States." *Western Political Quarterly* 43:535-59.

Entzinger, Han. 2006. "The Parallel Decline of Multiculturalism and the Welfare State in the Netherlands." In *Multiculturalism and the Welfare State: Recognition and Redistribution in Contemporary Democracies*, edited by Keith Banting and Will Kymlicka. Oxford: Oxford University Press.

Equality, Security and Community Survey. 2002-03 (wave II). Director of survey: Richard Johnston, principal investigator: Jonathan R. Kesselman, University of British Columbia. Funded by the Social Sciences and Humanities Research Council of Canada, grant number 412-97-0003.

Erickson, Bonnie. 2004. "A Report on Measuring Social Capital in Weak Ties." Paper presented at the Policy Research Initiative Expert Workshop on Measuring Social Capital for Public Policy, June 8.

Friedkin, Noah. 2004. "Social Cohesion." *American Review of Sociology* 30:409-25.

Glaeser, Edward L., David I. Laibson, Jose Scheinkman, and Christine L. Soutter.

2000. "Measuring Trust." *Quarterly Journal of Economics* 65 (3): 811-46.

Goodhart, David. 2004. "Too Diverse?" *Prospect*, February, 30-7.

Gregg, Allan. 2006. "Identity Crisis: Multiculturalism: A Twentieth-Century Dream Becomes a Twenty-First-Century Conundrum." *Walrus* 3 (2): 38-47.

Hero, Rodney, and Robert Preuhs. 2006. "Multiculturalism and Welfare Politics in the USA: A State-Level Comparative Analysis." In *Multiculturalism and the Welfare State: Recognition and Redistribution in Contemporary Democracies*, edited by Keith Banting and Will Kymlicka. Oxford: Oxford University Press.

Huntington, Samuel. 2004. *Who Are We? The Challenges to America's National Identity.* New York: Simon and Schuster.

Jenson, Jane. 1998. *Mapping Social Cohesion: The State of Canadian Research.* CPRN Study F-03. Ottawa: Canadian Policy Research Networks.

Joppke, Christian. 2004. "The Retreat of Multiculturalism in the Liberal State: Theory and Policy." *British Journal of Sociology* 55 (2): 237-57.

Lukes, Steven. 1973. *Émile Durkheim: His Life and Work: A Historical and Critical Study.* London: Allen Lane.

Mendelsohn, Matthew. 2002. "Measuring National Identity and Patterns of Attachment: Quebec and Nationalist Mobilization." *Nationalism and Ethnic Politics* 8 (3): 72-94.

Miller, David. 1995. *On Nationality.* Oxford: Oxford University Press.

_____. 2000. *Citizenship and National Identity.* Cambridge: Polity Press.

Organisation for Economic Co-operation and Development (OECD). 2001. *The Well-Being of Nations: The Role of Human and Social Capital.* Paris: OECD.

Osberg, Lars, ed. 2003. *The Economic Implications of Social Cohesion.* Toronto: University of Toronto Press.

Putnam, Robert. 1995. "Bowling Alone: America's Declining Social Capital." *Journal of Democracy* 6:65-78.

_____. 2000. *Bowling Alone: The Collapse and Revival of American Community.* New York: Simon and Schuster.

_____. 2004. "Who Bonds? Who Bridges? Findings from the *Social Capital Benchmark Survey*." Paper presented at the annual meeting of the American Political Science Association, September 2-5, Chicago.

Sniderman, Paul, Louk Hagendoorn, and Markus Prior. 2004. "Predisposing Factors and Situational Triggers: Exclusionary Reactions to Immigrant Minorities." *American Political Science Review* 98 (1): 35-49.

Soroka, Stuart, Keith Banting, and Richard Johnston. 2006. "Immigration and Redistribution in the Global Era." In *Globalization and Social Redistribution*, edited by Michael Wallerstein, Pranab Bardhan, and Samuel Bowles. Princeton and New York: Princeton University Press, Russell Sage Foundation.

Soroka, Stuart, John Helliwell, and Richard Johnston. 2007. "Measuring and Modelling Interpersonal Trust." In *Social Capital, Diversity, and the Welfare State*, edited by Fiona Kay and Richard Johnston. Vancouver: University of British Columbia Press.

Soroka, Stuart, Richard Johnston, and Keith Banting. 2004. "Ethnicity, Trust and the Welfare State." In *Cultural Diversity versus Economic Solidarity*, edited by Philippe Van Parijs. Brussels: De Boeck Université.

Soroka, Stuart, Richard Johnston, and Keith Banting. 2007. "Ethnicity, Trust, and the Welfare State." In *Social Capital, Diversity, and the Welfare State*, edited by Fiona M. Kay and Richard Johnston. Vancouver: UBC Press.

Uslaner, Eric. 2002. *The Moral Foundations of Trust.* Cambridge: Cambridge University Press.

Ties That Bind and
Ties That Divide

Commentary

IN THEIR CHAPTER "TIES THAT BIND? SOCIAL COHESION AND DIVERSITY IN CANADA," Stuart Soroka, Richard Johnston and Keith Banting ask whether newcomers are integrated into Canadian society in several ways. They report a mixed set of results and come to a generally optimistic conclusion. I will argue that the weight of their own evidence gives us reason to be concerned about non-Whites and newcomers. In addition, I will sum up some new evidence that we should be worried about the integration of non-Whites and newcomers into Canadian social networks, and about the chilly welcome they have received from some Canadians.

While Soroka, Johnston and Banting use several measures of integration, I think we should focus on just two: how strongly people feel they belong in Canada, and how many voluntary associations they belong to. These are especially interesting, in part because as we examine them, they seem to yield opposing messages. Sense of belonging is less intense for newcomers. It grows over time, so first-generation immigrants have a relatively weak sense of belonging, but their children do not; and the more years people spend in Canada, the greater their sense of belonging. However, many non-White people (especially those of East Asian, African or Caribbean origin) feel a weak sense of belonging, even after allowing for generation, time in Canada and other relevant controls. This is bad news. But a look at the measure of membership in voluntary associations seems to result in better news, which is an important basis for Soroka, Johnston and Banting's guarded optimism. Association participation is at a lower level for first-generation immigrants, but it is actually at a higher level for second-generation immigrants, as well as those who have been here longer; and non-Whites do not have lower levels of participation.

Sense of belonging and association activity are also worthy of most of our attention because they are the best measures that Soroka, Johnston and Banting use. They use pride in Canada as well, but this does not clearly measure incorporation, and it is likely to be high for newcomers for reasons other than how well they are included in Canadian society. Most immigrants not only come here voluntarily, but they also go to a great deal of trouble to get here, which means they arrive highly motivated to be proud of their efforts and the results. Soroka, Johnston and Banting also use two measures of trust in other people in general. Such generalized trust measures are very popular, but they may not be the best kind to use. In a Saskatchewan study, Gerry Veenstra distinguishes a number of different kinds of trust: in people in general, in people in the neighbourhood, in people in the community, in professionals, in local or provincial or federal government and so on (2002). He found that these measures are not strongly related to each other and have sources in different kinds of social experiences. Thus, general trust is not a good indicator of levels of trust in Canadian people and institutions, which is the kind of trust relevant to issues of social inclusion. Another pair of measures, support for gay marriage and support for women staying home, are meant to tell us whether newcomers bring different (especially less liberal) values with them. But these measures consist of two simple questions that provide a somewhat crude assessment of views on just two of many potentially important issues. They cannot tell us how people's outlooks compare on the much wider range of issues and values important in Canada today. Many of these issues are different from, and arguably more important than, support for gay marriage or women staying home. For example, Canada's social programs are often seen as a source of pride and a component of our national identity, and the election studies include extensive questions about support for social programs. Finally, Soroka, Johnston and Banting consider voting, basing their observations on the 2004 federal election survey. But election surveys are limited to Canadian citizens who speak at least one of the official languages, and it is those who are especially interested in a survey's topic who are most likely to respond, so the election survey results are biased toward those immigrants who are most incorporated into Canadian society and politics. These data may well paint a rosier picture of incorporation than is accurate.

This leaves us with just two measures: belonging and voluntary association membership. Belonging is an important measure because it sums up a person's

entire range of inclusion and exclusion experience; a sense of belonging is greatest among those whom the rest of us treat as part of our collective. Soroka, Johnston and Banting agree that this measure gives us grounds for concern, since a sense of belonging is weaker among those who are newest here and weaker among non-Whites than others — which suggests that immigrants and non-Whites are not as fully included in Canadian society as they should be.

Voluntary association membership seems at first glance to give more encouraging results. However, these results do not mean what Soroka, Johnston and Banting hope they mean. Their intention is to measure inclusion in the bridging social networks that connect different kinds of people. Bridging networks are an important form of social inclusion in themselves, since they link people to many parts of the Canadian social structure through personal relationships. Bridging networks are also important for their consequences, which include both personal benefits (such as better access to good jobs, wider familiarity with diverse cultures, a greater sense of control over one's life and better health [Erickson 2003]) and, possibly, social benefits (which are thought to include trust, civic engagement and positive attitudes toward people different from oneself, and hence higher levels of cooperative action). Since bridging networks are so important, Soroka, Johnston and Banting try to measure them by counting people's memberships in associations they think play a bridging role.

But association memberships may not provide links to every member. First, many memberships are in name only, and people will not make contacts through an association unless they take an active part in its activities. Second, Soroka, Johnston and Banting use a dataset that asks about very broad categories of associations, such as recreational or youth-oriented ones. Within each broad category are many specific groups that vary greatly in their composition and in the networking opportunities they offer. Thus, even if the set of people who belong to recreational groups is diversified, the people in a specific group may not be. There may, for example, be Asian sports groups, European sports groups and a range of other ethnically specific sports groups, so that participation in such groups produces bonding (in-group) networks, not bridging networks. Studies of specific voluntary associations find that the membership of an individual association is more homogeneous than the local community as a whole; and from this already restricted menu, people select others even more like themselves as friends (McPherson and Smith-Lovin 1987), so a lot of network formation through

associations contributes to bonding, not bridging ties. Thus, active participation in voluntary associations may lead to diverse networks — and indeed it does, on the whole (Erickson 2004). But association activity may not lead to wider networks for everyone, and mere membership may not lead to wider networks for anyone.

To see how well connected newcomers and non-Whites really become, we need to look at direct measures of their actual networks. Fortunately, there is some recent Canadian evidence related to this topic. The 2000 federal election survey includes a simple but powerful measure of the range of ties in a person's network; I designed this with the help of Elisabeth Gidengil. Respondents saw a list of 15 occupations, ranging from very high to very low in prestige. They indicated whether they knew anyone in each of these occupations. Those who know people in many of the occupations are acquainted with a wide variety of people and have many bridging ties to different levels of our working world. Those who know people in very few occupations live in relatively narrow, homogeneous social worlds. I found that network diversity did indeed grow with *active* participation in voluntary associations, which is the single most powerful source of bridging ties (Erickson 2004). But I also found that newcomers (people born outside Canada) and non-Whites (those of non-European origin) have less diverse networks than others. This was true even when controls were used for a number of factors relevant to network building: age, education, gender, having a job, income, having a partner or children, association activity, region, and rural or nonrural location. Note that association activity was one of the controls; when newcomers and non-Whites have association activity levels equal to the native-born and White people, they do not gain as much network diversity. When immigrants and non-Whites build fewer social connections from the same social experiences and personal resources, it suggests social discrimination. It is no wonder, then, that immigrants and non-Whites less often feel that they really belong.

Social inclusion and the resultant sense of belonging depend on how positively people feel toward newcomers and non-Whites, so it is important to ask what leads to positive feelings and how the sources of those feelings may be changing. The 2000 election survey also contains useful data on this topic, which a colleague and I will report in detail in a forthcoming paper (Coté and Erickson forthcoming). Immigration to Canada was once overwhelmingly White, but non-White immigration has grown greatly over the past four decades, so there is a lot of overlap between the categories "immigrant," "non-White" and "minority." Thus,

we found that attitudes toward all these categories formed a single strong scale of tolerance. The scale was based on responses to these questions and statements:[1]

- How much more should be done for minorities in Canada?
- Is it more difficult for non-Whites to succeed in Canada?
- Immigrants make an important contribution to society.
- Too many recent immigrants just don't want to fit into Canadian society.
- We should look after Canadians born in this country first and others second.
- Canada should admit more immigrants.

People with high scores on this tolerance scale have a positive view of the way newcomers fit in and contribute to society, they are willing to admit more immigrants, and they think immigrants should get looked after as well as the native-born. Tolerant people are aware of the discrimination that exists against minorities and think that more should be done to help them. Thus, tolerant people are more likely to behave in social and political ways that will enhance the inclusion and sense of belonging of newcomers and non-Whites.

What factors encourage tolerance? First, consider voluntary associations, the source of some optimism for Soroka, Johnston and Banting. If association activity leads to bridging ties, and hence to greater intergroup trust and more positive feelings, then it should also lead to greater tolerance — as many scholars (notably Robert Putnam) strongly predict. But we found that associations vary greatly in their effects: some promote tolerance, some reduce it, some do nothing. People active in environmental associations are more tolerant, perhaps because their political discussions highlight equity issues. People active in sports associations are less tolerant, perhaps because sports associations often highlight competition and downplay serious discussion of social issues. The positive effects of environmental groups and the negative effects of sports groups remain, even after controlling for other relevant factors like education, which suggests that group activities have impacts of their own. Some other associations do not seem to make a difference to their members but instead attract people who are likely to be more or less tolerant than average.

Some other associations do not seem to make a difference to their members but instead attract people who are likely to be more or less tolerant than average. People active in professional associations are more tolerant because they

are more educated, not because of the effects of the association activity; this suggests that newcomers and non-Whites will be fully included in professional associations when they qualify for membership in them. The mirror image of this finding is the finding for labour unions: people active in unions are less tolerant because they are less well educated, not because of the effects of the union activity; this suggests that minorities will face problems gaining social inclusion and acceptance in some unions. People active in ethnic or religious groups are more tolerant because they are often minorities themselves. Three other kinds of groups (community, business and women's associations) have no effect on tolerance at all. Thus, just because Soroka, Johnston and Banting find that as many non-Whites as others belong to associations, and that second-generation Canadians have rather high levels of membership, we should not be too optimistic. The impact of membership depends on the kind of association people join: they will find a much warmer welcome in some groups than in others.

A second important source of tolerance is social networks themselves. Soroka, Johnston and Banting — as well as Robert Putnam, and a number of others — think that associations are important precisely because they diversify networks, which leads to greater trust in, and positive attitudes toward, a wide range of people different from oneself. The more diverse the people one knows, the more tolerant one should be. But we found that diversity is not all of a kind; some types of network diversity enhance tolerance and some reduce it. In Canada in 2000, those who knew people in a larger number of middle-class occupations were more tolerant, while those who knew people in a larger number of working-class occupations were less tolerant. This, no doubt, is partly because of education: middle-class people are better educated, and better-educated people are more tolerant, so middle-class friends and acquaintances exert tolerant influences, while the opposite holds true for working-class contacts.

However, education is not the whole story. As Soroka, Johnston and Banting (and many others) observe, immigrants have been doing badly in the labour market over the past few decades. On arrival, many have trouble getting work. They are offered positions of lower status than their credentials merit, and the work has fewer rewards than the work they did in their homelands. They do not catch up for a very long time. All too often, newcomers and non-Whites are forced to compete with working-class people for working-class jobs. Thus, newcomers and non-Whites have become an economic threat, and the people who feel

threatened are more often working class, not middle class. Economic competition and perceived threat lead to lower tolerance. We found some evidence to suggest that it is economic competition — not necessarily working-class status — that fuels intolerance. People active in professional associations are more tolerant; people who live in metropolitan areas are more tolerant; but people active in professional associations and living in big cities are *less* tolerant than other professionals. That is, professionals are less tolerant if they live and work in the places where newcomers and non-Whites are most concentrated, and hence provide the most competition. We found a hint of the same pattern in business association activity, though the effect is not quite statistically significant. So the root of intolerance is not working-class status but competitive threat to people in any line of work.

If this line of argument is correct, it leads to some disturbing conclusions. Continued discrimination in the labour market will lead to continued intense competition in the restricted fields in which minorities can find work. This pattern will appear to be class based, and hence it will be tempting for middle-class people to blame working-class intolerance on working-class people themselves, forgetting that they (middle-class people) do not always welcome newcomers and non-Whites into *their* area of the job market. An intolerant reception will help to make minorities feel that they do not belong here as much as others do. At present, governments and employers are doing little or nothing to change such trends, despite their manifest unfairness and the damage they do to social cohesion in Canada. We need some serious policy initiatives as soon as possible.

Without strong policy intervention, current feelings of relative exclusion may persist longer than they used to. Soroka, Johnston and Banting show that differences (like a weaker sense of belonging) among first-generation immigrants are often not found in the second generation, and they conclude that newcomer difficulties will simply resolve themselves over time. But much of today's second generation is composed of the children of immigrants who arrived here some time ago, when an immigrant could make it in the labour market much more quickly. Tomorrow's second generation is growing up now, and their parents are faring poorly in the labour market and being excluded from social networks. Their current and future lives may not be as successful as those of past second generations.

I therefore end this discussion by underlining the more pessimistic of Soroka, Johnston and Banting's mixed conclusions. "[T]he greater difficulty experienced by recent cohorts of immigrants in entering the labour force is

worrisome, and it has the potential to blunt wider forms of social and political participation"; and "remaining differences across newer ethnic groups underscore the continued importance of our multicultural strategies." I agree with Soroka, Johnston and Banting's assessment that immigrants are no threat to Canadian social cohesion. Given half a chance, newcomers soon become strong, positive contributors. But current practices and policies do not give all immigrants and non-Whites fair access to Canadian labour markets and social networks, making it difficult for newcomers to belong as much as they would like. There are serious problems, not with the immigrants but with their hosts.

Note

1 Possible responses to the statements ranged
 from "strongly agree" to "strongly disagree."

References

Coté, Rochelle, and Bonnie H. Erickson.
 Forthcoming. "Untangling the Roots of
 Tolerance: How Forms of Social Capital
 Shape Attitudes towards Ethnic Minorities
 and Immigrants." *American Behavioral
 Scientist.*
Erickson, Bonnie H. 2003. "Social Networks: The
 Value of Variety." *Contexts* 2 (1): 25-31.
———. 2004. "The Distribution of Gendered
 Social Capital in Canada." In *Creation and
 Returns of Social Capital: A New Research
 Program*, edited by Henk Flap and Beate
 Volker, 27-50. London and New York:
 Routledge.
McPherson, J. Miller, and Lynn Smith-Lovin.
 1987. "Homophily in Voluntary
 Organizations: Status Distance and the
 Composition of Face-to-Face Groups."
 American Sociological Review 52 (3): 370-9.
Veenstra, Gerry. 2002. "Explicating Social
 Capital: Trust and Participation in the Civil
 Space." *Canadian Journal of Sociology* 27 (4):
 547-72.

The Political
Engagement of
New Canadians:
A Comparative
Perspective

T WO DEBATES IN CONTEMPORARY CANADIAN POLITICS THAT WOULD SEEM TO SHARE
some common ground have failed to cross paths to date. The first revolves
around the potential challenges posed to social cohesion by the increasingly
diverse ethnic and cultural composition of Canada's immigrant population. The
second concerns the broad-based disengagement from politics that has been a
signal feature of recent Canadian politics. That difficulties in integrating new-
comers to Canada might be one of the reasons behind democratic disengagement
has scarcely been raised as a possibility, much less explored in any depth.

It may be because the answer seems self-evident. It has long been known
and acknowledged that foreign-born Canadians participate in elections at the
same rate as the native-born (Black 2001). They vote, furthermore, for main-
stream parties rather than establishing ethnic-based alternatives (Kymlicka 1998,
18-19). By these basic measures, political engagement and attachment to the
political system appear to be alive and well among new Canadians. We thus find
research on their political involvement focusing more on institutional dynamics,
examining such areas as the representation of ethnic minorities among MPs in the
House of Commons (Black and Lakhani 1997; Stasiulis and Abu-Laban 1991;
Pelletier 1991). Any gaps or deficits identified in this research optic are normally
seen as reflections of the political system and the barriers it poses to full partici-
pation by Canadians from all backgrounds. The civic engagement of new
Canadians — their capacity and desire to involve themselves fully in the political
life of their adopted country — does not arise as a significant issue.

There are, however, good reasons to look more closely at this dimension of
the matter. Voter participation is a venerable barometer of political engagement,

but it is only one simple behavioural measure. It is possible that engagement of a deeper sort is lacking among those who have come to Canada from elsewhere, that their integration in the Canadian polity is relatively superficial. Getting people to the polls can, after all, be achieved in many ways. In tightly knit groups — a fair description of many of Canada's ethnic communities — the politically indifferent can sometimes be mobilized by influential community leaders who encourage community members to vote for a particular party or candidate. Certainly, there have been candidate nomination meetings, particularly in the past 20 years, for which the "ethnic vote" has come out in full force to back a favoured nominee (Stasiulis and Abu-Laban 1991, 16-40). In short, relatively simple forms of political participation can, in certain instances, signal ethnic solidarity as much as integration into the broader political life of the country.[1]

We can also ask whether there are any distinctive trends in political engagement among the newest of new Canadians. The liberalization of Canada's immigration law in the late 1960s opened the door to immigrants from all parts of the world, but it is only in the past 25 years that the blend has shifted decisively in favour of newcomers from nontraditional source countries outside Europe.[2] Moreover, tendencies toward disengagement from Canadian society could become more pronounced as larger communities of particular ethnic groups gradually form in this country. Furthermore, recent newcomers are more likely to hail from countries that are nondemocratic and would therefore lack experience with political participation, while others may come from places where the political culture differs greatly from Canada's, making integration in the Canadian polity more challenging. There may, then, be changes abroad within the immigrant population that will take time to appear as significant trends in the foreign-born population as a whole. To identify possible patterns of this sort, it is important to consult current data sources and to pay close attention to the experiences of recent cohorts of immigrants.

Also potentially contributing to new dynamics in the political integration of new Canadians are long-term changes in the media environment that have been linked to broader processes of political disengagement. The development of new forms of media, such as the Internet, and the proliferation of existing outlets through developments such as cable and satellite TV have created a more diverse and eclectic media environment than existed 30 years ago. The benefit of this, indeed the driving force behind it, is the enhancement of individual choice,

which allows people to pursue their own particular interests and diversions in concert with like-minded souls. The downside, however, is that it can lead to the fragmentation of civic discourse, as the possibilities for public conversation in shared media venues, such as national newspapers and television programs, diminish (Wattenberg 2003; Prior 2002). To the extent ethnic minorities in Canada have responded to this new environment by producing and consuming ethnically oriented media offerings at the expense of traditional Canadian fare, their engagement with Canadian society may have suffered, with potentially significant consequences for political interest and participation. Such effects would depend, of course, on the content of different ethnic media; some could well provide significant Canadian content and might, on balance, be expected to facilitate rather than hinder integration processes (Black and Leithner 1988). Perhaps more relevant, then, is possible growth in the availability of foreign media, particularly through electronic means (for example, Web versions of foreign newspapers), which would allow immigrants to keep abreast of events in the home country, but at the potential expense of involvement in the political life of their adopted country (Zhang and Hao 1997).

Lastly, the experience of other countries suggests the need to be attentive to the possible intersection of processes of democratic disengagement and social-cohesion challenges attendant on growing ethnic diversity. In the UK, for example, the debate on democratic disengagement parallels Canada's in many ways. It has become a significant issue in the last 10 years or so, its import amplified, as in Canada, by the large drop in voter turnout in the past two general elections. The widespread withdrawal of young people from traditional political activity is cause for great concern and an important part of the story behind democratic disengagement in both countries (United Kingdom, Electoral Commission 2002a; Fahmy 2003; Phelps 2004). But, unlike those in Canada, ethnic minorities in the UK have also been identified as a segment of the population markedly detached from national politics (Saggar 1998; United Kingdom, Electoral Commission 2002b). It is possible that we in Canada have overlooked something of significance; or that the UK experience is a harbinger of what lies ahead if our multicultural society moves down a path that the British are already following.

There are, then, good reasons to probe the matter more deeply. The analysis in this chapter undertakes a broad survey of levels of political engagement among new Canadians. Beginning with current Canadian survey data, the chapter

examines various measures of political engagement beyond simple electoral participation. In particular, the focus is on a series of interrelated political-attentiveness factors that have been identified as key deficit areas for young Canadians: political knowledge, political interest and attention to politics in the media (Blais et al. 2002, chap. 3; Howe 2003). Foreign-born Canadians are measured against the native-born to see if significant differences are apparent in these important areas of political engagement. Recent arrivals and those who arrived long ago are compared in an effort to identify emergent changes within Canada's immigrant population. The engagement levels of foreign-born respondents are also juxtaposed with those of young Canadians — the most decidedly disengaged segment of the population — to see whether any shortfalls that appear should be considered significant when the two groups are compared.

Further analysis provides other relevant comparisons. First, past Canadian surveys are consulted to see if current trends represent new developments or simply replicate long-standing patterns. Second, data from the British case are analyzed in order to pinpoint key dimensions of disengagement among ethnic minorities in the UK and to shed light on underlying factors contributing to this state of affairs. Out of these various elements of comparative analysis, a consistent conclusion emerges: the growing ethnic and cultural diversity of Canada's immigrant population has not generated significant problems of political integration. Further reflection on the general approaches taken to accommodate and integrate newcomers in Canada and the UK suggests important differences that help account for Canada's relative success in this regard.

Canada at Present

THE STARTING POINT FOR THE COMPARISONS IS CANADA AT THE PRESENT TIME. THE data sources used are the 2000 and 2004 Canadian Election Studies combined into a single dataset based on common questions asked in the two surveys. This ensures reasonable sample sizes for the smaller subsamples (immigrants of different periods) that are the key focus of the analysis.

Both studies are limited to Canadian citizens and those able to speak either English or French.[3] Since naturalization rates for immigrants are high in this country (Helliwell 2003), as is knowledge of official languages (a requirement for

citizenship in any event), the larger part of the foreign-born population in Canada would have been eligible to participate in the surveys.[4] Still, exclusions of this sort must be borne in mind, particularly when comparisons are drawn to the British case, in which the criteria for potential inclusion in the relevant surveys do differ somewhat.

Table 1 takes a first cut at the data, providing comparisons between native-born Canadians and those born elsewhere on various dimensions of political engagement. On almost all the measures considered, the foreign-born appear more engaged than other Canadians. With respect to political knowledge, measured by a series of questions asking respondents to identify prominent politicians and party policies, 46.6 percent of those born outside Canada were able to answer at least half of the items correctly. This figure is nearly five points higher than the corresponding result for native-born Canadians (41.9 percent). The foreign-born are also more interested in politics, as 52.5 percent fall into the top half of a 0-to-10 interest scale compared with 48.0 percent of native-born Canadians. Similarly, on a variety of measures, those born elsewhere are more inclined to pay attention to politics in the media, both print and broadcast. Indeed, the largest gap between the two groups is related to the proportion watching the leaders' debates during the 2000 and 2004 election campaigns; the percentage tuning in among the foreign-born is almost 10 percent higher than among native-born Canadians (54.7 versus 46.9). It is only with respect to voter turnout that foreign-born respondents appear less politically engaged, but the difference here is only 1.7 percentage points — a statistically significant but minor difference.[5]

Table 2 uses the same measures of political engagement as table 1; but, in recognition of potential changes in the political engagement of the foreign-born attendant upon evolving patterns of immigration over time, the data are now broken down by period of immigration. The periods considered are 1954 and earlier, 1955-69, 1970-84 and 1985-2003. This division provides reasonable sample sizes in each category and is also aligned with the changes in immigration policy that have altered the composition of Canada's foreign-born population since the late 1960s. Thus, within the two earliest cohorts, most respondents are from traditional source countries in Western and Eastern Europe as well as the United States. Only 21 percent (1954 and earlier) and 23 percent (1955-69) came to Canada from other parts of the world. In the more recent cohorts, the percentage from other countries rises sharply to 64 percent (1970-84) and 75 percent

Table 1 616

Measures of Political Engagement, Native-Born and Foreign-Born Canadians, 2000-04 (percent)

	Born in Canada	Born outside Canada
Voted in federal election	84.9	83.2
Political knowledge[1]	41.9	46.6
General political interest[2]	48.0	52.5
Newspaper reading[3]	44.4	48.4
Attention to election in newspapers[4]	32.1	38.5
Attention to election on TV[5]	43.4	45.7
Watched one of the leaders' debates	46.9	54.7
(Weighted N, range)[6]	(4,918-6,678)	(847-1,204)

Source: Calculations by author based on data from the 2000 and 2004 *Canadian Election Study*.
[1] Percentage of respondents who correctly answered more than half of the knowledge questions.
[2] Percentage of respondents who scored 6 or more on a 10-point scale.
[3] Percentage of respondents who reported reading a newspaper five days per week or more.
[4] Percentage of respondents who scored 6 or more on a 10-point scale.
[5] Percentage of respondents who scored 6 or more on a 10-point scale.
[6] Weights provided in the datasets (designed to produce nationally representative results) have been applied. Sample size varies because of differences in the number of respondents with valid data for the relevant survey question(s).

(1985-2003). It is this infusion of new Canadians from a panoply of places diverse in their languages, cultures and political traditions that raises the question of whether the political integration of newcomers to Canada might be emerging as a significant problem.

Two other features of the different immigrant cohorts are important to note. First, more recent arrivals, not surprisingly, are much younger than those who settled in Canada long ago. Whereas 61 percent of the 1985-2003 cohort are under age 40, almost all (97 percent) of the pre-1955 group are 50 or over. Secondly, immigrants of all periods tend to have slightly higher levels of education than native-born Canadians of the same age. Since both variables — age and education — have considerable effects on political engagement, they must be taken into account in seeking to isolate the effects of period of immigration.[6]

Table 2 works with the same measures of political engagement as table 1 to see whether these vary significantly by period of immigration. The first column simply replicates figures from table 1 for native-born Canadians. The next four columns report differences for the various percentage-based measures between immigrants of different periods and those born in Canada, controlling for age and education.[7] The final column in the table provides the same calculations for young Canadians as a whole, an important comparison group for assessing the significance of any differences that appear within the foreign-born population. The cited figures again represent percentage gaps, in this case between those aged 18 to 29 and all other respondents. The only control variable used in the calculations for young adults is education.

With the data laid out in this fashion, some important patterns are apparent. First, recent arrivals to Canada — those who immigrated to Canada in the 1985-2003 period — are less politically integrated than both earlier immigrants and native-born Canadians on two particular measures: voting and political knowledge. Taking into account age and education differences, there remains a 14.5 percent voter turnout gap in the 2000 and 2004 elections between recent immigrants and those born in Canada (a difference that has nothing to do with citizenship status, since all survey respondents were Canadian citizens).[8] And whereas immigrants from earlier periods are more knowledgeable about politics than other Canadians, those who arrived in the past 20 years are considerably less knowledgeable (17.2 percent fewer are able to answer more than half of the items correctly).

Table 2 618

| | Born in Canada | Immigrant cohorts |
		Before 1955
Voted in federal election	84.9	-2.8
Political knowledge[2]	41.9	7.2
General political interest[3]	48.0	5.6
Newspaper reading[4]	44.4	-6.1
Attention to election in newspapers[5]	32.1	3.5
Attention to election on TV[6]	43.4	1.2
Watched one of the leaders' debates	46.9	-1.8
(Weighted N, range)[7]	(4,918-6,678)	(135-177)

Source: Calculations by author based on combined data from the 2000 and
2004 *Canadian Election Study*.
Note: Calculations for immigrant cohorts control for age and education; calcula-
tions for the 18-29 age group control for education.
[1] Includes all respondents under age 30 (immigrants and native-born). The
comparison category for this group is all respondents aged 30 and over.
[2] Respondents who correctly answered more than half the knowledge questions.
[3] Respondents who scored 6 or more on a 10-point scale.
[4] Respondents who reported reading a newspaper five or more days per week.
[5] Respondents who scored 6 or more on a 10-point scale.
[6] Respondents who scored 6 or more on a 10-point scale.
[7] Weights provided in the datasets (designed to produce nationally representa-
tive results) have been applied. Sample size varies because of differences in the
number of respondents with valid data for the relevant survey question(s).

Table 2

Political Engagement of
Native-Born Canadians
and Immigrant Cohorts,
2000-04 (percent)

1955-69	1970-84	1985-2003	All respondents aged 18-29[1]
0.9	-3.0	-14.5	-21.1
5.6	4.3	-17.2	-25.6
3.8	-4.2	-2.6	-17.4
3.3	0.0	-1.5	-18.7
6.2	4.8	0.9	-9.7
-1.8	-4.5	1.7	-12.2
-0.2	5.9	5.5	-18.6
(214-310)	(239-331)	(228-351)	(1,091-1,548)

That these two measures should pop out in tandem is not surprising. Other research has shown that knowledge and electoral participation have become more tightly linked over time in Canada. The trend reflects a generational change: among older generations knowledge had, and continues to have, relatively little impact on voting, whereas among younger generations (those under 40) its effects are becoming quite acute (Howe 2003). Since many recent immigrants are part of this younger generation, they too have been affected by this intergenerational transformation.[9] Thus, while the strong connection between knowledge and voting among recent arrivals is worth marking as one way in which the political integration of Canada's immigrant population has become more challenging in recent times, it is equally important to underline that it reflects a phenomenon common to young Canadians in general; it is not peculiar to recent immigrants.

Another salient result recorded in table 2 — indeed, probably the more critical point to underline — is the absence of noteworthy differences on the other measures of political engagement for recent immigrants. Those who have come to Canada in the past 20 years exhibit, within the margins of error associated with the sample sizes involved, levels of political interest and attention to politics in the media on a par with other Canadians, as well as earlier immigrants. If new immigrants are lacking in political knowledge, they appear eager to learn — or at least as eager as the next Canadian, taking into account age and educational differences across groups. Given that political interest and attention to politics in the media are strong predictors of political knowledge, it is to be anticipated that the knowledge deficit for this cohort of immigrants will disappear over time, and that their electoral participation will follow suit. This expectation will be further examined later in the chapter.

Set against these patterns for recent immigrants to Canada are those for young Canadians, shown in the far-right-hand column of table 2. Some important contrasts are evident. The voting and knowledge deficits for those under 30 are considerably larger (-21.1 percent and -25.6 percent, respectively) than the gaps separating recent immigrants from other Canadians.[10] Moreover, unlike recent immigrants, younger Canadians lack the motivational and behavioural proclivities that might help close these gaps over time — that is, political interest and attention to politics in the media. On all the measures considered, young Canadians trail the rest of the population by sizable margins, ranging from -9.7 percent to -18.7 percent. Whether those under age 30 will continue to exhibit these tendencies as they grow older is, of course, a critical question, and it informs much of the current research on political

disengagement among the young (Blais et al. 2004; Howe 2003; O'Neill 2001). It will be answered definitively only as time marches on. But it is clear at present that young Canadians have more ground to make up across more dimensions of political engagement than do the newest cohort of new Canadians.

Canada in the Past

THUS, BASED ON RECENT SURVEYS OF THE CANADIAN POPULATION, NEW IMMIGRANTS appear relatively well integrated in terms of their current levels of political engagement and expectations for the future. This conclusion is reinforced by analysis of survey data from earlier periods. One relevant source is the 1984 *Canadian Election Study*. The study is sufficiently dated as to provide insight into a different era, a period when the liberalization of Canada's immigration policy was only 17 years old and early signs of obstacles to the political integration of new Canadians would likely have been starting to appear. The study is also relevant because it includes a reasonable selection of knowledge-based questions, one of the areas where recent immigrants are lagging by a fair margin in the 2000-04 data. As with the most recent Canadian Election Studies, the sample for the 1984 study was limited to citizens and to those able to speak one of the two official languages.[11]

Table 3 presents results designed to assess commonalities and differences between the earlier period and the present. The method of presentation is the same as in the previous table: percentage-based figures on various measures of political engagement are provided for native-born Canadians, followed by three columns reporting differences between this comparison group and various immigrant cohorts, controlling for age and education. What jumps out from the table is the similarities to current patterns of political engagement within the foreign-born population. Those immigrants who had been long resident in Canada by 1984 showed no signs of lagging behind the native-born in any respect. More recent arrivals, those immigrating in the 1970-84 period, were, as in the previous table, less politically engaged, but by a statistically significant margin ($p \leq .05$) in only two areas political knowledge (-20.0 percent) and, electoral participation (-7.1 percent). Thus, the same interpretation offered earlier suggests itself here: if newly arrived immigrants in 1984 were lacking in knowledge and less inclined to vote as a result,

Table 3 622

Political Engagement of
Native-Born Canadians
and Immigrant Cohorts,
1984 (percent)

	Born in Canada	Immigrant cohorts		
		Before 1955	1955-69	1970-84
Voted in federal election	84.6	0.1	-1.4	-7.1
Political knowledge[1]	40.8	-2.6	0.9	-20.0
General political interest[2]	59.7	3.1	4.6	4.1
Read about politics in newspapers and magazines ("often")	41.0	-3.7	4.6	-6.2
Watch political programs on TV ("often")	30.7	-2.5	-6.5	-5.0
Watched one of the leaders' debates	66.3	-4.0	-3.5	8.6
(Weighted N, range)[3]	(2,873-2,889)	(205-207)	(180-183)	(95-96)

Source: Calculations by author based on the *Canadian Election Study* (2004).
Note: Calculations for immigrant cohorts control for age and education.
[1] Respondents who answered 4 or more knowledge questions (out of 10) correctly.
[2] Respondents who answered that they follow politics "very" or "fairly" closely.
[3] Weights provided in the datasets (designed to produce nationally representative results) have been applied. Sample size varies because of differences in the number of respondents with valid data for the relevant survey question(s).

they nonetheless appeared eager to learn more and become fully integrated into the Canadian polity. Now, however, the expectation can be tested against subsequent reality by referring to the 2000-04 data. And the finding in the previous table was, of course, that the 1970-84 cohort was on a par with other Canadians in all areas of political engagement. Thus the knowledge deficit of this group in 1984 (-20.0 percent in table 3) is, in the 2000-04 data, a small knowledge surplus (+4.3 percent in table 2), while the voting gap in 1984 (-7.1 percent in table 3) has now diminished to statistical insignificance (-3.0 percent in table 2). Based on this one test, the conclusion would be that newcomers to Canada, if initially lacking in certain areas, make significant efforts from the start to understand Canadian politics and equip themselves for political participation, and they do eventually succeed in closing the gap to the point that their levels of political engagement are indistinguishable in all relevant respects from those of the native-born.

One other survey, from an earlier date still, reinforces the notion that there is a long-standing pattern of newcomers to Canada facing certain obstacles to political integration at the start that they eventually succeed in surmounting. The poll, a Gallup survey from 1956, is a useful early benchmark, as it predates the opening of Canada's immigration doors to migrants from all corners of the globe by a dozen years. It addressed only one area relevant to democratic engagement, but that area — political knowledge — is the most critical one, judging by previous results. This was measured, as in the 1984 survey, by a series of questions testing respondents' familiarity with Canadian provincial premiers. The survey also, unlike many other early Gallup polls, asked respondents whether they were born in Canada or elsewhere. It did not, however, ask those born outside Canada when they immigrated, so it is not possible to categorize immigrants by period of entry into Canada. But since people tend to immigrate early in life, it is a safe assumption that the younger immigrants, on the whole, would have arrived in Canada more recently than the older ones.[12] In other words, the age of survey respondents can serve as a rough proxy for period of immigration.

The results for this one important measure of political engagement, displayed in table 4, are consistent with the patterns seen earlier. Younger immigrants, likely to have been in Canada for a shorter period, were less knowledgeable than other Canadians (-7.7 percent); whereas older immigrants, more likely to be long-time residents, were *more* knowledgeable than other Canadians by about the same margin. As before, it is possible to fast-forward to later periods to see what subsequently

Table 4 624

Political Knowledge of
All Native-Born
Canadians, and of
Immigrants by Age,
Canada, 1956 (percent)

	Native-born Canadians	Immigrants, by age[1]		
		50 and over	40-49	21-39
Political knowledge[2]	39.7	7.8	10.4	-7.7
(N)	(1,640)	(188)	(78)	(119)

Source: Calculations by author based on an October 1956
Gallup poll (Canadian Institute of Public Opinion, poll 252).
[1] Calculations for immigrant age groups control for education.
[2] Percentage of respondents who answered 3 or more knowl-
edge questions (out of 10) correctly.

happened to the under-40 immigrants of the mid-1950s. Virtually all would have immigrated in 1954 and earlier and would consequently have fallen into the oldest cohort in the 1984 and 2000-04 data. Earlier tables revealed that this cohort was, at these later points, as knowledgeable about politics as other Canadians and indeed equally politically engaged across the board. Thus, the 1956 data are consistent with a general pattern of an early knowledge gap for new immigrants that gradually disappears over time and removes barriers to full political integration.

So viewed from the vantage point of both past and present, the general story of political engagement among Canada's foreign-born population seems to be one of successful integration. In an initial transition period, levels of political knowledge lag, as does participation to some degree; these two tendencies may have become more tightly intertwined in recent times, in keeping with a general pattern among Canadians below a certain age. But these are not surprising or troubling results. More consequential for long-term outcomes is that from the beginning, new Canadians show the same level of interest as their native-born compatriots of similar age and education and are as attentive to Canadian politics in the media. The result, consistent with previous findings (Black 1987, 1991; Simard et al. 1991), is that eventually they are as politically involved in all respects as native-born Canadians.

This is the optimistic assessment. Another view is that there is nothing in these figures to suggest that newcomers to Canada have avoided the rising tide of political disengagement that has affected the general population in recent times; they have simply continued to keep pace with broader trends. Thus, to the extent policies and initiatives are put in place to address the general problem of democratic disengagement in Canadian society, it would be prudent and appropriate to tailor approaches simultaneously to newcomers and their particular circumstances. This theme is revisited in the conclusion to this chapter.

Great Britain

THE FOREGOING ANALYSIS INDICATES THAT THE LACK OF ATTENTION ACCORDED THE foreign-born population in recent investigations into democratic disengagement in Canada is, to some degree, understandable. Whatever disengagement there is among new arrivals to this country is relatively superficial and dissipates

with time; to the extent newcomers are showing signs of flagging political engagement, this tendency would appear to be no more pronounced than that which is affecting the population at large. In Great Britain, by contrast, the debate on democratic disengagement has generated considerable commentary on the particular challenges of achieving the full involvement of immigrant communities in British political life. This reflects a more general pattern of significant and entrenched divisions in the British case, as measured by a wide range of social and economic indicators, between immigrant communities and mainstream British society (for further details, see Randall Hansen's chapter in this volume).

The British debate on integration has a lengthy history, dating back to the postwar years, when significant numbers of immigrants from extant and former British colonies began arriving in Britain, and it has of course gained greater significance since the London bombings of the summer of 2005. Given that Canada and Britain have much in common, not least the aspiration to ensure continued social and political cohesion within their increasingly diverse populations, it is worth drawing some direct comparisons to shed light on obstacles to successful political integration of immigrant communities and ways of overcoming them.

The first step in the analysis is to identify particular areas of political involvement where newcomers to the UK are trailing other Britons. This will then inform the identification of underlying causes of the shortfalls observed, which in turn will serve as the basis for some general reflection on features of Canadian and British society that have conditioned the ways in which new Canadians and Britons adapt to the political life of their adopted countries.

The data source drawn upon for the survey analysis is the 1997 *British Election Study (BES)*. The study has several advantages over other possible sources. First, because the proportion of nonnative residents is smaller in the UK than in Canada,[13] sample sizes are a problem with many potential data sources. In the 1997 *BES*, however, "ethnic minorities" were oversampled, producing a sample size of 707. The 1997 study also has a reasonable selection of knowledge-based questions, along with other measures of political engagement. It is, furthermore, relatively recent — not as recent as might be ideal, given that the debate on democratic disengagement in the UK really took flight following the plunge in voter turnout in the 2001 election (to 59 percent), but recent enough to allow for reasonable comparisons with current Canadian data. By carrying out similarly structured analysis focused on newcomers from different periods, it is possible to

identify precise areas where political engagement among Britain's ethnic minority communities is flagging. However, comparisons to earlier periods in the British case are not feasible, because of a lack of suitable data sources.

In utilizing the 1997 *BES*, we must bear certain characteristics of the surveyed population in mind. First, the oversampling was of "ethnic minorities," the term used in Britain to refer to groups that in Canada would be called "visible minorities." In the British case, this means mainly people of Asian background (principally from India, Pakistan and Bangladesh) and Blacks of African and Caribbean background. While the ability to speak English seems to have been a precondition for participating in the survey,[14] British citizenship was not. However, citizens of Commonwealth countries are eligible to vote in UK elections; thus most of the sample was, in fact, composed of eligible voters.[15] Nonetheless, to ensure comparability with the Canadian results, the British analysis was rerun to include only those members of ethnic minorities who were UK citizens — about two-thirds of the sample. No significant differences emerged. Therefore, results for the full sample of citizens and noncitizens are reported.

Another sampling issue is that the ethnic minority sample in the 1997 *BES* included both respondents born in the UK and those born elsewhere. This matter can be addressed easily enough, since respondents were asked if they were born in the UK and, if not, when they immigrated. Thus, in what follows, the sample is divided by period of immigration, though a separate ethnic minority sample born in the UK is also retained as it provides some additional insight into patterns of engagement among Britain's minority communities. Missing from the immigrant subgroups, however, because they were not asked the question about country of birth, are the small numbers of respondents who would have been born outside the UK but were not part of the ethnic minority subsample.[16] Another check to ensure comparability with the Canadian data was therefore undertaken. The Canadian samples for the two most recent immigrant cohorts were limited to respondents likely, judging by country of origin, to fall into the visible minority category, and the analysis was rerun. None of the results reported earlier changed in any significant way, so inclusion in the Canadian case of immigrants who were not visible minorities does not account for the contrasting patterns between Canada and the UK highlighted later.

These caveats and cautions duly noted, the analysis of the UK data begins in table 5. Results are presented in the same fashion as in the Canadian analysis.

Table 5 628

	Nonethnic minorities	Ethnic minority cohort
		Born in the UK
Voted in 1997 general election	78.6	0.0
Political knowledge[2]	47.3	-16.7
General political interest[3]	69.6	-7.2
Newspaper reading[4]	52.7	-8.0
Attention to politics in newspapers[5]	39.5	-1.2
TV news viewing[6]	66.3	-4.7
Attention to politics on TV news[7]	64.5	-5.6
(Weighted N, range)[8]	(2,763-2,769)	(208-209)

Source: Calculations by author based on combined data from the 1997 *British Election Study* and the 1997 *British Election Study: Ethnic Minority Survey.*
Note: Calculations for ethnic minority cohorts control for age and education; calculations for the 18-29 age group control for education.
[1] Includes all respondents under age 30 (immigrants and nonimmigrants). The comparison category for this group is all respondents aged 30 and over.
[2] Respondents who answered 5 or 6 knowledge questions (out of 6) correctly.
[3] Respondents who answered "some," "quite a lot" or "a great deal."
[4] Respondents who reported reading the newspaper four or more days per week.
[5] Respondents who answered "some," "quite a bit" or "a great deal."
[6] Respondents who reported watching TV news seven days per week.
[7] Respondents who answered "some," "quite a bit" or "a great deal."
[8] Weights provided in the datasets (designed to produce nationally representative results) have been applied. Sample size varies because of differences in the number of respondents with valid data for the relevant survey question(s).

Political Engagement of
Nonethnic Minorities
and Ethnic Minority
Cohorts, United
Kingdom, 1997
(percent)

Immigrated			All respondents aged 18-29[1]
Before 1970	1970-84	1985-97	
3.4	4.8	-4.2	-20.0
-11.7	-12.9	-29.3	-31.6
-2.2	-11.3	-16.5	-16.2
-12.7	-15.7	-21.1	-12.2
-4.1	-9.9	-9.3	-16.8
5.9	4.5	6.0	-21.6
2.4	-2.6	-3.9	-20.4
(178)	(199-200)	(110-112)	(761-762)

The first column, headed "nonethnic minorities," reports percentage-based measures of political engagement for all those who were not part of the ethnic minority sample — essentially equivalent to the "born in Canada" comparison group, given that the vast majority of these respondents would have been born in the UK. The next four columns report differences on these measures, controlling for age and education, between this comparison category and four groups of interest: ethnic minorities born in the UK and ethnic minorities born elsewhere who immigrated to the UK in three different periods.[17] Comparisons with young adults are provided in the final column, which reports differences between 18-to-29-year-olds and those 30 and over on the various percentage-based measures.[18]

There are some familiar patterns in the UK results. As in Canada, recent immigrants to the UK are, on most of the measures, less politically engaged than ethnic minority respondents who have been in the country for longer periods. This is consistent with the notion that there is a period of acclimatization during which new immigrants gradually become better integrated into the political life of their adopted country. It is also the case in the UK that engagement levels among the 18-to-29-year-olds serve as a useful foil to the results for ethnic minority categories. As in Canada, on several measures, recent immigrants and young people in the UK look much alike (the respective knowledge gaps, for example, are -29.3 percent and -31.6 percent). However, ethnic minorities resident in the UK for longer periods do not fall below the norm as much as young adults; this pattern also broadly parallels the Canadian data.

At the same time, there are also some significant differences between the British and Canadian cases. Whereas in Canada newcomers eventually close the gap and become as politically engaged as other Canadians, they do not appear to do so in the UK. Immigrants arriving in 1969 and earlier, while more politically engaged than recent arrivals, have still not caught up with others in British society, particularly in areas such as political knowledge, where today's recent immigrants are lagging the most. The same is also true of ethnic minority respondents born in the UK.[19]

The reason for these persistent gaps would appear to be that in the UK the political disengagement of newcomers is more pervasive than in Canada. It was observed earlier that new Canadian immigrants trailed the native-born in two areas only: political knowledge and electoral participation. With respect to political interest and following politics in the media — important motivational and behavioural

bases for further learning and political integration — immigrants were as engaged and attentive as other Canadians right from the start. In the UK, however, new immigrants are lagging in these other areas. Two measures in table 5 stand out: general political interest and newspaper reading. The gaps separating recent immigrants from the rest of the British population on these items are considerable: -16.5 percent and -21.1 percent, respectively. The differences remain significant for ethnic minorities resident in the UK for longer periods, including those born in the country. Some of the shortfall in political interest and newspaper reading is perhaps made up by the other important vehicle of political information — television news viewing — where the predilections of the ethnic minority population appear to be indistinguishable from those of the rest of British society.[20] But judging by the overall pattern in table 5 of significant and persistent political disengagement across any number of areas, this alone is not sufficient to draw ethnic minorities fully into the political fold.

One other interesting contrast with the Canadian case involves electoral participation. Despite their shortfalls in other areas of political engagement, ethnic minorities in the UK, both recent arrivals and long-time residents, vote at essentially the same rates as other Britons. In Canada, in contrast, political disengagement — more specifically, a knowledge deficit — appeared to be dragging down participation among new immigrants. The behaviour of ethnic minorities in the UK also contrasts with that of young people in that country. Those aged 18 to 29, in keeping with their significantly lower levels of knowledge, interest and attention to politics in the media, are considerably less likely to vote than older persons. The uninhibited participation of ethnic minorities in the UK raises questions about voter mobilization processes in that country. How is it that people who would be expected to stay home from the polls by virtue of a relative lack of political interest and knowledge instead participate at perfectly respectable rates? It may be that mobilization efforts grounded in appeals to ethnic solidarity, of which there has been much discussion recently in the British media (Casciani 2003, 2005), are one important explanation.

All in all, then, there is good reason for the concerns that have been expressed about the political integration of immigrant communities in the UK.[21] Unlike the Canadian case, the shortfalls in various areas cannot be explained away as the early and ephemeral phase of a normal transition period for newcomers. Instead, there is evidence of a more persistent and pervasive detachment from British politics among ethnic minorities.

What might account for the general difference between the two countries? The figures in table 6, based again on the 1997 *BES*, highlight some likely causal factors. The first variable examined is language spoken at home (English or other). Given that newspaper reading is one important area where ethnic minorities are trailing behind the rest of British society, it would not be surprising to see linguistic fluency playing a role. The second factor considered is strength of British identity, measured by a question that asked ethnic minority respondents whether they think of themselves as British or some other identity (see panel a). The potential relevance here is that affective sentiments often serve as an important motivational springboard for political involvement (Reitz 1980; Leighley and Vedlitz 1999, 1095-6); those who do not feel deeply attached to the larger British community would be less likely to concern themselves with its political life.[22] Finally, social class is introduced as a potentially pertinent division (see panel b). Class has historically been a major factor in many aspects of British politics, and UK immigrants are disproportionately concentrated in lower occupational categories as well as the ranks of the unemployed. In addition to possible obstacles to political integration posed by language and identity, this basic socioeconomic reality needs to be considered.

In all cases, significant relationships emerge between these three underlying factors and the measures of political engagement where the foregoing analysis revealed the greatest gaps for ethnic minorities: political knowledge, political interest and newspaper reading. Those who speak a language other than English at home, those indicating a stronger ethnic than British identity and those in the lower social classes tend, on the whole, to have lower levels of knowledge and interest and are less inclined to read newspapers on a regular basis.

Table 7 draws on these findings to assess how much the three factors help explain lower levels of political engagement among Britain's ethnic minorities. The first set of figures simply replicates the results from table 5, reporting the gaps in knowledge, interest and newspaper reading between the larger British population and the four categories of ethnic minority respondents, controlling for age and education. The second set of figures introduces controls for occupational class. To the extent the numbers move closer to zero, explanatory power can be attributed to the class variable. The numbers show some movement in that direction, but there remain significant unexplained gaps across most cells. The addition, in the third set of figures, of controls for language spoken at home and identity provides further explanatory punch. Indeed, these two factors appear to

Table 6

Impact of Demographic Characteristics and Identity on Political Engagement, United Kingdom, 1997

(a) Language spoken at home and identity (ethnic minority respondents only)

	Language spoken at home		Identity		
	English	Other	British > other	British = other	British < other
Political knowledge[1]	29.0	28.8	46.5	24.7	25.4
General political interest[2]	68.1	57.2	68.4	63.2	52.2
Newspaper reading[3]	46.3	27.4	42.6	37.2	27.3
(Weighted N, range)[4]	(313)	(383-384)	(121)	(361-362)	(162-163)

(b) Occupational class (all respondents)

	Professional/ managerial	Junior/ intermediate nonmanual	Skilled manual	Semiskilled/ unskilled manual or never employed
Political knowledge[1]	65.9	45.9	44.0	26.2
General political interest[2]	82.8	74.1	64.7	54.0
Newspaper reading[3]	55.3	47.9	56.6	42.3
(Weighted N, range)[4]	(647-648)	(1,110-1,111)	(685-687)	(990-992)

Sources: Calculations by author based on: panel a — *British Election Study: Ethnic Minority Survey*, 1997; panel b — combined data from the *British Election Study*, 1997, and the *British Election Study: Ethnic Minority Survey*, 1997.
[1] Percentage of respondents who answered 5 or 6 knowledge questions (out of 6) correctly.
[2] Percentage responding "some," "quite a lot" or "a great deal."
[3] Percentage who read the newspaper four or more days per week.
[4] Weights provided in the datasets (designed to produce nationally representative results) have been applied. Sample size varies because of differences in the number of respondents with valid data for the relevant survey question(s).

Table 7 634

Impact of Demographic Characteristics and Identity on Political Engagement of Ethnic Minority Cohorts, United Kingdom, 1997 (percent)

Controlling for:		Ethnic minority cohort			
		Born in the UK	Immigrated		
			Before 1970	1970-84	1985-97
Age and education	Knowledge	-16.7	-11.7	-12.9	-29.3
	Interest	-7.2	-2.2	-11.3	-16.5
	Newspaper reading	-8.0	-12.7	-15.7	-21.1
Age, education and occupational class	Knowledge	-12.9	-10.1	-10.2	-20.5
	Interest	-5.1	0.2	-8.7	-9.7
	Newspaper reading	-4.0	-12.6	-14.3	-16.3
Age, education, occupational class, language at home and identity	Knowledge	-8.2	-6.8	-5.8	-11.7
	Interest	1.2	8.3	2.0	4.8
	Newspaper reading	7.7	-0.1	2.6	5.6

Source: Calculations by author based on combined data from the British Election Study (1997) and the British Election Study: Ethnic Minority Survey (1997).

have a greater effect on the political disengagement of ethnic minorities than social class, at least with respect to political interest and newspaper reading, where the numbers for most categories of ethnic minorities now move into the red. There remain, however, unexplained gaps for political knowledge with all controls in place. But certainly some of the knowledge deficit of ethnic minorities can be linked to class, language and identity. In short, both socioeconomic and cultural factors appear to play some role in explaining the political disengagement of Britain's ethnic minorities. [23]

Conclusion

THE MAIN THRUST OF THIS COMPARATIVE INVESTIGATION INTO PATTERNS OF POLITICAL engagement and participation among immigrant communities in Canada and the UK has been on factors of immediate relevance. Political knowledge and interest, combined with attention to matters political in newspapers and on television, provide new residents with the motivation and wherewithal to involve themselves in the political processes of their adopted country. At the same time, the analysis recognizes a clear need to look beyond these measures to broader processes of immigrant integration in order to attain a deeper understanding of the dynamics involved and to identify policy levers that government can potentially shift. The background factors considered in this chapter include resources that groups might need to participate politically — specifically, socioeconomic resources and linguistic fluency — as well as a key motivational factor: the sense of belonging to the larger national community. In our brief analysis of the British case, these factors certainly seemed to provide some insight into why immigrants are not as politically engaged as other Britons.

If this suggests some of the things that might be done in the UK to bring ethnic minorities more fully into the fold of British politics, it also implicitly underscores what Canada has done well and must continue to do well if it is to ensure the continued political integration of its diverse population. The socio-economic integration of Canada's immigrants, traditionally a strong suit, has not been as successful in the past two decades (Schellenberg and Hou 2005; see also Jeffrey Reitz and Rupa Banerjee's chapter in this volume), and it therefore represents, for a variety of reasons, an important priority area for policy-makers. Linguistic fluency in

one of the two official languages is likewise a general desideratum that should continue to be addressed through programs designed to help immigrants with language acquisition. Finally, ensuring that new Canadians develop affective attachments to Canada must also remain a guiding tenet, though debates are sure to continue about whether the policy of multiculturalism, as currently configured, effectively serves this goal (Bissoondath 1994; Gwyn 1995; Kymlicka 1998; Helliwell 2003). While these dimensions are clearly important in their own right as critical underpinnings of various facets of immigrant integration, the analysis in this chapter would suggest that they are also key underpinnings of the political engagement of new Canadians, a consideration that becomes more compelling in light of current concerns about the state of Canadian democracy.

If these background dimensions of integration and their implications for political engagement merit further investigation, so too does another general characteristic of the two societies: the media environment. It was suggested earlier that the low levels of regular reading of mainstream British newspapers in certain ethnic communities could be largely explained by a preference among members of those communities for a language other than English, but another possibility must also be considered: namely, that certain ethnic communities tend to retain their native languages in part because of the widespread availability in their adopted country of high-quality media sources in their native tongues. The question naturally follows of whether there might be a significant difference between Canada and the UK in the degree to which ethnic media exist and have supplanted mainstream news sources for certain ethnic communities; and as a further line of inquiry, the extent to which changes taking place in one or both countries have been propelled by technological advances, rendering it easier to produce and deliver media products aimed at specific audiences.

Such questions are not easily answered. In the UK, for example, only one ethnic newspaper is tracked by the primary media monitoring agency, ABC. Furthermore, Britain's Electoral Commission, interested in examining the content of ethnic newspapers to determine the extent of their focus on British politics, had great difficulty locating back copies of most papers (United Kingdom, Electoral Commission 2002b, 30, 31). UK circulation figures for the foreign press — potentially a significant element of the ethnic press in a country with large concentrations of a few specific ethnic communities — seem equally difficult to determine. Meanwhile, the situation in Canada appears similar: the fragmented nature of the

ethnic media and the absence of centralized sources of information render analysis of the ethnic media environment very challenging. Therefore, it is hard to say how much this might be a contributing factor, either now or in the future, to insularity and political disengagement among ethnic minority communities.

It is, however, important to signal the possibility, since there are those who would contend that a media environment replete with choice may be one critical factor behind rising political disengagement among the young. Rather than any profound motivational impediments or resource-related debilities, this more prosaic explanation points to a proliferation of media choices that has allowed younger generations to consistently choose entertainment over information (Wattenberg 2003); consequently, the young pay little attention to politics, know little about it and are unlikely to take the initiative to improve the situation. Applied to the realm of immigrant politics, it is possible to imagine a country providing a welcoming and supportive environment to newcomers, yet still finding ethnic minority communities eschewing mainstream media sources (with significant implications for political engagement) simply because of the relative ease of accessing more familiar and comfortable ethnic media alternatives.

While the degree to which declining levels of political engagement can be linked to a changing media environment is debatable, there is greater consensus on the need to take action on the matter, to devise methods of piquing the political interest, attentiveness and knowledge of disengaged sections of the Canadian population. With respect to young Canadians, enhanced civics education in elementary and secondary schools has been advocated (Milner 2005, 17; New Brunswick Commission on Legislative Democracy 2004, 91-6), as have mock elections in high schools, which are now being organized in conjunction with federal and provincial elections by the Student Vote organization.[24] While it is hoped that such initiatives will have a considerable effect on those still in school, who will soon join the Canadian electorate as eligible voters, they will naturally have little impact on the other principal source of new participants in the political arena: new immigrants to Canada (aside, of course, from the children of immigrant families). It would therefore be prudent and appropriate to ensure that any services and programs designed to provide new arrivals with background civics education and familiarity with the Canadian electoral process are modified and improved to keep pace with policy initiatives targeted at young Canadians.

In short, there is good reason to continue monitoring the ways in which newcomers to Canada are adapting politically, as the various structures that will affect their behaviour and attitudes may be in a state of flux. It is likewise important to look closely at any general policy initiatives to ensure that the particular needs of immigrant communities are not overlooked. If the underlying theme of the current chatter about democratic disengagement is the need to fashion a political system that involves one and all on an equal footing, in a diverse country like Canada the particular challenges facing new Canadians must remain a constant consideration.

Notes

The *Canadian National Election Study* (1984, 2000 and 2004) was funded by the Social Sciences and Humanities Research Council of Canada (SSHRCC). Data for the 1984 and 2000 studies were made available by the Institute for Social Research (ISR) at York University; data for the 2004 study were accessed via the *Canadian Election Study* Web site (http://www.ces-eec.umontreal.ca/ces.html). Principal investigators for the studies were: R.D. Lambert, S.D. Brown, J.E. Curtis, B.J. Kay and J.M. Wilson (1984); André Blais, Elisabeth Gidengil, Richard Nadeau and Neil Nevitte (2000); and André Blais, Elisabeth Gidengil, Neil Nevitte, Patrick Fournier and Joanna Everitt (2004). The October 1956 Gallup poll (CIPO 252) was made available by the Data Centre at Carleton University, while the *British General Election Study* (1997) and the *British General Election Study: Ethnic Minority Survey* (1997) were made available by the Inter-University Consortium for Political and Social Research. Principal investigators on the *General Election Study* were A. Heath, R. Jowell, J. K. Curtice and P. Norris, and on the *Ethnic Minority Survey*, A. Heath and S. Saggar. In all cases, the original investigators, the study sponsors and the distributing agencies bear no responsibility for the analyses and interpretations presented here.

1 It is important to bear in mind, however, that shared demographic characteristics between voter and candidate appear to have an impact on voting choice among all voters, not just ethnic minorities (see Cutler 2002).

2 In the 1971-80 period, it was still the case that 42.9 percent of immigrants to Canada were from Europe or the United States. This figure fell to 29.6 percent in 1981-90, and 22.3 percent in 1991-2001 (Badets, Chard and Levett 2003).

3 Other recent Canadian surveys, such as the *Statistics Canada Ethnic Diversity Survey* (Badets, Chard and Levett 2003), have taken the step of interviewing respondents in other languages in order to reach all segments of the ethnic minority population. However, they do not generally provide as rich an array of questions relating to political engagement as the Canadian Election Studies.

4 A recent Statistics Canada study based on interviews with 12,000 recent immigrants to Canada (people arriving between September 2001 and October 2002) found that only 18 percent reported that they were unable to converse in either English or French within six months of their arrival (Statistics Canada 2005a, 29). Furthermore, according to the 2001 Census, only 6.4 percent of the total immigrant population could speak neither English nor French (calculated from figures in Statistics Canada 2005b).

5 The voter turnout figures derived from the Canadian Election Studies are considerably higher than the actual turnout in the 2000 and 2004 elections (see Pammett and LeDuc for a method of adjustment that corrects for this [2003, 20]). It is likely that the other measures of political engagement in table 1 suffer from similar inflation; that is, Canadians at large are not as interested in and knowledgeable about politics as the survey figures would suggest. There is no obvious reason to think, however, that this inflation would be greater among either native-born Canadians or immigrants, so this should not affect evaluation of potential differences in political engagement between the two groups.

6 A third sociodemographic control variable that might be considered is social class — or, as a proxy, income level. However, once age and education are controlled, income has a relatively small impact on the measures of political engagement considered here. Furthermore, income differences between immigrants and the native-born have traditionally been relatively modest in Canada, although the gap has become somewhat more significant in recent years

(as further discussed in the conclusion to this chapter). Later, however, when we consider the British case, we will give more attention to social class, as this is a more salient element of the debate on immigrant integration in the UK.

7 These calculations — here and later in the chapter — are based on ordinary least squares (OLS) regression models, in which each immigrant cohort is captured by a dummy variable and the nonimmigrant population serves as the comparison group.

8 A report based on *Statistics Canada's Ethnic Diversity Survey* identifies a much larger gap in voter participation between different cohorts of immigrants — 53 percent of those who have arrived since 1991 report voting in the 2000 election versus 92 percent of those arriving before 1961. It fails, however, to control for the age differences across immigrant cohorts that account for much of this gap (Badets, Chard and Levett 2003, 15).

9 Bivariate OLS regression of knowledge on voting (in the 2000 and 2004 elections) within each immigrant cohort produces the following estimates of the increased likelihood of voting for each additional correct knowledge answer: 1954 and earlier, 0.3 percent; 1955-69, 2.0 percent; 1970-84, 2.3 percent; 1985-present, 4.8 percent. Given that the full range on the knowledge scale is 10 in 2000 and 12 in 2004, the relationship between knowledge and electoral participation in the most recent cohort is clearly very strong.

10 A recent study by Elections Canada provides more definitive measurement of voter turnout by age group than is possible with survey-based estimates. Drawing on a large sample of voter-list records, the report finds that approximately 40 percent of those under age 30 voted in the 2004 federal election compared with approximately 64 percent of those 30 and over (these numbers are calculated by averaging the figures across age categories listed in Elections Canada 2005, 5). This suggests a slightly larger age gap in voter participation (24 percentage points), which presumably would become larger still if education could be included as a control variable.

11 While the study documentation indicates that the sampling frame for the study was simply the Canadian population aged 18 and over, examination of the screening questions indicates that the sample was limited to Canadian citizens only.

12 Data from the 2001 Census indicate that 86 percent of foreign-born Canadians had immigrated when they were under age 40 (Statistics Canada 2005c). Furthermore, in the 1950s, the median age of immigrants was about five years younger than it is today (Beaujot 1998, 7), suggesting that, if anything, the percentage of recent immigrants under age 40 would have been higher in the past.

13 The 2001 Canadian Census indicated that 18.4 percent of the population were born outside of Canada (Badets, Chard and Levett 2003, 1); in the UK, in the same year, 7.5 percent were born outside the country (BBC News n.d.).

14 The documentation does not specify whether all interviews were conducted in English; however, only English versions of the questionnaires are available, so this would appear to be the case. It is possible, however, that some informal translation took place, particularly since the interviewing was carried out face to face.

15 Verification of registration status and voter participation was carried out for the 1997 *BES*. The results reveal that 10.8 percent of the ethnic minority subsample and 5.8 percent of other respondents were "not entitled to vote," although details are not provided as to the reasons for ineligibility. Curiously, 42 percent of those classified as ineligible to vote responded that they had in fact voted when asked this question on the survey. Even allowing for some misreporting of voting, this figure does raise questions about the accuracy of the eligibility classification.

16 Based on figures compiled by the BBC using British census data (BBC News n.d.), the percentage of the total British population falling into this category would be approximately 2.6.

17 The periods are the same as those used in the Canadian analysis, except that the earliest two are collapsed into one because of sample-size considerations.

18 As in the Canadian case, and for consistency with the treatment of the ethnic minority subgroups, controls for education are applied in the calculations for the under-30 group.

19 The knowledge questions used in the 1997 *BES* were somewhat different from those used in the Canadian studies. They focused on what might be termed "civics knowledge" — for example, the number of members of Parliament, the length of time between general elections — rather than knowledge of current political issues and personalities. It might be expected that those born outside the country would be at a particular disadvantage in answering such questions, since the type of knowledge tested is that which might be taught in British schools. However, the fact that visible minority respondents born in the UK also fare poorly in answering these questions suggests that UK schooling is not the only factor at play.

20 This is another interesting contrast with 18-to-29-year-olds, whose lack of attention to politics applies to both newspapers and television.

21 Further analysis highlights some interesting variations in patterns of political engagement across the two largest ethnic minority groupings in the UK: Asians and Blacks. In the area of newspaper reading, it is members of the Asian community (mainly comprising people from India, Pakistan and Bangladesh) who are considerably less likely to read a paper four or more times a week. The percentage difference in regular newspaper reading for this group, control-

ling for age and education, is -16.9 ($p < .01$). The figure for Blacks, however, is not much below the national norm (-5.0 percent, $p = .20$). It is also the case that Blacks are more likely than average to be faithful viewers of television news (+19.3 percent, $p < .01$), unlike members of the Asian community (-3.9 percent, $p = .08$). But meanwhile, the lower levels of political knowledge that were apparent in table 5 appear in both communities, and indeed are slightly more pronounced among Blacks (-21.8 percent for Blacks, -14.7 percent for Asians, $p < .01$ in both cases). And, finally, with respect to voter participation, members of the Asian community are slightly more likely than average to vote (+4.0 percent, $p < .05$), whereas members of the Black community are less likely (-7.8 percent, $p<.05$). The areas in which political integration is falling short of the mark are clearly not the same for the two main minority groups in the UK.

22 Another motivational factor considered was attitudes toward British democracy, as captured by a standard question asking respondents how satisfied they were with "the way democracy works in Britain." Most members of the ethnic minority subgroups, however, reported *higher* levels of satisfaction with British democracy (the only exception was those born in the UK, but their levels of satisfaction were only moderately lower). Disillusionment with British democracy does not, therefore, appear to be a contributing factor (United Kingdom, Electoral Commission 2002b, 37-9).

23 One element of intraethnic minority variation should be noted. Whereas only 17.1 percent of Black respondents report speaking a language other than English at home, for Asian respondents, the figure is 71.2 percent. This is particularly relevant to the differences in regular newspaper reading reported in note 21. When language spoken at home is introduced as a control vari-

able, the considerable difference between the Asian and the nonethnic minority categories (-16.9 percent) is reduced to insignificance (-4.6 percent, $p = .21$). For the other two factors — identity and class — differences between the two largest ethnic minority communities in the UK are much less pronounced, their explanatory power across the two groups more uniform.

24 See www.studentvote.ca for further details.

References

Badets, Jane, Jennifer Chard, and Andrea Levett. 2003. *Ethnic Diversity Survey: Portrait of a Multicultural Society*. Cat. no. 89-593-XIE. Ottawa: Statistics Canada.

BBC News. n.d. "Born Abroad: An Immigration Map of Britain." Accessed September 27, 2005. http://news.bbc.co.uk/1/shared/spl/hi/uk/05/born_abroad/html/overview.stm

Beaujot, Roderic. 1998. "Immigration and Canadian Demographics: State of the Research." Special study, Strategic Research and Review, Citizenship and Immigration Canada. Ottawa: Minister of Public Works and Government Services Canada. Accessed June 29, 2006. http://www.cic.gc.ca/english/pdf/research-stats/demographics.pdf

Bissoondath, Neil. 1994. *Selling Illusions: The Cult of Multiculturalism in Canada*. Toronto: Penguin.

Black, Jerome H. 1987. "The Practice of Politics in Two Settings: Political Transferability among Recent Immigrants to Canada." *Canadian Journal of Political Science* 20 (4): 731-53.

____. 1991. "Ethnic Minorities and Mass Politics in Canada: Some Observations in the Toronto Setting." *International Journal of Canadian Studies* 3:129-51.

____. 2001. "Immigrants and Ethnoracial Minorities in Canada: A Review of Their Participation in Federal Electoral Politics." *Electoral Insight* 3 (1): 8-13.

Black, Jerome H., and A. Lakhani. 1997. "Ethnoracial Diversity in the House of Commons: An Analysis of Numerical Representation in the 35th Parliament." *Canadian Ethnic Studies* 29(1): 1-21.

Black, Jerome H., and Christian Leithner. 1988. "Immigrants and Political Involvement in Canada: The Role of the Ethnic Media." *Canadian Ethnic Studies* 20 (1): 1-20.

Blais, André, Elisabeth Gidengil, Richard Nadeau, and Neil Nevitte. 2002. *Anatomy of a Liberal Victory: Making Sense of the 2000 Canadian Election*. Toronto: Broadview Press.

Blais, André, Elisabeth Gidengil, Neil Nevitte, and Richard Nadeau. 2004. "Where Does Turnout Decline Come From?" *European Journal of Political Research* 43 (2): 221-36.

Casciani, Dominic. 2003. "Should Labour Fear the Muslim Vote?" BBC News, April 24. Accessed May 18, 2006. http://news.bbc.co.uk/1/hi/uk/2972279.stm

____. 2005. "Will Muslim Vote Be Centre Stage?" BBC News, May 4. Accessed May 18, 2006. http://news.bbc.co.uk/2/hi/uk_news/politics/vote_2005/frontpage/4511207.stm

Cutler, Fred. 2002. "The Simplest Shortcut of All: Sociodemographic Characteristics and Electoral Choice." *Journal of Politics* 64 (2): 466-90.

Elections Canada. 2005. "Estimation of Voter Turnout by Age Group at the 38th Federal General Election." http://www.elections.ca/loi/report_e.pdf

Fahmy, Eldin. 2003. "Youth, Social Capital and Civic Engagement in Britain: Evidence from the 2000/01 *General Household Survey*." Citizenship and Attitudes to Governance in Britain Project Working Paper 2. Swindon, UK: Economic and Social Research Council. http://www.bris.ac.uk/sps/ESRC-ODPM/WP2_ghs.pdf

Gwyn, Richard. 1995. *Nationalism without Walls: The Unbearable Lightness of Being Canadian*. Toronto: McClelland and Stewart.

Helliwell, John F. 2003. "Immigration and Social Capital: Issue Paper." Paper presented at the International Conference on the Opportunity and Challenge of Diversity, "A Role for Social Capital," November 24-25, Montreal.

Howe, Paul. 2003. "Electoral Participation and the Knowledge Deficit." *Electoral Insight* 5 (2): 20-5.

Kymlicka, Will. 1998. *Finding Our Way: Rethinking Ethnocultural Relations in Canada.* Don Mills, ON: Oxford University Press.

Leighley, Jan E., and Arnold Vedlitz. 1999. "Race, Ethnicity, and Political Participation: Competing Models and Contrasting Explanations." *The Journal of Politics* 61 (4): 1092-114.

Milner, Henry. 2005. "Are Young Canadians Becoming Political Dropouts? A Comparative Perspective." *IRPP Choices* 11 (3).

New Brunswick Commission on Legislative Democracy. 2004. *Final Report and Recommendations.* http://www.gnb.ca/0100/index-e.asp

O'Neill, Brenda. 2001. "Generational Patterns in the Political Opinions and Behaviour of Canadians: Separating the Wheat from the Chaff." *IRPP Policy Matters* 2 (5).

Pammett, Jon, and Lawrence LeDuc. 2003. "Explaining the Turnout Decline in Canadian Federal Elections: A New Survey of Non-voters." Ottawa: Elections Canada.

Pelletier, Alain. 1991. "Politics and Ethnicity: Representation of Ethnic and Visible-Minority Groups in the House of Commons." In *Ethno-cultural Groups and Visible Minorities in Canadian Politics: The Question of Access,* edited by Kathy Megyery. Vol. 7 of *The Research Studies of the Royal Commission on Electoral Reform and Party Financing.* Ottawa and Toronto: RCERPF, Dundurn Press, 101-59.

Phelps, Edward. 2004. "Young Citizens and Changing Electoral Turnout, 1964-2001." *The Political Quarterly* 75 (3): 238-48.

Prior, Markus. 2002. "Liberated Viewers, Polarized Voters — The Implications of Increased Media Choice for Democratic Politics." *Good Society* 11 (3): 10-16.

Reitz, Jeffrey G. 1980. *The Survival of Ethnic Groups.* Toronto: McGraw-Hill Ryerson.

Saggar, Shamit, ed. 1998. *Race and British Electoral Politics.* London: UCL Press.

Schellenberg, Grant, and Feng Hou. 2005. "The Economic Well-being of Recent Immigrants to Canada." In "Immigration and the Intersections of Diversity," edited by Myer Siemiatycki. Special issue, *Canadian Issues Canada/Thèmes Canadiens* (spring): 49-52.

Simard, Carolle, with the assistance of Sylvie Bélanger, Nathalie Lavoie, Anne-Lise Polo, and Serge Trumel. 1991. "Visible Minorities and the Canadian Political System." In *Ethno-cultural Groups and Visible Minorities in Canadian Politics: The Question of Access,* edited by Kathy Megyery. Vol. 7 of *The Research Studies of the Royal Commission on Electoral Reform and Party Financing.* Ottawa and Toronto: RCERPF, Dundurn Press, 161-261.

Stasiulis, Daiva, and Yasmeen Abu-Laban. 1991. "The House the Parties Built: (Re)constructing Ethnic Representation in Canadian Politics." In *Ethno-cultural Groups and Visible Minorities in Canadian Politics: The Question of Access,* edited by Kathy Megyery. Vol. 7 of *The Research Studies of the Royal Commission on Electoral Reform and Party Financing.* Ottawa and Toronto: RCERPF, Dundurn Press, 3-99.

Statistics Canada. 2003. "Canada's Ethnocultural Portrait: The Changing Mosaic." Cat. no. 96F0030XIE2001008. Accessed September 27, 2005. http://www12.statcan.ca/english/census01/products/analytic/

_____. 2005a. *Longitudinal Survey of Immigrants to Canada: A Portrait of Early Settlement Experiences.* Cat. no. 89-614-XIE. Accessed June 29, 2006. http://dsp-psd.tpsgc.gc.ca/Collection/Statcan/89-614-XIE/89-614-XIE2005001.pdf

_____. 2005b. "2001 Census." Cat. no. 97F0009XCB2001040. Accessed September 27, 2005. http://www12.statcan.ca/english/census01/products/standard/themes/

_____. 2005c. "2001 Census." Cat. no. 95F0359XCB2001004. Accessed September 27, 2005. http://www12.statcan.ca/english/census01/products/standard/themes/

Wattenberg, Martin. 2003. "Electoral Turnout: The New Generation Gap." *British Elections and Parties Review* 13:159-73.

United Kingdom. Electoral Commission. 2002a. *Voter Engagement and Young People*. London: Electoral Commission.

——. 2002b. *Voter Engagement among Black and Minority Ethnic Communities*. London: Electoral Commission.

Zhang, Kewen, and Xiaoming Hao. 1997. "The Internet and the Ethnic Press: A Study of Network-Based Chinese Publications." Paper presented at the annual conference of INET 97, June 24-27, Kuala Lumpur, Malaysia.

Conclusion: Diversity, Belonging and Shared Citizenship

Conclusion:

Diversity, Belonging

and Shared Citizenship

I N THIS VOLUME, LEADING SCHOLARS HAVE EXPLORED TWO BROAD POLICY AGENDAS generated by ethnic diversity in Canada and other Western countries. The first agenda is the multicultural agenda, which seeks to recognize cultural differences, to help minorities express their distinct identities and practices, and to build more accommodating conceptions of citizenship. The second agenda focuses on integration, seeking to bring minorities into the mainstream, strengthen the sense of mutual support and solidarity, and reinforce the bonds of a common community.

Most Western countries have pursued both agendas, to a greater or lesser degree, in recent decades. There is nothing inherently contradictory in the two agendas. Indeed, research by psychologists concludes that the most successful forms of immigrant integration occur when newcomers retain a sense of their heritage culture and seek involvement in the larger society, suggesting that governments should encourage both forms of community (Berry et al. 2006). In contemporary debates, however, many countries are shifting to a heavier emphasis on integration. This pattern is particularly marked in Europe, as the chapters by Christian Joppke and Randall Hansen highlight. Many Europeans fear that multiculturalism has bred separateness and cultural alienation, including among some children of immigrants born and raised in the West. In the United Kingdom, for example, Trevor Phillips, the head of the Commission for Racial Equality and himself a Black Briton, has warned that Britain is in danger of "sleepwalking into segregation" (T. Phillips 2005), and in France riots in major cities have illuminated the geographic, economic and social distance between minorities and the wider society. The common response has been to insist on higher levels of integration. The British prime minister recently proclaimed a "duty to

integrate" (Blair 2006), and some European countries have gone further, occasionally adopting relatively illiberal policies to advance an integrationist agenda.

Recent debates in Canada have not shifted as dramatically. Nevertheless, stress points are appearing, and a number of the chapters in this volume sound warning signals. It is an appropriate time to stand back and take stock. How well is Canada succeeding on the twin agendas of recognition and integration? Do we recognize and support diversity as much as our self-congratulatory pronouncements often suggest? Do we face deepening ethnic divisions that weaken our capacity for collective action and threaten our social cohesion? If there are problems around the corner, what should we do?

This chapter explores these questions, drawing on the evidence presented in this volume and elsewhere.[1] The first section starts by discussing the ways in which Canadians have traditionally approached recognition and integration, focusing in particular on the concept of shared citizenship. The following two sections take stock of the current state of diversity in Canada, asking whether the norms and expectations implicit in the concept of shared citizenship are being realized in practice: section 2 focuses on the multicultural agenda and section 3 turns to integration. The fourth section examines three priorities that flow from the stock-taking and policy issues implicit in these priorities.

Recognition, Belonging and Shared Citizenship: Canadian Approaches

CANADIAN APPROACHES TO DIVERSITY NATURALLY REFLECT CANADIAN REALITIES. THE starting point is that Canada is one of the most multicultural countries in the world. Among OECD countries, it is virtually unique in the coexistence of three dimensions of difference: the historic divide between English- and French-speaking communities, which represents the central reality of Canadian political life; the presence across the country of indigenous peoples, many of whom assert traditional claims to self-governance; and large immigrant communities, with over 18 percent of the people living in Canada having been born outside the country. Moreover, in contrast to some host countries whose immigrants come predominantly from one part of the world, creating a relatively homogeneous "Other,"

immigrants to Canada have come from many different parts of the world, creating a "diverse diversity" composed of a wide range of ethnicities, races and religions.

Canadian approaches to diversity are also shaped by the country's larger geopolitical position and the traditional nation-building strategies on which it has relied since 1867. Immigration was a key ingredient in Canada's first National Policy, which settled the West and secured Canada's territory from "sea to shining sea." From the very beginning, therefore, immigration has been central to our existence — geographically, economically and politically. Immigrants are us. In addition, geography insulates the country from some of the pressures of the twenty-first century. Buffered on three of its borders by oceans and on its southern border by the United States, itself an immigrant destination, Canada has not had to cope with high levels of illegal immigration. We are, as a result, less prone to concerns that immigration policy is "out of control," a fear that has contributed to the politics of backlash in some other countries. The buffering effects are not absolute, to be sure. Anxieties about a "clash of civilizations" and about Muslim extremism have washed over our borders, contributing to a heightened security agenda and tensions with the United States over border management. However, Canada has been fortunate: Islamic radicalism is a small element in the Muslim community here, and Canadian foreign policy, especially the decision not to join the Iraq war, has eased the heightened tensions existing in some countries.

These multiple forms of diversity and historic geopolitical strategies have informed the ways in which Canadians think about both recognition and integration.

Recognition of Diversity

The recognition and accommodation of diversity have been central features of Canadian political history, and contemporary debates over multiculturalism are simply the continuation of an ongoing Canadian conversation. This tradition is grounded in historic commitments to French Canada and to the Aboriginal peoples, who both see themselves — and are increasingly seen by others — as distinct societies or "nations" within the Canadian state. These accommodations framed the cultural context in which Canada responded to new forms of diversity resulting from immigration during the nineteenth and twentieth centuries. Indeed, as Stuart Soroka and his colleagues observe in their chapter, the "thinner" sense of Canadian culture resulting from accommodations among the historic communities "may actually have benefits in a multicultural era, making it easier for new Canadians to feel comfortable here."

Certainly Canadians have long understood both the benefits and ambiguities inherent in multiple forms of belonging, multiple views of history, multiple identities. The politics of the last half century have been dominated by efforts to recognize, accommodate and support evolving forms of cultural diversity, and to break down the ethnic and racial hierarchies described in *The Vertical Mosaic,* John Porter's classic study of the distribution of power published in the mid-1960s (Porter 1965).

A complex array of instruments has been directed to this task. As Will Kymlicka emphasizes in his chapter, the legal and institutional forms vary for French Canada, Aboriginal peoples and immigrant communities. The result is three "silos" that have different histories, are enshrined in different sections of the Constitution, are codified in different pieces of legislation and are shaped by different concepts and principles. In the case of French Canadians, the key norms are duality, bilingualism, federalism, distinct society and nation. For Aboriginal peoples, the central concepts are treaty rights, inherent Aboriginal rights, title to land, self-government and self-determination. For immigrant minorities, the central ideas are diversity, multiculturalism, tolerance, antidiscrimination, citizenship and integration. These norms represent the foundation stones for very different formal structures in each case. In combination, however, they create a complex architecture of difference in Canada.

In addition, Canadian governments have adapted a variety of policies to nurture a multicultural definition of Canadian identity that spans all three dimensions of difference. Historically, this process involved a concentrated deemphasis of the historic "Britishness" of Canada through the removal of royal insignia from many public institutions and the adoption of a new national flag. But the process also involved the celebration of a multicultural conception of the country. This symbolic reordering has been reflected, for example, in the choice of the governor general, who as the Queen's representative is the effective head of state and commander-in-chief of the armed forces. Since 1974, all governors general have come from non-British origins, and the last two appointments have been of visible minority women who were born outside the country and came to Canada as children. Similarly, the present lieutenant governor of Ontario is Aboriginal, and a number of other lieutenant governors in Ontario and other provinces are or have been visible minorities. In addition, the curricula in public schools in a number of provinces have been revised to highlight the contributions of minorities to Canadian history and culture, and the mandate of the public broadcasting system has also acquired a multicultural component. The *Broadcasting*

Act, 1968 requires the Canadian Broadcasting Corporation (CBC), among other things, to reflect "the multicultural and multiracial nature of Canada." The federal regulatory body that awards the CBC its licence requires the corporation "to report annually on its progress in implementing its commitment to 'more adequately reflect the multicultural and multiracial nature of Canada and the special place of Canada's Aboriginal Peoples, and to balance their representation on the air and in the work force in a manner that realistically reflects their participation in Canadian society, and that will help to counteract negative stereotypes'" (Canadian Radio-television and Telecommunications Commission 2000, 8).

Other policies have also sought to respect minority cultures. The federal government has formally apologized and offered redress for historic wrongs perpetrated against groups such as Japanese Canadians, Chinese Canadians and Aboriginal people who attended residential schools. In a similar vein, dress codes, which can kindle intense passions, have been adapted. The Royal Canadian Mounted Police revised its ceremonial dress code to allow Sikh officers to wear their turbans, and Sikhs may be exempted from mandatory motorcycle helmet laws or requirements for hardhats on construction sites. In a recent case, the decision of a Montreal school board to ban entirely the wearing of the kirpan, the Sikh ceremonial dagger, went as far as the Supreme Court of Canada. The court determined that the ban was disrespectful of people of the Sikh religion and set conditions under which a kirpan should be allowed.[2] In addition, the clothing choices of Muslim women generate less controversy in Canada than in some other countries. Muslim women regularly wear the hijab and other coverings in Canadian schools, universities and public spaces without significant controversy.

Finally, governments have provided tangible support in various forms, including financial support for ethnocultural programs; funding for minority language instruction in schools; and affirmative action through the federal government's employment equity program, which seeks to increase the representation of minorities in major educational and economic institutions.

Social Integration

Diversity also frames the way in which Canadians think about integration and community. Traditional approaches to social integration in many countries involved building a common national culture, including a uniform language, a consistent interpretation of history, a common set of traditions, a shared national identity and

singular loyalty. In Canada, such a definition of social integration would be immediately contested. As Gerald Kernerman (2005, 17) notes, "The embrace of diversity complicates the attempt to construct a common national identity, since there can be no explicit resort to a culturally, religiously or ethnically defined national identity." Social integration in Canada cannot demand adherence to a common culture or a single identity. It does not try to turn Canadians into a single people. Indeed, even the language of "social and political integration" can be problematic. Rather, the predominant definition of the integration agenda focuses on the need to build a sense of belonging and attachment to a country that incorporates distinct identities.

In Canada, the twin agendas of recognition and community are best captured by the language of "shared citizenship." Kymlicka encapsulates core elements of the idea of shared citizenship:

> [It] goes beyond the sharing of citizenship in the formal legal sense (that is, a common passport) to include such things as: feelings of solidarity with co-citizens, and hence a willingness to listen to their claims, to respect their rights and to make sacrifices for them; feelings of trust in public institutions, and hence a willingness to comply with them (pay taxes, cooperate with police); feelings of democratic responsibility, and hence a willingness to monitor the behaviour of the political elites who act in our name and hold them accountable; and feelings of belonging to a community of fate (that is, of sharing a political community).

How is a sense of shared citizenship reinforced in a society without a common culture? Not surprisingly, the sources of shared citizenship are diverse. As the British sociologist T.H. Marshall reminded us more than half a century ago, the modern conception of citizenship has been enriched by a wider set of civil, political and social rights (Marshall 1950; also Jenson and Papillon 2001). Canadian discourse sees each of these sets of rights as important sources of integration. In the first place, diversity policies are framed by the essential principles of the liberal-democratic state and by the protection of the rights of individuals through the Canadian Charter of Rights and Freedoms, the Quebec Charter of Human Rights and Freedoms, charters and codes in other provinces and human rights commissions. Central to the framework is the concept of equality expressed in section 15(1) of the Canadian Charter, which states that "every individual is equal before and under the law and has the right to the equal protection and equal benefit of the law without discrimination and, in particular, without discrimination based on race, national or ethnic origin, colour, religion, sex, age or mental or physical disability." The contributions by Kymlicka

and Pearl Eliadis capture well this dimension of Canadian thinking. For Kymlicka, the values of liberal-democratic constitutionalism motivate, shape and constrain diversity policies in Canada. Eliadis states the view with more flourish, arguing that in the pursuit of a fair society, "human rights and equality rights offer a more promising avenue than multiculturalism alone ever could…When multiculturalism is unhinged from equality, it tends to career off in unpleasant directions."

Social rights, in the form of access to health, education and income protection, represent a second source of cohesion. The welfare state has long been recognized as an instrument of social integration, helping to mediate conflicts and preserve stability in divided societies. In the words of Siobhan Harty and Michael Murphy (2005, 43), national social programs "became closely associated with citizenship models because they are the outcome of decisions taken around the obligations we owe our compatriots: co-responsibility, the pooling of risk and social solidarity." Marshall saw the welfare state as mitigating class divisions in Britain during the 1940s. In Canada, national social programs have also been seen as instruments of regional integration, creating networks of mutual support that span the country and reinforce the sense of a pan-Canadian community (Banting 1995). In the contemporary era, this integrative role extends to ethnic and racial differences. Commentators in some countries are increasingly skeptical that social policy can perform such a role, insisting that ethnic diversity tends to erode the social solidarity that sustains the redistributive state (Alesina and Glaeser 2004; Goodhart 2004). While racial differences may in fact weaken support for social programs in some countries, including the United States, the proposition that there is a universal or inevitable tension among diversity, recognition and redistribution is unsustainable (Banting and Kymlicka 2006). In Canada, studies of public attitudes find little evidence that ethnic diversity erodes support for social programs (Soroka, Johnston, and Banting 2007).

Universal public services such as health care and especially education play particularly important roles in this process. The strength of Canadian public schools, which continue to attract children from the broad mass of the population, including most offspring of the professional class, is widely underappreciated in this context. For many young Canadians, diversity is first lived at school; how it is recognized and accommodated there is highly significant. Similarly, the strengths of the postsecondary system are critical to openness in Canadian society. Comparative analyses find that intergenerational mobility is higher in Canada than in countries such as the United States and the United Kingdom, rivalling levels

found in Scandinavia (Corak 2001, 2004; Solon 2002). Traditionally, the children of immigrants have shared in this intergenerational mobility. The educational attainments and economic outcomes of the children of immigrants who came to Canada before the 1980s were as good as, and in many ways better than, those of children whose parents were born in Canada (Aydemir, Chen, and Corak 2005).

Finally, Canadian discourse highlights the central role of civic engagement and political participation in the integration of minority communities. Contemporary Canada is defined by multiple communities and identities, and the critical question is how the conflicts inherent in such diversity are resolved or managed. From this perspective, a key to social cohesion is consensus on the fundamental processes of collective deliberation, especially the institutions of liberal democracy, and the active participation of minorities in the processes of governance. Disengagement or disaffection from these collective processes among ethnic minorities would be a potentially dangerous sign.

The fundamentals of this approach to social integration are hardly unique to Canada. One finds similar themes in the debates of other countries. In the case of political participation, for example, British commentators also underline the "contractual" nature of citizenship, including a minimum duty of political participation (Goodhart 2006, 33). Indeed, the case was perhaps expressed most eloquently in the 2003 *Report of the "Life in the United Kingdom" Advisory Group*, chaired by Bernard Crick:

> When we use [the word] integration, we mean neither assimilation nor a society composed of...separate enclaves, whether voluntary or involuntary. Integration means not simply mutual respect and tolerance between different groups but continual interaction, engagement and civic participation whether in social, cultural, educational, professional, political or legal spheres. The basis of good citizenship is how we behave toward each other collectively and that is what binds us together, rather than assertions of national ethnic or religious priorities or particular interpretations of history. (United Kingdom, Home Office 2003, 12)

Despite these similarities, the Canadian approach to shared citizenship is distinctive in several ways. On one side, the celebration of diversity has become a feature of the country's very conception of itself, part of the conception of the "nation" that newcomers are invited to join. On the other side, the celebration of shared traditions, history, values and identity represents a decidedly secondary element in the glue that holds the country together. For good or ill, Canada is a particularly postmodern country.

How well is Canada doing in achieving this conception of shared citizenship? Are our established approaches to recognition and integration working as well as we like to think? Or is our traditional model breaking down in important ways? What are the broad conclusions that flow from the analyses in this volume?

The Recognition of Diversity and Shared Citizenship

IN HIS CHAPTER, KYMLICKA HIGHLIGHTS THE PROGRESS THAT HAS BEEN MADE ON recognizing and protecting diversity. There has been "a dramatic equalization" between francophone Quebecers and English-speaking Canadians, in part through the protection of French language rights by both the federal and Quebec governments. On Aboriginal rights, he argues that the federal government today accepts, at least in principle, that Aboriginal peoples "must have the land claims, treaty rights, cultural rights and self-government rights to sustain themselves as [distinct societies]." And as a result of multiculturalism and related policies such as employment equity, immigrant groups have achieved greater equality.

Kymlicka also points out that, despite this progress, some attempts at recognizing diversity have failed or moved forward with painful slowness. Notwithstanding major efforts, acknowledging Quebec's distinctiveness within the Constitution has proven impossible. The adoption by the House of Commons of a resolution recognizing the Québécois as a "nation" within Canada in November 2006 may have represented a breakthrough in terms of political discourse, but as yet the country shows no appetite for constitutional recognition of Quebec's distinctiveness. Moreover, although there has been growing acceptance of asymmetrical powers for Quebec in practice, little progress has been made on Quebec's historic demands for enhanced constitutional powers. Similarly, Kymlicka notes that progress on Aboriginal land claims and self-government agreements has been "very slow and uneven," a judgment echoed even more forcefully in the chapters by Daniel Salée and by Joyce Green and Ian Peach.

In the case of immigrant minorities, Kymlicka suggests the current policy framework may need to be updated to reflect the widely varying conditions of different groups. Historically, this silo was built on the assumption that all visible

minorities were disadvantaged, stigmatized or excluded. Today, however, anti-Black racism is qualitatively different from prejudice against other racial groups, and Islamophobia is qualitatively different from prejudice against other minority religions. Kymlicka suggests we need to pay more attention to the potential for increasing inequalities between different visible minorities as well as inequalities between visible minorities in general and White Canadians. In a similar vein, Salée points not only to the socioeconomic divide between the majority and ethnocultural minorities in Quebec but also to economic disparities between different minorities.

Variations also appear in the perceived levels of discrimination and vulnerability among racial minorities reported in the chapter by Jeffrey Reitz and Rupa Banerjee. Overall, a third of racial minorities report having experienced discrimination, a rate that varies from 28 percent of South Asians to 45 percent of Blacks (compared with 19 percent among Whites). More troubling, however, is the evidence that the sense of discrimination is higher among immigrants who have been in the country longer and among the children of immigrants. As Reitz and Banerjee note, the experience of the second generation is critical to the long-term effectiveness of the Canadian approach. While Canadian-born members of minorities may enjoy considerable educational and economic success, "their expectations of social acceptance, economic opportunity and equal partnership may be greater than that of their parents."

These attitudinal patterns are consistent with the sorts of tensions that emerge in daily life. Examples include a number of cases of arson directed at Jewish and Muslim religious institutions, the overrepresentation of Blacks and Aboriginal persons in the prison system, as well as racial profiling and incidents of abusive police treatment of young men from those communities, which are highlighted in the contributions by Green and Peach and by Eliadis. As Eliadis observes, the 7,000 human rights cases filed every year and reports on systemic discrimination are as telling as survey data. Her summary of the evidence from the Ontario criminal justice system is compelling: police stop Blacks twice as often as Whites; Whites are less likely to be detained before trial than Blacks, particularly on drug charges; and Blacks are denied bail more often and convicted more often. Even for simple possession of drugs, Black men are sentenced to prison 2.5 times more often than whites.

Clearly, we have unfinished business in building a society that accommodates and respects difference. Recently, however, Canadians have also had to

revisit the limits of this agenda. As noted earlier, the core commitment of a liberal state to individual rights and equality motivates but also constrains diversity policies. These constraints emerged sharply in the recent debate over the role of Sharia law, discussed in the commentary by Marion Boyd. As Boyd underscores, a basic tension inherent in a multicultural society is how to accommodate the culture of minority groups and yet protect the rights of individuals who are members of those minority groups. This issue was posed in pointed form by the proposal from a well-known Islamic leader to incorporate a business in Ontario that would offer arbitration of family law matters according to Islamic principles. All "good Muslims," proponents claimed, would be expected to have family matters resolved in this forum. The resulting debate divided both the Muslim community and the wider society, as some women's groups in both communities insisted that the protection of gender equality should trump demands framed in the language of diversity. After a short but intense debate, the Ontario government passed legislation that prohibits faith-based arbitration. The debate highlighted the occasional tensions between the twin agendas of our diverse society.

Social Integration and Shared Citizenship

B ACKLASH AGAINST MULTICULTURALISM IN OTHER COUNTRIES HAS BEEN DRIVEN BY fears for social integration. Across Europe in particular, there is a widespread concern that policies designed to accommodate diversity have gone too far, and have even been harmful. In Joppke's words, "The sense of failure is strong." In part, these concerns reflect the economic marginalization of minorities and the consolidation in some countries of a minority underclass defined by unemployment, poverty, frustration and alienation. However, the concerns go well beyond economic exclusion. In many countries, young, middle-class members of minority communities who have been born and educated in Europe seem disaffected from central elements of the national culture. The response has been a growing insistence on social or "civic" integration, a model that stresses using the common language in daily life; respect for the values of liberal democracy and human rights; knowledge of the history, customs and traditions of the country; a commitment to its political institutions and processes; and a common sense of national identity.

Should Canada be concerned? This section looks at the evidence on the economic, social and political dimensions of integration.

Economic Integration

While the historic economic differences between English- and French-speaking Canadians have largely disappeared over the last half century, the economic integration of other minorities is widely seen as a serious issue. As Salée (2006, 5) has observed, despite 40 years of studies and national debates about their place within Canadian society, "Aboriginal people face socioeconomic challenges that, in many ways, are far more daunting than those to which the general population is exposed." Although Canada as a whole regularly ranks at or near the top of the United Nations Human Development Index, First Nations on-reserve would rank 62nd, with some communities experiencing Third World conditions. Almost half of First Nations people on-reserves live in poverty, the unemployment rate is three times that in the non-Aboriginal community, and suicide is now among the leading causes of death among First Nations and Inuit children and youth.[3] Poverty rates are also troubling off-reserve. In Regina and Saskatoon in 2000, the median total income of Aboriginal residents was only slightly more than half that of non-Aboriginal residents (Siggner and Costa 2005, 21).

Until recently, the economic performance of immigrants was seen as a Canadian success story. In contrast to the more heavily regulated labour markets in Europe, flexible labour markets in Canada have traditionally eased the entry of immigrants into the economic mainstream, with poverty rates among newcomers typically falling below the rate for the population as a whole within a decade or so. Since the 1980s, however, immigrants have not enjoyed the same economic success. There is now a substantial literature tracking deterioration in the incomes of recent immigrants relative to earlier cohorts, a decline that seems to have been experienced most strongly among immigrant men from nontraditional source countries. This erosion has taken place despite an immigration policy that gives greater weight to educational qualifications, with recent cohorts of immigrants having more years of education on average than native-born Canadians. The *Longitudinal Survey of Immigrants* found that only 40 percent of skilled principal applicants who arrived in 2000-01 were working in the occupation or profession for which they were trained, and many immigrants with university degrees were working in jobs that typically require high school or less (Reitz and Banerjee, this volume; Picot, Hou, and

Coulombe 2006; Picot and Sweetman 2005; Reitz 2005; Aydemir and Skuterud 2005; Sweetman and McBride 2004; Frenette and Morissette 2003; Picot and Hou 2003; Hum and Simpson 2004).

Economic difficulties have been compounded by changes in the welfare state that have reduced the level of income protection. The chapter on the American experience by Mary Waters and Zoua Vang details the extent to which migrants and their children have been formally denied a range of social benefits in the United States. Canada has not done so formally, but the general weakening of income protection can indirectly have the same effect. For example, changes in the Employment Insurance (EI) program in the mid-1990s significantly increased the amount of time new entrants to the labour force, including recent immigrants, must have worked before qualifying for unemployment benefits. As a TD Bank special report argues, this policy change, in combination with changes in the labour market and continued regional differentials in benefit rules, has eroded effective coverage dramatically in those parts of the country in which newcomers congregate (TD Economics 2005). In 2004, only 22.3 percent of the unemployed in Toronto received unemployment benefits; in Vancouver it was 25.7 percent and in Montreal 34.3 percent, compared with considerably higher numbers in Quebec City and St. John's (Battle, Mendelson, and Torjman 2006; also Task Force on Modernizing Income Security for Working-Age Adults 2006). These added barriers to support are doubly important because eligibility for EI is a precondition for other labour market programs, including training programs and training allowances.

Canadian policy communities have seized on the issue of the economic integration of immigrants, and appropriately so. If the engine of economic integration continues to stall for many Aboriginal people and recent immigrants, Canadians may well experience the social tensions that have troubled other societies. Immigrants who were recruited to the country for their human capital are likely to be embittered if they are underemployed and undergoing deskilling. In consequence, the intergenerational mobility enjoyed by the children of immigrants who arrived before the 1980s may be at risk, especially for some groups such as Blacks. The result can only be higher levels of interethnic tension, putting under strain the wider societal consensus on the value of the multicultural conception of Canada.

Nevertheless, the chapters in this volume suggest that a concentration on economic integration is too narrow, and that we should also be concerned about the social and political dimensions of integration. We cannot assume that any fissures

in our sense of community are ultimately a reflection of economic problems alone. Our history should remind us that such an assumption would be wrong. The dramatic economic convergence between francophone Quebec and English-speaking Canada during the last half century has been accompanied by the growing strength of Quebec nationalism and sovereignist opinion in the province. The economic successes of Canadian-born Japanese Canadians, which are discussed below, did not reduce the intensity of their campaign for a formal apology and financial redress for the injustices done to them individually and collectively during the Second World War. Feelings of belonging, social solidarity and political community have a life of their own, and deserve attention in their own right.

Social Integration

On the positive side, there is little evidence of the deep social segregation feared in parts of Europe. Indeed, many of the traditional indicators of social integration that focus on social interactions and social behaviour remain relatively reassuring:

- ◆ While countries such as the Netherlands and Germany worry about minorities not learning the common language, Canada does not face the same problems, at least at the level of basic language proficiency. With English increasingly the international lingua franca and French another world language, immigrants to Canada usually have relevant language skills. In a survey of immigrants who arrived in Canada in 2000-01, fully 82 percent of respondents reported they were able to converse well in at least one of Canada's two official languages when they first arrived (Statistics Canada 2003). In addition, an analysis of 1991 Census data revealed that almost half of male immigrants from non-English-speaking countries usually speak one of the official languages at home (Chiswick and Miller 2001).

- ◆ There is also little evidence of entrenched racial concentration in poor ghettos. While in his commentary, David Ley reports that immigrants accounted for 77 percent of the population of low-income census tracts in Toronto in 2001, a study tracking residential patterns over time in the city finds that Blacks and South Asians follow a traditional assimilation model. Initial settlement is often in low-income enclaves shared by their own and other visible minority groups, but in the longer term Black and South Asian migrants who are more affluent live in higher-income

neighbourhoods dominated by Whites. An exception to this pattern is the Chinese community. Recent Chinese immigrants tend to settle in established Chinese neighbourhoods that include more affluent and longer-term immigrants, forming comparatively dense ethnic neighbourhoods (Myles and Hou 2004). The evidence for Aboriginal people is similarly nuanced. Evelyn Peters's chapter in this volume focuses on the level of concentration revealed by the 2001 Census and concludes that the conditions of isolation associated with underclass populations in US inner cities have not emerged here. John Richards's commentary looks at changes in the level of concentration since 1981 and concludes that the degree of change in Saskatoon and Regina has been notable.

◆ While rates of intermarriage (or mixed unions in the case of common-law couples) vary significantly across immigrant minorities, the 2001 Census revealed striking proportions of mixed couples among some minority communities: Japanese, 70 percent; Latin American, 45 percent; Black, 43 percent; and Filipino, 33 percent. The lowest rate was to be found among South Asians, at 13 percent (Milan and Hamm 2004).

Despite these reassuring signs, new evidence in this volume presents more mixed signals. The chapters by Reitz and Banerjee and by Soroka, Johnston and Banting assess the attitudinal underpinnings of social integration by examining such sensitive social indicators as sense of belonging in Canada, sense of pride in the country, trust in other Canadians, shared social values and life satisfaction. The findings of the two analyses disagree on some key points, especially the extent to which the second generation of immigrant minorities is integrated in Canadian life, but both chapters raise serious questions about social integration in this country.

Soroka, Johnston and Banting adopt a broad perspective, exploring differences across all three dimensions of Canadian diversity. Their results remind us that the greatest challenges to social cohesion in Canada may still be rooted in the historic tensions among the founding peoples, rather than in the attitudes and attachments of newcomers. On dimensions such as pride in Canada, a sense of belonging in the country and trust in other Canadians, it is francophone Quebecers and Aboriginal people who on average feel less integrated into the pan-Canadian community. Soroka and his colleagues do discover differences across immigrant groups as well, although these often reflect how long members of those groups have lived in Canada. The longer new immigrants are in Canada, the more their sense of pride

and belonging comes to equal — and in some cases exceed — that of long estab-lished groups. With the exception of measures of interpersonal trust, they find lit-tle evidence that members of the second generation of immigrant minorities are less integrated into Canadian life. Nevertheless, their analysis also reveals troubling lim-its to the integrative power of time spent in Canada. Although newcomers from southern and Eastern Europe become progressively more comfortable in the coun-try, visible minorities remain less confident that they fully belong here.

The chapter by Reitz and Banerjee concentrates on the experiences of racial minorities, comparing the attitudes and engagement of visible minorities with those of White counterparts, and distinguishing between the attitudes of recent and earlier immigrants and their children born in Canada. They conclude that social integration into Canadian society is slower for racial minorities than for immigrants of European origin, partly because of the sense of discrimination and vulnerability discussed earli-er. But their most striking conclusion concerns second-generation minorities, whom they rightly describe as "the harbinger of the future." Reitz and Banerjee find larger second-generation effects on a range of indicators of social inclusion, such as a sense of Canadian identity, a sense of belonging, life satisfaction and trust in other people. Their evidence leads them to conclude that educational and employment success by children of immigrants does not guarantee their social integration.

More research is essential. We need to sort through why findings differ on important issues, such as the level of integration of second-generation visible minorities. We also need to understand more fully the factors that shape the level of social inclusion and differences between minority groups. Reitz and Banerjee are clear that their effort to explain differences in the level of social integration across immigrant groups explains only a small part of the variation. Their find-ings on the role of perceived discrimination are important in underscoring the importance of antidiscrimination policies, especially as the findings are paralleled by studies comparing a number of countries (Berry et al. 2006). But there is still a large research agenda here.

Political and Civic Engagement

Engagement in political processes is also marked by strengths and weaknesses. On the positive side of the ledger, the rate of naturalization of newcomers, an essen-tial step for participation in electoral democracy, is among the highest in the world. According to a 2005 study, 84 percent of eligible immigrants were Canadian

citizens in 2001; in contrast, the rate was 56 percent in the United Kingdom, 40 percent in the United States and lower still in many European states (Tran, Kustec, and Chui 2005). On the negative side of the ledger, however, some minorities do not participate fully in the Canadian political process. While Quebecers turn out for federal elections at rates similar to those of other Canadians, the chapter by Paul Howe finds a 14.5 percent gap in reported turnout between Canadian-born voters and immigrants who arrived since 1985 and are eligible to vote. There is also some evidence that voting rates for Aboriginal people are significantly lower than for other Canadians. According to an Elections Canada report, in the 2000 federal election the turnout rate for 296 polling stations located on-reserves was 48 percent compared with a national turnout of 64 percent. The report noted, however, that turnout in federal elections among Aboriginal voters varies across communities and provinces; in some cases, it is higher than for the Canadian population as a whole (Elections Canada 2004a).

The reasons why members of some racial minorities and Aboriginal communities are voting at lower rates than other Canadians are complex. In part, the differences may reflect a larger number of younger people in some groups: lower turnout among young people is ubiquitous throughout Western democracies. The chapter by Soroka and his colleagues finds that the voting gaps among Aboriginal people and several visible minority groups cease to be statistically significant when they control for age. But wider cultural factors may also be relevant. A lack of interest in politics and cynicism toward politicians may be higher within some minority groups than within the population as a whole. In some cases, abstention may be a political statement; for example, some First Nations people, as a matter of principle, never vote in federal or provincial elections. Lack of information and lower levels of political knowledge could also be factors. For example, Paul Howe finds that Canadian citizens who had arrived in the past 20 years scored considerably less well on his measure of political knowledge than other Canadians.

Turning out to vote is only one form of political engagement. Actual representation in Parliament, provincial legislatures, territorial assemblies and city and municipal councils is the surest way to ensure minorities' voices are heard. Although there has been progress in the past decade or so, Canada has quite a way to go before the numbers of elected representatives from visible minorities and Aboriginal communities come close to their shares of the population. For example, following the 2004 federal election, visible minority members of Parliament filled only 7.1 percent of the

seats in the House of Commons, although they constituted 14.9 percent of the Canadian population (Black and Hicks 2006, 27). In part, this discrepancy reflects the parties' relatively low number of visible minority candidates. For example, in 2004 the Liberal Party of Canada, which traditionally does well in urban areas with large minority populations, nominated a visible minority candidate in only four of the 19 constituencies in the Greater Toronto Area, a region in which visible minorities represent 37 percent of the population (Bird 2005, 82). Although it is often assumed that local politics is more accessible to minorities, this does not seem to be the case in Canada's largest city. Following the November 2006 city council elections in Toronto, only four of the 45 councillors (8.9 percent) were from visible minorities. Aboriginal people are also underrepresented. In the 2004 federal election, six Aboriginal MPs represented 1.9 percent of the House of Commons membership, whereas 3.3 percent of Canadians identified themselves as Aboriginal in the 2001 Census. Moreover, the number of Aboriginal MPs dropped to five in the 2006 federal election (Smith 2006).

Engagement in civic associations has been celebrated as a means of building trust and enhancing the capacity for collective action in contemporary democracies (Putnam 2000). In the United States, there is troubling evidence that civic organizations have greater difficulty in bridging ethnic divisions as people living in ethnically diverse areas withdraw from all forms of community organizations, "hunkering down" in social isolation (Putnam 2004). So far, however, the evidence in Canada is less pessimistic. Existing studies find little evidence of significant hunkering down among Canadians living in ethnically diverse neighbourhoods (Soroka, Helliwell, and Johnston 2007). In addition, the chapter by Soroka, Johnston and Banting finds no significant variation across ethnic groups in participation in general-purpose social organizations, and the chapter by Reitz and Banerjee reports only a small racial gap in their measure of volunteering in voluntary organizations. Bonnie Erickson cautions in her commentary that some of the organizations in which minorities are involved (such as certain sports groups) may have an ethnically specific, rather than diverse, membership, leading to bonding rather than bridging social capital. However, the evidence that successful integration occurs when newcomers retain their ethnic identity and participate in wider society suggests that both bonding and bridging organizations have a role to play. The issue becomes the balance and interactions between the two. There is still much we need to learn in this area. In the meantime, it is important not to automatically transpose evidence from other countries to Canada.

Unfinished Business:
Strengthening Shared
Citizenship

T HE CUMULATIVE EVIDENCE IS CLEAR. CANADA HAS UNFINISHED BUSINESS BOTH IN recognizing and respecting difference and in strengthening social integration. It is time to turn to the agenda for the future.

As in the past, the future of Canadian diversity policies will reflect Canadian realities. At the centre of these realities will be the diverse nature of Canadian diversity, as reflected in the three dimensions of difference. The current complex architecture of diversity policy cannot be reduced to a single model of Canadian citizenship. Francophone Quebecers will continue to seek a distinctive place in Canada, defined on one side by their Québécois political identity and on the other by a sense of attachment to the country as a whole. The First Nations will continue to seek a different relationship with Canada, one defined by treaty rights, the title to land and self-government. Immigrant minorities will bring a third orientation to the pan-Canadian community. Despite the growing strength of transnational identities and the small number of immigrants who may see Canadian status as a fallback position, the vast majority of immigrants still seek to integrate into Canadian life. While they will continue to seek room to sustain their cultural traditions and practise their religions, they are unlikely to want to build separate societies within Canada, complete with a full set of public institutions specific to each community. These variable political identities explain the persistence of the three silos of Canadian diversity policies. Even if we sought to consolidate our understandings in a single piece of legislation, such legislation itself would inevitably reflect the variable geometry of Canadian citizenship.

We do, however, need to reinforce the underlying sources of our shared citizenship, the common commitments that shape and constrain all three silos. In our earlier discussion of shared citizenship, we drew on Marshall's conception of citizenship as embracing civil rights, political rights and social rights. In more contemporary language, shared citizenship in Canada is based on three equalities: the equality of individual rights or human rights, socioeconomic equality and political equality. These three equalities constitute the bedrock of the sense of a pan-Canadian community. Their implications may differ from one silo to another; and the problems facing different minorities may vary and require different responses.

But the underlying strength of the commitment cannot vary. The diverse Canadian approaches to diversity cannot stand if any silo is defined by discrimination, poverty and political weakness.

Advancing the three equalities addresses *both* the recognition and integration agendas. Efforts to increase the participation of minorities in judicial and political institutions, for example, recognize and legitimate the diversity they create by their presence in Canada, and foster their integration into our collective decision-making. The three equalities, as discussed here, certainly do not exhaust the diversity agenda. Strengthening links between Canada and Quebec, for example, certainly remains important. But the evidence does highlight the important aspects of the three equalities for the future of diversity in Canada

This section explores issues central to each of the three equalities. None of the issues will be a surprise to specialists working in each of the various silos that define the diversity policy. Moreover, specific recommendations are beyond the scope of this volume. But we can provide an overview of the complexity of the challenges before us and highlight themes that run through them.

The First Equality: Human Rights and the Justice System

THE IMMEDIACY OF THE HUMAN RIGHTS AGENDA IS REINFORCED BY THE EVIDENCE IN this volume about perceived discrimination among some visible minority groups, including second-generation children born and raised in Canada. While the battle against discrimination does not depend on the enforcement of rights alone, the justice system is a critical point of contact between the state and a diverse society. The institutions of justice stand as the primary protector of human rights, but their operations can also create frictions. To cite the most obvious example, tensions generated by charges of racial profiling by police forces, border agents and security agencies are corrosive of a sense of shared citizenship.

Key issues here include access, representation and structures. In his commentary in this volume, Roy McMurtry, chief justice of Ontario, expresses strong concern about equal access to justice in Canada. In his view, the increasing cost of litigation, cuts to legal aid, the termination of the Court Challenges Program

and the decline of pro bono work in major law firms are denying meaningful access to the justice system to Canadians with mid to low incomes. This trend has powerful implications for some minorities, especially Blacks and Aboriginal people, many of whom do not have meaningful access to the justice system.

Representation also matters. Again, McMurtry's words capture the issue: "When Aboriginal people go to court, they expect to lose because they have been arrested by a White police officer, they are prosecuted by a White Crown attorney, and they are tried by a White judge and usually a White jury. In jail, they are supervised by White guards." Of late, police have been under the spotlight, with major investigations in virtually every province and in every major urban police force. Many police forces have made progress in the recruitment of minorities, beginning particularly in the 1990s (Jain, Singh, and Agocs 2000). In the case of the RCMP, at the level of constables, Aboriginal individuals and visible minorities were close to or exceeded their proportion in the general Canadian population, in 2004. However, minority participation thinned out quickly in more senior ranks, and there was some evidence that momentum in recruitment was fading during the early 2000s (Royal Canadian Mounted Police 2005).[4] Moreover, some major police forces in the country still have further to go, and sustaining the momentum is critical. However, the spotlight also needs to shine more brightly on other parts of the justice system. The legal profession is achieving greater gender balance, but it still does not reflect the country's ethnic and religious diversity (Pendakur 1999). This limits the pool from which Crown prosecutors and judges come, as a glance at the makeup of the senior courts in Canada quickly confirms.

If the justice system does not reflect the society as a whole, pressure for more fully separate systems will grow, moving beyond, for example, the role of sentencing circles in Aboriginal communities. Some Muslims in Ontario supported the proposal for Sharia arbitration in part because of their lack of comfort with the formal system. McMurtry sees a similar imperative in the case of justice for Aboriginal people: "The remedy is not a separate justice system, which would be impractical, given the high percentage of Aboriginal persons living in urban communities. Instead, we need to ensure that Aboriginal people caught up in the justice system see more faces like their own."

Changes in access and minority representation are probably more important than changes in formal structures. But now is not the time to weaken the

institutions with responsibility for antidiscrimination protections. The commentary by Pearl Eliadis reflects concerns that this is precisely what is happening. Until recently, the key human rights machinery at the federal level and in four provinces with substantial minority communities — Ontario, Quebec, Saskatchewan and British Columbia — included both a commission that investigates and helps parties resolve complaints and a courtlike tribunal to which complaints are referred if they are not resolved. However, in 2002 British Columbia abolished the commission, requiring complaints to go directly to the tribunal. In 2006, Ontario also abolished the two-step process, and individuals now must file claims directly with the Human Rights Tribunal. However, the Ontario changes allow organizations to bring applications on another's behalf and retain the commission, which can intervene in any application before the tribunal and conduct general inquiries, such as its inquiry into the effects of racial profiling. The debate over whether these changes weaken human rights protections has been intense.

At the federal level, the government has taken the first step toward a notable extension of human rights legislation. In December 2006, the minister of Indian affairs and northern development introduced legislation to repeal section 67 of the *Canadian Human Rights Act, 1985*. That section prevented Aboriginal people living and working on-reserves from filing complaints with the Canadian Human Rights Commission against band councils or the federal government for decisions made under the *Indian Act, 1985*. The repeal of section 67 would grant First Nations people full access to the human rights protections that other Canadians have enjoyed since 1977.

Advancing the antidiscrimination agenda depends on other instruments as well. Multiculturalism programs, including antiracism initiatives, are important, as are the issues of economic and political integration discussed in the next sections. At the federal level, movement toward a broader approach began in the mid-1990s following the review of the multiculturalism programs of the Department of Canadian Heritage. Antiracism measures now occupy a larger part of the department's programming. Moreover, in 2005 the Government of Canada issued *Canada's Action Plan against Racism* (Department of Canadian Heritage 2005). In addition to committing federal departments and agencies to working together, the document emphasizes the importance of partnerships with civil society for a variety of initiatives to assist victims of discrimination, combat racism, counter hate messages and educate children and youth on diversity issues. Similarly, the Quebec

government is also taking a broad approach to racism and discrimination. In mid-2006, it launched a consultation process that is intended to lead to a government-wide policy on those questions (Quebec Éducation Loisir et Sport 2006).

In a diverse society, the commitment to human rights and fighting discrimination is central to both recognizing diversity and building community. There is a big agenda here: improving access to the courts by reinvesting in legal aid; enhancing minority representation in the justice system at all levels; strengthening human rights machinery; and sustaining antiracism advocacy and education.

The Second Equality: Socioeconomic Equality

A S WE HAVE SEEN, THE ECONOMIC CONVERGENCE BETWEEN FRENCH- AND ENGLISH-speaking Canada, a major success of the mid-twentieth century, has yet to be replicated in the case of Aboriginal people, and the engine of economic integration is stalling for many recent immigrants. Moreover, the welfare state provides less support to those on the margins of economic life than in the past. Getting the socioeconomic framework right is critical to the future of Canadian diversity.

This challenge needs to be seen in the context of the larger evolution of the global economy and contemporary approaches to economic security. With the emergence of the so-called knowledge/information era, the traditional trade-off between the social and economic spheres has undergone a remarkable transformation. The optimal way to ensure both economic competitiveness and social cohesion is to pursue these goals in tandem. Two strategies are critical. First, human capital and knowledge are the touchstone of economic competitiveness and social inclusion in the twenty-first century. As Lester Thurow (1993) noted some time ago, "If capital is borrowable, raw materials are buyable, and technology is copyable, what are you left with if you want to run a high wage economy? Only skills, there isn't anything else." Part of the challenge is to ensure that people acquire knowledge and skills, that their skills and credentials are recognized, and that we break down discriminatory practices and other barriers that prevent them from using their skills to achieve a rewarding livelihood. Second, our tax and transfer systems and other social protections must ensure that those who lack human capital or face multiple barriers are protected, and that the gap between

rich and poor does not grow so wide as to undermine real equality of opportunity, including educational opportunity, for succeeding generations.

Within this larger context, the specific issues and responses differ among Aboriginal people, recent immigrants and visible minorities more generally.

Aboriginal Well-Being

Nowhere are the twin agendas of recognition and integration as intertwined as with Canada's Aboriginal peoples. Yet Aboriginal inequality is not the product of any logical or inevitable tension between the two agendas. In practice, our collective political energies do shift from time to time between the two. But in the final analysis, we have not advanced either agenda adequately.

Since the adoption of the *Constitution Act, 1982*,[5] through which Canada became the first advanced democracy to constitutionally recognize indigenous rights, the agenda of recognition and self-government has received considerable attention. Self-government has been seen as having priority, on the grounds that the economic development prospects of Aboriginal peoples depend on the achievement of self-government. First Nations, it is argued, need the autonomy to govern their own communities and set their own economic development and other priorities. Over time, the modification of the *Indian Act* has allowed band councils to assume somewhat greater powers, but the result is closer to self-administration than self-government, and does not give Aboriginal people sufficient control over their economic future. The 1992 Charlottetown Accord did propose the constitutional entrenchment of the inherent right of Aboriginal self-government, along with other major constitutional reforms, but it failed in a national referendum. Self-government was also one of the core principles of the 1996 *Report of the Royal Commission on Aboriginal Peoples*. Although the federal government took some distance from the report, it did recognize, in a 1995 policy, that Canada's Aboriginal peoples have an inherent right to self-government under the *Constitution Act, 1982* (Indian and Northern Affairs Canada 1995).

Notwithstanding the failure to constitutionalize self-government, negotiations between the federal government and a number of First Nations have led, as of 2006, to 20 comprehensive land claim agreements. These communities secured ownership for more than 600,000 square kilometres of land and some $2.4 billion in cash (Auditor General of Canada 2006, chap. 7). The important James Bay and Northern Quebec agreements date from the 1970s. All but three

of the 14 Yukon First Nations now have land claim and self-government agree-
ments. The Inuit have done especially well, with the signing of agreements with
the Inuvialuit of the Western Arctic in 1984, Nunavut in 1993 and the Labrador
Inuit in 2003 — and, of course, the creation in 1999 of the public government
in the new territory of Nunavut.

 Elsewhere, however, the pace of land claim agreements has been exceed-
ingly slow. For example, in British Columbia 47 such negotiations have been
launched under a treaty process established in 1992, but only three final agree-
ments had been initialled by the end of 2006, in addition to the 1999 Nisga'a
Agreement (which was negotiated outside that process). While British Columbia's
2005 "New Relationship" Accord may herald a new era,[6] commentators, includ-
ing former Yukon premier Tony Penikett (2006, 3), have criticized the lack of
results and the large amount of money spent through the treaty process.

 More recently, attention has shifted to achieving economic development and
a better quality of life for Aboriginal people through other avenues. For example, in
the Kelowna Accord of November 2005, the first ministers and national Aboriginal
leaders agreed to a 10-year plan intended to improve Aboriginal quality of life in
education, health, housing and economic opportunities; to that end, Prime Minister
Paul Martin pledged $5 billion for the following five years. Following the change of
government in 2006, implementation of the Kelowna Accord as a whole did not
proceed, although the current Conservative government has made financial com-
mitments in some of the policy areas identified in the accord.[7] In British Columbia,
a potentially significant change has been launched in the education field. As a result
of a 2006 agreement, First Nations will be able to negotiate a Canada-First Nation
Education Jurisdiction Agreement that will allow them to remove themselves from
the relevant part of the *Indian Act* and assume jurisdiction for all levels of on-reserve
education. In a knowledge-based economy, higher levels of education are critical to
Aboriginal progress, as John Richards underlines in his commentary.

 For the majority of Aboriginal people who live off-reserve (in 2001, 49
percent of Canada's Aboriginal people lived in cities), public services such as edu-
cation and health are provided by provincial and municipal governments.
Provincial and municipal governments, sometimes in collaboration with the fed-
eral government (as in the Urban Aboriginal Strategy launched in 1998), are tak-
ing steps to improve the socioeconomic conditions of off-reserve Aboriginal
people. In some cases, new frameworks are being developed to encourage greater

community autonomy, notably in economic development. For example, 28 urban reserves have been created in Saskatchewan since 1988.

Despite some progress, the agenda remains daunting. Self-government negotiations will not succeed unless governments demonstrate political will and commit the resources to allow Aboriginal people to open new doors. More concerted attention to the situation of Aboriginal people off-reserve is also essential. Without such changes, Aboriginal people's sense of belonging to the Canadian community, which they helped found, is unlikely to grow.

Economic Integration of Immigrants

Here the issues are very different, as recent cohorts of immigrants have substantial human capital. Not surprisingly, much attention has been focused on the "discounting" of foreign education, credentials and experience. A recent study carried out for the IRPP concluded that, on average, a foreign university degree held by a non-White immigrant has a return worth less than one-third that of a degree obtained in Canada by a native-born Canadian (Alboim, Finnie, and Meng 2005). Other factors are also at work. The 1980s and 1990s saw an expansion of the numbers of Canadian-born university graduates coming into the labour market, generating stronger competition for skilled jobs. Increasing attention is also being focused on the language proficiency of immigrants, especially in more technical fields. And, undoubtedly, some element of the growing problems of immigrants reflects racial discrimination in the labour market. Certainly, racial minority immigrants face additional obstacles such as isolation in certain "occupational enclaves" and lack of access to social networks with the linkages necessary to assist them in finding good jobs (Reitz 2005).

Progress will require a much more sophisticated approach to immigrant integration than we have relied on until now (Alboim and McIsaac 2007). To a large extent, existing programs focus on reception needs of new arrivals rather than on the labour market entry needs of more educated immigrants. More recent policy innovations target the recognition of credentials. Provincial governments have the constitutional authority to regulate trades and professions, and some of them are beginning to tackle the issue. In 2006, the Ontario government passed Bill 124, creating a new *Fair Access to Regulated Professions Act,* which obliges 34 regulated professions, including physicians, accountants, lawyers, teachers, engineers and social workers, to adopt registration practices that are "fair, transparent and expeditious." Quebec is also moving on the file. After reports from advisory bodies in 2004 and 2005, a bill was tabled in

the National Assembly to amend the *Code des professions* to allow professional orders to issue three new kinds of permits in order to facilitate the professional integration of people educated or trained outside Quebec.[8] The federal government has also begun steps to create a Canadian Agency for Assessment and Recognition of Credentials. Despite the agency's name, it will focus primarily on the provision of information and referral services for credential assessment rather than on providing the assessment itself. These initiatives need to be complemented by "bridging" courses in colleges and universities, in which arriving professionals can top up their previous training.

While these initiatives are useful, the problems are much broader. Formal qualifications matter to regulatory bodies and universities, but employers are more interested in the competencies for which formal qualifications normally serve as a proxy. The strongest predictor of economic success among immigrants is not formal credentials but the level of ability in one or the other of Canada's official languages. For immigrants educated elsewhere, especially those in professional occupations, the requirements go well beyond basic English or French. Employers want employees who can not only read, write and express themselves in sophisticated ways, but who can also solve problems and work in teams, all of which require both command of technical vocabulary and understanding of cultural context and nuance.

Governments are only now coming to grips with this issue. There is a growing recognition of the need for advanced language training geared to labour market integration. However, the level of training currently provided varies dramatically across the country, and bringing existing programs up to the general standard required for labour force participation, let alone for specific professional sectors, will require a substantial additional investment. It will be a long time before we have a system across the country that can properly assess newcomers and steer them to courses appropriate to their professional sector. In addition, because some recent immigrants have difficulty accumulating enough hours of employment to qualify for Employment Insurance, they are not eligible for training allowances and often cannot afford to take advantage of federally funded courses, even when these are free, because they have to work to support themselves and their families.

The discounting of foreign work experience is best overcome by Canadian work experience. Governments have taken some limited steps along this path. For example, the Ontario government has invested more than $34 million since 2003 in 60 "bridge training" projects, many of which include work placements, to help newcomers work in some 100 trades and professions. Also, in 2006, the

province promised to create an internship program for internationally trained individuals, placing them in up to 70 six-month internship assignments in ministries and Crown agencies.[9] But such initiatives remain extremely modest. More powerful would be a program of incentives to encourage all employers to give newcomers the first Canadian job in which to develop and demonstrate their capacity to communicate and work effectively in Canada.

Not surprisingly, the size of the integration challenge is deflecting pressure back to immigration policy and the criteria governing immigrant selection. A number of changes are under debate. Federal-provincial agreements are being adjusted to allow international students studying in Canada, who will have domestic credentials and a substantial head start on their integration process, to work longer after graduation and to apply for immigrant status from inside the country. More radical options are also in the air. One idea is to adopt the new Australian model, making recognition of foreign credentials and competence in one of the official languages formal requirements for selection, a proposal that might have significant implications for the source countries for immigration to Canada. Employers are also taking a larger role. Applicants already receive significant additional points in the selection process if they have arranged employment; trade agreements create greater scope for employer-employee driven admissions; and provincial nominee programs are used to meet employer requests. Recently, however, there has been a large increase in the number of employers relying on the temporary workers program to achieve prompt results, not only for unskilled labour but also for professional employees.

Finally, the socioeconomic well-being of immigrants would be enhanced by the strengthening of social programs benefiting all workers. Several ways forward have been identified. The rules governing eligibility for EI might be eased for new entrants to the labour force, including immigrants, especially if EI is to remain the platform for a wider range of labour market programs. Alternatively, a new set of programs might be introduced to address the labour market needs of non-EI-eligible workers, including most immigrants (Battle, Mendelson, and Torjman 2006; Task Force on Modernizing Income Security for Working-Age Adults 2006). In addition, unskilled immigrants — and skilled immigrants trapped in unskilled jobs — would benefit from a serious effort to support all low-wage workers through income transfers. Some progress has been made on this agenda through the Canada Child Tax Benefit and the National Child Benefit, and the proposals for a working income tax benefit would also assist low-income workers, including many immigrants.

Economic Well-Being and Visible Minorities

Since their inception, employment equity policies have reflected the assumption that the danger of economic marginalization is not limited to immigrants but persists in subsequent generations. However, studies of *Canadian-born* visible minorities are challenging this assumption and revealing striking differences across groups. Krishna Pendakur and Ravi Pendakur examine the average earnings of Canadian-born men and women in different ethnic groups from 1971 to 1996, controlling for a variety of factors including age and schooling. They find that Japanese-Canadian men and women enjoyed higher average earnings than their counterparts of British origin consistently throughout this period; the same is true for Chinese-Canadian women, and by 1996 Chinese-Canadian men's earnings were equal to those of Canadians of British origin. In contrast, Black and Aboriginal workers face dramatic earnings gaps, and those gaps grew in the 1990s (Pendakur and Pendakur 2002). Similar conclusions emerge from a study by Derek Hum and Wayne Simpson (2006). Using 2002 data, they conclude that among Canadian-born workers there was no significant wage gap between visible minority and nonvisible minority workers as general categories. Breaking down the concept of visible minority, however, revealed a dramatic disadvantage for Black men and Latin American men.

These findings lead both sets of authors to reflect on the concepts normally utilized to analyze disadvantage and design policy responses. "Given that in 1986 almost half of Canadian-born working-age visible minorities were of Chinese or Japanese origins, this suggests that the visible minority category is somewhat blunt" (Pendakur and Pendakur 2002, 509).[10] Hum and Simpson (2006) extend the questioning to the policy level: "At the very least, our findings should sound a warning that treating visible minorities as a homogeneous group for public policy, particularly employment equity, is ill advised…The persistent disadvantage facing black men in Canada (and now, Latin American men) should no longer be submerged in a multicultural discourse nor confined exclusively within a 'visible minority' context." It is time for a national debate on how we define and respond to disadvantage in this country.

Underlying all of these challenges is the commitment to socioeconomic equality. Intriguingly, the role of human capital in the points system for selecting immigrants can be seen as a metaphor for a broader societal commitment to all Canadians, both those who come from abroad and those who are born here. While we need not go as far as Courchene (2001) when he argues for a Charter of Children's Human Capital Rights to inform our policy decisions in this area, it

is nonetheless the case that some similar social vision ought to be part of Canadian citizenship in the twenty-first century.

The Third Equality: Political and Civic Participation

A S WE HAVE SEEN, ELIGIBLE VOTERS FROM ABORIGINAL AND IMMIGRANT COMMUNITIES vote less often than other Canadians and are underrepresented in legislative bodies across the country. Both these questions deserve attention, as does the role of civil society organizations in promoting inclusion and shared citizenship.

Electoral Participation

Some election-management bodies have been reaching out to electors in communities with lower than average voting rates. Over the years, Elections Canada has developed a range of measures to facilitate voting by members of ethnocultural communities and Aboriginal people. These include communications activities; providing information about the electoral process in languages in addition to French and English (including a number of Aboriginal languages); and appointing community relations officers who distribute information, carry out liaison with community organizations and facilitate voting (see box 1).

In their chapter in this volume, Marc Hooghe, Tim Reeskens and Dietlind Stolle raise the idea of granting newcomers who have not yet become citizens the right to vote in local elections. This right exists in a number of European countries, and in some other countries the question is being debated (see box 2). Hooghe, Reeskens and Stolle do not see such limited voting rights as merely symbolic:

> Voting rights enhance the social status of immigrants and perhaps positively influence their trust levels, increase their participation in social-political life and afford them a better association with majority populations. Therefore, from a policy perspective, our research suggests that in the interest of social cohesion, granting voting rights is a step in the right direction.

Because of the high rate of naturalization of immigrants in Canada, such proposals have received less attention here. Nevertheless, some have suggested moving in this direction. For example, in October 2006, Toronto mayor David Miller said

that permanent residents should be given the right to vote in municipal elections. Such a change would allow newcomers to become familiar with the electoral process, and they might be more inclined to participate in federal, provincial and territorial elections once they become citizens. This proposal clearly merits further research and public debate.

Representation of Minority Communities

Research demonstrates that the representation of minorities in legislatures depends to a considerable degree on their capacity to be nominated as party candidates. This is particularly true when minorities are concentrated in specific areas rather than dispersed. Reforms thus tend to concentrate on measures that will facilitate their access to party nomination. Although it has been suggested that political parties should be required by law to choose more members of minorities as candidates, some parties have taken steps in this direction, such as setting targets. Others advocate changes in electoral laws. Some contend that proportional

BOX 1

Elections Canada: Outreach Initiatives for Ethnocultural Communities and Aboriginal People — 2004 General Election

Ethnocultural communities

Returning officers were authorized to appoint *ethnocultural community relations officers* in any electoral district in which at least 10 percent of the population had origins in China, India or the Philippines. In total, 59 such officers were appointed in 48 of the 50 eligible electoral districts.

Messages about the electoral process and how to vote were designed to attract specific groups, and a wide range of formats and languages were used.

Aboriginal communities

Returning officers were authorized to appoint *Aboriginal community relations officers* in any electoral district with a Métis settlement, at least one Aboriginal reserve, an Inuit hamlet or a friendship centre, or in which Aboriginal people made up at least 5 percent of the population. In total, 164 such officers were appointed in 124 of the 137 eligible electoral districts.

More than 600 polls were established on First Nations reserves and in Inuit and Métis communities, and 39 in friendship centres.

Under the Aboriginal Elder and Youth Program, elders and youth offer information and assistance to voters who may not be familiar with the federal electoral process. In the 2004, election, 173 elders and 182 youth were present at 262 polling stations in 48 electoral districts.

Source: Elections Canada 2004b, 41-42.

representation would provide incentives for parties to nominate more candidates from minorities (Law Commission of Canada 2004, 114). However, that would depend on the rules of the particular voting system and, as at present, decisions by the parties. Another route is through public funding of political parties. For example, the Quebec government's draft *Election Act* (tabled in December 2004), which

BOX 2

Voting Rights for Noncitizens in Local Elections in Europe: Examples of Legal Provisions and Recent Debate

Ireland: All non-Irish adults who are registered as residents have had the right to vote in municipal elections since 1963.

Denmark: Those who have been resident for three years have been allowed to vote in local elections since 1981.

Sweden: Foreigners resident for three years have been allowed to vote in local and regional elections, and in some national referendums, since 1975.

The Netherlands: Voting in local elections after five years as a resident has been allowed since 1985 (since 1979 in Rotterdam).

Finland: Immigrants resident for two years have been allowed to vote in local elections since 1996 (from 1991 to 1996, those resident for four years had this right).

Spain: In February 2006 the Spanish Congress of Deputies unanimously approved a motion to study the legal reforms that would be needed to enable immigrants resident in Spain to participate in the next municipal elections.

France: Interior Minister Nicolas Sarkozy has indicated he favours regularized immigrants being allowed to vote in municipal elections.

Sources: www.immigrantvoting.org/material/world.html; http://users.skynet.be/suffrage-universel/indexvo01.htm

proposed a semiproportional electoral system, included provisions to increase public funding for parties that nominated a sufficient number of non-francophone candidates.

There have also been proposals to enhance the representation of Aboriginal people in our legislatures. In its 1991 report, the Royal Commission on Electoral Reform and Party Financing drew on New Zealand's experience since 1867 with seats designated for the Maori, which is described in Roger Maaka's chapter. The commission recommended that a number of seats in the House of Commons be designated for Aboriginal people. The number of seats would vary depending on the level of registration on an Aboriginal electoral list. About the same time, Thomas Courchene and Lisa Powell (1992) proposed the creation of a "First Nations province" (FNP) comprising First Nations reserves across the country. This idea is premised on First Nations achieving self-government and becoming, in effect, an order of government analogous to other provinces. As in other provinces, members of Parliament would be elected from constituencies in the FNP in line with their population. Moreover, the elected leader of the FNP would be considered a first minister, participating in intergovernmental deliberations, and the FNP would have members in the Senate. None of these proposals has found significant support among Aboriginal leaders, perhaps because such reforms are seen as in conflict with the pursuit of self-government (Williams 2004). However, they have not had the same degree of public and expert discussion as some of the reforms mentioned above.

There is thus no shortage of proposals that could reduce the representational deficits of ethnocultural minorities and Aboriginal peoples. There is, however, a need for more serious debate on possible measures and the degree to which the benefits claimed by their advocates would actually occur.

Civil Society Organizations

Nongovernmental organizations (NGOs) can also contribute to promoting inclusion and shared citizenship. As mentioned above, integration is most effective when newcomers maintain attachment to their ethnic identity and participate in the wider society. This implies that both organizations in which members of a particular ethnic group bond with each other and organizations that bridge across ethnic communities have roles to play. In this regard, the proposition that ethnic diversity leads to a withdrawal from such organizations does not seem to be borne out in Canada.

A large number of nongovernment organizations are involved in assisting recent arrivals not only to find productive employment but also to adapt to their new environment (see, for example, the discussion of Vancouver's SUCCESS in David Ley's commentary). Such organizations are close to the immigrants and refugees with whom they are involved, and in many cases they can help ease integration into Canadian life by providing advice and assistance in the newcomers' mother tongue. Recent research confirms the importance of such networks. Irene Bloemraad (2006) compares the integration of the Vietnamese and Portuguese communities in Boston and Toronto, and concludes that the two ethnic groups are better integrated in terms of civic and political participation in Toronto than in Boston. The explanation lies at least in part in the fact that Canada's multiculturalism policy has encouraged the creation of a network of institutions that link immigrants to the larger society. Unfortunately, according to a recent study, such settlement programming in Canada has been hampered by limited funding and government-imposed constraints on the design and delivery of settlement services by nongovernmental organizations.[11] To allow agencies to have more autonomy to introduce programs that meet locally identified needs, program funding tied to the delivery of specific services should be supplemented by multiyear funding (Wayland 2006, 19).

Civil society organizations can also promote civic literacy,[12] within both minority communities and Canadian society as a whole. In the past decade, a number of organizations have emerged with a mission to enhance the degree to which Canadians, particularly youth, understand their country and its history, including the Historica

Foundation (launched in 1999) and the Dominion Institute (established in 1997). Other civil society organizations are helping foster key values of citizenship among young Canadians. For example, since 2003 Student Vote has organized mock elections in schools as a way of encouraging young Canadians to develop a habit of voting.

Another area in which civil society organizations are active is the sponsorship of youth exchanges. Some exchanges are community based, with a local service organization supporting the travel and related costs for youth to visit another part of Canada. Other exchanges are coordinated by a national body, a number of which are funded by Exchanges Canada.[13] One of the key principles underlying exchanges is that people can better understand difference by experiencing it. There is evidence this evolution does indeed occur.[14] As diversity has come to be viewed more widely, exchanges have expanded beyond official language groups. For example, the SEVEC Youth Exchanges Canada program now has an Aboriginal Exchange Program, one of the objectives of which is to "connect and facilitate interactions between Aboriginal youth and non-Aboriginal youth and/or those from a different Aboriginal culture" (SEVEC 2005, 11).

Youth exchanges and other activities of civil society organizations bring together people from different social and cultural backgrounds and help build civic literacy. This sector's potential contribution to shared citizenship merits deeper consideration by policy-makers and researchers. Should some public funding for nongovernmental organizations be targeted toward minority communities where such organizations are not as extensive? Are the creativity and energy of civil society organizations being sapped by the growing emphasis on project (rather than core) funding and tighter accountability requirements? Should the federal and other governments, as well as the private sector, provide more generous support for exchange programs and youth forums? How do such activities link to the role of the education system in helping young Canadians understand their country and each other? These and other questions deserve greater attention as part of efforts to realize more fully the potential of civic participation both within and across diverse communities.

Final Thoughts

I S THE CANADIAN APPROACH TO DIVERSITY BROKEN? THIS VERY QUESTION MISUNDERSTANDS the Canadian approach to diversity. Any summary assessment of the strengths and

weaknesses of our approach to ethnic diversity will inevitably vary across the three dimensions of difference. The position of the Québécois, although not a central focus of this volume, remains at the heart of Canadian political life. As the chapter by Soroka and his colleagues reminds us, the deepest divisions may be not between "new" Canadians and "old" Canadians, but between the founding peoples of the country. Although relations between Canada and Quebec have absorbed much of the political energies of the last half century, we still have not resolved the tensions surrounding the recognition and accommodation of Quebec nationalism within Canada.

An even more critical judgment is appropriate in the case of the position of First Peoples in Canada. Outside of the North, progress on the agenda of title to land and self-government has been painfully slow; and the record on the economic and social well-being of Aboriginal people is a national failure.

Much of the current debate swirls around immigrant integration and the well-being of visible minorities, and this volume provides evidence of important tensions here. In this area, however, a sense of proportion is required. Canada is not "sleepwalking into segregation." There is no justification for a U-turn in multiculturalism policies comparable to that underway in some European countries. There is no reason to assume the agendas of recognition and integration are in conflict. Nevertheless, the warning signs cannot be ignored. Policy debates have seized on the importance of economic integration, and there is no question that progress here is essential. However, economic integration, on its own, is not sufficient. The evidence in this volume is clear that economic success does not guarantee social integration. Feelings of belonging and engagement, a sense of mutual support and commitment, and participation in a common political community require separate attention and support. The agenda is multifaceted: reinforcing the machinery to protect human rights and fight discrimination; enhancing minority representation in critical institutions such as the justice system; and stronger efforts to encourage minorities to participate more extensively in the political life of the country.

Although summary evaluations are inevitably framed within the context of each dimension of difference, peering across the silos adds insight. One is inevitably struck by the persistent disadvantage of Black and Aboriginal individuals on many of the dimensions of inclusion examined in this book: the sense of belonging and pride in Canada, levels of perceived discrimination, interactions with the justice system, employment and labour market earnings, and political engagement. At the

same time, some ethnic minorities perform as well as or better than the Canadian average on many of these same measures. It would seem to be time for a national debate on the bluntness of categories such as "visible minority" and the desirability of more targeted policy responses to disadvantage in Canada.

Peering across the silos also clarifies what instruments are available to governments and civil society to strengthen our shared citizenship. Governments have little direct influence over social attitudes, such as feelings of belonging, trust, solidarity, pride in country and sense of identity. To a limited degree, policies can direct the education system and public broadcasting to celebrate shared values and tolerance, and civil society organizations can contribute through educational initiatives and exchanges to enhance mutual understanding and a sense of Canadian history. Symbols of nationhood, however, cannot be the only glue holding the country together. In a bilingual, multinational federal state, there are definite limits to our capacity to engage in nation-building enterprises.

Hence our stress on the three equalities as the bedrock of our shared citizenship. We build respect by respecting difference; we build tolerance by resisting discrimination; we build trust by being trustworthy; we build belonging by drawing people into the mainstream of civic and political life; we build solidarity by supporting all Canadians in need. Building shared citizenship is an ongoing task, especially in a diverse society, but there is good reason to hope that these fundamentals will sustain this distinctive Canadian project in the future.

Notes

1 We would like to thank Grant Holly and Laura O'Laughlin for the excellent research assistance they provided during the preparation of this chapter. We are also grateful for the insightful comments on earlier drafts we received from Naomi Alboim, Pearl Eliadis, Siobhan Harty, Will Kymlicka and France St-Hilaire. Any errors of fact or interpretation are our responsibility.

2 According to the Court, the kirpan must be worn under the clothes and sewn into a sheath; *Multani v. Commission scolaire Marguerite-Bourgeoys* (2006) SCC 6.

3 Data from Indian and Northern Affairs Canada Web site: www.ainc-inac.gc.ca/pr/info/finsocec/sdpr. Accessed January 3, 2007.

4 It is troubling that minorities represented a smaller share of RCMP cadets in the early 2000s than their share of the constable ranks in 2004, implying a slowing of momentum (Royal Canadian Mounted Police 2005).

5 The *Constitution Act, 1982* recognizes and affirms the existing Aboriginal and treaty rights of Aboriginal peoples (section 35(1)). Section 35(2) defines the Aboriginal peoples of Canada to include the Indian, Inuit and Métis peoples, and section 35(3) defines treaty rights to include "rights that now exist by way of land claims agreements or may be so acquired."

6 The "A New Relationship" Accord promises to "replace conflict and litigation with a new relationship based on sharing resource revenues, shared provincial-Aboriginal decision making, and provincial recognition of Aboriginal rights and title" (Penikett 2006, 254).

7 The May 2006 budget provided $450 million in additional funding for education, water and housing, and for women, children and families.

8 At the time of writing (January 2007), this bill had not yet been passed. For a description of the mandates and other aspects of the two consultative bodies established by the Quebec government in 2004 and links to their reports, see Québec, Immigration et Communautés culturelles, "Accès des immigrants aux professions et métiers réglémentés" at www.micc.gouv.qc.ca/fr/presse/index.html

9 On the Ontario government initiatives, see "Fair Access to Regulated Professions Act, 2006: Cornerstone of the Plan for Newcomer Success." www.citizenship.gov.on.ca/english/about/b080606.htm

10 Pendakur and Pendakur also note, however, that there is heterogeneity in earnings across the country, and that although Chinese men do well in Vancouver, where the Chinese community is large, they face earnings gaps in Toronto and Montreal. They therefore add that "the case for the bluntness of the (visible minority) category is partially driven by the heterogeneity of earnings across cities" (Pendakur and Pendakur 2002, 510).

11 The study noted that immigrant-serving agencies are constrained by a lack of stable core funding and must rely on service delivery contracts for language training and other programming, often on a year-to-year basis. Such contracts "often involve increased accountability requirements with little or no flexibility in program delivery or funding" (Wayland 2006, 17). These difficulties are not unique to immigrant-serving organizations. As Susan Phillips (2006, 26), a leading scholar of the voluntary sector, has noted, the tightening of the federal government's accountability regime in 2000 following the controversy over grants and contributions at Human Resources Development Canada "exert[s] top-down controls that reinforce the principal-agent nature of these relationships and greatly reduce the autonomy of voluntary organizations."

12 Henry Milner (2002, 2) defines civic literacy as "the knowledge and skills to act as competent citizens."

13 Exchanges Canada is a unit within the Department of Canadian Heritage; see

www.exchanges.gc.ca/about_Us.asp?
Language=0&MenuID=1

14 According to post-exchange questionnaires,
99.6 percent of group organizers for the
SEVEC Youth Exchanges Canada program
agreed that the exchanges gave participants
a better appreciation of Canada's diversity
(SEVEC 2005, 8).

References

Alboim, Naomi, and Elizabeth McIsaac. 2007
(forthcoming). "Making the Connections:
Federal Solutions on Immigrant
Employment." *IRPP Policy Matters.*

Alboim, Naomi, Ross Finnie, and Ronald Meng.
2005. "The Discounting of Immigrants'
Skills in Canada: Evidence and Policy
Recommendations." *IRPP Choices* 11(2).

Alesina, Alberto, and Edward Glaeser. 2004.
*Fighting Poverty in the US and Europe: A
World of Difference.* Oxford: Oxford
University Press.

Auditor General of Canada. 2006. *2006 Report of
the Auditor General of Canada.* Accessed
January 17, 2007. www.oagbvg.gc.ca/
domino/reports.nsf/html/06menu_e.html

Aydemir, Abdurrahman, and Mikal Skuterud.
2005. "Explaining the Deteriorating Entry
Earnings of Canada's Immigrant Cohorts,
1966-2000." *Canadian Journal of Economics*
38(2): 641-72.

Aydemir, Abdurrahman, Wen-Hao Chen, and
Miles Corak. 2005. "Intergenerational
Earnings Mobility among the Children of
Canadian Immigrants." Ottawa: Analytical
Studies Branch Research Paper Series,
Statistics Canada, Catalogue no.
11F0019MIE2005267.

Banting, Keith. 1995. "The Welfare State as
Statecraft: Territorial Politics and Canadian
Social Policy." In *European Social Policy:
Between Fragmentation and Integration,* edit-
ed by Stephan Liebfried and Paul Pierson.
Washington, DC: Brookings Institution.

Banting, Keith, and Will Kymlicka. 2006.
"Introduction: Multiculturalism and the
Welfare State: Setting the Context." In
*Multiculturalism and the Welfare State:
Recognition and Redistribution in
Contemporary Democracies,* edited by Keith
Banting and Will Kymlicka. Oxford: Oxford
University Press.

Battle, Ken, Michael Mendelson, and Sherri
Torjman. 2006. *Towards a New Architecture
for Canada's Adult Benefits.* Ottawa: Caledon
Institute for Social Policy.

Berry, John W., Jean S. Phinney, David L. Sam,
and Paul Vedder. 2006. "Immigrant Youth:
Acculturation, Identity, and Adaptation."
Applied Psychology: An International Review
55(3): 303-32.

Bird, Karen. 2005. "Guess Who's Running for
Office? Visible Minority Representation in
the 2004 Canadian Election." *Canadian
Issues* (summer): 80-3.

Black, Jerome H., and Bruce M. Hicks. 2006.
"Visible Minority Candidates in the 2004
Federal Election." *Canadian Parliamentary
Review* 29(2): 26-31.

Blair, Tony. 2006. "The Duty to Integrate: Shared
British Values." Address by the Prime
Minister to the Runnymede Trust. London,
December 8.

Bloemraad, Irene. 2006. *Becoming a Citizen:
Incorporating Immigrants and Refugees in the
United States and Canada.* Berkeley:
University of California Press.

Canadian Radio-television and
Telecommunications Commission (CRTC).
2000. "A Distinctive Voice for All
Canadians: Renewal of the Canadian
Broadcasting Corporation's Licences."
Public Notice 2000-1, January 6.

Chiswick, Barry R., and Paul W. Miller. 2001. "A
Model of Destination Language Acquisition:
Application to Male Immigrants in
Canada." *Demography* 38(3): 391-409.

Corak, Miles. 2001. "Are the Kids All Right?
Intergenerational Mobility and Child Well-
Being in Canada." In *The Longest Decade:
Canada in the 1990s. The Review of Economic
Performance and Social Progress,* edited by
Keith Banting, Andrew Sharpe, and France
St-Hilaire. Montreal: Institute for Research

on Public Policy and Centre for the Study of Living Standards.

_____.2004. *Generational Income Mobility in North America and Europe*. Cambridge: Cambridge University Press.

Courchene, Thomas J. 2001. *A State of Minds: Toward a Human Capital Future for Canadians*. Montreal: Institute for Research on Public Policy.

Courchene, Thomas J., and Lisa M. Powell. 1992. *A First Nations Province*. Kingston: Institute for Intergovernmental Relations.

Department of Canadian Heritage. 2005. *A Canada for All: Canada's Action Plan Against Racism*. Accessed January 16, 2007. www.canadianheritage.gc.ca/multi/plan_action_plan/pdf/action_e.pdf

Elections Canada. 2004a. "Aboriginal People and the Federal Electoral Process: Participation Trends and Elections Canada's Initiatives." Accessed January 16, 2007. www.elections.ca/content.asp?section=loi&document=abor&lang=e&textonly=false

Elections Canada. 2004b. *Report of the Chief Electoral Officer of Canada on the 38th General Election Held on June 28, 2004*. Accessed January 16, 2007. www.elections.ca/content.asp?section=gen&document=index&dir=rep/re2/sta2004&lang=e&textonly=false

Frenette, Marc, and René Morissette. 2003. "Will They Ever Converge? Earnings of Immigrant and Canadian Born Workers over the Last Two Decades." Ottawa: Analytical Studies Branch Research Paper Series, Statistics Canada, Catalogue no. 11F0019MIE2003215.

Goodhart, David. 2004. "Too Diverse?" *Prospect* (February), 30-7.

_____. 2006. "National Anxieties." *Prospect* (June), 30-5.

Hamdani, Daood. 2006. *Engaging Muslim Women: Issues and Needs*. Ottawa: Canadian Council of Muslim Women, October.

Harty, Siobhan, and Michael Murphy. 2005. *In Defence of Multinational Citizenship*. Cardiff: University of Wales Press.

Hum, David, and Wayne Simpson. 1998. "Wage Opportunities for Visible Minorities in Canada." Income and Labour Dynamics Working Paper Series, Statistics Canada, Catalogue no. 75F0002MIE1998017.

_____. 2004. "Economic Integration of Immigrants to Canada: A Short Survey." *Canadian Journal of Urban Research* 13(1): 46-61.

_____. 2006. "Revisiting Visible Minorities and Immigration Adjustment in Canada's Labour Market." Paper presented to the Canadian Employment Research Forum, Montreal, May 25-26.

Indian and Northern Affairs Canada. 1995. *Aboriginal Self-Government: The Government's Approach to Implementation of the Inherent Right and the Negotiation of Aboriginal Self-Government*. Accessed January 16, 2006. http://www.ainc-inac.gc.ca/pr/pub/sg/plcy_e.html

Jain, Harish, Pabudyal Singh, and Carol Agocs. 2000. "Recruitment, Selection and Promotion of Visible Minority and Aboriginal Policy Officers in Selected Canadian Police Services." *Canadian Public Administration* 43(1): 46-74.

Jenson, Jane, and Martin Papillon. 2001. *The Changing Boundaries of Citizenship: A Review and Research Agenda*. Canadian Policy Research Networks. Accessed January 16, 2007. http://www.cprn.com/documents/2096_en.pdf

Kernerman, Gerald. 2005. *Multicultural Nationalism: Civilizing Difference, Constituting Community*. Vancouver: UBC Press.

Law Commission of Canada. 2004. *Voting Counts: Electoral Reform for Canada*.

Marshall, T.H. 1950. "Citizenship and Social Class." In *Citizenship and Social Class, and Other Essays*, edited by T.H. Marshall and Tom Bottomore. Cambridge: Cambridge University Press.

Milan, Anne, and Brian Hamm. 2004. "Mixed Unions." *Canadian Social Trends* 73. Statistics Canada, Catalogue no. 11-008-XIE.

Milner, Henry. 2002. *Civic Literacy: How Informed Citizens Make Democracy Work*. Hanover, NH: University Press of New England.

Myles, John, and Feng Hou. 2004. "Changing Colours: Spatial Assimilation and New Racial Minority Immigrants." *Canadian Journal of Sociology* 29(1): 29-58.

Pendakur, Krishna, and Ravi Pendakur. 2002. "Colour My World: Have Earnings Gaps for Canadian-Born Ethnic Minorities Changed over Time?" *Canadian Public Policy* 28(4): 489-512.

Pendakur, Ravi. 1999. *Lawyers, Damn Lawyers and Statistics: Visible Minority Representation in the Legal Profession*. Ottawa: Department of Canadian Heritage.

Penikett, Tony. 2006. *Reconciliation: First Nations Treaty Making in British Columbia*. Vancouver/Toronto/Berkeley: Douglas and McIntyre.

Phillips, Susan. 2006. "The Intersection of Governance and Citizenship in Canada: Not Quite the Third Way." *IRPP Policy Matters* 7(4).

Phillips, Trevor. 2005. "After 7/7: Sleepwalking to Segregation." Accessed January 16, 2007. http://www.cre.gov.uk/Default.aspx. LocID-0hgnew07r.RefLocID-0hg00900c001001.Lang-EN.htm

Picot, Garnett, and Arthur Sweetman. 2005. "The Deteriorating Economic Welfare of Immigrants and Possible Causes: Update 2005." Analytical Studies Branch Research Paper Series, Statistics Canada.

Picot, Garnett, and Feng Hou. 2003. "The Rise in Low-Income Rates among Immigrants in Canada." Analytical Studies Branch Research Paper Series, Statistics Canada, Catalogue no. 11F0019MIE.

Picot, Garnett, Feng Hou, and Simon Coulombe. 2006. "Chronic Low Income and Low-Income Dynamics among Recent Immigrants." Unpublished paper, Business and Labour Market Analysis Division, Statistics Canada, October.

Porter, John. 1965. *The Vertical Mosaic: An Analysis of Social Class and Power in Canada*. Toronto: University of Toronto Press.

Putnam, Robert B. 2000. *Bowling Alone: The Collapse and Revival of American Community*. New York: Simon and Schuster.

_____. 2004. "Who Bonds? Who Bridges? Findings from the Social Capital Benchmark Survey." Paper presented to the annual meeting of the American Political Science Association, Chicago, September 2-5.

Québec. Éducation, Loisir et Sport. 2006. "Le ministre Jean-Marc Fournier annonce la création d'un comité consultatif sur l'intégration et l'accomodement raisonnable en milieu scolaire." Accessed January 16, 2007. www.mels.gouv.qc.ca/CPRESS/cprss2006/c061011.asp#annexe

Reitz, Jeffrey G. 2005. "Tapping Immigrants' Skills: New Directions for Canadian Immigration Policy in the Knowledge Economy." *IRPP Choices* 11(1).

Royal Canadian Mounted Police. 2005. *Regular and Civilian Members – Employment Equity Report 2004-2005*. Accessed January 17, 2007. http://www.rcmp-grc.gc.ca/ee/rm_cm_2004-05_e.htm

Salée, Daniel. 2006. "Quality of Life of Aboriginal People in Canada: An Analysis of Current Research." *IRPP Choices* 12(6).

SEVEC. 2005. *Annual Report 2004-05*. Society for Educational Visits and Exchanges in Canada, Ottawa. Accessed January 16, 2007. www.sevec.ca/publications/AnnualReport0405-Program-Reports_e.pdf

Siggner, Andrew J., and Rosalinda Costa. 2005. "Aboriginal Conditions in Census Metropolitan Areas, 1981-2001." Trends and Conditions in Census Metropolitan Areas, Statistics Canada, Catalogue no. 89-613-MWE2005008.

Smith, Loretta. 2006. "Mending Fences: Increasing Aboriginal Representation in Canada." Paper presented to the annual meeting of the Canadian Political Science Association, York University, June 1-3.

Solon, Gary. 2002. "Cross-Country Differences in Intergenerational Earnings Mobility." *Journal of Economic Perspectives* 16(3): 59-66.

Soroka, Stuart N., John F. Helliwell, and Richard Johnston. 2007. "Measuring and Modelling Interpersonal Trust." In *Social Capital, Diversity, and the Welfare State*, edited by Fiona M. Kay and Richard Johnston. Vancouver: UBC Press.

Soroka, Stuart, Richard Johnston, and Keith Banting. 2007. "Ethnicity, Trust, and the Welfare State." In *Social Capital, Diversity, and the Welfare State*, edited by Fiona M. Kay and Richard Johnston. Vancouver: UBC Press.

Statistics Canada. 2003. "Ethnic Diversity Survey: Portrait of a Multicultural Society." September. Catalogue no. 89-593-XIE.

Sweetman, Arthur, and Stephan McBride. 2004. "Postsecondary Field of Study and the Canadian Labour Market Outcomes of Immigrants and Non-immigrants." Analytical Studies Branch Research Paper Series, Statistics Canada, Catalogue no. 11F0019MIE2004233.

Task Force on Modernizing Income Security for Working-Age Adults. 2006. *Time for a Fair Deal*. Toronto: St. Christopher House and Toronto City Summit Alliance.

TD Economics. 2005. *From Welfare to Work in Ontario: Still the Road Less Travelled*. Special report. Toronto: TD Bank Financial Group.

Thurow, Lester C. 1993. "Six Revolutions, Six Economic Challenges." *Toronto Star*, January 28, A21.

Tran, Kelly, Stan Kustec, and Tina Chui. 2005. "Becoming Canadian: Intent, Process and Outcome." *Canadian Social Trends* 76. Statistics Canada, Catalogue no. 11-008.

United Kingdom. Home Office. 2003. *The New and the Old: Report of the "Life in the United Kingdom" Advisory Group*. Accessed January 16, 2006. http://www.ind.homeoffice.gov.uk/6353/aboutus/thenewandtheold.pdf

Urquhart, Ian. 2006. "A First Step to Helping Skilled Immigrants." *Toronto Star*, November 22.

Wayland, Sarah V. 2006. "Unsettled: Legal and Policy Barriers for Newcomers to Canada." Community Foundations of Canada, Ottawa, and the Law Commission of Canada. Accessed January 16, 2007. http://www.cfc-fcc.ca/socialjustice/pdf/LegalPolicyBarriersReview.pdf

Williams, Melissa S. 2004. "Sharing the River: Aboriginal Representation in Canadian Political Institutions." In *Representation and Democratic Theory*, edited by David Laycock. Vancouver: UBC Press.

Yasmeen Abu-Laban is an associate professor in the Department of Political Science at the University of Alberta. Abu-Laban has published widely in national and international journals on the Canadian and comparative dimensions of gender and ethnic politics, nationalism and globalization, immigration policies and politics, and citizenship theory. In addition, she is coauthor (with Christina Gabriel) of *Selling Diversity: Immigration, Multiculturalism, Employment Equity and Globalization*.

Rupa Banerjee is a doctoral candidate at the Centre for Industrial Relations and Human Resources at the University of Toronto. Her primary research interest lies in the economic and social integration of new immigrants to Canada. In addition, she is interested in workplace diversity and discrimination. Prior to entering the doctoral program, Banerjee served as the diversity and employment equity coordinator for General Electric Canada.

Keith Banting holds the Queen's Research Chair in Public Policy in the School of Policy Studies and the Department of Political Studies at Queen's University. His research interests focus on public policy in Canada and other Western nations, and he is the author or editor of over a dozen books on social policy, federalism and constitutional reform. His current research focuses on ethnic diversity and social policy, and he is coeditor of *Multiculturalism and the Welfare State: Recognition and Redistribution in Contemporary Democracies* (Oxford University Press, 2006). Banting was appointed a member of the Order of Canada in February 2005.

Marion Boyd was MPP for London Centre, Ontario, from 1990 to 1995. A member of the executive council throughout the Bob Rae government, she was minister of education (1990-91), of community and social services (1991-93) and of women's issues (1991-95). She was the first woman and nonlawyer attorney general (1993-95). She was a member and chair of the board of directors of the London Cross Cultural Learner Centre from 1984 to 1990. Since leaving politics, Boyd has served two terms on the Criminal Injuries Compensation Board and led the Task Force on the Health Effects of Woman Abuse. She conducted a review of the *Arbitration Act* for Ontario's attorney general and the minister responsible for women's issues, publishing a report entitled *Dispute Resolution in Family Law: Protecting Choice, Promoting Inclusion*.

Thomas J. Courchene is Jarislowsky-Deutsch Professor of Economic and Financial Policy at Queen's University; a member of the Department of Economics, the School of Policy Studies and the Faculty of Law; and director of the John Deutsch Institute for the Study of Economic Policy. From 1965 to 1988 he was a professor of economics at the University of Western Ontario. Courchene spent the fall term of 1986 as a visiting professor at the École nationale d'administration publique (Montreal). For the academic year 1987-88 he occupied the John P. Robarts Chair in Canadian Studies at York University. From 1988 to 1992 he was director of the School of Policy Studies at Queen's University.

Pearl Eliadis is a human rights lawyer specializing in democratic development and national institutions. She served on four UN missions to Rwanda, working on the Unity and Reconciliation Commission in the aftermath of the genocide. In 2006 she chaired the Human Rights Task Force for the Renewal Commission (Liberal Party of Canada). From 1995 to 2001 she was director of policy and education at the Ontario Human Rights Commission, and from 1990 to 1995 she was president of Equitas, Canada's leading human rights education NGO. Eliadis has published several books, reports and articles, including *International Human Rights Law: Theory and Practice* (with Irwin Cotler, 1992), the report *Policy and Exclusion: Normative Approaches to Policy Research*, and *Designing Government* (2005). She received the Women of Distinction Award in 2006 and the 1992 Canada 125 Medal for community service.

Bonnie H. Erickson is a professor of sociology at the University of Toronto. She studied at the University of British Columbia and at Harvard University. Her research interests include social networks, culture and inequality (especially class, gender and ethnic stratification). Current projects include a comparison of gender stratification and gender differences in social networks in Canada and Japan; how social networks, voluntary associations and individual characteristics affect tolerance for minority groups in Canada; and social and cultural capital within and between major ethnic groups in Toronto, and how such capital affects individual success in work and group success in public perception and political views.

Katherine Graham is a professor and dean of the Faculty of Public Affairs at Carleton University. Her interests are in the field of public policy and the manage-

ment of government, including policy and program evaluation. She has focused these interests on local government, Aboriginal policy and civic engagement. She has served as an adviser to all three levels of government in Canada and to governments abroad. She is also an experienced facilitator, having served in this capacity for Canadian Heritage, Justice Canada and the Canadian International Development Agency, among others. She serves as an academic resource to the Aboriginal Leadership Institute and the Canadian Bureau for International Education.

Joyce Green is an associate professor of political science at the University of Regina, where she teaches Canadian politics and critical theory and researches questions relating to colonialism and decolonization in Canada. Green is editor of *Making Space for Aboriginal Feminism* (Halifax: Fernwood), due to be published in 2007. Her most recent publication is "From *Stonechild* to Social Cohesion: Anti-Racist Challenges for Saskatchewan," *Canadian Journal of Political Science* (September 2006).

Randall Hansen is an associate professor and Canada Research Chair in Immigration and Governance in the Department of Political Science at the University of Toronto. His published works include *Citizenship and Immigration in Post-War Britain* (2000); *Towards a European Nationality* (2001); *Dual Nationality, Social Rights, and Federal Citizenship in the U.S. and Europe* (2002); *Immigration and Asylum from 1900 to the Present* (2005); and articles on immigration, citizenship, and asylum published in *World Politics*, *Comparative Political Studies*, and the *European Journal of Political Research*.

Marc Hooghe is an associate professor of political science at the Catholic University of Leuven (Belgium). He obtained Ph.Ds in political science and sociology, and he has published widely on social capital, social cohesion and political participation. Recently, his work has appeared in *Electoral Studies*, *Party Politics*, the *European Journal of Political Research*, *Scandinavian Political Studies* and the *British Journal of Political Science*. He is president of the Belgian Political Science Association and editor of *Acta Politica: International Journal of Political Science*.

Paul Howe is an associate professor in the Department of Political Science at the University of New Brunswick. Before joining UNB in 2001, he was research director

of the Governance Program at the Institute for Research on Public Policy. He is co-editor of *Judicial Power and Canadian Democracy* and *Strengthening Canadian Democracy* and author of numerous journal articles. His current research examines patterns of civic participation in Canada and other countries, with a particular focus on the political disengagement of young Canadians.

Richard Johnston is professor of political science and research director of the National Annenberg Election Study at the University of Pennsylvania. He has also taught at the University of British Columbia. He is author or coauthor of five books, coeditor of three books and author or coauthor of over 50 articles and chapters. He was principal investigator of the 1988 and 1992-93 *Canadian Election Survey* and director of surveys for the *Equality, Security, and Community* research group.

Christian Joppke is a professor of political science at the Graduate School of Government at the American University of Paris. Previously he held appointments at the University of Southern California, Los Angeles (1990-94), the European University Institute, Florence (1994-2002), the University of British Columbia (2003-04), and International University Bremen (2004-06). His research areas are political sociology and comparative politics, focusing on citizenship and immigration, ethnic and race relations, and social movements and the state. He has written or edited numerous books and articles, most recently *Selecting by Origin: Ethnic Migration in the Liberal State* (2005).

Sheema Khan obtained a B.Sc. in chemistry from McGill University, and an AM in physics and a Ph.D. in chemical physics from Harvard University. She has worked as a research scientist in drug delivery technology and is currently a patent agent with an Ottawa law firm. She writes a column for the *Globe and Mail* on issues pertaining to Muslims in Canada. Khan has testified before Commons and Senate committees regarding the media, security and civil liberties. She served on an expert witness panel on the aftermath of 9/11 for the Canadian Muslim community for the Arar Commission. She chairs the Canadian Council on American-Islamic Relations (CAIR-CAN) and sits on the board of the Canadian Civil Liberties Association.

Will Kymlicka received his BA in philosophy and politics from Queen's University in 1984 and his D.Phil. in philosophy from the University of Oxford

in 1987. He is the author of *Liberalism, Community, and Culture* (1989), *Contemporary Political Philosophy* (1990; second edition 2002), *Multicultural Citizenship* (1995), *Finding Our Way: Rethinking Ethnocultural Relations in Canada* (1998) and *Politics in the Vernacular: Nationalism, Multiculturalism, Citizenship* (2001). He is currently the Canada Research Chair in Political Philosophy at Queen's University and a visiting professor in the Nationalism Studies Program at the Central European University in Budapest. He is a fellow of the Royal Society of Canada and the Canadian Institute for Advanced Research.

David Ley is Canada Research Chair of Geography at the University of British Columbia, a fellow of the Pierre Trudeau Foundation and a fellow of the Royal Society of Canada. He is an urban geographer whose work on immigration and urbanization has appeared in recent issues of *Global Networks, Annals of the Association of American Geographers, Urban Studies, Journal of Ethnic and Migration Studies* and *Transactions of the Institute of British Geographers*. He is writing a book entitled *Millionaire Migrants*, a study of wealthy immigrants to Canada from East Asia.

Roger Maaka is head of the Department of Native Studies at the University of Saskatchewan. He was head of the Maori Department at the University of Canterbury, New Zealand. He is a member of the Waitangi Tribunal for the Indigenous Flora and Fauna and Intellectual Property Enquiry. His research interests include urbanization and indigenous people, Native/indigenous studies as an academic discipline, post-treaty settlement development, the construction of contemporary indigenous identities and indigeneity as a global social movement.

Marie Mc Andrew is a professor in the Department of Education and Administration of Education Studies at the University of Montreal. In 1989-91 she was an adviser to the deputy minister at the Quebec Ministère des Communautés culturelles et de l'Immigration. In 1996-2002 she was director of Immigration and Metropolis at the Inter-university Research Centre of Montreal on Immigration, Integration and Urban Dynamics. Mc Andrew coordinates the Groupe de recherche sur l'ethnicité et l'adaptation au pluralisme en éducation, an interdisciplinary research team working in partnership with the Ministère de l'Éducation, the Ministère des Relations avec les citoyens et de l'Immigration and several school boards on the island of Montreal. Her book *Immigration et diversité à l'école: le débat*

québécois dans une perspective comparative won the Donner Prize in 2001. She has held the Chair for Ethnic Relations since 2003. In June 2005, she received the Prix québécois de la citoyenneté Jacques-Couture pour le rapprochement interculturel.

R. Roy McMurtry was elected to the Ontario legislature in 1975. He was appointed to the cabinet of Premier William G. Davis as the attorney general for Ontario, a position he held until 1985. McMurtry played a major role in the patriation of the Canadian Constitution in 1982 and the creation of the Canadian Charter of Rights. The Ontario legislature passed more than 50 law reform statutes that he introduced as attorney general, including the first major family law reform legislation in Canada and the legislation creating a bilingual court system. From 1978 to 1982 McMurtry served as the solicitor general for Ontario. From 1985 until 1988 McMurtry was Canada's high commissioner to Great Britain. In 1991 he was appointed associate chief justice, and in 1994 chief justice of the Superior Court, Trial Division. In February 1996 he was appointed chief justice of Ontario.

Ian Peach is currently the director of the Saskatchewan Institute of Public Policy. A constitutional lawyer by training, Peach has previously worked for the governments of Ontario, Canada and Yukon, and for the past nine years he has worked for the Government of Saskatchewan. He has extensive experience as a policy-maker and negotiator on constitutional, Aboriginal self-government and Aboriginal economic development issues, among other areas.

Evelyn Peters completed her BA (honours) at the University of Winnipeg and her MA and Ph.D. in geography at Queen's University. Between 1990 and 1993 she held a postdoctoral Canada Research Fellowship. Upon completing her doctoral degree, she taught at Carleton University for one year, before taking up a tenure stream appointment at Queen's University. In 1994-95 she worked as a policy analyst on urban Aboriginal issues with the Royal Commission on Aboriginal Peoples. In 2001 she moved to the Department of Geography, University of Saskatchewan, to take up a Canada Research Chair. An urban social geographer by trade, she has focused in her research on Aboriginal people.

Susan Phillips is a professor and director of the School of Public Policy and Administration at Carleton University, where she has held a faculty position since

1988. She is also senior research scholar with the Centre for Voluntary Sector Research and Development at Carleton. Phillips's recent work has focused on a comparative analysis of models of shared governance and regulation of the third sector. In 1998 her coauthored article on gender and public administration received the J.E. Hodgetts Award for the best paper published in English in *Canadian Public Administration*. From 2000 to 2005 she served as the codirector of the Voluntary Sector Evaluation Research Project, a Community-University Research Alliance (CURA) project supported by the Social Sciences and Humanities Research Council and the Max Bell Foundation.

Tariq Ramadan is a visiting professor at St. Antony's College, Oxford University, and a senior research fellow at the Lokahi Foundation. Ramadan taught Islamic studies and philosophy at the University of Fribourg and the College of Geneva. He was professor of Islamic studies and Luce Professor of Religion, Conflict and Peace-Building at the Kroc Institute of the University of Notre Dame in the United States (2004). He had to resign that post because the US administration revoked his visa. He has authored or coauthored over 20 books and 700 articles. Ramadan serves as an expert on various commissions linked to the European Parliament in Brussels, and he was appointed to the task force that Prime Minister Tony Blair established following the July bombing attacks in London.

Tim Reeskens is a Ph.D. student at the Catholic University of Leuven (Belgium), where he works on the relationship among diversity, integration regimes and social cohesion. He obtained MAs in sociology and in quantitative methods. His research interests include social cohesion, diversity, methodology and sociology of religion. Recently his work has been published in *Patterns of Prejudice* and *Tijdschrift voor Sociologie*.

Jeffrey G. Reitz, FRSC, is R.F. Harney Professor of Ethnic, Immigration and Pluralism Studies at the Munk Centre for International Studies, University of Toronto. His research has examined immigration, race and ethnic relations in cross-national comparative perspective. His earlier book *Warmth of the Welcome: The Social Causes of Economic Success for Immigrants in Different Nations and Cities* (1998) provided the framework for more recent work including "Canada: Immigration and Nation-Building in the Transition to the Knowledge Economy" (2004) and "Tapping Immigrants' Skills: New Directions for Canadian Immigration Policy in the Knowledge Economy" (2005).

John Richards served as a member of Allan Blakeney's government in Saskatchewan in the 1970s. He is trained as an economist and is a member of the faculty in the new Simon Fraser University Public Policy Program. He has written extensively on social policy in Canada, and he holds the Roger Phillips Chair in Social Policy at the C.D. Howe Institute. His most recent book is *Creating Choices: Rethinking Aboriginal Policy*. He coedits *Inroads*, a Canadian policy journal. In addition, he has taught and conducted research in Bangladesh over the last decade. He heads the Centre for Policy Research, an institute linked to the International University of Business Agriculture and Technology in Dhaka.

Daniel Salée is a professor of political science and principal of the School of Community and Public Affairs at Concordia University. He also serves as co-director of the Concordia-UQAM Chair in Ethnic Studies. He is a member of the UQAM-based Centre de recherche sur l'immigration, l'ethnicité et la citoyenneté (CRIEC). His research has focused mainly on the politics of the relations between the French-speaking majority and members of linguistic, cultural, racialized and immigrant minorities and First Peoples in Quebec. His most recent work explores the interface between the national question and citizenship and the politics of state/First Peoples relations in Quebec and Canada.

Leslie Seidle is senior research associate at the Institute for Research on Public Policy. He previously held senior positions within the Government of Canada and was senior research coordinator for the Royal Commission on Electoral Reform and Party Financing (1990-91). He has published a wide range of book chapters and articles on electoral processes, institutional and constitutional reform and public management, and is the editor or coeditor of numerous books on these issues, including *Reforming Parliamentary Democracy* (2003).

Stuart Soroka is an associate professor and William Dawson Scholar in the Department of Political Science at McGill University, and director of the Canadian Opinion Research Archive at Queen's University. His research focuses on the links between public opinion, public policy and mass media. He is the author of *Agenda-Setting Dynamics in Canada* (2002), and his work has been published in journals including the *Journal of Politics*, the *British Journal of Political Science*, the *Canadian Journal of Political Science* and the *Policy Studies Journal*.

Dietlind Stolle is an associate professor in political science at McGill University. She conducts research in the areas of voluntary associations, trust, institutional foundations of social capital and new forms of political participation. Her work has appeared in *American Behavioral Scientist*, the *British Journal of Political Science*, the *International Review of Political Science, Party Politics, Political Behavior, Political Psychology* and various edited volumes. She coedited *Generating Social Capital: Civil Society and Institutions in Comparative Perspective* (with Marc Hooghe, 2003).

Zoua M. Vang is a Ph.D. candidate in sociology at Harvard University. She holds an MA in sociology from Harvard and a BA in psychology and sociology from the University of Pennsylvania. Vang is also a doctoral fellow with the Multidisciplinary Program on Social Policy and Inequality at the Kennedy School of Government. Her research interests are in immigration, comparative race and ethnicity, urban sociology, crime and violence, health disparities and social policy. She is the recipient of a National Institutes of Health National Service Research Award, several National Science Foundation funded research grants, the Aage Sorenson Memorial Award and several dissertation fieldwork grants from the Harvard Center for European Studies, the Rappaport Center for Greater Boston and the American Society of Criminology.

Mary C. Waters is the M.E. Zukerman Professor of Sociology at Harvard University, where she has taught since 1986. She is the author or editor of numerous books and articles on ethnicity, race relations and immigration, including *The New Americans: A Guide to Immigration since 1965* (2007) and the award-winning *Black Identities: West Indian Immigrant Dreams and American Realities* (1999). She is a director of the New York Second Generation Project, a large study of young adults in New York City. This research is summarized in two books, *Becoming New Yorkers: Ethnographies of the New Second Generation* (2004) and *The Second Generation Advantage: The Children of Immigrants Inherit the City* (forthcoming). Her new research compares the education of immigrants and their children in the United States and Great Britain.

MEMBER OF SCABRINI GROUP

Québec, Canada
2007